OTHER A TO Z GUIDES FROM
THE SCARECROW PRESS, INC.

0 4 17
6.

t, Mary
r., 2006
ng Ho-

yssides,

s, 2006.
ane H.

07.
yton R.

)07.
ith Ian

55. *The A to Z of the War of 1812* by Robert Malcomson, 2009.
56. *The A to Z of Feminist Philosophy* by Catherine Villanueva Gardner, 2009.
57. *The A to Z of the Early American Republic* by Richard Buel Jr., 2009.
58. *The A to Z of the Russo–Japanese War* by Rotem Kowner, 2009.
59. *The A to Z of Anglicanism* by Colin Buchanan, 2009.
60. *The A to Z of Scandinavian Literature and Theater* by Jan Sjåvik, 2009.
61. *The A to Z of the Peoples of the Southeast Asian Massif* by Jean Michaud, 2009.
62. *The A to Z of Judaism* by Norman Solomon, 2009.
63. *The A to Z of the Berbers (Imazighen)* by Hsain Ilahiane, 2009.
64. *The A to Z of British Radio* by Seán Street, 2009.
65. *The A to Z of The Salvation Army* by Major John G. Merritt, 2009.
66. *The A to Z of the Arab–Israeli Conflict* by P R Kumaraswamy, 2009.
67. *The A to Z of the Jacksonian Era and Manifest Destiny* by Terry Corps, 2009.
68. *The A to Z of Socialism* by Peter Lamb and James C. Docherty, 2009.
69. *The A to Z of Marxism* by David Walker and Daniel Gray, 2009.
70. *The A to Z of the Bahá'í Faith* by Hugh C. Adamson, 2009.
71. *The A to Z of Postmodernist Literature and Theater* by Fran Mason, 2009.
72. *The A to Z of Australian Radio and Television* by Albert Moran and Chris Keating, 2009.
73. *The A to Z of the Lesbian Liberation Movement: Still the Rage* by JoAnne Myers, 2009.
74. *The A to Z of the United States–Mexican War* by Edward H. Moseley and Paul C. Clark Jr., 2009.
75. *The A to Z of World War I* by Ian V. Hogg, 2009.
76. *The A to Z of World War II: The War Against Japan* by Anne Sharp Wells, 2009.
77. *The A to Z of Witchcraft* by Michael D. Bailey, 2009.
78. *The A to Z of British Intelligence* by Nigel West, 2009.
79. *The A to Z of United States Intelligence* by Michael A. Turner, 2009.

The A to Z of Renaissance Art

Lilian H. Zirpolo

The A to Z Guide Series, No. 93

The Scarecrow Press, Inc.
Lanham • Toronto • Plymouth, UK
2009

Published by Scarecrow Press, Inc.
A wholly owned subsidiary of
The Rowman & Littlefield Publishing Group, Inc.
4501 Forbes Boulevard, Suite 200, Lanham, Maryland 20706
http://www.scarecrowpress.com

Estover Road, Plymouth PL6 7PY, United Kingdom

British Library Cataloguing in Publication Information Available

Library of Congress Cataloging-in-Publication Data

The hardback version of this book was cataloged by the Library of Congress as
follows:

Zirpolo, Lilian H.
 Historical dictionary of Renaissance art / Lilian H. Zirpolo.
 p. cm. — (Historical dictionaries of literature and the arts ; no. 21)
 Includes bibliographical references.
 1. Art, Renaissance—Dictionaries. 2. Artists—Biography—Dictionaries.
 I. Title.
 N6370.Z57 2008
 709.02'403—dc22 2007022350

ISBN 978-0-8108-6880-9 (pbk. : alk. paper)
ISBN 978-0-8108-7043-7 (ebook)

♾™ The paper used in this publication meets the minimum requirements of
American National Standard for Information Sciences—Permanence of Paper
for Printed Library Materials, ANSI/NISO Z39.48-1992.

Printed in the United States of America

Contents

Editor's Foreword

The subseries on visual art in the series Historical Dictionaries of Literature and the Arts starts off auspiciously with this volume on what is probably the most important and best-known—and also most popular—period of Western art. It was, as its name denotes, a period of rebirth, reaching back to models dating from antiquity, but also a period of nearly frantic innovation and creativity that affected, among other things, painting, sculpture, and architecture. It was dominated by the towering figures of Leonardo da Vinci, Michelangelo, Raphael, and Titian. And it left an incredible artistic heritage, including, among so many other examples that most people have seen in one way or another, the *Mona Lisa*, the Sistine ceiling, and the statue of *David*, to say nothing of the Cathedral of Florence and other notable buildings. Although this period, which stretched roughly from 1250 to 1648, now lies several centuries back in our history, its imposing influence can still be felt today.

This makes *The A to Z of Renaissance Art* particularly welcome, for it provides an abundance of useful information, starting with a chronology that traces the major events over some four centuries. The introduction then offers an overview of the period and its achievements. But the dictionary section, which readers will probably wish to peruse more than just once, is the core of the work, with literally hundreds of entries on significant painters, sculptors, architects, and a varied cast of patrons, from emperors and kings on down to the not-so-fortunate middle and lower classes. There are also entries on major themes, techniques, and technical terms, to say nothing of those selections that describe outstanding works of art. Admittedly, there are relatively few illustrations, but otherwise it would never have been possible to include so much information on so many people and works—not just those with whom we are already familiar but also lesser lights who sometimes go unnoticed in the illustrated works but without whom the Renaissance would never

xiii

have been as rich as it was. Moreover, this book ends with an extensive bibliography that directs readers to other valuable sources.

Compiling such a volume was obviously a major project, and it is hard to imagine how only one person could have written it, but this was the impressive achievement of Lilian H. Zirpolo. Dr. Zirpolo studied art history at Rutgers University, has published articles in leading art journals as well as one book, *Ave Papa/Ave Papabile*, and is working on two more books. During her busy career, she also cofounded the WAPACC Organization and *Aurora, the Journal of the History of Art*. Although she specializes in the art of early modern Italy and Spain, in this historical dictionary she has managed to cover the whole scope of the Renaissance, from start to finish, wherever it was present. Amazingly, this is done in a literate but congenial style that can be read and enjoyed by specialists, artists, historians, and anyone else who is interested—all of whom should be pleased to have this handy guide to such an important period in the history of art.

Jon Woronoff
Series Editor

Preface

The Renaissance was an era of artistic awakening. The recovery of the Greco-Roman heritage from the East and the Byzantine examples imported to the West inspired artists to abandon the modestly scaled, abstracted representations of the Middle Ages in favor of monumental images that blatantly reflected their abilities. Artists, in fact, began to sign their works with great pride because the achievement of the individual was now celebrated, an honor earlier denied by the collectivist mind-set that had permeated the medieval era. The old techniques from the ancients were revived and new ones were developed to achieve greater verism. Although the art of the Renaissance still functioned as object for religious devotion and instruction, secular themes were introduced as well. No longer merely a utilitarian object, art became a pricey commodity that could be collected, sold, gifted, and appreciated purely for its aesthetic qualities. Much of the Renaissance impulse was determined by rivalries among artists as well as patrons who wished to outshine each other, rivalries that resulted in some of the most remarkable achievements in the history of art.

To attempt to condense the history of Renaissance art into a reference book such as this is a major challenge. Therefore, I have had no other option but to be very selective. The most important artists of the era, major patrons, and key Renaissance masterpieces are certainly included. Important events in history that may have either affected the production of art or that place the material at hand in its proper historical context, as well as art technique and the most often rendered subjects are also featured. The Renaissance inaugurated the concept of recording the lives of the artists and their activities in biographical compendia. It was also a time when masters theorized about art and architecture and recorded their thoughts in writing. Therefore, entries on these themes also figure in the dictionary. However, I have had to

exclude most of the material pertaining to the rich history of manu-script illumination in Northern Europe, a decision based on the fact that many of these objects were rendered by anonymous masters. Also missing are entries on Netherlandish and German architecture since, for the most part, it remained essentially Gothic.

Aside from factual material, I have written on the formal aesthetic qualities of each work discussed, as these reveal the unique expressive power of each one of the masters who created them. It is my hope that readers will see this book not merely as reference tool but also as a springboard to further research.

Acronyms and Abbreviations

CE	Common Era
BCE	Before the Common Era
bef.	before
beg.	begun in
c.	circa
Cod.	Codex
d.	died
fin.	finished in
fol.	folio
Fr.	French
Gall.	Gallo
Lat.	Latin
Ms.	manuscript
r.	reigned
v.	verso

Chronology

1204 Byzantium: The Crusaders conquer Byzantium, resulting in the rediscovery by the West of ancient Greek texts.

1209 Italy: St. Francis establishes the Franciscan Order. The rule of the order receives confirmation in 1223 from Pope Honorius III.

1253 Italy: Building of the Church of San Francesco in Assisi is completed.

1255 Italy: Nicola Pisano begins work on the pulpit of the Baptistery of Pisa.

1260 Italy: The Monteaperti Battle between Siena and Florence takes place. The Sienese defeat the Florentine army, they dedicate their city to the Virgin to thank her for her protection, and begin construction of the Siena Cathedral in her honor. St. Bonaventure begins work on his *Legenda Maior*, the official life of St. Francis. In c. 1260, Jacopo da Voragine composes the *Golden Legend*.

1265 Italy: Charles d'Anjou claims the kingdom of Naples. Nicola Pisano receives the commission for the pulpit of the Cathedral of Siena.

1278 Italy: Nicola Pisano works on the exterior sculptures of the Baptistery of Pisa and completes the Fontana Maggiore in Perugia. The original *Sancta Sanctorum* in Rome is destroyed by an earthquake. Nicholas III has it rebuilt.

1279 Italy: Construction of the Church of Santa Maria Novella in Florence begins. Cimabue works on the frescoes in the Upper Church of San Francesco, Assisi, sometime after 1279.

1285 Italy: Giovanni Pisano begins work on the Cathedral of Siena façade. He surrenders his Pisan citizenship to become a citizen of Siena.

Duccio receives the commission for the *Rucellai Madonna* from the Confraternity of the Laudesi to be placed in the Church of Santa Maria Novella, Florence. In c. 1285, Giotto begins work on the *Crucifixion* for the Church of Aracoeli, Rome. **Spain:** Charles of Valois, son of Philip III the Bold, is crowned king of Aragon by Cardinal Jean Cholet.

1287 Italy: The Council of Nine assumes power in Siena. In c. 1287, Giotto works on the scenes from the life of St. Francis in the Upper Church of San Francesco, Assisi. These are based on St. Bonaventure's *Legenda Maior*.

c. 1290 Italy: Cardinal Bertoldo Stefaneschi commissions mosaics from Cavallini for the apse of Santa Maria in Trastevere, Rome. Cavallini also receives the commission to paint the *Last Judgment* at Santa Cecilia in Trastevere, Rome, from Cardinal Jean Cholet.

1293 Italy: Cardinal Jean Cholet commissions Arnolfo di Cambio to create a baldachin for the main altar of Santa Cecilia in Trastevere, Rome.

1294 Italy: Jacopo Torriti works on the mosaics at Santa Maria Maggiore, Rome. Construction of the Church of Santa Croce, Florence, begins, possibly under Arnolfo di Cambio's direction.

1295 Italy: The Visconti become the rulers of Milan.

1296 Italy: Construction of the Cathedral of Florence begins under the direction of Arnolfo di Cambio.

1297 Italy: Ottone Visconti, archbishop of Milan, arranges for the appointment of his great-nephew Matteo Visconti as *Capitano del Popolo*. With this, Matteo becomes lord of Milan. **France:** A Duch de Siene is documented in Paris. He is believed to be Duccio, who has traveled to Paris to obtain firsthand knowledge of French Gothic art.

1298 Italy: Construction of the Palazzo Pubblico in Siena, the city's seat of government, is initiated.

1299 Italy: Arnolfo di Cambio begins construction of the Palazzo Vecchio in Florence, the city's governmental building.

1300 Italy: In Florence, the Guelfs split into two factions, the Bianchi and Neri. Two years later, the Neri seize power and expel the Bianchi,

among them the poet Dante. In c. 1300, Giotto and Arnolfo di Cambio are in Rome working for Pope Boniface VIII.

1301 Italy: Giovanni Pisano executes the pulpit for Sant' Andrea in Pistoia.

1303 Italy: Pope Boniface VIII attempts to stop the hostilities between France and England over the fiefs of Guienne and Gascony. His efforts result in a major quarrel with Philip IV of France, whom he excommunicates. The pope is seized by Philip's advisor, Guillaume de Nogaret, the feudal Colonna family of Rome, and a group of mercenaries who demand his resignation. The Roman populace rescues Boniface and he is able to continue his reign with the protection of the Orsini, staunch enemies of the Colonna.

1305 Italy: Giotto works on the frescoes of the Arena Chapel in Padua, commissioned by Enrico Scrovegni as his family's private place of devotion.

c. 1307 Italy: Giotto paints the *Stefaneschi Altarpiece* for Cardinal Jacopo Stefaneschi to be placed in the canon's choir at Old St. Peter's in Rome. Giotto also renders for the cardinal the *Navicella* in the courtyard façade of Old St. Peter's.

1308 Italy: Dante works on the *Divine Comedy*, which will prove to be a major influence on art, especially in representations of the *Last Judgment*. Duccio begins work on the *Maestà Altarpiece*. Lorenzo Maitani arrives in Orvieto to work on the cathedral.

1309 Italy: Robert D'Anjou becomes king of Naples. **France:** Pope Clement V moves the seat of the papacy to Avignon, thus initiating the Babylonian Captivity, which will last until 1377. **Germany:** Henry VII of Luxemburg is crowned king of Germany.

1311 Italy: Margaret, wife of Henry VII of Luxemburg, dies in Genoa. Giovanni Pisano works on her monument in the Church of San Francesco in Castelleto. Simone Martini begins work on the *Maestà* fresco in the Council Chamber of the Palazzo Pubblico, Siena.

1317 Italy: St. Louis of Toulouse is canonized. To commemorate the event, his brother, Robert D'Anjou, king of Naples, commissions Simone

Martini to render the *St. Louis of Toulouse Altarpiece*. Lippo Memmi paints the *Maestà* in the Palazzo Comunale di San Gimignano.

1323 Italy: St. Thomas Aquinas is canonized by Pope John XXII. **France:** Pucelle begins work on the *Belville Breviary*. **Spain:** The Count of Orgáz, benefactor of the Church of San Tomé and the Augustinian Monastery of San Esteban in Toledo, dies and supposedly Sts. Augustine and Stephen (Esteban) descend from heaven to bury him, the scene El Greco will depict in 1586 for San Tomé.

1325 Italy: Pietro Lorenzetti begins work on the scenes from Christ's Passion in the transept of the Lower Church of San Francesco in Assisi. In c. 1325, Giotto works on the Bardi Chapel in the Church of Santa Croce, Florence. **France:** Jean Pucelle begins work on the *Hours of Jeanne d'Evreux*.

1328 Italy: Luigi Gonzaga is elected Captain General of the People and thus becomes the ruler of Mantua. Giotto arrives in Naples to work for Robert D'Anjou for whom he paints scenes in the Castel Nuovo. In c. 1328, Simone Martini paints the frescoes in the Montefiore Chapel in the Lower Church of San Francesco in Assisi.

1330 Italy: Andrea Pisano receives the commission for the bronze doors of the Baptistery of Florence. In the 1330s, Francesco Traini paints the *Triumph of Death* in the Campo Santo in Pisa, and Bernardo Daddi begins work on the Pulci Chapel at Santa Croce, Florence.

1333 Italy: Simone Martini paints the *Annunciation* for the Cathedral of Siena, with Lippo Memmi executing the outer panels. The Arno River floods and Taddeo Gaddi provides plans to rebuild the Ponte Vecchio and Ponte Trinità in Florence. **France:** Petrarch recovers Cicero's *Pro Archia* in Liège.

1334 Italy: Giotto returns to Florence from Naples and is appointed Director of the Cathedral Works. He begins construction of the cathedral's campanile.

1335 Italy: Ambrogio Lorenzetti begins work on the *Maestà Altarpiece* for the high altar of the Church of Sant' Agostino in Massa Marittima. **France:** Simone Martini arrives in the papal court in Avignon, bringing the Sienese mode of painting to the region and thus inaugurating the International Style.

1337 Italy: Francesco Talenti, Neri Fioravanti, and Benci di Cione work on the construction of Orsanmichele in Florence.

1338 Italy: Ambrogio Lorenzetti paints the *Allegory of Good and Bad Government* in the Palazzo Pubblico in Siena.

1340 Italy: In Venice, the Doge's Palace is constructed. Taddeo Gaddi paints the frescoes in the refectory of the Church of Santa Croce, Florence. In the 1340s, Francesco Traini paints the *Triumph of St. Thomas* in the Church of Santa Caterina in Pisa, and Maso di Banco works on the Bardi di Vernio Chapel in Santa Croce, Florence. **France:** In the 1340s, Simone Martini paints frescoes of the *Blessing Christ* and *Madonna of Humility* for Cardinal Jacopo Stefaneschi in the Church of Notre-Dame-des-Doms in Avignon. He also works on his *Road to Calvary*.

1341 Italy: Petrarch is crowned poet laureate on the Capitoline Hill, Rome, in the manner of the ancients.

1345 Italy: Doge Andrea Dandolo makes additions to the *Pala d'Oro* altarpiece in Venice. Petrarch recovers Cicero's letters in Verona.

1346 Italy: The Bardi and Peruzzi banks in Florence go bankrupt as Edward III of England and other international rulers default on their loans.

1348 Italy: The Black Death strikes, decimating the European population. In Italy, the event has a grave impact on art. Andrea Pisano, Pietro and Ambrogio Lorenzetti, and Bernardo Daddi die from the plague. Andrea da Firenze begins work on the Guidalotti Chapel in Santa Maria Novella, Florence. **France:** Queen Joanna I of Sicily, Countess of Provence, sells Avignon to the papacy, an ownership that will last until 1791 when the city is incorporated into the French territory.

c. 1350 Italy: Boccaccio begins work on the *Decameron*.

1355 Italy: In Siena, the Council of Nine falls from power. Andrea Orcagna and Nardo del Cione begin work on the Strozzi Chapel at Santa Maria Novella, Florence.

1356 Germany: Emperor Charles IV draws up a constitution assigning seven electors to be in charge of selecting Germany's emperors. This prevents the establishment of a centralized form of government in the region.

1358 **Italy:** Orcagna is documented in Orvieto supervising the execution of the mosaics on the cathedral's façade.

1360 **Italy:** Giangaleazzo Visconti of Milan marries Isabelle of Valois, daughter of King John II of France, whose dowry includes land in the Champagne region. He thus establishes monarchic ties that ensure his position of power. **France:** Jean, son of King Jean II the Good, receives the Duchies of Berry and Auvergne from his father. In c. 1360, André Beauneveu enters in the service of Charles V of France. Philip the Bold receives the Duchy of Touraine.

1363 **Burgundy:** Philip the Bold receives the Duchy of Burgundy as reward for his participation in the Battle of Poitiers against England.

1364 **Italy:** The Battle of Cascina between Florence and Pisa takes place. Florence wins. The event will be commemorated later by Michelangelo in a fresco in the Sala del Consiglio in the Palazzo Vecchio, Florence.

1370s **Italy:** Bonifazio Lupi commissions Altichiero to paint the frescoes in the Chapel of St. James at San Antonio in Padua.

1374 **France:** André Beauneveu enters in the service of Louis de Mâle, Count of Flanders.

1377 **Italy:** Altichiero frescoes the Oratory of St. George in Padua for Raimondo Lupi. **France:** The Babylonian Captivity in Avignon ends.

1378 **Italy:** The Great Schism begins. The Ciompi, the woolen industry's day laborers in Florence, revolt for not being allowed to form a guild. They force the Florentine government to grant them guild status and to institute legislations to improve their living standards. A few weeks later, the legislations are rescinded.

1380 **France:** Jean, Duke of Berry, becomes a member of the regency council for his nephew Charles VI, heir to the French throne. André Beauneveu enters in the duke's service and begins work on 24 illustrations of apostles and prophets in the *Psalter of the Duke of Berry*. Jean Bondol works on the *Bible of Jean de Sy*.

1382 **Italy:** The Albizzi return to Florence after their exile in 1378 and establish an oligarchic regime.

1384 **Burgundy:** Louis de Mâle, Count of Flanders, dies and his lands pass to his son-in-law, Philip the Bold, Duke of Burgundy. Philip moves his court to Dijon.

1389 **Burgundy:** Philip the Bold places Claus Sluter in charge of the sculptural decorations at the Chartreuse de Champmol in Dijon.

1394 **Burgundy:** Melchior Broederlam begins work on the *Dijon Altarpiece* for the Chartreuse de Champmol in Dijon.

1395 **Italy:** Giangaleazzo Visconti becomes Duke of Milan. **Burgundy:** Claus Sluter begins work on the *Well of Moses* for the Chartreuse de Champmol in Dijon.

1397 **Italy:** The Medici open their bank in Florence.

1400 **Italy:** Most of Plato's manuscripts are recovered from Constantinople. These will be translated later into Latin and thus made available to a Western audience. In c. 1400, Cennino Cennini publishes *Il libro dell' arte*. **Spain:** Andrés Marzal de Sax begins work on the *Retable of St. George*.

1401 **Italy:** The competition for the east doors of the Baptistery of Florence takes place. Ghiberti wins.

1402 **Italy:** Giangaleazzo Visconti of Milan surrounds Florence but dies suddenly, forcing his army to retreat. Giovanni di Bicci de' Medici is elected prior of the *Signoria*, Florence's legislative body. **Burgundy:** Pol and Jean Limbourg are employed by Philip the Bold as manuscript illuminators.

1406 **Italy:** Padua falls to Venice, and Florence takes Pisa.

1410 **France:** In c. 1410, the Boucicaut Master renders the *Dialogues of Pierre Salmon* and *Les Grandes Heures du duc de Berry*, and the Limbourg brothers create their own *Grandes Heures* for the duke. **Spain:** Marzal de Sax receives free lodging from the city of Valencia in recognition of his artistic abilities and his willingness to impart his knowledge of art to local masters.

1411 **Italy:** The filling of the niches at Orsanmichele, Florence, with statuary begins, with Donatello executing his *St. Mark* for the Arte dei Linaiuoli e Rigattieri and Nanni di Banco the *Quattro Coronati* for the

Arte dei Maestri di Pietra e Lengame. **Spain:** Luis Borrasá begins work on the *Retable of St. Peter* in the Church of Santa María, Tarrasa.

1415 Italy: Donatello executes his *St. George* for Orsanmichele, Florence, a commission he receives from the Arte dei Corazzai e Spadai. He also begins work on the prophets for the niches of the Campanile. **Flanders:** In c. 1415, Robert Campin paints his *Entombment Triptych*.

1416 France: The Limbourg brothers execute *Les Trés Riches Heures du duc de Berry*. The duke, their patron, dies shortly thereafter. **Burgundy:** Jean Malouel paints the *Martyrdom of St. Denis*, perhaps for the Chartreuse de Champmol in Dijon.

1417 Germany: The Council of Constance puts an end to the Great Schism by deposing competing popes and electing Martin V to the throne.

1419 Italy: Brunelleschi begins work on the Ospedale degli Innocenti, Florence. The *Hieroglyphica* of Horus Apollo is discovered by a monk on the island of Andros, Greece. The text will be published first in Venice in 1505 and inspire Andrea Alciato to write his *Emblemata*.

1420 Italy: Martin V moves the papacy back to Rome and begins the renovation of pilgrimage sites. Brunelleschi initiates construction of the dome of the Cathedral of Florence. **Flanders:** Robert Campin paints the *Nativity* in c. 1420.

1421 Italy: Brunelleschi begins work on the Old Sacristy in the Church of San Lorenzo as a final resting place for Giovanni di Bicci de' Medici.

1422 France: Charles VI of France dies and the infant Henry VI of England is installed to the French throne, with the Duke of Bedford acting as his regent.

1424 Flanders: Jan van Eyck enters in the service of Philip the Good, Duke of Burgundy.

1425 Italy: Ghiberti begins work on the *Gates of Paradise* for the Baptistery of Florence and Jacopo della Quercia on the main portal of San Petronio, Bologna. In c. 1425, Felice Brancacci commissions Masaccio and Masolino to paint frescoes in his chapel in the Church of

Santa Maria delle Carmine, Florence. **Flanders:** Jan van Eyck paints the *Ghent Altarpiece*.

c. 1426 Flanders: Robert Campin executes the *Mérode Altarpiece*.

1427 Italy: The *catasto*, a property tax, is introduced in Florence. Leonardo Bruni is named the city's chancellor. Masaccio paints the *Holy Trinity* in the Church of Santa Maria Novella, Florence.

1428 Italy: Masolino works on the decorations of the Castiglione Chapel at San Clemente, Rome. **Flanders:** Jan van Eyck travels to Lisbon, sent by Philip the Good on a diplomatic mission. In c. 1428, he paints his *Annunciation*, and Robert Campin executes the *Virgin and Child before a Fire Screen*.

1429 France: Joan of Arc takes control of the French army, drives the English out of France, and leads Charles VII to his coronation in Reims. She is captured two years later by Burgundian troops and burned at the stake in Rouen.

1430s Italy: Poggio Bracciolini begins work on his *De Varietate Fortunae*, which describes the ruins of Rome. Fra Angelico moves into the Monastery of San Marco, Florence, which Michelozzo renovates under the patronage of Cosimo de' Medici. Donatello works on his *Cantoria* for the Cathedral of Florence and his *Mary Magdalen*. **Flanders:** Jan and Hubert van Eyck execute the *Crucifixion* and *Last Judgment* panels.

1432 Italy: Sigismondo Malatesta becomes the ruler of Rimini. The Battle of San Romano takes place, an event Paolo Uccello depicts in three scenes. Leon Battista Alberti is appointed apostolic abbreviator at the Vatican. **Flanders:** Robert Campin is banished from Tournai for immoral behavior and forced to go on pilgrimage to St. Gilles in Provence. Jacqueline of Bavaria, daughter of Count William IV of Holland, intervenes and Campin's sentence is reduced to only the payment of a fine. In c. 1432, Rogier van der Weyden paints the *Virgin and Child in a Niche*.

1433 Italy: The Medici are exiled from Florence. Lorenzo Valla is expelled from Pavia for writing an open letter criticizing a jurist and ridiculing Pavian jurisprudence. Holy Roman Emperor Sigismund gives

Gianfrancesco Gonzaga of Mantua the title of marquis. Brunelleschi begins work on the Pazzi Chapel in the Church of Santa Croce, Florence, and Fra Angelico paints the *Linaiuoli Altarpiece*. **Flanders:** In c. 1433, Jan van Eyck renders the *Madonna with the Chancellor Nicolas Rolin*.

1434 Italy: Cosimo de' Medici returns to Florence, removes the Albizzi from power, and takes their place. Brunelleschi begins work on the Church of Santa Maria degli Angeli, the seat of the Camaldolites of Florence. **Flanders:** Jan van Eyck paints the *Arnolfini Wedding Portrait* and begins work on the *Madonna of Canon George van der Paele*.

1435 Italy: Leon Battista Alberti's treatise *On Painting* is published. The work will help disseminate the one-point linear perspective technique thought to have been invented by Brunelleschi. **Flanders:** Rogier van der Weyden moves to Brussels and becomes the city's official painter. **Germany:** In c. 1435, Stephan Lochner begins work on the *Last Judgment Altarpiece* for the Church of St. Lawrence in Cologne. In c. 1435, Konrad Witz paints the *Heilspiegel Altarpiece* in Basel.

1436 Italy: The Sylvestrine monks are expelled from the Monastery of San Marco, which is then given to the Dominicans. Michelozzo begins work on the Palazzo Medici-Riccardi, and Brunelleschi begins work on the Church of Santo Spirito in Florence. Uccello paints the monument to Sir John Hawkwood in the Cathedral of Florence. **France:** The French recapture Paris from the British. **Spain:** Luis Dalmau returns to Barcelona after a five-year stay in Flanders where he was sent to learn the Flemish tapestry technique. He eventually melds local and Flemish elements in his art, thus establishing the Hispano-Flemish style.

1438 Italy: The ecumenical Council of Basel transfers to Ferrara, its purpose to end the schism of the Eastern and Western churches. In the following year, the Council of Ferrara is moved to Florence and results in the formal reunification of the Greek Orthodox and Roman Catholic churches. Fra Angelico begins painting his frescoes in the monks' cells at the Monastery of San Marco, Florence. **Flanders:** In c. 1438, Rogier van der Weyden paints the Prado *Deposition* for the Archer's Guild of Louvain and the *Calvary Triptych*. **Germany:** In c. 1438, Stephan Lochner renders the *Madonna in the Rose Bower*.

1439 **Italy:** Cosimo de' Medici establishes the Platonic Academy in Florence.

1440 **Italy:** The Battle of Anghiari between Florence and Milan takes place, with Florence emerging victorious. Leonardo will later paint a fresco of the subject in the Sala del Consiglio of the Palazzo Vecchio, Florence, opposite Michelangelo's *Battle of Cascina*. Andrea del Castagno works on the fresco on the façade of the Palazzo del Podestà, now Bargello, in Florence, depicting members of the Albizzi family and their associates hanging upside-down, their sentence for treason. Lorenzo Valla writes the *Donation of Constantine* in which he declares an eighth-century document used by the papacy to support its claims to temporal power to be a forgery. **France:** In the 1440s, Jean Fouquet paints the portrait *Pope Eugenius IV and His Nephews* during his stay in Rome, thereby establishing a new genre of papal portraiture.

1444 **Italy:** Federico da Montefeltro becomes ruler of Urbino, and Ludovico Gonzaga of Mantua. Donatello begins work on the high altar of San Antonio, Padua. **Flanders:** Petrus Christus paints the *Exeter Madonna*.

c. 1445 **Italy:** Bernardo Rossellino works on the tomb of Leonardo Bruni, chancellor of Florence; Domenico Veneziano paints his *St. Lucy Altarpiece* for the Church of Santa Lucia de' Magnoli; and Donatello begins work on the *Monument of Gattamelata* to be placed in the Campo Santo in Padua. **Spain:** In 1445, Luis Dalmau renders the *Virgin of the Councilors* for the town hall chapel in Barcelona. In c. 1445, Bernardo Martorell begins work on the *Retable of the Transfiguration* for the Barcelona Cathedral.

1447 **Italy:** Filippo Maria Visconti, ruler of Milan, dies without a male heir. He is succeeded by his son-in-law Francesco Sforza. Andrea del Castagno works on the refectory frescoes in the Monastery of Sant' Apollonia, Florence. In c. 1447, Lorenzo Ghiberti begins work on the *Commentarii*, the earliest autobiography by an artist.

1448 **Italy:** The plague strikes again in Florence, lasting for three consecutive summers. The pope invites Lorenzo Valla to Rome to translate Greek texts. Andrea del Castagno paints his series on illustrious men and women in the Villa Carducci at Legnaia, and Fra Angelico renders his frescoes in the Chapel of Nicholas V at the Vatican. **Flanders:**

In c. 1448, Rogier van der Weyden paints the *Seven Sacraments Altarpiece* and Petrus Christus the *Lamentation.* **Spain:** Jaime Huguet returns to Barcelona from Zaragoza and Tarragona and becomes the city's leading master.

1449 **Italy:** Polissena Sforza, wife of Sigismundo Malatesta dies, probably from poisoning. Her husband is suspected of her murder. **Flanders:** Petrus Christus renders his *St. Eligius as a Goldsmith.* **France:** Jean Fouquet applies for papal legitimization of his birth.

1450 **Italy:** Leon Battista Alberti begins work on the *Tempio Malatestiano* in Rimini. In c. 1450, Paolo Uccello works on the *Chiostro Verde* scenes at Santa Maria Novella, Florence, and Antonello da Messina on his *St. Jerome in His Study.* **Flanders:** Dirk Bouts begins work on the *Deposition Altarpiece.* **France:** Jean Fouquet paints his self-portrait on enamel, the first to be executed by a Northern master. In c. 1450, he begins work on his *Melun Diptych* for Etienne Chevalier, controller general to King Charles VII. **Portugal:** Nuno Gonçalves becomes court painter to Alfonso V.

1452 **Italy:** Borso d'Este assumes the rulership of Ferrara. Fra Filippo Lippi begins work on the frescoes in the choir of Prato Cathedral, commissioned by the Datini family. **France:** Enguerrand Charonton paints the *Virgin of Mercy* for the Celestine Convent of Avignon.

1453 **Italy:** The Medici appoint Poggio Bracciolini the new chancellor of Florence. Leon Battista Alberti begins work on the Palazzo Rucellai, Florence. Desiderio da Settignano executes the *Tomb of Chancellor Carlo Marsuppini* in the Church of Santa Croce, Florence. **France:** The Hundred Years' War with England comes to an end. France becomes a free monarchy.

1454 **Italy:** The Peace of Lodi is effected between Venice and Milan. Permanent boundaries between these two territories are established and Francesco Sforza is confirmed Duke of Milan. Mantegna begins work on the Ovetari Chapel in the Church of the Eremitani, Padua. In c. 1454, Andrea del Castagno works on the *Vision of St. Jerome* in the Church of Santisima Annunziata, Florence, and Piero della Francesca renders scenes from the *Legend of the True Cross* at San Francesco in Arezzo. **France:** Enguerrand Charonton paints his *Coronation of the Virgin* for the Church of the Carthusians in Villeneuve-lès-Avignon.

1456 **Italy:** Andrea del Castagno paints his monument to Niccolò da Tolentino in the Cathedral of Florence. Mantegna begins work on the *San Zeno Altarpiece* for the Church of San Zeno in Verona and Leon Battista Alberti on the façade of Santa Maria Novella, Florence, financed by Giovanni Rucellai. Filarete works on the Ospedale Maggiore in Milan, where Antonello da Messina is recorded in the Sforza court working alongside Petrus Christus. **Germany:** Gutenberg produces the first printed Bible.

1459 **Italy:** Bernardo Rossellino carries out the urban planning of the town of Pienza for Pope Pius II. Mantegna moves to Mantua to work for Duke Ludovico Gonzaga. In c. 1459, Benozzo Gozzoli paints the *Procession of the Magi* in the Palazzo Medici-Riccardi. **Spain:** Jaime Huguet begins work on his *Retable of Sts. Abdón and Senén* (1459–1460) in the Church of Santa María, Tarrasa.

1460 **Italy:** Antonio Rossellino initiates work on the *Tomb of the Cardinal of Portugal* at San Miniato, Florence, and Leon Battista Alberti on the Church of San Sebastiano, Mantua, for Ludovico Gonzaga. In c. 1460, Giovanni Bellini paints the *Agony in the Garden*. **Portugal:** In c. 1460, Nuno Gonçalves begins work on his *Retable of St. Vincent* for the Convent of St. Vincent in Lisbon.

1461 **Italy:** Filarete begins work on a treatise on architecture that includes a description of the invented city of Sforzinda, named after his patrons, the Sforza dukes of Milan.

1462 **Italy:** Pope Pius II excommunicates Sigismondo Malatesta on charges of impiety and sexual misconduct and casts him to hell in front of St. Peter's, Rome.

1465 **Italy:** The first printing press is established in Italy, in Subiaco. Mantegna begins work on the *Camera Picta* in the Palazzo Ducale, Mantua. In c. 1465, Pollaiuolo engraves the *Battle of the Ten Nudes*, and Verrocchio begins sculpting his *Doubting of Thomas* at Orsanmichele for the Guild of Merchants.

1468 **Italy:** Cardinal Basilius Bessarion leaves his collection of Greek manuscripts to the Republic of Venice. It becomes the core of the collection of the Library of St. Mark. **Flanders:** Hans Memlinc begins

work on the *Donne Triptych* for Sir John Donne of Kidwelly, and Dirk Bouts becomes the official painter of Louvain.

1469 Italy: Lorenzo "the Magnificent" de' Medici takes over as ruler of Florence. Marsilio Ficino begins work on the *Theologia Platonica*, where he seeks to reconcile Christianity with pagan philosophy.

1471 Italy: Ercole I d'Este becomes Duke of Ferrara. Domenico Ghirlandaio decorates the Vespucci Chapel in the Church of Ognissanti, Florence. **Germany:** Michael Pacher begins work on the *Altarpiece of St. Wolfgang*. **Portugal:** Nuno Gonçalves becomes the official painter of the city of Lisbon.

1474 Italy: Federico da Montefeltro becomes Duke of Urbino. Marsilio Ficino writes his *Concerning the Christian Religion*. **Flanders:** In c. 1474, Hugo van der Goes begins work on the *Portinari Altarpiece*.

1475 Italy: Pope Sixtus IV establishes the Vatican Library. He also gives official approval to the doctrine of the Virgin's Immaculate Conception, though it does not become Church dogma until 1854. Antonello da Messina arrives in Venice and brings with him the oil painting technique. Girolamo Savonarola enters the Dominican Order. **Flanders:** In c. 1475, Hieronymus Bosch paints the *Seven Deadly Sins*.

1476 Italy: Giangaleazzo Maria Sforza of Milan is murdered by republican conspirators in the Church of San Stefano. Francesco di Giorgio Martini arrives in Urbino and works on the building of the Ducal Palace. **France:** Nicolas Froment paints his *Altarpiece of the Burning Bush* at the Cathedral of St.-Sauveur in Aix-en-Provence.

1477 Burgundy: Charles the Bold dies. His lands are inherited by his daughter, Mary of Burgundy.

1478 Italy: The Pazzi Conspiracy against the Medici takes place in Florence. Giuliano de' Medici is killed and his brother Lorenzo "the Magnificent" is wounded. The conspirators are captured and executed. Bramante begins work on the Church of Santa Maria presso San Satiro in Milan. The Scuola di San Rocco is founded in Venice. **Flanders:** Hugo van der Goes enters the Monastery of the Red Cloister in Soignes as a lay brother. **Spain:** The tribunal of the Inquisition is reinstated.

1479 Italy: The Venetians establish ties with the Turks and Sultan Mahomet II. Gentile Bellini is sent to Constantinople to work for the sultan. **Flanders:** Hans Memlinc paints the *Altarpiece of the Virgin and Angels.*

1480 Italy: Marsilio Ficino translates the works of Plotinus and Proclus, thus providing information on the ancient Platonists. Melozzo da Forli begins work on *Sixtus IV, His Nephews, and Platina, His Librarian.* In the 1480s, Giuliano da Sangallo works on the Villa Medici at Poggio a Caiano, and Botticelli paints his *Venus and Mars* and *Birth of Venus* for the Medici. **Flanders:** Hans Memlinc is recorded among the wealthiest citizens of Bruges who were required to pay added tax to finance the war against France. He paints the *Life of the Virgin and Christ* panel.

1481 Italy: Work on the wall frescoes in the Sistine Chapel, Rome, by Perugino, Botticelli, Ghirlandaio, and others is initiated. Leonardo goes to Milan to enter in the service of the Sforza dukes and begins work on the *Adoration of the Magi* for the monks of San Donato in Scopeto. Filippino Lippi receives the commission to complete the decoration of the Brancacci Chapel in the Church of Santa Maria delle Carmine, Florence. Verrocchio begins work on the *Colleoni Monument* for the Campo dei Santi Giovanni e Paolo in Venice. Melozzo da Forli paints his *Christ in Glory* for the Church of Santi Apostoli, Rome. **Flanders:** Hugo van der Goes suffers a mental breakdown. In c. 1481, he paints the *Dormition of the Virgin.*

1482 Burgundy: Mary of Burgundy dies. Her lands are inherited by her children, Margaret and Philip the Handsome. Margaret marries the heir to the French throne, later Charles VIII, and the Burgundian lands become part of France. Philip succeeds his father, the Hapsburg Archduke Maximilian, and the Low Countries are thus annexed to the Hapsburg dominion.

1483 Italy: Pope Sixtus IV imposes an interdict (suspension of public worship and withdrawal of the Church's sacraments) on Venice. Giovanni Bellini receives the appointment of official painter of the Venetian Republic. Leonardo begins work on the *Madonna of the Rocks*, commissioned by the Confraternity of the Immaculate Conception in Milan, and Ghirlandaio receives the commission for the Sassetti Chapel

in the Church of Santa Trinità, Florence. Botticelli paints for the Medici the *Nastagio degli Onesti* panels for the celebration of the Pucci-Bini wedding. **Spain:** Pedro Berruguete returns to Spain after a stay in the ducal court of Urbino and begins work on the *Retablo de Santa Eulalia* for the Church of Santa Eulalia in Paredes de Nava.

1485 Italy: Leon Battista Alberti's *De re aedificatoria* is published, a treatise on architecture inspired by Vitruvius' writings on the subject. It provides the earliest modern account of the architectural orders.

1490 Italy: Mauro Codussi begins work on the façade of the Scuola di San Marco, Venice. Girolamo Savonarola transfers to the Monastery of San Marco, Florence, at the request of Lorenzo "the Magnificent" de' Medici. He is appointed prior of the monastery in the following year. **Flanders:** Hieronymus Bosch paints the *Hay Wain Triptych.* **Spain:** Bartolomé Bermejo renders his *Pietà* for the funerary monument of Canon Luis Desplá in the Cathedral of Barcelona.

1492 Italy: Lorenzo "the Magnificent" de' Medici dies. Pinturicchio begins work on the frescoes in the Borgia Apartments at the Vatican for Pope Alexander VI. **Germany:** Dürer travels to Colmar to work with Martin Schongauer only to find that the master had died the year before. Instead, he enters the studio of Schongauer's brother Georg in Basel. **Spain:** Ferdinand of Castile and Isabella of Aragon expel the Jews from Spain and annex Granada to their dominion. They also finance Christopher Columbus' first voyage to the Americas, which brings great prosperity to their kingdom and ensures its position as the most powerful state in Europe.

1494 Italy: Ludovico "il Moro" Sforza becomes Duke of Milan after deposing his nephew Giangaleazzo. He encourages Charles VIII of France to invade Naples. Piero de' Medici cedes Pisa to Charles, resulting in Medici exile from Florence, an action provoked by the preachings of Savonarola. **Germany:** Dürer travels to Venice.

1495 Italy: Botticelli paints the *Calumny of Apelles*, the earliest Renaissance work to recreate an *ekphrasis* from antiquity. In c. 1495, Vittore Carpaccio begins work on the paintings for the Confraternity of St. Ursula in Venice. **Spain:** Juan de Flandes is sent to the Spanish court of Holy Roman Emperor Maximilian I to paint portraits of the

royal children. In the following year, Isabella of Spain appoints him official court painter.

1496 Italy: Isabella d'Este plans her *studiolo* in the Palazzo Ducale, Mantua. Gentile Bellini paints the *Procession of the Relic of the True Cross* for the Scuola di San Giovanni Evangelista, Venice. Michelangelo goes to Rome and renders his *Bacchus*. **Germany:** Dürer enters in the service of Frederick the Wise, elector of Saxony, and in c. 1496 he paints for him the *Dresden Altarpiece*.

1497 Italy: Leonardo begins work on the *Last Supper* in the refectory of the Monastery of Santa Maria delle Grazie, Milan. In Florence, Savonarola destroys precious art objects in the "Bonfire of the Vanities." He is excommunicated by the pope and, in the following year, he is declared a heretic and executed. **Germany:** Dürer renders his famed woodcuts of the *Apocalypse*.

1499 Italy: Francesco Colonna publishes the *Hypnerotomachia Polifili* in Venice, an architectural work of fiction amply illustrated with woodcuts that include monuments from antiquity.

1500 Italy: Louis XII of France invades Milan and imprisons Ludovico Sforza. Leonardo leaves Milan for Venice and Bramante for Rome. In c. 1500, Giorgione paints the *Castelfranco Altarpiece* and *The Tempest*, and Michelangelo works on the *Taddei Tondo*. **France:** Jean Bourdichon begins work on the *Book of Hours of Anne of Brittany*.

1501 Italy: Michelangelo begins work on the *David* for one of the buttresses of Florence Cathedral. Leonardo provides a cartoon for his *Madonna and Child with St. Anne* for the high altar of the Church of Santissima Annunziata in Florence.

1503 Italy: Leonardo paints the *Mona Lisa*. In c. 1503, Michelangelo begins work on the *Doni Tondo* and Giuliano da Sangallo the Younger moves to Rome where he works as Bramante's assistant. **Germany:** Matthias Grünewald paints the *Mocking of Christ* for the Church of Aschaffenburg.

1505 Italy: Michelangelo begins work on the tomb of Pope Julius II and Giovanni Bellini paints the *St. Zaccaria Altarpiece*. In c. 1505, Raphael renders the portraits *Angelo Doni* and *Maddalena Strozzi*. **Flanders:** In c. 1505, Hieronymus Bosch begins work on the *Garden of Earthly Delights*. **Germany:** Dürer visits Italy for the second time. In

Venice, he paints the *Rozenkranz Madonna* for the Church of San Bartolomeo, commissioned by the Fondaco dei Tedeschi, the association of German merchants in Venice.

1506 Italy: Julius II takes Bologna and annexes it to the Papal States. Construction of New St. Peter's begins in Rome under his rule, with Bramante providing his plan for the project. In the following year, the pope issues indulgences to finance the cost of its construction. Jacopo Sansovino travels to Rome and enters the circle of Bramante. **Germany:** Conrad Meit enters in the service of Frederick the Wise, elector of Saxony. **Netherlands:** Philip the Handsome dies and his son, Charles V of Spain, inherits the Low Countries.

1508 Italy: The Montefeltro line dies out and the della Rovere take over as the rulers of Urbino. Julius II forms the League of Cambrai with King Louis XII of France and Holy Roman Emperor Maximilian I to curtail Venice's territorial expansion. The league collapses in 1510 when the pope allies himself with Venice to drive the French out of Italy. Michelangelo begins painting the frescoes on the Sistine ceiling and Baldassare Peruzzi works on the Villa Farnesina for Agostino Chigi. **Flanders:** Quinten Metsys paints the *Deposition* for the Chapel of the Carpenters' Guild in Antwerp Cathedral. **Germany:** Dürer begins work on the *Holy Trinity*.

1510 Italy: Raphael initiates work in the Stanza della Segnatura at the Vatican. In the following year he has the opportunity to view Michelangelo's Sistine ceiling while in progress and is so taken by it that he changes his style to a more monumental mode of painting. He also includes Michelangelo among the great ancient philosophers in his *School of Athens*, one of the frescoes in the Stanza. In c. 1510, Giorgione paints the *Fête Champetre* and *Sleeping Venus*. **Netherlands:** In c. 1510, Jan Mostaert paints the *Passion Triptych*.

1512 Italy: The Medici return to Florence. The Holy League, formed in 1511 by Pope Julius II, Venice, Holy Roman Emperor Maximilian I, and Ferdinand II of Aragon, expel the French from Italy and reinstate the Sforza as the rulers of Milan.

1513 Italy: Machiavelli composes *The Prince*. Raphael paints the *Sistine Madonna* and begins work on the frescoes in the Villa Farnesina, Rome. Leonardo moves to Rome at the invitation of Pope Leo X.

He engages in scientific experiments at the Vatican. Antonio da Sangallo the Younger begins work on the Palazzo Farnese, Rome, commissioned by Cardinal Alessandro Farnese, who will later be elected to the papal throne as Paul III. **Germany:** Hans von Kulmbach paints the *Tucher Altarpiece.*

1515 Italy: Venice allies itself with France. The French recover their territories in Italy and two years later return the lands taken from Venice by the League of Cambrai. **Flanders:** Jan Gossart renders *St. Luke Painting the Virgin* for the Church of St. Ronbout at Malines. **Germany:** Matthias Grünewald completes the *Isenheim Altarpiece.* **France:** Louis XII dies and is succeeded by Francis I. **Netherlands:** Bernard van Orley is commissioned by Philip the Handsome to paint six portraits of his children to be given to the king of Denmark. This leads to his appointment as court painter to Margaret of Austria, regent of the Netherlands, in 1518.

1516 Italy: Ariosto publishes his *Orlando Furioso*, an epic poem that celebrates the ancestry of the d'Este family, rulers of Ferrara. Titian receives the commission for the *Assumption Altarpiece* in the Church of Santa Maria Gloriosa dei Frari in Venice, Raphael paints the portrait *Baldassare Castiglione*, and Michelangelo works on the façade of the Church of San Lorenzo, Florence. **France:** Jean Clouet is documented as court painter to Francis I.

1517 Italy: Raphael paints the *Transfiguration* and Andrea del Sarto executes the *Madonna of the Harpies.* **Germany:** Martin Luther nails his Ninety-Five Theses on the main portals of Wittenberg Cathedral in Germany, initiating the Reformation. In c. 1517, Grünewald begins work on the *Stuppach Madonna.* **France:** Francis I invites Leonardo to his court. The artist is given the Château de Cloux as his residence, where he engages in scientific experiments and the staging of pageants for the king. **Spain:** Charles V takes the Spanish throne.

1518 Italy: Antonio da Sangallo the Elder begins construction of the Church of the Madonna di San Biagio, Montepulciano. **Netherlands:** Jan van Scorel travels to Italy, where in 1521 he is charged by Pope Hadrian VI with the care of the antiquities in the Belvedere at the Vatican, a position he holds until 1523 when the pope dies.

1519 **Italy:** Michelangelo begins work on the Medici Chapel in San Lorenzo, Florence, and Titian on the *Madonna of the Pesaro Family.* Federigo Gonzaga becomes Marquis of Mantua. **Netherlands:** Jan Mostaert is documented working for Margaret of Austria. **Spain:** Charles V becomes Holy Roman Emperor.

1521 **Spain:** Charles V invades Northern Italy, at the time controlled by the French, and convokes the Diet of Worms where he vehemently opposes the doctrines of Martin Luther, vows to fight heresy, and enacts the Edict of Worms that outlaws Lutheranism. Charles splits the Hapsburg dominion in half by granting the Austrian empire to his brother Ferdinand I. He will later cede the rest to his son Phillip II of Spain.

1523 **Italy:** The plague strikes Florence. St. Antonine Pierozzi, once prior of the Monastery of San Marco in Florence, is canonized. Rosso Fiorentino renders his *Moses Defending the Daughters of Jethro* and then moves to Rome. **Germany:** Dürer completes his treatise on art. Hans Holdbein the Younger paints the portrait *Erasmus of Rotterdam* in Basel.

1524 **Italy:** Michelangelo begins work on the Laurentian Library in Florence. Parmigianino arrives in Rome, where he remains until 1527. Before his trip, he paints his *Self-Portrait in a Convex Mirror.* In c. 1524, Giulio Romano arrives in Mantua to work for Duke Federigo Gonzaga.

1525 **Italy:** Emperor Charles V captures Francis I of France in Pavia and forces him to sign the Treaty of Madrid with which he renounces his claims to Northern Italy and cedes Burgundy to Charles. As soon as he is released, Francis recants and forms the League of Cognac with Pope Clement VII, Venice, Milan, and Florence against the emperor. Pontormo begins work on the *Deposition* for the Capponi Chapel in Florence. **Germany:** The Peasant's Revolt takes place and is crushed by the Swabian League, resulting in the death of approximately 100,000 peasants. The event marks the end of the golden age of art in Germany. Dürer publishes *The Teaching of Measurements with Rule and Compass.* Barthel Beham and his brother Sebald are expelled from Nuremberg for their anarchistic and heretic inclinations.

1527 **Italy:** The sack of Rome by the imperial forces of Charles V takes place. The Medici are expelled from Florence, and Michelan-

gelo's *David* is damaged in the ensuing riots. Pietro Aretino settles in Venice. Giulio Romano begins work on the Palazzo del Tè in Mantua for Federigo Gonzaga. **England:** Hans Holbein the Younger, who moved to England in 1526, paints portraits of Sir Thomas More and his family.

1528 Italy: Baldassare Castiglione publishes the *Book of the Courtier*. Andrea Doria drives the French troops out of Genoa with the help of Emperor Charles V. He establishes a new republican constitution and declares himself dictator. **Germany:** Dürer's *Four Books on Human Proportions* is published posthumously. Hans Burgkmair paints *Esther and Ahasuerus* for Duke William IV of Bavaria. **France:** Jean Clouet is named chief painter to Francis I.

1529 Italy: Sansovino is made principal architect of the city of Venice. **Germany:** In c. 1529, Altdorfer paints the *Battle of Alexander*.

1530 Italy: Pope Clement VII crowns Charles V Holy Roman Emperor in Bologna in exchange for the reinstatement of the Medici in Florence. The Medici and Federigo Gonzaga of Mantua are conferred the title of duke. **France:** Rosso Fiorentino arrives in France and, with Primaticcio, establishes the Fontainebleau School. In c. 1530, Joos van Cleve enters in the service of Francis I. **Netherlands:** Bernard van Orley enters in the service of Mary of Hungary, Charles V's sister and regent of the Netherlands.

1533 England: During a second stay in England, Hans Holbein the Younger paints *The Ambassadors*, a tour de force of optical illusion.

1534 Italy: Michelangelo receives the commission to paint the *Last Judgment* on the altar wall of the Sistine Chapel from Pope Paul III. Parmigianino paints the *Madonna with the Long Neck*. **Spain:** St. Ignatius of Loyola establishes the Jesuit Order, which receives confirmation from Pope Paul III in 1540.

1536 England: Hans Holbein the Younger becomes Henry VIII's court painter.

1537 Italy: Jacopo Sansovino receives the commission to build the Library of St. Mark in Venice to house the collection of Greek manuscripts donated by Cardinal Bessarion to the Venetian Republic in 1468.

Alessandro de' Medici is assassinated and Cosimo I de' Medici assumes power in Florence.

1545 Italy: Pope Paul III convokes the Council of Trent, thus launching the Counter-Reformation. Bronzino paints the *Deposition* for the Chapel of Eleonora da Toledo in the Palazzo Vecchio, Florence. Benvenuto Cellini returns to Florence after having worked for Francis I of France. He enters in the service of Cosimo I de' Medici and sculpts for him the *Perseus and Medusa* for the Loggia dei Lanzi. Michelangelo finishes the tomb of Pope Julius II. A frost causes the roof of the Library of St. Mark, Venice, to collapse and Sansovino is imprisoned for it. His friends Titian and Aretino intervene. Sansovino is released and he resumes his post as principal architect of the Venetian Republic.

1546 Italy: Michelangelo takes over the construction of New St. Peter's. **France:** Pierre Lescot begins work on the west wing of the Louvre Palace in Paris.

1548 Italy: Tintoretto paints his *St. Mark Freeing a Christian Slave*. Titian spends nine months in Germany and there he paints the portrait *Charles V on Horseback*. **Spain:** St. Ignatius of Loyola publishes the *Spiritual Exercises*.

1550 Giorgio Vasari publishes his first edition of the *Lives of the Most Excellent Painters, Sculptors, and Architects*, thus becoming the first art historian in history. Daniele Barbaro is elected Patriarch of Aquileia. Palladio begins work on the Villa Rotonda. In c. 1550, Bronzino paints the portrait *Eleonora da Toledo and Her Son Giovanni de' Medici*. **France:** Philibert de L'Orme begins construction of the Chateau d'Anet for Diane de Poitiers, Henry II's mistress. In c. 1550, François Clouet paints the *Lady in Her Bath*, believed to be a portrait of Diane.

1557 Italy: Venice is struck by a bout of the plague that will last until 1577. The city looses 30 percent of its population. Siena is taken by Florence and becomes part of the Duchy of Tuscany. **Spain:** Spanish troops win the Battle of San Quentin against the French. To celebrate the victory, Philip II of Spain vows to build the Monastery of San Lorenzo in El Escorial.

1558 Spain: Charles V abdicates and retires to the Monastery of Yuste.

1560 **Italy:** Bartolomeo Ammannati begins work on the Pitti Palace courtyard in Florence for the Medici. In c. 1560, Cosimo I de' Medici asks Vasari to build the Uffizi in Florence to consolidate all governmental offices under one roof. Paolo Veronese travels to Rome.

1562 **Italy:** The Accademia del Disegno is established in Florence. **Netherlands:** Pieter Bruegel the Elder paints his *Dulle Griet [Mad Meg]*.

1563 **Italy:** The last session of the Council of Trent takes place. Among the topics discussed is the role of art in the fight against the spread of Protestantism. Ammannati works on his *Neptune Fountain* in the Piazza della Signoria, Florence, and Veronese paints the *Marriage at Cana* for the refectory of San Giorgio Maggiore in Venice. **France:** Germain Pilon begins work on the tombs of Henry II and Catherine de' Medici at St. Denis in Paris under the direction of Primaticcio. **Netherlands:** Pieter Bruegel the Elder paints the *Tower of Babel*.

1564 **Italy:** Tintoretto is charged with the frescoes in the Scuola di San Rocco, Venice, which he completes in 1587. Michelangelo completes work on the Piazza del Campidoglio, Rome.

1567 **Netherlands:** Philip II of Spain sends the Duke of Alba to restore order in the Netherlands after the local Protestants engage in an iconoclastic campaign. William "the Silent" of Orange leads a revolt against the Spaniards that results in the emancipation of the Dutch Provinces in 1581.

1568 **Italy:** Cardinal Farnese funds the building of the Church of Il Gesù in Rome, the mother church of the Jesuit Order. El Greco arrives in Venice. **Spain:** Navarrete is appointed court painter by Philip II.

1569 **Italy:** Cosimo I de' Medici is made Grand Duke of Tuscany. Daniele Barbaro publishes the *Prattica della prospettiva*, which includes a description of the *camera obscura* used by artists as a perspective aid.

1570 **Italy:** Palladio publishes the *Quattro Libri*, his treatise on architecture. Vasari and assistants work on the *studiolo* of Francesco I de' Medici in the Palazzo Vecchio, Florence.

1573 **Italy:** Torquato Tasso publishes the *Aminta*, one of the best examples of Renaissance pastoral drama. Veronese is brought before the

tribunal of the Inquisition for painting his *Last Supper* in the Monastery of Santi Giovanni e Paolo in a manner that is deemed offensive as it includes dwarfs, buffoons, and animals. Veronese avoids persecution by changing the title of the work to *Feast in the House of Levi*. **Spain:** St. Theresa of Avila writes *The Way of Perfection*, which includes her prescriptions on how to attain spiritual excellence. With this and other writings, she establishes herself as one of the great mystics of the era.

1575 Italy: Torquato Tasso finishes work on the *Gerusalemme Liberata*, an epic poem that celebrates d'Este ancestry and that will become a major source of subjects for artists. Federico Barocci begins work on the *Madonna del Popolo*. **Spain:** Navarrete paints his *Abraham and the Three Angels* for El Escorial.

1576 Italy: In c. 1576, Titian paints the *Pietà* for his own tomb, and Carlo Maderno moves to Rome from Capolago, now Switzerland. **Flanders:** Flanders joins the Dutch Provinces in the revolt against Spain only to be recovered in 1584 by the Spanish army. **Spain:** El Greco moves to Toledo at the invitation of Don Diego de Castilla.

1577 Italy: St. Charles Borromeo publishes his treatise on church building and decoration. Torquato Tasso is imprisoned for his violent outburst in front of Lucrezia d'Este. Palladio begins construction of *Il Redentore* in Venice.

1579 Netherlands: The United Provinces of Holland, led by William "the Silent" of Orange, sign the Union of Utrecht, which leads to their independence from Spain in 1581.

1580 Italy: Gregory XIII recognizes the Order of the Discalced Carmelites established by St. Theresa of Avila. **Portugal:** As the son of Isabella of Portugal, Philip II of Spain lays claim to the Portuguese throne when Sebastian I dies without an heir. With the Portuguese crown, he also obtains Brazil and its colonies in Africa and the West Indies.

1581 Netherlands: Philip II of Spain denounces William of Orange as a traitor and offers a reward on his head, at the same time as Brabant, Flanders, Utrecht, Gelderland, Holland, and Zeeland declare Philip's deposition from sovereignty over them.

1582 Italy: The Gregorian calendar is introduced. Archbishop Gabriele Paleotti of Bologna writes his *Intorno alle imagini sacre e pro-*

fane, a treatise on the correct depiction of religious subjects in art. The Carracci open the Accademia dei Desiderosi. Agostino Carracci travels to Venice and executes engravings of the works of Titian and other Venetian masters. **Spain:** Alonso Sánchez Coello begins work on the *Martyrdom of Sts. Justus and Pastor* for El Escorial.

1584 Flanders: Justus Lipsius publishes his *De Constantia* where he expounds his Neo-Stoic philosophy. **Netherlands:** William of Orange is assassinated in Delft by a Catholic fanatic.

c. 1585 Italy: Veronese paints the *Triumph of Venice* in the Great Hall of the Doge's Palace in Venice. **Spain:** Alonso Sánchez Coello paints the portrait *Infanta Isabella Clara Eugenia with Magdalena Ruiz*.

1588 England: Philip II sends the Spanish Armada to England, which he ruled briefly while married to Mary Tudor, a Catholic who sought to reinstate Catholicism to her kingdom but died (1558) before accomplishing her goal. Her Protestant sister, Queen Elizabeth, ascended the throne as her successor. Philip uses the fact that the British provided support to the Protestants in Holland during their revolt as an excuse to oust Elizabeth from power. Heavy winds and large ships prove disastrous to the Spanish Armada as they try to invade England.

1589 Italy: Annibale Carracci paints the *San Ludovico Altarpiece* for the Church of Santi Ludovico e Alessio in Bologna. **Flanders:** Justus Lipsius publishes his *Politicorum sive civilis doctrinae*.

1593 Italy: The Accademia di San Luca is established in Rome. Cesare Ripa publishes the *Iconologia*, a manual on the representation of allegorical figures. **France:** Henry IV converts to Catholicism and is crowned king in the following year.

1598 Italy: Carlo Maderno works on the façade of Santa Susanna, Rome, and Annibale Carracci on the Farnese ceiling in the Palazzo Farnese, Rome, and also paints his *Christ in Glory*. **France:** Henry IV signs the Treaty of Nantes and ends the Wars of Religion in France. He begins an urban renovation campaign in Paris that results in the construction of the Pont Neuf, Place Dauphine, and Place Royale (now Vosges).

1599 Italy: Caravaggio begins work on the Contarelli Chapel at San Luigi dei Francesi, Rome. The body of St. Cecilia is discovered under

the high altar of Santa Cecilia in Trastevere. To mark the event, Stefano Maderno is commissioned in the following year to render her as she was found, his work to be incorporated into the church's high altar.

1600 Italy: Caravaggio paints his first version of the *Supper at Emmaus* and receives the commission for the Cerasi Chapel at Santa Maria del Popolo, Rome. Bartolomeo Schedoni is temporarily banished from Parma for his violent behavior. Rubens travels to Italy, where he enters in the service of the Gonzaga in Mantua. **France:** Henry IV marries Marie de' Medici. **Spain:** El Greco paints the *View of Toledo*.

1603 Italy: Caravaggio begins work on his *Entombment*. He openly ridicules Giovanni Baglione when the latter's *Resurrection* in the Church of Il Gesú, Rome, is unveiled. Baglione takes Caravaggio to court for slander. In c. 1603, he paints his *Divine Love* as response to Caravaggio's *Amor Vincit Omnia*. **Spain:** Rubens is sent to Spain by the Duke of Mantua, where he paints the *Equestrian Portrait of the Duke of Lerma*, which will become the prototype for subsequent Spanish royal equestrian portraits. Juan Sánchez Cotán almost completely abandons his career as painter when he enters the Carthusian Monastery of Granada as a lay brother.

1604 Netherlands: Karel van Mander publishes the *Schilderboeck*, a biography of artists that will become the major biographical source on Northern masters.

1605 Italy: Pope Paul V calls for a competition to convert St. Peter's from a central to a longitudinal plan basilica. Carlo Maderno wins the competition. **England:** The Gunpowder Plot to assassinate James I, his family, and members of the aristocracy by blowing up Parliament fails. Paul V sends a letter to the king asking that the Catholics in England be spared the consequences. Inigo Jones enters in the service of Anne of Denmark, wife of James.

c. 1607 Italy: Giovanni Battista Agucchi begins work on his treatise on painting. Domenichino is believed to have a hand in the project.

1609 Flanders: Having returned to Antwerp in 1608, Rubens is appointed court painter to Archdukes Isabella and Albert of Flanders. He marries Isabella Brant and commemorates the event by painting the

Honeysuckle Bower. **Spain:** Vicente Carducho becomes court painter to Philip II.

1610 **Flanders:** Rubens paints the *Elevation of the Cross* for the Church of St. Walburga. **France:** Henry IV is assassinated. He is succeeded by his son Louis XIII, then a minor. Marie de' Medici, Henry's wife, becomes Louis' regent.

1612 **Italy:** Artemisia Gentileschi is raped by Agostino Tassi. After a seven-month trial, Tassi is acquitted and Artemisia marries a relative of one of the key witnesses. The couple moves from Rome to Florence to avoid gossip. Domenichino works on the frescoes in the Polet Chapel at San Luigi dei Francesi, Rome. **Flanders:** Rubens paints the *Four Philosophers* as homage to his deceased brother and Justus Lipsius.

1613 **Italy:** Guido Reni paints the *Aurora* in the Casino Rospigliosi, Rome. In c. 1613, he renders the *St. Sebastian Thrown into the Cloaca Maxima.* **England:** Inigo Jones becomes Surveyor of the King's Works. He travels to Italy with Thomas Howard, Earl of Arundel.

1615 **France:** Salomon de Brosse initiates the construction of the Luxembourg Palace for Marie de' Medici where Rubens will paint in 1622–1625 his famed Medici Cycle. Louis XIII marries Anne of Austria.

1616 **France:** Cardinal Richelieu is appointed secretary of state. **England:** Inigo Jones receives the commission to design the Queen's House in Greenwich for Henrietta Maria, Charles I's wife.

1617 **Italy:** Giulio Mancini begins writing his *Considerazioni sulla pittura,* a guide for art collectors and patrons. **France:** Louis XIII attains his majority. He exiles his mother, Marie de' Medici, to Blois. Concino Concini, Marquis of Ancre, Marie's favorite, is assassinated.

1619 **France:** Marie de' Medici escapes from Blois and allies herself with her younger son, Gaston D'Orleans, against Louis XIII. **England:** Inigo Jones begins work on the new Banqueting House in Whitehall Palace, London, after the old structure burns down.

1622 **Italy:** St. Ignatius of Loyola and St. Theresa of Avila are canonized by Gregory XV. **France:** Cardinal Richelieu negotiates a reconciliation between Louis XIII and Marie de' Medici.

1623 **France:** George de la Tour is documented working for the Duke of Lorraine. François Mansart begins work on the façade of the Church of Feuillants and Château de Berny. **Spain:** Velázquez moves from Seville to Madrid to become court painter to Philip IV.

1624 **Italy:** Bernini renovates the façade of the Church of St. Bibiana, Rome, and begins the execution of a standing statue of the saint in the following year. He also begins work on the baldachin of St. Peter's. The remains of St. Rosalie are recovered in Palermo, and Anthony van Dyck is commissioned to paint scenes in the Oratory of St. Rosalie to commemorate the event. Nicolas Poussin settles in Rome. Simon Vouet is elected president of the Accademia di San Luca. **France:** Cardinal Richelieu is appointed first minister of France. Orazio Gentileschi is working in Marie's court.

1625 **England:** Charles I ascends the throne. Orazio Gentileschi becomes his court painter.

1626 **Italy:** Urban VIII forces Duke Francesco Maria della Rovere to cede the Duchy of Urbino to the papacy.

1627 **Italy:** The French Gonzaga become the rulers of Mantua as the Italian family line ends. Poussin paints his *Et in Arcadia Ego*, a scene he will render once again in 1637–1638. In c. 1627, he paints the *Triumph of Flora*. **France:** Simon Vouet returns to France after his stay in Italy and becomes official court painter. He establishes a workshop in the Louvre where he trains some of the most important French artists of the next generation. Cardinal Richelieu seizes La Rochelle, a Huguenot stronghold.

1629 **Italy:** Bernini begins work on the crossing of St. Peter's for which he will contribute his statue of *St. Longinus*. Andrea Sacchi begins work on his *Divine Wisdom* in the Barberini Palace, Rome, and Valentin de Boulogne paints the *Martyrdom of Sts. Processus and Martinian* for one of the altars of St. Peter's. **France:** Richelieu defeats the French Protestants and signs the Peace of Alais, which abolishes their political rights and protections. **Netherlands:** Rembrandt paints *Judas Returning the Thirty Pieces of Silver*. **England:** Rubens paints the *Allegory of War and Peace* at Whitehall Banqueting House. Anthony van Dyck paints his *Rinaldo and Armida* for Endymion Porter, while serving as court painter

to Charles I. **Spain:** Velázquez travels to Italy. Zurbarán settles in Seville to become the most important master there.

1630 Italy: Artemisia Gentileschi moves to Naples and renders her *Self-Portrait as Allegory of Painting*. In the 1630s, the Cortona/Sacchi controversy at the Accademia di San Luca on the correct depiction of history paintings takes place. Dutch artists living in Rome form a group led by Pieter van Laer, known as the Bamboccianti, who specialize in genre scenes. Bernini proposes the building of the towers of St. Peter's, Rome, which Urban VIII approves. The south tower is built but cracks almost immediately and is torn down. The fiasco proves to be a major blow to Bernini's career. **France:** Louis XIII exiles his mother, Marie de' Medici, permanently from court. She lives out the rest of her days in Germany. The Luxemburg Palace is sealed and Rubens' Medici Cycle in one of its galleries is not rediscovered until the end of the 17th century, when it causes a major sensation.

1633 Italy: Pietro da Cortona begins work on the *Glorification of the Reign of Urban VIII* in the Barberini Palace, and Bernini begins construction of Sant' Andrea al Quirinale, Rome. **France:** Jacques Callot renders *Les Grandes Misères de la Guerre*, which record the horrors that resulted from Cardinal Richelieu's invasion of Nancy in the Lorraine region. Mathieu Le Nain is named official painter of the city of Paris. **Spain:** Vicente Carducho writes the *Diálogos de la Pintura*.

1634 Italy: Pietro da Cortona is granted permission to build his own funerary chapel in the Church of Santa Martina, Rome. During construction, the body of St. Martina is recovered. To celebrate the event, Cardinal Francesco Barberini, Urban VIII's nephew, commissions Cortona to build a whole new church on the site.

1640 Italy: In 1640, Poussin is summoned to the French court where he remains until 1642. In the 1640s, he develops his Theory of the Modes. **Netherlands:** Rembrandt paints his *Self-Portrait Leaning on a Stone Sill*, based on Raphael's portrait of *Baldassare Castiglione* he sees at an auction. **Spain:** Portugal revolts against Spain and the Spanish monarch loses his position as their king. Zurbarán paints his *Christ and the Virgin in the House at Nazareth*.

1641 Italy: Pope Urban VIII seizes the Duchy of Castro from the Farnese when they default on their interest payments. He returns the duchy

to them in 1644 when both parties sign a peace agreement. Domenichino dies and is suspected of having been poisoned by jealous local masters while working in Naples. Francesco Borromini receives the commission for the Church of San Ivo della Sapienza, Rome, from Urban VIII. **France:** Vouet paints the *Presentation* for the high altar of the Novitiate Church of the Jesuits in Paris, commissioned by Cardinal Richelieu. **England:** William Dobson succeeds Anthony van Dyck as court painter to Charles I.

1642 Italy: Giovanni Baglione publishes his *Vite de' pittori, scultori, e architetti.* **Netherlands:** Rembrandt paints *The Night Watch.*

1643 Spain: Philip IV dismisses the Count of Olivares, his minister, for his political and economic failures. **England:** Civil war breaks out as a result of confrontations between Parliament and the Puritans who opposed Charles I's religious policies. This leads to Charles I's execution in 1649.

1645 Italy: Bernini begins work on the Cornaro Chapel at Santa Maria della Vittoria, Rome, where he will execute his famed *Ecstasy of St. Theresa.*

1648 Italy: Bernini begins work on the *Four Rivers Fountain* in the Piazza Navona, Rome. **France:** The French Academy is established, its principles based on those of Nicolas Poussin. Laurent de La Hyre paints his *Allegory of the Regency of Anne of Austria*, Eustache Le Seur begins work on his St. Bruno series for the Chartreuse de Paris, and Jacques Sarazin begins work on his *Tomb of Henri de Bourbon* in the Church of St. Paul-St. Louis. **Netherlands:** The Peace of Westphalia is negotiated and Philip IV of Spain recognizes the independence of the Dutch provinces. **Spain:** Velázquez paints the *Rokeby Venus* for Gaspar Méndez de Haro, marquis of Carpio and Heliche.

Introduction

The art of the Renaissance is usually the most familiar to nonspecialists, and for good reason. This was the era that produced some of the icons of civilization, including Leonardo da Vinci's *Mona Lisa* and *Last Supper* and Michelangelo's Sistine ceiling, *Pietà*, and *David*. Marked as one of the greatest periods in history, the outburst of creativity of the era resulted in the most influential artistic revolution ever to have taken place. The period produced a substantial number of notable masters, among them Donatello, Filippo Brunelleschi, Masaccio, Sandro Botticelli, Raphael, Titian, and Tintoretto, who were fortunate to work in an ambiance that encouraged creativity and art production and who enjoyed the financial backing of eager patrons who believed in the power of art as manifestation of social, political, religious, and intellectual attitudes. The result was an outstanding number of exceptional works of art and architecture that pushed human potential to new heights, among them Masaccio's *Holy Trinity*, Donatello's *Judith and Holofernes*, Leon Battista Alberti's *Tempio Malatestiano*, Botticelli's *Primavera*, Giovanni Bellini's *San Giobbe Altarpiece*, Raphael's *School of Athens*, and Titian's *Venus of Urbino*. The movement was launched in Italy and gradually spread to the Netherlands, Germany, Spain, France, and other parts of Europe and the New World, with figures such as Robert Campin, Jan van Eyck, Rogier van der Weyden, Albrecht Dürer, and Albrecht Altdorfer emerging as the leaders in the Northern artistic front. While disagreements on the chronology of the Renaissance exist, most disciplines place the era between the years 1250 and 1648. The first of these two dates marks the death of Holy Roman Emperor Frederick II, which ended the Hohenstaufen rule and gave rise to the Hapsburg imperial line, and the second is the year when the Peace of Westphalia was effected, putting an end to the Thirty Years' War.

The term *Renaissance*, which translates to rebirth, is a French word first used by historians Jules Michelet and Jacob Burckhardt to denote the renewed interest in all aspects of the classical world that existed during that time period and the application of Greco-Roman learning and methodologies to everything from culture and politics to philosophy, religion, and the sciences. Michelet and Burckhardt were merely translating the term from the Italian *Rinascita*, first mentioned in print in 1550 by Giorgio Vasari in *Le Vite de' più eccellenti pittori, scultori, ed architettori* [*The Lives of the Most Excellent Painters, Sculptors, and Architects*], but utilized since the era of Petrarch and Dante. Petrarch, in fact, had concluded that the heights of human achievement had been reached during the Greco-Roman era and he called for a return to the ideals of the classical past and its humanistic method of learning. It was also Petrarch who labeled the medieval era the Dark Ages and classified it as a stagnant episode in history.

A major factor in the renewed interest in antiquity was the conquest in 1204 by the crusaders of the Byzantine Empire, which resulted in the rediscovery of the writings of the ancients that had been lost to the West for a number of centuries but preserved in the East. This conquest also resulted in the migration of Greek humanists to the Italian peninsula; their familiarity with the classical past facilitated the dissemination of the newly acquired knowledge. Italian men of letters eventually contributed to this dissemination by translating ancient manuscripts from Greek into Latin, thereby making them available to a Western audience, and also by recovering the ancient Roman heritage that had remained just as obscure as the Greek past. Among these men were Poggio Bracciolini, Lorenzo Valla, Marsilio Ficino, and Daniele Barbaro, who played key roles in the development of the Renaissance ethos. The introduction of the printing press in the 1450s allowed for the more economical production of Greco-Roman texts and their translations than hand-written, illuminated copies, thus making them available to a much wider audience. Some of the recovered texts specifically dealt with art; for example, the original ancient version of Vitruvius' treatise on architecture (*De architectura*) provided direct information on the ancient principles of building design and soon inspired Renaissance architects to write their own treatises.

The Renaissance began in central Italy, and specifically in Florence. Italy at the time was not one nation; rather, it consisted mainly of a se-

ries of autonomous city-states ruled by a prince or merchant family. Florence, located in the Tuscan region, was at the time one of the largest cities of Europe, boasting by the 13th century over 100,000 inhabitants when London and Paris each only had approximately 20,000 residents. Its flourishing economy, based on cloth manufacturing and banking, permitted the necessary capital to finance major artistic endeavors. The Ciompi Revolt (1378), carried out by day laborers in the cloth industry, paved the way for the Albizzi family to emerge as the rulers of an oligarchic political system. In 1434, that system was taken over by Cosimo de' Medici, from one of the leading banking families of Florence. Medici rule was to last until 1737, with few interruptions, and the family's interest in learning and the arts would give momentum to the development of the Renaissance. Soon, the Renaissance ideals would spread to the neighboring Tuscan cities of Pisa and Siena, and farther to places like Padua, Venice, Urbino, Mantua, and Rome.

Art historians have divided the Italian Renaissance period into various subcategories based on the stylistic changes and technical developments that took place in each era: the Proto-Renaissance, which encompasses the second half of the 13th and most of the 14th centuries; the Early Renaissance, the label given to the art of the 15th century; the High Renaissance, when Leonardo, Michelangelo, and Raphael brought the developments of the previous century to their highest refinement; Mannerism, a movement that dissented from the rationality and classicism of the High Renaissance; and Baroque, which rose in roughly the 1580s in response to the requirements of the Counter-Reformation Church as it attempted to curtail the spread of Protestantism. These labels, however, are not as clear cut as one would like them to be, as overlaps are not uncommon. So, for instance, while Botticelli was creating his lyrical masterpieces for the Medici rulers of Florence, masterpieces normally qualified as Early Renaissance, Leonardo was inaugurating the High Renaissance by introducing pyramidal compositions and voluminous figures with naturalistic forms and lifelike temperament. While Michelangelo was sculpting his expressive forms and imbuing them with life, the Mannerists were distorting their figures' anatomical details and posing them in bizarre, contorted ways. And as Mannerists were receiving papal commissions all over Rome, Caravaggio was introducing to the city a new, theatrical mode of painting that rejected the contortions and ambiguities of

Mannerism, instead embracing naturalistic forms and unambiguous scenes that evoked piety from viewers.

THE PROTO-RENAISSANCE

The art of the Proto-Renaissance, sometimes also called Late Gothic or Late Medieval, has a distinct Byzantine flavor. The reason for this is that, aside from reintroducing the classical written heritage to the West after the conquest of Byzantium in 1204, the crusaders also brought back Byzantine icons, illuminated manuscripts, carvings, and other such art objects that they had seized—objects that deeply influenced the art of Italy. The devastation caused by the crusades in Byzantium not only lead to the migration of scholars to Italy, but it also led to the migration of artists in search of new patronage. Once they began catering to Italian patrons, these masters created art in the mode in which they had been trained. The *Maniera Greca*, as the Byzantine manner is usually called, which is characterized by the use of brilliant colors, heavy gilding, striations to denote the folds of fabric, and segments for the figures' anatomical details, became the preferred style, with Italian painters such as Berlinghiero and Bonaventura Berlinghieri, Coppo di Marcovaldo, Guido da Siena, and Cimabue adopting it as their own and becoming its greatest exponents. Byzantine elements also made their way into the field of sculpture, though the Gothic style of Northern Europe, and particularly France, was a more prevalent influence in this medium. The composition of the *Nativity* scene in Nicola Pisano's pulpit for the Baptistery of Pisa (1255–1260), for example, relies on Byzantine renderings, especially in the reclining pose of the Virgin Mary. The overall appearance of the pulpit, with its trilobed arches and columns resting on lions, is, however, French Gothic. There is a third component to Pisano's design: an awareness of ancient statuary, as the Virgin in the *Adoration of the Magi* panel recalls the seated Phaedra in the sarcophagus at Campo Santo, Pisa, that features the legend of Hippolitus. Also, Pisano's allegorical figure of Fortitude, above one of the columns' capitals, is a classicized male Herculean nude that presents a less schematic and more realistic rendering of anatomy.

This interest in resurrecting ancient realism had much to do with the recovery from Byzantium of the works of Aristotle, who had advocated

the empirical observation of nature and its phenomena. His view deeply influenced the art of the period as artists began to examine nature carefully and to imitate its details on pictorial and sculptural surfaces. They studied the works of the ancients carefully, as the masters from the past had also relied on nature for their representations. Pisano looked to ancient remains in the Tuscan region. In Rome, the ancient heritage was even more palpable as Roman and Early Christian remains were available for study at every turn. Therefore, the art of Rome during the Proto-Renaissance era, though influenced by the *Maniera Greca*, relied most heavily on the ancient prototypes, and particularly Early Christian mosaics, which looked to pagan techniques and visual language that evoked the same naturalism Aristotle had promoted. This resulted in a more realistic and monumentalized art than in the Tuscan region. Jacopo Torriti's apse mosaics at Santa Maria Maggiore (c. 1294) and Pietro Cavallini's *Last Judgment* fresco in Santa Cecilia in Trastevere (c. 1290) are representative of this approach.

Another important occurrence during the Proto-Renaissance era that proved to be a major force in the development of art was a shift in attitude toward religion. In 1209, St. Francis established the Franciscan Order and, contrary to the medieval custom among monks to seclude themselves from the rest of the world in monasteries, he and his followers went out into the streets and preached the word of God while ministering to the poor and the sick. They sermonized about love and kindness toward mankind and the valuing of nature and its creatures as God's creations. This view, which contradicted the medieval tendency to scare the masses into believing by reminding them of the damnation that would occur if the teachings of the Church were not scrupulously followed, resulted in a softening of religion and, in turn, the themes of religious images also softened. The previous emphasis on punishment and the supernatural was now replaced by the human aspect of the divine protagonists in the story of salvation. Also, the valuing of nature advocated by these preachers gave further impetus to the renewed Aristotelian interest in imitating the natural world in art.

The artist who broke away completely from the Byzantine tradition to pursue a purely naturalistic form of representation was Giotto. Considered the father of the Renaissance, Giotto was the first to be recognized while living as one of the greatest artists in history and the first to attain international fame. Accolades from Dante in the *Purgatory* and

Boccaccio in the *Decameron* to Vasari in the *Vite* and Ceninno Cennini in his *Il libro dell' arte* paint a picture, so to speak, of an artist who was greatly admired, and for good reason. As Cennini put it, "Giotto translated the art of painting from Greek to Latin." The high demand for his works took him to North, South, and Central Italy, the Arena Chapel in Padua remaining as one of his best-preserved and greatest achievements. Here, Giotto replaced the gilded backgrounds of the *Maniera Greca* with rocky landscapes and ultramarine blue skies to bring the scenes down from a divine to an earthly level. The figures and draperies are modeled with shadows in certain strategic places to create the illusion of volume, and the stage set in each fresco is detailed carefully with buildings placed at an angle so two sides can be seen at one time, granting them a three-dimensional appearance. But, more than anything else, the works by Giotto are deeply human and emotional. Emphatic grimaces and gestures tell the story of Christ, his mother, and grandparents in a compelling way never before seen in art. The abstracted symbolic representations of the medieval era here gave way to realistic narratives.

While Giotto was developing this new visual language, Duccio was establishing himself as a leading figure in the art scene in Siena. Duccio chose to continue painting in the *Maniera Greca* yet combined it with the latest developments introduced by Giotto. The work that brought him great fame was the *Maestà Altarpiece* (Siena, Museo dell' Opera del Duomo), painted in 1308–1311 for the main altar of the Cathedral of Siena. With scenes of the infancy of Christ, his ancestry, Passion, and death, the altarpiece is closely related to Giotto's Arena Chapel narratives, clearly denoting competition between the two masters from enemy Tuscan cities. Once Duccio completed his work, it was carried by the citizens of Siena with great pomp from his studio to the cathedral. A contemporary account relates that members of the Sienese government and clergy carried candles and torches, while others played trumpets and bagpipes. Siena could now boast of an artist as gifted as Giotto.

Both masters had a great following. Giotto's successful career required many assistants to fulfill the large number of commissions he was receiving. Because of his talent, however, he overshadowed many of his pupils, of which only a handful were able to emerge as artists in their own right. Among these were Maso di Banco, Bernardo Daddi, and Taddeo Gaddi. Giotto's Arena Chapel frescoes in Padua prompted

the development of a local school of painting in that city led by Altichiero. Among Duccio's followers were Simone Martini, who assisted the master on the *Maestà Altarpiece*, and the brothers Pietro and Ambrogio Lorenzetti, who became the leading artists of Siena once Martini left the city for Avignon, France.

In 1348, the Black Death struck and both Florence and Siena lost roughly 50 to 75 percent of their populations. Many artists succumbed to the plague, including Bernardo Daddi and the Lorenzetti brothers, making way for a new wave of artists. Since catastrophes such as this were deemed to be God's punishment, the works commissioned at this time reverted to the medieval subjects of death and final judgment meant to expiate whatever sins were believed to have caused the onset of the plague and its deadly consequences. Andrea Orcagna painted the *Enthroned Christ with Virgin and Saints* (1354–1357) for the Strozzi Chapel at Santa Maria Novella in Florence inspired by the apocalyptic themes in the Book of Revelations, Giovanni da Milano created his *Pietà* (1365, Florence, Accademia) showing the suffering Christ who sacrificed himself to save humanity, and Francesco Traini rendered the *Triumph of Death* (mid-14th century) in the Campo Santo in Pisa to remind viewers of the temporality of life.

THE EARLY RENAISSANCE

In 1401, a specific event marked the end of the Proto-Renaissance era and inaugurated a new moment in history—the Early Renaissance. This event was the competition held in Florence for the execution of the east doors of the Baptistery, the Romanesque structure across from the cathedral where all Florentine citizens were baptized. Andrea Pisano had already executed in the previous century the south doors, which featured scenes from the life of St. John the Baptist, and the new portals were to harmonize with his design and depict stories from the Old Testament. Artists were asked to submit a relief depicting the sacrifice of Isaac in gilded bronze enclosed in a quatrefoil design similar to those used by Pisano on his doors. Seven artists submitted their entries, including Lorenzo Ghiberti, Filippo Brunelleschi, and Jacopo della Quercia. The prize went to Ghiberti, whose entry utilized a classical vocabulary suitable to the tastes of the day.

In the following year, Giangaleazzo Visconti of Milan, who controlled most of Northern Italy and a large part of Central Italy, had Florence surrounded on three sides. But, as he readied for the final blow, he died suddenly and his army had no choice but to retreat. The Florentines viewed the incident as an act of God. They expressed the pride they felt for having been spared from the clutches of their powerful enemy by embellishing their city with new structures, sculptures, and paintings. One of those projects was the building of the dome of the Cathedral of Florence, begun by Arnolfo di Cambio in 1296 and completed by Francesco Talenti in the 1350s, save for the dome. When Arnolfo had rendered his plans, he had left an octagonal opening for the dome that spanned 140 feet, and no architect had the skills to build a structure large enough to cover that opening. All this changed when Brunelleschi entered the scene. In 1407 he suggested to the committee of Cathedral Works that a drum be built to support the dome. Three years later, the drum was approved and Brunelleschi was asked in 1417 to provide a model. In 1420 his design was accepted and building commenced soon thereafter.

To prevent the dome from buckling under its own weight, Brunelleschi built a double-shelled structure over a skeleton of 24 ribs, only 8 of which are now visible from the exterior. To further lighten the dome, he utilized stone at the base and brick on the upper portions and capped it with a lantern to stabilize the ribs and prevent them from arching outward. Not only did Brunelleschi provide an unprecedented design, but he also invented a series of machines for greater building efficiency. He was able to resolve the problems involved in the construction of the massive dome by traveling with the sculptor Donatello to Rome and carefully studying the structures the ancients had built, taking exact measurements of each. Other buildings by Brunelleschi include the Ospedale degli Innocenti (1419–1424), the Church of San Lorenzo (beg. 1421) with its Old Sacristy (1421–1428), and the Pazzi Chapel at Santa Croce (1433–1461). These, like the dome, break away from the medieval mode of building, instead embracing the ancient principles of balance, order, and symmetry, as well as Pythagorean methods of proportion.

While Brunelleschi revolutionized the field of architecture, Donatello did the same in sculpture, and Masaccio in painting. Donatello had assisted Ghiberti in the execution of the bronze doors for the Baptistery and soon surpassed his master's talents. For one of the exterior niches at Or-

sanmichele, Florence, he created the *St. Mark* statue (1411–1413); his patrons were the members of the Guild of Linen Drapers and Peddlers, the Arte dei Linaiuoli e Rigattieri. Appropriately, the saint stands on a sculpted pillow, one of the products manufactured by the guild. Inspired by ancient prototypes, Donatello's figure stands in *contrapposto* (counterpoise), his appearance that of a philosopher from antiquity. His one leg is engaged, the other resting, his shoulders and hips forming two opposing diagonals—a natural pose, first utilized in sculpture by the ancients, that implies movement and that, once reintroduced in the 15th century, allowed sculptors to represent the figure in every position imaginable.

Vasari relates that, upon seeing the completed statue in the artist's studio, the members of the guild rejected it. Donatello promised he would correct the elongations and exaggerated features they found so troublesome once the work was installed in its niche. At the final site, Donatello placed a screen around the statue and pretended to work on it. Once he revealed it to his patrons, they enthusiastically approved the commission. It escaped the guild members that Donatello had included the elongations and distortions to compensate for the fact that the work would be viewed from below and at a distance. This visual compensation allowed viewers to perceive the figure's anatomical proportions, once in its intended placement, as logical and to see clearly the details of the figure from afar, including the furrowed brows and intense gaze that grant him an aura of power and intelligence. Donatello would later create other statues for the niches of Orsanmichele, including *St. George* (c. 1415–1417) for the Arte dei Corazzai e Spadai (Guild of Armorers and Swordmakers), a work that captures the anticipation of the saint facing his imminent combat with the dragon. His *Zuccone* (1423–1425), for one of the niches in the Campanile of the Cathedral of Florence, seems to be caught in some sort of spiritual frenzy as he speaks to the multitudes below about the coming of the Lord. The expressiveness of these figures affirms Donatello's mastery at infusing life into the sculpted image, one of the earliest Renaissance masters to achieve this.

Like Donatello, Masaccio sought to attain lifelike reality. He was the first to use one-point linear perspective in painting, a mathematical method thought to have been devised by Brunelleschi that entails converging all of the orthogonals at a single vanishing point to construct a three-dimensional space on a two-dimensional surface. Masaccio's *Holy Trinity* fresco at Santa Maria Novella in Florence

(1427) uses this technique to render a chapel with Brunelleschian architectural elements that is so convincing as to grant the illusion that a hole has been punched through the wall to reveal an adjoining space. God the Father stands on a platform and presents the crucified Christ to the viewer, the vanishing point placed in the center of the masonry altar below the figures. Flanking them are the Virgin Mary and St. John, and outside the painted chapel are the Lenzi, husband and wife who commissioned the work from the artist. Together the figures form a pyramid that is as rational, orderly, and balanced as Brunelleschi's buildings. Masaccio again utilized one-point linear perspective to render the *Tribute Money* in the Brancacci Chapel at Santa Maria delle Carmine, Florence (c. 1425), the vanishing point directly above Christ's head, which makes him the physical as well as spiritual center of the painting. Masaccio here combined the Brunelleschian formula with the ancient method of atmospheric perspective—the blurring of forms as they move further into the distance to also enhance the depth of the space depicted. For the first time since antiquity, the figures in this fresco cast shadows on the ground in response to the true light that enters the chapel through its window, a feature that integrates the painting into the physical space it occupies.

The technical advancements introduced by Brunelleschi, Donatello, and Masaccio were perfected by subsequent masters, thus inaugurating what Frederick Hartt called the Second Renaissance Style. Leon Battista Alberti became Brunelleschi's heir; not only did he design imposing structures that utilized a classical vocabulary—such as the *Tempio Malatestiano* in Rimini (beg. 1450), the façade of Santa Maria Novella in Florence (c. 1456–1470), and the Church of Sant' Andrea in Mantua (beg. 1470)—but he also wrote a number of influential treatises. In this he was inspired by the writings of the ancient Roman engineer Vitruvius. His topics varied from architecture, sculpture, and painting to horses and the family. With his writings on art and architecture, Alberti was able to raise the fields to a scientific and humanistic level. Alberti rejected the vestiges of Gothicism left in Brunelleschi's structures. His vocabulary instead was purely classical and more monumental than that of his predecessor. For his Church of Sant' Andrea in Mantua, he utilized the ancient triumphal arch motif, appropriately to denote the triumph of the Christian Church over paganism. For his Santa Maria Novella façade, he looked to pedimented ancient temple types, while

his Palazzo Rucellai in Florence (beg. c. 1453) is the earliest Renais-
sance structure to use the Colosseum principle—the correct application
of the ancient orders, with the Doric superimposed by the Ionic and then
the Corinthian.

In painting, the heirs of Masaccio were Fra Angelico and Fra Filippo
Lippi. These men adopted the master's mathematical perspective for-
mula as well as the solidity of his figures and draperies. But, while
Masaccio had placed his figures in front of natural or man-made set-
tings, Fra Angelico and Lippi's figures truly exist in and interact with
their surrounding spaces. Under the sponsorship of Cosimo de' Medici,
Fra Angelico adorned the cells of the Monastery of San Marco, Flo-
rence, with images that inspired devotion among the monks who therein
resided. The appealing pastel colors, sweet, humble figure types, and
sparse settings Fra Angelico used reflect the purpose of these frescoes
and the ascetic life of the men who prayed and meditated in front of
them. Lippi, who took his vows less seriously than Fra Angelico, ren-
dered matronly Madonnas with diaphanous draperies arranged in varied
directions to add visual interest and animation. His *Madonna and Child*
(c. 1455; Florence, Uffizi) presents monumental figures, the Christ
Child a pudgy infant who seeks his mother's embrace. One of the an-
gels who supports him has a mischievous grin, showing that Lippi de-
sired to give his figures a personality and not just concentrate on ren-
dering their physical appearance. The composition of this work, with
the figures by a window through which a landscape is seen, presages the
portraits rendered by Leonardo where figure and nature commingle.

By midcentury, Paolo Uccello, Domenico Veneziano, Andrea del
Castagno, and Piero della Francesca had taken the lead. Uccello was
best known for his obsessive use of one-point linear perspective and
foreshortening, as seen in his *Battle of San Romano* series (c. 1430s;
London, National Gallery; Paris, Louvre; and Florence, Uffizi),
painted for the Medici, and his *Deluge* (c. 1450) in the Chiostro Verde
(Green Cloister) at Santa Maria Novella. His gridlike arrangements re-
sulted in orchestrated scenes that denoted his approach to the craft of
painting from a scientific, methodical standpoint. Though Domenico
Veneziano was also methodic in his use of perspective, his forte was in
colorism and light. In his *St. Lucy Altarpiece* (c. 1445–1447; Florence,
Uffizi), he combined pastel hues in pleasing ways and bathed the scene
with a bright light to emphasize its sacred nature. For Andrea del

Castagno, the figure in movement was key. His *Crucifixion with Four Saints* (c. 1445; Florence, Sant' Apollonia Refectory) shows his interest in human anatomy and the response of muscles and tendons to physical stress. His *David* shield (c. 1451; Washington, National Gallery) presents the youthful would-be king of the Israelites with windswept drapery—one of the earliest Renaissance representations of the human form in action. For Piero della Francesca, the human form could be rendered through the use of simple geometric shapes, such as cylinders, spheres, and cones, clearly seen in his *Resurrection* (c. 1458; San Sepolcro, Museo Civico). His geometric approach won him the admiration of the Cubists in the early 20th century.

Hartt recognizes three major trends that developed in Florence in the late 15th century: the first led by Pollaiuolo and Verrocchio, who approached the human form scientifically; the second championed by Botticelli, who was concerned with rendering poetic images; and the third represented by Ghirlandaio, who recorded contemporary life as he saw it. Pollaiuolo was among the first to dissect human corpses to gain a better understanding of the body's structure. Like Andrea del Castagno, he was fascinated with the body in action and concentrated on depicting it in complex movements, as in his *Hercules and Antaeus* (c. 1460; Florence, Uffizi) where the mythical hero combats the son of Gaia, the Earth. His *Battle of the Ten Nudes* (c. 1465; New York, Metropolitan Museum) recalls illustrations in anatomy manuals as each figure is posed differently and performs a different action. Verrocchio, the teacher of Leonardo, not only wished to present the human form with all its anatomical details, but he also was keenly interested in physiognomic treatises that related the human temperament to that of animals. So, for example, his *Colleoni Monument* (1481–1496; Venice, Campo dei Santi Giovanni e Paolo) presents the commander Bartolomeo Colleoni with leonine features to enhance his heroism.

Botticelli was a member of the court of Lorenzo "the Magnificent" de' Medici and his works reflect the interests of his patron, particularly Neoplatonism, a philosophy based on the teachings of Plato that embraces the concept that the soul possesses a high, pure form and a low, corrupt part. While common individuals succumb to passions and vices, enlightened ones are able to achieve the soul's ascent through contemplation and its eventual union with the highest principle. Botticelli's works, such as the *Primavera* (c. 1482; Florence, Uffizi), are considered

by some to translate visually the Neoplatonic concepts of interest to the members of the Medici court, their purpose to aid viewers in attaining a higher level of contemplation. While Botticelli catered to the Medici, Ghirlandaio's patrons were mostly successful Florentine merchants who may not have been as interested in intellectualism. Instead of providing images with philosophical intonations for these patrons, Ghirlandaio included them among the witnesses of religious scenes, allowing these to unfold in local Florentine settings. His frescoes in the Sassetti Chapel (1483–1486) at Santa Trinità, Florence, for instance, place recognizable members of the Tornabuoni family, related to the Medici by marriage, among those who observe the miracle effected by St. Francis in front of the Church of Santa Trinità, not where the event is said to have taken place. In the *Birth of the Virgin* in the Cappella Maggiore at Santa Maria Novella (1485–1490), Ghirlandaio depicted Ludovica Tornabuoni within a Florentine domestic setting.

Some of these masters from the Tuscan region traveled to other parts of Italy, taking the new Tuscan vocabulary with them. Domenico Veneziano worked in Perugia in the 1430s, as did Benozzo Gozzoli, a pupil of Fra Angelico, in nearby Montefalco in the 1450s. Pietro Vannucci, called Perugino, learned the Florentine vocabulary from their example, thus bringing Perugia out from artistic obscurity. He eventually received the attention of Pope Sixtus IV, who invited him to Rome to render *Christ Giving the Keys of the Kingdom of Heaven to St. Peter* (1482) on one of the walls of the Sistine Chapel. This was part of a major decorative campaign for a building that to this day is used to elect the new pontiff, with a large number of artists involved, including Botticelli. In a commission that proved to be somewhat of a disaster from the artistic standpoint, Perugino's fresco stands out as the most successful. His elegant figures with their dreamy eyes and swaying poses would prove to be a major influence on the art of his pupil Raphael.

Melozzo da Forli, a native of the Romagna region, also worked for Sixtus IV in Rome. He had come into contact with Piero della Francesca at the court of Federico da Montefeltro in Urbino through whom he would have acquainted himself with the new mode of painting. Once in Rome, he created frescoes utilizing a *di sotto in sù* technique, an exaggerated form of foreshortening. His *Christ in Glory* (1481–1483), painted for the Church of Santi Apostoli, Rome (partially destroyed; fragments in the Vatican Museum and the Quirinal Palace in Rome),

formed part of an *Ascension* frescoed in the church's apse with the apostles witnessing the event below and Christ and windswept musical angels hovering above. The illusion Melozzo sought to create was that of a vision taking place in the heavens above the viewer, which was to open the doors to the development of illusionistic ceiling painting.

Lippi, Uccello, and Castagno worked in Venice, and Donatello in nearby Padua. Though a school of painting had already been established in the region by Paolo Veneziano in the previous century, the impact of the new Florentine mode was deeply felt, with a major school emerging dependent on these examples. Jacopo Bellini established a family of artists that included his two sons Giovanni and Gentile, and his son-in-law Andrea Mantegna. Best known for his drawing books, now housed in the Paris Louvre and the British Museum, Jacopo's greatest contribution was as a teacher. The drawings in these books show his complete understanding of one-point linear perspective, this commingled with the Venetian interest in the depiction of nature or man-made scenery dominant over humanity. Religious and mythological scenes become subordinate to the landscape or the Venetian urban environment.

Mantegna, a native of the Paduan region, was particularly interested in antiquity and Donatello's sculptures. His figures demonstrate a solidity and monumentality that translate into painting what Donatello had created in bronze and stone. In fact, his *St. James Led to His Execution* (1454–1457) painted in the Ovetari Chapel in the Church of the Eremitani, Padua (destroyed; known through photographs) includes a figure with a shield that is based on Donatello's *St. George* at Orsanmichele, Florence. In rendering the *San Zeno Altarpiece* (1456–1459; Verona, Church of San Zeno), Mantegna again looked to Donatello, and specifically his altar at San Antonio, Padua (1444–1449) for his figural and architectural arrangements. Like Melozzo, Mantegna was a master of foreshortening. His ceiling in the *Camera Picta* (1465–1474) at the Ducal Palace in Mantua, painted for Ludovico Gonzaga and his family, is made to look like an open oculus surrounded by a parapet with putti and servants leaning over it to gaze down at the viewer.

Mantegna's brother-in-law, Gentile Bellini, was the Venetian counterpart to the Florentine Ghirlandaio. Like his Tuscan colleague, Gentile specialized in images that included the people of his city and recorded its important events. His *Procession of the True Cross* (1496;

Venice, Accademia) commemorates a specific cortege in 1444 in which the relic of the True Cross, owned by the Scuola di San Giovanni Evangelista and whose members paid for the painting, effected a miraculous cure, proving its validity. The painting is of great historical value, not only in that it includes members of the confraternity, clergy, the doge (the chief magistrate of the Republic of Venice), and his retinue, but it also depicts the Basilica of San Marco as it looked in the 15th century, including the decorations by Paolo Uccello on the façade, which have since been destroyed.

Giovanni Bellini, Gentile's brother, stands out as the most admired of the Venetian masters of the period. His *Frari* (1488; Venice, Santa Maria Gloriosa dei Frari) and *San Giobbe* (c. 1487; Venice, Accademia) altarpieces established a new standard in Venice for the depiction of the Madonna and Child that entailed elevating these figures on a high throne with elaborate architecture to set them apart from the accompanying saints. These two paintings Bellini rendered in oil applied in various translucent layers, giving a velvety quality to the painted surface. He learned the technique from Antonello da Messina who, while active in Naples, had had the opportunity to study the works of the Flemish masters. The Flemish School will be discussed in detail below. Here, it will suffice to note that, by now, Flemish art was well represented in Italy and, in fact, the art collection of King Alfonso of Naples included examples from the Northern masters, where Antonello would have studied them. Also, in 1456, Antonello was working in the court of Galeazzo Maria Sforza in Milan, possibly alongside Petrus Christus, the painter from Bruges from whom he would have learned firsthand how to apply oil glazes onto the pictorial surface to achieve luminous, velvety effects. If color and light are the true subjects of Bellini's paintings, it is because of the environment in which he worked. Venice is composed of a series of islets contained within a sheltered lagoon along the Adriatic Sea. Color and light bounce off the water surfaces, effects that could not have been replicated on the painted surface had it not been for the oil technique learned from Antonello. The particular golden glow of Bellini's paintings was also inspired by the mosaics inside the Basilica of San Marco. In fact, the two paintings by Bellini just mentioned place the Virgin and Child in front of an apse covered with mosaics that imitate those in the Venetian landmark.

THE HIGH RENAISSANCE

As Giovanni Bellini was creating his masterpieces in Venice, and Botticelli his in Florence, Leonardo da Vinci was already inaugurating the High Renaissance by utilizing the innovations introduced during the century and taking them to their ultimate state. Leonardo was what one would call a true Renaissance man. Not only was he active as painter, but his interests reached just about every area of learning. He delved into anatomy, hydraulics, optics, astronomy, mathematics, and urban planning, to name a few of his areas of interest. He kept scrupulous notes of his experiments, research, and discoveries, which have survived to provide testimony to his inquisitive nature. Leonardo was also instrumental in elevating the artist's status from craftsman to genius. He wrote a treatise on painting and in it he compared the creative power of artists to those of God. For him, painting was to be considered a liberal, not manual, art and to take precedence over poetry and music because it depends on the eye, for him an organ superior to the ear on which these other outlets for creativity rely.

His masterpiece is, of course, the *Mona Lisa* (1503), one of the most venerated works of art ever created. Though hordes of people flock to the Louvre Museum in Paris every day to view the work, few understand the true importance of the *Mona Lisa* to the history of art. The woman portrayed is Lisa di Antonio Maria Gherardini, wife of the prominent Florentine banker Francesco del Giocondo, hence the reason she is sometimes also called *La Gioconda*. Prior to this portrait, the usual format was head and shoulders. Here, Leonardo extended the view to include her torso and hands, which permits the assessment that the figure is seated. She also looks directly at the viewer when most female portraits of the era showed the figure in profile. Leonardo's contemporaries were creating portraits of women that emphasized their social status by the elegant costumes and jewelry they wore. Leonardo, on the other hand, removed any blatant display of luxury, instead focusing on the woman herself. *Mona Lisa* smiles at the viewer, a detail that grants her a personality and denotes that Leonardo sought to capture her appearance as well as her psychology. She forms a large, solid pyramid placed in front of a landscape that echoes the forms of her body and hair, tying the two together. The sfumato, a shading technique Leonardo

devised, grants her an aura of mystery. With this portrait, Leonardo introduced a new, more naturalistic mode of portrayal.

Other works by Leonardo were just as innovative. His *Last Supper* (1497–1498) in the refectory of Santa Maria delle Grazie, Milan, depicts the moment when Christ establishes the Eucharist as a sacrament by inviting his disciples to drink the wine, representative of his blood, and the bread, which denotes his body. This is also the moment when Christ declares that one of his followers will betray him and they, in turn, react to this momentous statement by engaging in agitated gestures as if to say, "Lord, is it I?" in accordance with the biblical account of the event. The drama of the moment makes this work stand out from earlier representations of the theme. Leonardo's interest in mathematics and numerology is clearly reflected in this work, as the apostles are posed in four groups of three, the windows behind Christ number three, and the doorways on the lateral walls number four. These ciphers and their sum have spiritual significance. Three refers to the Holy Trinity and the three Theological Virtues, while four is the number of the Gospels, Cardinal Virtues, rivers of paradise, and seasons of the year. Seven, the sum of the two, are the gifts of the Holy Spirit, the joys of the Virgin, and her sorrows. Three multiplied by four is 12, and 12 is the number of the apostles, the gates of Jerusalem, the months of the year, the hours of the day, and the hours of the night. With this, Leonardo expressed the perfection of God's creation of both spirit and matter.

While Leonardo considered painting to be the noblest form of art, Michelangelo placed sculpture at the highest level. Nourished by a wet nurse in a village of stonecutters called Settignano, Michelangelo often joked that he had become a sculptor because he had suckled the instruments of his trade with his wet nurse's milk. But, in spite of his preference for sculpture, Michelangelo also excelled in painting and was able to create one of the most outstanding examples of art: the Sistine ceiling (1508–1512). The work was commissioned by Pope Julius II, the nephew of Sixtus IV who had patronized the decoration of the walls in the Sistine Chapel where Perugino contributed his fresco, *Christ Giving the Keys of the Kingdom of Heaven to St. Peter*, previously mentioned. Preparatory drawings indicate that Michelangelo first intended to paint the 12 apostles separated into compartments. He then, contemporaries inform us, complained to the pope that the

ceiling's overall design would not be imposing enough, with Julius replying that Michelangelo could do as he wished. It is not clear whether this account is in fact accurate. What is clear is that Michelangelo created a ceiling that was unlike any other seen before. The ceiling, as it was executed, is organized into three bands. On the outer bands are enthroned prophets and sibyls who foretold the coming of Christ. Above each sit two *ignudi* (nude male figures) holding a medallion painted to resemble bronze. In the central band are nine scenes from the Book of Genesis that deal with the story of Creation, up to the *Drunkenness of Noah*. Between the prophets and sibyls are triangular fields with Christ's ancestors; at either side of each are seated bronze-colored nudes. Christ's ancestors also occupy the lunettes above the windows. On the spandrels in the corners of the ceiling are narratives from the Old Testament that prefigure the sacrifice of Christ, such as the *Brazen Serpent*, which speaks of Christ on the cross. Many interpretations have been given of Michelangelo's ceiling, one of which ties it to Neoplatonism, a plausible reading as the artist was part of the Medici court. According to this view, Michelangelo's ceiling speaks of the history of humankind as it gradually moved from a time before religion, to paganism, and finally the Christian era. The crescendo from blindness to enlightenment corresponds to the Neoplatonic tenet of the soul's trajectory from the mundane to the spiritual through contemplation in order to achieve union with the highest principle.

Michelangelo's best-known sculpture is the *David* (1501–1504; Florence Accademia). Originally intended for one of the buttresses of the Cathedral of Florence just below the dome, the figure was so well received that the fathers of the city decided to place it instead in front of the Palazzo Vecchio, the seat of government, as a symbol of the new Florentine Republic established when the Medici were temporarily expelled from the city. As the work was meant to be viewed from below and at great distance, Michelangelo exaggerated the figure's proportions, just as Donatello had done at Orsanmichele. Unlike earlier representations of David, Michelangelo's is a grown man, not a shepherd boy. He is a powerful, fully nude figure rendered in the Greco-Roman mode to enhance his heroism. Instead of standing on Goliath's head, as in the earlier examples, here David is shown before the confrontation, his anticipation clearly denoted by his furrowed brow and tense muscles. In this, Michelangelo was inspired by Donatello's *St. George* at

Orsanmichele, which also presents the figure before combat with the enemy, his face showing signs of anticipation and tension.

The third key figure of the High Renaissance is Raphael. Raphael was not as innovative as Leonardo or Michelangelo, but he certainly was one of the best-loved artists of the era. The grace and beauty of his paintings are what his contemporaries found so appealing about the master. He specialized in Madonna figures, these inspired by Leonardo's pyramidal Virgins in the landscape. But, when he arrived in Rome to work for Pope Julius II and saw Michelangelo's Sistine ceiling, his style changed to a more monumentalized mode of painting. His *School of Athens* (1510–1511) in the Stanza della Segnatura at the Vatican is his response to Michelangelo's work. Painted with greater vigor than his earlier renditions, the fresco speaks of the spirit of the Renaissance, as it includes the greatest ancient men of learning then so admired. Plato and Aristotle stand in the background center, each accompanied by their respective followers. Aristotle points down and Plato up to denote that the former was interested in nature and its phenomena while the latter preferred to focus on elusive subjects such as ethics and morality. Other important figures of the history of philosophy and learning accompany these men, including Socrates, Diogenes, Pythagoras, Ptolemy, and Heraclitus. This last is a portrait of Michelangelo dressed in a stonecutter's smock and boots. He is shown brooding because melancholy was then considered a sign of genius. With this, Raphael paid homage to the man who had just achieved the impossible.

Raphael's scene takes place in an architectural setting that recalls Donato Bramante's buildings. Bramante was the leading architect in Rome at the time when Michelangelo and Raphael were working there. He built the *Tempietto* (c. 1502–1512) in the courtyard of San Pietro in Montorio, Rome, to commemorate the site where St. Peter was supposedly crucified, a commission financed by Isabella and Ferdinand of Spain. The small, centrally planned structure was inspired by Early Christian *martyria* that, as their name indicates, marked the spot where saints were martyred. The *Tempietto* features a completely classical vocabulary, with Doric columns and frieze capped by a balustrade, followed by a hemispherical dome reminiscent of the dome of the Pantheon, built in the Roman era. Christian liturgical instruments, such as the challis and paten, adorn the frieze and denote that, in spite of the pagan vocabulary, the building is very much a Christian structure.

In 1506, Julius commissioned Bramante to provide a plan for a new St. Peter's, the mother church of the Catholic faith, as the old Early Christian basilica had fallen into disrepair. Of Bramante's design, all that is left is a coin minted by Cristoforo Caradoso, one of his assistants, and a half-plan that suggests that he wanted to build again a centrally planned *martyrium*, in this case to mark the site of St. Peter's tomb. Bramante died and his project was not completed until Michelangelo took over in 1546. Working under Pope Paul III, he modified Bramante's plan by thickening the outer walls and four main piers. He also simplified the interior space arrangements for a more unified design and defined more clearly the entrance to the basilica. The final result is an organic structure with rhythmic repetitions, alternating forms, and in and out movements of the exterior walls. The dome, completed by Michelangelo's pupils after his death, is a Brunelleschian type that sits on a base and is built around a skeleton of ribs. A lantern stabilizes the ribs as they did in Brunelleschi's dome for the Cathedral of Florence.

The artists of the High Renaissance mentioned thus far represent the Florentine/Roman School. As discussed previously, their art depended on order, balance, and symmetry. In painting, drawing the figure and objects with great precision prior to adding color was the norm, and light was no more than a tool to enhance the sculptural quality of the various forms depicted. As a result, the images of the Florentine/Roman artists, save for Leonardo's, are solid and linear, each section clearly recognizable and separate from the next. In Venice, a competing group emerged, led by Giorgione, Titian, Tintoretto, and Paolo Veronese. These individuals used the foundations Bellini had laid as a springboard for further advancement. As mentioned, Bellini rendered images where colorism and warm glows were the most outstanding features. The Venetian artists of the 16th century continued the layered application of oils to obtain these effects, but now their brushwork became as lush as the colors they were using and their figures became more sensuous. Also, the Venetians became aware of Leonardo's art and began experimenting with his sfumato technique, applying it in certain areas to soften line and contours and to achieve ethereal effects. They also adopted Leonardo's characteristic placement of humans within nature. For the Venetians, in fact, the sensuous nude in the landscape became a common feature of their art, as Giorgione's *Fête Champêtre* (c. 1510; Louvre, Paris) and *Sleeping Venus* (c. 1510; Dres-

den, Gemäldegalerie) epitomize. Hence, what distinguishes the Venetians from the Florentine/Roman masters is that they created their forms with color and light, their loose brushwork lending vibrancy to their images. These differing approaches by the two groups gave way to debates on *colorito* (colorism) versus *disegno* (draughtsmanship) that were to last well into the 18th century when the Poussinists, who favored the classicism and precision of the Florentine/Roman School, debated against the Rubenists, who preferred the lush application of paint to augment the dynamism and drama of their scenes.

The vitality of Venetian art depended as well on the introduction of diagonal arrangements. Titian's *Madonna of the Pesaro Family* in the Church of Santa Maria dei Frari, Venice (1519–1526), is of the same stock as Bellini's *San Giobbe* and *Frari* altarpieces. The Virgin and Child sit on an elevated throne, saints flank them at either side, architecture sets them apart from the other figures, and color and light take on a primary role. Titian, however, moved his scene to an open portico, allowing sunlight to bathe the various surfaces, and pushed the throne to the right to form a right triangle that differs from the pyramidal compositions of the members of the Florentine/Roman School, which are centered and perfectly symmetrical. This right triangle introduces a sharp diagonal line that adds a sense of movement to the scene. For added animation, Titian's Christ Child is a pudgy infant who stands on his mother's lap and plays peek-a-boo with her veil, obviously undisturbed by the fate that awaits him.

As Titian aged and his eyesight failed, his brushwork became looser. His apprentice, Tintoretto, also applied his colors loosely, using large brushes and working at great speed. Though Tintoretto learned well the lessons Titian offered, his works possess an originality that departs from his teacher's art. Tintoretto's works present noisy, overpopulated scenes that are filled with action. In his *Last Supper* in the Scuola di San Rocco, Venice (1577–1581), the table on which Christ and his disciples take their last meal together is placed in a diagonal that recedes rapidly into space. Instead of showing Christ seated in the center of the composition, as Leonardo depicted him, he stands at the back of the room and administers the Eucharist to St. Peter. In the foreground, the servants who served the meal rest on the steps where a dog wags its tail, hoping to receive a morsel. The reverence of Leonardo's *Last Supper* is lost in Tintoretto's version and, instead, Christ and the apostles are presented as

everyday men who have gathered at an inn. Only the administration of the Eucharist in the background hints at the fact that this is no ordinary moment. In this, he was following Jacopo Bellini's custom of treating religious scenes as incidental occurrences unfolding in a large setting. Veronese, Tintoretto's competitor, also depicted the Last Supper as a noisy event populated with figures. The work, painted for the refectory (dining hall) of the Dominican Monastery of Santi Giovanni e Paolo in Venice, was deemed indecorous by the officials of the inquisition because, more than Tintoretto's version, it lacked any suggestion of sacredness. Veronese rendered the moment as a contemporary Venetian banquet attended by the local nobility, dressed in their most sumptuous clothes and bedecked in jewels. Buffoons and dwarfs are there for their entertainment, as are exotic animals, and some of the individuals depicted are in a drunken stupor. Veronese was able to avoid persecution simply by changing the title of the work to the *Feast in the House of Levi* (1573; Venice, Accademia), a less sacred episode in Christ's life.

Veronese stands as one of the great masters of illusionism. His *Triumph of Mordecai* (1556) at San Sebastiano and *Triumph of Venice* in the Hall of the Great Council of the Doge's Palace (c. 1585), both in Venice, are ceiling paintings that present the figures *di sotto in sù*. In the *Triumph of Mordecai*, a procession passes above the viewer, the horses so foreshortened as to reveal their undersides. Figures look down, recalling the individuals in Mantegna's *Camera Picta* who peer down from the ceiling's painted oculus. The *Triumph of Venice* also presents a pageantry scene, with the allegorical representation of the city enthroned in the clouds like a Virgin Mary, floating above the viewer.

MANNERISM

At a certain point in his career, Michelangelo became dissatisfied with the order, symmetry, and balance of the Renaissance and began to experiment with an anticlassical vocabulary. The unprecedented architectural forms he introduced in the vestibule of the Laurentian Library (1524–1534) and Medici Chapel (Old Sacristy of San Lorenzo, 1519–1534), and the sculptural figures in this last commission with their muscular forms and unsteady poses, gave impetus to the develop-

ment of Mannerism, a movement that emerged in Florence in roughly the 1520s as a revolt against the strict classicism imposed by the Renaissance masters on art and architecture. Working for Duke Federigo Gonzaga of Mantua, Giulio Romano designed the Palazzo del Tè, one of the great masterpieces of Mannerist architecture. Like Michelangelo, Giulio broke away from the rationality of the Renaissance by spacing pilasters asymmetrically, breaking the stringcourses with massive keystones, and adding pronounced rustications on all the surfaces.

Jacopo da Pontormo and Rosso Fiorentino were the early exponents of Mannerist painting. Pontormo's key work is the *Deposition* (1525–1528; Florence, Capponi Chapel), an image filled with baffling ambiguities. Although the title of the painting denotes that it is meant to represent the removal of the body of Christ from the cross for burial, the cross is missing. The composition is circular, with a void in the center where a series of stacked hands can be seen—so the main focus of the work is not the dead Christ but those hands. The scene moves up instead of logically receding into space so that the figures seem to float and the colors are combined abruptly, not harmoniously, with too much blue used. The lighting is harsh, without the subtle Renaissance gradations from light to medium to dark, and, finally, the figures, though inspired by Michelangelo, are in poses that would be impossible for humans to attain, with body parts that do not seem to belong to any of the characters included. Rosso Fiorentino's *Descent from the Cross* (1521; Volterra, Pinacoteca) is no less jarring. The light here is so harsh that it divides the draperies into facets and the poses are so contorted that they grant a sense of turbulence to the scene. The oval composition with a void in the center is also present here. What is Michelangelesque in Rosso's work is Christ's pose. His body is a reversed version of Christ in Michelangelo's *Pietà* at the Vatican.

Mannerism soon spread to other parts of Italy and Europe. Perino del Vaga pioneered it in Rome and Genoa, Domenico Beccafumi in Siena, Correggio in Parma, and Parmigianino in Parma, Rome, and Bologna. A second wave of Mannerist artists emerged toward the middle of the 16th century, including Agnolo Bronzino, Vasari, and Federico Barocci. Benvenuto Cellini, Bartolomeo Ammannati, and Giovanni da Bologna translated the Mannerist idiom into sculpture, and Ammannati, Vasari, and Giulio Romano into architecture.

THE BAROQUE ERA

In 1517, the authority of the Church was threatened when Martin Luther, dissatisfied with the excessive sale of indulgences and abuses from the clergy, posted his Ninety-Five Theses on the main portals of Wittenberg Cathedral, Germany. Soon these theses, which attacked the pope and explained Luther's own position on contrition and penance, were circulated throughout Northern Europe, giving impetus to the Reformation. As a result, Protestantism emerged as a new religion meant to satisfy the needs of those who questioned the excessive power of the Catholic Church.

In 1545, Pope Paul III convoked the Council of Trent to fight the spread of Protestantism and to enact reforms that would eliminate abuses related to Church administration, an act that would officially launch the Counter-Reformation. The council's last session took place in 1563 and is of particular importance to the history of art because enactments were then made that stipulated the proper way to depict religious subjects. Art, it was decreed, should instruct the faithful on redemption, the intercessory role of the saints and the Virgin, and the veneration of relics. Religious images were to invoke piety and inspire viewers to engage in virtuous behavior. The effects of these enactments were not felt until over a decade later when key Church figures began writing treatises to instruct artists on the Tridentine stipulations. St. Charles Borromeo, archbishop of Milan, provided in 1577 a treatise on the proper building of churches, and Gabriele Paleotti, archbishop of Bologna, wrote the *Intorno alle imagini* in 1582, a guide on the correct depiction of sacred and profane images. These events marked the beginning of the Baroque era.

The first church to be built that satisfied the demands of the Counter-Reformation was Il Gesù in Rome (1568–1575; façade fin. 1584), the mother church of the Jesuit Order. Financed by Cardinal Alessandro Farnese, a relative of Pope Paul III, the building was designed by Giacomo da Vignola, who used Leon Battista Alberti's Sant' Andrea in Mantua as his prototype. Like Alberti, Vignola eliminated the aisles, leaving only a broad barrel-vaulted nave to accommodate large crowds and to prevent visual obstructions to the main altar where the rituals of the mass take place. Vignola's façade, reworked by Giacomo della

Porta, looked to Alberti's at Santa Maria Novella, Florence, imitating its two-story elevation, equal height and width, and decorative scrolls that visually connect the upper and lower stories. Il Gesù became the standard Counter-Reformation design for longitudinal churches.

The artistic reform in painting was led by Federico Barocci in Urbino, the Carracci in Bologna, and Caravaggio in Rome. In this discussion, Barocci was already placed among the Mannerists. However, in the 1580s, he suddenly changed his style and began creating works that were well suited to the demands of the Counter-Reformation. His *Visitation* (1586; Rome, Chiesa Nuova) presents common figure types, made more appealing by the various touches of pink on their cheeks and lips and the tilting of their heads as they witness Mary visiting her cousin Elizabeth to inform her that she is with child. The ambiguities of Mannerist art are gone. Instead, sharp diagonals direct the viewer's gaze toward the main protagonists, who occupy the center of the composition. Contemporary accounts relate how all of Rome lined up for three days to view the work once it arrived from Urbino and of St. Philip Neri experiencing ecstatic raptures in front of the painting. Clearly, the artist rendered an appealing image that evoked emotive responses from viewers, as the stipulations of the Council of Trent and the treatises published thereafter demanded.

In Bologna, Annibale, Agostino, and Ludovico Carracci established an academy that offered a progressive learning environment where students could draw from life, receive lessons in anatomy, and participate in competitions and learned discussions about art. Their purpose was to restore art from what they viewed as the excesses of Mannerism, their intensions expounded clearly in Annibale's *Butcher Shop* (c. 1582; Oxford, Christ Church Picture Gallery), as has been noted in current scholarship on the Carracci. This work includes the portraits of the three Carracci, with Ludovico, who was the son of a butcher, standing behind the counter, Agostino weighing meat to the left, and Annibale slaughtering a lamb in the foreground. The contorted, overdressed figure on the extreme left refers to what they perceived as the inadequacy of Mannerism as visual language, while the meat that hangs in the shop expresses the Carracci's style, which they described as *da viva carne* (of living flesh), meaning that, unlike the Mannerists, they painted from nature. Annibale used Michelangelo's *Sacrifice of Noah* on the Sistine ceiling

as the prototype for the slaughtering of the lamb to allude to their desire to rescue painting from the artificiality of Mannerism and to restore it to the classicism of the great Renaissance masters.

The Carracci were very eclectic, their style melding elements from Michelangelo, Raphael, Titian, and even the Mannerist Correggio, whom they deeply admired. Caravaggio looked mainly to the Venetians, adopting their rich palette and gold lighting. He gave the Venetian manner a new twist by pushing the figures close to the foreground and showing them with all their imperfections, exaggerating the diagonal arrangements, and dramatizing the light through pronounced contrasts of light and dark. His paintings in the *Contarelli Chapel* (1599–1600, 1602) in the Church of San Luigi dei Francesi, Rome, meet all the Tridentine demands. They depict the three main events in the life of St. Matthew: his calling by Christ, his writing of the Gospel, and his martyrdom. The story is conveyed clearly through dramatic gestures and glances, and the stories validate sainthood and the nobility of dying for the faith, both questioned by the Protestants. The scene of Matthew's conversion invites those who may have strayed from the Church to return.

Of the three reformers, Caravaggio had the greatest impact as his style spread throughout Europe. In Italy, Caravaggism lost its appeal by 1620 and the Carracci followers came to dominate the scene, among them Domenichino, Guercino, Giovanni Lanfranco, Francesco Albani, and Andrea Sacchi. In the 1630s, a Neo-Venetianism was established by Pietro da Cortona who would revolutionize the art of ceiling painting by allowing his figures to weave in and out of fictive frameworks. His *Glorification of the Reign of Urban VIII* in the Barberini Palace in Rome (1633–1639), which presents these features, contrasts markedly with Sacchi's *Divine Wisdom* (1629–1633) in the same building. Sacchi's work includes a lesser number of figures and lesser dynamism, which makes for easier readability. The differing styles of these two individuals resulted in a series of debates at the Accademia di San Luca, Rome's painting academy, on the proper representation of history paintings. This was nothing more than a revival of the 16th-century debate on colorism versus draughtsmanship, of the Venetian versus the Florentine/Roman mode, of visual vibrancy versus classical restraint. The debate had already existed among connoisseurs of the 17th century, some of which preferred the classicism of the Carracci while others were parti-

sans of Caravaggio's naturalism. This dichotomy of visual preference spilled into sculpture and architecture as well. In sculpture, Gian Lorenzo Bernini embodied the dramatic, theatrical mode of representation, with his *Ecstasy of St. Theresa* in the Cornaro Chapel at Santa Maria della Vittoria, Rome (1645–1652), serving as an example. Alessandro Algardi chose the classical approach, as demonstrated by his *Tomb of Pope Leo XI* (1634–1644) at St. Peter's. Surprisingly, in architecture, Bernini was the one to favor classical, sober lines while Francesco Borromini designed structures that took on biomorphic forms, swelling and contracting before the viewer's eyes.

The Baroque era lasted until the end of the 17th century, which falls outside the scope of the present study. Left is the task of examining the art created in the other major artistic centers of Europe. For this, it is necessary to return to the 14th century.

ART OUTSIDE OF ITALY

The mode of painting that developed in Italy in the early 1300s, with its emphasis on naturalism, spread to Northern Europe when Simone Martini, Duccio's pupil, arrived in Avignon, France, in 1335 to work in the papal court. Pope Clement V had moved the papacy to Avignon in 1309 to avoid the constant conflicts caused by rival political factions in Rome, as well as the intrusions of the Holy Roman Emperor. This period in the history of the papacy, which was to last until 1377, is called the Babylonian Captivity. When Martini went to Avignon, he brought with him the Sienese mode of painting, a style that, as mentioned, combined Byzantine gilding and brilliant colors with the naturalism and monumentality introduced by Giotto. As the papal court was frequented by prelates and other individuals from all over Europe who conducted business there, soon this mode of painting spread throughout France, the Netherlands, Austria, Bohemia, and Catalonia, and aptly became known as the International Style.

In France, the moment was ripe for the eager reception of Martini's manner as interest in naturalism already existed there prior to the master's arrival. The same impetus that had prompted Italian artists to strive for more naturalistic forms also touched the masters of the North. Here, a major force in this respect was St. Thomas Aquinas, who had declared

the physical world to be a metaphor for the spiritual. Also, as in Florence, France enjoyed the wealth necessary to produce works of art. Charles V of France and the Dukes of Anjou, Orleans, Berry, and Burgundy, all grandsons of Philip VI from the French royal house of Valois, shared a passion for art, and particularly illuminated manuscripts. Under these men, the International Style came to its highest glory, maintaining its position until the 1420s, when war with England and internal strife resulted in the decline of art production in the region.

Of the art objects from France's International Style, only illuminated manuscripts have survived, with few exceptions. In this medium, it was Jean Pucelle who held the lead. It was he who, aware of Duccio's works, combined the French Gothic mode with the new treatment of space introduced by the Italians. His *Annunciation* in the *Hours of Jeanne d'Evreux* (1325–1328; New York, Cloisters) presents the Virgin and Angel Gabriel within an architectural setting constructed through the use of orthogonals that attempt to converge in the center of the composition, therefore granting the work a sense of volume. Once the International Style made its way to Northern Europe, illuminations became more emphatically luxurious, though still retaining their emphasis on realism, with André Beauneveu and the Limbourg brothers at the forefront, all patronized by the Duke of Berry. The Limbourg brothers, in fact, created one of the most handsome illuminations of the International Style, *Les Trés Riches Heures du duc de Berry* (1416; Chantilly, Musée Condé), with landscapes populated by courtly men and women and peasants performing activities appropriate to their social rank.

FLANDERS AND THE LOW COUNTRIES

In 1384, Louis de Mâle, Count of Flanders, died and his son-in-law, Philip the Bold, the Valois Duke of Burgundy, inherited the Flemish lands. These were to remain under Burgundian rule until 1477 when Charles the Bold, the last Duke of Burgundy, died. Philip moved his court seat to Dijon and there he asserted his wealth and power through, among other things, the patronage of art. Philip focused mainly on the Chartreuse de Champmol, the local Carthusian convent he established to house the tombs of the Burgundian dukes. There, Claus Sluter worked on the *Well of Moses* (1395–1406; Dijon, Musée Archéologique), Jean

Malouel on a series of large scale paintings, and Melchior Broederlam on the side wings for a carved altarpiece, the *Dijon Altarpiece* (1394–1399; Dijon, Musée des Beaux-Arts); these last were indebted to Italian art, and particularly the Lorenzetti brothers, in the construction of the background architecture, the treatment of the landscape, and the volume of the figures. The bright colorism and heavy gilding were also elements borrowed from the Sienese masters and characteristic of the International Style. Typically Northern was the emphasis on symbolism. The round tower in the background of Broederlam's *Annunciation* refers to Jerusalem, the old law of Moses, and the Old Testament, while the Gothic chapel in which the scene takes place denotes the New Testament and the new law of Christ. Further, the tumbling statue in the *Flight into Egypt* is a detail from an apocryphal account where pagan idols fall as Christ is taken to safety.

In mid-15th century, Philip the Good, Duke of Burgundy from 1419–1467, set up courts in Bruges, Brussels, and Lille in an effort to form an empire of his own situated between France and Germany. In so doing, he attracted merchants, bankers, artists, and all sorts of individuals who wished to benefit from his patronage. The result was a major economic expansion in Flanders and the development of what became the most influential art center of Northern Europe. There, the International Style evolved into a more sober, less luxuriant visual language, first in Tournai, a major trade center known primarily for its manufacture of tapestries, and later the port city of Bruges, which by now had become the commercial link between North and South as well as a major banking center. The pioneer of this new mode of painting was the Master of Flémalle, now identified as Robert Campin of Tournai, who placed religious episodes in believable domestic settings while emphasizing a vivid colorism and sculptural forms inspired by the statuary for which Tournai was well known. Following the tradition established by Broederlam, Campin's works also include what Erwin Panofsky called "disguised symbolism." His *Mérode Altarpiece* (c. 1426; New York, The Cloisters) is his grand masterpiece. The triptych's central panel shows the *Annunciation* in a Flemish household setting, with the Virgin seated on the ground and reading her book of devotions. Her position denotes her humility while her action speaks of her piety. As the angel alights to announce the coming of the Lord, a miniaturized Christ Child carrying the cross enters the room through a window and flies toward his

mother's womb. The action of passing through glass without shattering it signifies the preservation of Mary's virginity in spite of the conception. The objects around the room add to the symbolic import of the painting: the niche in the background speaks of the tabernacle in the temple, and the hanging towel refers to the washing of the hands by the priest before the mass. With these inclusions, Campin brought the spiritual to a human level to incite devotion from the faithful as they viewed the painting.

Campin executed the *Mérode Altarpiece* in the oil medium, one of the earliest artists to use it, with it providing more options than just the rather lusterless finish of tempera. His emphasis on even the minutest details in this painting denotes that he was tied to the miniaturist tradition established by manuscript illuminators such as Pucelle and the Limbourg brothers. Campin's figures, however, are weightier than those rendered by the miniaturists and covered by heavy draperies that are more decorative than realistic as they form an endless cascade of fabric that falls in a series of carefully arranged angular folds. These became the main features of Flemish art.

In Bruges, Jan van Eyck held the lead. Working as the official painter to Philip the Good from 1424 until his death in 1441, van Eyck, like Campin, blended naturalistic elements with disguised symbolism. His *Ghent Altarpiece* (c. 1425–1432; Ghent, Cathedral of St-Bavon) is one of the greatest masterpieces of Flemish art. It presents a rendering in brilliant colors of the apocalyptic *Adoration of the Lamb*, with God the Father enthroned above it. He wears a papal tiara and is flanked by the Virgin Mary and St. John the Baptist, angels, and the nude Adam and Eve, whose sin required the coming of Christ and his sacrifice. Inscriptions above Mary and John extol their virtues respectively as mother and forerunner of Christ. The humanization of the protagonists of the story of salvation that had touched the Italian masters and caused them to shift from troubling scenes of damnation to benevolent images of love and forgiveness also touched the masters of the North. As a result, van Eyck's God the Father is not the stern God who administers punishment but rather the loving paternal figure who gives up his own son to save humanity. This is clearly brought across by the pelicans depicted behind him, who tear their chest open to feed their young with their own blood. The details of figures and objects are astonishing, again pointing to the miniaturist tradition as

the foundation from which Flemish art developed. By the time van Eyck had rendered this work, Masaccio had already introduced one-point linear perspective to Italian painting and other artists were using it freely. In the North, the technique did not become known until the following century. The paintings by van Eyck, however, present a logical recession into space arrived at not by a specific mathematical formula but intuitively through the close imitation of nature.

Campin's pupil, Rogier van der Weyden, also from Tournai, was the third of the pioneers of Flemish art. In 1436, he became the official painter of the city of Brussels. Unlike his master, van der Weyden had little interest in representing everyday objects set in household scenes. Instead, he pressed his figures into shallow spaces in imitation of Gothic niche statuary and imbued his images with heart-wrenching emotionalism. In his *Deposition* (c. 1438; Madrid, Prado), commissioned by the Archers' Guild of Louvain for Notre Dame Hors-les-Murs, the figures are made to look like sculpture come alive. A fainting Mary occupies the foreground surrounded by others who are doubled over in pain, their eyes and noses red from the tears they have shed. The painting invites viewers to pity the Lord for the suffering he had to endure, just as the figures around him do.

A second generation of Flemish masters continued the style established by Campin, van Eyck, and van der Weyden. They include Petrus Christus, Hugo van der Goes, Hans Memlinc, and Gerard David. Petrus Christus, van Eyck's pupil and successor, continued the custom of rendering every detail. His *St. Eligius as a Goldsmith* (1449; New York, Metropolitan Museum) presents the metalsmith saint in his shop weighing a wedding ring he wishes to sell to a young couple. A convex mirror on the counter reflects the market square where the shop is located and two male figures who look in, a feature that calls to mind van Eyck's *Arnolfini Wedding Portrait* (1434; London, National Gallery), which includes a mirror that, like Christus', unites the pictorial space with the space occupied by the viewer.

Hugo van der Goes was active in Ghent. In 1478, he entered the Monastery of the Red Cloister in Soignes, near Brussels, as a lay brother. Of his works, only the *Portinari Altarpiece* (c. 1474–1476; Florence, Uffizi) can be attributed to him firmly. Commissioned by Tommaso Portinari, an Italian representative of the Medici bank in Bruges, the painting represents the *Adoration of the Shepherds* witnessed by

members of Portinari's family. Like van der Weyden, van der Goes created a work with deep emotional content. The idealized Portinari exhibit great decorum, contrasting with the crude shepherds who seem to be in an ecstatic state as they kneel in front of the newly born Christ Child. This work was taken by Portinari to Italy when his tenure in Flanders as a Medici bank representative ended and caused a major sensation there. Ghirlandaio was deeply influenced by van der Goes' painting, as his *Nativity and Adoration of the Shepherds* (1483–1486), the altarpiece in the Sassetti Chapel at Santa Trinità, Florence, testifies. In this work, Ghirlandaio's shepherds are as crude as van der Goes' and the detailed objects in the foreground were also borrowed from the Flemish master.

Perugino was also aware of Flemish art and looked to Memlinc for inspiration, imitating his pale, delicate figures, emphasis on details, and drapery types. Memlinc worked in Bruges and painted in the manner of van der Weyden, though without the deep pathos. In his *Martyrdom of St. Sebastian* (c. 1470; Brussels, Musées Royaux des Beaux-Arts), the saint does not seem too affected by the fact that he is being shot by archers for refusing to forsake his faith. His delicate, graceful form contrasts markedly with the brutish men who effect his martyrdom. Here, Memlinc's interest in the representation of the nude male body is clear. In 1484, he would experiment with the female nude as well, as seen in his *Bathsheba* panel at the Stuttgart Staatsgalerie (1484). When Memlinc died, Gerard David became the leading painter of Bruges. Once exposed to Memlinc's art, David's figures, which had been solid and linear, became softer and more naturalistic. His rendering of space also gained greater rationality, as demonstrated by his *Judgment of Cambyses* (1498; Bruges, Groeningemuseum), originally intended for Bruges' Town Hall. Utilizing an Eyckian method, David established depth by diminishing the size of the tiles on the floor as they move away from the viewer. He also placed the figures in a diagonal and added two windows beyond the crowd that offer an Eyckian miniaturized view of Bruges with all details included.

The last of the great masters of the Flemish School was Hieronymus Bosch. A native of sHertogenbosch, now Holland, Bosch rejected conventional subjects, instead creating fantastic landscapes populated by humans engaged in bizarre activities and monstrous creatures. The *Hay Wain Triptych* (c. 1490–1495; El Escorial, Monasterio de San Lorenzo) utilizes the usual altarpiece format, yet the subject is unconventional as

it does not conform to any particular biblical or apocryphal account. In the central panel, the hay wagon of earthly goods is followed by various characters, including the pope and members of the clergy, the emperor and the nobility, the rich and the poor. Lovers sit on top of the wagon accompanied by an angel and a demon, and are clearly expected to choose between evil and good. The representations in the lateral panels suggest they will choose sinful pleasures. On the left are the *Creation of Eve*, the woman who caused the Fall, the *Expulsion from Paradise*, and *Rebel Angels Being Cast Out of Heaven*. On the right is hell and includes Bosch's usual demonic creatures torturing those who wasted their lives on worldly pleasures. Though the intended meanings of many of Bosch's works are no longer fully understood, immediately recognizable is the humorous component to his art and his ability to recognize the absurdity of living. For Bosch, human nature is to sin and, in his mind, sinning comes with dire consequences.

By the time Bosch had created the *Hay Wain Triptych*, the Duchy of Burgundy had disintegrated. In 1477 Charles the Bold, Philip the Good's successor, died. Louis XI of France occupied Burgundy and became the guardian of Charles' daughter and heiress, Mary of Burgundy, whom he married off to the Hapsburg Archduke Maximilian of Austria, later Holy Roman Emperor. Mary died in 1482 and her lands were inherited by her children, Margaret of Austria and Philip the Handsome. Margaret was married off to Louis' son and heir and, with this, France obtained the lands of Burgundy. Philip succeeded his father and, consequently, the Low Countries became part of the Hapsburg dominion. Philip married Juana la Loca (Joan the Mad), the daughter of Ferdinand and Isabella of Spain, and he established the Spanish Hapsburg dynasty as King Philip I.

In the 16th century, Mannerism made its way to the Low Countries, where the major art center shifted from Bruges to Antwerp. Called the Romanists, the leading figures of this Italianate mode were Jan Gossart (called Mabuse), Joos van Cleve, Bernard van Orley, and Jan van Scorel. Gossart trained in Antwerp before entering in the service of Philip the Handsome in Walcheren, near Middleburg. In 1508, he traveled to Rome with Philip, which gave him the opportunity to study the art of the Italian and ancient masters. This experience was to have an immense impact on his art, as he began to experiment with one-point linear perspective and the classical nude form. His *Neptune and Am-*

phitrite (1516; Berlin, Staatliche Museen), part of a mythological series created for Philip's Suytborg Castle, is a completely classicized and idealized rendition of two mythical characters, the first in Flemish history—characters that differ markedly from the nudes Memlinc had rendered in the previous century. Van Cleve was also active in Antwerp. Sometime after 1530, he went to work for Francis I of France, and there he became acquainted with the art of Leonardo. This resulted in major changes in his style that included the use of deep contrasts of light and dark to model figures and objects. The crowding of figures in his *Last Judgment* (c. 1520–1525; New York, Metropolitan Museum) and their elongation and contortions are all Italian Mannerist elements that van Cleve would have seen well represented in Francis' court. Van Orley was court painter to Margaret of Austria, regent of the Netherlands, and later her successor, Mary of Hungary. He was exposed to the Italian manner in 1517 when he supervised the execution of tapestries based on the cartoons Raphael had rendered. His *Last Judgment Altarpiece* (1525; Antwerp, Musée Royal des Beaux-Arts) includes a domelike rendition of the heavens with Christ at the apex, recalling Raphael's semicircular arrangement of the heavens in the *Disputà* in the Stanza della Segnatura at the Vatican. Van Scorel was in Venice in c. 1518–1519, and two years later he also went to Rome where the Dutch Pope Hadrian VI put him in charge of the antiquities housed in the Belvedere, a position he held until 1523 when the pope died. Venetian and Mannerist influences often appear in van Scorel's art. His *Mary Magdalen* (c. 1529, Amsterdam, Rijksmuseum) places a monumental figure within a landscape that is charged with atmospheric effects, recalling the landscapes of Giorgione and Titian. Mary Magdalen's porcelain-like complexion, her elongated anatomy, and her elaborate costume are Mannerist features.

Aside from Mannerism, the 16th century also saw the development of genres, including landscape painting, still lifes, and peasant scenes. Pieter Aertsen's *Butcher Shop* (1551; Uppsala, University Collection) is a Mannerist rendition that includes the *Flight into Egypt* behind the meats displayed in the foreground. Contrary to tradition, the still life in this painting takes on the central role and the religious scene becomes an incidental element. Pieter Bruegel the Elder specialized in peasant scenes where the individuals are shown either working or feasting. His *Harvesters* (1565; New York, Metropolitan Museum), part of a series

depicting the seasons, is an objective view of toiling peasants, while the *Wedding Dance* (1566; Detroit Institute of Art) presents a comical scene of men and women frolicking outdoors.

The Reformation was a major force behind the rise of genre painting, as Protestants do not decorate their churches or utilize religious imagery as a visual focus for devotion. This meant that artists had to adjust to an art market where religious works were no longer needed. As part of Catholic Spain, the official religion of the Netherlands was Catholicism. However, Protestantism there had spread considerably and, by the mid-1560s, those who embraced this new faith were causing civil disturbances to protest their persecution by Church authorities. Troubled by the profusion of religious imagery in the local churches, which in their view conflicted with the second commandment on idolatry, the Protestants initiated an iconoclastic campaign that resulted in the destruction of these sacred objects. In 1567, King Philip II of Spain sent the Duke of Alba to the Netherlands to restore order. In turn, William "the Silent" of Orange, the stadtholder (governor) of Holland, Utrecht, and Zeeland appointed to the office by Philip himself, led a revolt that resulted in the declaration of emancipation by the United Dutch provinces in 1581. In 1576, Flanders had joined in the revolt, but in 1584 the Spanish army recovered the territory. Consequently, Flanders remained Catholic while the Dutch territories embraced Protestantism as their official religion.

For that reason, religious art continued to be commissioned in large quantities in Flanders well into the 17th century. Then, the main figures in the region were Peter Paul Rubens, Anthony van Dyck, and Jacob Jordaens. Of the three, Rubens was the most accomplished. He traveled to Italy in 1600 and to Spain in 1603 and, with this, he became enamored with the art of Titian, well represented in both regions. He also learned well the lessons Caravaggio had to offer. His *Elevation of the Cross* (1610–1611; Antwerp, Cathedral) was painted for the Church of St. Walburga in Antwerp. The triptych presents a scene set against a Titianesque landscape rendered in loose strokes and brilliant colors. The turmoil of men straining to raise the cross and the dog barking in the foreground are also borrowed from Venetian art. The contrasts of light and dark, on the other hand, and the crude figure types are elements one would find in Caravaggio's paintings. Van Dyck's career was somewhat overshadowed by that of Rubens. In fact, he worked in the same regions and for some of the same patrons as the older master. In the 1630s, he

was in the court of Charles I of England and there he catered to the king and the nobility. His *Rinaldo and Armida* (1629; Baltimore Art Museum) shows that his style was closely tied to that of Rubens, particularly in the lush application of paint. Van Dyck exerted tremendous influence in the development of the art of England, and particularly portraiture. There the British artist William Dobson followed van Dyck's example and rendered portraits of members of the royal court with the same dynamism and lush surfaces as those of the Flemish master. Jordaens did not travel to the major art centers of Europe or ever work in any court. Instead, he catered primarily to a bourgeois audience. His *Martyrdom of St. Apollonia* (1628; Antwerp, Augustinian Church) depicts the saint having her teeth pulled one by one by her tormentors with heavy pincers for refusing to renounce the Catholic faith. The work, like Caravaggio's scenes of conversion and martyrdom in the Contarelli Chapel, speaks of upholding Catholicism at all cost and the dignity of sacrifice for its sake.

In the United Dutch provinces, the leading figures in the first half of the 17th century were Frans Hals, Rembrandt, and the Utrecht Caravaggists. Frans Hals specialized in portraiture, catering mainly to the bourgeoisie. He excelled particularly at rendering portraits of militia companies, such works as the *Officers and Sergeants of the St. Hadrian Civic Guard of Haarlem* (c. 1633; Haarlem; Frans Halsmuseum), where he infused with life a scene normally depicted by others as men posing around a table. In Hals' painting, the men have gathered at an enclosed courtyard and turn as if the presence of the viewer has interrupted their conversation. Some stand, others sit, both groups forming a horizontal line across the pictorial space. This horizontal is balanced by the verticals and diagonals formed by the men's lances, banners, and sashes. The constant movement of lines in various directions animates the scene, as do the choppy brushstrokes Hals used to apply the color.

Rembrandt was perhaps the most talented of the 17th-century Dutch masters. He was deeply influenced by Caravaggio and Rubens, though his paintings possess a pathos the two other masters lacked. Also, Rembrandt's figures feature a glow that seems to come from within and a very unique palette composed mainly of earth tones and golds, both elements adding to the emotive content of his works. In his *Judas Returning the Thirty Pieces of Silver* (1629; Yorkshire, Mulgrave Castle),

the emotionalism is so intense, in fact, that Constantijn Huygens, secretary to Frederick Henry, Prince of Orange, praised it in his autobiography, calling Rembrandt the greatest of the history painters. Although the art market in the Netherlands had changed as a result of the Protestant Reformation, Rembrandt specialized in religious scenes, particularly from the Old Testament. This is because there were still individuals living in the Dutch provinces who professed Catholicism in private and who, therefore, required these images for devotion.

Rembrandt was active first in Leiden and later in Amsterdam. In Utrecht, there was also a large Catholic population. In this region, a group of artists, called the Utrecht Caravaggists, emerged. It included Dirck van Baburen, Hendrick Terbrugghen, and Gerrit van Honthorst. All three masters went to Rome either in the first or second decade of the 17th century, where they rendered mainly religious scenes in the Caravaggist style. When they returned to Utrecht, they almost completely abandoned religious depictions, instead favoring genre paintings. Van Baburen's *Procuress* (1622; Boston, Museum of Fine Arts), Terbrugghen's *The Pipe Player* (1624; Cologne, Wallraf-Richartz Museum), and Honthorst's *Merry Fiddler* (1623; Amsterdam, Rijksmuseum) are three examples of the works they rendered upon their return North. The first shows a brothel scene, and the other two male musicians. All three works borrow from Caravaggio's in theme and in style. The figures are shown in three-quarter format, pushed so close to the foreground that they occupy most of the pictorial space, rendered in brilliant colors, with linear contours, dressed in contemporary costumes, and illuminated through the use of theatrical lighting.

The popularity of genre scenes continued throughout the rest of the century, much owed to the Little Masters, so called because of the small scale in which they worked. This was a group of artists who specialized in depictions of domestic interiors, barrack scenes, cityscapes, tavern scenes, and other mundane topics, among them Johannes Vermeer, Pieter de Hooch, Gerard Terborch, Gabriel Metsu, and Jan Steen. They catered not to monarchs and the nobility but to the middle classes who used their works for no other purpose than to decorate their homes. These paintings were no longer necessarily executed to order but could be produced without a patron in mind and then sold by dealers or art galleries. With this, the art market as it is known today was set.

GERMANY

Like Flanders, Germany was an important trade and industrial center because its rivers and alpine passes provided natural routes for the transportation of goods from the Mediterranean to Northern Europe. However, it lacked a centralized government, as in 1356 Emperor Charles IV drew up a constitution stipulating that seven electors would be in charge of selecting Germany's emperors. These electors were the archbishops of the cities of Trier, Cologne, and Mainz, and the rulers of the Palatinate, Saxony, Brandenburg, and Bohemia. This meant that the power of the emperor was a shared power, a situation that kept the region divided into small principalities that often engaged in war against each other or the emperor. In fact, it was not until 1871 that Germany was finally united into one nation. The impact on art as a result of these divisions was the development of distinct regional styles that depended on Flemish examples.

Stephan Lochner held the lead in Cologne. His *Madonna in the Rose Bower* (c. 1438–1440; Cologne Wallraf-Richartz-Museum) presents doll-like rounded, voluminous figures inspired by Flemish prototypes, though less modeled and more subdued in color. The angular draperies of the figures are also Flemish, though not as pronounced. Konrad Witz was from Rottweil in Württemberg and moved to Basel, where he dominated the scene. His key work is the *Miraculous Draft of Fishes* (1444; Geneva, Musée d'Art et d'Histoire), part of the *St. Peter Altarpiece* commissioned by Bishop François de Mies for the chapel of Notre-Dame des Maccabées in the Cathedral of St.-Pierre in Geneva. The scene shows that Witz was as interested in rendering nature with all its details as the Flemish masters. Hans Pleydenwurff was the most important painter in Nuremberg. His *Descent from the Cross* (1462; Nuremberg, Germanisches Nationalmuseum), originally part of the *Breslau Altarpiece*, exhibits the same solidity of figures, angular drapery folds, and the deep pathos of van der Weyden, though his compositional arrangement emphasizes the vertical, not horizontal, axis.

The introduction of the printing press by Johannes Gutenberg gave German artists the upper hand in the field of engraving. Israhel van Meckenem the Younger of Bocholt, for example, left over 600 plates with scenes from everyday life, such as the *Morris Dance* (c. 1475), a form of comical acrobatic dance performed during carnival; *The Visit to*

the Spinner (c. 1495), which presents a middle-class domestic setting; and *Self-Portrait with His Wife Ida* (c. 1490), among the earliest self-portraits in an engraving to have survived. Martin Schongauer from Colmar left approximately 115 plates, the *Temptation of St. Anthony* (c. 1470–1475) being the most often reproduced in the scholarly literature. These men paved the way for later masters, such as Albrecht Dürer, Hans Holbein the Younger, Lucas Cranach the Elder, and Albrecht Altdorfer, who would exploit the printing medium to the fullest.

The 16th century brought on the Protestant Reformation, which caused further dissent among the German principalities. At this time, two tendencies developed in Germany: a continuation of the primitive mode that departed from Flemish art, as introduced earlier by Lochner, Witz, Pleydenwurff, and Pacher, and an idealized, classicized art based on Italian precedents, which by now had become well-known in the North. The key representative of the first tendency was Matthias Grünewald, active in Mainz. His works are characterized by a deep emotionalism that brings the primitive style of his predecessors to a new, higher plane. His *Isenheim Altarpiece* (fin. 1515; Colmar, Musée d'Unterlinden) epitomizes his ability to evoke pity from viewers as it shows a crucified, broken, and bloodied Christ with a deeply distraught Mary Magdalen at his feet, contorting in agony. Grünewald could also depict great joy, as his *Stuppach Madonna* (c. 1517–1520), painted for the Church of Stuppach, demonstrates. Here the Virgin and Child are caught in an intimate, playful moment, their bliss resonating like a joyful song in their movements and exuberant facial expressions. Grünewald's colors are as bright as those used by the Flemish masters, his lighting magical and resplendent.

The artist who best exemplifies the German classical tendency is Dürer, the most important master of the North in the 16th century. Active in Nuremberg, Dürer perfected his drawing skills by copying Mantegna's mythological engravings, adding his own touches to try to improve upon the work of the Italian master. In 1494, Dürer went to Venice, where he was able to study Italian art firsthand. This resulted in richer textural surfaces and figures that better conformed to the classicizing tendencies of the South, as seen in his prints *Hercules at the Crossroads* (c. 1497–1498) and *Four Witches* (c. 1497), and in paintings such as the *Adoration of the Magi* (1504; Florence, Uffizi), which he rendered for Frederick the Wise, elector of Saxony, inspired by

Leonardo's work of the same subject. Dürer took a second trip to Italy in 1505–1507 to study the technique of one-point linear perspective and, while there, he visited Giovanni Bellini, whom he deeply admired. Upon his return, he rendered the *Adoration of the Holy Trinity* (1508–1511; Vienna, Kunsthistorisches Museum) for the chapel in an almshouse in Nuremberg founded by Matthew Landauer, who is included in the painting among the worshipers. Dürer also began work on a theoretical treatise on art, which he completed in 1523. Two years later, he published *The Teaching of Measurements with Rule and Compass* and, in 1527, he issued an essay on *The Art of Fortification* while also working on his *Four Books on Human Proportions*, published posthumously in 1528.

Dürer is considered the Leonardo of the North, as he was not only an artist but also an intellectual. His treatises represent the introduction of analytical thought into art in Northern Europe. Like Leonardo, Dürer sought to raise the status of the artist from craftsman to creator, a point he drove across on a number of occasions with his self-portraits. In the 1500 version now in the Alte Pinakothek, Munich, he presented himself as a Christ type with long tresses and beard to impart his view that art is produced from the hand of a creator.

Other 16th-century German artists of note are Altdorfer, Cranach, and Holbein. Altdorfer was the most important member of the Danube School that developed along the Danube River from Regensburg, where he lived, to Austria, its members focusing mainly in the depiction of emotive landscapes. Altdorfer's *Danube Landscape near Regensburg* (c. 1522–1525; Munich, Alte Pinakothek) is completely devoid of figures and the customary religious intonations. Instead, he depicted nature for nature's sake and poeticized it to invoke emotive responses from viewers. His *Battle of Alexander* (1529; Munich, Alte Pinakothek), commissioned by Duke William IV of Bavaria, emphasizes the horror of war by the addition of a cataclysmic sky and a barren landscape that seems to engulf the battling figures. Cranach was also a member of the Danube School, active in Vienna and later in Wittenberg, where he worked for Frederick the Wise. For Cranach, the landscape was also an important element, which he included as backdrops to his portraits and mythologies. Examples of this are his portraits of Johannes Cuspinian and his wife, Anna (both c. 1502; Winterhur, Oskar Reinhart Collec-

tion), where the figures are set in front of atmospherically charged landscapes, and his *Judgment of Paris* (1530; Karlsruhe, Staatliche Kunsthalle), which features the goddesses Venus, Minerva, and Juno in the nude silhouetted against an evocative natural background. Holbein was from Augsburg, but active first in Basel and later England. He specialized in portraits with an Italianate twist that emphasized strongly modeled figures with linear, well-defined contours, as, for example, the portrait he rendered of the humanist Erasmus of Rotterdam (c. 1523; Paris, Louvre) in profile, at a desk, writing.

The golden age of painting in Germany ended in 1525 with the Peasant's Revolt, caused by discontent among the peasantry for the exploitation they were suffering at the hands of the nobility and the heavy taxation being imposed upon them due to economic decline and military expenditures. Among their demands were the abolition of serfdom, the right to fish and hunt, and the right to choose their own pastors. Though at first concessions were made to their demands, in the end the revolt was crushed by the Swabian League, causing the death of approximately 100,000 peasants.

SPAIN

In the 15th century, Spain was also deeply affected by the works of the Flemish masters, particularly after the Low Countries had fallen in the hands of the Spanish Hapsburgs. The Spanish artists adopted the Flemish figure types, heavy drapery, elaborate architectural and landscape settings, and deep emotionalism. Distinctively Spanish, however, was the rejection of bright pigments in favor of muted tones, the continued use of the gilded backgrounds of the International Style, less emphasis on minutia, looser brushwork, and a lack of interest in spatial clarity and in disguised symbolism. Among the greatest exponents of the Hispano-Flemish mode of painting were Luis Dalmau, the first to introduce it to Spain in the mid-1440s, Fernando Gallego, Juan de Flandes, and Bartolomé Bermejo. There were also Spanish painters of the 15th century who continued painting in the International Style, including Luis Borrassá, Bernardo Martorell, and Marzal de Sax. The Sienese influence on these masters had much to do with the fact that

Spain had contact with Italy since the kingdoms of Naples and Sicily were ruled by the Spanish crown.

In the 16th century, Charles V of Spain, the son of Philip the Handsome and Juana la Loca, patronized mainly foreign masters, among them Bernard van Orley, Pieter Coecke, and Titian. His son, Philip II, followed suit, though he also commissioned works from the locals, including Navarrete, Sánchez Coello, and El Greco, who had settled in Toledo, for the monastery he established at El Escorial in honor of St. Lawrence to commemorate Spanish victory in the Battle of San Quentin in 1557 against the French. The Spanish architect Juan Bautista de Toledo designed the structure and Toledo's pupil, Juan de Herrera, completed it. The Italians Fabrizio Castello, Pellegrino Tibaldi, and Luca Cambiaso also contributed to its decoration.

The Golden Age of Spain did not occur until early in the 17th century when Francisco Ribalta launched it. He was the first Spanish master to experiment with the Caravaggist mode of painting, a mode he learned in Valencia when he studied the collection of his patron, the Archbishop Juan de Ribera, who directed the Counter-Reformation in the region. Ribalta's *St. Bernard Embracing Christ* (c. 1625; Madrid, Prado) depicts a vision experienced by the saint who founded the Cistercian Order to assert the validity of mystic episodes ridiculed by the Protestants. The proximity of the figures to the frontal plane, the theatrical lighting, and the deep emotionalism of the saint as he embraces Christ are all Caravaggist elements.

The most important master of the Spanish School was Diego Velázquez. A native of Seville, Velázquez began his career painting *bodegónes*, still lifes with a distinct Spanish flavor. The *Old Woman Cooking Eggs* (1618; Edinburgh, National Gallery of Scotland), a Caravaggist work in the manner of Ribalta, is one such *bodegón* and presents a woman adding the final ingredient to garlic soup—eggs—which Velázquez shows about to congeal. In 1623, the artist moved to Madrid, became court painter to Philip IV, and abandoned the depiction of *bodegónes* altogether. From this point on, he specialized mainly in portraiture, though at times he also rendered mythologies and, less often, religious scenes. He gained confidence after a trip to Italy and a visit by Rubens to the Spanish court. His *Las Meninas* (1656; Madrid, Prado) is one of the most innovative group portraits in history. It includes the artist himself in the act of painting a portrait of

Philip's daughter, the Infanta Margarita. She is surrounded by her maids of honor, court attendants, dwarfs, and dog. A mirror in the background shows the reflection of the king and his consort who have entered the room and interrupted the activities of those depicted. The scene takes place in the artist's studio, which qualifies the art of painting as noble since it is the royal couple who visits the artist as he works, instead of summoning the artist to their own quarters. So here again was a master who wished to augment the status of painting and define his portrait as the product of a creative genius.

Like Velázquez, Francisco de Zurbarán was deeply affected by Caravaggism. He specialized in depictions of single saints either on their knees meditating or standing heroically, their attributes included for easy recognition by viewers. His *St. Margaret of Antioch* (1634; London, National Gallery) is one such example. According to her legend, the devil appeared to her in the form of a dragon and swallowed her. She carved her way out of the beast with a small crucifix she kept with her. In this work, the dragon wraps around the saint, who holds the crucifix and is dressed as a shepherdess because her story specifies that she was raised in the country. Her monumental scale and heroism recall Caravaggio's *St. Catherine of Alexandria* (1598; Thyssen Bornemisza Collection), but her charm and aesthetic appeal are distinctive of Zurbarán.

Jusepe de Ribera was also a Spanish Caravaggist. An early stay in Naples coincided with Caravaggio's visit there, which is how Ribera became acquainted with the master's style. He later worked in Rome and then Parma, finally settling permanently in Naples where he would be known as Lo Spagnoletto (The Spaniard). His *Drunken Silenus* (1626; Naples, Museo Nazionale di Capodimonte) presents a comical rendition of the mythical follower of Bacchus. He reclines as the female nudes the Venetians depicted, yet he is a drunken overweight figure, his large belly sagging to the ground, a far cry from the sensuous women Giorgione and Titian rendered. Soon after Ribera created this work, he began experimenting with the classical, idealist mode of the Carracci and their followers as Neapolitan patrons were demanding these sorts of scenes. His brushwork loosened, his figures moved further into space, and his backgrounds became more elaborate. However, he never completely shed his interest in depicting common folk with all their imperfections. His *Clubfooted Boy* (1642; Paris, Louvre) is a sympathetic representation of a deformed child.

Holding his crutch across his shoulder, wearing tattered clothes, and sporting a huge smile, the boy has stopped to greet the viewer. In his hand is a paper with the Latin phrase that reads in English *Give me alms for the love of God*. The low horizon emphasizes his deformity as it brings it closer to the viewer but also casts the figure as a monumental, heroic type. The painting reminds us of the Counter-Reformation notion that charity is the vehicle to the attainment of salvation.

FRANCE

It is fitting to end this discussion on the Renaissance with France, as it was France that robbed Italy of its primacy as cultural and artistic center toward the end of the 17th century. The arrival of the International Style in Avignon during the Babylonian Captivity has already been discussed. That France held the lead in art until the 1420s when war with England and internal strife stifled the production of art was also mentioned. In 1422, Charles VI of France died and Philip the Good made certain that Henry VI of England, then an infant, would take the French throne, appointing the British Duke of Bedford to act as Henry's regent until the child reached maturity. The reason for Philip's move was that the economy of Flanders was tied to England because the British provided the wool that the Flemish manufactured into cloth. Joan of Arc freed Orleáns from the British and led Charles VII to his coronation in Reims in 1429, only to be burned at the stake at Rouen in 1431 after her capture by the Burgundian troops. The French took control of Paris once again in 1436 and, by 1453, theirs finally became a free monarchy. In the midst of this turbulence, a handful of artists were able to emerge as leading figures, among them Jean Fouquet, Nicolas Froment, and Enguerrand Charonton, their art a melding of Flemish and Italian elements as Charles VIII and his successor, Louis XII, were involved in the Italian Wars, resulting in further Italian influence entering France.

In the 16th century, Mannerism reached France and became associated with courtly art. Though Leonardo had moved to France to work for Francis I, Louis XII's successor, his art had little impact in the region. On the other hand, the Mannerists Rosso Fiorentino, Benvenuto Cellini, and Francesco Primaticcio, who also spent time in Francis' court, deeply influenced the development of French art. Working in the

Palace of Fontainebleau, Rosso and Primaticcio invented a new type of decoration that combined stucco, metal, and woodwork with painting and sculpture. With this, they established the Fontainebleau School. Cellini created his famed saltcellar for Francis (1540–1544; Vienna, Kunsthistorisches Museum) and, at Fontainebleau, he rendered a bronze relief lunette to be placed above a doorway depicting Diana, goddess of the hunt (1542–1544; Paris, Louvre), thus contributing to the spread of Mannerism in France.

Sixteenth-century French architecture was also Italianate. Giacomo da Vignola and Sebastiano Serlio both worked for Francis I and brought the classical vocabulary established by Bramante, Michelangelo, and others to France. Their example had an impact on Pierre Lescot's design for the west wing of the Louvre, Paris (1546–1548) that, though somewhat more feminine and ornate than Italian palaces, features the correct application of the classical orders, a Brunelleschian repetition of arches on the lower story, and alternating pediments above the windows of the second floor. Lescot's design was to influence the architecture of Philibert de L'Orme, who built the Château d'Anet (b. 1550) in Paris for Diane de Poitiers, mistress to Henry II, Francis' successor. Of this building, only the frontispiece, entrance gate, and some of the chapel remain and, like Lescot's Louvre wing, blends Italian and French elements. L'Orme would have learned the correct application of the orders, which he used in his building, from Serlio, Vignola, and Lescot, but also from his direct study of Italian architecture during a visit to Rome in 1533.

The two main figures in sculpture in 16th-century France were Jean Goujon and Germain Pilon. Goujon was deeply influenced by the works of Rosso, Primaticcio, and Cellini at Fontainebleau, adopting especially their elongated, elegant forms and emphasis on varied textures. His *Pietà* (1544–1545; Paris, Louvre) features these characteristics, adding the deep emotionalism and expressiveness found in French Medieval sculpture. Pilon's *Lamentation* (c. 1580–1585; Paris, Louvre) is a bronze relief that originally formed part of the decoration of a chapel in the Church of Ste. Catherine du Val-des-Ecoliers in Paris. The artist had worked with Primaticcio and adopted the Mannerist elongations, yet the gestures in this work are more exaggerated, the lines more expressive, and the draperies considerably more complex than Primaticcio's.

François Clouet was court painter to Henry II, Francis II, and Charles IX. Like the architects and sculptors of the era, he too borrowed

Italianate elements, but combined them with Netherlandish features. His *Lady in Her Bath* (c. 1550–1570; Washington, National Gallery) may portray Diane de Poitiers, though some have questioned this identification. The woman is shown as a half-length figure, her arm leaning on the rim of her tub, a pose borrowed from Italian examples, such as Titian's *Man with Blue Sleeve* (c. 1511–1515; London, National Gallery). The nursing mother who smiles at the viewer, the interior domestic setting, and the maidservant who has fetched the water for Diane's bath are genre elements common to Netherlandish art.

In 1594, Henry IV took the throne, and three years later he ended the Wars of Religion in France by signing the Treaty of Nantes that guaranteed religious freedom to the Huguenots (French Protestants). Having achieved peace, he set out to improve the urban fabric of Paris. To this end, he completed the Pont Neuf, Place Dauphine (both beg. 1598) and Place Royale (now Place des Vosges; 1605), the latter to serve as a gathering place during feasts and to offer housing for the aristocracy. The end of the civil war also resulted in the building of new palaces, with Jean du Cerceau, Salomon de Brosse, and later Jacques Lemercier, François Mansart, and Louis Le Vau emerging as the leading architects of the period. In 1600, Henry married Marie de' Medici and, in 1610, he was assassinated, leaving Louis XIII, then a child, as his heir and Marie as the boy's regent. De Brosse built the Luxembourg palace for Marie (beg. 1615), and Rubens painted the *Medici Cycle* in one of its galleries (1622–1525) to glorify her as queen, mother, and regent.

At 13, Louis was considered to have reached maturity and he took the reigns of the kingdom from Marie. In 1615, she married him off to Anne of Austria, and two years later king and mother had a major fall-out. In 1622, Cardinal Richelieu, the king's secretary of state and, after 1624, first minister of France, saw the wisdom to negotiate their reconciliation. Peace between mother and son did not last long. Marie conspired against Richelieu for his tolerant policies toward the Protestant Huguenots and, as a result, her son banished her permanently to Germany, where she spent the last years of her life.

Under Louis XIII, Simon Vouet made his career as the leading painter in France. His studio, in fact, became a place of dissemination of the king's artistic ideology and where some of the most important French Baroque artists were trained, including Eustache Le Seur, Charles Le

Brun, and Pierre Mignard. Vouet had already enjoyed success in Italy, where he worked until 1627. There he had adopted a Caravaggist mode of painting, rendering scenes such as *St. Jerome and the Angel of Judgment* (c. 1625; Washington, National Gallery) and the *Birth of the Virgin* (c. 1620; Rome, San Francesco a Ripa). By the mid-1620s, when interest in Caravaggism had lessened in Italy, he modified his style to the classicist mode patrons were demanding. His figures became more elegant and porcelain-like and his colors purer with an emphasis on silvery tones, much like the paintings of Guido Reni, a member of the Carracci School. Upon his return to Paris, Vouet brought this classicist vocabulary, with it infusing French painting, which by now had become rather stagnant, with new life.

Vouet's career was threatened when in 1640 Nicolas Poussin, the French master who had settled in Rome, was summoned by Louis XIII to court. Like Vouet, Poussin had also experimented early in his career with the Caravaggist mode and later embraced the classical-idealist mode of the Carracci. In the mid-1640s, he developed a method of painting he called the *grande maniera* (grand manner) based on the classical Greek modes of music used to express different moods. It entailed codifying poses and assigning to each an emotion. Though his *Rape of the Sabine Women* (c. 1635; New York, Metropolitan Museum) was executed earlier than his formulation of the *grande maniera*, it already reveals Poussin's cerebral approach to painting. The women who are being carried off by the Roman soldiers feature poses one would see in a choreographed ballet. Like dance, the painting evokes mood though the movement of the figures. Poussin's subjects changed along with his style. Whereas earlier he had favored mythologies, he now preferred stoic scenes that spoke of heroism and vindication. Poussin's art principles became central to the teachings of the French Academy. This institution was established in Paris 1648 with the blessing of Louis XIV, Louis XIII's heir, its original purpose to provide art instruction in a progressive environment. Later, however, the king used the academy as a vehicle to impose his taste in art, which happened to coincide with Poussin's philosophies. No sooner did the king die than members of the court began to commission lighthearted images that rejected the stoicism and severity of Poussin's (and Louis') art ideology, giving rise to the Rococo era.

CONCLUDING REMARKS

When Burckhardt wrote his seminal work, *Die Kultur der Renaissance in Italien* (published in 1860), he saw the Renaissance as a complete break from the Middle Ages. Today, scholars prefer to view the Renaissance as a continuation rather than the complete rejection of the previous historical period, and no one would dare qualify the medieval era as the Dark Ages, as Petrarch had called it. Scholarship on the Renaissance has benefited as well from the new approaches introduced in the 20th century, including feminism, psychoanalysis, and semiotics. These approaches have injected a new vitality to the study of the Renaissance, as they have revealed not only its key players but also those who were marginalized. It has offered greater understanding of the psychological forces that shaped the era and has recognized the signs and symbols then used to communicate contemporaneous ideals.

Though now viewed as a continuum of the previous era, the Renaissance saw the unprecedented transformation of art from miraculous and totemic artifact to object appreciated mainly for its intrinsic aesthetic value. Art became a commodity that could be collected, sold, or offered in exchange for sociopolitical favors. This elevation of art resulted in the concomitant rise in status of the artist from skilled craftsman to creative genius, moving closer to our own romantic notions of the function of art as vehicle of personal expression and of the artist as the lone figure struggling to translate those personal views and thoughts into a visual language.

The Dictionary

– A –

ACCADEMIA DI SAN LUCA, ROME. Founded in **Rome** in 1593, the Accademia di San Luca was an association of artists dedicated to **St. Luke**, who was believed to have painted the true portrait of the **Virgin Mary**. It replaced the medieval **Guild** of Painters, Miniaturists, and Embroiderers, which by now had become antiquated. Its establishment was inspired by the Accademia del Disegno, founded in **Florence** in 1562 under the protection of Cosimo I de' **Medici**. In turn, the Accademia di San Luca inspired the establishment of the **French Academy** of Painting and Sculpture in 1648. The purpose of the Accademia was to provide artists with instruction and to regulate standards. The educational curriculum it offered included classes in **perspective, foreshortening**, anatomy, and drawing from both the nude and plaster casts taken from ancient statuary. It also became a place for artists to gather and discuss art theory. It was here that **Pietro da Cortona** and **Andrea Sacchi** debated the proper depiction of history scenes in c. 1630. *See also* CORTONA/SACCHI CONTROVERSY.

ADORATION OF THE MAGI. The magi were three kings who followed the star of Bethlehem that led them to the newborn Christ for whom they brought the gifts of frankincense, myrrh, and gold. In the Church calendar, this event, the Feast of the Epiphany, is celebrated each year on 6 January. Images of the Adoration of the Magi have a long history that dates back to the Early Christian era when these men were depicted in Roman catacombs as Mithraic astrologers. In the medieval period, they came to represent the three known continents of Asia, Africa, and Europe, hence their depiction as ethnic figures

from each one of these areas. For artists of the Renaissance, the depiction of the Adoration of the Magi presented an opportunity to demonstrate their skill in rendering crowded scenes in a coherent manner. **Gentile da Fabriano**'s rendition (1423; **Florence, Uffizi**) is a courtly scene of the **International Style**. **Benozzo Gozzoli**'s (c. 1549; Florence, **Palazzo Medici-Riccardi**) and **Sandro Botticelli**'s (early 1470s; Florence, Uffizi) make sociopolitical statements relating to the **Medici**, while **Leonardo da Vinci**'s rendition (1481; Florence, Uffizi) captures the frenzy of the magi as they try to get close to the newborn Christ Child.

***AENEID* BY VIRGIL (First Century BCE).** The *Aeneid* is a Latin epic poem that tells the story of Aeneas, the hero who left Troy and traveled to Italy, where he established the Latin race. The text was among the sources utilized by patrons and artists to render historical and mythical scenes. One of those scenes is *Aeneas, Anchises, and Ascanius Fleeing Troy*, which was depicted by **Federico Barocci** in a painting (1598; **Rome**, Galleria **Borghese**), by **Agostino Carracci** in an engraving based on Barocci's rendering (1595; New York, Metropolitan Museum), and by **Gian Lorenzo Bernini** in sculpture (1618–1619; Rome, Galleria Borghese).

AERTSEN, PIETER (1508–1575). Netherlandish painter who specialized in **genre** scenes. Aertsen was a pupil of Allart Claesz and became a member of the Antwerp **guild** in 1535. In 1563, he left Antwerp and is listed in documents as a citizen of Amsterdam, where he remained until his death in 1575. His best-known work is the *Butcher Shop* (1551; Uppsala, University Collection), which shows the **flight into Egypt** in the distant landscape seen behind the meats displayed in the foreground. The still life, in Renaissance art usually an incidental element, is here given the greatest prominence, while the religious scene is relegated to a secondary placement. Two fish on a platter in the foreground that form a cross, however, have been read as references to Christ's future sacrifice and thus tie the still life to the background scene. The animal carcass suspended in the distance as if hanging from a cross and overseen by two male and two female figures has also been viewed as reference to the **Crucifixion**.

AGONY IN THE GARDEN. An event that took place the night before Christ was arrested by the Roman soldiers and submitted to the **Crucifixion**. Christ went to the garden of Gethsemane with **Peter**, James, and **John**. His disciples fell asleep and he, tormented by his future death, began to pray. An angel appeared to him to give him strength and, by the time the night was over, Christ accepted his fate. The scene was rendered by **Andrea Mantegna** (mid-1450s), **Giovanni Bellini** (c. 1460; both London; National Gallery), and **Albrecht Altdorfer** (1515; Monastery of Sankt-Florian near Linz) at daybreak, this last with brilliant lighting effects that render the sky orange-red. **El Greco** (1605–1610; Budapest, Szepmuveszeti Muzeum) and **Jan Gossart** (1510; Berlin, Gemäldegalerie) preferred to depict the moment as a nocturnal scene.

AGUCCHI, GIOVANNI BATTISTA (1570–1632). Giovanni Battista Agucchi was the secretary to Cardinal **Pietro Aldobrandini**, Clement VIII's nephew. In 1621, he also became secretary to Pope **Gregory XV**, who was, like Agucchi, a native of **Bologna**. In c. 1607–1615, Agucchi wrote a treatise on painting, perhaps jointly with **Domenichino**. In it, he expressed that art that idealizes nature, like that of **Raphael** and **Annibale Carracci**, is meant for a sophisticated, erudite audience, while the naturalist mode that dwells on the imperfect, represented by **Caravaggio**, caters to the common, uninformed viewer. For him, Caravaggio and the **Mannerists**, whose art he qualified as barbaric, had deserted the idea of beauty that artists must formulate in their minds to render a more perfect scene than nature. Agucchi's work proved to be greatly influential in **Giovan Pietro Bellori**'s theoretical writings on art. Bellori's adulation of Annibale Carracci as the one who restored art to its former Renaissance glory and his **Neoplatonic** concept that artists must improve upon an imperfect nature by rendering it not as it is but as it ought to be are concepts he borrowed from Agucchi.

ALBANI, FRANCESCO (1578–1660). One of the members of the **Carracci** School, Albani achieved great fame during his lifetime and well into the 18th century, especially in France where his idyllic landscapes were well admired. He began his training in **Bologna** with the Flemish master Denys Calvaert, but later moved to the Carracci

Academy to study under **Ludovico Carracci**. In 1601, he moved to **Rome**, where he lived with **Guido Reni** and acted as assistant to Ludovico's brother, **Annibale**. Albani returned to Bologna in 1617 and there he ran a successful workshop until his death. One of his most successful compositions is the *Triumph of Diana* (c. 1618; Rome, Galleria Borghese), part of a series of four pictures commissioned by Cardinal **Scipione Borghese**, a work with dainty figures in elegant poses set against a lush landscape. These types of images by Albani were influential in the development of French Rococo painting.

ALBERTI, LEON BATTISTA (1404–1472). After **Filippo Brunelleschi**'s death in 1446, Alberti became the leading architect of the Renaissance. He was born into a noble family that had been exiled from **Florence** in 1402 and was educated in the universities of Padua and **Bologna**, where he studied law. He is known to have traveled extensively, visiting different cities in Italy, Germany, and the Low Countries. In 1432, Alberti became an apostolic abbreviator at the Vatican, which gave him the opportunity to study the ancient ruins of **Rome**. In 1446, his friend Tommaso Parentucelli ascended the papal throne as **Nicholas V** and appointed the architect advisor on papal restoration projects. Alberti was not only an architect but also a writer. He contributed treatises on architecture, painting, sculpture, poems, comedies, the family, and even horses. His *De re aedificatoria* provides the earliest proper account of the **classical** architectural orders of the Renaissance era. His treatise on painting disseminated the **one-point linear perspective** technique, thought to have been developed by Brunelleschi. Alberti was in fact such an admirer of Brunelleschi that he dedicated the treatise to him. He also built upon the architectural principles of order, balance, and symmetry established by his predecessor to create some of the most influential buildings of the Renaissance.

In the jubilee year of 1450, **Sigismondo Malatesta**, Lord of Rimini, was in Rome to participate in the celebrations, and there he met Alberti. In Rimini, the architect Matteo de' Pasti was working on the *Tempio Malatestiano*, a shrine meant to commemorate Sigismondo's deeds and serve as his funerary chapel. Alberti criticized Pasti's design, so Malatesta invited him to provide plans for a new exterior. These he provided and Pasti was forced to carry out the

work based on Alberti's design. The project was halted in 1461 when Sigismondo had a fall-out with the pope that resulted in his public excommunication. In Florence, Alberti provided the façade for the Church of **Santa Maria Novella** in c. 1456–1470. Financed by Giovanni Rucellai, Alberti here applied the same geometric and mathematical principles that Brunelleschi had used. His design became the prototype for the façade of **Il Gesù** (1568–1584) in Rome, the first **Baroque** church built. Giovanni also commissioned from Alberti the Palazzo Rucellai (beg. c. 1453) for use as his family residence. Based on **Michelozzo**'s design for the **Palazzo Medici**, the building uses the **Colosseum principle**, with orders that change at each level and become lighter and more feminine as the building ascends—the first domestic structure of the Renaissance to employ this feature. In 1460, Alberti began work on the Church of San Sebastiano, Mantua, for Duke Ludovico **Gonzaga**, a building altered in the early 20th century to serve as a war memorial. Alberti conceived the original structure as a **Greek cross plan**, the first of its kind from the Renaissance, with an upper and lower church. In 1470, he also began work on the Church of **Sant' Andrea**, Mantua, also for the Gonzaga duke, as repository for the relic of the holy blood of Christ brought by St. Longinus to the city.

The theoretical treatises Alberti wrote, coupled with his humanistic approach to building, raised the field of architecture to a scientific level. With this, Alberti paved the way for 16th-century masters, such as **Leonardo da Vinci** and **Michelangelo**, who expended great effort to elevate the status of art from manual labor to liberal art and that of the artist from craftsman to divinely inspired creator.

ALBIZZI FAMILY. Originating in Arezzo, the Albizzi moved to **Florence** in the 12th century where they came to play a major role in the city's government. After the **Ciompi Revolt** of 1378, they were exiled from Florence, only to return in 1382 to head an oligarchic regime. Under the Albizzi, Florence began extending its dominion into the rest of Tuscany. Arezzo was acquired in 1384, Montepulciano in 1390, Pisa in 1406, Cortona in 1411, and Livorno in 1421. In 1433, the Albizzi were instrumental in effecting **Cosimo de' Medici**'s exile. Cosimo, however, returned the following year to Florence and successfully removed the Albizzi from power.

ALCIATO, ANDREA (1492–1550). Italian jurist and writer from Milan who taught in **Bologna**, Ferrara, **Avignon**, and Pavia, where he died. His most successful text was the *Liber Emblemata*, the first book of emblems to be published in the 16th century. The first edition appeared in Augsburg in 1531, and it was reprinted between 1532 and 1790 in at least 130 editions in various languages. Alciato's inspiration was the *Hieroglyphica* of Horus Apollo, a manuscript dating to the fifth century, discovered by a monk on the Greek island of Andros in 1419. At the time of discovery, the *Hieroglyphica* was erroneously believed to be a Greek translation of an Egyptian text that explained the meaning of hieroglyphs. The text sparked great interest on the subject, particularly among the literati of **Florence**. Alciato's *Emblemata*, like the *Hieroglyphica*, sought to explain a pictographic language. It provided a series of emblems accompanied by short poems that elucidated their allegorical meaning. The book was widely used by artists as a source for allegorical representation.

ALDOBRANDINI, CARDINAL PIETRO (1571–1621). Cardinal Pietro Aldobrandini was the nephew of Pope Clement VIII. He was educated in the Oratory of Santa Maria in Vallicella in **Rome** and elevated to the cardinalate in 1593. Under his uncle's regime, Cardinal Aldobrandini became papal secretary of state. In 1598, he was instrumental in recovering the city of Ferrara for the papacy, a deed he celebrated by building the Villa Aldobrandini at Frascati as a refuge from his daily obligations at court. In 1602, **Carlo Maderno** built the Water Theater behind the villa, adding an inscription to its hemicycle that hailed the cardinal as the restorer of peace to Christendom and the one to have recovered Ferrara for the Papal States. The cardinal was also the patron of **Annibale Carracci** who, along with assistants, painted for his private chapel a series of **lunette** landscapes, the most famous of which is the *Rest on the Flight into Egypt* (1603; Rome, Galleria Doria-Pamphili).

ALEXANDER VI, POPE (RODRIGO BORGIA; r. 1492–1503). Alexander VI received the cardinalate from his uncle, Pope Calixtus III, in 1456 and the vice-chancellorship to the Holy See in the following year. He was a licentious prelate who fathered several chil-

dren and won the papal election by offering bribes to the cardinals at the conclave of 1492, as well as promises of enrichment. Alexander's papacy was punctuated by scandal and blatant nepotism. His daughter Lucretia Borgia was the wife of Alfonso I d'**Este**, Duke of Ferrara, a marriage arranged by the pope to further the family's social position. His son Cesare carried out a ruthless military campaign to recover territories that had belonged to the Papal States in the medieval era, and he committed or caused various assassinations, including perhaps his own brother's, marring the reputation of the Borgia papacy. In 1497, Alexander excommunicated the overzealous monk **Girolamo Savonarola**, who had sternly criticized his abuses from the pulpit. Alexander was the patron of the painter Pinturicchio who created a series of **frescoes** for him in the Borgia Apartments at the Vatican (1492–1494). These frescoes include the legend of Isis and Osiris to denote the Borgia family's supposed descent from these Egyptian divinities.

ALGARDI, ALESSANDRO (1595–1654). **Bolognese** sculptor who trained with Giulio Cesare Conventi. In c. 1625, Algardi went to **Rome** and there he worked with **Domenichino**. He also restored antiques and produced small-scale sculptures for collectors. When Innocent X was elected to the papacy in 1644 and **Gian Lorenzo Bernini** temporarily fell in disfavor, Algardi's career began to flourish. Though the two men were rivals, Algardi's *St. Mary Magdalen* (c. 1628; Rome, San Silvestro al Quirinale) was influenced by Bernini's statue of St. Bibiana in the church of the same appellation. One of Algardi's most notable works is the *Tomb of Pope Leo XI* (1634–1644; Rome, **St. Peter's**), commissioned by Leo's grandnephew, Cardinal Roberto Ubaldini, which borrows from Bernini's *Tomb of Pope Urban VIII*, at St. Peter's (1628–1647). In both, an enthroned **effigy** is centered between two **Virtues**. Yet, while Bernini used colored marble with varying vein patterns, Algardi preferred a pure white marble. Also, Algardi rejected the transient elements of Bernini's work in favor of a sense of permanence. A **relief** in the front of the sarcophagus shows the conversion of **Henry IV of France** to Catholicism, a triumphant event Leo negotiated for the Church while cardinal legate in France. The large relief at St. Peter's titled the *Meeting of Attila and Pope Leo the Great* (1646–1653) is another of

Algardi's great achievements. The idealized, **classicized** vocabulary he normally used reached its greatest height in this relief.

ALL' ANTICA. An Italian term used to indicate the use of an ancient vocabulary to create a painting, sculpture, or building. In the Renaissance, **Filippo Brunelleschi** was the first to reintroduce the Greco-Roman vocabulary to architecture. Not only are the repetitive arches and columns in his **Ospedale degli Innocenti** (1419–1424) based on ancient Roman examples, but so is his approach to architecture. The order, balance, and mathematical symmetry he applied to the structure are the principles the Romans also used. His designs inspired **Masaccio**'s architecture in the **fresco** of the *Holy Trinity* at **Santa Maria Novella, Florence** (1427). In sculpture, it was **Nicola Pisano** who first experimented with the *all' antica* vocabulary. Some of the reliefs in the pulpit he created for the Baptistery of Pisa (1255–1260) reflect his careful examination of ancient sarcophagi.

ALLA PRIMA. An Italian term used to indicate a painting technique that entails applying oil paints directly on the raw canvas without the use of an underdrawing. The preferred method of **Caravaggio, Peter Paul Rubens, Frans Hals**, and **Jusepe de Ribera**, it allows for speed of execution as well as greater fluidity. Works created through this method often have many *pentimenti*, changes and corrections made by the artist as he or she works out the details of the scene.

ALLEGORY OF VENUS AND CUPID (1540s; London, National Gallery). Cosimo I de' **Medici** commissioned this work from **Bronzino** to be given to King **Francis I of France**. As a work meant for an erudite audience, it features a complex iconographic program that is no longer completely understood. The scene is revealed by Father Time (Chronos) and his daughter Truth, who lift the drapery that once covered the figures. In the center are **Venus**, holding the apple of Hesperides she won from Paris for her beauty, and her son **Cupid**, fondling her breast and kissing her. At Cupid's feet, Venus' doves mimic the behavior of mother and son. On the left, an old woman, identified variously as Envy, Despair, or Syphilis, tears out her hair, while on the right is Inconstancy with her scaly tail, lion legs, honeycomb, and scorpion. In front of her, Folly (sometimes also identi-

fied as Jest or Pleasure) throws rose petals at Venus. The scene presents an erotic image with unusual color combinations of violets, pinks, and soft greens set against the figures' pale ivory complexions. These elements, along with the circular composition with central void and the elongated figures in impossible poses, place the work among the top masterpieces of the **Mannerist** style.

ALTARPIECE. A painted or sculpted panel that either stands on the altar of a church or hangs above it, its primary function being to serve as visual focus during meditation or prayer. Altarpieces created in Italy during the 14th and 15th centuries often have multiple panels that can be opened and closed, as well as **pinnacles** that imitate the Gothic architectural vocabulary and a *predella*. An example of this is **Pietro Lorenzetti**'s *Virgin and Child with Saints, Annunciation, and Assumption* painted for the Pieve di Santa Maria in Arezzo (1320). The Northern examples of the same period can be quite complicated, and open in a series of stages to reveal the interior scenes, as in, for example, **Matthias Grünewald**'s *Isenheim Altarpiece* (fin. 1515; Colmar, Musée d'Unterlinden). These polyptychs, as they are called, were usually painted in **grisaille** in the exterior and with brilliant colors in the interior to add a sense of awe when opened during feast days. In Spain, altarpieces are called retables (in Spanish, *retablos*) and have panels that remain opened and are often contained in heavy sculptural frames. By the 16th and 17th centuries in Italy, these complex formats were rejected in favor of representations on a single field. In the North, they continued for a longer period, with **Peter Paul Rubens'** *Elevation of the Cross* for the Church of St. Walburga in Antwerp (1610–1611), providing an early 17th-century example. *See also SAN ZENO ALTARPIECE,* SAN ZENO, VERONA; *ST. LUCY ALTARPIECE;* TRIPTYCH.

ALTDORFER, ALBRECHT (c. 1480–1538). Painter from the Danube School, active mainly in Regensburg, where he became a citizen in 1505. Little is known of Altdorfer's activities up to that year. The number of properties he owned in Regensburg attest to the fact that he had a successful career. He also played an important role in civic affairs. He was a member of the council of Regensburg in 1519, 1526, and again in 1533 when Lutheranism was officially adopted in

the city. In 1526, he was appointed official architect, his charge to build wine cellars and slaughterhouses, and in 1528, he was invited to serve as mayor, an offer he is known to have refused.

Altdorfer's first signed painting is the *Satyr Family* (1507; Berlin, Staatliche Museen), a work that shows his keen interest in the depiction of the landscape. The nude female with her back turned to the viewer recalls the nudes rendered by **Giorgione**. Though no concrete evidence exists, it is possible that Altdorfer may have traveled to Italy in the early years of his career, where he would have seen Italian works of this kind. By 1515, Altdorfer's style became more heroic, with larger figures, a more vivid choice of colors, and greater contrasts of light and dark. His works in the Monastery of Sankt-Florian near Linz, Austria, demonstrate this change in his style. Here, he painted a series depicting the **Passion of Christ** and the life of **St. Sebastian**. One of these works shows the **Agony in the Garden**, a scene with a reddish sky that forecasts the turbulent events that await Christ. The **foreshortening** of the **apostles** in the foreground again betray Altdorfer's knowledge of **Venetian** art, as these elements are also found in the work of **Giovanni Bellini** and **Andrea Mantegna**, though the intense, dramatic colors come from **Matthias Grünewald**. Sharp foreshortenings are even more prevalent in the *Beating of St. Sebastian*, also part of the Sankt-Florian series. In this work, the architectural background recalls the architecture of **Donato Bramante**, which suggests that Altdorfer may have had engravings of the architect's works, while the sculptural solidity of the figures again suggest his familiarity with Mantegna's style. By 1520, Altdorfer abandoned the use of intense color contrasts and the movement of his figures also diminished. This is exemplified by his *Finding of the Body of St. Florian* of c. 1520 (Nuremberg, Germanisches Nationalmuseum).

The subject of Altdorfer's *Danube Landscape near Regensburg* (c. 1522–1525; Munich, Alte Pinakothek) is simply the landscape. There are no figures or religious implications in the painting. Nature here is poeticized, as it is in one of his greatest masterpieces, the *Battle of Alexander* (1529; Munich, Alte Pinakothek), commissioned by Duke William IV of Bavaria. In this work, the horror of war is emphasized by the cataclysmic sky and barren setting. In spite of the large number of figures engaged in battle, it is the engulfing land-

scape that lends the emotional content to the work. In 1537, Altdorfer painted *Lot and His Daughters* (Vienna, Kunsthistorisches Museum), a Northern version of the Venetian reclining nude type. The anatomical excellence of the Venetians is here lost, particularly in the awkwardness of the female form, which confirms that Altdorfer was at his best when he focused on the landscape.

ALTICHIERO DA ZEVIO (active c. 1369–1384). In the second half of the 14th century, a school of artists developed in Padua, inspired by **Giotto's frescoes** in the **Arena Chapel**. One of the leading figures of this school was Altichiero. Originally from Verona, in the 1370s, Altichiero worked in Padua for the Lupi, a family of **condottieri** who served the city's rulers, the Carrara. Bonifazio Lupi commissioned Altichiero to decorate the family funerary chapel in the Church of San Antonio (il Santo), directly across the tomb of St. Anthony. The scenes chosen were from the life of St. James, Bonifacio's patron saint. The altar wall features a monumental *Crucifixion* with the cross in the foreground and incidental scenes behind it. The image offers contrasts between the suffering Christ and the grieving figures at the foot of the cross and the busy, noisy, apathetic individuals in the middle and background who barely notice the event. The teaching offered by the image is that only those who believe in Christ will be saved, an appropriate theme for a funerary setting. The *Crucifixion* is a precedent for the fresco of the same subject by **Tintoretto** in the **Scuola di San Rocco, Venice** (1564), which also depicts a noisy, active scene. The Lupi frescoes were such a success that in 1377 Raimondo Lupi asked Altichiero to fresco the **Oratory of St. George** next door to the Santo, used by his family as a funerary chapel, with scenes from the life of St. George. These images, like the ones in the Santo, show convincing perspective, figures that move realistically in the rendered space, and individualized facial features that suggest that some of the figures may actually be portraits of members of the Lupi family.

AMMANNATI, BARTOLOMEO (1511–1592). Tuscan sculptor and architect who assisted **Jacopo Sansovino** in **Venice** and **Michelangelo** and Giacomo da Vignola in **Rome**. By 1555, Ammannati was in **Florence** serving the **Medici** dukes. His most important architectural

work is the Palazzo Pitti Courtyard (beg. 1560), a commission he received from Cosimo I de' Medici who purchased the palace in 1549 and that is one of the great masterpieces of the **Mannerist** movement. His *Neptune Fountain* (1563–1575), in the Piazza della Signoria, Florence, is his most notable sculpture commission. In the early 1580s, Ammannati developed strong ties to the **Jesuit Order**. The influence of the Jesuits led to his public renunciation of the depiction of the nude form, which he now deemed sinful. In his declaration, he contended that an artist could just as well show his skill by rendering the clothed figure and he made specific reference to the shameful nude god of the oceans featured in his *Neptune Fountain*.

AMOR VINCIT OMNIA. In English, *Love conquers all*. This theme, based on **Virgil**'s *Eclogues*, became common in the early years of the 17th century, though **Parmigianino** had already provided his version in 1535: the *Cupid Carving His Bow* in the Kunsthistorisches Museum, Vienna. In 1601–1602, **Caravaggio** created his *Amor Vincit Omnia* (Berlin, Gemäldegalerie) for his patron **Vincenzo Giustiniani**, a work that features a naughty adolescent **Cupid** who smiles unabashedly at the viewer. At his feet are musical and geometry instruments, as well as armors to denote that love conquers all, even reason. In c. 1603, **Giovanni Baglione** rendered his *Divine Love* (**Rome**, Galleria Nazionale d'Arte Antica) in response to Caravaggio's painting, for Giustiniani's brother, Benedetto. While Caravaggio's depicts earthly love, Baglione's presents its divine counterpart subduing Cupid and Satan.

ANATOMY LESSON OF DR. TULP (**1632; The Hague, Mauritshuis**). Painted by **Rembrandt**, the work is a group portrait of members of the Surgeons' **Guild** in Amsterdam witnessing a demonstration given by Dr. Nicolaes Tulp during a human dissection. Dr. Tulp lectures on the movement of the fingers and the response of tendons, bones, and muscles to that movement. Viewers are made to feel as if they have interrupted the lecture, as three of the men depicted turn to look in our direction. The lighting in the work is typical of Rembrandt's style. It is a golden glow stemming from a hidden source that illuminates the corpse and the faces of those present. While the back-

drop is a fully developed room, it remains darkened so that the focus is on the men and Dr. Tulp's actions.

ANDREA DA FIRENZE (ANDREA BONAIUTI; active 1346–1379). **Florentine** painter, best known for his **frescos** in the **Guidalotti Chapel** at **Santa Maria Novella** in Florence (1348–1355), which feature scenes of significance to the **Dominicans** who used the room as their chapter house. Andrea's *Virgin and Child with Ten Saints*, a panel at the National Gallery in London (c. 1460–1470), has also been associated with Santa Maria Novella, the seat of the Dominican Order in Florence, since all of the saints depicted, including **Catherine**, **Thomas Aquinas**, and Peter Martyr, were significant to these monks and all had altars dedicated to them in their church. The artist is documented in 1377 working on frescoes of the Life of St. Raynerius in the Campo Santo in Pisa.

ANGUISSOLA, SOFONISBA (1528–1625). Sofonisba Anguissola was the first woman artist to attain international fame. As a woman, she was at a disadvantage since the painting of large **altarpieces** and **frescoes** was considered a male occupation and drawing from the nude was limited to male artists. Sofonisba was able to circumvent these difficulties by specializing in portraiture. Her father, a Cremonese nobleman who could not afford to raise all of his seven children, sent her and one of her sisters to study painting in the studio of the Cremonese **Mannerist** Bernardo Campi so they could earn their keep.

Sofonisba is credited with introducing a new group portrait type, one where the figures are not simply posing, but engaged in some sort of activity. An example of this is the *Portrait of the Artist's Three Sisters and Their Governess* (1555; Poznan, Narodowe Museum), where her siblings play a game of chess. In the work, the younger girl who observes the game laughs as she watches her sister make her final winning move, a detail that reveals Sofonisba's ability to capture the psychology of the sitters she knew so intimately. Sofonisba's skill in rendering her sitters' physical as well as inner individuality is also seen in her *Portrait of the Artist's Sisters and Brother* (c. 1555; Wilshire, Methuen Collection), where the naïve expression of her

loved ones is captured effectively. In her *Self-Portrait at the Spinet with a Chaperone* (1561; Northampton, Earl Spencer Collection), Sofonisba presents herself as a member of a cultured nobility and, in so doing, she places her career as artist in the realm of the liberal arts, not manual labor. Her drawing of a *Boy Bitten by a Crayfish* (c. 1555; Naples, Museo Nazionale di Capodimonte) provided the prototype for **Caravaggio**'s *Boy Bitten by a Lizard* (1595–1596; London, National Gallery). In 1559, Sofonisba was called to Spain to serve as court painter and lady-in-waiting to Queen Elizabeth of Valois. Most of the works she created during her stay there are either undocumented or were destroyed in a fire at court in the seventeenth-century. Sofonisba died at the age of 97, the second oldest Italian artist on record.

ANJOU, ROBERT D' (1277–1343). Robert D'Anjou was the son of Charles II D'Anjou, king of Naples and Sicily, and Mary of Hungary. As a child, he and his brothers were exchanged for his father when captured by Alfonso III of Aragon in 1288 during a naval battle. Seven years of negotiation finally earned the children's release and in 1295, when Robert's brother Charles Martel died, Robert became the heir to the throne of Sicily. He lost the territory when local barons rejected him in favor of Frederick III of Aragon. In 1309, Robert's father died and he was crowned king of Naples. Clement V approved his appointment and in 1311 made him papal vicar of the Romagna to resist Emperor Henry VII's invasion. In 1312, Robert was successful in impeding Henry's occupation of **Rome** and, in the following year, he became the leader of the **Guelf** party in **Florence** against the emperor.

Also known as Robert the Wise, D'Anjou was a major patron of the arts, his learned nature recorded by both **Boccaccio** and **Petrarch**. It was Robert who called **Simone Martini** to Naples to paint the *Altarpiece of St. Louis of Toulouse* (1317; Naples, Museo Nazionale di Capodimonte); the king's brother Louis had renounced the throne of Naples, had become a Franciscan, had died in 1297, and was canonized in 1317. Chronicles of the day place **Giotto** in the king's court from 1328 to 1334, rendering paintings for the royal residence at Castel Nuovo (lost). The *Tomb of Mary of Hungary* (1325), for Robert's mother, by Gagliardo Primario and Tino da Camaino at Santa Maria Donnaregina, Naples, and Robert's own tomb (beg.

c. 1343) by Pacio and Giovanni Bertini at Santa Chiara in the same city were also the result of his patronage.

ANNE, SAINT. Saint Anne is the mother of the **Virgin Mary** and wife of **Joachim**. She miraculously conceived her daughter at an advanced age. The story of Mary's conception is one of the subjects depicted in **Giotto**'s **Arena Chapel** in Padua (1305) and **Taddeo Gaddi**'s **Baroncelli Chapel** at **Santa Croce** in **Florence** (1332–1338). In these **frescoes**, Anne meets her husband at the Golden Gate of Jerusalem and conceives miraculously when the two embrace. The **Birth of the Virgin** is also a popular subject in art and usually shows Anne reclining on her bed and midwives attending to the newborn. Examples include **Pietro Lorenzetti**'s *Birth of the Virgin* (1342; Siena, Museo dell' Opera del Duomo), **Vittore Carpaccio**'s version in the Carrara Gallery in Bergamo (c. 1504), and **Simon Vouet**'s scene (c. 1620) in the Church of San Francesco a Ripa, **Rome**. Anne often appears at the side of her daughter and the Christ Child, as in **Leonardo da Vinci**'s *Madonna and Child with St. Anne* (c. 1508–1513) in the Louvre in Paris; in **Jacopo da Pontormo**'s of the same subject (c. 1529) executed for the Convent of St. Anne in Verzaia, just outside Florence (now Paris, Louvre); and in **Jusepe de Ribera**'s *Holy Family with Sts. Anne and Catherine of Alexandria* (1648) at the Metropolitan Museum in New York.

ANNUNCIATION. The earliest example of the Annunciation as the main subject of an **altarpiece** is **Simone Martini**'s version of 1333 painted for the **Cathedral of Siena** and now in the **Uffizi** in **Florence**. The scene depicts the moment when the **Virgin Mary** is told by the archangel Gabriel that she will conceive the Christ Child who will provide humankind with salvation. As he utters the words, the Holy Spirit, denoted as rays of light emanating from a dove, enters the room and effects the conception. This is one of the most often depicted religious scenes in art. **Fra Angelico** painted several Annunciations during his stay at the **San Marco Monastery** in Florence (1438–1445) as solemn moments that invite introspection. **Leonardo da Vinci** brought the scene outdoors and included an ancient funerary urn as reminder of Christ's future sacrifice (late 1470s; Florence, Uffizi). **Andrea del Sarto** placed the scene in front of a temple, with Gabriel on the right

instead of the customary left (1512; Florence, Palazzo Pitti) while **Tintoretto**'s version (1583–1587; **Venice, Scuola di San Rocco**) shows Gabriel dramatically flying into the room and startling the Virgin. **Lorenzo Lotto**'s (c. 1527; Recanati, Pinacoteca Comunale) shows the Virgin recoiling as God the Father points emphatically in her direction, as if to denote that she is the one chosen to bring his son into the world.

ANNUNCIATION TO THE SHEPHERDS. The scene stems from the Gospel of **St. Luke**. On the night of Christ's birth, an angel appeared to a group of shepherds who were watching their flock in Bethlehem and told them that the Savior was born. This story gave artists the opportunity to depict a nocturnal scene. In the **Baroncelli Chapel** at **Santa Croce, Florence** (1332–1338), by **Taddeo Gaddi**, shepherds are awakened by an angel whose bright light illuminates the nocturnal landscape. Jacopo Bassano also used the angel as the source of light in his 1555–1560 *Annunciation* (Washington, National Gallery), an unusual rendition in that the shepherds are a family group with a woman milking a cow on the right. One of the men shields his eyes from the angel's light. In 1416, the **Limbourg brothers** depicted the scene in *Les Très Riches Heures du duc de Berry* (fol. 48r; Chantilly, Musée Condé) with a whole chorus of musical angels appearing to the shepherds to add a celebratory mood to the event. *See also* JEAN, DUC DE BERRY.

ANTONINE PIEROZZI, SAINT (1389–1459). Dominican monk, appointed archbishop of **Florence** by Pope Eugenius IV in 1446, canonized in 1523. St. Antonine was responsible for convincing **Cosimo de' Medici** to expel the Sylvestrine monks from the **San Marco Monastery, Florence**, and to turn it over to the Dominicans. St. Antonine was appointed the prior of San Marco and, aside from effecting religious reforms while occupying that position, he also acted as patron to **Fra Angelico**. Part III of his *Summa Theologica* includes advice to painters on the depiction of religious scenes. Elements that provoke sexual desire, vanity, or laughter, he wrote, should be eliminated from these types of works, as should any **apocryphal** details, such as midwives in the *Nativity*. Instead, artists should follow the scriptures. These prescriptions influenced the development of art in Florence and reflect St. Antonine's ascetic monasticism.

APOCALYPSE. The Apocalypse stems from the Revelations of **St. John**, the last book in the Bible. It refers to cataclysmic events that will precede the **Last Judgment** based on the saint's visions. The account includes the four horsemen who unleash their wrath on earthly **vices**, beasts who threaten humanity, the enthroned God flanked by crowned men in white garb witnessing the event, and a descending heavenly city. St. John's account of the Apocalypse provided plenty of inspiration to artists, including **Albrecht Dürer** who created a woodcut print of the *Four Horsemen of the Apocalypse* in 1498, the **Limbourg brothers** who included the enthroned God the Father flanked by the crowned men in *Les Très Riches Heures du duc de Berry* (1416; Chantilly, Musée Condé), and **Hans Memlinc** who painted the *Vision of St. John on Patmos* (1479; Bruges, Hospital of St. John) as one of the side panels to the *Altarpiece of the Virgin and Angels*. In this last work, St. John sits on a rock and experiences the strange visions that led him to write the Book of Revelations.

APOCRYPHA. A collection of Early Christian stories that did not receive canonical acceptance as they were not included in the original Hebrew Bible. Only recently has the Apocrypha been incorporated into the Catholic Bible, yet Protestants and Jews reject it. The Apocrypha became one of the sources for religious stories used by artists. Depictions of **Judith and Holofernes**, **Susanna and the elders**, and Daniel in the lion's den, for example, rely on this text.

APOLLO. Son of **Jupiter** and Letona; **Diana**'s twin brother. Apollo is the sun god and also the god of the arts, poetry, music, eloquence, and medicine. Apollo loved Daphne. One day, as he pursued her, the river god Peneius protected her by transforming her into a laurel tree—the scene depicted by **Antonio del Pollaiuolo** in 1470–1480 (London, National Gallery) and **Gian Lorenzo Bernini** in 1622–1625 (**Rome**, Galleria **Borghese**). Distraught, Apollo declared the laurel his sacred tree. For this reason, he is normally crowned with a laurel wreath. Apollo also loved the Cumean **Sibyl** but, because she rejected him, he denied her youth. **Michelangelo** depicted the woman on the **Sistine ceiling** at the Vatican (1508–1512) as old and wrinkled. As the sun god, Apollo appears in **Guido Reni**'s *Aurora* (1613) in the Casino Rospigliosi, Rome, riding his chariot across the firmament. In

Diego Velázquez' *Forge of Vulcan* (1630; Madrid, Prado), he informs Vulcan of **Venus'** infidelity, and in **Raphael's** *School of Athens* (1510–1511; Vatican, **Stanza della Segnatura**) he is shown as a statue in a niche with lyre in hand in his role as the god of poetry and eloquence who inspires the learned men from antiquity. *See also* APOLLO AND DAPHNE.

APOLLO AND DAPHNE. A mythological story from **Ovid's** *Metamorphoses*, often represented in art. **Apollo** ridicules **Cupid** for his archery skills, so Cupid retaliates by causing the god to fall in love with the wood **nymph** Daphne. Tired of Apollo's advances, Daphne flees but the god follows her. She screams for help and the river god Peneius protects her by transforming her into a laurel tree. Frustrated and distraught, Apollo declares the laurel to be his sacred plant to be woven into wreaths to crown heroes. One of the earliest representations of the subject in Renaissance art is *Apollo and Daphne* by **Antonio del Pollaiuolo** (1470–1480; London, National Gallery), where the god takes hold of the nymph whose arms have already taken on the form of branches. The image denotes the victory of chastity, so prized in the Renaissance, over sexual desire. In the early 17th century, **Gian Lorenzo Bernini** provided one of the most dramatic representations of the mythical story (1622–1625; **Rome**, Galleria **Borghese**). In this sculpture, Daphne's body is in the actual process of transformation. Bark partially encloses her lower body, her toes have begun to take root, and branches and leaves are slowly sprouting from her fingers.

APOSTLES. The word *apostles* stems from the Greek *apostellos* and stands for *to send forth*. It refers to the 12 disciples of Christ who were charged with the mission to spread his word throughout the world. There are four biblical sources that give the names of the apostles: **Matthew** 10: 1–5, Mark 3:16, **Luke** 6:14, and the Book of Acts 1:13. These men are **Peter**, his brother Andrew, James, James' brother **John**, Philip, Bartholomew, Thomas, Matthew, James the son of Alphaeus, Thaddaeus (also called Judas, the brother of James), Simon, and Judas Iscariot. After Judas betrayed Christ, he was replaced by Matthias (Acts 1:21), and later **Paul** also became part of the group. Of these men, Peter, Andrew, Philip, Bartholomew, Thaddeus,

and Simon were crucified. James was killed by a sword, Matthew by a halberd, and Thomas by a spear. James the son of Alphaeus and Matthias were stoned to death, Paul was beheaded, Judas Iscariot hung himself, and John is believed to have died of natural causes. The *Crucifixion of St. Peter* was rendered by **Michelangelo** in the Pauline Chapel at the Vatican (1542–1550) and **Caravaggio** in the **Cerasi Chapel** at Santa Maria del Popolo, **Rome** (1600). *St. James Led to His Execution* by sword is one of the scenes **Andrea Mantegna** included in the Ovetari Chapel at the Church of the Eremitani, Padua, in 1454–1457.

The calling of the apostles by Christ was also a common subject in art, as **Domenico del Ghirlandaio**'s *Calling of Sts. Peter and Andrew* in the **Sistine Chapel**, Rome (1482), and Caravaggio's *Calling of St. Matthew* in the **Contarelli Chapel** at San Luigi dei Francesi, Rome (1599–1600), show. The apostles were present at the **Last Supper**, as depicted by **Andrea del Castagno** (1447) in the **refectory of Sant' Apollonia**, and at **Pentecost** when they began to speak in foreign tongues, as **El Greco** portrayed them in c. 1608–1610 (Madrid, Prado). The apostles witnessed the **Dormition** and **Assumption** of the **Virgin**, with **Hugo van der Goes** (c. 1481; Bruges, Groeningemuseum) and **Titian** (1516–1518; **Venice**, Santa Maria dei Frari) depicting each scene respectively. Peter, James, and John were present at the **Agony in the Garden** as Mantegna (mid-1450s) and **Giovanni Bellini** (c. 1460, both London, National Gallery) represented them. Thomas doubted Christ's **Resurrection**, so Christ showed him his wounds from the Crucifixion, a scene **Verrocchio** presented in his sculpture of c. 1465–1483 for one of the niches of **Orsanmichele**, **Florence**. Finally, John is the author of the Book of Revelations, the last book in the Bible, which provided much inspiration to artists; for example, **Hans Memlinc** painted the **apocalyptic** *Vision of St. John on Patmos* (1479; Bruges, Hospital of St. John) as one of the side panels to the *Altarpiece of the Virgin and Angels*.

APRON. Formed by the panels at either side of 13th-century wooden **crucifixes**, below the arms, usually filled with painted images of Christ's **Passion** and **Resurrection**. An example is the apron in **Coppo di Marcovaldo**'s *Crucifixion* in the Pinacoteca at San Gimigniano (second half of the 13th century). Sometimes the figures of the

grieving **Virgin Mary** and **St. John** occupy this space, as in the *Crucifixion* by **Berlinghiero Berlinghieri** (early 13th century; Lucca, Pinacoteca). Later, **Cimabue** would cast the apron figures to the end of the arms of the cross and fill the space with decorative patterns to place all focus on the suffering figure of Christ. Examples are his *Crucifixion* panels at San Domenico, Arezzo (c. 1280), and at **Santa Croce, Florence** (1287–1288).

APSE. A semicircular or polygonal projection in a church, usually covered by a half-**dome**. Though apses can be found at the end of the **transept** arms or in the chapels of a church, most commonly they protrude from the building's east end and serve to house the main altar. As focus during the mass and other ceremonies, the apse walls are many times decorated with **mosaics** or **frescoes** meant to enhance the religious experience. An example of apse mosaic decoration is **Jacopo Torriti's** *Coronation of the Virgin* (c. 1294) at Santa Maria Maggiore, **Rome**. Examples of apse fresco decorations include those by **Cimabue** in the Upper Church of **San Francesco**, Assisi (after 1279), and by **Fra Filippo Lippi** in the Cathedral of Spoleto (1466–1469), both depicting the life of the **Virgin**, as well as **Melozzo da Forli's** *Christ in Glory* in the Church of Santi Apostoli (1481–1483; destroyed), where he introduced the *di sotto in sù* technique to **Rome**.

ARENA CHAPEL, PADUA (1305). The Arena Chapel is **Giotto's** best-preserved work. The artist received the commission from Enrico Scrovegni, a wealthy merchant whose father, Reginaldo Scrovegni, was the leading **banker** of Padua, qualified by **Dante** in the *Inferno* as an usurer. Enrico, troubled by the fact that usury is one of the **Seven Deadly Sins**, an activity in which he also engaged, built the Arena Chapel (beg. 1303) to expiate his sins and ensure his attainment of salvation. It is not clear how Giotto received the commission, though it is believed that it was through Scrovegni's wife, Iacopina d'**Este**, who was related to the Stefaneschi for whom Giotto had worked in **Rome**. The chapel received its appellation from the ancient Roman ruins of the arena upon which it was built. Though meant as a private family chapel, the Scrovegni occasionally allowed access to the public to view the **frescoes**. In 1304, Pope Benedict IX

(1303–1304) in fact granted indulgences to pilgrims who visited the site. The fact that it was available for viewing ensured Giotto's success locally and abroad.

The chapel is barrel **vaulted** and features six narrow windows on the south side, allowing a great deal of wall space for Giotto's frescoes. Thirty-eight scenes, taken from **Jacobus de Voragine**'s *Golden Legend*, are arranged on three bands, with the life of the **Virgin** and her parents, **Joachim** and **Anne**, featured on the upper tier. In the middle level are scenes depicting Christ's life and mission, and on the lower tier are his **Passion**, death, and **Resurrection**. At the very bottom of the walls are faux marble panels flanked by the Seven Virtues and Deadly Sins, painted in **grisaille**. On the chapel's **triumphal arch** is a depiction of the **Annunciation**, and on the entrance wall is a **Last Judgment** with Enrico at the foot of Christ's empty cross presenting a model of the chapel to the Virgin of Charity, the Virgin Annunciate, and the angel Gabriel, the three figures to whom the chapel is dedicated. The chapel was consecrated on 15 March 1305, on the Feast of the Annunciation.

The importance of Giotto's work in the Arena Chapel lies in the fact that he rejected the then-popular *Maniera Greca* mode of painting in favor of a more naturalistic representation of figures and backgrounds. Instead of the gilded backdrops of the *Maniera Greca*, Giotto chose a striking ultramarine blue that serves to unify the scenes. He rejected the gold striations of the Greek manner in favor of draperies that fall in a believable mode. He gave volume to his figures and placed them within, not in front of, structures and landscapes. In response to the "love thy neighbor as thine own self" teachings of **St. Francis** and his followers, Giotto humanized the depictions by including scenes of Christ's infancy, Joachim and Anne embracing, and angels crying over the death of Christ. Instead of symbolic images of Christ's sacrifice and focus on his divine nature, Giotto created a narration of his story, and that of his parents and grandparents, that present him as a character who belongs to the human realm and with which the faithful can identify.

ARETINO, PIETRO (1492–1556). Poet and satirist from the region of Arezzo who spent his formative years in Perugia, where he wrote his earliest poems. In 1517, Aretino went to **Rome** where he worked for

Agostino Chigi, the wealthy **banker** and patron of **Raphael**, becoming a part of the Chigi-Pope **Leo X** circle. After Leo's death, Cardinal Giulio de' **Medici**, the pope's cousin, was Aretino's main patron. For the cardinal, he wrote scurrilous pieces on his competitors. When in 1522 Hadrian VI was elected to the throne instead of Cardinal Giulio, Aretino saw the wisdom to seek patrons outside of Rome. He moved to Mantua, where he worked for **Federigo Gonzaga**. Once Giulio attained the throne as **Clement VII** (1523), Aretino returned to Rome, yet soon death threats prompted by the sonnets he had written to accompany **Giulio Romano**'s banned engravings of sexual positions (*I modi*) and his insults directed at the influential Bishop Giovanni Giberti forced him to leave. After wandering through the north of Italy, he finally settled in **Venice** in 1527, where he spent the rest of his life. There he became a close friend of **Titian**, who painted his portrait (1545; **Florence**, Palazzo Pitti), and **Jacopo Sansovino**, whom he defended when imprisoned for the collapse of the roof of the **Library of St. Mark**. Among Aretino's plays are *Il Marescalco* (published in 1533) and *La Talanta* (1542), and among his comedies is *La Cortigiana* (1534), a parody on **Baldassare Castiglione**'s *Il Cortegiano*. His *Raggionamenti* (1534) includes a **Neoplatonic** discussion in a brothel.

ARISTOTLE (384–322 BCE). Contrary to **Plato**, who concentrated on abstract concepts, his pupil Aristotle advocated knowledge through empirical investigation. Aristotle was from Stageira on the coast of Thrace. His father, court physician to King Amyntas III of Macedon, died when Aristotle was still a child. At 18, Aristotle was sent by his uncle and guardian to Athens to complete his education. There he studied under Plato for 20 years, after which he moved first to the court in Atarneus and later back to Macedonia, where he became the tutor of the young Alexander the Great. Returning to Athens once Alexander's education was completed, he opened his own school of peripatetic philosophy. He left Athens when the pro-Macedonian government there was overthrown and went to Chalcis, where he died in 322 BCE.

In the Renaissance, Aristotle became the most widely read author from antiquity. He held his place as the fundamental authority in the major universities in Europe from the 12th to the end of the 17th cen-

tury. In both Protestant and Catholic primary and secondary schools, Aristotelian philosophical and scientific principles provided the basis for their curriculum. Among Aristotle's extant treatises are the *Physics, Metaphysics, Poetics, Rhetoric, Politics,* and *Nichomachean Ethics.* Aristotle's interest in the observation of nature and its phenomena did much to advance realism in painting and sculpture in the 13th century, when crusaders recovered his texts from Byzantium and brought them back to the West.

***ARNOLFINI WEDDING PORTRAIT* (1434; London, National Gallery).** More than the double portrait of the Italian merchant Giovanni Arnolfini and his wife, Giovanna Cenani, the *Arnolfini Wedding Portrait* is believed to be an actual marriage document. Signed and dated "Johannes de eyck fuit hic, 1434" on the back wall of the bedroom in which the scene unfolds, the elegant calligraphy employed is that normally used by notaries of the era on legal documents. The artist and a companion are reflected in the convex mirror below the signature and serve as the witnesses to the marriage. The groom has removed his shoes to denote that the event takes place in hallowed ground as marriage is one of the Church's sacraments. The dog in the foreground is a symbol of fidelity, while the single lit candle in the chandelier denotes the presence of the Lord, his **Passion** depicted in the roundels adorning the mirror frame. On the bedpost is a carving of **St. Margaret**, patron saint of childbirth, included to denote the hope of fertility, and a broom, symbol of cleanliness and domesticity. Finally, the oranges on the window sill symbolize the bride's dowry as they refer to the golden balls St. Nicholas threw through the window of the house of three sisters who could not marry for lack of dowries.

ARNOLFO DI CAMBIO (c. 1245–c. 1310). Italian architect and sculptor, born in Colle di Val D'Elsa, the pupil of **Nicola Pisano** whom he assisted on the Siena **pulpit**. Arnolfo left Pisano's studio sometime after 1268, and in 1277 he is recorded in the court of Charles D'**Anjou**. His earliest known commission is the *Arca di San Domenico*, **St. Dominic**'s tomb at San Domenico Maggiore in **Bologna** (1264–1267), the work originally given to Pisano who, in turn, gave it to his pupils as he was occupied with the Siena pulpit.

Arnolfo contributed three of the caryatid figures that support the *Arca*, the **Virgin** and Child in the center front, and some of the narrative **reliefs** of St. Dominic's life. In 1293, Arnolfo received a solo commission from Cardinal **Jean Cholet** to build the baldachin (ceremonial canopy) for the main altar of Santa Cecilia in Trastevere, **Rome**. He was also responsible for the design of two important tombs: the *Monument of Cardinal Guillaume de Braye* in San Domenico, Orvieto (c. 1282), and the tomb of **Boniface VIII** for Old **St. Peter's**, of which only the portrait bust of the pope has survived (c. 1300; Vatican **Grotto**). As architect, Arnolfo made a number of important contributions. In **Florence**, he built the Church of La Santisima Trinità (1250s), the **Franciscan** Church of **Santa Croce** (beg. 1294), and the **Palazzo Vecchio** (1299–1310). He is also recorded in 1300 working on the **Cathedral of Florence**. These contributions to the Florentine urban fabric gained him such fame that he was exempted from paying taxes.

ASCENSION. The Ascension refers to Christ's ascent into heaven 40 days after his **Resurrection**. The scene is commonly depicted in art, with **Giotto** providing an early example in the **Arena Chapel**, Padua (1305). Here, Christ stands on a cloud with arms extended and gradually disappearing into the heavens. At either side are angels who accompany him, while below are the witnesses to the event, including the **Virgin Mary**. In **Pietro Perugino**'s version (1496–1498; Lyon, Musée Municipal des Beaux-Arts), Christ ascends in a *mandorla* surrounded by seraphim and musical angels, while **Tintoretto**'s *Ascension* (1578–1581; **Venice**, **Scuola di San Rocco**) is a more believable rendition, with Christ balancing himself on substantial clouds convincingly supported by **foreshortened** angels.

ASSUMPTION OF THE VIRGIN. The moment when the **Virgin Mary** is carried up to heaven after her **Dormition**. In art, the scene usually includes her tomb, with the **apostles** witnessing in awe as she ascends. This is how **Titian** depicted the event in 1516–1518 in his rendition for the Church of Santa Maria dei Frari, **Venice**; **Andrea del Sarto** for the Church of San Antonio dei Servi in Cortona (1526–1529); and **Peter Paul Rubens** for the Cathedral of Antwerp

(1626). **Nicolas Poussin** omitted the apostles (c. 1626; Washington, National Gallery), instead including three putti who throw flowers into the Virgin's tomb. *See also ASSUMPTION OF THE VIRGIN, PARMA CATHEDRAL.*

ASSUMPTION OF THE VIRGIN,* PARMA CATHEDRAL (1526–1530).** **Correggio** received the commission for the ***Assumption after attaining great success with his *Vision of St. John the Evangelist on Patmos*, the **dome fresco** in the Church of San Giovanni Evangelista in Parma (1520–1524). Like the *Vision of St. John*, his *Assumption* is a tour de force of illusionism. It occupies the cathedral's main octagonal dome and is made to look as if the architecture has been removed to reveal a vision of the **Virgin** ascending to heaven. The **foreshortening** of the figures is so heavy that they do in fact seem to be rising, their undersides clearly visible. Figures and clouds are arranged in concentric circles, with the Virgin being raised up by putti as she extends her arms to welcome her reunion with her son, who greets her into heaven. Correggio beautifully integrated the oculi (round openings) at the base of the dome into the composition as the **apostles** and other witnesses of the miraculous event seem to either sit or lean on them. The realism, energy, and drama of the scene greatly influenced future generations of artists, particularly **Baroque** masters who sought to replicate Correggio's convincing illusionism, among them **Giovanni Lanfranco**, who based his *Virgin in Glory* **fresco** on the dome at Sant' Andrea della Valle, **Rome**, on Correggio's masterpiece.

ATMOSPHERIC PERSPECTIVE. Sometimes also referred to as aerial perspective, atmospheric perspective is a technique first utilized in **fresco** painting during the Roman era that allows for the three-dimensional representation of outdoor scenes. The technique entails blurring objects, figures, and other elements within the landscape that are in the distance, as they would look if the eye were to perceive them in a real outdoor setting. Its effectiveness also depends on the softening of colors used for the rendering of those distant elements. The technique was reintroduced in the 15th century by **Masaccio**, who first used it in his frescoes in the **Brancacci Chapel**, **Florence** (c. 1425).

AUGUSTINE, SAINT (354–430). Born in Tagaste to a pagan Roman official and Christian mother, Augustine was brought up a Christian. In 370, he went to Carthage to study rhetoric and law. He eventually abandoned law and Christianity all together, took a mistress with whom he lived for 15 years, and had a son with her in 372. During this time, he became keenly interested in philosophy and, after teaching at Tagaste and Carthage for the next decade, he moved first to **Rome**, where he opened a school of rhetoric, and then Milan where he heard the sermons of Bishop Ambrose. Influenced by the man's preachings, Augustine returned to his Christian faith and was baptized in 387. After losing his son, he devoted himself to monasticism and preaching. In 395, he was appointed coadjutor to Bishop Valerius of Hippo and in the following year he succeeded him as bishop. He died at Hippo during a siege.

Augustine was a prolific writer. He left about 200 treatises, 300 letters, and 400 sermons that have had a major impact in theology and philosophy. His thinking dominated Western Christian thought for centuries, which has earned him placement among the Doctors of the Church. Not only is St. Augustine often included in paintings—for example, in **Fra Filippo Lippi**'s *Barbadori Altarpiece* (beg. 1437, Paris, Louvre) and **El Greco**'s *Burial of Count Orgáz* (1586; Toledo, Church of Santo Tomé)—but his writings also affected the iconography of decorative programs. **Michelangelo**'s **Sistine ceiling** in the **Sistine Chapel**, Rome (1508–1512), for instance, has been interpreted at times as a work that reflects the saint's exegesis.

AURORA. In mythology, Aurora is the dawn. She rises early in the morning and rides her chariot through the skies to announce the sunrise. She falls in love with Cephalus, which causes her to abandon her duties and bring disorder to the universe. **Cupid** resolves the situation by shooting one of his arrows into Cephalus so he can reciprocate Aurora's love for him. Both **Guido Reni** (1613; **Rome**, Casino Rospigliosi) and **Guercino** (1621; Rome, Casino **Ludovisi**) depicted Aurora crossing the firmament. Reni's shows her heading **Apollo**'s chariot, with the Hours surrounding him. Guercino placed her in her own chariot with Day and Night at either side. **Agostino Carracci** is thought to have been the one to depict *Cephalus and Aurora* on the **Farnese ceiling**, Rome (c. 1598–1600), a subject also tackled by

Poussin in 1631–1633 (London; National Gallery) and **Peter Paul Rubens** sometime in the 1630s (lost).

AVIGNON. City in Southern France situated on the left bank of the Rhone River. In 1309, Pope Clement V, who had been living in France since 1306, moved the papal seat from **Rome** to Avignon, thus initiating the **Babylonian Captivity** that was to last until 1377. He did this to avoid the constant conflicts caused by the rivaling factions of Rome and intrusions from the Holy Roman Emperor. During this time, seven popes reigned in Avignon, all of French nationality. When Clement decided to move to Avignon, the city did not belong to the French crown but rather to Charles II D'**Anjou**, king of Naples and Count of Provence. In 1348, Queen Joanna I of Sicily, Countess of Provence, sold the city to the papacy, an ownership that lasted until 1791, when Avignon was incorporated into the French territory. Under the popes, Avignon flourished. Its population increased to approximately 40,000 inhabitants and the presence of the pontiffs ensured a building and economic boom. Cardinals built their palaces there and, in 1335, the Papal Palace was also constructed. This prosperity attracted artists such as **Simone Martini** and literary figures such as **Petrarch**, both of whom benefited immensely from papal patronage during their stay in the city.

– B –

BABUREN, DIRCK VAN (c. 1595–1624). Leading figure among the **Utrecht Caravaggists**. Baburen went to **Rome** in c. 1612 where he came upon the works of **Caravaggio** and his close follower, **Bartolomeo Manfredi**. He remained there until 1622, painting mainly religious scenes. When he returned to Utrecht, Baburen almost completely abandoned religious art, concentrating instead on **genre** works, though he remained faithful to the Caravaggist mode. His *Procuress* (1622; Boston, Museum of Fine Arts) is among his best-known works. Thematically, it relates to Caravaggio's **cardsharps** and fortune tellers. Visually, it borrows Caravaggio's heavy **chiaroscuro** and use of three-quarter figures that occupy most of the pictorial space. Not only did Baburen adopt the basic elements of the

Caravaggist mode, but he also quoted directly from specific paintings by the Italian master. His old procuress is, in fact, based on Abra, the old servant in Caravaggio's **Judith and Holofernes** (c. 1598; Rome, Galleria Nazionale d'Arte Antica).

BABYLONIAN CAPTIVITY. Term used to refer to the period from 1309 to 1377 when the seat of the papacy was in **Avignon**, France. Pope Clement V moved his court there to avoid the constant conflicts caused by the rivaling factions of **Rome** and intrusions from the Holy Roman Emperor. Seven popes reigned during this period, all of French nationality. The term "Babylonian Captivity" was adopted to equate what some viewed as the captivity of the papacy by the French kings to the exile of the Jews in Babylon from the kingdom of Judea. The term also refers to **Petrarch's** "unholy Babylon," which he likened to the harlot of the **Apocalypse**. In this context, it alludes to the papacy's lavish expenditures and abuses while in Avignon.

BACCHINO MALATO **(1594; Rome, Galleria Borghese).** The *Bacchino Malato* is believed to be **Caravaggio's** self-portrait in the guise of **Bacchus**, the mythological god of wine. Caravaggio here presented himself as a crude type dressed in a toga, seated at a table, holding grapes, and crowned with a wreath. Rendered while he worked in the studio of the Cavaliere d'Arpino, the painting was one of three purchased by Cardinal **Scipione Borghese** for his collection. At the time of its execution, Caravaggio fell seriously ill and was forced to remain in the hospital for a long stay. The figure in the painting bears a pale, unhealthy complexion; its title translates from the Italian to *Little Ill Bacchus*. This demonstrates Caravaggio's insistence on rendering nature with all its imperfections, then a truly innovative approach to painting.

BACCHUS. The mythological god of wine and fertility, son of **Jupiter** and Semele. When Jupiter accidentally killed Semele, he removed the fetus from the woman's body and sewed it onto his thigh. Once born, Bacchus was entrusted to the care of **nymphs**, **satyrs**, and the wise **Silenus**. The envious **Juno**, Jupiter's consort, struck Bacchus with madness, forcing him to wander around the world. In Phrygia, he was cured by Cybele, and then he went to Asia where he taught

men the cultivation of wine. **Caravaggio**'s rendition of *Bacchus* (1595–1596; **Florence, Uffizi**) shows the god with flushed cheeks from the effects of drinking. **Michelangelo** presented the figure in a similar inebriated state in his sculpture of 1496–1497 (Florence, Museo Nazionale del Bargello). On the **Farnese ceiling** (c. 1597–1600; **Rome, Palazzo Farnese**), **Annibale Carracci** showed him triumphantly returning from India, his consort Ariadne at his side, and **Titian** also painted Bacchus with Ariadne (1518–1523; Madrid, Prado) for Alfonso I d'**Este**'s *Camerino d'Alabastro* in the Ducal Palace of Ferrara.

BADALOCCHIO, SISTO (1585–after 1620). Italian painter and engraver who studied with **Agostino Carracci** in his hometown of Parma. When Agostino died in 1602, Badalocchio's protector Ranuccio I **Farnese** sent him to **Rome** to work alongside **Annibale Carracci** on the **Farnese ceiling** (c. 1597–1600; Rome, **Palazzo Farnese**). In Rome, Badalocchio collaborated with **Giovanni Lanfranco** on several projects, including a series of engravings based on **Raphael**'s Vatican **Loggia frescoes** (1607). Badalocchio's *Susanna and the Elders* (c. 1609; Sarasota, Ringling Museum) is one of his best-known works. Here, he used an ancient crouching **Venus** type as the model for Susanna, a motif **Ludovico Carracci** was to repeat in 1616 in his version in the London National Gallery. Though the subject was often depicted by members of the Carracci School, the linear contours and colors in Badalocchio's work recall the paintings of **Bartolomeo Schedoni** who was a **Caravaggist**.

BAGLIONE, GIOVANNI (c. 1566–1643). Roman painter and biographer, the rival of **Caravaggio**. Baglione began his career as a **Mannerist**. His most important works from this phase are the **frescoes** in the Capella Paolina at Santa Maria Maggiore in **Rome** he executed for Pope **Paul V** (1611–1612). In c. 1600, he changed his style to **Caravaggism**, in response to the demands of his patrons. In c. 1603, he painted for Benedetto Giustiniani, the *Divine Love* (Rome, Galleria Nazionale d'Arte Antica) as response to Caravaggio's *Amor Vincit Omnia* painted for Giustiniani's brother, **Vincenzo**. Caravaggio openly ridiculed Baglione's abilities as painter when the latter's *Resurrection* was unveiled in the Church of **Il Gesú**, Rome. Baglione

retaliated by accusing Caravaggio of slander, and the transcripts of the trial of 1603 are still preserved. Baglione's greatest contribution to art was in writing. In 1639, he published a guide to Roman churches and, in 1642, his *Vite de' pittori, scultori, e architetti* [Lives of Painters, Sculptors, and Architects], two texts that offer a wealth of information on contemporary masters and commissions.

BALDINUCCI, FILIPPO (1625–1697). Though an accomplished draughtsman, Baldinucci is best known for his biography of the artists, the *Notizie de' professori del disegno da* **Cimabue** *in qua*. He is also important to art historians for his biography of **Gian Lorenzo Bernini** commissioned by Queen Christina of Sweden, who abdicated the throne in 1654 to move permanently to **Rome** and to whose intellectual circle Baldinucci belonged. Baldinucci was born to a prominent **Florentine** family. In 1664, he was employed by Leopoldo de' **Medici**, first as his bookkeeper and later as art consultant. In this capacity, he was charged with the cataloguing of the Medici drawing collection and the purchase of new items for its enrichment. He also enlarged the Medici collection of paintings, by including, among other items, a series of artists' self-portraits. His travels throughout Italy to search for works, his endless evaluation of these items, and his contact with artists are what led him to write the *Notizie*, first published in 1681 in six volumes. In composing his biographies, he examined a number of documents, including account books, inventories, diaries, and letters, at the time considered a novel method of scholarship.

BALDOVINETTI, ALESSO (1425–1499). The pupil of **Domenico Veneziano**, Baldovinetti was born to an aristocratic **Florentine** family. He is credited with translating the **Sweet Style Desiderio da Settignano** introduced in sculpture to painting. His *Annunciation* (1447) and *Virgin and Child with Saints* (c. 1454) at the **Uffizi**, Florence, and his smiling *Virgin and Child* in the Louvre, Paris (c. 1460), exemplify his adoption of this approach. The figures in these paintings are delicate and elegantly posed and they tenderly glance at each other, common elements of Desiderio's mode. Baldovinetti was also an accomplished portraitist. His *Portrait of a Young Woman* (c. 1465) at the London National Gallery shows the unidentified sitter in pro-

file, wearing an elaborate costume and jewelry, the customary format of mid-15th-century Italy for female portraiture. In 1462, Baldovinetti received the commission to **fresco** scenes in the cloister of the Church of Santisima Annunziata in Florence. These, unfortunately, are severely damaged. As **Giorgio Vasari** informs, Baldovinetti finished off the frescoes in a dry technique to protect them from humidity, which caused the surfaces to flake off. Although the outcome turned out to be a disaster in terms of conservation, his method testifies to his desire to discover more effective modes of artistic production.

BANKING. From the 14th century on, banking was central to the **Florentine** economy. Banking families, such as the Bardi, **Peruzzi**, **Medici**, and Acciaiuoli, owed their wealth to the making of loans, collection of moneys owed to the papacy and other entities, currency exchange, the arranging of insurance, and the engaging in direct commerce through branches all over Europe, Constantinople, and Jerusalem. The supremacy of the Florentines in the banking industry continued well until the 16th century, though the Bardi and Peruzzi declared bankruptcy in the 1340s when rulers such as Edward III of England and others defaulted on their loans. After the 16th century, the major banking families were the Spinola, Pallavicini, and Sauli of Genoa, who benefited from their dealings with Spain and the silver and gold the Spanish monarchy had obtained from the Americas. Germany at this time also came to the forefront with the establishment of banks by the Fugger and Welser families of Augsburg, whose wealth was determined by their involvement in **Hapsburg** finances.

BANQUET OF THE OFFICERS OF THE ST. GEORGE CIVIC GUARD COMPANY OF HAARLEM (1616; Haarlem, Frans Halsmuseum). Painted by **Frans Hals** for the oldest militia group of the city of Haarlem, the **St. George** Civic Guard Company, also known as the *Oude Schuts*. In gratitude for the services provided by these men, it was customary for the city to organize three banquets a year in their honor. Hals chose to portray the guards while participating in one of these events. A tradition already existed for these types of group portraits, usually stiff representations with figures lined up on three sides of a table. Hals infused the type with life by arranging

the figures in two diagonals and by granting them informal poses. Some of the men sit, others stand, they eat, drink, and engage in conversation. The constant repetition of oblique lines created by sashes, drapes, banners, and figures grants the work a dynamic quality. The most innovative aspect of the rendering is that Hals counted the viewer as a participant in the scene by directing some of the guards' gazes outside the painting. It is as if the viewer's sudden presence in front of the work has interrupted the men's conversation.

BAPTISM OF CHRIST. The scene depicts the establishment of baptism as a sacrament, when Christ stands in the River Jordan and his cousin, **St. John the Baptist**, pours water over his head as a purifying ritual. Then God the Father appears in the heavens and pronounces that Christ is his son. In art, the scene is usually depicted with the dove of the Holy Spirit descending upon the figures. Examples include **Andrea Pisano**'s **quatrefoil** gilded bronze relief on the south doors of the **Baptistery of Florence** (1330–1333) and **Piero della Francesca**'s scene painted in the 1450s (London, National Gallery) as the central panel of a **polyptych** for the Camaldolese abbey of San Sepolcro. **Andrea del Verrocchio**'s version of c. 1472–1475 (**Florence, Uffizi**) shows the hands of God releasing the Holy Dove. Two angels, the one on the left executed by **Leonardo da Vinci** while apprenticed with Verrocchio, kneel in response to the solemnity of the event. **Tintoretto**'s version (c. 1570; Madrid, Prado) is a pretext for the depiction of the sensuous male nude form, while **El Greco**'s (1608–1614; Toledo, Hospital de San Juan Bautista de Afuera) shows an explosion of lines and color in the upper portion where God the Father gives his blessing to his son and angels witness the event. Finally, **Gerard David** viewed the scene (c. 1502–1507; Bruges, Groeningemuseum) as an opportunity to not only depict the seminude body of Christ but also his legs under water.

BAPTISTERY OF FLORENCE. A Romanesque octagonal structure, built at the end of the 11th century over the ancient ruins of a fifth-century Roman temple dedicated to **Mars**. Clad in the exterior with two-toned marble and dedicated to **St. John the Baptist**, patron saint of the city of **Florence**, the structure served as the place where all Florentine citizens were baptized. In the 13th century, a major deco-

rative campaign to embellish the building's interior was launched. The octagonal **vault** was covered with **mosaics** that depict scenes from the Creation, the **Last Judgment**, angels, **apostles**, and the lives of Patriarch Joseph, St. John the Baptist, and Christ, all arranged in concentric bands. Above the altar is a large figure of Christ as judge, sitting on a rainbow and enclosed in a heavenly circle. These mosaics have been attributed to **Coppo di Marcovaldo**, though some believe them to have been executed by masters from **Venice**, where the medium was more commonly used. In 1330–1334, the sculptor **Andrea Pisano** was commissioned to create a set of gilded bronze doors for the Baptistery, composed of 14 rectangular reliefs. The upper 10 panels represent scenes from the life of the Baptist, from the announcement of his birth made to his father Zacharias, to his decollation and burial. The remaining lower panels contain the **Virtues**. In 1401, a major competition was launched for the execution of the Baptistery's **east doors**. It was won by **Lorenzo Ghiberti** who submitted a *Sacrifice of Isaac* panel that conformed to the new **classicism** expected in art. In 1425–1452, Ghiberti also executed the final set of doors that led from the Baptistery to the **Cathedral of Florence**, called the *Gates of Paradise*.

BARBADORI ALTARPIECE (beg. 1437; Paris, Louvre). The *Barbadori Altarpiece* was executed by **Fra Filippo Lippi** for the Barbadori Chapel in the Church of **Santo Spirito, Florence**. The work relies on **Masaccio's** *Holy Trinity* at **Santa Maria Novella**, Florence, in its pyramidal composition and hierarchic placement of figures. In Lippi's painting, the **Virgin** and Child are elevated from the rest and isolated by the *aedicula* behind them. Below are two kneeling saints, **Augustine** and Fredianus, who complete the pyramid. As in the *Holy Trinity*, Lippi's scene unfolds in a believable **Brunelleschian** interior that is completely dependent on ancient architectural types. The figures' *contrapposto*, the definition of their forms through the use of **chiaroscuro**, and their solidity, all stem from Masaccio. Lippi's figures, however, are more aesthetically pleasing and his drapery folds more realistic and varied, these last learned from **Donatello**. A major innovation in Lippi's painting is the fact that his Madonna is standing, not seated, as she was traditionally rendered. Also, Lippi included himself in the work. He is the figure

on the extreme left, dressed as a Carmelite monk and resting his chin on the parapet.

BARBARO, DANIELE (1513–1570). Member of the **Venetian** nobility and important patron of the arts. Daniele Barbaro was educated in Padua in philosophy, mathematics, and science. He was the founder of the *Orto dei Semplici*, the most important Padovese botanical garden, acting as its superintendent from 1545. From 1548 until 1550, Barbaro also acted as ambassador to England and, in 1550, he was elected Patriarch of Aquileia, an episcopal see transferred to Venice in 1450. In this capacity, he participated in the **Council of Trent**. In 1556, he published an edition of **Vitruvius'** *De architectura* with his own commentaries. Over a decade later, he also published the *Pratica della prospettiva* [*The Practice of Perspective*, 1569], which includes a description of the *camera obscura*, a device used by artists as an aid in rendering three-dimensional scenes. Daniele was the patron of **Andrea Palladio** and **Paolo Veronese**, both working in his Villa Barbaro at Maser, the one building the structure and the other decorating it with **frescoes**. **Titian** painted his portrait in c. 1545 (Madrid, Prado).

BARBERINI FAMILY. Of Tuscan origin, the Barberini settled in **Florence** in the 11th century where they became part of the merchant class. In 1623, their prominence increased when Cardinal Maffeo Barberini ascended the papal throne as Pope **Urban VIII** and showered his family with favors. He elevated his brother Antonio and nephews Francesco and Antonio to the cardinalate, and his nephew Taddeo he appointed prefect of **Rome** and prince of Palestrina. The benefices amassed by these individuals enriched the family in great measure, allowing them to spend generously on the arts. In 1628–1633, **Carlo Maderno** designed for them a magnificent palazzo in Rome that in the early 1630s was **frescoed** by **Andrea Sacchi**, **Pietro da Cortona**, and others with impressive scenes that spoke of the family's sociopolitical eminence. When Urban was succeeded by Innocent X, the Barberini were accused of misappropriating public funds. Their possessions were seized and they were forced to leave Rome. They took refuge in France, where Cardinal Jules Mazarin, first minister to Louis XIV, offered them protection. Mazarin eventu-

ally persuaded Innocent to recant the accusations by threatening to invade the Papal States, and the Barberini were able to return to Rome, though they were never to regain the social position they enjoyed during Urban's reign.

BARDI CHAPEL, SANTA CROCE, FLORENCE (c. 1325). **Giotto**'s **frescoes** in the Bardi Chapel at **Santa Croce**, **Florence**, were whitewashed in the 18th century and uncovered in the 19th century, when they were over-restored. Eventually the excessive overpaint was removed to reveal the original frescoes. These, surprisingly, are in fair condition, save for some bare spots where a tomb once stood. The Bardi were a prominent Florentine family who made their fortune through **banking**. With branches in Italy, England, France, and Flanders, by 1310 they were the wealthiest family of Florence. Their chapel at Santa Croce offered the opportunity to assert publicly their socioeconomic position. They gave the task to decorate their chapel to Giotto, who by then had attained great fame. Santa Croce served as the mother church of the **Franciscan Order** in Florence. Appropriately, the Bardi chose scenes from the life of the order's founder, **St. Francis**. Of the narratives, the *Death of St. Francis*, *St. Francis Receiving the Stigmata*, and the *Trial by Fire* are the most poignant. This last scene, which shows St. Francis about to walk on fire to prove his faith to the Moslem priests of the Sultan of Egypt, includes one of the earliest representations in art of figures with African features. The scenes depend on St. Bonaventure's *Legenda Maior*, the official account of St. Francis' life.

BARDI DI VERNIO CHAPEL, SANTA CROCE, FLORENCE (c. 1340). The Bardi di Vernio Chapel was **frescoed** by **Maso di Banco**, one of **Giotto**'s pupils and followers. The theme chosen was the story of St. Sylvester, who reigned as pope from 314 to 335 and who cured Emperor Constantine the Great from leprosy by persuading him to convert to Christianity and to close the empire's pagan temples. The cycle begins with the emperor's conversion and ends with the *Cleansing of the Roman Capitol* of the corruption of pagan **Rome**. Of the scenes in the chapel, the most often discussed is *St. Sylvester Resuscitating Two Deceased Romans*, which depicts another of the miracles the saint effected. Two men were killed at the Roman Forum by

the breath of a dragon, here read as the symbol of religious ignorance. Sylvester closed the dragon's throat so it would cause no further harm and he then revived the victims, much to the amazement of onlookers. In the fresco, the Roman Forum is rendered not as it looked in the fourth century when the scene occurred, but in its ruinous state of the 14th century when Maso painted it, this to denote the end of the pagan era. It has been suggested that the events from the lives of a pope-saint were chosen to refer to the Bardi as the **bankers** of the papacy.

BARGELLINI MADONNA (1588; Bologna, Pinacoteca Nazionale). Created by **Ludovico Carracci** for the Capppella Boncompagni in the Church of the Monache Convertite in **Bologna**, the *Bargellini Madonna* borrows its composition from **Titian's** *Madonna of the Pesaro Family* (c. 1519–1526; **Venice**, Santa Maria dei Frari). As in the Venetian prototype, Ludovico's shows the enthroned **Virgin** and Child elevated and to the side with saints **Dominic**, **Francis**, **Martha**, and **Mary Magdalen** at their feet, putti hovering above, and columns framing the scene. The monumentality of the figures, their closeness to the viewer, and the emotional component of the work, on the other hand, are Ludovico's own choices. These elements add a greater sense of immediacy to the figures depicted—a **Baroque** characteristic. Several figures point to the Virgin in grand gestures to bring her to the viewer's attention, while two putti crown her with a flowered wreath and angels play musical instruments, granting the work a celebratory mood. In turn, the Virgin looks directly at the viewer as if to denote her availability as the intercessor between humanity and God. In the background is a portrait of the city of Bologna set against a luminous blue sky, included to situate the scene in a locale familiar to viewers and to denote that theirs is a city that receives the Virgin's blessing and protection.

BAROCCI, FEDERICO (c. 1535–1612). Painter from Urbino, qualified as one of the art reformers of the **Baroque** era. Early in his career, Barocci served Guidobaldo II **della Rovere**, Duke of Urbino, in whose collection he studied the works of **Titian** and **Raphael**, both fundamental to the development of his career. Sometime in the mid-1550s, Barocci went to **Rome**, where he worked with the Zuccaro brothers whose **Mannerist** style he adopted. There he enjoyed the

protection of Cardinal Giulio della Rovere, Guidobaldo's son. Barocci's paintings were not well received in Rome. After a serious illness in 1565, he decided to return to Urbino, where he finally developed his own personal style, attaining tremendous success.

The *Madonna del Popolo* (1575–1579; **Florence, Uffizi**), painted for the **Confraternity** of the Misericordia in Arezzo, is an oval composition with central void and contorted figures that represents his Mannerist phase. It looks to **Correggio** for inspiration, especially in the softening of contours and overall hazy quality. His *Visitation* (1586) in the Chiesa Nuova, Rome, belongs to his mature period. The everyday types, the sense of tenderness they evoke, the realistic still-life details, the diagonals that direct the viewer's gaze toward the main event, and the use of pink to soften the scene are all elements that meet the demands of the **Council of Trent** regarding the proper depiction of religious subjects. Contemporary accounts relate how all of Rome lined up for three days to view the work once it arrived from Urbino. These accounts also speak of St. Philip Neri, the founder of the **Oratorians** to whom the Chiesa Nuova belonged, experiencing ecstatic raptures in front of the painting. Barocci's *Stigmatization of St. Francis* (c. 1595), painted for the Church of the Capuchins in Urbino, depicts the saint's mystical experience that resulted in his receiving the wounds of Christ, here shown as actual nails piercing his palms. The **Counter-Reformation** Church demanded historical accuracy and the nails are mentioned in the written account of the saint's life. Protestants had questioned the validity of sainthood and of mystical experiences. Therefore, Barocci, like many artists who served the Counter-Reformation Church, often depicted mystical events and visions.

BARONCELLI CHAPEL, SANTA CROCE, FLORENCE (1332–1338).

Frescoed by **Taddeo Gaddi**, **Giotto**'s pupil and principal assistant, the Baroncelli Chapel, one of the largest in **Santa Croce**, boasts scenes from the life of the **Virgin**, her parents **Joachim** and **Anne**, and Christ. The Baroncelli were a wealthy **Florentine banking** family who wanted their chapel to speak of their privileged position. In Giotto's absence from Florence (he was in Naples in 1328–1334), they gave the commission to his pupil Taddeo, who was running the master's workshop. Some have suggested that it was

Giotto who provided the designs for Taddeo to follow since the **altarpiece** in the chapel, the *Baroncelli Polyptych*, is Giotto's signature work. Like Giotto, Taddeo gave volume to his figures and draperies, placed them within believable architectural spaces and landscapes, and stressed familial affection and the humanity of Mary and Christ. Taddeo's figures, however, are more slender than Giotto's. Also, unlike his teacher, he had a particular interest in nocturnal scenes, such as his ***Annunciation to the Shepherds*** where an angel emerges from the dark sky to announce the birth of Christ.

BAROQUE. Baroque is a term used to denote the art from roughly the 1580s to the end of the 17th century. Its development coincides with the **Counter-Reformation** when the Catholic Church sought to curtail the spread of Protestantism that threatened its hegemony. In the last session of the **Council of Trent**, which took place in 1563, enactments were made on the proper depiction of religious subjects to combat the threat. It was decreed that religious images were to invoke piety, inspire viewers to engage in virtuous behavior, and provide instruction on redemption, the intercessory role of the saints and the **Virgin**, and the veneration of relics. Most importantly, works of art were to validate visually Catholic dogma questioned by the Protestants. The effects of these enactments were not felt until over a decade later when key Church figures began writing treatises to instruct artists on the Tridentine stipulations. St. Charles Borromeo, archbishop of Milan, provided in 1577 a treatise on the proper building of churches and **Gabriele Paleotti**, archbishop of **Bologna**, wrote the *Intorno alle imagini* in 1582, a guide on the correct depiction of sacred and profane images.

The first church to be built that satisfied the demands of the Counter-Reformation and that launched the Baroque was **Il Gesù** in **Rome** (1568–1584), the mother church of the **Jesuit Order**, designed by Giacomo da Vignola, who eliminated the aisles to prevent any visual obstructions to the main altar where the rituals of the mass take place. In the exterior, completed by Giacomo della Porta, a rapid movement from sides to central bay and a progressive move forward of the engaged pilasters as they come closer to the entrance serve to invite the faithful in and symbolically welcome those who may have strayed from the true faith. The artistic reform in painting was led by

Federico Barocci in Urbino, the **Carracci** in Bologna, and **Caravaggio** in Rome, all offering images that rejected the ambiguities of **Mannerism** and presented instead clear renditions that appealed to the senses and emotions. Of these, Caravaggio had the greatest impact as his naturalistic style with theatrical lighting effects spread throughout Europe, though in Italy Caravaggism lost its appeal by 1620 and the **classicism** of the Carracci followers came to dominate the scene. Key figures in this group were **Domenichino, Guercino, Giovanni Lanfranco, Francesco Albani**, and **Andrea Sacchi**. In the 1630s, a Neo-**Venetianism** was established by **Pietro da Cortona** that would contrast markedly to **Andrea Sacchi**'s meticulous renditions, again conjuring the marked contrasts between baroque vibrancy and classical restraint. These contrasts of style also permeated the sculpture and architecture of the period. In sculpture, **Gian Lorenzo Bernini** embodied the dramatic, theatrical mode of representation while **Alessandro Algardi** embraced a less exuberant language. In architecture, it was Bernini who favored the classical, sober lines of the High Renaissance, while **Francesco Borromini** experimented with swelling and contracting biomorphic forms.

***BATTISTA SFORZA AND FEDERICO DA MONTEFELTRO, POR-TRAITS OF* (1472; Florence, Uffizi). Piero della Francesca** portrayed Battista **Sforza** posthumously on the year of her death from childbirth. This work may have been hinged together with its companion portrait of Battista's husband, **Federico da Montefeltro**. In both, the figures are shown in profile with fertile landscapes behind them, suggestive of their vast domain. On the verso of each portrait is a triumphal procession, inspired by the triumphs described by **Petrarch** in his writings. Battista sits on a chariot pulled by a unicorn, symbol of chastity and fidelity. Allegorical representations of Chastity, Modesty, Charity, and Faith accompany her to indicate that these are her character traits. Federico is being crowned by Fortune and accompanied by Justice, Prudence, Fortitude, and Temperance, again references to his qualities. The paintings were inspired by ancient Roman medals where a portrait in profile is included on the front and a narrative on the verso. As such, they speak of the duke and duchess' position of power and desire for remembrance. An inscription below each portrait lauds them further. While Federico is

hailed a great ruler, Battista is honored through her husband's accomplishments, this in spite of the fact that she herself ruled Urbino during her husband's absences. In portrait pairs where husband and wife are depicted, the male usually takes the dexter side. In this case, it is Battista who takes that position. The reason is that Federico was disfigured by the stroke of a sword while participating in a tournament. His nose was broken and he lost his right eye. After that, he was usually portrayed from the left side.

BATTLE OF ANGHIARI (**1503–1506; destroyed).** The Battle of Anghiari was fought on 29 June 1440 by the **Florentine** army, led by Micheletto Attendolo and Gianpaolo Orsini, against the Milanese forces of Niccolò Piccinino, with the Florentines attaining victory. In 1503, **Leonardo da Vinci** was commissioned by the Florentine Republic to **fresco** the event in the Sala del Consiglio (Council Chamber) in the **Palazzo Vecchio**, the city's seat of government. At the same time, **Michelangelo** was asked to paint the *Battle of Cascina* on the opposite wall. Destroyed in 1557 to make way for **Vasari**'s frescoes that glorified the **Medici**, Leonardo never completed the work because his experiments with new fresco techniques led to problems from the start. The central portion of the composition is known only through several copies, including one by **Peter Paul Rubens** (1615; Paris, Louvre). These reveal that the work captured effectively the chaos of war and the despair, fear, and hostility of the men involved. Though the work was never completed, it exerted tremendous influence throughout the Renaissance and well into the 19th century.

BATTLE OF CASCINA (**1504–1506; destroyed).** A conflict between **Florence** and Pisa that took place on 28 July 1364, with Florence emerging as the victor. In 1504, the fathers of the Florentine Republic decided to commemorate the event by commissioning **Michelangelo** to render a **fresco** of the subject in the Sala del Consiglio (Council Chamber) of the **Palazzo Vecchio**, the city's seat of government. It fell on **Leonardo** to render the *Battle of Anghiari* of 1440 between Florence and Milan in the opposite wall. Like Leonardo's fresco, Michelangelo's remained incomplete since in 1505 Pope **Julius II** summoned the artist to **Rome** to work on his tomb. Michelangelo

returned briefly to Florence in 1506, worked on the fresco a bit longer, but never completed it. In 1557 the frescoes in the room were replaced by **Vasari**'s works, meant to glorify the **Medici**. Michelangelo's fresco, like Leonardo's, is known only from extant sketches. These reveal that he chose to render the Florentine soldiers, who had been cooling off in the Arno River when the Pisans attacked, rushing to dress so they could fight the enemy. This would give Michelangelo the opportunity to demonstrate his skills in depicting the male nude form in different, complex poses. The cartoon for the fresco, also destroyed, is known to have been greatly admired and used as prototype by both High Renaissance and **Mannerist** artists.

BATTLE OF SAN ROMANO (1432). A battle in which the **Florentines**, led by **Niccolò da Tolentino**, were victorious against the Sienese army of Bernardino della Ciarda. The event was commemorated in three panels painted by **Paolo Uccello**, now respectively in the National Gallery in London, Louvre in Paris, and **Uffizi** in Florence (1430s). The first shows Niccolò da Tolentino leading his troops to victory amidst the chaos of the battlefield. Armored horsemen charge against each other, while a fallen soldier and discarded weapons litter the foreground. The second depicts Micheletto da Cotignola, a **condottiere** allied with the Florentines, framed by the lances held upright around him. In the third panel, Bernardino della Ciarda is thrown off his horse while other fallen soldiers and horses occupy the foreground. The paintings are thought to have been created for the **Medici**, since they are listed in a 1492 inventory of their possessions. They divulge Uccello's obsessive use of **perspective** and **foreshortening** to the point that verism is lost. Instead, the compositions become decorative, static, and devoid of the emotive component needed to render a convincing battle scene.

BATTLE OF THE LAPITHS AND THE CENTAURS (c. 1492; Florence, Casa Buonarroti). This sculpture **relief** belongs to **Michelangelo**'s formative years while training in the **Medici** household with his master, Bertoldo di Giovanni. The subject of the work, which stems from **Ovid**'s *Metamorphoses*, was suggested by the poet Angelo Poliziano who was a member of **Lorenzo "the Magnificent" de' Medici**'s court. According to the written account,

the Centaurs, half-men and half-horses, stormed a Lapith wedding celebration and attempted to carry off the women. Michelangelo presented the scene as if part of the deep carvings in a Roman sarcophagus. All of the figures are male and nude, the master's favored subject. They emerge from the background and intertwine in complex poses. Though a very early work by Michelangelo, it shows his knowledge of anatomy, even at his formative stages. Muscles stretch and contract in response to movement, and bones, tendons, and other details are rendered accurately.

BEAUNEVEU, ANDRÉ (1335–c. 1401). French sculptor and manuscript illuminator from Valenciennes in Hainaut. Beauneveu is documented in Paris in c. 1360, working for Charles V of France until 1374 when he moved to the court of Louis de Mâle, Count of Flanders. In c. 1380 he became **Jean, duc de Berry**'s court artist. For him he made 24 illustrations of **prophets** and **apostles** in the *Psalter of the Duke of Berry* (Paris, Biliothèque National) in c. 1380–1385. These enthroned figures show a move toward naturalism and a solid, sculptural approach to the figure. A fragment head of an apostle Beauneveu executed in stone for the duke as part of the decorations in the chapel of the Château de Mehun-sur-Yèvre is now in the Louvre in Paris (c. 1400) and presents an example of his sculpture. *See also* ILLUMINATED MANUSCRIPT.

BECCAFUMI, DOMENICO (1485–1551). Sienese **Mannerist** painter who began his career by following the Sienese tradition of the late 15th century, a style he abandoned once he was exposed to the art **Michelangelo** and **Raphael** had created in **Rome**. The composition of Beccafumi's *Stigmatization of St. Catherine of Siena* (c. 1518; Siena, Pinacoteca Nazionale), meant for the Benedictine Convent of Monte Oliveto, depends on Raphael's symmetrical arrangements. The earth tones and use of **sfumato** he borrowed from **Leonardo da Vinci**, and the sculptural forms from Michelangelo. Yet, while his representation owes debt to the greatest masters of the High Renaissance, it is nevertheless an anticlassical image without central focus. It also features unrealistic proportions and an extreme low placement of the background city, elements that classify the work as Mannerist. Beccafumi's *Christ in Limbo* (c. 1535; Siena Pinacoteca Nazionale)

represents his mature style. Here he created a complex composition with a large number of figures arranged in a semicircle, not the usual Renaissance pyramid or other geometric arrangement. The figures in the foreground are heavily **foreshortened** and the scene seems to move up rather than back. These illogical elements are what place Beccafumi among the great masters of the Mannerist style.

BEHAM, BARTHEL (1502–1540). German painter and engraver trained by **Albrecht Dürer**. A native of Nuremberg, Barthel Beham and his older brother Sebald, also an artist, were expelled from the city in 1525 for their anarchistic and heretic inclinations. In 1527, Beham went to Munich and, three years later, he entered into the service of Duke William IV of Bavaria. Beham is believed to have died during a journey to Italy in 1540. While his engravings closely adhere to Dürer's style, his portraits, on the other hand, are tied to the Italian **Mannerist** aloof types rendered by **Bronzino**. They also betray the influence of **Hans Holbein the Younger** in their clarity and emphasis on detail. His portraits *Ludwig X of Bavaria* (1537–1538; Vienna, Liechtenstein Museum) and *Ottheinrich, Prince of Pfalz* (1535; Munich, Alte Pinakothek) are examples of his Italianate approach.

BELLINI, GENTILE (active c. 1460–1507). Venetian painter; the son of **Jacopo** and brother of **Giovanni Bellini**. Gentile catered mainly to the *scuole* (**confraternities**) of Venice, though he is also known to have obtained governmental commissions, including a cycle in the **Doge's Palace**, destroyed by fire in 1577. His major extant works are the paintings he created for the Scuola di San Giovanni Evangelista to be hung in their meeting hall. Of these, the *Procession of the Relic of the True Cross* (1496; Venice, Galleria dell' Accademia) is a journalistic scene that records a specific procession in 1444 when the relic cured an ill man, proving the relic's validity. The work is invaluable not only for its artistic merits but also historically because it reveals the appearance of the façade of the Basilica of St. Mark as it looked in the late 15th century. Gentile included the now-destroyed *St. Peter* by **Paolo Uccello** on the basilica's left **pinnacle**. The *Miracle of the Cross at the Bridge of San Lorenzo* (1500; Venice, Galleria dell' Accademia), also painted by Gentile for the Scuola di San Giovanni, shows another miraculous event where the relic fell

into the water and eluded all who tried to rescue it except Andrea Vendramin, the head of the confraternity. In 1479, the Venetian State sent Gentile to Constantinople, then under Turkish rule, to work for Sultan Mahomet II. Few works from his stay in the Turkish court have survived, mainly some portraits, including that of the sultan (1480) in the London National Gallery. His decorations for the imperial harem in Topkapi are also lost. Within a year, Gentile was back in Venice. He left, supposedly, because he feared for his life. The sultan had disapproved of a painting Gentile had shown him of the decollation of **St. John the Baptist**. He called in two slaves and ordered one of them to chop off the other's head. Then he exclaimed, "This is how a freshly severed head should look."

BELLINI, GIOVANNI (active c. 1460–1516). Giovanni Bellini is credited with transforming **Venice** into one of the most important artistic centers of the Renaissance. He was the son of **Jacopo Bellini**, brother of **Gentile**, and brother-in-law of **Andrea Mantegna**, who deeply influenced him early on. Giovanni's *Agony in the Garden* (c. 1460; London, National Gallery) is in fact based on Mantegna's work of the same subject painted a decade earlier, though with less pronounced **foreshortening** and detailing. He also omitted Mantegna's usual references to the ancient Roman world. Giovanni's *Pesaro Altarpiece* (1470s; Pesaro, Museo Civico) likewise borrows the architectural elements and figural arrangements from Mantegna's *San Zeno Altarpiece* (1456–1459; Verona, San Zeno). To this period also belongs his *Pietà* (1460) in the Pinacoteca di Brera, Milan, the *Polyptych of St. Vincent Ferrer* in the Church of S. Giovanni e Paolo, Venice (1464–1468), and the *Virgin and Child* (1460–1464) in the Accademia Carrara, Bergamo. This last work is one of many half-figured Madonnas Giovanni painted, a format he popularized and that came to be identified with the Venetian School.

In 1475, Giovanni's style changed as a result of his exposure to the work of **Antonello da Messina**. Antonello arrived in Venice in that year, bringing with him the new application of **oil** glazes in layers he learned from the Early Netherlandish masters. Giovanni adopted this technique, resulting in a richer palette and velvety surfaces. His *Frari* (1488; Venice, Santa Maria Gloriosa dei Frari) and *San Giobbe* altarpieces (c. 1487; Venice, Galleria dell' Accademia)

exemplify this shift in his style. In both, he softened the contours of figures and objects, warmed up the colors, and bathed the surfaces with a golden glow—changes that would later become pivotal to the development of the art of Venetian masters such as **Titian** and **Tintoretto**. In these two altarpieces, Giovanni also established a new type for the Venetian enthroned Madonna and Child, with figures that are elevated from the saints and flanked by columns or pilasters, perhaps inspired by **Fra Filippo Lippi**'s *Barbadori Altarpiece* (beg. 1437; Paris, Louvre) where the Virgin stands on a platform in front of an *aedicula* above the accompanying saints and angels. The influence of Antonello is also perceived in Giovanni's portrait *Doge Leonardo Loredan* (c. 1500, London, National Gallery). The clear rendering of details, the nonidealization of the figure, and his placement in front of a parapet onto which Giovanni signed his name are all elements he learned from Antonello. These works present a lighter palette, common of Giovanni's art of the 1500s, seen also in his *San Zaccaria Altarpiece* (1505) for the Church of San Zaccaria, Venice. This painting follows the format of the earlier *Frari* and *San Giobbe* altarpieces, yet here an aura of silence permeates the scene as the figures do not interact, instead immersing themselves in reading or meditation. Also, the landscape now predominates. Though the figures are enclosed in an **apse**, the sides of the structure are open to allow a glimpse of the outdoors.

Though Bellini favored religious subjects, at times he also tackled mythologies and allegories. His *Feast of the Gods* (1514; Washington, National Gallery), painted for Alfonso I d'Este's **Camerino d'Alabastro** in Ferrara, illustrates a passage from **Ovid**'s *Fasti*. His *Young Woman with a Mirror* (c. 1515; Vienna, Kunsthistorisches Museum), a soft, delicate nude set against a dark wall with a window that permits a glimpse of a distant, loosely painted landscape, is thought to represent an allegory of Vanity. In this last work, Giovanni signed his name on a fictive crumpled paper next to the figure, an element again borrowed from Antonello who, in turn, borrowed it from the Early Netherlandish masters.

In 1483, Giovanni was recognized by the Venetian Republic for his artistic achievements with an appointment as official painter. His reputation was not limited to Venice. **Albrecht Dürer** visited the region in 1506–1507 and made it a point to meet Giovanni, writing later that

the man was already of advanced age but still the best painter in the city. Bellini's impact on the development of art is immeasurable. He established many of the standards the new generation of Venetian masters would follow, particularly the compositional types, rich tonalities, loose application of paint, and superb effects of lighting.

BELLINI, JACOPO (active c. 1424–1471). The founder of a family of painters in **Venice** composed of his two sons, **Gentile** and **Giovanni Bellini**, and his son-in-law, **Andrea Mantegna**. Jacopo was trained by **Gentile da Fabriano** from whom he learned the **International Style**. In 1441, he is documented in Ferrara working in the court of Lionello d'**Este** alongside **Antonio Pisanello**. There he painted the *Madonna of Humility with a Donor* (c. 1450; Paris, Louvre) with Lionello kneeling in prayer in front of the **Virgin**. She and the Christ Child are of considerably larger proportions than the donor to signify their preeminence over mortals, this reiterated by the inscription on Mary's halo that hails her as "Queen of the World." In the distance the magi approach to worship the newly born Christ. Their presence, the emphasis on luxurious fabrics, gilding, and brilliant colors qualify this work as a masterpiece of the International Style. Though an accomplished painter, Jacopo is best known for his drawings. Two bound volumes of his works on paper are now housed in the London British Museum and Paris Louvre, respectively, and are believed to have functioned as instructional materials for his sons and pupils. The drawings present all sorts of subjects, including religious, archaeological, and mythological and are known to have inspired Venetian masters well into the 16th century.

BELLORI, GIOVAN PIETRO (1613–1696). Theorist and antiquarian who wrote the *Lives of the Modern Painters, Sculptors, and Architects* (1672), one of the most important biographical sources for **Baroque** art. Bellori was also one of the greatest exponents of the **Neoplatonic** theory of art. His interpretation of **Annibale Carracci**'s **Farnese ceiling**, which centers on the premise that it depicts the struggle between Divine and Profane Love, is still considered valid. *L'Idea* (1664), which he presented at the **Accademia di San Luca**, **Rome**, and included as the preface to his *Lives*, explains the method that, in his view, artists must use in rendering a work of art.

This method is based on the Neoplatonic concept that Earth is a corrupt reflection of the heavens. Therefore, artists must form in their minds an idea of greater beauty. They must select from nature the most aesthetically pleasing parts and combine them to create an idealized depiction—the method used by the ancient painter Zeuxis when he rendered the portrait of Helen of Troy. For Bellori, the artists who best accomplished this were Annibale Carracci, **Guido Reni**, **Domenichino**, and Carlo Maratta. Bellori is also credited with promoting the systematic documentation of Rome's ancient patrimony, foreshadowing the methodological approach used in modern archaeology.

BERLINGHIERI, BERLINGHIERO (active c. 1225–bef. 1236). One of the earliest Italian masters to be known by name. Berlinghiero was from Milan and is documented in Lucca, a **banking** community near Pisa, in 1225 where he established a family of painters that included his son **Bonaventura Berlinghieri**. His *Crucifixion* at the Lucca Pinacoteca (early 13th century) originally hung in the Monastery of Santa Maria degli Angeli, Lucca, and is signed *Berlingerius me pinxit* (Berlinghiero painted me) at the base, denoting the renewed interest in the 13th century in celebrating individual achievement. On the **apron**, Mary points to Christ to indicate that he is the Savior and **St. John** rests his head on his right hand, a traditional gesture of grief. At the ends of the arms of the cross are the symbols of the four **Evangelists**, who related Christ's story, and above Christ is the **Virgin Mary** flanked by two angels. The panel is painted in the *Maniera Greca* style, and shows a *Christus triumphans*. Based on the figure types and stylistic elements of this work, a *Virgin and Child* at the Metropolitan Museum has also been attributed to Berlinghiero.

BERLINGHIERI, BONAVENTURA (active 1228–1274). Italian painter, active in Lucca, the son of **Berlinghiero Berlinghieri**. Bonaventura is chiefly known for his **St. Francis** panel in the Church of San Francesco in Pescia, a small town near Lucca. The panel, painted in the *Maniera Greca* style, is signed and dated 1235 at St. Francis' feet, which means that it was painted only seven years after the saint's canonization (1228), making it the earliest known work to

depict his story. Considered a second Christ, St. Francis is shown in a similar manner as the Christ in the **Crucifixions** of the 13th century. The saint stands in the center of the panel, the stigmata (wounds resembling those on Christ's crucified body) on his hands and feet clearly showing. At either side of the saint are scenes that narrate the visions he experienced, his preachings, and the miracles he effected. This makes clear that the purpose of the panel was to instruct the faithful on the cult of this newly canonized saint.

BERMEJO, BARTOLOMÉ (c. 1405–1498). Spanish painter from Cordoba who may have trained in Flanders, as suggested by the fact that his works can be linked to those of **Petrus Christus** and **Hans Memlinc.** Some have suggested that instead Bermejo's training took place in Portugal in the workshop of **Nuno Gonçalves,** the leading master of that region in the 15th century whose work betrays an awareness of Flemish art. Bermejo was in Aragon from 1474 to 1477 where he painted his *St. Michael* (1474–1477; Luton Hoo, Wernher Collection), a work signed and dated that closely resembles Flemish versions of the same subject, especially in the angular drapery folds. In 1486, the artist was in Barcelona collaborating with **Jaime Huguet** on paintings for Santa María del Mar and, in 1490, he created his famed *Pietà* for the Cathedral of Barcelona, a work commissioned by Canon Luis Desplá as part of his funerary monument. In 1495, Bermejo also designed stained glass windows for the cathedral.

BERNINI, GIAN LORENZO (1598–1680). The son of the **Mannerist** sculptor Pietro Bernini, Gian Lorenzo was the most important sculptor and one of the most notable architects of the **Baroque** period. Born in Naples while his father was working in that region, in c. 1606 he moved with his family to **Rome.** There, Pope **Paul V** and his nephew Cardinal **Scipione Borghese** noticed Bernini's precocious talent and soon the young boy was creating sculptures for them. In his youth, Bernini also spent three years at the Vatican studying the ancient statuary and works by **Michelangelo** and **Raphael.** He was particularly taken with Michelangelo's accurate anatomical details and the sensuousness of his male forms—elements Bernini incorporated into his *Martyrdom of St. Sebastian* (c. 1615–1616; Thyssen-Bornemisza Collection), one of the early works he rendered for the

Borghese. Also for his patrons was his first large-scale sculpture, the *Aeneas, Anchises, and Ascanius Fleeing Troy* (1619; Rome, Galleria Borghese), followed by **Pluto and Proserpina** (1621–1622) and **Apollo and Daphne** (1622–1625), both for Cardinal Scipione and now in the Galleria Borghese, Rome. For this last commission, Cardinal Maffeo **Barberini**, later Pope **Urban VIII**, is said to have composed the inscription on the cartouche at the base. Cardinal Maffeo supposedly also held a mirror for Bernini so he could use his own likeness to execute his **David** (1623–1624; Rome, Galleria Borghese). This was his last large-scale commission for the Borghese since soon thereafter Maffeo was elected pope (1623) and he appointed Bernini the official papal artist.

In 1624, Urban charged Bernini with the renovation of the façade of the fifth-century Church of St. Bibiana in Rome. The saint's body was found while the work was carried out so, to commemorate the recovery, Urban asked Bernini to also execute for the church a statue of the saint enduring her martyrdom (1624–1626). Also in 1624, Urban charged Bernini with the large bronze *Baldacchino* (1624–1633) for the altar of **St. Peter's**. Then, in 1629–1630, he put the artist in charge of the decoration of the basilica's crossing. This entailed filling the niches on the four main pillars that support the **dome** with statues related to relics housed at St. Peter's. Bernini provided the *St. Longinus* and then asked **Francesco Mochi** to render the statue of St. Veronica, Andrea Bolgi the **St. Helena**, and **François Duquesnoy** the St. Andrew. From 1628 to 1647, Bernini was busy executing the pope's tomb (Rome, St. Peter's) and, from 1648 to 1651, he was also working on the **Four Rivers Fountain** at the Piazza Navona, Rome, commissioned by Urban's successor, Innocent X. His later works include the **Cornaro Chapel** at Santa Maria della Vittoria, Rome (1645–1652), the Cathedra Petri (1657–1666) and *Tomb of Alexander VII* (1671–1678), both at St. Peter's, and the *Death of the Blessed Ludovica Albertoni* (1674) in the Altieri Chapel at San Francesco a Ripa, Rome.

As sculptor, Bernini stressed theatricality, the use of various materials of different colors and textures, and the combination of different media. He was a religious individual who had close ties to the **Jesuits** and is known to have practiced **St. Ignatius of Loyola**'s *Spiritual Exercises*. St. Ignatius advocated meditation to feel the suffering of

Christ, and Bernini's sculptures are similarly made to appeal to the viewers' senses and to enhance their emotional response. In architecture, Bernini was somewhat more conservative, preferring to adhere to the principles established by ancient and Renaissance architects. From 1656 to 1667, he was busy with the Piazza of St. Peter's, which he based on Michelangelo's *Piazza del Campidoglio* (fin. 1564). He created the *Scala Regia*, the ceremonial stairs that lead from the Vatican Palace into St. Peter's, in 1633–1666; the Church of Sant' Andrea al Quirinale in Rome for the Jesuit Order in 1658–1670; and the churches of Santa Maria dell' Assunzione in Ariccia and San Tommaso di Villanova at Castel Gandolfo in 1662–1664 and 1658–1661, respectively, these last two for Pope Alexander VII. In 1664, Bernini also submitted designs for the east façade of the Louvre in Paris at the invitation of Louis XIV. In the end, these were rejected, though they exerted great influence in the development of French architecture.

BERRETINI DA CORTONA, PIETRO (1597–1669). Tuscan painter and architect who trained in **Florence** in the studio of the **Mannerist** Andrea Commodi. In c. 1612, Commodi took Cortona to **Rome** and placed him in the workshop of his colleague Baccio Ciarpi. Sometime in the 1620s, Cortona came into contact with the Sacchetti, good friends of Pope **Urban VIII**, who became his most important early patrons. In c. 1623–1624, he rendered for them his *Triumph of Bacchus* and, in c. 1629, the *Rape of the Sabine Women* (both Rome, Capitoline Museum), two works that show Cortona's close affinity to **Venetian** colorism and loose brushwork. In 1633, Cortona was working for the **Barberini**, Urban's family, creating for them one of his most important works, the *Glorification of the Reign of Urban VIII*, in the grand salon of their palazzo in Rome. This dynamic composition, with figures weaving in and out of the *quadratura* framework, is one of the grand masterpieces in the history of ceiling painting. Cortona's **frescoes** in the Palazzo Pitti, Florence (1637–1647), commissioned by Grand Duke Ferdinand II de' **Medici**, and the Palazzo Pamphili, Rome (1651–1654), painted for Pope Innocent X, are no less exuberant.

As architect, Cortona seems to have been self-taught. Among his earliest structures is the Villa del Pigneto (late 1630s), built for the Sacchetti just outside of Rome, a structure fronted by complex ter-

races and stairways inspired by the ancient Temple of Fortuna Primigenia in Rome and **Donato Bramante**'s Belvedere Court (beg. 1505) at the Vatican. Cortona also worked on several churches in the papal city: **Santi Luca e Martina** (1635–1664), a new façade for Santa Maria della Pace (1656–1667), Santa Maria in Via Lata (beg. 1658), and San Carlo al Corso (beg. 1668). Cortona was among the first to experiment with convex and concave architectural forms, which many of his buildings possess. His energetic compositions and illusionistic devices did much to facilitate the development of Rococo art and architecture, particularly in Germany.

BERRUGUETE, PEDRO (c. 1450–1504). Spanish painter from Paredes de Nava who in 1477 is documented in Urbino, Italy, working with **Joos van Ghent** in the ducal palace of **Federico da Montefeltro**. There he painted the portrait of the duke and his son (1480–1481; Urbino, Galleria Nazionale) and assisted in the decoration of the ducal library and studio. By 1483, Berruguete was back in Spain. His *predella* paintings of five **prophets** and King **David** for the *Retablo de Santa Eulalia* (after 1483) in the church of the same appellation in Paredes de Nava show his assimilation of the Italian style. The **foreshortening** of the figures' hands, the naturalistic arrangement of draperies, the voluminous forms, and anatomical details follow Italian precedents.

BESSARION, CARDINAL BASILIUS (c. 1403–1472). Cardinal Bessarion was one of the most important contributors to and promoters of Greek scholarship in the Renaissance. Born in Trebizond, Greece, and educated in Constantinople, Bessarion was appointed bishop of Nicea in 1437 and, in the following year, he attended the Council of Ferrara and **Florence** to promote the reunification of the eastern and western churches. There he gained the favor of Pope Eugenius IV who appointed him cardinal in 1439, after which he took up residence in **Rome**. His palace became the locus of learned discussions among the leading humanists of the era. Bessarion commissioned the translation of Greek manuscripts into Latin, making the works available to the West, and he himself translated **Aristotle**'s *Metaphysics* and Xenophon's *Memorabilia*. He bequeathed his vast

collection of Greek manuscripts to the **Venetian** Republic in 1468, which became the nucleus of the **Library of St. Mark** in Venice.

BETRAYAL OF CHRIST BY JUDAS. The betrayal by Judas takes place after the **Last Supper** when Christ goes to the Garden of Gethsemane to pray (**Agony in the Garden**). Judas leads the Roman soldiers and priests to Christ and kisses him so he may be identified as the individual to be arrested. **Peter** is so enraged by the event that he pulls out a knife and cuts off the ear of Malchus, one of the priests' servants. The scene is rendered by **Giotto** in the **Arena Chapel**, Padua (1305), where Judas puckers his lips to kiss Jesus. He also envelops the Lord with his cloak to effectively convey the drama of the moment depicted. To the left is Peter, with knife in hand, behind Malchus. Similar scenes are offered by **Duccio** in the *Maestà Altarpiece* (1308–1311; Siena, Museo dell' Opera del Duomo), **Fra Angelico** at **San Marco Monastery** in **Florence** (c. 1450), and **Dirk Bouts** in the Alte Pinakothek, Munich (c. 1450). **Caravaggio**'s *Betrayal of Christ by Judas* (1602–1603; Dublin, National Gallery of Ireland) presents a close-up view of the event, with three-quarter figures in emotive gestures, among them the painter himself.

BIER. A stand on which a corpse is placed in preparation for burial or to be carried in a funeral procession. In Renaissance sculpted funerary monuments, the **effigy** of the deceased is usually shown lying on a bier, as in **Bernardo Rossellino**'s *Tomb of Chancellor Leonardo Bruni* (c. 1445) and **Desiderio da Settignano**'s *Tomb of Chancellor Carlo Marsuppini* (1453), both at **Santa Croce**, **Florence**. In both monuments, the bier is placed above the sarcophagus, with angels at either side holding an inscription with laudatory remarks on the **virtues** and accomplishments of the deceased.

BIRTH OF THE VIRGIN. The celebration of the birth of the **Virgin Mary** on 8 September has taken place since the sixth century when her cult intensified after the Council of Ephesus. The story is not biblical but rather **apocryphal**. Mary's parents, **Joachim** and **Anne**, were old when they conceived her, so her birth is considered miraculous. In art, the event is usually depicted in an interior domestic setting, with St. Anne reclining on the bed and the newborn being

washed by the midwives who assisted in the birth. This is how **Pietro Lorenzetti** (1342; Siena, Museo dell' Opera del Duomo) and **Domenico Beccafumi** (c. 1542; Siena, Accademia) depicted the scene. In these works, Joachim is seated in an adjacent room awaiting the news of the child's birth. **Albrecht Altdorfer** placed his rendition (1525; Munich, Alte Pinakothek) in a Gothic interior church setting with a crown of angels hovering above the seated Anne, who holds the Virgin in her arms. With this he asserted the religious significance of the birth of the mother of God and her role as *Ecclesia*, Holy Mother of the Church.

BIRTH OF VENUS **(c. 1485; Florence, Uffizi).** Painted by **Sandro Botticelli** probably for Lorenzo di Pierfrancesco de' **Medici** in whose house, the Villa Castello, the painting once hung alongside Botticelli's *Primavera* (c. 1482; **Florence, Uffizi**). The scene ultimately stems from a poem by the Greek Hesiod who wrote that **Venus** was born from the foam produced by Uranus' testicles when they were cut off by his son Saturn and thrown into the sea. The true source of Botticelli's painting, however, is an *ekphrasis* written by the poet Angelo Poliziano, from the Medici circle, on the **reliefs** cast by Vulcan for the doors of Venus' temple. In the work, Venus stands naked on a seashell and is being blown ashore by the winds. A female, identified either as Pomona (goddess of the trees), Flora (goddess of the flowers), or an Hour, greets her with a robe in hand. Venus' pose is that of a *Venus Pudica* type from antiquity, an image of the goddess covering her nudity with her arms. The painting does not follow nature. Instead, the figures are elongated, with little volume and anatomical detailing, milky complexions, complex curvilinear drapery folds, and hair strands that seem to take on a life of their own. **Atmospheric perspective** is absent in the landscape, so that every wave, cloud, and flower is clearly visible regardless of its distance from the foreground. Yet, while Botticelli ignored all the technical advances introduced to painting in the 15th century, he managed to produce a work that is graceful, elegant, and aesthetically pleasing.

BLACK DEATH. A bout of bubonic plague that struck Europe in 1348 and decimated a large percentage of the population. Art was affected by the plague. Several important masters succumbed to it, including

Andrea Pisano, **Pietro** and **Ambrogio Lorenzetti**, and **Bernardo Daddi**. Further, since the plague was considered punishment for sins committed, patrons commissioned religious works that served to expiate whatever sins had brought on the catastrophe. Most of the works commissioned in the mid-14th century in **Florence** and Siena, where 50 to 75 percent of the population is thought to have perished, dealt with scenes of death and final judgment. The plague recurred sporadically until the 18th century when it was finally brought under control. In Florence, it struck again in 1448, lasting for three consecutive summers. In 1557–1577, **Venice** lost 30 percent of its population to the disease. The **doge** vowed that if the city was delivered from the plague, he would commemorate the event by building a church in honor of Christ the Redeemer. **Andrea Palladio** received the commission, building *Il Redentore* (beg. 1577). To this day, a procession on the Feast of the Redeemer (the third Sunday in July) takes place, ending in the church with a thanksgiving mass.

BOCCACCIO, GIOVANNI (1313–1375). Considered one of the greatest Italian poets in history, Boccaccio was born either in the Tuscan town of Certaldo or in **Florence**. He spent his youth in Naples where his father worked as representative of the Bardi **bank**. There he studied law and commerce and eventually recognized that his true calling was writing. In Naples he composed his *Caccia di **Diana*** (c. 1334), *Filostrato* (c. 1335), and *Teseida* (1339–1341). By 1341, he was back in Florence and there he began work on his *Decameron* (c. 1350), which tells the tale of 10 aristocratic youths who flee Florence to avoid the **Black Death**. They set up court in the Tuscan countryside where they pass the time by telling each other stories. Among these is the story of **Nastagio degli Onesti**, a subject sometimes depicted on domestic furnishings decorated with didactic narratives. The work was so successful that in the 16th century it was declared the canon of vernacular prose. During the mid-1350s, Boccaccio established a close friendship with **Petrarch** and acted as Florentine ambassador to **Rome**, Ravenna, **Avignon**, and Brandenburg. Among his later works is the *De mulieribus claris*, the first collection of biographies of women in Western literature and a major source of subjects for artists. Boccaccio spent his last years lecturing on **Dante** in Certaldo and Florence.

BODEGÓN. Spanish term used to denote a still life or a scene where kitchen implements or food preparation are included. *Bodegónes* usually possess a decisively Spanish flavor, with foods that form the ingredients of the local cuisine, as in, for example, the *Still Life with Game Fowl, Fruit, and Vegetables* by **Juan Sánchez Cotán** (1602; Madrid, Prado), **Diego Velázquez**'s *Old Woman Cooking Eggs* (1618; Edinburgh, National Gallery of Scotland), and **Francisco de Zurbarán**'s *Still Life with Lemons, Oranges, and Rose* (1633; Pasadena; Norton Simon Museum). Sometimes, the terracotta and metal vessels included in the paintings reflect the local artisanry, like the large jars in Velázquez's **Water Carrier of Seville** (1619; London, Wellington Museum).

BOLOGNA. In the sixth century BCE, Bologna, then called Felsina, was the economic center of Etruscan society because its location along the Po River and at the foot of the Apennines allowed for commercial links with other civilizations. In 189 BCE, Felsina became part of the Roman Empire, and was renamed Bononia. The Romans built the Via Emilia, which connected the city to the network of Roman roadways, facilitating its growth. By the sixth century CE, the city had come under Byzantine rule, and in the medieval era rivaling families took over—first the Pepoli, followed by the **Visconti**, and Bentivoglio. In 1506, Pope **Julius II** took the city and annexed it to the Papal States, with papal rule lasting until the 18th century. Bologna was the first city in Europe to establish a university, which made it the intellectual center of Western culture. During the Renaissance, it was also known for its silk industry. From the point of view of artistic production, Bologna did not gain fame as a major artistic center until the end of the 16th century when the **Carracci** established their academy there and trained a whole generation of masters, including **Domenichino**, **Francesco Albani**, and **Guido Reni**.

BOLOGNA, GIOVANNI DA (JEAN DE BOULOGNE; 1529–1608). Sculptor from Flanders who in 1550 went to Italy where, after studying in **Rome** for two years, he settled in **Florence**. There he became the leading **Mannerist** sculptor. His best-known work is the ***Rape of the Sabine Woman*** (1581–1582; Florence, **Loggia** dei Lanzi) commissioned by Duke Francesco I de' **Medici**. The

work shows three figures interlocked in a vertical, corkscrew composition (*serpentinata*) that grants a different view at each side and forces the viewer to walk around it. Bologna looked to the recently recovered Hellenistic *Laocoön Group* for inspiration. The pose of the crouching male, the woman's arm gestures, and their deep pathos stem from the ancient prototype. Bologna's bronze *Mercury* (1580) is in the Museo Nazionale del Bargello in Florence and once served as a fountain in the Medici household. Here, Mercury, the messenger of the gods, balances on his left foot over the mouth of Zephyrus, the west wind. This and other works by Bologna, with their well-balanced and dynamic compositions, proved to be a major force in the development of **Baroque** sculpture in Italy and the North.

BONDOL, JEAN (active 1368–1381). Manuscript illuminator and tapestry designer from Bruges who headed the manuscript workshop of King Charles V of France. Bondol's illuminations show his desire to create rational spaces and naturalistic figures, as exemplified by the *Parting of Lot and Abraham* in the *Bible of Jean de Sy* (c. 1380; Paris, Bibliothèque Nationale, Ms. 15397, fol. 14) believed to be by his hand. His *Charles V and Jean de Vaudetar* in the *Bible Historiée* (1371; The Hague, Rijksmuseum Meermanno-Westreenianium, Ms. 10 B 23, fol. 2) shows the French king dressed as a master of arts from the University of Paris. He receives the manuscript from the kneeling Vaudetar, who paid for the work. His throne is shown in three-quarter view to add depth to the image, this negated by the fleur-de-lis patterning in the background. The *Gotha Missal* in the Cleveland Museum of Art (c. 1375), named after its 18th-century owners, has also been attributed to Bondol and his workshop and is believed to have been intended for King Charles' private chapel. The mushroomlike trees, the figures rendered mostly in *grisaille* and set against a polychromatic background, and the gold decorative scrolls in the missal are characteristic of Bondol's style. *See also* ILLUMINATED MANUSCRIPT.

BONIFACE VIII (BENEDETTO CAETANI; r. 1294–1303). Boniface's reign was filled with failed policies. He supported the restoration of Sicily to Charles II of Naples, but he was forced to accept its independence under Frederick of Aragon. He also failed in his medi-

ation between **Venice** and Genoa in effecting Scotland's independence from England, and in securing the Hungarian crown for Charles I Carobert. He tried to end hostilities between France and England over the fiefs of Guienne and Gascony, but his efforts resulted in a major quarrel with Philip IV of France, whom he excommunicated in 1303. The pope was seized by Philip's advisor, Guillaume de Nogaret, the feudal Colonna family of **Rome**, and a group of mercenaries who expected him to resign, but the Roman populace came to his rescue. Boniface was able to continue his reign until his death thanks to the protection of the Orsini, staunch enemies of the Colonna. Boniface was the patron of **Arnolfo di Cambio** who designed his tomb in c. 1300. His portrait bust is the only piece of the tomb to have survived and is now housed in the Vatican **grotto**. Boniface also summoned **Giotto** to the Vatican to create a **fresco** (c. 1300), now badly damaged, depicting his addressing the crowds.

BOOK OF HOURS. A book used for private devotion that contains the prayers of the Divine Office meant to be recited at the canonical hours of the day (matins, lauds, nones, vespers, etc.). These texts sometimes include a calendar with illustrations of the labors of the months. They are usually beautifully **illuminated** as they were created for patrons of high standing. One of the most outstanding examples is the **Limbourg brother**'s *Les Très Riches Heures du duc de Berry* (Chantilly, Musée Condé) of 1416. Other examples include the *Book of Hours of Jean le Meingre, Maréchal de Boucicaut* (beg. c. 1409; Paris, Musée Jacquemart-André, Ms. 2) by the **Boucicaut Master** and the *Book of Hours of Anne of Brittany* (1500–1507; Paris, Bibliothèque Nationale, Ms. lat. 9474) by **Jean Bourdichon**. *See also* JEAN, DUC DE BERRY.

BORGHESE, CARDINAL SCIPIONE (1576–1633). Cardinal Scipione Borghese was the nephew of Pope **Paul V**, who made him a cardinal in 1605 upon his ascent to the papal throne. The appointment allowed Cardinal Scipione to amass a vast fortune, which helped finance his art patronage and collecting activities. His Villa Borghese in **Rome** became a showcase of ancient statuary as well as contemporary art. He commissioned from **Gian Lorenzo Bernini** the *Aeneas, Anchises, and Ascanius* (1619), *Pluto and Proserpina* (1621–1622), and *Apollo and Daphne* (1622–1625).

From **Domenichino** he obtained *Diana and the Hunt* (1617) and from **Francesco Albani** a series of four mythologies (c. 1618), all of which remain in the Galleria Borghese in Rome. He is also the one who purchased from the Cavaliere D'Arpino **Caravaggio**'s *Bacchino Malato*, *Boy with Basket of Fruits* (both 1594; Rome, Galleria Borghese), and *Boy Bitten by a Lizard* (1595–1596; London, National Gallery).

BORRASSÁ, LUIS (c. 1360–1426). Painter from Barcelona, Spain, who adopted the **International Style**. Only 11 works are firmly attributed to Borrassá, based on documentation. About another 20 resemble his style and have therefore been tentatively given to him as well. Borrassá is known to have worked in the convent of St. Damián in Barcelona in 1383 and to have created the *Retable of the Archangel Gabriel*, now in the city's cathedral, in 1390. In 1411–1413, he also executed the *Retable of St. Peter* in the Church of Santa María, Tarrasa, one of his best-known works. Borrassá had a number of pupils and followers, including Gerardo Gener, Juan Mates, and Jaime Cabrera.

BORROMINI, FRANCESCO (1599–1667). Francesco Borromini was one of the leading architects of the **Baroque** era. He was a distant relative of **Carlo Maderno** and began his career in the latter's workshop as a stone-carver and draughtsman. Borromini had a difficult personality. He was ill tempered, extremely envious of **Gian Lorenzo Bernini**, and he suffered from hypochondria and bouts of melancholy. His eccentric mode of dressing, lack of restraint, and states of depression were only tolerated by his patrons because these were then considered a sign of genius. As he had a reputation for providing innovative designs at reasonable cost, Borromini received a number of commissions from religious orders that could not afford the sumptuous marble constructions carried out by other masters. His **San Ivo della Sapienza** (1642–1650) is the church he incorporated into the courtyard of the University of **Rome**. Here, Borromini created a biomorphic plan (some see it as the **Barberini** emblematic bee) by juxtaposing two superimposed triangles to form a six-pointed star, probably as reference to the star of Solomon, known for his wisdom—appropriate for a university setting. Borromini here played

with convex and concave forms, one of his greatest interests. The result is a structure with rhythmic forms that seem to expand and contract. The same features appear in his **Oratory of St. Philip Neri** (1637–1650), next to the Chiesa Nuova, the Collegio di Propadanda Fide (1654–1667), and San Carlo alle Quattro Fontane (beg. 1665), all in Rome. Borromini committed suicide by impaling himself with a sword. Twenty-four wax models of his buildings were listed in his death inventory, which demonstrates that he approached architecture like a sculptor, hence their organic, movemented forms.

BOSCH, HIERONYMUS (1450–1516). Flemish master whose unique style has earned him placement among the most inventive painters in history. Bosch's lack of interest in the rendition of realistic forms and choice of bizarre themes have fascinated art historians who until recently believed that his works were nothing more than fantasies meant to amuse viewers. Now, the view among scholars is that there is deeper meaning to his works. He is now seen as a moralist whose paintings translate the sermons of his day and speak of man's foolishness and its unavoidable cost. His grandfather moved from Aschen to sHertogenbosch, now Holland, in 1399, from which Bosch took his name. He is thought to have been trained by his father, also a painter. Little else is known of his life, except that he was a member of the **Confraternity** of Notre Dame, that he received commissions from Philip the Handsome of Burgundy, and that he married Aleyt Goyaerts van den Meervenne sometime between 1479 and 1481. The fact that his paintings were often copied suggests that he enjoyed great popularity.

The *Seven Deadly Sins* (c. 1475; Prado, Madrid), a painted tabletop once owned by **Philip II of Spain** along with its companion piece, the *Seven Sacraments* (now lost), is believed to be Bosch's earliest work. The *Death of the Miser* (c. 1485–1490; Washington, National Gallery) shows the foolishness of a dying man who takes the money bag from a demon, though the angel next to him points to the **crucifix** at the window as the road to salvation. The *Hay Wain Triptych* (c. 1490–1495; El **Escorial**, Monasterio de San Lorenzo) shows in the central panel a large hay wagon, symbol of earthly goods, followed by the pope, the emperor, noblemen, clergymen, nuns, the rich, and the poor. Among the crowd are the Seven Deadly Sins and on the

wagon sit a pair of lovers accompanied by an angel who looks up at Christ in the clouds and by a demon who dances and plays his elongated nose like a trumpet. On the left panel are the *Creation of Eve* and *Expulsion from Paradise*, with rebel angels above being cast out of heaven. On the right is a depiction of hell where sinners are tortured by demons. Bosch's best-known work is the **Garden of Earthly Delights** (c. 1505–1510; Madrid, Prado), a painting that also presents the Creation on the left panel and hell on the right. In the center, humanity engages in all sorts of strange, sinful activities. Though the work is not fully understood and has given scholars much to write about, it is undoubtedly also a moralizing scene that casts humanity in a satirical light.

BOTTICELLI, SANDRO (ALESSANDRO DI MORIANO FIL-IPEPI; 1445–1510). *Botticelli* (*little barrel*) was a nickname first given to the artist's brother who was presumably overweight. Botticelli was trained in the studio of **Fra Filippo Lippi** alongside Lippi's son **Filippino**. He also worked in **Andrea del Verrocchio**'s studio alongside **Leonardo da Vinci**. From this background one would expect an artist who used the latest advances in **perspective, foreshortening**, and anatomy. Yet, Botticelli rejected the naturalistic methods of contemporary masters, instead opting for lyrical representations not necessarily dependent on visual truth. His *Adoration of the Magi* (early 1470s; **Florence, Uffizi**), commissioned by Guasparre del Lama for the Church of **Santa Maria Novella**, Florence, does not rely on one-point linear perspective, but rather on several simultaneous viewpoints. This work owes to **Benozzo Gozzoli**'s *Procession of the Magi* in the chapel of the **Palazzo Medici** in that it too represents the members of the **Confraternity** of the Magi engaging in procession, including **Cosimo de' Medici**, his sons Piero the Gouty and Giovanni, and his grandsons **Lorenzo** and Giuliano.

In 1481, Botticelli was called to **Rome** by Pope **Sixtus IV** to work alongside **Pietro Perugino, Domenico del Ghirlandaio**, and others on the wall **frescoes** in the **Sistine Chapel**, Vatican. The scenes were to represent subjects from the life of Moses that prefigured that of Christ and asserted the pope's divinely sanctioned right to lead the Church. Though the program turned out to be

somewhat of a fiasco as severe stylistic and compositional discrepancies exist between the scenes, Botticelli's contribution, the *Punishment of Korah, Dathan, and Abiram* (1481–1482), is among the best in the commission. In 1482, Botticelli's father died and the artist was forced to return to Florence. The papal commission he received placed him among the most sought-after masters of the Early Renaissance. In the 1480s he painted a series of important mythological works for the Medici, believed to reflect the **Neoplatonic** thought that permeated their court. His *Primavera, Pallas, and the Centaur* (both c. 1482; Florence, Uffizi), *Birth of Venus* (c. 1485; Florence, Uffizi), and *Venus and Mars* (c. 1482; London, National Gallery) have given art historians much topic for discussion as their subjects are not completely understood. What is understood, however, is that the works were meant for an erudite audience interested in literature and philosophy. The figures in these paintings, with their graceful, elongated forms, are of the same stock as Botticelli's Madonnas, among them the *Madonna and Child with Adoring Angel* (c. 1468, Pasadena, Norton Simon Museum), *Madonna of the Magnificat* (c. 1485; Florence, Uffizi), and *Madonna of the Book* (1483; Milan, Museo Poldi Pezzoli).

In his late phase, Botticelli's palette became more brilliant, with an emphasis on primary colors, and emotive representations. These changes may have been the result of his involvement with **Girolamo Savonarola**, the ascetic **Dominican** monk who acted as prior of the **San Marco Monastery** after **St. Antonine** and who initiated a political movement against the Medici. Botticelli's two *Lamentations* (Milan, Museo Poldi Pezzoli and Munich, Altepinakothek) of the 1490s reveal this change in his style. In these paintings, Botticelli gave his figures a deep sense of sorrow to evoke compassion from the viewer. His *Mystic Nativity* (1500; London, National Gallery) is a work with a strange **apocalyptic** subject that is not completely understood and that represents a major departure from his usual poetic representations. Savonarola died in 1498 after excommunication from the Church, and Botticelli fell in disfavor because of his association with the monk. He died in obscurity, and was forgotten until the late 19th century when scholars rediscovered his works and gave him his rightful place in the history of Renaissance art.

BOUCICAUT MASTER (active c. 1400–1430). The leading manuscript illuminator in Paris in the early years of the 15th century. He is not known by name, but his execution of the *Book of Hours of Jean le Meingre, Maréchal de Boucicaut* (beg. c. 1409; Paris, Musée Jacquemart-André, Ms. 2) is what gives him his current appellation. To the Boucicaut Master are also attributed illuminations in the *Dialogues of Pierre Salmon* (c. 1410–1415; Geneva, Bibliothèque Publique et Universitaire, Ms. fr. 165) and *Les Grandes Heures du duc de Berry* (1409; Paris, Bibliothèque Nationale, Ms. lat. 919). The Boucicaut Master stands out from other manuscript illuminators of his era in that he achieved a greater sense of realism, mainly through the use of **atmospheric perspective** and a single viewpoint—a realism he was able to integrate into the courtly scenes expected by his patrons. *See also* ILLUMINATED MANUSCRIPT; JEAN, DUC DE BERRY.

BOULOGNE, VALENTIN DE (1591–1632). French painter, active in **Rome**. Valentin de Boulogne was born into a family of artists and artisans. He moved to Rome in c. 1612 where he soon became influenced by **Caravaggio**'s style. His *Cardsharps* (c. 1615–1618; Dresden, Gemäldegalerie) closely relates to Caravaggio's painting of the same subject (1595–1596; Fort Worth, Kimball Museum of Art) in its dramatic use of **chiaroscuro**, crude figure types, emphatic gestures and glances, and theatrical costumes. In the late 1620s, Valentin entered in the service of the **Barberini**. For them he painted the *Allegory of Rome* (1628; Rome, Villa Lante), depicted as a female with shield, lance, and tower on her head in accordance with Cesare Ripa's *Iconologia*. The fruits at her feet denote prosperity under **Urban VIII**, the Barberini pope. In 1629, Valentin received from Urban his most important commission, the *Martyrdom of Sts. Processus and Martinian* for one of the altars of **St. Peter's**, a **Counter-Reformatory** work that speaks of the glory of martyrdom for the sake of the faith and the triumph of the Church.

BOURDICHON, JEAN (1457–1521). French **illuminator** who studied under **Jean Fouquet** and who worked for Louis XI of France, his wife Charlotte of Savoy, Charles VIII, Louis XII, and Louis' wife Anne of Brittany. Bourdichon, in fact, is best known for Anne's **book of hours** (1500–1507; Paris, Bibliothèque Nationale,

Ms. lat. 9474), which he illuminated with 51 scenes. His style is characterized by the use of rounded forms, detailed depictions of draperies, large areas of pure color, and emphasis on clarity. His goal was to emulate panel painting on parchment surfaces rather than follow the Northern medievalist tradition.

BOUTS, DIRK (THEODORIK ROMBOUTSZOON; c. 1420–1475). Netherlandish master, probably born in Haarlem, who settled in Louvain, becoming the city's official painter in 1468. The style Bouts used in his early works combines elements borrowed from **Petrus Christus**, **Rogier van der Weyden**, and **Jan van Eyck**, as demonstrated by his *Infancy Altarpiece* (c. 1445; Madrid, Prado). The treatment of the architectural details in this work stems from Christus' *Nativity* (c. 1445; Washington, National Gallery), the short figures with large heads are from van der Weyden, while the palette and textural details depend on van Eyck. Bouts' *Deposition Altarpiece* (c. 1450–1455; Granada, Capilla Real) was inspired by van der Weyden's Prado *Deposition* (c. 1438). As in the prototype, Bouts presents a deeply emotional scene, though his is filled with more action. The *Last Supper Altarpiece* (1464–1467; Louvain, Church of St. Pierre) is Bouts' best-known work. It presents the institution of the Eucharist as a sacrament, a subject demanded in the contract for the work, which has survived. The document also informs readers that two professors of theology from the University of Louvain determined the subject. Surrounding this central scene are panels titled the *Meeting of Abraham and Melchizedek*, *Sacrifice of the Paschal Lamb*, *Gathering of Manna*, and *Elijah and the Angel*, all prefigurations to the central event. Bouts is also well known for his devotional images of the **Virgin** and Child, as exemplified by the versions in the London National Gallery (c. 1465) and at the Metropolitan Museum in New York (1455–1460).

BOY BITTEN BY A LIZARD (1595–1596; London, National Gallery). This work belongs to **Caravaggio**'s early career and demonstrates the impact of **Venetian** art on his style. The sensuousness of the figure, with the shirt off the shoulder to reveal the soft skin, intense colors, and golden lighting, are borrowed from the likes of **Titian**, while the pushing of the figure and still-life elements to

the foreground recall the immediacy of **Lorenzo Lotto**'s subjects. The work also demonstrates Caravaggio's awareness of **Sofonisba Anguissola**'s *Boy Bitten by a Crayfish* (c. 1555), a drawing now at the Museo Nazionale di Capodimonte, Naples. The subject of the painting is not completely understood. The rose worn by the boy behind the ear is associated with **Venus** and amorous enticement. The cherries on the table carry erotic connotations, while the jasmine in the vase is a symbol of prudence. The word for *lizard* in Greek is similar to the word *phallus*, which peppers the scene with even greater erotic content. These symbolic elements suggest, as scholars have recognized, that the work speaks of engaging in love with prudence to avoid pain.

BRACCIOLINI, POGGIO (1380–1459). Italian humanist, Latinist, and collector of ancient art and manuscripts. Poggio Bracciolini belonged to the circle of the humanist Chancellor Coluccio Salutati in **Florence**, where he developed a keen interest in the recovery of ancient Roman manuscripts. In 1403 he was appointed apostolic secretary to the papal court, a charge that allowed him to travel to other parts of Europe. While in France, he discovered in the ecclesiastical libraries of Cluny and St. Gallen manuscripts of unknown texts by Cicero and Quintilian, and an ancient version of **Vitruvius**'s *De architectura*. Later searches in France, Germany, and England led to the discovery of writings by Columella, Petronius, and Tacitus. In the 1430s, he began work on his *De Varietate Fortunae* where he described the ancient ruins of **Rome**. In 1453, he was appointed chancellor of Florence by the **Medici**. There he translated Lucian's *Golden Ass* and wrote the *History of Florence*.

BRAMANTE, DONATO (DONATO DI PASCUCCIO; 1444–1514). The leading architect of the High Renaissance. Bramante trained as a painter, probably with **Piero della Francesca** or **Andrea Mantegna**. His career as architect began in Milan where, alongside **Leonardo da Vinci**, he worked for the **Sforza** rulers. His earliest known commission is the Church of Santa Maria presso San Satiro (beg. 1478), where the most interesting feature is the illusionistic **relief in perspective** he added to extend visually the shallow space of the **apse**.

In Milan, Bramante also worked on the Church of Santa Maria delle Grazie (beg. 1493) to serve as the final resting place of the Sforza family. The work was begun by Guiniforte Scolari and passed on to Bramante so he could modernize the design. Bramante, who left the project incomplete when he moved to **Rome** in 1499, added the **transept**, crossing (where the **nave** and transept cross), and apse utilizing an **Albertian** vocabulary. In Rome, Bramante created his most important masterpieces: the Tempietto at San Pietro Montorio (c. 1502–1512), the Belvedere Court at the Vatican (beg. 1505), and the plan for New **St. Peter's** (1506). With these monuments, he gave the lead in architecture, until then held by **Florence**, to Rome.

BRANCACCI CHAPEL, SANTA MARIA DEL CARMINE, FLO-RENCE (c. 1425). Commissioned by Felice Brancacci from **Masaccio** and **Masolino**, the scenes in this chapel depict the story of **St. Peter**. Most of the **frescoes** on the wall have been attributed to Masaccio, while the scenes on the **vault** and **lunettes**, destroyed in the mid-18th century, are usually given to Masolino. Felice married the daughter of Palla Strozzi and, upon the return of their enemy **Cosimo de' Medici** to **Florence** in 1434, he was exiled along with his wife's family. The Carmelite monks who resided at Santa Maria del Carmine then took the chapel away from Felice and erased the family portraits that were featured in the frescoes. In the 1480s, **Filippino Lippi** completed the chapel's décor, repairing some of the scenes. In 1771 a fire swept through the church, causing damage to the chapel. Since then, the frescoes have been well restored, the latest campaign in 1980–1990.

Of the scenes by Masaccio, the one to stand out is the *Tribute Money*. Based on the Gospels of **St. Matthew**, the work uses a **continuous narrative** technique to relate the arrival of Christ and the **apostles** at Capernaum where Peter is asked by a collector to pay his taxes. The scene has propagandist content in that at the time a tax was levied on Florentine citizens based on exemptions and deductions, called the *catasto*, intended to finance the war against Milan. The fresco contends that taxes are a fact of life and that even important biblical figures were required to pay it. More than the propagandist content, it is the technical innovations Masaccio introduced in this

painting that are of great importance to the development of art. He used **one-point linear** and **atmospheric perspective** to render a three-dimensional space. The figures stand in *contrapposto*, they cast shadows on the landscape, and their draperies are pulled by gravity. The light, now from a single source, corresponds to the natural light that enters the chapel.

Among Masolino's extant scenes are the *Healing of the Lame Man* and the *Raising of Tabitha*. In one field, the scene depicts two miracles effected by St. Peter. Placed opposite Masaccio's *Tribute Money*, Masolino's fresco also employs the one-point linear perspective technique, with the vanishing point in the center. Again, the light in the fresco corresponds to the natural light that enters the chapel, the figures cast shadows, and the scenery is a recognizable Florentine street and buildings. Though Masolino followed the techniques introduced by Masaccio in painting, his figures lack the visual impact of his partner's. The contrast of styles in both masters is best illustrated by comparing the *Temptation* by Masolino to the *Expulsion* by Masaccio, scenes that face each other across the entrance to the chapel. Both represent the earliest examples in Renaissance painting of the fully nude form, yet Masaccio's figures show greater understanding of human anatomy. While Masolino's Adam and Eve stand in an almost completely frontal pose, Masaccio's effectively move within the pictorial space. It is not clear exactly where Masolino's figures stand, but Masaccio's are unmistakably anchored to the ground and cast shadows. Masaccio's angel who expels Adam and Eve from the Garden of Eden is **foreshortened** to seem as if emerging from the skies. The figures are clearly distressed, denoted by the fact that Adam covers his face, a traditional gesture of grief, and Eve grimaces as she tries to cover her nudity with her arms. Her pose is that of a *Venus Pudica* from antiquity, a **Venus** type who covers herself after being surprised at her bath.

Santa Maria del Carmine is the monastery where **Fra Filippo Lippi** grew up, which means that he had plenty of opportunities to study the frescoes in the Brancacci Chapel and he may have in fact witnessed both Masaccio and Masolino painting their respective scenes. Of these two masters, the one to have a fuller impact on Fra Filippo's art was Masaccio, from whom he would adopt the massive figures, pyramidal compositions, and use of the latest perspective techniques.

BROEDERLAM, MELCHIOR (1355–1411). Flemish master, known only for his *Dijon Altarpiece* (1394–1399; Dijon, Musée des Beaux-Arts), painted for the Chartreuse de Champmol, the Carthusian monastery of Dijon established by **Philip the Bold**, Duke of Burgundy. The work shows the *Annunciation*, *Visitation*, *Presentation*, and *Flight into Egypt* on two panels of irregular shape. These scenes owe debt to Italian developments of the era, particularly the three-dimensional architectural representations of **Ambrogio Lorenzetti**.

BRONZINO, AGNOLO (AGNOLO TORI, 1503–1572). Italian **Mannerist** painter who trained with **Jacopo da Pontormo** and who became the leading artist in **Florence** after his master's death. Bronzino worked as court painter to Duke Cosimo I de' **Medici** and excelled mainly as a portraitist. His *Eleonora da Toledo and Her Son Giovanni de' Medici* (c. 1550; Florence, **Uffizi**) is one of the great masterpieces of the Mannerist movement and reflects the refined tastes of the Medici court. Cosimo's wife is here shown in a luxurious costume, befitting her aristocratic rank. She is presented as an exemplary mother who lovingly embraces her son, her elongated fingers and torso and porcelain-like skin being typical of Bronzino's visual vocabulary. The *Portrait of a Young Man* (c. 1550) at the New York Metropolitan Museum again stresses the sitter's social station. The unidentified male features a lavish costume and aloof demeanor. He holds a book in his hand to denote his main pastime, the pursuit of knowledge. Bronzino's *Deposition* (1545; Besançon, Musée des Beaux-Arts), intended as the **altarpiece** for the chapel of Eleonora in the **Palazzo Vecchio**, is among the most visually appealing religious works he created. The painting owes much to Pontormo in the complexity of the composition, the lighting effects, and colorism. In fact, the crouching figure who supports the body of Christ is closely related to the crouching male in Pontormo's *Deposition* (1525–1528) in the Capponi Chapel in the Church of Santa Felicità, Florence. Bronzino's *Allegory of Venus and Cupid* (1540s; London, National Gallery) has baffled scholars who have tried to unravel its intended meaning. Meant for a highly educated audience, the work is filled with allegorical figures in strange combinations that are no longer completely understood. Bronzino was also an accomplished poet, and perhaps poetry played a part in the iconography of his painting.

BROSSE, SALOMON DE (1571–1626). French architect related to **Jean du Cerceau**. De Brosse is credited with introducing **classicism** to French architecture. Unlike du Cerceau, who conceived his buildings in terms of textural decoration, de Brosse thought in terms of mass. His most notable commission was the Luxembourg Palace in Paris (beg. 1615), which he received from **Marie de' Medici**. Marie asked her aunt, the Grand Duchess of Tuscany, to send her the plans for the Palazzo Pitti in **Florence**, where she grew up, to be used as the model for de Brosse's project. Marie circulated the plans throughout European courts for comments, but, in the end, de Brosse did not follow the Italian palace design. Instead, he built a typical French château type. The building features a *corps-des-logis* (main body) flanked by two wings, and a screen that encloses the central court. This resulted in a completely symmetrical and logical design. Only the heavy **rustications** on the façade recall **Bartolomeo Ammannati**'s **Mannerist** rustications of the Palazzo Pitti. The rest of the structure is completely classical. Its massive arches, coupled by the rustications, create a masculine architecture that speaks of monarchic power.

BRUEGEL THE ELDER, PIETER (c. 1525–1569). Bruegel is thought to have been born in the town of Bruegel near Breda, now Holland, from which he received his name. He studied with **Pieter Coecke**, whose daughter he married. When Coecke died in 1550, Bruegel moved to Antwerp where he worked in the engraving shop of Hieronymus Cock. There he entered the painter's **guild** in 1551 and, in c. 1552, he went to Italy where he may have worked for Giulio Clovio, also the patron of **El Greco**, as suggested by the fact that Clovio owned some of his paintings (now lost). In c. 1553, Bruegel returned to Antwerp where he remained for a decade. He then moved to Brussels where he spent the rest of his life.

Bruegel is among the first artists to create pure **genre** scenes that are devoid of religious undertones, and the first to unite landscape to genre. His *Netherlandish Proverbs* (1559; Berlin, Gemäldegalerie) shows a man banging his head against the wall to suggest futility. The pies on the roof in the foreground refer to the popular catchphrase "There'll be pie in the sky when you die," the man with a globe on his thumb implies his having the world on the palm of his hand, while

the inverted globe on the left refers to the upside-down, disordered world. Bruegel used the same all-inclusive approach in his *Children's Games* (1560; Vienna, Kunsthistorisches Museum) where every imaginable game is included, among them leapfrog and hoops. Some of Bruegel's works are related to **Hieronymus Bosch**'s in that they too present scenes that speak of man's folly. Examples of this include his *Dulle Griet* [*Mad Meg*; 1562; Antwerp, Musée Mayer van den Bergh] and the *Tower of Babel* (1563; Vienna, Kunsthistorisches Museum). The first shows, again, a multitude of figures, now in a hellish setting. The figure in the center is Mad Meg, a witch who pillages hell. The meaning of the work is not completely understood, though it has been suggested that she may represent Avarice, one of the **Seven Deadly Sins**, or Madness. The *Tower of Babel* shows building trades and other activities, again referring to futile effort and human ambition overriding capability.

By the mid to late 1660s, Bruegel abandoned the encyclopedic representations of activities and overpopulated fantastic landscapes in favor of monumentalized peasants engaging in everyday chores and celebrations. Examples of this are the *Wedding Dance* (1566; Detroit Institute of Art) and *Wedding Feast* (c. 1566–1567; Vienna, Kunsthistorisches Museum). These types of compositions often stress the comical aspect of the individuals depicted, or the vulgar. Bruegel stands out from among his contemporaries in that his works capture the absurdity of human nature in a way that can be truly categorized as charming and full of humor.

BRUNELLESCHI, FILIPPO (1377–1446). Considered the pioneer of Early Renaissance architecture. The son of a **Florentine** notary and diplomat, Brunelleschi received a humanistic education. He was trained as a goldsmith, and turned to architecture after losing to **Lorenzo Ghiberti** the competition for the **east doors** of the **Baptistery of Florence** (1401). His greatest achievement is the **dome** of the **Cathedral of Florence**. **Arnolfo di Cambio** and Francesco Talenti had built the cathedral in the 14th century, save for the octagonal dome. The opening they left above the crossing (where the **transept** and **nave** cross) spanned 140 feet and no architect of the period possessed the engineering skills to cover such a large expanse. We know from **Giorgio Vasari** that Brunelleschi traveled to **Rome** with

Donatello to study the Roman remains, and there he took precise measurements of ancient buildings. The knowledge he gained facilitated his successful design for the dome. A dome of such large proportions would have collapsed under its own weight had it not been for Brunelleschi's innovative double-shelled construction, the first of its kind. To facilitate the task of building it, Brunelleschi devised a series of mechanical cranes and hoisting machines, and he even arranged for a canteen at dome level for laborers to take their meals without leaving the worksite.

In 1419–1424, Brunelleschi was occupied with the **Ospedale degli Innocenti**, the Florentine foundling hospital built with funding from the **Guild** of Silk Merchants and Goldsmiths to which the architect belonged, no doubt a factor in his obtaining the commission. Like the cathedral dome, the hospital was inspired by ancient Roman architecture. The **loggia**'s round arches, the columns that support them, its capitals, and the corbels that provide added support, all stem from Roman examples. So does the sober design, the rhythm established by the constant repetition of forms, and the emphasis on balance and symmetry. Brunelleschi also built two large churches in Florence: **Santo Spirito** (beg. 1436) and San Lorenzo (beg. 1421). In designing these structures, he rejected the Italo-Gothic style employed by his predecessors, instead opting for a **classicized** vocabulary dependent on ancient Roman prototypes. He also introduced a rational mathematical system of proportions, later adopted by other Renaissance architects, including **Leon Battista Alberti**.

While working on San Lorenzo, Brunelleschi completed the **Old Sacristy**, the funerary chapel of Giovanni di Bicci de' **Medici** attached to the church's left transept. The **Pazzi Chapel** (1433–1461), the Chapter House of **Santa Croce**, also by Brunelleschi (completed by his pupils after his death), is a more elaborate version of the Medician structure. The plans for these two spaces are based on simple quadrangular and circular forms that emphasize balance, symmetry, harmony, and proportions. In 1434–1437, Brunelleschi worked on the Church of Santa Maria degli Angeli, the seat of the Camaldolite Order in Florence and the earliest **central plan** church to be built in the 15th century. The church was modified in the 1930s, though extant plans and elevations reveal Brunelleschi's intentions—to create a structure dependent on the number eight. The result of this

Pythagorean approach was an interior composed of an octagonal nave capped by an octagonal dome supported by a drum that sits on eight piers. The nave is surrounded by eight chapels, one used as the entrance to the church, six dedicated to the **apostles**, and the chapel facing the entrance assigned to the **Virgin Mary**.

Brunelleschi died in 1446. Though he worked primarily in Florence, his influence was far-reaching, mainly thanks to his follower **Michelozzo** who worked in **Venice**, Pistoia, Montepulciano, Milan, and even Dalmatia, spreading Brunelleschi's ideas. By rejecting the French Gothic style in favor of a classicized vocabulary and by introducing a new, rational principle of proportions based on Pythagorean thinking, Brunelleschi single-handedly altered the course of architecture in Italy and abroad. He also can be credited with being among the first to intellectualize the field of architecture, which up to that point had been viewed exclusively as no more than a manual labor.

BUONARROTI, MICHELANGELO. *See* MICHELANGELO BUONARROTI.

BURGKMAIR, HANS (1473–1531). German painter, woodcutter, and engraver from Augsburg, the son of Thoman Burgkmair, also a painter. Hans is thought to have been trained in the workshop of **Martin Schongauer** in Colmar. By 1498, he was back in Augsburg where he married Hans Holbein the Elder's sister and established himself as an independent master. He may have visited **Venice**, Milan, and the Netherlands, travels that were to influence his art in great measure. His *St. John Altarpiece* (1518; Munich, Alte Pinakothek) features Venetian colorism and emphasis on landscape details. His *Mystic Marriage of St. Catherine* (1520; Hannover, Niedersächsische Landesgalerie) includes Northern figure types in three-quarter length sitting in front of a landscape, recalling the compositions of **Giovanni Bellini**. As in the art of this Italian master, the **Virgin** and Child are separated from the rest of the scene by a cloth of honor. Among Burgkmair's patrons were Emperor **Maximilian I** for whom he created a number of woodcuts, and Duke William IV of Bavaria for whom he painted *Esther and Ahasuerus* in 1528 and the *Battle of Cannae* (both Munich, Alte Pinakothek) in the following year.

BURIAL OF COUNT ORGÁZ (1586; Toledo, Church of Santo Tomé). Created by **El Greco**, the *Burial of Count Orgáz* was commissioned by Andrés Nuñez, the parish priest of Santo Tomé. It depicts a miracle that unfolded during the count's burial in 1323. He was the benefactor of the church and of the nearby **Augustinian** Monastery of San Esteban (**St. Stephen**) and, to thank him for his generosity, Sts. Augustine and Stephen supposedly descended from heaven to bury him. In the painting, the gentlemen of Toledo are in the process of lowering the body into the tomb, which is appropriately located directly beneath the painting. Above, the **Virgin** and Christ await the count's soul, depicted as a child being carried up to heaven by an angel, a mode of representation borrowed from 16th-century devotional prints. To separate the earthly from the heavenly, El Greco elongated and abstracted the divine figures and deepened his palette to render this upper section of the painting. The work's message of attainment of salvation through charity and good deeds in life was a concept stressed by the **Counter-Reformation** Church whose doctrines were closely followed by the clergy of Toledo, then the most important center of Catholicism, after **Rome**.

BURIAL OF ST. PETRONILLA (1623; Rome, Capitoline Museum). This work is **Guercino**'s famous **altarpiece** for the altar of St. Petronilla in **St. Peter's**, **Rome**, commissioned by Pope **Gregory XV**. Of huge proportions, the painting depicts the burial of the supposed daughter of **St. Peter** who was martyred for refusing to compromise her chastity. The work is no longer in situ and, therefore, it has lost Guercino's intended effect of making it seem as if the body of Petronilla were being lowered onto the actual altar above which the painting was originally placed. This is an element Guercino borrowed from **Caravaggio** who used the device in his *Entombment* (1603–1604) for the Vittrici Chapel in the Chiesa Nuova, Rome. In the painting's upper portion, Guercino again showed the saint, now being received into heaven by the Savior while a putto gives her the crown of martyrdom. The painting uses a **Carraccesque** zigzagging composition that leads the viewer's eye from the earthly to the heavenly realm, this movement enhanced by Guercino's loose brushwork. The constant repetition of earth tones and deep blues, typical of Guercino's palette, serves to

visually unify the lower and upper parts of the work. As a product of the **Counter-Reformation**, the painting speaks of the nobility of Christian martyrdom, deemed pointless by Protestants.

***BUTCHER SHOP* (c. 1582; Oxford, Christ Church Picture Gallery).** Painted by **Annibale Carracci**, the *Butcher Shop* belongs to his early career. There already was an established tradition in **Bologna** for these types of **genre** scenes, but these were usually comical renditions by **Mannerist** artists, such as Bartolomeo Passerotti, **Agostino Carracci**'s teacher. Annibale instead rendered the scene with the utmost dignity. It has been suggested that the figures in the painting are the portraits of **Ludovico**, Agostino, and Annibale Carracci and that it speaks of their artistic philosophy. Ludovico, who was the son of a butcher, is the one standing behind the counter, Agostino is to the left weighing meat, and Annibale is the man who slaughters the lamb in the foreground. The contorted, overdressed figure on the extreme left is thought to symbolize the excesses of Mannerism. The Carracci described their style of painting as *da viva carne* or *of living flesh*. The meat hanging in the shop no doubt refers to this premise. By using **Michelangelo**'s *Sacrifice of Noah* on the **Sistine ceiling**, Vatican (1508–1512), as the prototype for the slaughtering of the lamb in the foreground, Annibale could allude to the Carracci as the reformers who rescued the art of painting from the artificiality of Mannerism and restored it to the **classicism** of the Renaissance.

– C –

CAJÉS, EUGENIO (1574–1634). Spanish painter of **Florentine** descent, trained in the **Mannerist** style. His father was Patrizio Cascezi, one of the artists involved in the decoration of the Monastery of San Lorenzo in El **Escorial**. It is from his father that Cajés learned the Italianate mode of painting, though visits to Florence would have given him further understanding of the latest Italian developments. Cajés' early works are collaborations with his father. In 1608, he entered the service of Philip III of Spain, and, in 1612, he became the king's official painter. One of Cajés' most successful works is the

Meeting at the Golden Gate (c. 1604; Madrid, Museo Real Academia de Bellas Artes), originally part of the **altarpiece** of the Church of San Felipe el Real in Madrid.

CALLOT, JACQUES (c. 1592–1635). Leading figure of the school of Nancy on the Lorraine region of France. Callot came from a well-to-do family that was connected to the ducal court of Lorraine. He was apprenticed to a local goldsmith and, in 1608, he went to **Rome** to complete his training with the engraver Philippe Thomassin. In 1611, Callot moved to **Florence** where he worked for Cosimo II de' **Medici**, Grand Duke of Tuscany. For him he created a series of plates recording the funerary ceremonies of Margaret of Austria, wife of Philip III of Spain (d. 1611), and another of the life of Cosimo's father, Ferdinand I de' Medici. In 1621, when Cosimo died, his wife, Maria Magdalena of Austria, cancelled Callot's pension, forcing him to return to Nancy where he became the leading master of the Lorraine region. He spent the rest of his career creating engravings of **grotesque** figures, gypsies, and other such colorful individuals, as well as landscapes and political scenes. An example of his comical representations is his etching *Scaramucia and Fricasso* (c. 1622), which depicts two characters from the commedia dell' arte (Italian theatrical farces) that Callot included in his *Balli di Sfessania* series. Examples of his political images are the scenes from *Les Grandes Misères de la Guerre* (1633) that record the horrors caused by Cardinal **Richelieu**'s invasion of Nancy.

***CAMERA PICTA*, PALAZZO DUCALE, MANTUA (CAMERA DEGLI SPOSI; 1465–1474).** The *Camera Picta*, or Painted Chamber, is the audience room in the Ducal Palace in Mantua **frescoed** by **Andrea Mantegna** for Ludovico **Gonzaga** and his family. The scenes utilize a journalistic approach as they depict contemporary events related to the ducal family. Ludovico is shown receiving a letter that informs him of his son's recent appointment as cardinal. At his side are his wife, Barbara of Brandenburg, their children, courtiers, and dwarfs. The painted space continues the actual architecture of the room, with figures climbing stairs that lead to the real mantle above the fireplace. Also included is the meeting between Ludovico and his son and a hunting scene. On the ceiling, Roman busts of emperors are

painted in a monochrome palette to compare Ludovico's rulership to theirs. In the center is a painted oculus (round opening) that permits a view of the sky. Surrounding it is a balustrade from which putti and servants, rendered in heavy **foreshortening**, peer down at the viewer and smile. The trompe l'oeil effect is enhanced by a large fictive planter that seems about to topple and crash into the viewer's space. Mantegna's technical mastery in these scenes recall **Melozzo da Forlì**'s *di sotto in sù* and other illusionistic devices he used in his works for **Sixtus IV** and his family, the **della Rovere**. It also foreshadows the spectacular illusionistic ceilings of the 17th century.

CAMERINO D'ALABASTRO, PALAZZO DUCALE, FERRARA. The Camerino d'Alabastro was the study of Alfonso I d'**Este**, Duke of Ferrara, a room built in alabaster, hence its appellation. It was conceived in direct competition with the *studiolo* of **Isabella d'Este**, Alfonso's sister. For its decoration, Alfonso commissioned a series of erotic mythologies from the most important masters of the era, including **Giovanni Bellini**, **Raphael**, and **Titian**, based on the *ekphrases* provided by Philostratus the Elder of works he saw in a villa in Naples in the third century. Giovanni Bellini rendered the *Feast of the Gods* (1514; Washington, National Gallery), **Raphael** was assigned the *Triumph of Bacchus*, and Fra Bartolomeo the *Worship of Venus*. Fra Bartolomeo died in 1517 and Raphael in 1520, both leaving their works unexecuted. Alfonso then hired **Titian**, who rendered the *Worship of Venus* (1518; Madrid, Prado), based on Fra Bartolomeo's preparatory drawing, and then also the *Bacchanal of the Andrians* (1518–1523; Madrid, Prado) and *Bacchus and Ariadne* (1520–1522; London, National Gallery). When the d'Este line died out at the end of the 16th century, Ferrara reverted back to the Papal States and the paintings in the Camerino d'Alabastro were removed and dispersed. As a result, debate exists as to the original placement of the works within the room and its significance.

CAMPANILE OF THE CATHEDRAL OF FLORENCE (1334–1350s). The construction history of the Campanile of the **Cathedral of Florence** is rather complex. In 1334, **Giotto** was appointed director of the Cathedral Works. Primarily a painter, he probably had little experience as architect, though some have attributed the design of the

Arena Chapel to him. Giotto's design for the Campanile is recorded in a tinted drawing on parchment now housed in the Museo dell' Opera del Duomo in Siena. It provided for a Gothic-inspired structure with pointed windows, **tracery**, and a large spire. The foundations of the Campanile were laid and the first story completed according to Giotto's specifications. When he died in 1337, **Andrea Pisano** and Francesco Talenti were put in charge. They modified Giotto's design as they found it to be structurally weak, particularly the delicate spire he wanted to cap with a statue of the archangel Michael. In the end, the spire was replaced by a heavier flat top able to withstand high winds. Talenti inlaid the Campanile's exterior with colored marbles to match those of the **Baptistery**, a few steps away from the cathedral. Andrea, who was also a sculptor, provided rhomboid **relief** medallions to adorn the base of the Campanile and statues for its niches.

CAMPIN, ROBERT. *See* MASTER OF FLÉMALLE.

CANTORIA. A choir gallery in a church. Both **Luca della Robbia** and **Donatello** created *cantorie* for the **Cathedral of Florence** (both now in **Florence**, Museo dell' Opera del Duomo). Della Robbia's, executed in 1431–1438, was originally meant for above the door to the cathedral's north sacristy. It contains eight **reliefs** with youths singing, dancing, and playing musical instruments. All of Psalm 150, which speaks of praising the Lord through dance and music, is inscribed in its front. Donatello created his in the 1430s–1440s and it was placed above the entrance to the cathedral's south sacristy. It features putti holding wreaths and running behind columns, as well as a **mosaic** background for a sparkling surface effect. Both artists were inspired by ancient Roman reliefs, and both depicted figures engaged in celebration. Yet, while della Robbia's figures feature sweet expressions, are contained in separate fields, and maintain their decorum, Donatello's are caught in a frenzy, their physiognomies exaggerated and distorted for greater emotive content.

CARAVAGGIO, MICHELANGELO MERISI DA (1571–1610). Caravaggio was probably born in Milan. In 1572, he is documented in the town of Caravaggio where his family owned property, hence

his name. In 1588–1592, he apprenticed with Simone Peterzano, a Milanese painter thought to have been a pupil of **Titian**. After his apprenticeship ended, Caravaggio and his brother went to **Rome** and, on the way there, they stopped in **Venice** where the artist had the opportunity to study the works of Titian, **Giorgione**, **Tintoretto**, and other local masters. When they arrived in Rome, Caravaggio's brother entered a **Jesuit** seminary, and he entered in the service of the Cavaliere D'Arpino, a **Mannerist** painter favored by Pope Clement VIII. There, his main task was to paint still-life elements. Among the works he rendered while in Arpino's studio are his *Boy with Basket of Fruits*, *Bacchino Malato* (both 1594; Rome, Galleria Borghese), and *Boy Bitten by a Lizard* (1595–1596; London, National Gallery). These three paintings were purchased by Cardinal **Scipione Borghese**, Pope **Paul V**'s nephew, from Arpino. They were considered quite innovative at the time in that they presented common figure types placed as close to the foreground as possible, in half-length format, set against an undefined background, with dramatic use of **chiaroscuro**—elements then rare in art. Caravaggio fell seriously ill while in Arpino's studio and was hospitalized for an extended period of time. After leaving the hospital, he began to peddle his paintings in the streets of Rome, the first artist known to do so.

Sometime in the early to mid-1590s, Caravaggio came into contact with Cardinal Francesco Maria del Monte, who offered him lodging in his home. The first painting del Monte purchased from Caravaggio was the *Cardsharps* (1595–1596; Fort Worth, Kimball Museum of Art), also unusual for its theme and visual qualities. Caravaggio's *Bacchus* of 1595–1596 (**Florence**, **Uffizi**) belongs to this period as well, an unclassicized version of the god of wine with cheeks flushed from drinking. In front of him are fruits in various states of ripeness, an element the Dutch **Baroque** masters would later adopt as a *vanitas* symbol. Bacchus is shown with all his imperfections. He is short and stocky, with dark brows and hair, and dirty fingernails. Caravaggio's *Concert of Youths* (1595; New York, Metropolitan Museum), which also falls in this period of his career, shows similar crude figure types engaged in music making.

Among Caravaggio's earliest religious works are his *Rest on the Flight into Egypt* (c. 1594; Rome, Galleria Doria-Pamphili), *Judith Beheading Holofernes* (c. 1598; Rome, Galleria Nazionale d'Arte

Antica), *St. Catherine of Alexandria* (1598; Thyssen-Bornemisza Collection), and *Supper at Emmaus* (1600; London, National Gallery). These works served well the demands of the **Counter-Reformation**. The immediacy of the figures, emphatic gestures, and dramatic lighting effects demand the emotional involvement of the viewer. St. Catherine and Judith are depicted as heroines, the one willing to die for the sake of the faith, the other risking her life to deliver her people from the enemy. The *Supper at Emmaus* portrays a scene of recognition of the true faith, an appropriate subject in an era when the Church sought to prevent the spread of Protestantism. In 1599, Caravaggio received his first public commission, the **Contarelli Chapel** in the Church of San Luigi dei Francesi, Rome, a huge success that gained him international fame. In 1600, the commission for the **Cerasi Chapel** at Santa Maria del Popolo, Rome, followed. By now, the connoisseur Marchese **Vincenzo Giustiniani** had become Caravaggio's most ardent supporter, and it was for him that the artist painted the *Amor Vincit Omnia* (1601–1602; Berlin, Gemäldegalerie), a work that speaks of the power of love over reason and that prompted visual responses from other masters, including **Giovanni Baglione**.

In 1605–1606, Caravaggio painted the *Death of the Virgin* (Paris, Louvre) for the chapel of Laerzio Cherubini at Santa Maria della Scala, Rome. The painting was rejected because it presented the **Virgin** as a decomposing corpse with bare feet and bloated features. Soon after its completion, Caravaggio murdered a man over a wager on a tennis match. In the process, he was badly wounded in the head. After recovering in the Roman countryside, he spent the rest of his years moving from Naples to Malta to Sicily. In Naples, Caravaggio painted the *Seven Acts of Mercy* (1606) for the Church of the Madonna della Misericordia and the *Flagellation of Christ* (1607; Naples, Museo di Capodimonte) for the DeFranchis family. This last shows a more spontaneous brushwork than in his Roman works and a softening of the earlier sharp diagonals. His *Beheading of St. John the Baptist* (1608) he painted in Malta, for the Church of St. John in Valetta. He was forced to flee from Malta after he attacked a nobleman, and moved to Messina, Sicily, where he painted his *Raising of Lazarus* (1609; Messina, Museo Nazionale). Among his last works is the *David with the Head of Goliath* (1610; Rome,

Galleria Borghese), a painting of tremendous psychological depth, perhaps reflective of the mood Caravaggio was in from constantly running from the law.

In 1610, Pope Paul V pardoned Caravaggio for the murder charges in Rome and summoned him back. When Caravaggio landed on the southern border of Tuscany to enter Rome, he was mistakenly seized and imprisoned. As a result, he caught a fever and died a few days later, never reaching his final destination. Caravaggio's art exerted tremendous impact in the history of art. Although his popularity had waned in Italy by the early 1620s, in the rest of Europe his style spread like wildfire. Caravaggism was adopted by **Rembrandt** and the **Utrecht Caravaggists** in the Netherlands, **Peter Paul Rubens** in Flanders, and **George de la Tour** and the **Le Nain brothers** in France, to name only a few.

CARDSHARPS (1595–1596; Fort Worth, Kimball Museum of Art). This was the first painting Cardinal Francesco Maria del Monte purchased from **Caravaggio**. At the time, the subject of the work was quite unusual in that it depicted figures simply engaged in a game. **Sofonisba Anguissola** had painted such scenes, but hers were intended as portraits. The subject soon became quite popular among Caravaggio's followers in Italy and the Netherlands. The work shows three men playing cards, two of them cheating; clearly, gambling is involved. The glances and emphatic gestures leave little doubt as to the men's intentions. They stand around a table where a space has been left open for viewers, thus inviting them to participate in the scene. The three-quarter length of the figures, their proximity to the spectator, sharp contours, theatrical lighting, and rich colorism are all elements Caravaggio learned from **Venetian** masters.

CARDUCHO, VICENTE (1576–1638). Florentine-born **Mannerist** painter who was active, along with his brother Bartolomé, in the court of **Philip II of Spain**; both men were involved in the decoration of the Monastery of San Lorenzo in El **Escorial**. In 1609, Carducho succeeded his brother as royal painter. In that capacity, he was charged with the commission to paint *St. John the Baptist Preaching* (1610; Madrid, Museo Real Academia de Bellas Artes) for the Basilica of **St. Francis** in Madrid. In 1618, he also executed the **altarpiece**

for the Monastery of Guadalupe in Cáceres and, from 1626 to 1632, he painted a series of 56 canvases for the Royal Monastery of Paular near Segovia. In 1623 his position was threatened when **Diego Velázquez** arrived at the court in Madrid. Carducho is best known as an art theorist. His *Diálogos de la Pintura* (1633) did much to raise the status of painters in Spain from craftsman to genius. It championed **Michelangelo** and the **classical** Italian tradition and criticized **Caravaggio** for his excessive naturalism—in reality, an attack on Velázquez, who also stressed naturalism and who overshadowed Carducho at the Spanish court.

CARPACCIO, VITTORE (active c. 1488–1526). Carpaccio may have studied with **Gentile Bellini** in **Venice** and, like Gentile, he catered mainly to the Venetian *scuole* (**confraternities**) and used a journalistic approach. His greatest achievement is the series he created for the meeting hall of the Confraternity of St. Ursula in Venice in c. 1495–1496. The source for these paintings was **Jacobus da Voragine's** *Golden Legend* where St. Ursula, daughter of the king of Brittany and betrothed to the pagan prince of Britain, asks her father for a postponement of the wedding to travel to **Rome** in a pilgrimage and effect her future husband's conversion. Her father agrees and they set out with 10 of her ladies in waiting, each accompanied by 1,000 maidens. On their return from Rome, they are captured by the Huns in Cologne and, when Ursula refuses to marry their king, she and the maidens are martyred. Carpaccio related the story in nine large paintings, now housed in the Galleria dell' Accademia, Venice. He situated the scenes in his own city by including figures in contemporary costumes, canals in the background, and Venetian-styled buildings. In the *Departure of the Prince from Britain, His Arrival in Brittany,* and *Departure of the Betrothed Couple for Rome,* the Venetian naval fleet is rendered on the Grand Canal, and the forts of Rhodes and Candia, at the time two of Venice's fortresses, also appear. Carpaccio's other works include the *Vision of St. Augustine,* part of a series for the Scuola di San Giorgio degli Schiavoni, Venice (1502), the *Meditation on the Passion* (c. 1510; New York, Metropolitan Museum), the *Sermon of St. Stephen* (1514; Paris, Louvre) from the series for the Scuola dei Lanieri a Santo Stefano, and the *Dead Christ* (c. 1520; Berlin, Staatliche Museen). These works are

permeated with a stillness characteristic of Carpaccio's style, a brilliant palette, and emphasis on detailed description.

CARRACCI REFORM. The Carracci Reform is a term used to denote the efforts of **Annibale, Agostino,** and **Ludovico Carracci** to restore painting from what they viewed as the excesses of **Mannerism**. Their art philosophy developed from their dissatisfaction with the state of art in their native **Bologna** and their exposure to the works of **Raphael, Correggio,** and **Titian**. Raphael's *Sistine Madonna* (1513; Dresden Gemäldegalerie) was at the time in nearby Piacenza and Correggio's works were in Parma, also at close distance. Agostino is known to have visited **Venice** in 1582 where he made a number of engravings after the works of Titian and other Venetian masters, and Annibale was there in 1588. From Raphael the Carracci borrowed the elegant **classicism** of the figures and emphasis on draughtsmanship, from Correggio the softening of forms and tenderness of the figures, and from Titian the vibrant colorism and animated compositions. Thus their style became an eclectic blend of borrowed elements that rejected the esoteric ambiguities of the Mannerist style and embraced the more lucid approach offered by the masters they admired.

In 1582, the Carracci opened a private academy in Bologna, first called the Accademia dei Desiderosi and later the Accademia degli Incamminati. Their academy soon began to fill with students from other workshops who wanted to benefit from the more progressive learning environment it offered. It provided a forum where students could exchange ideas, receive anatomy lessons from trained doctors, and participate in competitions. Excursions to the Bolognese countryside to sketch the landscape were part of the curriculum, as were pictorial games meant to sharpen students' drawing skills—exercises that led to Annibale's development of caricature. The establishment of the Carracci Academy coincided with the publication of the Bolognese Archbishop **Gabriele Paleotti**'s *Intorno alle imagini* (1582), which dealt with the proper depiction of religious subjects. Following the prescriptions of the **Council of Trent** on religious art, Paleotti criticized the ambiguities of the Mannerist style and called instead for coherent scenes that evoked piety and devotion in viewers. As the Carracci shared Paleotti's views on Mannerism, these artists became the first to fulfill the archbishop's demands.

In 1595, Annibale went to **Rome** to work for the **Farnese** and there he created his greatest masterpiece, the **Farnese ceiling** (c. 1597–1600; Rome, **Palazzo Farnese**), a work inspired by **Michelangelo's Sistine ceiling frescoes** (1508–1512; Vatican). Members of the Carracci School followed him, worked as his assistants, and dispersed the Carracci **classicist** ideology so effectively that, by the 1620s, it became the most popular style in art. The clarity and striking visual appeal of the scenes on the Farnese ceiling won Annibale the classification of restorer of painting to its former Renaissance glory. Not by coincidence, when he died in 1609, he was buried in the Pantheon alongside Raphael. *See also BUTCHER SHOP.*

CARRACCI, AGOSTINO (1557–1602). The brother of **Annibale** and cousin of **Ludovico Carracci**, with whom he carried out the **Carracci Reform**. Agostino was primarily an engraver, though he also was active as teacher and painter. His career is not well documented. He is known to have been in **Venice** twice, making engravings after the works of **Titian** and **Veronese** with which he introduced the Venetian visual vocabulary to his native **Bologna**. In c. 1598, he joined his brother in **Rome** to work in the **Palazzo Farnese** where he is believed to have been the one to execute the **frescoes** depicting Cephalus and **Aurora** and Galatea. Disagreements with Annibale forced him to leave Rome. He moved to Parma, where he remained until his death in 1602. His most notable work is the ***Last Communion of St. Jerome*** (c. 1592–1593; Bologna, Pinacoteca Nazionale), already greatly admired in his lifetime. One of his most unusual paintings is the *Triple Portrait of Hairy Harry, Mad Peter, and Tiny Amon* (c. 1598–1600; Naples, Museo di Capodimonte), which depicts a dwarf and other odd figures living in Cardinal Odoardo Farnese's court amidst exotic animals.

CARRACCI, ANNIBALE (1560–1609). Annibale Carracci, his brother **Agostino**, and cousin **Ludovico** were responsible for effecting the **Carracci Reform**. Of the three, Annibale was the one to achieve the greatest recognition for having brought art back to the **classicism** of the Renaissance masters, particularly **Raphael**. Early on in his career, Annibale painted **genre** scenes that depicted common figures in all their dignity, among them the *Boy Drinking* (c. 1582–

1583; Cleveland Museum of Art), the *Bean Eater* (1583–1584; **Rome**, Galleria Colonna), and the *Butcher Shop* (c. 1582; Oxford, Christ Church Picture Gallery), this last thought to visually expound the Carracci's art philosophy. In c. 1583, Annibale received his first public commission, the *Crucifixion* for the Church of Santa Maria della Carità, **Bologna**, a clear, sober rendition that conforms to the demands of the **Counter-Reformation** and Archbishop **Gabriele Paleotti** regarding the proper representation of sacred subjects. His *San Ludovico Altarpiece* (c. 1589; Bologna, Pinacoteca Nazionale) he painted for the Church of Santi Ludovico e Alessio and demonstrates the influence of **Correggio** in the softness of the contours and the swaying pose of **St. John the Baptist**. In these years, Annibale also executed some mythologies, including the *Venus, Satyr, and Two Cupids* (c. 1588; **Florence**, **Uffizi**) and *Venus Adorned by the Graces* (1594–1595; Washington, National Gallery). These works show his interest in **Venetian** art as they both feature voluptuous female nudes rendered in lush colors and bathed by light in the manner of **Titian**.

In 1595, Cardinal Odoardo **Farnese** summoned Annibale to Rome to decorate his recently built **palazzo**. In c. 1596, Annibale painted the *Hercules at the Crossroads* (Naples, Museo Nazionale di Capodimonte) to be mounted on the ceiling of the cardinal's study. Then, between c. 1597 and 1600 he **frescoed** the gallery with scenes depicting the loves of the gods utilizing a *quadro riportato* technique. Centered on the **Farnese ceiling** is the *Triumph of Bacchus*, a scene that would later influence **Guido Reni**'s *Aurora* (1613) in the Casino Rospigliosi, Rome, and **Guercino**'s ceiling fresco of the same title (1621) in the Casino **Ludovisi**. In these years, Annibale carried out other commissions for the Farnese, including the *Christ in Glory* (c. 1597; Florence, Palazzo Pitti) and the *Pietà* (1599–1600; Naples, Museo Nazionale di Capodimonte). Annibale's Roman works reflect his study of Raphael's paintings in the **Stanza della Segnatura** (1510–1511) and **Michelangelo**'s **Sistine ceiling** (1508–1512), both at the Vatican. Their clarity, emphasis on soft pastel tones, and rational compositions clearly derive from the works of these Renaissance masters. The semicircular arrangement of the *Christ in Glory* stems directly from Raphael's *Disputà* in the Stanza.

Annibale was also an accomplished landscapist. In fact, he is one of the artists to bring landscape painting to the realm of high art. In

1603, the artist was occupied with painting landscape **lunettes** for Cardinal **Pietro Aldobrandini** in his palace chapel. Of these, the most notable is the *Rest on the Flight into Egypt*, a classicized landscape composed of alternating areas of land and water balanced by the verticality of the trees. By this time, Annibale had become seriously ill and affected with bouts of depression. He died in 1609 and was buried in the Pantheon in Rome alongside Raphael, a fitting tribute for the man who had been hailed as the one to restore painting from the excesses of **Mannerism** and to have brought it back to its former Renaissance glory.

CARRACCI, LUDOVICO (1555–1619). The cousin of **Annibale** and **Agostino Carracci**, with whom he effected the **Carracci Reform**. Ludovico was the son of a **Bolognese** butcher and was trained by the **Mannerist** painter Prospero Fontana. After his apprenticeship, he traveled to **Venice**, Parma, and **Florence** to study the works of **Titian**, **Correggio**, and **Raphael**, all of whom proved to be a major force in the development of the Carracci's philosophy of art—a philosophy that rejected the excesses of Mannerism and favored the **classicism** of the High Renaissance masters. When Annibale and Agostino left Bologna for **Rome** to work for the **Farnese**, it was Ludovico who continued running the Carracci Academy, where he trained the next generation of masters who later would help disseminate the Carracci's artistic ideals. His most notable works include the *Bargellini Madonna* (1588; Bologna, Pinacoteca Nazionale), the *Cento Madonna* (1591; Cento, Museo Civico), the *Martyrdom of St. Peter Thomas* (c. 1608; Bologna, Pinacoteca Nazionale), and *St. Sebastian Thrown into the Cloaca Maxima* (c. 1613; Los Angeles, J. Paul Getty Museum).

CASTAGNO, ANDREA DEL (c. 1419–1457). Andrea del Castagno was born in the Mugello, near **Florence**. Little is known of his life, though **Giorgio Vasari** described him as a violent individual, stating that he murdered his competitor **Domenico Veneziano** out of envy. In the 19th century, Vasari's account was debunked when documentation with the exact date of Castagno's death surfaced—four years before Veneziano's. In 1440, Castagno received the commission to

paint on the façade of the Palazzo del Podestà in Florence, now the Bargello, a **fresco** (destroyed in 1494) depicting members of the **Albizzi** family and their associates hanging upside-down for committing treason. In 1442, he worked in **Venice** on the **vault** of the Chapel of St. Tarasius in the Church of San Zaccaria, his earliest documented work. There he rendered the figures of God the Father, saints, and **Evangelists**, frescoes that contributed to the introduction of the Florentine style to Venice. In c. 1445, Castagno was back in Florence painting his *Crucifixion with Four Saints* for the cloister of Santa Maria degli Angeli (now in the **refectory of Sant' Apollonia**). Here, his interest in the accurate rendering of the human form in movement, learned from **Donatello**, is clearly noted. The solidity and crudeness of the figures, on the other hand, Castagno borrowed from **Masaccio**. In 1447, Castagno created his greatest masterpiece, the frescoes in the refectory of Sant' Apollonia. These works include the *Last Supper*, which demonstrates his mastery at rendering **perspective**, *Crucifixion*, *Entombment*, and *Resurrection*. A year after their completion, Castagno was working on a series of frescoes depicting illustrious men and women in the **loggia** of the Villa Carducci at Legnaia (now Florence, **Uffizi**). The sculptural quality of the figures in the Carducci series, their anatomical details, and assertive stances again recall Donatello's sculptures.

Castagno's *Vision of St. Jerome* (c. 1454–1455), a fresco in the Church of the Santisima Annunziata, Florence, commissioned by Girolamo Corboli, presents the saint as a toothless old man with the crudity of Masaccio's figures. Flanked by Paola and Eustochium, mother and daughter saints, Jerome views the crucified Christ above him, the vision that persuaded him to go into the desert near Antioch to learn Hebrew so he could translate the original text of the Bible into Latin (the Vulgate). God the Father holds up his son as he does in Masaccio's *Holy Trinity* (1427; Florence, **Santa Maria Novella**). Here, however, the figures are so convincingly **foreshortened** as to appear to be floating above the saint. Castagno's depiction of muscles, bone structure, and the other anatomical details of Christ's nude torso are even more convincing than in his earlier crucifixions. Corboli belonged to the Girolamite community of flagellants, which explains the reason why Christ wears a rope around his head, instead of

the usual crown of thorns. Castagno's equestrian portrait *Niccolò da Tolentino* (1456) in the **Cathedral of Florence** was conceived as a companion to **Paolo Uccello**'s *Sir John Hawkwood on Horseback.* Castagno, in fact, intended it as visual criticism of his competitor's work. A more animated horse, with greater emphasis on its musculature, the turn of the head toward the viewer, and its fluttering tail has produced a more imposing rendition of a hero on horseback.

Castagno's figures are by no means beautiful. Their visual impact instead depends on the accuracy of their anatomical details, the convincing response of their muscles and tendons to physical stress, and dynamic motion—the artist's primary interests. With this, Castagno presaged the scientific approach of **Antonio del Pollaiuolo**, **Andrea del Verrocchio**, and **Leonardo da Vinci**, three masters who would engage in human dissections to gain full understanding of the body's structure and its functions.

CASTIGLIONE, BALDASSARE (1478–1529). Italian author and diplomat, best known for his *Il cortegiano* [*The Courtier*], first published in **Venice** in 1528, a work that greatly influenced Renaissance culture. Castiglione was born in Casàtico, near Mantua, where his family served as soldiers and administrators to the Mantuan court. After completing his humanistic education, he entered in the service of **Ludovico "il Moro" Sforza**, ruler of Milan, where he remained until 1499, the year his father died. He returned to Mantua briefly to work for Francesco **Gonzaga**, but soon moved to the court of Guidobaldo da **Montefeltro**, Duke of Urbino. In 1513, Guidobaldo's successor, Francesco Maria **della Rovere** made Castiglione a count and sent him to **Rome** as his ambassador. It is there that he met **Raphael** who in 1516 painted Castiglione's famed portrait (Paris, Louvre). In 1524, Pope **Clement VII** sent Castiglione to Spain to the court of **Charles V**, but when in 1527 Charles' troops **sacked Rome** and imprisoned the pope, the mortified Castiglione's health deteriorated and he died in Toledo two years later. Written in the form of a philosophical discussion, *Il cortegiano* presents a portrayal of the court of Urbino and offers advice on the proper conduct of courtiers. For Renaissance readers, it became the standard manual for aristocratic manners. For the modern reader, it offers a glimpse of Renaissance court life.

CASTOR AND POLLUX SEIZING THE DAUGHTERS OF LEU-CIPPUS **(1618; Munich, Alte Pinakothek).** Mythological scene painted by **Peter Paul Rubens** depicting the twin sons of **Jupiter** and Leda abducting the daughters of Leucippus, whom they later marry. The work utilizes an unusual rhomboidal composition that holds together effectively the two horses, two males, two females, the putto, and the fluttering draperies. The female figure with her bent leg was modeled after **Michelangelo**'s lost *Leda and the Swan,* an appropriate reference to the birth of Castor and Pollux resulting from this union. Some see the painting as an allegory of marriage, as the women are willing participants in an abduction that ultimately results in nuptials. Others see it as a political allegory that speaks of Spain's seizure of Antwerp and Amsterdam to raise them to a higher, more prosperous level.

CATHEDRAL OF FLORENCE. *See* FLORENCE, CATHEDRAL OF (1296–1350s).

CATHEDRAL OF SIENA. *See* SIENA, CATHEDRAL OF.

CATHERINE OF ALEXANDRIA, SAINT. The legend of St. Catherine of Alexandria is believed to have been invented to provide the faithful with an exemplar of Christian moral virtue. According to this legend, Catherine was born in Alexandria to a pagan patrician family related to Emperor Constantine the Great. She converted to Christianity after experiencing a vision, and she denounced Emperor Maxentius, Constantine's rival, for persecuting Christians. Maxentius called the greatest thinkers to Alexandria, where they debated St. Catherine on the existence of God and his incarnation. Not only did she convince them to convert to Christianity, but she also managed to convert Maxentius' wife Faustina, his army commander, and soldiers. Maxentius condemned her to death on a spiked wheel, but an angel delivered her from her martyrdom. Finally, she was beheaded. One of the most spectacular depictions of St. Catherine of Alexandria is by **Caravaggio** (1598; Thyssen-Bornemisza Collection). Here the saint is shown as a heroic figure who leans on the broken wheel and holds the sword of her decapitation. Catherine's life was depicted by **Masolino** in the Castiglione Chapel in the Church of San Clemente,

Rome (c. 1428–1430), in five scenes, including her disputation with the sages. The saint was immensely popular in the Renaissance and **Baroque** eras, as she is supposed to have weakened Maxentius' power, facilitating Constantine's victory and establishment as sole emperor. Since he converted to Christianity, St. Catherine is considered to have played a key role in effecting the triumph of the faith over paganism. *See also* MYSTIC MARRIAGE OF ST. CATHERINE.

CAVALLINI, PIETRO (PIETRO DE' CERRONI; 1240/1250– c. 1330). Italian Proto-Renaissance painter and **mosaicist** from the Roman School. **Lorenzo Ghiberti**, who greatly admired Cavallini, left information on the extensive works rendered by the master that paint a picture of a highly successful career. Among these were cycles in Old **St. Peter's**, **St. Paul** outside the Walls, San Francesco, San Crisogno, and Santi Maria and **Cecilia** in Trastevere in **Rome**. Of these, only the last two have survived. Cardinal Bertoldo Stefaneschi commissioned Cavallini to add a band of mosaics depicting the **Virgin**'s life (c. 1290) below those already in the **apse** of Santa Maria in Trastevere, executed in the previous century. Cavallini's other extant commission came from the French Cardinal **Jean Cholet**, whose titular church was Santa Cecilia. These **frescoes**, now in ruinous state, depict scenes from the Old and New Testaments, including the **Last Judgment** (c. 1290). Scholars have noted that Cavallini's figures bear a striking resemblance to Byzantine works from the **Palaeologan** dynasty. At this time, artistic exchange was common between Byzantium and western Europe, so it is quite possible that Cavallini traveled to Serbia, then part of the Byzantine Empire, to view the Palaeologan frescoes in the Church of the Holy Trinity in Sopočani, built by Italian architects.

CECILIA, SAINT. St. Cecilia is the patron saint of music. She was from a Roman patrician family who raised her as a Christian and married her off to Valerian against her will. On her wedding day she did not participate in the celebrations, instead singing to God in her heart, asking him to keep her body immaculate, which is how **Domenichino** portrayed her (c. 1617; Paris, Louvre). Cecilia converted Valerian to Christianity and convinced him to respect her chastity. Her Christian beliefs led to her persecution. She was sen-

tenced to die by suffocation but, when she was miraculously saved, she was partially beheaded and left to suffer a slow death. **Stefano Maderno** depicted her as a corpse with partially severed head (1600; **Rome**, Santa Cecilia in Trastevere) as she was found when her body was disinterred in 1599. She is also the subject of Domenichino's **frescoes** in the Polet Chapel at San Luigi dei Francesi, Rome (1612–1614), which show scenes from her life with special focus on her charity and heroism.

CELLINI, BENVENUTO (1500–1571). **Florentine** sculptor and goldsmith; among the most important figures of **Mannerist** sculpture. Cellini spent his early years in **Rome**, creating mainly medals and decorative objects. From 1540 to 1545, he worked for King **Francis I** of France for whom he created a gold and enamel salt cellar (1540–1544; Vienna, Kunsthistorisches Museum) adorned with figures of **Neptune**, god of the sea, and Tellus, goddess of the Earth, to denote the two places from which salt and pepper respectively originate. At the king's Palace of Fontainebleau, Cellini created a bronze **relief lunette** above a doorway depicting **Diana**, goddess of the hunt (1542–1544; Paris, Louvre). In 1545, he returned to Florence to work for Duke Cosimo I de' **Medici**, creating for him the *Perseus and Medusa* (1545–1554) to be placed in the **Palazzo Vecchio**'s **Loggia** dei Lanzi alongside **Donatello**'s *Judith and Holofernes* (1459). Cellini considered this pairing when he rendered his work. Both sculptures show the heroes reacting passively to the horror of the event and both feature two figures forming a vertical composition, with the victim resting on a cushion. Other works by Cellini include the bust portraits *Bindo Altoviti* (1549; Boston, Isabella Stewart Gardner Museum) and *Cosimo I de' Medici* (c. 1545–1548; Florence, Museo Nazionale del Bargello) and his *Crucifixion* in El **Escorial** (1556–1562). Cellini was also an author, penning his autobiography in 1558–1562, a work that reveals his egotistic personality, violent tendencies, and tumultuous life.

***CENTO MADONNA* (1591; Cento, Museo Civico). Ludovico Carracci** rendered the *Cento Madonna* for the Capuchin Church of Cento, near **Bologna**. **St. Francis**, who was important to the Capuchins because the statutes of their order depend on that of the

Franciscans, kneels at the foot of the throne occupied by the **Virgin and Child**. He pleads to the Virgin to view favorably the donors of the **altarpiece**, shown on the lower right. On the lower left is another Franciscan, possibly Brother Leo, Francis' faithful companion, while behind the throne two angels discuss the event. **St. Joseph** sits to the right, leaning his elbow on the throne. He is shown below the Virgin and Child to denote his lack of involvement in Christ's conception. **Venetian** influence on this work is clear. The elevated throne of the Virgin, the architectural elements that frame the scene, and the outdoor setting, all stem from Venetian art. Yet the emotive components, the dynamic poses of the Virgin and Child, both of whom lean forward to listen to the St. Francis' plea, and the closeness of the figures to the viewer are particular to Ludovico's style. One of the most admired works by Ludovico, the *Cento Madonna* exerted particular influence on the art of **Guercino**, a native of Cento.

CENTRAL PLAN. An architectural plan that is circular, polygonal, or square. The earliest central plan structure of the Renaissance was **Filippo Brunelleschi**'s Santa Maria degli Angeli in **Florence**, built in 1434–1437 for the Camaldolite Order. Centrally planned buildings are often capped by a **dome**. **Donato Bramante**'s Tempietto in **Rome** (c. 1502–1512) is such an example, inspired by Early Christian *martyria* that mark the spot where saints were martyred. Brunelleschi's **Pazzi Chapel**, Florence (1433–1461), is a square-domed central structure flanked by a rectangle at either side. A central plan can also be shaped like a **Greek cross** with arms of equal length, like Bramante's design for New **St. Peter's** (1506), which became the basis for **Michelangelo**'s final version of the structure (fin. 1564).

CERASI CHAPEL, SANTA MARIA DEL POPOLO, ROME (1600). The success of the **Contarelli Chapel** at San Luigi dei Francesi in **Rome** resulted in further public commissions for **Caravaggio**, including the Cerasi Chapel. Here, Caravaggio had the opportunity to work alongside **Annibale Carracci** who painted the **altarpiece** titled the *Assumption of the Virgin*. The chapel belonged to Monsignor Tiberio Cerasi, treasurer general to Clement VIII. His friend Marchese **Vincenzo Giustiniani**, who purchased Caravaggio's

rejected altarpiece for the Contarelli Chapel, acted as the adviser on the project. Caravaggio painted two scenes: the *Crucifixion of St. Peter* and *Conversion of St. Paul*. A precedent already existed for this juxtaposition—the Pauline Chapel at the Vatican by **Michelangelo** (1542–1550). The *Crucifixion of St. Peter* places the saint in a diagonal toward the altar. He is depicted as a strong, muscular figure to denote the strength of the Christian church he founded. The *Conversion of St. Paul* shows the apparition that caused the saint to embrace Christianity as a dramatic burst of light that corresponds to that entering the chapel in the afternoon hours. Having fallen off his horse, Paul extends his arms in a Hebrew gesture of prayer, while the animal's caretaker remains in the dark and is oblivious of the miraculous event unfolding. As in the *Crucifixion*, St. Paul is placed in a diagonal that directs the viewer's attention to the altar. These two paintings, with their dramatic **chiaroscuro**, theatrical gestures, crude figure types, rich **Venetianized** palette, and dark, undefined backgrounds, provide a major contrast to Annibale's *Assumption*. Annibale's work takes place in a well-defined outdoor setting, populated by a large number of figures, with more subdued chiaroscuro. While Caravaggio depicted nature with all its imperfections and the otherworldly only as light, Annibale had no qualms about showing the **Virgin** on a cloud being raised up to heaven by cherubs. This serves to illustrate the vastly different approaches of the two major figures of the early **Baroque** era.

CERCEAU, JEAN DU (c. 1585–1650). Member of a French family of architects founded by his grandfather, Jacques Androuet du Cerceau. Jean du Cerceau is best known for his design of the Hôtel de Sully in Paris (beg. 1625), built for the financier Mesme Gallet in the vicinity of the new Place Royale (now Place des Vosges), part of **Henry IV**'s urban improvement and then one of the city's most aristocratic neighborhoods. It is called *Sully* after Henry IV's minister Maximilien de Béthune, duc de Sully, who purchased the property in 1634. The structure is a typical French château with a *corps-de-logis* (main body) flanked by wings, faced with heavy ornamentation and textures, and featuring an alternation of **pedimented** windows and niches filled with allegorical sculpted figures.

CHANTELOU, PAUL FRÉART DE (1609–1694). French collector, connoisseur, and writer who served as steward to King Louis XIV of France. Chantelou is important to the history of art in that the king asked him to escort **Gian Lorenzo Bernini** through Paris in 1665 when the artist arrived to finalize the details of the east façade of the Louvre commission. On the occasion, Chantelou kept a diary recording the details of Bernini's visit as well as discussions they had on the master's working methods, commissions, and artistic philosophy. For this, the diary is a pivotal document to the history of **Baroque** art. Also pivotal is a letter **Nicolas Poussin** wrote to Chantelou, one of his patrons, in 1647 comparing the various expressive means he used in one of his works to the ancient Greek musical modes. The remarks Poussin made in this letter became the basis for his Theory of Modes and his *Grande Maniera*.

CHAPEL OF NICHOLAS V, VATICAN (CAPPELLA NICOLINA; 1448). In 1448, Pope **Nicholas V** charged **Fra Angelico** with the commission to render **frescoes** in his private chapel at the Vatican depicting the lives of Sts. **Stephen** and **Lawrence**. Based on the biblical Acts of the **Apostles** and **Jacobus da Voragine**'s *Golden Legend*, respectively, the scenes depict the consecration of each saint as deacon, their distribution of alms to the poor, their judgments, and martyrdoms. Additionally, St. Stephen is shown preaching in the presence of the Doctors of the Church, and St. Lawrence receives the treasures of the Church from Pope Sixtus II, who in the frescoes bears Nicholas V's likeness. The reason for the pairing of these two saints is that St. Stephen's body arrived in **Rome** from Jerusalem in the sixth century, and was then reburied at S. Lorenzo Fuori le Mura alongside St. Lawrence's remains. Nicholas V had the saints' tombs reopened in 1447, and both were found to be well preserved. The frescoes in Nicholas' chapel celebrate this miraculous event.

CHARLES I OF ENGLAND (1600–1649). The son of James I and Anne of Denmark, Charles I became next in line to the British throne in 1612 when his elder brother died. In 1623, negotiations for his marriage to the Infanta Maria of Spain began, but these fell through when the Spaniards demanded that Charles convert to Catholicism. Instead he married Henrietta Maria of France, daughter of **Henry IV**

and **Marie de' Medici**, also a Catholic. He ascended the throne in 1625. Confrontations with Parliament and the Puritans, who opposed his marriage to a Catholic and his religious policies, resulted in civil war, his trial, and execution. Charles was an important patron of the arts. **Orazio Gentileschi** became his court painter in 1625 and rendered the *Allegory of Peace* on the ceiling of the Queen's House in Greenwich (1638–1639), built by **Inigo Jones**. **Peter Paul Rubens** painted for Charles the *Apotheosis of James I* (1629) for Inigo's Banqueting House in Whitehall Palace, in front of which the king was executed in 1649. **Anthony van Dyck** was also in Charles' court and painted *Le Roi à la Chasse* [*Portrait of Charles I*; 1635; Paris Louvre], one of the most remarkable royal portraits in history.

CHARLES V OF SPAIN, HOLY ROMAN EMPEROR (1500–1558). Charles V was the son of Philip the Handsome, Duke of Burgundy, and Juana la Loca of Castile. Born in Ghent, he was brought up in Flanders and, when his father died in 1506, he inherited the duchy of Burgundy, with his aunt, **Margaret of Austria**, serving as regent until 1515 when he reached the majority. In 1517, Charles took the Spanish throne and, in 1519 he became Holy Roman Emperor. In 1521, he invaded Northern Italy, at the time controlled by the French, and then in Germany he convoked the Diet of Worms where he vehemently opposed the doctrines of Martin Luther, vowed to fight heresy, and enacted the edict that outlawed Lutheranism. In 1525, he captured **Francis I** of France in Pavia and forced him to sign the Treaty of Madrid with which Francis renounced his claims to Northern Italy and ceded Burgundy to Charles. As soon as he was released, however, Francis recanted and formed the League of Cognac with Pope **Clement VII**, **Venice**, Milan, and **Florence** against the emperor. Charles retaliated by **sacking Rome** in 1527. In 1554, he ceded Naples and Sicily to his son **Philip II**. In the following year, he also gave him the Netherlands, and in 1556 he made him king of Spain and gave him Milan. In 1558, he abdicated the imperial throne, giving it to his brother Ferdinand I, and retired to the Monastery of Yuste, near Cáceres, Spain, where he lived out the rest of his days. Charles V was the patron of **Titian**, who spent nine months in Germany painting portraits of the emperor and his family, including the famed *Charles V on Horseback* (1548; Madrid, Prado). Charles was

so pleased with Titian that he conferred the knighthood upon him. **Bernard van Orley** and **Pieter Coecke** were also his court painters.

CHARLES V ON HORSEBACK (1548, Madrid, Prado). Titian painted this equestrian portrait of **Charles V** in 1548 when he spent nine months in Germany rendering the likenesses of the emperor and members of his family. The painting commemorates Charles' victory in the Battle of Mühlberg of 1547 against the Schmalkaldic League formed by Protestant princes to defend themselves from the imperial forces. Since antiquity, the ability to ride a horse was equated with the ability to rule and engage successfully in battle. In this portrait, Titian depicted Charles as a heroic and triumphant ruler. He wears his official military garb with a royal sash across his chest, and holds a lance as if ready for combat. The scene is made more poignant by the crepuscular sky in the background, demonstrating Titian's ability to render natural lighting effects. When Charles abdicated the imperial throne in 1558, he retired to Spain, and there the portrait was studied by **Peter Paul Rubens** and **Diego Velázquez**, who used it as their prototype for their portraits of members of the Spanish court.

CHARONTON, ENGUERRAND (ENGUERRAND QUARTON; c. 1420–1466). French painter from Laon who moved to Southern France in 1444 where he was active in Aix-en-Provence, Arles, and **Avignon**. From the **banker** Pierre Cadard, Charonton received the commission to paint the *Virgin of Mercy* (1452; Chantilly, Musée Condé) for the Celestine Convent of Avignon. In the work, executed in collaboration with Pierre Villate of Limoges, members of the clergy and monarchy kneel under the protection of the Virgin's open mantle. Saints **John the Baptist** and **John the Evangelist** recommend Cadard's parents—Jean, the physician to Charles VI's children, and his wife, Jeanne des Moulins—who kneel in prayer at either side. Charonton also painted the *Coronation of the Virgin* (1454; Villeneuve-lès-Avignon, Musée de l'Hospice) for the Church of the Carthusians in Villeneuve-lès-Avignon. Below the main scene is a **crucifixion** flanked by the cities of Jerusalem and **Rome** and angels who carry the souls of the blessed up to heaven, with the donor, the priest Jean de Montagnac, at the foot of the cross. On the lowest portion of the painting are depictions of purgatory and hell. The most

striking aspects of Charonton's work are the aesthetic appeal of the **Virgin**, the use of brilliant colors, the hierarchic placement of the figures, and the clear organization of the complex scene.

CHIAROSCURO. An Italian term that refers to the contrasts of light and dark in a painting. This means that the forms are not defined by contouring lines but rather by the juxtaposition of light and dark areas. **Caravaggio** was one of the masters best known for his bold use of chiaroscuro. He lit his figures from a single, usually hidden, source to create theatrical effects that enhanced the drama of his scenes—his purpose to appeal to the senses or to solicit religious devotion from the faithful. In his *Calling of St. Matthew* (1599–1600) in the **Contarelli Chapel** at San Luigi dei Francesi, **Rome**, for instance, he set his figures against a dark background, lighting only the main protagonists in strategic places to call attention to the significance of the moment when Christ invites the saint to join him.

CHIGI, AGOSTINO (1465–1520). Sienese **banker** who made his fortune through shipping and real estate. Agostino Chigi was also the main financier of the papacy under popes **Alexander VI**, **Julius II**, and **Leo X**, and he held the monopoly of the alum mines of Tolfa. This made him the richest man in **Rome**. Agostino was infamous for his unrestrained behavior. He hosted a banquet in the **loggia** of his **Villa Farnesina**, built for him by Baldassare Peruzzi along the banks of the Tiber River and decorated by Peruzzi, **Raphael**, and Sebastiano del Piombo. Guests were served dinner on silver and gold plates that were tossed by servants into the river as they cleared them from the table. After the astounded guests left the banquet, the servants retrieved the plates that had fallen on strategically placed nets. Agostino, a cultured individual with great interest in humanism and antiquity, was also the patron of **Pietro Aretino**.

***CHIOSTRO VERDE*, SANTA MARIA NOVELLA, FLORENCE (GREEN CLOISTER).** The *Chiostro Verde* owes its name to the **frescoes** painted on its walls by **Paolo Uccello** and assistants in a green monochrome palette with *terra verde* (*green earth*), a pigment with a high iron-oxide content. Begun in 1430, these works depict scenes from the Book of Genesis and were heavily damaged in 1966

when a major flood occurred in **Florence**. The frescoes are arranged in two tiers and cover the patriarchal ages of Noah, Abraham, and Isaac, emphasizing the themes of ancestry and inheritance. From among the scenes, *The Deluge* (c. 1450) stands out as a masterful study in **perspective** and **foreshortening**. Here, Noah's ark is shown from two angles. On the left is a heavy storm with lightning and wind-god included and victims who desperately try to stay afloat. On the right emerges Noah from the ark to see the dove return with the olive branch taken from dry land. The scene unfolds in a space that recedes rapidly in the distance. It conflates the fury of nature with the desperation of humans faced with a horrid ordeal. Uccello's *Sacrifice of Noah and Drunkenness of Noah* (c. 1450) also demonstrate his command of perspective. Here, God the Father is foreshortened so effectively as to appear to be floating above the other figures, and the pergola that supports the vines recedes convincingly into space.

CHOIR. In a church, the choir comprises the **transept**, crossing (where the transept and **nave** cross), and **apse**. In medieval times, the choir was separated from the nave by a rood screen, eventually eliminated to conform to changes in liturgy. The choir is often decorated with **frescoes**. One example is the cycle depicting the lives of Sts. **Stephen** and **John the Baptist** by **Fra Filippo Lippi** in the **Prato Cathedral** (1452–1466). **Benozzo Gozzoli**'s first major commission was to fresco the choir of San Francesco in Montefalco with the life of **St. Francis**, which he completed in 1452, and **Domenico del Ghirlandaio**'s most important fresco cycle is in the choir of **Santa Maria Novella**, **Florence**, depicting the lives of the **Virgin** and St. John the Baptist (1485–1490).

CHOLET, CARDINAL JEAN (c. 1212/1220–1292). Jean Cholet was made cardinal in 1281 by Pope Martin IV. He served as legate in Gerona, Spain, where in 1285 he crowned Charles of Valois, son of Philip III the Bold, king of Aragon, with his own hat after Martin IV had deposed Peter III the Great for his recent conquest of Sicily. Cardinal Cholet commissioned **Arnolfo di Cambio** and **Pietro Cavallini** to embellish Santa Cecilia in Trastevere, **Rome**, his titular church. Arnolfo was charged with creating the baldachin or ceremonial canopy (1293) over the main altar and Cavallini with painting a

series of **frescoes**, including the *Last Judgment* (c. 1290). Cholet had a magnificent collection of manuscripts and bequeathed approximately 2,400 volumes to the Abbey of Saint Lucien, Beauvais, where he is buried.

CHRIST'S ENTRY INTO JERUSALEM. Christ's entry into Jerusalem marked the beginning of the **Passion** and is celebrated yearly by Christians on Palm Sunday. Christ rode through the city gates on a donkey while his followers cut tree branches and laid them on the ground in front of him as they praised him. Examples of the scene in art include **Giotto**'s version in the **Arena Chapel** in Padua (1305), **Duccio**'s in the *Maestà Altarpiece* (1308–1311; Siena, Museo dell' Opera del Duomo), **Pietro Lorenzetti**'s (c. 1320–1330) in the Lower Church of **San Francesco** in Assisi, the **Limbourg brothers'** in *Les Très Riches Heures du duc de Berry* (fol. No. 173v; 1416; Chantilly, Musée Condé), and **Albrecht Dürer**'s woodcut in the London British Museum (1511). *See also* JEAN, DUC DE BERRY.

CHRISTUS, PETRUS (c. 1410–1472/1473). Flemish painter who continued **Jan van Eyck**'s style, which has prompted scholars to suggest that he was van Eyck's pupil. Petrus Christus is first documented in 1444, when he was granted citizenship in Bruges. In 1454, he was commissioned by the Count of Etampes to render three copies of an image of the **Virgin** in Cambrai said to have effected miracles. In 1457, a Piero of Bruges is recorded in the **Sforza** court of Milan, though it is not certain if he is the same Petrus Christus who was active in the North.

Petrus' *Exeter Madonna* (1444; Berlin, Staatliche Museen) and *Nativity* (c. 1445; Washington, National Gallery) are among his earliest extant works. The first borrows elements from van Eyck's *Madonna with the Chancellor Nicolas Rolin* (c. 1433; Paris Louvre) and the second unites Eyckian features, particularly the treatment of the kneeling angels, with **Rogier van der Weyden**'s treatment of architecture. The swooning Virgin and mourners clasping their hands together in Petrus' *Lamentation* (c. 1448; Brussels, Musées Royaux des Beaux-Arts) recall like features in van der Weyden's *Deposition* (c. 1438; Madrid, Prado). His *St. Eligius as a Goldsmith* (1449; New York, Metropolitan Museum) presents the metalsmith in his shop

selling a wedding ring he weighs on a hand-held scale to a young couple. A girdle used for wedding ceremonies rests on the shop counter in the foreground. Also on the counter is a convex mirror that reflects the market square where the shop is located, as well as two male figures who look in—a feature that calls to mind van Eyck's *Arnolfini Wedding Portrait* (1434; London, National Gallery). With the mirror, Petrus, like van Eyck, cleverly united the pictorial space with that occupied by viewers. Petrus was also an accomplished portraitist. His *Portrait of a Carthusian* (c. 1446; New York, Metropolitan Museum) shows the man behind a parapet upon which perches a fly. Some have suggested that the insect is there as reminder of the transience of life, though it could be that Petrus was simply showing his ability to fool the eye.

CHRISTUS TRIUMPHANS. In English, *Christ Triumphant.* A symbolic image, typical of the *Maniera Greca* style, where Christ is shown alive on the cross to denote that he has triumphed over death. The figure is usually depicted with a serene facial expression and opened eyes directed at the viewer. On the **apron**, at either side of Christ, the **Virgin Mary** usually presents her son as the Savior by pointing in his direction and **St. John** brings his right hand to his head in a traditional gesture of grief. One such *Crucifixion* type where the artist who rendered it is known by name is **Berlinghiero Berlinghieri**'s example at the Lucca Pinacoteca, which dates to the early 13th century. The type was replaced by the second half of the 13th century with the *Christus Patiens* [*Suffering Christ*], a change attributed to **Franciscan** influence.

CIMABUE (CENNI DI PEPI; active c. 1272–1302). Considered the leading painter of the **Florentine** School in the 13th century, and the one to have brought the *Maniera Greca* style to its highest refinement. *Cimabue* (*dehorner of oxen*) was a nickname he received as a result of his supposed aggressive disposition. The *Enthroned Madonna and Child* (c. 1280; Florence, **Uffizi**) painted for the Church of Santa Trinità, Florence, is usually attributed to the artist. The **altarpiece** stands out from others of the period in its monumental scale (at the time, the largest altarpiece ever created) and the attempt to construct a three-dimensional space around the figures.

Cimabue is documented in **Rome** in 1272, where he must have seen Early Christian and medieval examples that may have inspired his monumental panel. Two *Crucifixions*, one at San Domenico in Arezzo (c. 1280) and the other at **Santa Croce**, Florence (c. 1287–1288), are also attributed to him. In these examples, the **apron** is filled with decorative patterning, rather than the usual figures or narratives, which places all focus on the crucified Christ. Sometime after 1279, Cimabue went to Assisi to work on the **frescoes** of **San Francesco**, which the church built to mark the burial site of **St. Francis**. In the **apse**, he painted the life of the **Virgin** and in the **transept** two crucifixions, an **Apocalypse**, and episodes from the lives of Sts. **Peter** and **Paul** (attributed to Cimabue's assistants). These frescoes are heavily damaged, mainly due to the oxidation of the white lead paint the artist used. In spite of this, one can still appreciate Cimabue's desire to move toward greater realism and emotional content. In particular, the *Crucifixion* on the left transept shows intense drama, underscored by the windswept draperies of the figures and their poignant gestures.

CIOMPI REVOLT (1378). The Ciompi were day laborers who worked in **Florence** in the wool cloth industry. In 1378, they revolted for not being allowed to form a **guild** and hence were being deprived of political representation. They forced the government to grant them guild status and to enact concessions that improved their living conditions. For a few weeks, Florence experienced a true democracy that granted its fair share to the working class, but the enactments were cancelled when the city's guilds pulled together to bring back the old order. Though the effects of the Ciompi Revolt were short lived, it helped consolidate the oligarchic political system of the **Albizzi** and later the **Medici** in Florence.

CLASSICISM. In art and architecture, classicism is a term used to refer to a style that has affinities to the visual vocabulary of the Greco-Roman era. This style adheres to the Greco-Roman ideal of beauty achieved through harmony of proportions, simplicity of ornamentation, and emotional restraint. The artist of the Renaissance who best exemplifies the adoption of classicism in painting is **Raphael**. In sculpture, it was **Lorenzo Ghiberti** who reintroduced classicism to

the field by studying ancient prototypes, while in architecture, **Filippo Brunelleschi** was the first to reject Gothic forms in favor of an ancient vocabulary and rational principles of construction.

CLEMENT VII (GIULIO DE' MEDICI; r. 1523–1534). Clement VII was the illegitimate son of Giuliano de' **Medici**, who was killed in the **Pazzi Conspiracy**. In 1513, he was appointed archbishop of **Florence** and cardinal by his cousin, Pope **Leo X**, who, in 1517, also made him his vice-chancellor. Having attained the throne in 1523, Clement was faced with the struggle between France and Spain for control over Northern Italy. In 1524, he allied himself with **Francis I** of France, but, when Francis was captured in Pavia in the following year, he had no choice but to seek the protection of **Charles V**. In 1526, in an effort to limit Charles' power, the pope again changed sides, joining the League of Cognac with France, Milan, Florence, and **Venice**. In retaliation, Charles **sacked Rome** (1527) and took Clement prisoner. The pope was released after he agreed to allow Charles to occupy several cities in the Papal States. In 1529, Clement allied himself with Charles against the Protestants in Germany and the Turks, who were then advancing on Vienna. In 1530, he crowned Charles Holy Roman Emperor in exchange for the reinstatement of Medici rule in Florence. Clement was the patron of **Pietro Aretino** and Niccolò Machiavelli. He commissioned from **Michelangelo** the **Laurentian Library** (1524–1534) and **New Sacristy of San Lorenzo** (1519–1534) in Florence, as well as the *Transfiguration* (1517; Rome, Pinacoteca Vaticana) from **Raphael**.

CLERESTORY. The term refers to the row of windows in the upper part of a wall. Clerestories were used by the ancient Romans in their basilicas, baths, and other such structures to bring light into the interior. The Early Christian masters borrowed the Roman basilican plans to build religious structures. As a result, clerestories became a common feature of churches, placed above the **nave** arcade to bring light into the nave. In the medieval era, clerestory windows were often filled with stained glass to enhance the building's sacred character.

CLEVE, JOOS VAN (JOOS VAN DER BEKE; c. 1485–1540/1541). Painter from the city of Cleve in the lower Rhine who was active in

Antwerp after 1511. Van Cleve was elected dean of the **Guild** of Painters in Antwerp in 1515, and again in 1525. He is believed to have trained with Jan Joest with whom he worked on the *Altar of St. Nicholas* in Calcar in 1505–1508. He also collaborated with **Joachim Patinir**, as **Karel van Mander** informs. The *Rest on the Flight into Egypt* (c. 1515–1524; Brussels, Musées Royaux des Beaux-Arts), previously given exclusively to Patinir, is now viewed as a collaboration with van Cleve. Sometime after 1530, van Cleve went to work for **Francis I** of France in whose court he became acquainted with **Leonardo da Vinci**'s style. His portrait of Francis in the John G. Johnson Collection in Philadelphia (after 1530) shows the king as a voluminous figure, modeled through the use of **chiaroscuro**— elements borrowed from Leonardo, combined with the Northern emphasis on the details of the face and hands that lean on a parapet. Van Cleve's *Last Judgment* (c. 1520–1525; New York, Metropolitan Museum) also presents a blend of Northern and Italianate elements. The **Mannerist** crowding of figures and their elongation and contortions demonstrate van Cleve's interest in the latest Italian movements. The brilliant colors, nonclassical nudes, and nonidealized figure of Christ are common features of Northern art. Van Cleve, together with **Jan Gossart**, **Jan van Scorel**, and **Bernard van Orley**, is classified as a Romanist master and credited with introducing to the Low Countries the Italianate mode of painting.

CLOUET, FRANÇOIS (c. 1510–1572). François Clouet succeeded his father **Jean** as court painter in France. He worked in this capacity for kings Henry II, Francis II, and Charles IX. His *Lady in Her Bath* (c. 1550–1570; Washington, National Gallery) is one of two of his signed works and is thought by some to depict Diane de Poitiers, mistress of Henry II. Others identify her as Marie Touchet, the mistress of Charles IX. The half-length idealized nude in the painting is rendered in the Italianate mode, while the rest of the elements in the work are Flemish, including the nursing woman, symbol of domesticity; the maidservant who brings water for the bath, symbol of temperance; the fruits in the foreground a young boy picks, symbol of the transience of youth; and the pearls worn by the central figure, which are there to indicate her chastity. The portrait *Apothecary Pierre Quthe* (1562; Paris, Louvre) is Clouet's other signed work. It presents

the sitter with an opened herbarium, a reference to the garden of medicinal plants he kept. Like the *Lady in Her Bath*, this work depends on Italian and Northern prototypes, specifically the male portraits of **Agnolo Bronzino** and **Anthonis Mor**.

CLOUET, JEAN (c. 1485–1540). Painter active in the French court of **Francis I**. Clouet's biographical details are sketchy. He may have been born in Flanders and arrived in France at an early age. He is documented in 1516 as one of the artists serving the French king. By 1528, he was the court's chief painter. Only a handful of panel works by Clouet survive, mainly portraits and miniatures, though documents reveal that he also rendered some **altarpieces** in Tours, which have not been traced. Among the works attributable to him are *Madame de Canaples* (1525; Edinburgh, National Gallery of Scotland), the *Man Holding Petrarch's Works* (c. 1530; Windsor, Royal Collection), and the portrait *Francis I* (c. 1525; Paris, Louvre), this last sometimes also attributed to his son, **François Clouet**. These works demonstrate that his style owes a debt to the Flemish school, particularly in the emphasis on the facial features and hands, the details of the costumes, and the half-length poses. A group of approximately 130 drawing portraits in charcoal or chalk in the Musée Conde, Chantilly, has also been attributed to Clouet. These record the likenesses of members of the French court and exhibit greater simplicity and realism than his panel portraits.

COECKE VAN AELST, PIETER (1502–1550). Netherlandish painter, trained by **Bernard van Orley**. Coecke traveled to Italy sometime after 1517, when his training ended. By 1527, he was back in the Netherlands where he settled in Antwerp and entered the **Guild** of Painters. In 1533, he is documented in Constantinople unsuccessfully trying to obtain tapestry commissions and, in the following year, he became court painter to Emperor **Charles V**. He may have taken part in the conquest of Tunis by Charles' army in 1535. Coecke was also a sculptor, architect, and designer of stained glass, as well as the author of a book titled *The Manners and Customs of the Turks*, published posthumously by his wife. Coecke's *Last Supper* (1531; Brussels, Musées Royaux des Beaux-Arts) shows his awareness of

Leonardo da Vinci's painting of the same subject in Milan (1497–1498) as he too placed Judas opposite Christ and gave his figures animated movement, the scene unfolding in a **classical** setting. The work was so successful that 41 copies of it remain in various museums around the world.

COFFER. In architecture, a coffer is a sunken panel on a ceiling or **dome** that has both structural and ornamental purposes. Structurally, it lightens the ceiling as less concrete or other materials are needed for its construction. Coffers were a common feature of Roman architecture, as exemplified by those forming the dome of the Pantheon in **Rome**. Renaissance architects revived the use of coffers in the 15th century, among them **Leon Battista Alberti** who coffered the barrel **vault** over the **nave** of **Sant'Andrea, Mantua** (beg. 1470), to direct the viewer's eyes to the altar. Other examples include the entrance vestibule in the **Palazzo Farnese**, Rome (c. 1513–1589), built by **Antonio da Sangallo the Younger**, where the barrel vault is coffered, and the entrance to the **Oratory of St. Philip Neri**, Rome (1637–1656), by **Francesco Borromini**, which is contained in a coffered niche in perspective.

COLLEONI MONUMENT, **CAMPO DEI SANTI GIOVANNI E PAOLO, VENICE (1481–1496).** Executed by **Andrea del Verrocchio**, this monument commemorates Bartolomeo Colleoni, commander of the **Venetian** army who left in his will 100,000 ducats to the Venetian Republic to finance the war against the Turks and to erect his monument on the Piazza San Marco in Venice. The Venetian government complied with his wishes, save for the fact that they erected the statue in the Campo dei Santi Giovanni e Paolo, not the piazza. Loosely based on **Donatello**'s *Equestrian Monument of Gattamelata* in Padua (c. 1445–1453; Piazza del Santo), Colleoni's shows the commander on his horse rendered as a more powerful and energetic figure than Donatello's. Colleoni presses his legs against the stirrups to raise himself higher, pushes his chest forward, and turns his head to the side—elements that have produced a dynamic composition and that grant the subject an aura of heroism. Colleoni's facial features are that of a lion, reflecting Verrocchio's interest in physiognomy, which was to influence his pupil **Leonardo da Vinci**

who shared his interest. The work was not meant as a true portrait of the sitter but rather as a depiction of the ideal army commander.

COLOSSEUM PRINCIPLE. In architecture, the term applies to the stacking of the **classical** architectural orders on the exterior of a building in emulation of the Colosseum in **Rome**. Usually the Doric, the heavier and more masculine of the orders, is used for the lower story to grant the structure a visually solid base. The Ionic order, more feminine and ornate than the Doric, is used for the second story, and the Corinthian, the lightest and most decorative of the three, for the third level. **Leon Battista Alberti** was the first to apply this principle to Renaissance architecture in the Palazzo Rucellai, **Florence** (beg. c. 1453). **Giuliano da Sangallo** applied it to the façade of the Church of Santa Maria delle Carceri (1484–1492) in Prato and **Jacopo Sansovino** to the **Library of St. Mark**, Venice (1537–1580s). When the classical vocabulary of the Italian architects spread to other parts of Europe, in France **Philibert de L'Orme** applied the Colosseum principle to his Château d'Anet (beg. 1550) and **François Mansart** to the Church of Feuillants (1623–1624), both in Paris. In England, **Inigo Jones** used it in the Banqueting House at Whitehall Palace (1619–1622).

COMMENTARII **(c. 1447–1448).** The *Commentarii*, written by **Lorenzo Ghiberti**, is the first Renaissance text to provide the autobiography of an artist and a survey of **Florentine** art. It also offers discussion on the works from antiquity, the Sienese masters of the 14th century, and optics. In it, the author laments the destruction of ancient statuary for fear of idolatry, praises the Byzantine revival of art (which he qualifies as crude), and credits the rise of painting in all its glory to **Giotto**. His discussion continues with Giotto's followers and other masters working in Florence and Siena. It culminates with Ghiberti's account of his own activities, demonstrating his conscious desire to place himself within an artistic tradition. Ghiberti calls himself a student of nature who applies what he observes to his own art and praises his own achievements, particularly his victory in the competition for the **east doors** (1403–1424) of the **Baptistery of Florence**. His text is important in that it provides a wealth of informa-

tion on the artists he discusses and their works, some of which no longer exist. It also enhances today's understanding of Renaissance attitudes, including the celebration of individual achievement and the gauging of good art by how well it emulates the work of the ancients.

CONCERT OF YOUTHS **(1595, New York, Metropolitan Museum).** This is the first commission **Caravaggio** received from Cardinal Francesco Maria del Monte, one of his early patrons. It depicts three young men dressed *all' antica* engaging in music making. Caravaggio's inspiration for this theme came from the works of artists active in **Venice**, such as **Lorenzo Lotto** and Palma Vecchio, who depicted women in contemporary garb engaged in similar activities. Caravaggio transformed these scenes of aristocratic leisure into a mythological rendering, as noted by the presence of the winged Eros (**Cupid**), god of love. The music sheet in the foreground is there to invite the viewer to join the young men in their activity. Musical instruments are a symbol of love and also of harmony. This, coupled with the erotic appearance of the figures, enhances the theme of amorous enticement that permeates the painting.

CONDOTTIERI. Condottieri were mercenary military commanders employed by rulers of Italian city-states from the medieval era until roughly the end of the 15th century. The word *condottieri* derives from the fact that the military contract they signed was called a *condotta*. Among the most prominent condottieri were members of the Lupi family, who served the rulers of Carrara in the 14th century; Micheleto da Cotignola and **Niccolò da Tolentino** who participated in the **Battle of San Romano** on the side of **Florence**, as depicted by **Paolo Uccello** in the painting of the same name (1430s; London, National Gallery; Paris, Louvre, and Florence, **Uffizi**); Erasmo de Narni, called Gattamelata, whose **equestrian monument** by **Donatello** is in the Piazza del Santo in Padua (c. 1445–1453); Bracciolo da Montone who trained Lionello d'**Este** of Ferrara on the military arts; **Federico da Montefeltro**, ruler of Urbino, who supported his city's economy by acting as military commander for hire; and Bartolomeo **Colleoni**, whose monument (1481–1496) by **Andrea del Verrocchio** stands in the Campo dei Santi Giovanni e Paolo in **Venice**.

CONFRATERNITIES. Confraternities (in Italian, *confraternite*) were quasi-religious brotherhoods that existed throughout the towns and cities of Italy. Members came together to perform charitable deeds and also to socialize. Confraternities were responsible for generating much of the art created during the Renaissance. Their meeting halls were often decorated with **frescoes**. They also required **altarpieces**, crosses, and banners to be carried by members during processions. The outside walls of the Confraternity of the Bigallo in **Florence**, for example, was decorated with frescoes that advertised their function: to care for the orphaned children of Florence and to find suitable adoptive mothers for them. The same confraternity commissioned **Bernardo Daddi** to paint the *Bigallo Triptych* (1312–1348; Florence, Museo del Bigallo), a portable work depicting the Enthroned **Virgin** and Child. The Confraternity of the Misericordia in San Sepolcro, who cared for the ill and buried the dead, commissioned **Piero della Francesca** to paint the *Misericordia Altarpiece* in 1445, and the Confraternity of the **Immaculate Conception** commissioned from **Leonardo da Vinci** the *Madonna of the Rocks* (1483–1486; Paris, Louvre) for the Church of San Francesco Grande in Milan. In **Venice**, confraternities were called *scuole*. The Scuola di San Giovanni Evangelista commissioned **Gentile Bellini** to paint the *Procession of the Relic of the True Cross* (1496) and the *Miracle of the Cross at the Bridge of San Lorenzo* (1500), both now in the Galleria dell' Accademia, Venice. **Vittore Carpaccio** was commissioned by the Venetian Confraternity of St. Ursula to paint a series depicting the story of their patron saint and, from 1564 until 1587, **Tintoretto** created a number of religious works for the **Scuola di San Rocco**.

CONTARELLI CHAPEL, SAN LUIGI DEI FRANCESI, ROME (1599–1600, 1602). The Contarelli Chapel was **Caravaggio**'s first public commission. It belonged to the French Cardinal Mattieu Cointrel (in Italian, *Contarelli*) who in 1585 left funds in his will for its decoration. According to **Giovanni Baglione**, Caravaggio received the commission through his patron, Cardinal Francesco Maria del Monte, who was a friend of Virgilio Crescenzi, the executor of Cointrel's will. The two scenes chosen, meant for the chapel's lateral walls, were from the life of **St. Matthew**, Cointrel's namesaint. The first, the *Calling of St. Matthew*, shows Christ pointing to the saint as

if asking him to become one of his disciples—a gesture borrowed from **Michelangelo**'s *Creation of Adam* on the **Sistine ceiling**, **Rome** (1508–1512). Next to him is **St. Peter**, like Christ dressed *all' antica* to stand out against the rest of the protagonists who are garbed in theatrical costumes. St. Matthew, who was a tax collector, counts the money on the table, while a *repoussoir* figure in the foreground directs the viewer into the scene. Only the saint is aware of Christ's presence and the only one touched by the dramatic light that enters the room from a hidden source on the upper right. The eyeglasses of the figure standing by St. Matthew has been read as symbol of the shortsightedness of those who engage in the sin of usury. The second scene is the *Martyrdom of St. Matthew*, which proved to be a major challenge for Caravaggio. The contract stipulated that it take place in the interior of a church and include a large number of figures. X-rays reveal many *pentimenti*, with major changes to the setting and the scale of the figures. The final scene, inspired by **Tintoretto**'s *St. Mark Freeing a Christian Slave* (1548; **Venice**, Galleria dell' Accademia), resulted in a successful rendition of a man who chose to die rather than renounce the faith—a timely subject for the era of the **Counter-Reformation**. The tenebristic lighting Caravaggio used in these two paintings and the strong diagonals included to enhance movement add to the theatricality and emotive quality of the works.

In 1602, Caravaggio was called back to render his *St. Matthew and the Angel* for the altar wall. He painted a first version (destroyed in 1945) showing the saint writing his gospel guided by an angel, his crossed legs the attribute of scholars. The painting was rejected as the saint's perplexed expression in reaction to the angel guiding his hand was read as a sign of feeblemindedness and his exposed limbs were deemed indecorous. The rejected version was purchased by **Vincenzo Giustiniani**, who appreciated Caravaggio's intentions. Caravaggio then created a second version that presented St. Matthew as an ancient philosopher with a halo to denote his divinity and the angel enumerating the words of God rather than guiding the saint's hand. The Contarelli Chapel proved to be a major success and placed Caravaggio among the most sought-after masters of his era.

CONTINUOUS NARRATIVE. A technique used to depict several episodes of a story on one pictorial field. **Masaccio**'s *Tribute Money*

in the **Brancacci Chapel** at Santa Maria del Carmine, **Florence** (c. 1425), for instance, presents in three episodes the arrival of Christ and the **apostles** at Capernaum. **Lorenzo Ghiberti** was able to organize coherently the multiple scenes of the story of Jacob and Esau in his *Gates of Paradise* (1425–1452) for the **Baptistery of Florence** by utilizing this method. **Fra Filippo Lippi** also used a continuous narrative technique in his **frescoes** in the **choir** of **Prato Cathedral** (1452–1466).

CONTRAPPOSTO. The posing of figures in sculpture and painting that imitates the natural human stance. When the human body stands in a relaxed pose, one leg bears its weight (the engaged leg) while the other remains free. In this position, the hips and shoulders form opposing diagonals. *Contrapposto* was developed by Greek sculptors and painters of the **classical** era and constituted a major breakthrough as it allowed for the naturalistic rendering of the human form. It also allowed for the representation of the body in motion. In the 15th century, *contrapposto* was reintroduced into art to recreate the freedom of movement found in Greco-Roman examples. **Donatello** used it first in his *St. Mark* at **Orsanmichele**, **Florence** (1411–1413), and **Masaccio** in his *Tribute Money* in the **Brancacci Chapel** at Santa Maria del Carmine, Florence (c. 1425). The *contrapposto* technique was pushed to its limits in the 16th and 17th centuries when artists, eager to show off their artistic skill, used it to convey human experience and emotions.

COPPO DI MARCOVALDO (c. 1225–1274). Florentine artist who painted in the *Maniera Greca* tradition. Coppo di Marcovaldo fought in the **Guelf** Florentine army during the Monteaperti Battle of 1260. He was captured and taken prisoner by the Sienese and, after his release, he settled permanently in Siena. Scholars attribute the emotional content of his works to his war experiences, though the spread of **Franciscan** doctrines in the 13th century also may have played a part in this. Undeniable is his role as one of the founders of the Sienese School. The Monteaperti Battle was won by the Sienese Ghibellines and to give thanks to the **Virgin** for their victory, they commissioned Coppo to paint the main **altarpiece** for their Church of Santa Maria dei Servi, the *Madonna del Bordone*, a work signed and

dated 1261. Also signed and dated is Coppo's *Crucifixion* in the Cathedral of Pistoia (1274). Two other panels are attributable to him based on their stylistic similarities to the above works. One is the *Crucifixion* in the Pinacoteca in San Giminiano and the other the *Madonna and Child* at San Martino ai Servi in Orvieto. The **mosaics** on the vault of the **Baptistery of Florence** have been attributed by some scholars to Coppo as well, though others believe them to have been executed by **Venetian** masters who were more adept at working in the mosaic medium.

CORNARO CHAPEL, SANTA MARIA DELLA VITTORIA, ROME (1645–1652). The Church of Santa Maria della Vittoria, **Rome**, belongs to the Discalced Carmelites, the order established by **St. Theresa of Avila**. When Cardinal Federigo Cornaro, Patriarch of **Venice**, established his funerary chapel in this church after moving to Rome in 1644, naturally he picked a major event in St. Theresa's life to adorn it. He gave the commission to the sculptor **Gian Lorenzo Bernini**, therefore granting him the opportunity to render one of the great monuments of the **Baroque** era. Above the altar of the chapel is St. Theresa floating among the clouds in the midst of a mystical experience she recounted in her writings. A sublime angel appeared to her and pierced her heart with an arrow, which, as she described, left her all afire and felt like the caress of God on her soul. Fittingly, Bernini's angel is draped in flamelike folds, tilts his head, and tenderly smiles at the saint. Saint Theresa's description of the event is quite sexual, with phrases one would expect in a narrative of a woman's intimate encounter with a lover. For that reason, Bernini depicted her in an orgasmic state. The colored marbles with varying veins, the metal rods descending on the saint from a hidden window to suggest spiritual light, and the heavenly glory painted on the ceiling add to the mystical sense of the event depicted. On the side walls of the chapel, members of the Cornaro family witness and discuss St. Theresa's experience. Bernini was a staunch Catholic, had close relations with the **Jesuits**, and practiced **St. Ignatius of Loyola**'s *Spiritual Exercises*, which urged the faithful to picture each religious event in its setting and to meditate until able to feel the emotions of the characters in the story. Bernini applied these concepts to the *Ecstasy of St.*

Theresa in the Cornaro Chapel. His work heightens the senses and brings the religious narrative to life.

CORONATION OF THE VIRGIN. The Coronation, a theme that enjoyed great popularity in 13th-century Italy, had its origins in French Gothic art. In these scenes, the **Virgin** and Christ are shown enthroned and Christ crowns his mother queen of heaven. That the scene takes place in a divine realm is usually indicated by the blue or gilded background, the inclusion of astral bodies, or the enclosure of the figures in either a *mandorla* or a sphere. The *Coronation* by **Jacopo Torriti** at Santa Maria Maggiore (c. 1294), for instance, shows Christ and the Virgin enclosed in a blue orb dotted with stars, the sun and the moon at their feet. **Fra Filippo Lippi** introduced a new compositional type in his *Coronation of the Virgin* for the main altar of Sant' Ambrogio, **Florence** (1441–1447). Instead of sitting next to Christ, Lippi's Virgin kneels in prayer in front of God the Father who crowns her. In c. 1597, **Annibale Carracci** (New York, Metropolitan Museum) presented the coronation as an act carried out by both God and Christ, with the Holy Dove floating above and musical angels adding a festive mood. This type of rendition also existed in the North, with **Enguerrand Charonton**'s *Coronation of the Virgin* (1454; Villeneuve-lès-Avignon, Musée de l' Hospice) providing an example.

CORREGGIO, ANTONIO ALLEGRI DA (1494–1534). Painter from Parma whose works anticipated the artistic developments of the **Baroque** era. Correggio was deeply influenced by **Leonardo da Vinci**, from whom he adopted the emphasis on earth tones and use of **sfumato** to soften contours. Correggio's works also demonstrate his awareness of **Raphael**'s paintings in **Rome**, which he may have studied through engravings then circulating in Italy and abroad. Correggio was a master of illusionism, as exemplified by his **dome frescoes** in the Church of San Giovanni Evangelista and the Cathedral of Parma. The first painting is titled the *Vision of St. John the Evangelist on Patmos* (1520–1524) and the second the *Assumption of the Virgin* (1526–1530). In both, figural poses recall those rendered by Raphael in the Vatican **Stanze** (1510–1511) and **Villa Farnesina**, Rome (1513–1518). Yet, Correggio's **foreshortening** is so pro-

nounced that the figures seem to be rising to heaven, their undersides clearly discerned. These works were to have an impact on the illusionistic ceilings of the Baroque era, particularly those rendered by **Giovanni Lanfranco** whose *Virgin in Glory* at Sant' Andrea della Valle, Rome, is completely based on Correggio's *Assumption.*

Among Correggio's individual religious paintings are the *Mystic Marriage of St. Catherine* (c. 1520; Paris, Louvre), *Il Giorno* (after 1523; Parma, Galleria Nazionale), *La Notte* (1522; Dresden, Gemäldegalerie), and *Noli me tangere* (c. 1525; Madrid, Prado). These feature soft, sensuous figures linked through gestures to create deeply emotional scenes. Among Correggio's mythologies are his *Danaë* (c. 1531; Rome, Galleria Borghese), *Jupiter and Ganymede*, and *Jupiter and Io* (both early 1530s; Vienna, Kunsthistorisches Museum), all three painted for **Federigo Gonzaga**, Duke of Mantua. These portend the sensuous French Rococo renditions of the 18th century.

CORTONA, PIETRO DA. *See* BERRETINI DA CORTONA, PIETRO.

CORTONA/SACCHI CONTROVERSY (c. 1630). The term refers to a series of theoretical debates that took place in the **Accademia di San Luca**, **Rome**, regarding the proper representation of histories. A group, led by **Andrea Sacchi**, declared that history paintings should be composed according to the **Aristotelian** rules of tragedy, with a minimal number of actors and emphasis on grandeur and clarity. A second group, led by **Pietro da Cortona**, believed instead that histories should follow the precepts of epic poetry, with a multitude of figures, settings, and subplots, all held together by a common theme. Sacchi and Cortona truly practiced what they preached. In comparing the former's *Divine Wisdom* (1629–1633) to the latter's *Glorification of the Reign of Pope Urban VIII* (1633–1639) both **frescoed** ceilings in the Palazzo **Barberini**, Rome, it becomes clear that Sacchi did in fact limit the number of protagonists, rendering them with great precision. Cortona, on the other hand, allowed multiple characters to weave in and out of the fictive architecture, granting the work a spontaneity and vibrancy lacking in Sacchi's work.

COSMATESQUE STYLE. The Cosmatesque Style, popular in the 12th and 13th centuries, takes its name from the Cosmati, a family of craftsmen, sculptors, and architects who created **mosaics** with geometric designs to decorate architectural surfaces. Their work is found in **Rome** in the churches of Santa Maria in Ara Coeli, Santa Saba, San Tommaso in Formis, and Santa Maria Maggiore, to name a few. It can also be seen in the **Sancta Sanctorum** in the Church of St. John Lateran.

COTÁN, JUAN SÁNCHEZ. *See* SÁNCHEZ COTÁN, JUAN.

COUNCIL OF TRENT (1545–1563). The Council of Trent is so called because it opened in the city of Trent (in Italian, *Trento*) in Northern Italy, convoked by Pope **Paul III** to respond to the advance of the Protestant **Reformation** and to enact reforms that would eliminate abuses related to Church administration. This marked the beginning of the **Counter-Reformation.** In responding to the accusations and criticisms of the Protestants, the council succeeded in codifying Catholic dogma, in reaffirming the validity of priesthood and the sacraments, and in reasserting clerical celibacy, the virtues of sainthood, the role of the **Virgin** in the story of salvation, and the efficacy of indulgences and relics. The council's last session is of particular interest to art historians because it was then that enactments were made regarding the depiction of religious subjects. It was decreed that the purpose of art was to instruct the faithful on the subject of redemption, on the intercessory role of the saints and the Virgin, and on the veneration of relics. Religious images were to remind individuals of the gifts bestowed upon them by Christ and God's miracles enacted through the saints, to inspire them to fashion their own life in imitation of these divine figures, and to foster piety.

COUNTER-REFORMATION. A movement set off by the Catholic Church to curtail the spread of Protestantism that was threatening its power. Though the official launching of the Counter-Reformation took place at the **Council of Trent**, convoked in 1545 by Pope **Paul III**, steps had already been taken to fight Protestantism. In 1540, Paul confirmed the **Jesuit Order**, its main purpose to convert the heathen through missionary work. Two years later, he established the Inquisition to extirpate heretics from the Catholic world and the Index of

Forbidden Books to prevent the propagation of dissenting ideas. New dioceses were established in regions where Protestantism was considered a threat and seminaries opened so clerics could be trained to fight hereticism effectively.

The Counter-Reformation affected art as well. A vast number of churches were erected, many following the prescriptions of St. Charles Borromeo, one of the guiding forces of the Council of Trent who, in 1577, wrote a treatise on the building of these structures. **Gabriele Paleotti**, archbishop of **Bologna**, wrote the *Intorno alle imagini* in 1582, a guide on the proper depiction of sacred and profane images, as specified by the Tridentine council. These types of texts served to propagate the guidelines for **Baroque** art: clarity of representation, historical accuracy, emphasis on emotional content to invoke piety, and narratives that assert the validity of Catholic doctrines, particularly those questioned by the Protestants.

CRANACH THE ELDER, LUCAS (1472–1553). One of the leading painters of the Danube School, Lucas Cranach the Elder was born in Kronach, Germany, and trained by his father Hans, who was also an artist. He is known to have been in Vienna in c. 1502 when he painted the portrait *Johannes Cuspinian*, a professor at the local university, and his wife, Anna, both now in the Oskar Reinhart Collection in Winterhur, Delaware. These portraits place the figures in front of **atmospheric** landscapes with contrasts of fully foliated and barren trees that recall the landscape forms of **Albrecht Dürer**. Cranach's *Rest on the Flight into Egypt* (1504; Berlin, Staatliche Museen) also places great emphasis on the landscape details. Soon after completing the work, Cranach moved to Wittenberg where he became court painter to Frederick the Wise, elector of Saxony. Cranach spent the rest of his life working for the electorate not only in his capacity as painter but also as diplomat. In 1509, he traveled to the Netherlands where he is known to have painted a portrait of the young Emperor **Charles V**, now lost. There he was exposed to the Netherlandish and Italianate styles.

Cranach's mature works show a tendency toward a decorative manner, as seen in his portrait *Henry the Pious* (1514; Dresden, Staatliches Kunstsammlungen) and *Judith with the Head of Holofernes* (c. 1530; New York, Metropolitan Museum). In both, the figures are compressed into a dark setting and the emphasis is

on patterning and sharp contrasts of vivid color. His *Judgment of Paris* (1530; Karlsruhe, Staatliche Kunsthalle) presents the goddesses **Venus**, **Minerva**, and **Juno** posing in the nude, their sinuous forms silhouetted against his usual landscape type. For Cranach, proportions were not an issue; instead, his emphasis was on aesthetically pleasing forms.

Among Cranach's mature religious pictures is the *Allegory of Redemption* (1553–1555; Weimar, Stadtkirche), painted after he moved to Augsburg in 1550. The work, completed by his son, Lucas Cranach the Younger, includes Martin Luther standing at the foot of the **Crucifixion** next to Cranach himself and **St. John the Baptist**. Luther points to the biblical passage that speaks of the blood of Christ as redeeming agent. From Christ's side wound ensues his blood and falls on Cranach, an indication that clerical intercession is not imperative to the attainment of salvation and that the blood of Christ is sufficient to effect redemption—one of the declarations made by Luther who repudiated the authority of priests and the pope. Cranach died in Augsburg, after a long and highly successful career.

CRUCIFIXION. The Crucifixion is the central symbol of Christianity. The earliest visual examples date to the fourth century and consist of only an empty cross. Depictions of the crucified Christ first appeared in the fifth century, though signs of his physical suffering were not included in these portrayals. Instead, he was shown as a *Christus Triumphans* gazing directly at the viewer. This type of representation was common in the early years of the Proto-Renaissance era, usually rendered in the *Maniera Greca* style. Crucifixions from this period featured an **apron** below the arms where the **Virgin Mary** and **St. John** were usually included, as exemplified by **Berlinghiero Berlinghieri**'s *Crucifixion* (Lucca, Pinacoteca) of the early 13th century. By the second half of the 13th century, in response to **Franciscan** influence, the *Christus Triumphans* type was replaced by the *Christus Patiens [Suffering Christ]*, with **Coppo di Marcovaldo**'s *Crucifixion* in the Pinacoteca at San Giminiano providing an example. In c. 1280, **Cimabue** painted a *Crucifixion* in the left transept of **San Francesco** in Assisi as a melodramatic, windswept image of pain and suffering. In the 1370s, **Altichiero** rendered his version at San Antonio in Padua that included incidental scenes behind the cru-

cified Christ, such as Roman soldiers gambling. For **Andrea del Castagno**, the *Crucifixion* (c. 1445; **Florence**, Santa Maria degli Angeli) provided an opportunity to render the anatomy of the seminude figure of Christ accurately, while **Pietro Perugino** (1481; Washington, National Gallery) preferred to evoke meditation from viewers on Christ's suffering. **Tintoretto**'s version in the **Scuola di San Rocco, Venice** (1564), is one of the most spectacular crucifixions ever rendered. The cross of one of the thieves crucified alongside Christ is in the process of being raised. The scene is noisy and full of action, bringing to life the narrative of the Gospels in a way that had not been done previously. In the 17th century in Seville, Spain, debates on whether Christ was crucified with three nails or four made their way into the devotional art produced there at the time. Both **Francisco de Zurbarán** (*Crucified Christ*, 1627; Chicago, Art Institute) and **Juan Martinez Montañéz** (*Christ of Clemency*, 1603–1606; Cathedral of Seville) opted for four nails instead of the customary three to augment the sense of Christ's suffering.

CRUZ, JUAN PANTOJA DE LA (c. 1553–1608). Spanish painter who studied under **Alonso Sánchez Coello**, whom he succeeded as court painter to **Philip II** of Spain. One of Pantoja's portraits of the monarch is housed in the Monastery of San Lorenzo in El **Escorial** (1570s) and presents him as an aloof full-length figure standing in front of a **classicized** column in the manner of Coello. Pantoja's portrait of the king's son, Philip III (1608; Castres, Musée Goya), whom he also served, shows the heir to the throne garbed in the mantle and habit of the Order of the Golden Fleece to which he belonged. Again, a full-length figure, he stands against a dark background, his costume and aloofness the symbols of his royalty. This type of portraiture became one of the standards for the depiction of members of the Spanish court.

CUPID. The son of **Venus** and **Mercury**, Cupid is the god of love who causes those he pierces with his arrows to fall in love. He appears in **Parmigianino**'s *Cupid Carving His Bow* (1535; Vienna, Kunsthistorisches Museum) and in **Caravaggio**'s *Amor Vincit Omnia* (1601–1602; Berlin, Gemäldegalerie) surrounded by various objects related to learning that denote the power of love over reason. Sometimes

Cupid is chastised for causing amorous indiscretions, including his own mother's illicit affair with **Mars**, the scene rendered by **Bartolomeo Manfredi** in his *Cupid Punished by Mars* (1605–1610; Chicago, Art Institute). In *Cupid Complaining to Venus* (c. 1529; London, National Gallery) by **Lucas Cranach the Elder**, the god of love is surrounded by a swarm of bees and he informs his mother that he has been stung. The scene, which some interpret as warning against the deadly risks of venereal disease then spreading through Europe, stems from the writings of Theocritus, who likens the wounds Cupid inflicts with his arrows to bee stings. Cupid himself succumbs to love when he meets Psyche, their marriage banquet **frescoed** by **Raphael** and assistants in the **Villa Farnesina**, **Rome** (1513–1518).

CUPID CARVING HIS BOW (1535; Vienna, Kunsthistorisches Museum). Painted by **Parmigianino**, the work is categorized as homoerotic for the sensual rendition of **Cupid** as a fleshy young nude boy. The god of love has steadied himself for the task of carving by resting his left foot on some books, his disheveled hair curled, betraying the effort he is exerting. The books are there to denote that love conquers all, even reason—a symbolic element made more poignant by Cupid's turn of the head toward the viewer and cautionary glance. Between Cupid's legs are two struggling putti. One forcefully grabs the other's right hand and moves it toward Cupid's right leg as he smiles at the viewer. The other putto resists as he is reluctant to fall in love and lose his ability to reason. This theme would become quite popular in the **Baroque** era, especially among the **Caravaggists**. *See also AMOR VINCIT OMNIA.*

– D –

DADDI, BERNARDO (active c. 1312–1348). An apprentice of **Giotto**, Daddi became the leading artist of **Florence** in 1337 when his master died. Though Daddi was deeply influenced by Giotto's naturalism, his images are more graceful and capture more effectively the tenderness and intimacy of human relationships. Daddi specialized in small panels and portable **altarpieces** meant for private devotion. Among these are his *Bigallo Triptych* (1312–1348) in the

Museo del Bigallo, Florence; the *Virgin and Child Enthroned* (1338) in the Courtauld Institute, London; and the *Virgin and Child with Saints and Angels* (1334) at the **Uffizi**, Florence. The **frescoes** in the Pulci Chapel at **Santa Croce**, Florence (c. 1330), which depict scenes from the lives of Sts. **Lawrence** and **Stephen**, have been attributed to Daddi and his workshop.

DALMAU, LUIS (active 1428–1461). Painter responsible for introducing the Hispano-Flemish style to Spain. Dalmau became acquainted with the art of Flanders, especially **Jan van Eyck**'s, in 1431 when King Alfonso of Aragon sent him there to learn the Flemish tapestry technique so a similar industry could be instituted in Valencia. He remained in Flanders until 1436, when he returned to Barcelona. His *Virgin of the Councilors* (1445; Barcelona, Museo de Arte de Cataluña), painted for the local Town Hall Chapel, is the work with which he inaugurated the Hispano-Flemish mode. It borrows the symmetrical arrangement, postures of the figures, and Gothicized interior from van Eyck's *Madonna of Canon George van der Paele* (1434–1436; Bruges, Groeningemuseum) and *Ghent Altarpiece* (c. 1425–1432; Ghent, Cathedral of St.-Bavon). The *Virgin of the Councilors* is Dalmau's only work attributable with certainty to him.

DANAË. The daughter of Acrisius, king of Argos, Danaë was confined by her father to prevent her from conceiving the child an oracle predicted would kill him. **Jupiter**, who lusted after Danaë, appeared to her in the form of a shower of gold. From their union Perseus was born who accidentally killed Acrisius during a javelin-throwing contest. The scene was fairly common in the Renaissance as it provided artists with the opportunity to depict the female nude form. Both **Correggio** (c. 1531; **Rome**, Galleria **Borghese**) and **Titian** (1554; Vienna, Kunsthistorisches Museum) depicted Danaë as a reclining nude figure. **Jan Gossart** (1527; Munich, Alte Pinakothek) instead rendered her seminude and seated, fascinated by the speckles of gold that fall from above.

DANTE ALIGHIERI (1265–1321). Italian poet who authored the *Divine Comedy* (1307–1321). The son of a **Guelf** notary from **Florence**, Dante fought in 1289 in the Battle of Campaldino, which led to the

defeat of the Ghibellines. In 1295, he became a member of the **Guild of Physicians and Apothecaries**, a membership needed to fulfill his posts as diplomat and magistrate. By 1300 the Guelfs divided into two rivaling factions, the Bianchi and Neri, and when the Neri seized power in Florence in 1302, the Bianchi, among them Dante, were exiled from the city. Dante traveled through Italy, and perhaps also Paris and England. He died in Ravenna in 1321.

Dante's *Divine Comedy* describes his journey through hell (*Inferno*), purgatory (*Purgatorio*), and paradise (*Paradiso*), guided first by the Roman poet **Virgil** and then his beloved Beatrice. Written in the vernacular, Dante inaugurated a new literary genre and made the Tuscan dialect he used the standard Italian language. Until the 16th century, Dante's influence on art and culture was clearly felt. The depiction of hell in the **Strozzi Chapel** at **Santa Maria Novella**, Florence (1355–1357), by Nardo del Cione is based on Dante's *Inferno* and, in **Michelangelo**'s *Last Judgment* in the **Sistine Chapel**, Vatican (1536–1541), Charon, one of Dante's characters in the same text, mans the boat that takes the souls to the underworld. Other artists celebrated Dante by including his portrait in **fresco** cycles. In the Villa Carducci at Legnaia (1448), **Andrea del Castagno** placed him among the illustrious men and women he rendered. In the **Stanza della Segnatura** (1510–1511), **Raphael** placed Dante in Parnassus alongside **Petrarch**, **Giovanni Boccaccio**, and the Ferrarese poet Ludovico Ariosto.

DAVID (c. 1446–1460; Florence, Museo Nazionale del Bargello). Rendered by **Donatello**, this is the first freestanding nude figure to have been created since antiquity. David is shown as the shepherd boy who volunteered to deliver the Israelites from the Philistines by killing their leader, the giant Goliath. In his left hand he holds the stone he delivered with a sling to knock the man down and in his right is the sword he used to sever his head. The figure stands in an exaggerated *contrapposto* that gives him a marked sway, his left foot resting on the giant's severed head and his left arm akimbo. His hat, identified as that worn by shepherds, and military sandals, coupled by his soft, rather effeminate body, grant an erotic quality to the work. The wreath around the base of the statue symbolizes victory. The details of this commission are unclear, yet the sculpture was seen in the courtyard of the **Palazzo Medici** in 1469 during a wedding celebra-

tion, which would suggest that Donatello created the work for the Medici. Some art historians in fact believe that the statue may have once served as a fountain in the middle of their courtyard. In **Florence**, David became a symbol of the strength of the small city-state forced to face its more powerful enemies and was, therefore, the subject of a number of Renaissance sculptures and paintings.

DAVID **(1501–1504; Florence, Accademia). Michelangelo** received the commission to create a statue of David for one of the buttresses of the **Cathedral of Florence** below the **dome**. Since the work was intended to be viewed from below and at a distance, he rendered a colossal figure. When completed, it was so well received that the **Florentines** felt it should be given a more honorable placement. A group of artists, including **Sandro Botticelli**, **Filippino Lippi**, and **Leonardo da Vinci**, were appointed to decide where the statue should go. They chose the piazza in front of the **Palazzo Vecchio**, the Florentine seat of government, to stand as symbol of the new republic formed after the **Medici**'s recent expulsion from the city (1494). In 1527, Medici supporters threw a bench at the statue, shattering one arm and a hand. **Giorgio Vasari** and Francesco Salviati, then teenagers, recovered the broken pieces so it could be restored.

David was a favorite subject in Florence since his triumph against the giant Goliath could be translated to the city's triumph over its more powerful enemies. Yet, earlier renditions, namely by **Donatello** (c. 1446–1460) and **Andrea del Verrocchio** (1470s; both Florence, Museo Nazionale del Bargello), depicted the figure as a young shepherd boy. Michelangelo's instead is an adult rendered in the Greco-Roman tradition, his nudity a symbol of his heroism. While the earlier works stressed David's victory, Michelangelo instead rendered the moment before the confrontation with the giant, capturing the figure's sense of anticipation. With sling over his shoulder and stone in his right hand, David tenses his muscles, furrows his brow, and gazes intensely at his target. The inspiration was Donatello's *St. George* at **Orsanmichele**, Florence (1415–1417), who also readies for confrontation. Michelangelo's rendition would influence **Gian Lorenzo Bernini**, whose *David* in the Palazzo **Borghese**, **Rome** (1623–1624), takes the idea one step further by showing the figure pulling the sling to hit his target.

DAVID WITH THE HEAD OF GOLIATH (1610; Rome, Galleria Borghese). This is one of **Caravaggio's** last works. The head of Goliath is a self-portrait, and some have suggested that the young David portrays the artist as well, but in his youth. It is an unusual depiction of the subject in that it lacks the heroic qualities of the *David* figures by **Donatello** (c. 1446–1460), **Andrea del Verrocchio** (1470s; both **Florence**, Museo Nazionale del Bargello), or **Michelangelo** (1501–1504; Florence, Accademia). Instead, the shepherd boy is here shown with a pensive, sad expression that may reflect the artist's mood from repeatedly running from the law. The figures are set against a dark background and pushed to the foreground so as to emphasize the horror of the event. The viewer is repulsed by the bleeding head of Goliath and at the same time awestruck by the scene's psychological depth.

DAVID, GERARD (c. 1460–1523). Painter from Oudewater, Holland, the son of Jan David, also an artist who was probably responsible for Gerard's training. In 1484, David became a member of the painter's **guild** in Bruges and, when **Hans Memlinc** died in 1494, he took his place as the city's leading master. In 1501, David was elected dean of the guild, having already served in its council for several years. His *Christ Nailed to the Cross* (c. 1480–1404; London, National Gallery) exemplifies his early style, characterized by the use of strong colors, motionless figures, and little emotional content. Once David arrived in Bruges and was exposed to Memlinc's art, his style changed drastically. His figures became softer and more naturalistic, and his modeling of forms and rendering of space became more rational. His *Judgment of Cambyses* (1498; Bruges, Groeningemuseum) demonstrates these changes. Here, space is established through the use of the tiles on the floor, the diagonal placement of the figures, and a gradual recession culminating in various adjoining spaces. The story, taken from the writings of Herodotus, shows the arrest, judgment, and flaying of the unfair judge Sisamnes—a fitting subject for a work commissioned for the council room of Bruges' Town Hall.

After the *Judgment of Cambyses*, David's art again underwent a transformation. He shed the excessive overcrowding of his earlier works and gave his figures a certain gentility. His *Marriage at Cana* (c. 1503; Paris, Louvre) and *Mystic Marriage of St. Catherine* (1505;

London, National Gallery), this last painted for Virsch van Capelle, the cantor of St. Donatian in Bruges, feature this softening and delicacy in the appearance of the individuals depicted. David's most important work is the ***Altarpiece of the Baptism of Christ*** (c. 1502–1507; Bruges, Groeningemuseum), a **triptych** with the donors Jan de Trompes of Ostende, his wife Elizabeth van der Meersch, and their children witnessing the event at either side. David was the last of the great masters from Bruges; after his death, the city lost its artistic preeminence to Antwerp.

DE RE AEDIFICATORIA **(c. 1443).** A treatise written by **Leon Battista Alberti** in which he expounded his architectural theories. In this, he was inspired by the first-century engineer **Vitruvius** who provided the only text on architecture to have survived from antiquity. *De re aedificatoria*, like Vitruvius' treatise, comprises 10 books and the headings in both are almost completely alike. In his text, Alberti provided the first proper modern account of the **classical** orders and advocated the use of a fixed module or its fraction as the basis for devising a building. He equated the harmony of a structure to musical harmony, achieved through the use of numerical proportions as they relate to the intervals of music. Alberti's intellectualization of architecture elevated the field to the scientific and humanistic realms.

DEATH OF THE VIRGIN **(1605–1606; Paris, Louvre).** The *Death of the Virgin* was **Caravaggio**'s last **altarpiece** before he fled from **Rome** after killing a man over a tennis wager. It was commissioned by the papal lawyer Laerzio Cherubini for his chapel in the Church of Santa Maria della Scala. According to Christian doctrine, the Virgin Mary did not die. Rather, she fell into a deep sleep and was taken up to heaven to reign as queen alongside her son (the **Dormition**). Caravaggio, however, presented the scene as an actual death, the Virgin a bloated, decomposing corpse modeled after the body of a prostitute fished out of the Tiber River. She is surrounded by the **apostles**, who mourn her loss. They are barefoot since the church for which the altarpiece was commissioned belonged to the Discalced (barefoot) Carmelites. **St. Mary Magdalen**, who was not present at the Dormition, is included as a mourning figure in the foreground. She is there to refer to one of the charitable works the Discalced Carmelites of

Santa Maria della Scala performed—the taking in and reforming of prostitutes. The *Death of the Virgin* was rejected by the fathers of Santa Maria because they felt that the depiction of the Virgin in rigor mortis lacked decorum. Nevertheless, the painting was exhibited for a week and the people of Rome stood in line for hours to see it. At the time, **Rubens** was in the papal city and, after viewing the painting, he immediately advised his patron, the Duke of Mantua, to purchase it, which the duke did.

DE LA CRUZ, JUAN PANTOJA. *See* CRUZ, JUAN PANTOJA DE LA.

DELLA ROVERE FAMILY. Originally from Liguria, the della Rovere achieved prominence when Cardinal Francesco della Rovere was elected to the papal throne in 1471 as **Sixtus IV**. Their social position and wealth were sealed when in 1503 Sixtus' nephew, Cardinal Giuliano della Rovere, was elected Pope **Julius II**. Sixtus had invested his nephew Giovanni with the lordship of Senigallia and this new title made possible Giovanni's marriage to Giovanna di **Montefeltro**, the daughter of the Duke of Urbino. As a result, the della Rovere became the rulers of Urbino in 1508 when the Montefeltro line died out. The della Rovere name is closely tied to some of the most important masters of the Renaissance, including **Melozzo da Forli**, who worked for Sixtus; **Raphael**, **Michelangelo**, and **Donato Bramante**, who were employed by Julius II; **Titian**, who served Duke Guidobaldo della Rovere; and **Federico Barocci**, whose protector was Duke Guidobaldo II. *See also* URBAN VIII.

DELUGE. The theme of the deluge comes from the biblical story of Noah. God, who wanted to purge the world of evil and corruption, commanded Noah, the only righteous individual on Earth, to build an ark based on certain specifications so that he and his family could be saved from the flood. Noah was instructed to take a male and female from each animal species and bring them onto the ark so they could be saved as well. After the flood ended and the waters receded, Noah, his family, and the animals left the ark and repopulated the Earth. The deluge is a fairly common subject in art, with **Paolo Uccello**'s version in the *Chiostro Verde* (c. 1450; **Florence, Santa Maria Novella**) and **Michelangelo**'s on the **Sistine ceiling, Rome** (1508–1512) providing

some of the most exceptional Renaissance examples. **Hieronymus Bosch** painted *Noah's Ark on Mount Ararat* (1500–1504; Rotterdam, Museum Boymans-van Beuningen), where the ark came to rest after the flood ended, the drowned corpses strewn about.

DEPOSITION. *See* DESCENT FROM THE CROSS.

DESCENT FROM THE CROSS. Pontius Pilate granted permission to Joseph of Arimathea and Nicodemus to remove Christ's body from the cross for burial. The Descent from the Cross shows the moment when this task is carried out by the two men. One of the most remarkable examples of this theme is **Rogier van der Weyden**'s **altarpiece** of c. 1438 in the Madrid Prado. It shows the **Virgin Mary** swooning at the foot of the cross, her body echoing that of Christ to denote that his suffering is also hers. The anguish of the others present is clearly denoted in their facial expressions and postures, and particularly their eyes, red and swollen from crying. **Gerard David**'s version of c. 1510–1515 at the New York Frick Collection is no less dramatic. Here, the Virgin takes Christ's limp hand and presses it against her face, while **Mary Magdalen** wipes her tears with the back of her right hand. **Jacopo da Pontormo**'s rendition for the Church of Santa Felicità, **Florence** (1525–1528), is a **Mannerist** version of the event. The figures are still in extreme anguish, yet the cross was omitted from the scene. The circular composition with a void in the center, the harsh combination of colors and lighting, and contorted poses of the figures add to the turbulence of the event, and place this work among the great examples of Mannerist art. **Rembrandt** painted his *Descent from the Cross* in c. 1633 (St. Petersburg, Hermitage Museum) with the theatrical lighting effects and emotive components that characterize the **Baroque** style.

DESIDERIO DA SETTIGNANO (c. 1430–1464). Italian sculptor from the town of Settignano, a small village near **Florence**. The dependence of Desiderio's **reliefs** on techniques introduced by **Donatello** suggest that he may have trained with the sculptor. In fact, his *Virgin and Child* (c. 1460) in the Philadelphia Museum is rendered in *relievo schiacciato*, a Donatello invention. Desiderio's overall style, however, differs from Donatello's in that his figures are more refined and possess a certain sweetness. Owing to this, his approach

is usually described as the **Sweet Style**, which came to dominate the art of the mid-14th century. In 1453, Desiderio was commissioned to create a tomb for the Florentine Chancellor Carlo Marsuppini in the Church of **Santa Croce**, Florence. Conceived as a pendant to **Bernardo Rossellino**'s tomb of Chancellor Leonardo Bruni, Desiderio included the same elements as Rossellino: the **effigy** lying on a **bier** above the sarcophagus, angels supporting a laudatory inscription, **classical** pilasters, and **lunette** with an image of the Virgin and Child. Desiderio is best known for his depictions of children. His *Head of a Child* in the Washington National Gallery (c. 1460) was inspired by ancient Roman portrait busts, as was his *Laughing Boy* (1453–1463) in the Kunsthistorisches Museum in Vienna. Figures laughing or smiling are in fact characteristic of Desiderio's art. These works exemplify the master's ability to manipulate marble to achieve the proper light and dark effects.

DEUTSCH, NIKLAUS MANUEL (1484–1530). Swiss painter, engraver, and stained-glass designer from Bern who also had a career as statesman, mercenary, and poet. Deutsch's profession as artist only spans a decade (1514–1524), and his style is closely linked to that of **Hans Baldung Grien** in that, like Grien, he depicted macabre scenes, as included in the *Temptation of St. Anthony* (1520; Bern, Berner Kunstmuseum), a work filled with **grotesque** demonic creatures. His *Judgment of Paris* (1524; Basel, Kunstmuseum) presented an opportunity to render the female nude, which in Deutsch's case is distinctly Northern in its oversimplification of anatomical details and rounded abdominal area. The emphasis on decorative patterning and linearity are also elements common to his art.

DI SOTTO IN SÙ. A ceiling painting technique whereby figures are heavily **foreshortened** to appear to be floating above the viewer. **Andrea Mantegna** used the technique on the ceiling of the *Camera Picta* in the Ducal Palace in Mantua (1465–1474), and **Melozzo da Forli** introduced the method to **Rome** in his **apse frescoes** in the Church of Santi Apostoli (1481–1483; fragments now in Rome, Vatican Pinacoteca and Palazzo Quirinale). In **Venice** artists learned to exploit the technique to achieve greater veracity. **Paolo Veronese** showed the underside of the parading horses in the *Triumph of*

Mordecai (1556; Venice, San Sebastiano), paving the way for the illusionistic ceilings of the **Baroque** era, including **Giovanni Lanfranco**'s *Virgin in Glory* (1625–1627; Rome, Sant' Andrea della Valle) and **Pietro da Cortona**'s *Glorification of the Reign of Pope Urban VIII* (1633–1639; Rome, Palazzo **Barberini**). *See also* ONE-POINT LINEAR PERSPECTIVE.

DIANA. Goddess of the hunt, the daughter of **Jupiter** and Latona, and twin sister of **Apollo**. Diana's main trait is that she values her chastity. The crescent moon she wears on her head is one of her attributes, as are the **nymphs** and hunting dogs that accompany her. Among artworks that depict the goddess are **Francesco Albani**'s *Triumph of Diana* (c. 1618; **Rome**, Galleria **Borghese**), which refers to the triumph of chastity; **Domenichino**'s *Diana and the Hunt* (1617; Rome, Galleria Borghese), based on an episode in **Virgil**'s *Aeneid*; and **Benvenuto Cellini**'s *Diana* **lunette relief**, a sensuous nude meant as part of the décor in the Palace of Fontainebleau and now at the Louvre in Paris. **Titian** painted *Diana and Actaeon* (1559; Edinburgh, National Gallery of Scotland), the myth in which the hunter accidentally surprised the goddess at her bath. In retaliation, she transformed him into a stag to be mauled by his own dogs.

DOBSON, WILLIAM (c. 1610–1646). English artist who in 1641 succeeded **Anthony van Dyck** as court painter to **Charles I** of England. Dobson's style is closely related to that of van Dyck but also shows an awareness of **Titian**, whose works in the royal collection he copied. During the civil war in England, Dobson was in Oxford where the king set up a temporary court. There he created a number of portraits. Among his best are the royalist *Endymion Porter* (c. 1643; London, Tate Gallery) and *The Painter with Sirs Charles Cottrell and Balthasar Gerbier* (c. 1645; Guildford, Albury Park). These works feature the same loose brushwork, shimmering fabrics, and lively compositions as the portraits by van Dyck and Titian.

DOGE. The word *doge* is from the **Venetian** dialect and translates to *duke*. The doge was the chief magistrate of the Republic of Venice, an elected official who served for life. The office was first established in 697 when the scattered settlements in the area pulled together and

elected Paoluccio Anafesto to govern their newly formed city. Since the 12th century, the election of the doge was carried out by a committee selected by the Great Council, the governing body of Venice. One of the doge's tasks was to participate in a ceremony that took place each year on **Ascension** Day. Followed by a procession of clerics and nobles, he would go out on a ceremonial barge and toss a ring into the Adriatic to symbolically enact the ancient ritual of the marriage to the sea. With this, the doge asserted Venice's preeminence as a maritime power.

DOGE'S PALACE, VENICE (1340–1438). The **Doge**'s Palace was the seat of government in **Venice**. In this region, fortifications were not necessary since the Adriatic Sea provided protection from invasion. Therefore, the Doge's Palace, unlike the **Palazzo Pubblico** in Siena or the **Palazzo Vecchio** in **Florence**, is not a fortified structure. In fact, it is quite inviting in that the lower story is an open arcade, a sort of promenade for Venetians to take shelter from the elements. Above this lower story is a second arcade with narrower openings surmounted by **quatrefoils**. The upper level is a solid block covered in a diamond pattern and capped by flamelike elements. As in Venetian art of the period, the structure commingles Western with Eastern elements. The arcades, quatrefoils, and pointed windows of the upper story were all inspired by the French Gothic style. The flamelike elements that cap the building, however, add an Islamic flavor. This hybrid design is the result of Venice's ties with the Byzantine Empire and the Eastern world.

DOME. Domes are hemispherical **vaults**, first introduced in large scale by the Romans. The architects of the Byzantine era pioneered an effective method of construction entailing the use of **pendentives** that transfer the weight of the dome to the piers below. This new method allowed for more extensive unobstructed interior expanses, as well as the enclosure of a square opening with a circular dome. In the Renaissance, dome construction achieved its greatest technical heights when **Filippo Brunelleschi** devised the double-shelled dome at the **Cathedral of Florence** (1420–1436). The dome became a standard feature of religious architecture, with **Donato Bramante**'s *Tempietto* at San Pietro in Montorio, **Rome** (c. 1502–1512), and **Michelangelo**'s

final design for New **St. Peter's** (1564) providing some of the most exceptional examples. Domes provide a surface on which **mosaics** or **frescoes** that depict important religious narratives can be rendered. An example of a dome mosaic is the one attributed to **Coppo di Marcovaldo** in the **Baptistery of Florence**, which depicts the **Last Judgment** and the lives of Christ, **St. John the Baptist**, and the Patriarch Joseph (13th century). A frescoed dome is **Giovanni Lanfranco**'s *Virgin in Glory* at Sant' Andrea della Valle, Rome (1625–1627).

DOMENICHINO (DOMENICO ZAMPIERI; 1581–1641). Domenichino was a member of the **Carracci** School. He first studied with the Flemish artist Denis Calvaert in **Bologna**, transferring to the Carracci Academy in c. 1595 to train with **Ludovico** and **Agostino Carracci**. In 1602, he went to **Rome** where he became one of **Annibale Carracci**'s most important assistants. There he befriended Monsignor **Giovanni Battista Agucchi**, who promoted his career and with whom he may have collaborated on a treatise on painting.

Domenichino's *Christ at the Column* (1603; private collection) he rendered soon before moving into Agucchi's home. It shows Christ after the **Flagellation** without his tormentors—an idealized iconic image exemplary of Domenichino's **classical** decorum. In 1609, Domenichino worked alongside **Guido Reni** in the Oratory of Sant' Andrea, Rome, painting the *Martyrdom of St. Andrew*. His first signed **altarpiece** is the *Last Communion of St. Jerome* (1614; Vatican, Pinacoteca), painted for the Congregation of San Girolamo (**Jerome**) della Carità, an image based on Agostino Carracci's famed painting of the same subject that Domenichino must have seen in 1612 when he briefly returned to Bologna. Having completed his own version, **Giovanni Lanfranco** accused him of plagiarism. In these same years, he also decorated the Polet Chapel in the Church of San Luigi dei Francesi, Rome (1612–1614), for Pierre Polet with scenes from the life of **St. Cecilia**. St. Cecilia was also the subject of his c. 1617 painting (Paris, Louvre) of the saint playing a viola while a putto holds her music score.

Domenichino was also an accomplished portraitist and landscapist. Remarkable examples of his portraiture are *Monsignor Giovanni Battista Agucchi* (early 1620s; York, Art Gallery) and *Pope Gregory XV and Cardinal Ludovico Ludovisi* (1621–1623; Béziers, Musée des

Beaux-Arts). Among his landscapes are the scenes from the legend of **Apollo** in the Villa Aldobrandini at Frascati (1616–1618) and *Diana at the Hunt* (1617; Rome, Galleria Borghese) commissioned by Cardinal **Scipione Borghese**. Domenichino moved to Naples in 1631 to work in the Cappella del Tesoro in the Church of San Genaro, a commission that was to occupy him for about a decade. He died in Naples in 1641, believed to have been poisoned by local artists who, out of jealousy, had threatened his life and reputation.

DOMINIC, SAINT (1170–1221). Born in Calaruega, Spain, St. Dominic was educated in the University of Palencia and appointed canon of Osma in 1199. In 1203, he accompanied the bishop of Osma to Languedoc where he preached against the heresies of the local Albigensians, a religious sect condemned by the papacy. In 1208, the Albigensians murdered the papal legate Peter of Castelnan and, in retaliation, Pope Innocent III launched a crusade against them. Saint Dominic followed the papal army and preached to the heretics in the hopes of converting them. In 1214, Count Simon IV of Montfort, who headed the crusade, gave Dominic a castle at Casseneuil where he and six of his followers established the **Dominican Order**. Two years later, the order received papal approval. Dominic spent the rest of his days traveling in Italy, Spain, and France, attracting new followers and establishing new Dominican houses. He died in **Bologna** where he went to convoke the first general council of his order. He was canonized in 1234.

DOMINICAN ORDER. The Dominican Order was established by **St. Dominic** in 1214 when he gathered a group of priests in the castle at Casseneuil in Languedoc owned by Count Simon IV of Montfort, who headed a crusade against the Albigensians whose religious inclinations the papacy deemed heretical. In 1216, the saint traveled to **Rome** to obtain papal approval for the order, which was duly granted. Unlike the self-sufficient medieval monastic orders, the Dominicans were a mendicant group that relied on charity. Their main purpose was to convert the Albigensians and to preach the word of God in the vernacular language. In 1229, the papacy established the Inquisition and the Dominicans were assigned to carry it out. This is what earned them the name *Domini canes*, the Lord's dogs who fight heresy. They

are depicted in **Andrea da Firenze**'s **Guidalotti Chapel** at **Santa Maria Novella** (1348–1355) in the Dominican church of **Florence** as ferocious dogs who chase the wolves of heresy. Among the most important Dominicans is **St. Thomas Aquinas**, one of the greatest theologians in history.

DONATELLO (DONATO DI NICCOLÒ BARDI; 1386–1466). The most innovative sculptor of the 15th century. Donatello was the son of Niccolò di Betto Bardi, a **Florentine** wool carder. He is documented in 1404–1407 in **Lorenzo Ghiberti**'s workshop, assisting in the execution of the **east doors** (1403–1424) of the **Baptistery of Florence**. Donatello was **Filippo Brunelleschi**'s friend, and the two traveled together to **Rome** to study the remains of the ancients—a visit that would affect both masters deeply. The knowledge Donatello gained allowed him to render his *St. Mark* at **Orsanmichele** (1411–1413) for the Arte dei Linaiuoli e Rigattieri, the Florentine **Guild** of Linen Drapers and Peddlers, as a powerful ancient philosopher type in *contrapposto*—a natural, believable stance. To compensate for the fact that the statue would be viewed from below and at a distance, Donatello elongated the figure's proportions and exaggerated its anatomical features, the earliest Renaissance master to do so. The **St. George** (1415–1417), also for Orsanmichele, he executed for the Arte dei Corazzai e Spadai, the Guild of Armorers and Swordmakers. Appropriately, the figure once wore a helmet and held a sword. Shown moments before the confrontation with the dragon, the saint's anticipation is read plainly in his anxious expression. At the base of the statue, St. George is shown slaying the dragon, a **relief** Donatello rendered in the *relievo schiacciato* technique he invented.

From 1415 until 1435, Donatello also worked on a series of **prophets** for the niches at the top of the **Campanile** of the **Cathedral of Florence**, each made to interact with viewers 30 feet below. His *Zuccone* (1423–1425; Florence, Museo dell' Opera del Duomo) is one among them. Instead of the conventional bearded old prophet, this figure relies on ancient Roman orator types with toga and opened mouth as if speaking. Donatello's figure is emaciated, as if caught in a moment of revelation, his features deeply carved so his expression may be perceived clearly from a distance. Also expressive are Donatello's *Cantoria* (1430s–1340s) for the Cathedral of

Florence (Florence, Museo dell' Opera del Duomo), the bronze *David* (c. 1446–1460; Florence, Museo Nazionale del Bargello), the *Equestrian Monument of Gattamelata* (c. 1445–1453; Padua, Piazza del Santo), and the scenes in the high altar of San Antonio in Padua (1444–1449).

Donatello eventually abandoned his reliance on **classical** principles to further explore the psychological depth of his subjects. His *Mary Magdalen* (1430s–1450s; Florence, Museo dell' Opera del Duomo) is an emaciated, toothless figure with sunken cheeks—a vivid portrayal of the woman who lived in the wilderness for four decades and engaged in prayer and penance. His *Judith* (c. 1446–1460; Florence, **Palazzo Vecchio**) seems in a trance as she decapitates Holofernes out of duty. Donatello's technical abilities and mastery at conveying meaning provided inspiration for **Michelangelo**, who, like his predecessor, understood the value of considering the physical and psychological interaction between art and observer.

DONI TONDO (c. 1503; Florence, Uffizi). The *Doni Tondo* is the first known painting by **Michelangelo**, created after he saw **Leonardo da Vinci**'s cartoon for the *Madonna and Child with St. Anne* exhibited in the Monastery of Santisima Annunziata, **Florence**, on which he based his composition. The *Doni Tondo* depicts the Holy Family as three solid figures who form a pyramid, with the **Virgin** sitting on the ground, silhouetted against **St. Joseph** and the Christ Child. Behind them are the young **St. John the Baptist** and five nudes sitting on a low, semicircular wall. The painting was commissioned by Angelo Doni, a prosperous Florentine weaver, perhaps on the occasion of his marriage to Maddalena Strozzi. Certainly, the work can be related to marriage as it portrays Joseph and Mary as the model Christian couple. Also, the *tondo* (circular) format is associated occasionally with nuptials. It has been suggested that the crescent wall on which the nudes sit may refer to the Strozzi coat-of-arms, composed of three crescent moons, and that the nudes in the background possibly represent Mercy, Kindness, Humility, Modesty, and Patience—the five **Virtues** enumerated by **St. Paul** in Colossians III:12–17 and essential to maintaining harmony in marriage. The men have stripped so they may clothe themselves with these Virtues, as per St. Paul's in-

structions. Some scholars date the work somewhat later than c. 1503 and explain the presence of the Baptist as reference to the Doni's first four sons, all named after the saint, who died in infancy. The solidity of the figures, their well-defined contours, and precise description of all the elements within the work reflect Michelangelo's sculptural approach to painting.

DORIA, ANDREA (1466–1560). The foremost admiral of his era. Andrea Doria was a member of one of the oldest and most powerful families of Genoa. As a young adult, he served in the papal guard under Innocent VIII. In 1522, he joined the French forces of **Francis I** against the imperial army. But when the French gave commercial priority to Savona over Genoa, Andrea instead pledged his loyalty to Emperor **Charles V.** In 1528, with the help of the imperial army, Andrea drove the French out of Genoa, established a new republican constitution and declared himself its dictator. In 1547–1549, Andrea was able to suppress effectively the conspiracies against him carried out by the Fieschi and Cibo families. In 1559, once more with the aid of Charles V (before his death in 1558), he recovered Corsica for Genoa. Andrea's sumptuous palace became the locus of artistic activity, led by **Perino del Vaga.** Among the most notable artists to contribute to the renovation and decoration of Andrea's residence were il Pordenone and **Domenico Beccafumi.**

DORMITION. According to Christian doctrine, the **Virgin Mary** did not die but rather fell asleep peacefully in the presence of the **apostles** and was carried by angels up to heaven (the **Assumption**), where she was crowned queen. **Jacopo Torriti** represented the *Dormition of the Virgin* (c. 1294) in his **mosaic** at Santa Maria Maggiore, **Rome.** **Fra Angelico** combined the *Dormition and Assumption* (c. 1432) in an **altarpiece** now housed in the Isabella Stewart Gardner Museum, Boston, and **Hugo van der Goes'** rendition of the subject (c. 1481; Bruges, Groeningemuseum) shows the Virgin experiencing a vision of her son who has come to receive her into heaven as she lies in her bed in her final moments on Earth. Finally, **Caravaggio** opted for a realistic rendition of death (1606; Paris, Louvre) by showing the Virgin as a bloated, decaying corpse. *See also DEATH OF THE VIRGIN.*

DOSSI, DOSSO (GIOVANNI DE LUTERI; c. 1490–1542). Artist from Ferrara who became court painter to Alfonso I d'**Este**, along with his brother Battista Dossi. His works often portray complex subjects that rely on fantasy and his style is closely linked to that of the **Venetian** masters in their colorism and light effects. After 1520, Dosso's paintings became more sculptural, often borrowing poses from **Michelangelo**'s works in **Rome** and ancient statuary, which suggests a visit to the papal city. His best-known work is *Melissa* (1520s; Rome, Galleria **Borghese**), based on a scene from *Orlando Furioso* by Ludovico Ariosto, the Ferrarese poet who, like Dosso, served the d'Este duke. Other paintings by Dosso include his *Holy Family with the Young St. John the Baptist, a Cat, and Donors* (c. 1512–1513; Philadelphia Museum of Art), the *Three Ages of Man* (c. 1515; New York, Metropolitan Museum of Art), and the *Allegory of Fortune* (c. 1530; Los Angeles, J. Paul Getty Museum).

DUCCIO DI BUONINSEGNA (active 1278–1319). Duccio was the leading figure of the Sienese School of painting. Little is known of his training. That he was temperamental is attested by the number of fines levied against him for various transgressions, including refusal to swear fealty to a civic official, declining to take part in the war of Maremma, and engaging in witchcraft. Unlike his contemporary **Giotto** who rejected the *Maniera Greca*, Duccio followed this tradition, bringing it to its ultimate refinement. In 1285, he received from the **Confraternity** of the Laudesi a commission to paint an **altarpiece** for the Church of **Santa Maria Novella** in **Florence**, called the *Rucellai Madonna* due to its location in the church's Rucellai Chapel. Two other works of this period are attributed to him, the *Crevole Madonna* (1283–1284; Museo dell'Opera del Duomo) and the *Madonna del Buonconvento* (c. 1295; Buonconvento, Museo d'Arte Sacra della Val d'Arbia). Duccio may have been in Paris in 1297 where a "Duch de Siene" is documented, which would have given him firsthand knowledge of the French Gothic style. In 1302, he received payment for an altarpiece depicting the **Virgin** and Child in majesty for the Cappella dei Nove in the Sienese **Palazzo Pubblico**, now lost. In 1308 he was to repeat this theme in his most important commission, the *Maestà Altarpiece* (1308–1311; Siena, Museo dell' Opera del Duomo), for the main altar in the **Cathedral of Siena**. The

round stained glass (1285–1308) in the **apse** of the cathedral, also designed by Duccio, depicts scenes from the life of the Virgin, the four **Evangelists**, and Sts. Bartholomew, Ansano, Crescenzio, and Savino, significant to the Sienese. Duccio ranks among the most important masters of the Proto-Renaissance era and is recognized for having established the Sienese School of painting. As the teacher of **Simone Martini**, he provided the impetus for the development of the **International Style**.

DUQUESNOY, FRANÇOIS (1597–1643). Flemish sculptor from Brussels who spent most of his career in **Rome**. Duquesnoy was trained by his father, Jerome, who was also a sculptor. In 1618, he moved to Rome, and became close friends with **Nicolas Poussin** and **Andrea Sacchi**. Together, these three masters did much to advance **Baroque classicism** in the papal city. Duquesnoy's *St. Susanna* (1629–1633) in the Church of Santa Maria di Loreto, Rome, is one of his most famous works. Inspired by **Gian Lorenzo Bernini**'s *St. Bibiana* and an ancient statue of *Urania* then in the Capitol, **Giovan Pietro Bellori** praised Duquesnoy's figure and declared it the canon for the depiction of clothed saints. Duquesnoy's *St. Andrew* (1629–1633) is one of four works commissioned by **Urban VIII** for the crossing (where the **nave** and **transept** cross) of **St. Peter's**, executed under Bernini's direction. This commanding figure leans on the cross of his martyrdom, extends his left arm, and looks up to the heavens where he will be granted salvation. His dramatic gesture, flowing drapery, and emotive restraint define the work as classicist. Duquesnoy died a premature death in 1643.

DÜRER, ALBRECHT (1471–1528). Albrecht Dürer stands out from among the Northern artists of his era not only for his mastery but also for the fact that he viewed art as much more than a manual craft and for his own self-image as innovator. While little documentation exists to reconstruct the careers of many of his contemporaries, Dürer left written records of his activities, including a diary and letters. Dürer was the son of a Hungarian goldsmith after whom he was named and who settled in Nuremberg, Germany, in 1455. After receiving training from his father, Dürer entered the studio of Michael Wolgemut (1486) to complete his studies. The

Self-Portrait in silverpoint he created two years earlier, at the age of 13 (Vienna, Albertina), demonstrates that he was a child prodigy. This would be the first among several self-portraits, each presenting the artist in a novel manner. In the 1493 self-portrait in the Louvre, Paris, Dürer presented himself as the bridegroom, the *eryngium* flower in his right hand then considered an aphrodisiac. The tasseled headdress Dürer wears refers to the customary binding of tassels by bride and groom to express fidelity. The prickly *eryngium*, a symbol of Christ's **Passion**, coupled with the inscription above that states that Dürer's affairs are ordained on high, asserts a divine source for his artistic genius. The 1500 self-portrait (Munich, Alte Pinakothek) goes a step further as Dürer presents himself as a frontal Christ-like figure to denote that art comes from the hand of a creator. His art philosophy parallels that of **Leonardo da Vinci**, who also likened the creative genius of artists to that of God, the creator of the universe. With this, Dürer paved the way for the humanistic world of the Renaissance to enter the North.

In 1492, Dürer set out to Colmar to work with the engraver **Martin Schongauer**. By the time he arrived, Schongauer was dead, so Dürer instead worked with the engraver's brother Georg in Basel. There he received a number of commissions for engravings, a field in which he greatly excelled. Among the works he executed were the woodcut frontispiece for the *Epistolae Beati Hieronymi* (published in 1492 by Nicolaus Kesler), which shows a **St. Jerome** and his lion, and illustrations for an unpublished edition of the comedies of Terence (Basel, Kupferstichkabinett; some question the attribution to Dürer).

In 1494, Dürer returned to Nuremberg to marry Agnes Frey, the daughter of a respected coppersmith—a union arranged by his father. Through his childhood friend, Willibald Pirckheimer, he became acquainted with the city's leading humanists who came to respect not only his artistic but also intellectual abilities. To perfect his skills, Dürer began drawing from **Andrea Mantegna**'s mythological engravings. One of these drawings, the *Death of Orpheus* (1494; Hamburg, Kunsthalle) shows the artist's desire to surpass the Italian master by adding greater contrasts of light and dark, movement, and drama than in the original work. A trip to **Venice** in 1494 provided further opportunities to study the works of the Italians. The result was

a richness of texture and tonality never before seen in prints. Examples include Dürer's *Hercules at the Crossroads* (c. 1497–1498) and *Four Witches* (c. 1497), both works exhibiting **classicized** figures with convincing details of anatomy and areas darkened with heavy crosshatchings to enhance their nude forms. Dürer's famed woodcuts of the *Apocalypse* (1497–1498) are a tour de force of dramatic intensity and action.

By 1496, Frederick the Wise, elector of Saxony, was granting commissions to Dürer, including the *Dresden Altarpiece* (c. 1496; Dresden, Kunstsammlungen), a work depicting the Madonna adoring the sleeping Christ Child in a three-quarter format, flanked by architecture, and set against a landscape in the manner of **Giovanni Bellini**. He also painted for the Elector the *Adoration of the Magi* (1504), a work inspired by Leonardo's (1481; both **Florence**, **Uffizi**) of the same subject. Dürer took a second trip to Italy in 1505–1507, where he informed his friend Pirckheimer in a letter that he was taking lessons in **one-point linear perspective**. In Venice he painted the *Rozenkranz Madonna* (1505–1506; Prague; National Gallery) for the Church of San Bartolomeo, commissioned by the Fondaco dei Tedeschi, the association of German merchants in Venice. While there, he had the opportunity to meet Giovanni Bellini, who by now was very old, as Dürer's letters to Pirckheimer reveal.

Of the paintings Dürer created after his Italian trip, the *Adoration of the Holy Trinity* (1508–1511; Vienna, Kunsthistorisches Museum) is the most impressive. Painted for the chapel in an almshouse in Nuremberg founded by Matthew Landauer, from whom Dürer received the commission, the work borrows from **St. Augustine**'s *City of God* where individuals from all ranks of society, here Landauer included, come together to adore the Trinity. Dürer also began work on a theoretical treatise on art soon after his return from Italy, a work he completed in 1523. He also entered in the service of Emperor **Maximilian I**. Dürer's last major painting commission was the *Four Apostles* (1526; Munich, Alte Pinakothek) for the town council of Nuremberg. The last of his years the artist devoted to his writing efforts. In 1525, he published *The Teaching of Measurements with Rule and Compass* and, in 1527, he issued an essay on *The Art of Fortification* while also working on his *Four Books on Human Proportions*. Pirckheimer had this last text published in 1528, after Dürer's death.

Dürer's influence on art was vast. Not only did he influence German masters but also Flemish, French, Spanish, and Italian artists.

DYCK, ANTHONY VAN (1599–1641). Anthony van Dyck was a child prodigy who by 14 was executing portraits for important patrons. The son of a prosperous cloth merchant from Flanders, van Dyck's career was overshadowed by that of **Peter Paul Rubens**, who some believe to have been his teacher. In fact, wherever van Dyck went, Rubens had already been. In 1621, he arrived in Italy where he had the opportunity to study the works of the **Venetians**, and particularly **Titian**. In the 1630s, he was in England, working as court painter to **Charles I**. When Rubens died in 1640, van Dyck went back to Antwerp hoping to take his place as head of the Flemish School. The archdukes of Flanders wrote to King **Philip IV** of Spain that van Dyck was arrogant and undependable, thereby ending his aspirations. There was reason for the archdukes to speak of the master in these terms. In Italy, he was called the *pittore cavalieresco* (cavalier painter) because of his many servants, expensive wardrobe, and refusal to associate with anyone in a lower social rank. In England, he entertained frequently and lavishly, excesses that may have hastened his death.

In 1620, van Dyck painted the portrait *Isabella Brant* (Washington, National Gallery) of Rubens' first wife. Perhaps the work was intended as a gift for Rubens and Isabella prior to van Dyck's trip to Italy. The loose brushwork, choice of palette, elaborate costume, and red background drapery to emphasize the sitter are all Rubensian elements. The portraits *Cardinal Bentivoglio* (1622; **Florence**, Palazzo Pitti) and *Elena Grimaldi* (1625; Washington, National Gallery) van Dyck painted in **Rome** and Genoa respectively. The first shows the cardinal in deep thought after having read a letter. The second stresses the sitter's social standing as she is sumptuously dressed and accompanied by a slave boy who holds a parasol over her. In Sicily, van Dyck was commissioned to paint a series of works for the Oratory of the Rosary in Palermo, including the *Madonna of the Rosary*, to commemorate the recovery in 1624 of the remains of St. Rosalie. In England, he painted for Endymion Porter, a member of the royal court, one of his most admired works, *Rinaldo and Armida* (1629; Baltimore, Museum of Art), based on **Tasso's** *Gerusalemme Liber-*

ata. Van Dyck's *Lady Digby as Prudence* (1633; London, National Portrait Gallery) also belongs to this period, as does *Le Roi à la Chasse* (*Portrait of Charles I*) (1635; Paris, Louvre), one of the most remarkable royal portraits ever rendered. Van Dyck revolutionized portrait painting in England. Before him, miniaturist Elizabethan portraiture was the norm and, though Paul van Somer, also from Antwerp, and the Dutch Daniel Mytens were in London in the second decade of the 17th century and brought their realistic mode to England, it was not until van Dyck entered the scene that English portraiture was finally infused with life.

– E –

EAST DOORS, BAPTISTERY, FLORENCE (1403–1424). In 1401, a competition was announced in **Florence** for the east doors of the **Baptistery** that faced the cathedral. The south doors had already been executed in the previous century by **Andrea Pisano** with scenes from the life of **St. John the Baptist**, patron saint of Florence. Seven artists submitted entries to the competition, including **Filippo Brunelleschi**, **Lorenzo Ghiberti**, and **Jacopo della Quercia**. Participants were to follow certain specifications. Entries were to represent the *Sacrifice of Isaac*, they were to be executed in bronze, and enclosed in a **quatrefoil** to harmonize with Andrea Pisano's **reliefs** on the south doors. In the end, Ghiberti won the competition as his relief was better suited to current tastes. Rejecting the medieval vocabulary that had permeated sculpture in the previous century, Ghiberti rendered a **classicized** Isaac, one of the earliest nudes of the Renaissance to depend on ancient prototypes. At first, officials intended the east doors (now the north doors) to include scenes from the Old Testament, with the winner's entry filling one of the panels. Soon, however, the source was changed to the New Testament and Ghiberti's *Sacrifice of Isaac* (now in Florence, Museo Nazionale del Bargello) was saved for inclusion in a third set of doors.

The east doors, like Andrea Pisano's, are divided into 28 quatrefoils, arranged in seven rows of four. Each field is enclosed by a square composed of foliage, fruits, insects, lizards, and birds and, at each intersection, a bust of either a **prophet** or prophetess emerges.

On the lowest panels are the four **Evangelists** and four Doctors of the Church. Of the scenes from the New Testament, which relate the story of Christ, the most often discussed is the *Flagellation*. Here, the event unfolds in front of a classical portico. Like Brunelleschi's architecture, the scene is symmetrical and balanced. The figure of Christ is based on ancient models, with realistic anatomical details and believable drapery. Once installed, the doors were highly praised by contemporaries. The competition for the commission marked the transition from the Proto- to the Early Renaissance era.

EFFIGY. A commemorative representation of an individual, especially in sculpture or medals. The earliest tomb effigies of the Renaissance showed the deceased as a corpse, with the *Tomb of Mary of Hungary* (1325; Naples, Santa Maria Donnaregina) by Gagliardo Primario and Tino da Camaino providing a Proto-Renaissance example. In the 15th century, this mode persisted, as **Bernardo Rossellino**'s *Tomb of Leonardo Bruni* in the Church of **Santa Croce**, **Florence** (c. 1445) illustrates. It was not until the 16th century that live effigies became common. In the 1532 project for the *Tomb of Pope Julius II*, **Michelangelo** planned for a reclining effigy, and his tombs of the **Medici** dukes in the **New Sacristy of San Lorenzo**, Florence (1519–1534), present seated effigies above the tomb. The most animated examples are from the 17th century, among them the enthroned effigy in the *Tomb of Pope Urban VIII* by **Gian Lorenzo Bernini** at **St. Peter's**, **Rome** (1628–1647), who raises his right arm in a blessing gesture and is enveloped by movemented drapery.

EKPHRASIS. A poetic, written description of a work of art. This literary genre, first introduced in late antiquity, gained great momentum during the Renaissance. Not only did it flourish once again as a literary medium, but patrons often commissioned works of art that recreated the descriptions provided by the ancients. **Raphael**'s *Galatea* in the **Villa Farnesina**, **Rome** (1513), depends on an *ekphrasis* authored by Philostratus the Elder, and Sodoma's *Marriage of Alexander and Roxana* in the same location (1516–1519) owes its visual components to Lucian's description of a painting by the ancient master Apelles commissioned by Alexander the Great. Another *ekphrasis*

written by Lucian provided the prototype for **Sandro Botticelli**'s *Calumny of Apelles* (1495; **Florence, Uffizi**), the earliest Renaissance painting to recreate an *ekphrasis* from antiquity. **Titian**'s *Worship of Venus* (1518; Madrid, Prado) depends on Philostratus the Younger's description, and his *Bacchus and Ariadne* (1520–1522; London, National Gallery) is based on an *ekphrasis* by Catullus that describes a bedspread created for the wedding of Peleus and Thetis. Among the Renaissance writers who delved in the genre are the poet Angelo Poliziano, who wrote an *ekphrasis* on the reliefs cast by Vulcan for the doors of his consort's temple that provided the inspiration for Botticelli's *Birth of Venus* (c. 1485; Florence, Uffizi), and the humanist Mario Equicola, who wrote the *ekphrasis* that **Giovanni Bellini** used for his *Feast of the Gods* (1514; Washington, National Gallery). Emulating the past, or perhaps even recreating it, was meant to bring prestige to writers, patrons, and artists for the erudition they demonstrated.

EL GRECO (DOMENIKOS THEOTOKOPOULOS; 1541–1614). Born in Candia, Crete, El Greco was trained in the Byzantine tradition. In 1568, he traveled to **Venice**, which, at the time, ruled Crete. There he discovered the art of **Tintoretto** and was deeply inspired by it. Two years later he moved to **Rome** where he entered in the service of the **Farnese** and began painting in a Venetianized style. His *Christ Healing the Blind* (c. 1576; New York, Metropolitan Museum) shows the loose Venetian brushwork and deep tones of Tintoretto, elements that would become characteristic of his own style.

El Greco did not achieve success in Rome, as his works only appealed to a small group of patrons. In 1576, Don Diego de Castilla, dean of the Cathedral of Toledo, invited him to Spain to render works at the Church of Santo Domingo el Antiguo that memorialized Castilla's mistress and their child. It was in Toledo that the artist received the sobriquet *El Greco* (The Greek). One of the works for Castilla was the *Holy Trinity* (1577–1579; Madrid, Prado), a painting whose theme and composition were inspired by **Albrecht Dürer**'s work of the same subject (1511; Vienna, Kunsthistorisches Museum). It shows God the Father as the "throne of mercy," as he is described in the Book of Exodus. He supports the dead body of Christ, who is based on **Michelangelo**'s in the Vatican *Pietà*. The Santo Domingo

commission proved to be a complete success and established El Greco as a master of note.

In 1580, El Greco received from King **Philip II** of Spain the commission to paint the ***Martyrdom of St. Maurice and the Theban Legion*** for the Monastery of San Lorenzo in El **Escorial**. Philip paid for the work, but then stored it in the monastery basement and never again commissioned El Greco; perhaps the master's style was too abstract and progressive for its time. This work was followed by his famed ***Burial of Count Orgáz*** (1586), painted for the Church of Santo Tomé, Toledo, and *St. Martin and the Beggar* (1596–1599; Washington, National Gallery) for the city's Chapel of San José. El Greco's *View of Toledo* (1600; New York, Metropolitan Museum) has a cataclysmic quality that some have read as commentary on the Inquisition carried out in Toledo, then the second major Catholic center in the world and the leader of the Spanish **Counter-Reformation**. The portrait *Cardinal Fernando Niño de Guevara* (1605; New York, Metropolitan Museum) shows the head of the Spanish Inquisition seated, wearing glasses, his windswept drapery adding to his threatening demeanor.

Though considered a **Mannerist** for his elongation and distortion of forms, some prefer to classify El Greco as Proto-**Baroque** because his religious paintings addressed the concerns of the Counter-Reformation. Some, like *Christ Healing the Blind*, speak of the blindness of those who reject Catholicism in favor of Protestantism. Others, such as *St. Martin and the Beggar* and the *Burial of Count Orgáz*, stress salvation through charity, a key message imparted by the Church in these years. Among El Greco's pupils, **Luis Tristán** is the most noted.

ELEVATION OF THE CROSS (**1610–1611; Antwerp Cathedral**). In 1609, the fathers of the Church of St. Walburga in Antwerp decided to commission a new **altarpiece**. It fell on **Peter Paul Rubens** to carry out the work, a charge he received from Cornelis van der Geest, a wealthy merchant, art collector, and one of the church's wardens. The altarpiece originally included a ***predella***, a figure of God the Father with angels crowning the main scene, and above that a pelican tearing its chest open to feed its young—a symbol of Christ's sacrifice. In the 18th century, the altarpiece was taken by the French, who

removed the secondary elements. It was returned in the following century to Antwerp where it was placed in the North **transept** of the cathedral since, by then, St. Walburga was no longer standing. When opened, the **triptych** presents a continuous scene along its three panels. Here, crude, muscular types pull up the cross with great effort. The **crucified** Christ is shown as a **classicized**, seminude heroic figure that contrasts with the crudeness of his tormentors. The scene is animated by the barking dog included on the left and the oblique placement of the cross and figures. These features qualify the work as **Caravaggist**. When closed, the altarpiece shows Sts. Amandus and Walburga on the left panel and Eligius and **Catherine** on the right, which indicates that the scenes of the *predella* may have depicted the legends of these saints.

ENGELBRECHTSZ, CORNELIS (1468–1533). Dutch **Mannerist** painter from Leiden. Engelbrechtsz is thought to have been trained by Colijn de Coter, a follower of **Rogier van der Weyden**. His style relates to that of Jacob Cornelisz van Oostsanen, particularly in the crowding of forms and rich surface ornamentation. His *Crucifixion* (c. 1520–1525; New York, Metropolitan Museum) shows figures with dramatic gestures and emotive facial expressions, all pushed close to the foreground against a cloudy sky. His forms are elongated and contorted, features that qualify him as a Mannerist painter. His *Constantine and St. Helena* (c. 1510–1520; Munich, Alte Pinakothek) depicts a youthful saint dressed in contemporary garb, holding the true cross. Constantine, dressed as a Northern emperor, holds the sword and orb, symbols of power. Engelbrechtsz was the teacher of **Lucas van Leyden**, who became one of the leading masters of the region.

ENTOMBMENT. The entombment refers to the biblical account of Christ's burial. Pontius Pilate granted permission to Joseph of Arimathea and Nicodemus to retrieve the body from the cross. In keeping with Jewish funerary customs, **Mary Magdalen** anointed Christ's body, and it was then wrapped in a white shroud and placed in the sepulcher. Both **Raphael** (1507; **Rome**, Galleria **Borghese**) and **Titian** (c. 1523–1525; Paris, Louvre) showed the *Entombment* with men carrying the dead body in a white cloth for burial. **Caravaggio**'s version

of 1603–1604 for the Vittrici Chapel in the Chiesa Nuova (Rome, Pinacoteca Vaticana) is an iconic image of figures cascading diagonally to lower the Savior into the tomb. **Rembrandt**'s (1639; Munich, Alte Pinakothek) instead presents the moment when Christ is laid on his **bier**, the scene dramatically lit by candlelight.

EQUESTRIAN MONUMENT OF GATTAMELATA, **PIAZZA DEL SANTO, PADUA (c. 1445–1453)**. This work was commissioned from **Donatello** by the **Venetian** Senate to honor the **condottiere** Erasmo da Narni, known as Gattamelata, who served as chief commander of the Venetian army and left funds in his will for his own monument. Donatello based his work on the ancient equestrian statue of *Marcus Aurelius* (**Rome**, Capitoline Museum), then thought to represent Constantine the Great. He also was inspired by **Paolo Uccello**'s *Sir John Hawkwood on Horseback* (1436) in the **Cathedral of Florence**. Gattamelata is shown as a forceful commander, stressed by the ferocious Victory figure on his breastplate. The tension on the man's jaw and neck muscles, his piercing gaze, and lines on his forehead grant him an aura of authority. The noble nature of the animal serves to enhance Gattamelata's heroism. Donatello was as comfortable rendering the anatomy of the man as that of the horse. The animal's well-defined tendons and muscles, its flaring nostrils, and opened mouth are the details that denote Donatello's mastery.

ESCORIAL. On 10 August 1557, the feast day of **St. Lawrence, Philip II of Spain** vowed at the Battle of San Quentin that, if his troops emerged victorious against the French, he would build a monastery in the saint's honor. The Spaniards won the battle, an event that eventually led to the peace of Cateau-Cambrésis between France, England, and Spain (1559). Philip fulfilled his promise by building the Monastery of San Lorenzo del Escorial (beg. 1563). He charged Juan Bautista de Toledo with the task and, when Toledo died in 1567, his pupil Juan de Herrera took over the project, bringing it to completion in 1584. The complex includes a palace for the king, his family, and courtiers, a seminary, basilica, and royal crypt. Its gridlike design, punctuated by four towers at the corners, two campaniles, and the **dome** of the basilica, is thought by some to have

been inspired by the grill of St. Lawrence's martyrdom. Others see the building's plan as a modernized version of the Temple of Solomon described by Flavius Josephus, the Jewish historian of the first century. If this is the case, then the architecture would speak of Philip as the new Solomon, the biblical builder hailed for his wisdom. Philip brought a team of Italian masters to El Escorial to decorate the complex, among them Fabrizio Castello, Pellegrino Tibaldi, and Luca Cambiaso. The Spanish artists **Juan Fernández de Navarrete** and **Alonso Sánchez Coello** were also involved, as was **El Greco**.

ESTE FAMILY. The ancestry of the d'Este dates back to the Carolingian era. Their name derives from the Castle of Este near Padua. In the late Middle Ages, they gradually took dominion of the Eastern half of the Italian Po Valley, so that, by the second half of the 13th century, they controlled Ferrara, Modena, Rovigo, and Reggio. Strategic marriage alliances with other noble families, like the **Sforza** and **Gonzaga**, ensured their hegemony. The d'Este court in Ferrara became a major center of art and culture. Both **Jacopo Bellini** and **Antonio Pisanello** worked for Lionello d'Este. **Giovanni Bellini** and **Titian** contributed works for Alfonso I's *Camerino d'Alabastro*. **Dosso Dossi** worked as Alfonso's court painter and the poet Ariosto as his military and diplomatic agent. Ariosto, in fact, wrote the *Orlando Furioso* while in his service, an epic poem that celebrated d'Este ancestry and provided inspiration to painters. Poets **Torquato Tasso** and Giovanni Battista Guarini were active in Alfonso II's court. The d'Este women were also key figures in the history of Italian culture. Iacopina d'Este, the wife of Enrico Scrovegni, was instrumental in obtaining the services of **Giotto** to **fresco** the **Arena Chapel** (1305) in Padua. **Isabella d'Este**, Marchioness of Mantua, and her sister Beatrice, Duchess of Milan, promoted cultural life in their own courts. Isabella patronized artists such as **Andrea Mantegna** while her sister sponsored **Leonardo da Vinci**. The d'Este's glory years ended when Alfonso II died in 1597 without heirs. He appointed Cesare d'Este, his uncle's illegitimate son, as his successor, a choice disapproved by the papacy. The d'Este were expelled from Ferrara and Pope Clement VIII turned over the government of the city to a cardinal legate, ending 300 years of rule.

ESTE, ERCOLE I D', DUKE OF FERRARA (1431–1505). Duke of Ferrara from 1471; father of Beatrice, **Isabella**, and Alfonso I d'**Este**. In 1474, Ercole married Eleonora of Aragon, the daughter of the king of Naples, an alliance that proved politically beneficial to Ferrara. His nephew Niccolò orchestrated a failed coup against him, after which his term as duke brought great political stability, save for the war with **Venice** in 1481 over the salt monopoly. Ercole allied himself with the papal forces, Milan, and Naples, and peace was achieved in Bagnolo in 1484, with Ferrara losing Polisene to its enemy. Ercole's expansion of Ferrara beyond its walls, referred to as the Herculean Addition, more than tripled the size of the city. His architect was Biagio Rossetti, who designed for him a number of palaces and churches, including the famed Palazzo dei Diamanti, completed in 1493.

ESTE, ISABELLA D', MARCHIONESS OF MANTUA (1474–1539). Isabella was the daughter of **Ercole I d'Este**, Duke of Ferrara, and Eleonora of Aragon. She was the recipient of a solid **classic** education from the literati in her father's service. At the age of 16, she married Francesco **Gonzaga**, Marquis of Mantua, and ruled the city with great skill during her husband's absences. At her new court, Isabella became a generous patron of art, literature, and music. She was also a major collector of antiquities and, as her letters reveal, at times she went to great lengths to obtain pieces for her collection. Some of the artists she patronized included **Titian** and **Leonardo da Vinci**, both of whom rendered her portrait—Titian in 1536 (Vienna, Kunsthistorisches Museum) and Leonardo in 1499 (chalk drawing; Paris, Louvre). In 1496, Isabella began the planning of her *studiolo* in the Mantuan Ducal Palace for which she commissioned a series of works with allegorical content. Among the artists who contributed works for the project were **Andrea Mantegna**, who rendered the *Expulsion of the Vices from the Garden of Virtue* (1497); **Pietro Perugino**, who painted the *Battle between Chastity and Love* (1503–1505); and Lorenzo Costa, who provided the *Allegory of the Court of Isabella d'Este* (c. 1506; all in Paris, Louvre).

ET IN ARCADIA EGO. In English, *also in Arcadia I am.* Arcadia is the land of milk and honey of **Virgil**'s *Eclogues* where shepherds and shepherdesses frolic about. *Et in Arcadia Ego* is the topic of a paint-

ing by **Guercino** rendered in c. 1618 (**Rome**, Galleria Nazionale d' Arte Antica) and two by **Nicolas Poussin** in 1627 (Chatsworth, Devonshire Collection) and 1637–1638 (Paris, Louvre), respectively. These show shepherds and shepherdesses stumbling upon a tomb, implying that *Et in Arcadia Ego* are the words spoken by Death as a reminder that, even in the land of milk and honey, life is only temporary.

EVANGELISTS. The Evangelists were the writers of the Gospels, the first four books in the New Testament where the story of Christ is told. In the medieval era, the Evangelists were represented symbolically, with the winged man denoting **Matthew**, the lion for Mark, the ox for **Luke**, and the eagle for **John**. These creatures stem from a vision experienced by Ezekiel where they surrounded the throne of God. In the Renaissance, **Andrea del Castagno** rendered the Evangelists writing their Gospels, their symbols included, in the Chapel of Tarsasius at San Zaccaria, **Venice** (1442), as did **Benozzo Gozzoli** in his **frescoed vault** in the Cappella di Sant' Agostino at San Gimignano (1464–1465). **Jacob Jordaens** painted the Evangelists together in a single canvas comparing one Gospel against the other (c. 1625; Paris, Louvre) and Fra Bartolomeo rendered *Christ and the Four Evangelists* (1516; **Florence**, Palazzo Pitti), a work that glorifies the rituals of the mass. **Raphael** painted the *Vision of Ezekiel* (1518; Florence, Palazzo Pitti), where a robust figure of God the Father hovers above the Earth and is supported by the symbols of the Evangelists.

EYCK, JAN VAN (bef. 1395–1441). Jan van Eyck is among the greatest innovators of the 15th century. Both **Giorgio Vasari** and his Northern counterpart, **Karel van Mander**, wrote that it was Jan who invented the **oil painting** technique. He is documented in the court of John of Bavaria, Count of Holland, in 1422, leaving in 1424 after the count's death to settle in Bruges. There he received the attention of Philip the Good, Duke of Burgundy, and became his official painter in the following year. He remained in the duke's service until his death in 1441, as painter and diplomat. In this last capacity, he was sent to Catalonia, Spain, in 1427 to paint the portrait of a possible marriage partner for Philip. This alliance was not to be, but, in 1428, Jan traveled to Lisbon for the same purpose, a journey that ended in Philip taking Isabella of Portugal as his bride. Van Eyck's

brother Hubert was also a painter, though not a single work can be attributed firmly to him. An inscription on the *Ghent Altarpiece* (c. 1425–1432; Ghent, Cathedral of St-Bavon) identifies Hubert as the one to have executed the work, with Jan completing it in 1432. The *Crucifixion* and *Last Judgment* panels at the Metropolitan Museum in New York (c. 1430–1435) are also thought to have been a collaboration between the two brothers.

In Jan's case, nine of his works include his signature, the earliest being the *Madonna in a Church* (c. 1425; Berlin, Gemäldegalerie). Here the **Virgin** is taller than the **nave** arcade of the Gothic structure to symbolize that, according to Catholic doctrine, she is *Ecclesia*, the Holy Mother of the Church. Jan's *Annunciation* (c. 1428; Washington, National Gallery) shows the Virgin kneeling in front of her book of devotions. On the ground, the tiles feature scenes from the Old Testament that prefigure the coming of Christ and the months, with March, when the Feast of the Annunciation is celebrated, at Mary's feet. The *Madonna with the Chancellor Nicolas Rolin* (c. 1433; Paris, Louvre) and *Madonna of Canon George van der Paele* (1434–1436; Bruges, Groeningemuseum) are also among Jan's masterpieces. The first presents the chancellor of Burgundy in prayer in front of the Virgin, who receives her crown from an angel. The detailed landscape in the distance denotes Jan's dependence on the Flemish miniaturist tradition. In the second painting, the Virgin and Child are brought closer to the viewer and centralized. Canon van der Paele kneels to the right, his eyeglasses increasing the size of the lettering in his book of devotions. Another element within the painting that denotes Jan's interest in optics is the inclusion of his own reflection in **St. George**'s armor. Both works establish the devotion of the men depicted toward the Virgin and Child, creating the sense that they imagine the divine figures in their presence as they engage in their daily prayers.

Another work where Jan's attention to visual phenomena is shown is the *Arnolfini Wedding Portrait* (1434; London, National Gallery), where he included his reflection in the convex mirror that hangs on the back wall. Several single portraits by Jan also exist, including the famed *Man in a Red Turban* (1433; London, National Gallery), believed by some to be a self-portrait, and the portrait of his wife, *Margaret van Eyck* (1439; Bruges, Groeningemuseum).

Jan's interest in rendering every detail with exactitude is clearly seen in these works. Every strand of hair, skin fold, and vein is clearly denoted. Both figures are in a three-quarter position, with eyes firmly fixed on the viewer.

Jan's art mingles the visual with the symbolic and the secular with the religious. Carvings in the spaces populated by his figures and everyday objects laden his images with deep spiritualism. His rendering of every detail betrays his close observation of the world and desire to replicate it on the pictorial surface, while his masterful manipulation of the oil painting technique resulted in realistic **atmospheric** and lighting effects. His most faithful follower was **Petrus Christus**, who some believe to have been Jan's pupil and who continued the Eyckian emphasis on realism, interest in depicting reflective objects, and richness of surface and colorism.

– F –

FABRIANO, GENTILE DA (active c. 1390–1427). Marchigian master who painted in the **International Style** and who was active in **Rome**, **Florence**, Siena, **Venice**, and Orvieto. Gentile is known to have painted **frescos** in the **Doge's Palace** in Venice in 1408 and at the Church of St. John Lateran in Rome in 1427. These works, unfortunately, were destroyed. His major surviving masterpiece is the *Adoration of the Magi* (1423; Florence, **Uffizi**) for the Church of Santa Trinità in Florence, commissioned by the wealthy banker Palla Strozzi for his funerary chapel. The **altarpiece**'s *predella* features three other scenes from Christ's childhood: the *Nativity*, *Flight into Egypt*, and *Presentation in the Temple*. Of these, the *Nativity* is the most innovative, as it presents the earliest instance when shadows are cast in response to an illuminated source within the painting.

FALL OF THE GIANTS, PALAZZO DEL PRINCIPE, GENOA (c. 1529). **Perino del Vaga** painted this ceiling **fresco** as part of the decorations of **Andrea Doria**'s Palazzo del Principe. The scene, located in the Sala dei Giganti (Room of the Giants), depicts the Olympian defeat of the giants, sons of the earth goddess Gaia. Saturn, one of the giants, had devoured each one of his children because

his father Uranus had prophesied that one of them would defeat him. His consort, Rhea, hid their son **Jupiter** from him and, once fully grown, Jupiter forced Saturn to disgorge his siblings (**Juno, Neptune**, Pluto, and Ceres). Together, they overthrew Saturn; Jupiter, Neptune, and Pluto then divided the universe among themselves. Jupiter became the god of the heavens, Neptune of the oceans, and Pluto of the underworld. The giants rose up against them. To reach Mount Olympus where the gods presided, they stacked Mount Pelion atop Mount Ossa, but were miserably defeated by the gods and cast to the underworld. In the fresco, Jupiter is shown with thunderbolt in hand and the zodiac belt around him, a reference to his having brought order to the universe and established the seasons. Below, the defeated giants lay on the ground in contorted poses. The fresco reveals the influence of **Raphael** with whom Perino worked while in **Rome**, particularly in the arrangement of the upper portion of the scene, which closely resembles the composition in Raphael's *Psyche Received at Mount Olympus* in the **Villa Farnesina** (1517–1518). Doria's ally, **Charles V**, used the Sala dei Giganti as his temporary throne room. The fresco by Perino served as allegory of the emperor's victories against the Protestants.

FARNESE CEILING, PALAZZO FARNESE, ROME (c. 1597–1600). Commissioned by Cardinal Odoardo **Farnese** from **Annibale Carracci** for his newly built **Palazzo Farnese** in **Rome**. The subject of the Farnese ceiling is the loves of the gods, the inspiration for its overall arrangement being **Michelangelo**'s **Sistine ceiling** (1508–1512; Vatican). As in the prototype, the Farnese ceiling consists of a painted architectural framework or *quadratura* that divides the scenes into three coherent bands and includes nude figures and medallions. The work was meant to harmonize as well with **Raphael's** mythological **frescoes** (1513–1518) in the **Villa Farnesina** across the Tiber River, by now also owned by the Farnese family.

Using a *quadro riportato* technique, the artist placed the *Triumph of Bacchus* in the center. It shows the god of wine and his consort, Ariadne, in procession with bacchants and **satyrs** around them in a frenzied revelry. Following **Giovan Pietro Bellori**'s interpretation, the image is seen as a **Neoplatonic** allegory of divine love triumph-

ing over its earthly counterpart. Among the most notable secondary scenes are *Venus and Anchises* and *Polyphemus and Galatea*. The first is accompanied by an inscription that reads "this was the beginning of Rome," referring to the birth of Aeneas, founder of the Latin race, from their union. The scene is eroticized by Anchises' removal of the goddess' sandal and her *Venus Pudica* pose that indicates her hesitancy to give in to the advances of a mere mortal. In *Polyphemus and Galatea*, the theme is unrequited love as the **nymph** ridicules the Cyclops for wooing her. Because Galatea loves Acis, Polyphemus kills his contender with a rock, a scene also frescoed on the ceiling. Other scenes include *Cephalus and Aurora*, which is believed to have been executed by **Agostino Carracci** who assisted Annibale; *Diana and Pan*; **Hercules** *and Iole*; *Dedalus and Icarus*; *Diana and Callisto*; **Mercury** *and Apollo*; and *Arion and the Dolphin*.

The Farnese ceiling is one of the greatest masterpieces of the early **Baroque** era. As part of the decorations of a cardinal's palace, its blatant sensuality has prompted intense discussion among scholars regarding the frescoes' intended meaning. The ceiling was already recognized as a masterpiece during Annibale's lifetime and wielded tremendous influence on artists active in the 17th century. Both *Aurora* ceilings by **Guido Reni** (1613; Rome, Casino Rospigliosi) and **Guercino** (1621; Rome, Casino **Ludovisi**) owe their compositions to Annibale's work.

FARNESE FAMILY. Farnese ancestry can be traced back to the 12th century in **Rome**. It was not until the reign of **Alexander VI** (1492–1503) that the family achieved considerable prestige thanks to the amorous liaison between the pope and Giulia Farnese. In 1534, their fortune increased when one of their own ascended the papal throne as Pope **Paul III** who appointed his son Pierluigi the Duke of Parma, Piacenza, and Castro (1545), the first two regions ruled by the Farnese until 1731 and the last until 1649. The family's political hegemony was strengthened further when, in 1538, Ottavio Farnese, Pierluigi's son, married Margaret of Parma, the illegitimate daughter of Emperor **Charles V**. The Farnese are closely tied to the history of Renaissance and **Baroque** art. **Titian**, **El Greco**, **Annibale** and **Agostino Carracci**, **Domenichino**, **Francesco Mochi**, and

Bartolomeo Schedoni are all linked to the history of their patronage. *See also* URBAN VIII.

FEAST IN THE HOUSE OF LEVI **(1573; Venice, Galleria dell'Accademia).** The *Feast in the House of Levi* was painted by **Paolo Veronese** for the **Dominican** Monastery of Santi Giovanni e Paolo in **Venice.** The real subject of the painting is the *Last Supper*. No sooner had Veronese completed it than he was summoned in front of the tribunal of the Inquisition and accused of rendering the solemn moment when Christ establishes the Eucharist as a sacrament as an indecorous scene filled with buffoons, dwarfs, drunken figures, and animals. To circumvent the harsh penalties levied by the tribunal on those accused of committing heresy, Veronese simply changed the title of the painting to the *Feast in the House of Levi*, a less solemn episode in Christ's life. The work relates compositionally to his *Marriage at Cana* (1563) in the Monastery of San Giorgio Maggiore, Venice. In both, the scene is made to look like a contemporary Venetian banquet lacking reverence. The emphasis on sumptuous fabrics, contemporaneous characters, and the **Palladian** architectural backdrop cast this work as decidedly Venetian.

FEAST OF HEROD. An episode from the life of **St. John the Baptist.** Herod married Herodias, his brother's wife, and the saint pointed out to them that their union was unlawful. Insulted, Herodias persuaded her husband to have the saint imprisoned. At a banquet, Salome, Herodias' daughter, danced for Herod so delightfully that Herod promised he would grant her anything she wished. After consulting with her mother, Salome asked for the head of the Baptist, which was granted. The feast of Herod is depicted in three scenes in **Fra Filippo Lippi's frescoes** in the **choir** of the **Prato Cathedral** (1452–1466). In the central scene, Salome dances for Herod, she receives the head of St. John on a platter on the left, and, on the right, she presents the platter to her mother while two servants huddle in horror. **Benozzo Gozzoli** painted the *Feast of Herod and Beheading of St. John the Baptist* (c. 1461–1462; Washington, National Gallery) on a single panel, and **Donatello** presented the episodes of the story in his **relief** for the baptismal font in the **Cathedral of Siena**

(c. 1425) not side by side as in the painted examples, but rather one behind the other convincingly receding into space.

FÊTE CHAMPETRE **(c. 1510; Louvre, Paris).** Painted by **Giorgione**, though some art historians believe it to be by the hand of his pupil **Titian**, while others have suggested that the work represents a collaboration between master and pupil. This is an unconventional picture in terms of its subject matter, which is not completely understood. The most accepted interpretation is that the scene depicts an allegory of poetry. The lute played by one of the figures in the middle ground is a symbol of this literary form, as is the shepherd included in the background. The two nude women are thought to represent the **muses** who inspire the creative processes involved in composing poetry, their nudity separating them from the earthly realm in which the two men exist. One of the women collects water from a well, perhaps the Hippocrene fountain, the source of inspiration in Mount Helicon where the muses reside. Giorgione added an ethereal quality to the work by adopting **Leonardo da Vinci**'s **sfumato** technique. He also borrowed Leonardo's palette of deep ochres punctuated by deep red and olive tones. The work elaborates on the scenes created by **Giovanni Bellini** where the landscape takes on an important role.

FICINO, MARSILIO (1433–1499). Priest, doctor, musician, translator of ancient texts, writer, philosopher, and key figure of the Renaissance. Marsilio Ficino enjoyed the patronage of the **Medici** rulers of **Florence**. While in the service of **Cosimo de' Medici**, Ficino translated the dialogues of **Plato**, making them available to the West for the first time and thus providing the essential texts for the revival of Platonism. With Cosimo's backing, he also established the Platonic Academy in Florence. His translations were followed by his own writing of the *Theologia Platonica* (1469–1474), *Concerning the Christian Religion* (1474), and *On the Threefold Life* (1489), works that seek to reconcile pagan philosophy with Christianity. In the 1480s and early 1490s, while working for **Lorenzo "the Magnificent" de' Medici**, he also translated the writings of Plotinus and Proclus, thus enlightening his followers on the **Neoplatonists** from antiquity. At Lorenzo's court, Ficino was one of

those learned members who, along with **Sandro Botticelli**, the young **Michelangelo**, and the poet Angelo Poliziano, shaped the character of Renaissance intellectual and cultural life.

FILARETE, ANTONIO (ANTONIO AVERLINO; c. 1400–1469). **Florentine** architect and sculptor who began his career in **Rome**. There, Filarete executed the bronze doors of Old **St. Peter's**, a commission that proved to be a major fiasco, forcing him to leave the city. He arrived in Milan in 1456 where he immediately set out to work on the design of the Ospedale Maggiore, until recently the city's principal hospital. In 1461–1464, Filarete wrote a treatise in which he described an imaginary city called Sforzinda in honor of his patrons, the **Sforza** rulers of Milan. Filarete based the social structure of Sforzinda, where some **vices** are tolerated and harmony resides, on **Plato**'s descriptions in the *Laws* of every aspect of city and suburban life. **Giorgio Vasari** qualified Filarete's treatise as the most ridiculous book ever written. Regardless of his assessment, the text is of significance to the history of architecture as it exerted great influence on the architectural experiments with **centrally planned** structures of **Leonardo da Vinci** and **Donato Bramante**, also employed by the Sfoza in Milan. It also provides insight into Renaissance attitudes toward urban planning.

FIORENTINO, ROSSO (GIOVANNI BATTISTA DI JACOPO; 1495–1540). Italian **Mannerist** painter; called *Rosso* (red) by his contemporaries for his red hair. Rosso Fiorentino was the pupil of **Andrea del Sarto** and a close friend of his fellow student **Jacopo da Pontormo**, the two becoming the leading masters of the Mannerist movement. The *Descent from the Cross* (1521; Volterra, Pinacoteca) Rosso painted for the Cathedral of Volterra in fact relates to Pontormo's version in the Capponi Chapel in the Church of Santa Felicità, **Florence** (1525–1528), in that it too features an oval composition with a void in the center and includes figures in extreme anguish. Particular to Rosso's style is the harsh lighting dividing the figures' anatomy and drapery into facets. Like all Mannerists, Rosso looked to **Michelangelo** for inspiration. The pose of his dead Christ in this painting is based on Michelangelo's *Pietà* (1498–1499/1500) at the Vatican. Further, Rosso's *Moses Defending the Daughters of Jethro*

(c. 1523; Florence, **Uffizi**) borrows from Michelangelo's *Brazen Serpent* on the **Sistine ceiling**, Vatican (1508–1512). This scene depicts a group of Midianite shepherds taking the water the daughters of Jethro drew from a well to give to their flock. Moses, who witnesses their transgression, drives the Midianites away and recovers the water, an action that results in his marriage to Zipporah, one of Jethro's daughters. The painting shows the scene from an unusual viewpoint. Michelangelesque nude males in contorted poses jut out at the viewer, some cropped by the frame—anti**classical** elements that mark the work as Mannerist.

In 1523, Rosso moved to **Rome**, but was forced to flee in 1527 due to the **sack** by imperial forces. To this period belongs his *Dead Christ with Angels* (1525–1526; Boston, Museum of Fine Arts), painted for the Florentine bishop Leonardo Tornabuoni, which borrows its composition from Michelangelo's Florentine *Pietà* (c. 1550; Florence, Museo dell' Opera del Duomo) and abandons Rosso's earlier facetted forms and harsh tonalities and lighting. After wandering through Umbria and Tuscany for some time, Rosso finally settled in France in 1530 where he worked for **Francis I** in the Palace of Fontainebleau. There, along with **Francesco Primaticcio**, he founded the Fontainebleau School, a French version of Italian Mannerism.

FLAGELLATION. The Flagellation is the moment when Christ, after having appeared before Pontius Pilate, is tied to a column and beaten with whips—a scene often depicted in art. Examples include **Lorenzo Ghiberti**'s *Flagellation* on the **east doors** of the **Baptistery of Florence** (1403–1421); **Fernando Gallego**'s in the Museo Diocesano, Salamanca (c. 1506); **Jaime Huguet**'s in the Louvre, Paris (1450s); Sebastiano del Piombo's in San Pietro in Montorio, **Rome** (1516–1521); and **Caravaggio**'s in the Museo Nazionale di Capodimonte, Naples (1607).

FLANDES, JUAN DE (c. 1460–1519). Flemish painter who was active in Spain and who may have received his training in Antwerp. In 1495, Juan de Flandes was sent to the Spanish court by Holy Roman Emperor **Maximilian I** to render the likenesses of the royal children. Among these is the *Portrait of an Infanta* (1496; Madrid, Museo Thyssen-Bornemisza), believed to represent Catherine of Aragon as

a child. In 1496, Queen Isabella of Spain appointed Flandes court painter. For the queen, he created the so-called *Polyptych of Isabel la Católica*, originally composed of 47 miniature panels, of which fewer than 30 survive, these scattered in various museums around the world. *Christ Crowned with Thorns* (c. 1498; Detroit, Institute of Arts) is one of those panels and presents a delicate rendition with luminous surfaces, typical of the miniaturist tradition. After Isabella's death in 1504, Juan de Flandes created **retables** for the chapel of the University of Salamanca and the Cathedral of Palencia, where he died in 1519.

FLIGHT INTO EGYPT. When Herod ordered the **massacre of the innocents**, an angel warned Mary and **Joseph** of the impending danger to the Christ Child. To ensure his safety, the holy couple took the boy to Egypt. In art, the scene is presented in various forms. Sometimes the **Virgin** and Child sit on a donkey led by Joseph, an image that grants an opportunity to portray the landscape, as in **Annibale Carracci**'s *Flight into Egypt* of 1603 (**Rome**, Galleria Doria-Pamphili), and **Melchior Broederlam**'s **triptych** for the Carthusian Monastery of Dijon (1394–1399), which combines the *Flight* with Christ's *Presentation in the Temple*. Other works show the Holy Family resting from their journey, as in **Lucas Cranach the Elder**'s *Rest on the Flight into Egypt* of 1504 (Berlin, Staatliche Museen) where angels comfort the Virgin and Child. **Caravaggio**'s rendition of c. 1594 (Rome, Galleria Doria-Pamphili) shows an angel playing music, the score held by Joseph, as Mary soothes the Christ Child to sleep. On a few occasions, artists depicted the return of the Holy Family from Egypt, as in **Nicolas Poussin**'s example in the Cleveland Museum of Art (c. 1627). Here Mary, Joseph, and an older Christ Child travel back to Nazareth on a barge.

FLORENCE. The history of Florence begins with the settlements of the Etruscans whose remains can still be found in the region. In 59 BCE, Julius Caesar gave the land of Florentia to his retired soldiers who, thanks to its primordial location near the Via Cassia and along the Arno River, were able to transform it into a flourishing city. By the early 13th century, in spite of strife between the **Guelfs** and the Ghibellines, Florence became one of the most prosperous and pow-

erful cities of Europe, its stable economy dependent on cloth manufacturing and **banking**. The **Ciompi Revolt**, carried out by day laborers in the cloth industry, paved the way for the **Albizzi** family to emerge as the rulers of an oligarchic political system. This coincided with the arrival in Florence of the **Medici** who, by the end of the 14th century, established a bank that gave them great wealth and allowed them to become one of the city's leading families. In 1433, **Cosimo de' Medici** led a political faction that opposed the Albizzi and was exiled for it, yet the faction was influential enough to have him recalled in the following year. The Albizzi were removed from power and Cosimo became the new ruler of Florence. Two more exiles interrupted Medici rule: the first in 1494 when Piero de' Medici ceded Pisa to Charles VIII of France, thereby angering the Florentines who were already riled up by the preachings of **Girolamo Savonarola**, and in 1527 when they were expelled from the city after the **sack of Rome**. Three years later, the imperial forces captured Florence and reinstated the Medici as hereditary dukes. In 1569, the Medici were made Grand Dukes of Florence, ruling the city in that capacity until 1737, when the family died out.

Key events in Florentine history include the Battle of Monteaperti of 1260 when the Sienese defeated the Florentine army, only to be under siege by Florence in 1554–1555 and finally taken in 1557. Pisa was able to ward off Florentine subjugation in the 1215 Battle of Montecatini, but in 1406 they were overtaken. One of the greatest enemies of Florence was Milan. On several occasions the Milanese forces tried to take over the city, but each time they were unsuccessful. A key moment in the struggle against Milan occurred in 1402; it seemed that Florence would fall to the enemy when **Giangaleazzo Visconti**, commander of the Milanese army, suddenly died. The **Battle of Anghiari** in 1440 led to victory against Milan, an event commemorated by **Leonardo**'s **fresco** in the Sala del Consiglio of the **Palazzo Vecchio**; **Michelangelo**'s *Battle of Cascina*, a conflict between Pisa and Florence in 1364 where the latter emerged victorious, is frescoed on the opposite wall. In 1478, the **Pazzi Conspiracy** took place, which resulted in the murder of Giuliano de' Medici and the wounding of his brother **Lorenzo "the Magnificent."** The conspirators were hunted down and severely punished for their transgression. In 1526, the League of Cognac, an alliance between Pope

Clement VII, Francis I of France, **Venice**, Florence, and Milan was formed to drive imperial power out of Italy. In retaliation, the imperial forces of **Charles V** invaded **Rome** in 1527, and burned and sacked the city, for which the Medici were exiled. It was the 1530 Battle of Gavinana that resulted in the capture of Florence by the imperial forces and the installation of Alessandro de' Medici as hereditary Duke of Tuscany.

Florence is the cradle of the Renaissance and much of it is owed to the Medici, as it was under their patronage that many of the key figures of art, culture, and science worked, among them the artists **Donatello, Filippo Brunelleschi, Sandro Botticelli**, Michelangelo, **Giorgio Vasari, Giovanni da Bologna**, and **Agnolo Bronzino**, the humanist **Poggio Bracciolini**, the philosopher **Marsilio Ficino**, the satirist **Pietro Aretino**, the poet Angelo Poliziano, and the astronomer Galileo Galilei. The Medici also played an important role in the Renaissance revival of ancient texts. Under Cosimo's patronage, Ficino translated a number of ancient manuscripts from the Greek, making them available for the first time in the West. In 1439, Cosimo established the Platonic Academy where Ficino taught. The religious orders that settled in Florence also contributed to the cultural fabric of the city and its growth. They erected churches, convents, and monasteries throughout, and then commissioned artists to decorate these spaces. **Arnolfo di Cambio**, for example, built **Santa Croce**, and **Fra Angelico** painted a series of frescoes in the **San Marco Monastery**. The chapels in the newly built churches were assigned to important families who then commissioned artists to embellish them. Santa Croce alone boasts the chapels of the **Bardi** and **Peruzzi, Bardi di Vernio**, and **Baroncelli** frescoed by **Giotto, Maso di Banco**, and **Taddeo Gaddi**, respectively. Florence lost its preeminence as center of culture and intellectual life in the **Baroque** era when the lead was taken by Rome.

FLORENCE, CATHEDRAL OF (1296–1350s). The Cathedral of **Florence** was begun by **Arnolfo di Cambio** in 1296. Twice the work was halted, first in 1310 when Arnolfo died, and later in 1348 when the **Black Death** struck. After contributions by **Giotto** and later **Andrea Pisano**, it was Francesco Talenti who in the 1350s brought the building to completion, except for the **dome** and façade (fin. 19th

century). When Talenti took over as Director of the Cathedral Works, he modified Arnolfo's plan to create a more imposing design, one that would outdo the **cathedrals of Siena** and Pisa, the enemies of Florence. Talenti used four massive square bays to form the **nave**, with aisle bays that measure half their width, and he designed an octagonal crossing (where the nave and **transept** cross), echoing its shape in the transept arms and **apse**. By commingling these octagons with a rectilinear nave, he in essence fused together a **central** with a **Latin cross plan**. For the exterior, Talenti chose color marble inlays that harmonize with the **Baptistery** only a few feet away. In the interior, he supported the Gothic arches of the nave arcade and the four-partite **vaults** with massive piers that grant a solid appearance. The crossing was to be covered by a large octagonal dome. However, the expanse was so vast (140 feet) that Florentines would have to wait until the 15th century to find an architect with the skills to build it. In 1420–1436, the task fell to **Filippo Brunelleschi** who, as **Giorgio Vasari** wrote, traveled to **Rome** to study and measure ancient structures, which is how he acquired the knowledge needed to build the cathedral dome. Inspired by the ancient prototypes, Brunelleschi devised a double-shelled construction over a skeleton of 24 ribs, only eight of which are visible from the exterior. A lantern allows light to enter the church and stabilizes the structure by preventing the outward tilting of the ribs. The first of its kind, Brunelleschi's design provided the light construction required to prevent the collapse of such a large dome. Now the landmark of Florence, the dome towers over the city and speaks, as it did in the Renaissance, of the civic pride of its citizens.

FLORIS, FRANS (1516–1570). Flemish **Mannerist** painter from Antwerp who established his workshop in 1540 after his return from a trip to **Rome**. One of his most important patrons was **William "the Silent" of Orange**; one of his most notable works is the *Fall of the Rebel Angels* (1554; Antwerp, Musée Royal des Beaux-Arts), once part of a **triptych** Floris rendered for the Fencer's **Guild** of Antwerp. The work presents a confusing mass of nude forms in dramatic movement, characteristic of his style, that recalls **Perino del Vaga**'s *Fall of the Giants* (c. 1529) in the Palazzo del Principe, Genoa. Floris was also a portraitist. His portrait *Falconer's Wife* (1558; Caen, Musée

des Beaux-Arts) presents a nonidealized heavy-set woman in monumental form, her facial expression revealing her personality. Among Floris' other works are the *Judgment of Paris* (c. 1548; Kassel, Staatliche Museen), the *Banquet of the Gods* (1550; Antwerp, Koninklijk Museum voor Schone Kunsten), and the *Head of a Woman* (1554; St. Petersburg, Hermitage Museum); this last is believed to be a study for a larger composition.

FORESHORTENING. A technique that allows artists to render on a flat surface compositional elements in such a way as to grant the illusion that they are receding into space. It entails reducing the dimensions of an object or parts of the figure to conform to the proper spatial relationship. So, for instance, when **Andrea Mantegna** painted his *Lamentation over the Dead Christ* (c. 1490; Milan, Brera), he shortened Christ's legs, arms, and thorax to place the viewer at his feet as one of the mourners. In Mantegna's ceiling in the **Camera Picta** (1465–1474; Mantua, Palazzo Ducale), similar adjustments to the figures grant the illusion that they stand on a parapet above the viewer. *See also DI SOTTO IN SÙ*; ONE-POINT LINEAR PERSPECTIVE.

FORLI, MELOZZO DA (1438–1494). Painter from Forli, a town in the Romagna region of Italy. Little is known of Melozzo's formative years, and scholarship on this master is complicated by the fact that much of his work has been destroyed. He was active in **Rome**, Loreto, and Urbino, where he worked alongside **Piero de la Francesca** in the court of **Federico da Montefeltro**. Giovanni Santi, **Raphael**'s father, wrote a poem in which he praised Melozzo for his unsurpassed ability to render **perspective**. This fact is demonstrated by the few works by Melozzo to have survived, including *Sixtus IV, His Nephews, and Platina, His Librarian* (1480–1481; transferred to canvas; now Rome, Pinacoteca Vaticana), one of the **frescoes** he created for Sixtus as part of the decorations of the pope's rebuilt and reorganized library at the Vatican. This scene, the earliest known papal ceremonial portrait of the Renaissance, unfolds in an audience room rendered in convincing perspective, with the pope enthroned and surrounded by his nephews, including Cardinal Giuliano **della Rovere** who later would become Pope **Julius II**, **Michelangelo**'s patron.

Kneeling in the foreground is Platina, the humanist who worked as the pope's librarian. He points to the inscription below the figures that extols his patron's achievements while the della Rovere oak branches, the papal family's heraldic symbols, are intertwined on the piers in the foreground. In 1481–1483, Melozzo also frescoed the **apse** in the Church of Santi Apostoli, Rome (fragments now in Vatican, Pinacoteca, and Rome, Palazzo Quirinale), a work that utilizes the *di sotto in sù* technique, an extreme form of **foreshortening**. Partially destroyed in the 18th century during the building's renovation, the scene, believed to have been commissioned by Cardinal Giuliano della Rovere, depicts Christ in Glory surrounded by windswept musical angels. Melozzo treated the apse as an outdoor space where a miraculous vision unfolds, with figures viewed from below that seem to float above the faithful. This work presages the illusionistic ceiling frescoes of the late 16th and 17th centuries that seem to break architectural boundaries.

FOUQUET, JEAN (c. 1420–c. 1481). The most important French painter of the 15th century, Jean Fouquet was born in Tours, perhaps the illegitimate son of a priest, as suggested by the fact that the artist applied in 1449 to have his birth legitimized by the pope. Nothing is known of his training. In the 1440s he was in **Rome**, where he painted the portrait *Pope Eugenius IV and His Nephews,* now lost, as related by **Antonio Filarete** in his architectural treatise. Fouquet was back in Tours by 1447. There he set up shop and remained until his death sometime around 1481, as indicated by the documented references in that year to his wife as a widow. His self-portrait, an enamel created in c. 1450 (Paris, Louvre) and signed with a large and elaborate calligraphy, is the earliest known Northern self-portrait that does not tie into any sort of religious theme. In about the same year, Fouquet also painted the *Melun Diptych* (Antwerp, Musée Royal des Beaux-Arts, and Berlin, Staatliche Museen), his most famous work. The bipaneled **altarpiece** shows the donor, Etienne Chevalier, King Charles VII's controller general, with his namesaint **Stephen** petitioning the **Virgin** and Child for his salvation. Some have suggested that the Virgin is a portrait of Agnes Sorel, the king's mistress who had involvements with Chevalier in governing the kingdom and who died in 1450. If this is in fact the case, then the work would be a

commemorative piece in her honor. The work shows Fouquet's characteristic abstract, rounded shapes, emphasis on clarity, and linear contours. Fouquet also created a number of manuscript illuminations, including the *Book of Hours* of *Etienne Chevalier* (1452–1460), now in the Musée Condé in Chantilly, and **Giovanni Boccaccio**'s *Des Cas des Nobles Hommes et Femmes Malheureuses* of c. 1458 now in Munich (Bayerische Staatsbibliothek; Cod. Gall. 369). *See also* ILLUMINATED MANUSCRIPT.

FOUR RIVERS FOUNTAIN, **PIAZZA NAVONA, ROME (1648– 1651).** The *Four Rivers Fountain* is the work of **Gian Lorenzo Bernini**, who received the commission from Pope Innocent X. Placed in front of the Church of Sant' Agnese and a few steps away from the pope's family palace, it incorporates an Egyptian obelisk that references the pagan era. Allegorical representations of the rivers Plata, Nile, Danube, and Ganges seated around the obelisk speak of the spread of Christianity over the four corners of the world and its triumph over paganism. The dove that surmounts the obelisk, one of the pope's emblematic symbols, signifies that triumph is achieved through his wise leadership. The sound and movement created by the water gushing from the irregular rocks that support the obelisk grant a celebratory mood to the work. The fountain was a major feat of engineering because the obelisk is only held by the corners, the rest floating in midair, an element Bernini would later apply to his *Cathedra Petri* (1657–1666) at the Vatican, the reliquary that holds the throne of **St. Peter**.

FRA ANGELICO (FRA GIOVANNI DA FIESOLE, GIOVANNI DI PIETRO; c. 1400–1455). A **Dominican** friar, Fra Angelico became the leading painter of **Florence** in the 1430s. He was from Fiesole where he entered the Dominican monastery in c. 1418, and there he is believed to have **illuminated** some manuscripts, though none have been identified. Sometime in the 1430s, he moved to the **San Marco Monastery** in Florence where from 1438 until 1445 he painted a series of **frescoes** in the cells and corridors. He also created the *Linaiuoli Altarpiece* (1433; Florence, Museo di San Marco), his first major work. Commissioned by the Arte dei Linaiuoli, the **Guild** of Linen Merchants, the altarpiece shows an *Enthroned **Virgin** and*

Child flanked by St. Mark, to whom the monastery is dedicated, and **St. John the Baptist**, patron saint of Florence. **Masaccio**'s influence in this work is clear, especially in the rendition of the solid figures of the saints, their stern appearance, and the spatial depth. Fra Angelico substituted the gold background normally seen in traditional images of this type with a gold curtain. In so doing, he provided a fully developed, convincing space for his figures to occupy. His *Descent from the Cross* (1434; Florence, Museo di San Marco) was commissioned by Palla Strozzi for his funerary chapel in the Church of Santa Trinità, Florence, to stand alongside **Gentile da Fabriano**'s *Adoration of the Magi* (1423; Florence, **Uffizi**). This is the first Renaissance work to successfully integrate figures into a three-dimensional landscape. Characteristic of Fra Angelico is the compassionate portrayal of a tragic moment, reflecting the serenity and discipline required for a monastic existence. In 1443, Pope Eugene IV visited San Marco and two years later called the artist to **Rome** to work on the frescoes of the Chapel of the Sacrament at the Vatican (destroyed). For **Nicholas V** he created his last major commission, the frescoes in the pope's private chapel (the **Chapel of Nicholas V**, Vatican; 1448), rendering scenes from the lives of Sts. **Lawrence** and **Stephen**. Fra Angelico died in Rome in 1455 and was beatified in 1983.

FRANCESCA, PIERO DELLA (c. 1406–1492). Italian painter born in Borgo San Sepolcro in the Tuscan region to a family of leather merchants. Piero della Francesca was not only an artist but also a mathematician, geometrician, and theorist. He authored two treatises, one on **perspective** and painting and the other on geometry. The details of his training as painter are not completely clear, though it is possible that he studied with **Domenico Veneziano** whom he assisted on the now-lost **frescoes** in the Church of Sant' Egidio, **Florence**.

Piero's earliest work is the *Misericordia Altarpiece* (beg. 1445; San Sepolcro, Museo Civico), commissioned by the **Confraternity** of the Misericordia of San Sepolcro. The contract for the work stipulated that it had to be executed by Piero himself within three years. Piero ignored the stipulations and the work was completed by his assistants a decade later. He painted the *Baptism of Christ* in the London National Gallery (c. 1450) for the Chapel of San Giovanni in the Pieve of San Sepolcro, and the *Resurrection* (c. 1458), now in the

San Sepolcro Museo Civico, was originally intended for the San Sepolcro Town Hall. Piero's most extensive commission is the *Legend of the True Cross* in the Cappella Maggiore at the Church of San Francesco in Arezzo (c. 1454–1458), a complex cycle he painted for the Bacci family based on **Jacobus da Voragine**'s *Golden Legend*. Piero also worked in Rimini for **Sigismondo Malatesta**, painting his patron's portrait (Paris, Louvre) and frescoes in the *Tempio Malatestiano* in 1451. In the earlier years of the 1470s, he was in Urbino working for Duke **Federico da Montefeltro**. There he rendered the portraits of the duke and his wife, **Battista Sforza** (1472), inspired by ancient Roman coinage.

Piero conceived his figures and objects in geometric terms. He used cylinders for limbs, spheres for faces and eyes, and circles, triangles, squares, and rectangles for architecture. His simplified approach was greatly admired by the Cubists of the 20th century who employed a similar approach to the construction of their compositional elements. Like Domenico Veneziano, Piero used light instead of line to describe his forms. The vivid palette he employed, composed mostly of pastel colors, is also borrowed from his master.

FRANCIS I OF FRANCE (1494–1547). A member of the Valois dynasty, Francis I was the son of Charles d'Angoulême and Louise of Savoy. He received the title of Duke of Valois at the age of four. In 1514, he married Claude, the daughter of Louis XII and Anne of Brittany. As the Salic laws of France prevented women from ascending the throne, Francis became the king when Louis XII, his cousin, died (1515). Francis was involved in the Italian wars when Spain and France were vying for control of Northern Italy. In 1525, he was captured by Emperor **Charles V** who forced him to sign the Treaty of Madrid in which he renounced all claims to Italian territories and ceded Burgundy to Charles. As soon as he was released, however, Francis allied himself with **Clement VII, Venice**, Milan, and **Florence** (the League of Cognac) against the emperor. Francis was a humanist and his court became a major center of art and culture. The French **Jean Clouet** was his court painter. Francis also imported artists from other parts of Europe, including **Joos van Cleve, Benvenuto Cellini, Rosso Fiorentino, Francesco Primaticcio, Sebastiano Serlio**, and **Leonardo da Vinci**.

FRANCIS, SAINT (c. 1181–1226). Saint Francis was the son of a wealthy silk merchant from Assisi. Two visions persuaded him to renounce his wealth and to devote himself to the care of the ill and the needy. For this, his father disowned him. St. Francis soon developed a large following, resulting in the founding of the **Franciscan Order**. In 1209, the order received the approval of Pope Innocent III and, in 1219, St. Francis went to Egypt to convert Mohammedans to Christianity. There he met Sultan Malek al-Kamil but failed to effect his conversion. In 1223, St. Francis built a crèche at Grecchia, establishing a custom still carried out today at Christmas time. In 1224, while praying in Mount Alverna, the crucified Christ appeared to him and he received the stigmata (the wounds of Christ). St. Francis died in 1226 in Assisi and was canonized two years later.

The impact of St. Francis on religious life was huge, as was his influence on art. While most monks of his era lived in seclusion, he and his followers went out into the streets and preached love and compassion for the downtrodden. As a result, subjects in art changed from scenes of damnation to the infancy of Christ and the affection he and his mother, the **Virgin**, felt for one another. The **frescoes** in the **Arena Chapel** (1305) by **Giotto** and the scenes in **Duccio**'s *Maestà Altarpiece* (1308–1311; Siena, Museo dell' Opera del Duomo) exemplify this shift. The story of St. Francis was recorded by St. Bonaventure in the *Legenda Maior*. Considered the official text on the saint's life, the *Legenda* became the source for artists in the representation of the saint. The frescoes in the Lower Church of **San Francesco** in Assisi, attributed to Giotto, assiduously follow Bonaventure's text to instruct the faithful on the cult of the recently canonized saint. Giotto again used the text when depicting the life of St. Francis in the **Bardi Chapel** at **Santa Croce**, **Florence**, as did **Domenico del Ghirlandaio** when he painted the frescoes in the **Sassetti Chapel** in the Florentine Church of Santa Trinità.

FRANCISCAN ORDER. A mendicant order of friars established by **St. Francis** of Assisi in 1209 to minister to the ill and the needy. The rule of the order was confirmed in 1223 by Pope Honorius III. In 1212, St. Claire joined St. Francis and, in 1215, he established a convent and placed her as its superior, thus granting her the opportunity to found the Order of the Poor Claires, the female counterpart to the

Franciscans. In 1221, St. Francis also established the tertiaries (Brothers and Sisters of Penance), composed of lay individuals who embraced the Franciscan life without giving up marriage and family ties. The Franciscans contributed greatly to the development of Renaissance art. Their Church of **San Francesco** in Assisi is filled with **frescoes** by leading masters, including **Cimabue**, **Giotto**, and **Simone Martini**. Santa Maria dei Frari in **Venice** boasts works by the likes of **Titian**, and San Francesco in Borgo di Sansepolcro features the work of **Sassetta**. In **Florence**, the Franciscans built the Church of **Santa Croce** where the works of **Taddeo Gaddi**, **Maso di Banco**, Giotto, **Filippo Brunelleschi**, **Desiderio da Settignano**, and **Bernardo Rossellino** remain.

FRENCH ACADEMY. The French Academy was established in Paris in 1648 to prevent the city's **guild** from placing restrictions on artists. The founding members (the **Le Nain brothers**, **Laurent de la Hyre**, Charles Lebrun, and others) petitioned Louis XIV, then a child, for permission to establish said institution. Anne of Austria, the king's mother and regent, favored the suppression of guilds, so permission was granted. The purpose of the academy was to provide art instruction for students, live models to draw from, and lectures by specialists. In 1655 the king allocated a stipend for the academy's upkeep and gave its members the use of the Collège Royal de l'Université as headquarters. In the following year, the headquarters were moved into the Louvre Palace, and in 1661 a dictatorship was established under minister Jean Baptiste Colbert and Lebrun, who by now had become painter to the king. All artists in the king's service were required to join the academy or lose their privileges, and the king's tastes were imposed upon them. The basis for the academy's teachings now relied on **Nicolas Poussin**'s views that painting must appeal to reason, it must be intellectual, and cater to the well educated. Nature should not be imitated but improved upon, and only noble subjects with dignified figures and gestures should be rendered. With this, the original purpose of the establishment of the academy to provide artistic freedom was unfortunately lost.

FRESCO. A painting technique devised during antiquity to decorate the walls or ceilings of private and public buildings. It entails coating

the pictorial surface with a layer of coarse lime plaster (*arriccio*) on which the intended scene is drawn using red earth pigment (*sinopia*). The painting is then carried out in sections (*giornate*). Each section is covered with a layer of smooth plaster (*intonaco*) onto which pigments diluted in water are applied while the plaster is still wet. Once the plaster dries, the paint becomes a part of the wall. This technique creates a durable image that can last for centuries. Once the fresco is completed, touch-ups can be made using a *fresco secco* method where pigment is applied to the dried wall. This technique is less durable and in time can cause the paint to flake off.

FROMENT, NICOLAS (c. 1430–1490). Artist from the Provence region of France, born in Uzès and active in **Avignon**, where he died. Froment's earliest known work is the *Raising of Lazarus* (1461; **Florence, Uffizi**), thought to have been painted for the Convento del Bosco near Florence. It is not clear whether Froment visited Italy or if the painting was rendered in France and then shipped. The work shows a massive overcrowding of figures pushed close to the foreground and sharp, angular lines in the manner of **Robert Campin**. Froment's *Altarpiece of the Burning Bush* (1476; Aix-en-Provence, Cathedral of St.-Sauveur) is his best-known work. Painted for René D'**Anjou** who is included in the left panel, it presents the theme from the life of Moses that prefigures the **Immaculate Conception** of the **Virgin** and the Nativity of Christ.

FUNERAL OF PHOCION (1648; Paris, Louvre). Painted by **Nicolas Poussin**, the *Funeral of Phocion* depicts an episode related by Plutarch in his *Lives*. Phocion was an Athenian general who fought against Philip of Macedon. Against the wishes of the Athenians, he worked out a truce with the Macedonians and, as a result, was forced to poison himself with hemlock, his corpse banished from the city. In Poussin's work, Phocion's body is being carried out of Athens. In the story, he is later vindicated and given the burial of a hero within the city's walls. In a companion piece also by Poussin, the *Gathering of the Ashes of Phocion* (1648; Liverpool, Walker Art Gallery), the hero's wife collects his remains for proper burial. Poussin's treatment of the landscape in these works owes a debt to the landscapes of **Annibale Carracci** and **Domenichino**. As in his prototypes, Poussin

portrayed a nature tamed by man, with calculated parallel planes that recede into space balanced by the verticality of strategically placed trees. Poussin's **classicized** approach befits the ancient story of vindication and moral virtue.

– G –

GADDI, TADDEO (active c. 1328–1366). One of **Giotto**'s pupils, principal assistant, and most faithful follower. Cennino Cennini claimed in *Il libro dell' arte*, written in c. 1400, that Gaddi was also Giotto's godson and that he worked for him for 24 years. Taddeo's most important commission is the **Baroncelli Chapel** at **Santa Croce, Florence** (1332–1338), one of the largest in the church. The scenes here depict the life of the **Virgin**, her parents **Joachim** and **Anne**, and Christ. Some have suggested that Giotto provided the designs for the **frescoes** since the chapel's **altarpiece**, the *Baroncelli Polyptych*, is signed by him. The stained glass window in the chapel, which shows **St. Francis** receiving the stigmata (the wounds of the **crucified** Christ), is also by Taddeo. One of Taddeo's most ambitious works is the *Tree of Life* of c. 1340 in the **refectory of Santa Croce**, one of the earliest examples of refectory decoration. It depicts a complex genealogical theme related to the **Franciscan Order**, meant to inspire contemplation. Taddeo also worked as architect, providing plans for the rebuilding of the Ponte Vecchio and Ponte Trinità in Florence (destroyed in the 16th century) after the Arno River flooded in 1333.

GALLEGO, FERNANDO (c. 1440–c. 1507). The earliest Castilian painter to have a documented career. According to **Antonio Palomino**, Gallego was born in Salamanca, Spain. He may have visited the Netherlands and Louvain as denoted by the fact that his style has some affinity to that of **Dirk Bouts**. Gallego is known for his dramatic depictions of religious scenes, as demonstrated by his *Pietà* (1470s; Madrid, Prado) and *Flagellation* (c. 1506; Salamanca, Museo Diocesano). In 1468, he is documented in Plasencia and, in 1473, in Soria. The works he executed for the cathedrals in these two cities are unfortunately no longer extant. Gallego also painted the as-

trological **frescoes** on the ceiling of the University of Salamanca's library, one of the earliest astral cycles rendered in Spain.

GARDEN OF EARTHLY DELIGHTS (c. 1505–1510; Madrid, **Prado**). Created by **Hieronymus Bosch**, the *Garden of Earthly Delights* is a **triptych** that speaks of the consequences of immoral behavior. It shows in the central panel nude males and females indulging in worldly pleasures. To the left is the *Creation of Eve* in Eden and to the right a depiction of hell. Here, a monstrous figure devours and defecates the souls of sinners, a detail that has been recognized to stem from the *Visione Tondalus*, a medieval narrative provided by an Irish Benedictine monk known only as Marcus who resided in the Cistercian Monastery of St. James in Regensburg. When the panels are closed, the scene depicted is the third day of Creation. Several attempts have been made to explain fully the meaning of the work. One suggestion is that it relates to the beliefs of the Adamites, a sect that originated in the second century that advocated a return to the simplicity of life in the Garden of Eden. **Saint Augustine** described their practices in his writings, stating that the Adamites referred to their church as paradise, they rejected marriage as it did not exist in Eden, believed in sexual freedom, and worshiped in the nude. Others relate the work to the four stages of the alchemical processes, as the architectural forms in Bosch's painting resemble alchemical vessels.

GATES OF PARADISE, **BAPTISTERY OF FLORENCE (1425–1452)**. Executed by **Lorenzo Ghiberti**, the *Gates of Paradise* were the last set of bronze doors commissioned for the **Baptistery of Florence**. Initially, Ghiberti was asked to include 28 scenes from the Old Testament enclosed in **quatrefoil** fields to match his earlier **east doors** (1403–1424). The number was then reduced to 24 and finally to 10 panels. Also different is the fact that gilding was applied to the entire surface and the quatrefoil rejected in favor of quadrangular fields. The **prophets** and **Evangelists**, usually relegated to the lower panels, were here moved into small niches along the borders. These alternate with bust heads emerging from circular fields, one recognized as Ghiberti's self-portrait. The main scenes depict the biblical narrative from the Creation to the era of Solomon. These all utilize

the then newly introduced **one-point linear perspective** technique and diminished depth of carving in the background to further the illusion of depth. They also use the **continuous narrative** technique whereby several episodes of the same story are rendered on one pictorial field. Of the panels, the one to stand out is *Jacob and Esau*, in the center of the left door, which includes God's warning to Rebecca that conflict will plague the relationship of her unborn sons, the birth of the two boys, Isaac sending his son Esau to the hunt, and Jacob receiving Isaac's blessing. The scenes are coherently arranged along the panel, with a series of **classical** arches that recede believably into space, providing logical partitions between the various episodes. Ghiberti's are the doors that face the walkway leading from the Baptistery to the **Cathedral of Florence**—in Italian, the *paradiso*. This inspired **Michelangelo** in the 16th century to coin the name *Gates of Paradise*. By this he meant that the doors were so extraordinary as to be worthy for use as the gates to heaven.

GENRE. A French term thought to have been coined in the 18th century by the philosopher and writer Denis Diderot to classify the paintings of French masters who depicted scenes from everyday life. This type of art did not rely on written sources, but rather it captured the daily routine of simple folk or the bourgeoisie. Genre scenes were particularly popular in the Netherlands where Protestant iconoclasm eliminated the need for devotional religious imagery. These works usually are filled with symbolic content that offer proper moral examples to viewers.

GENTILESCHI, ARTEMISIA (1593–1652). Artemisia was the daughter of **Orazio Gentileschi**, who trained her. Unlike other female artists of her era, she did not settle for lower genres but rather insisted on rendering mainstream scenes. Her favored subject was the female heroine, such as **Judith** and Lucretia. One of her earliest works is the *Woman Playing a Lute* (c. 1610–1612; **Rome**, Palazzo Spada), which she painted in Rome while in her teens. It shows her full command of the **Caravaggesque** vocabulary with a naturalistic figure emerging from the shadows to occupy most of the pictorial space. Her *Judith Slaying Holofernes* (1612–1613; Naples, Museo

Nazionale di Capodimonte) presents a tighter composition than Caravaggio's version (c. 1598; Rome, Galleria Nazionale d'Arte Antica), the subject one Artemisia would tackle on several occasions. In 1612, she was brutally raped by Agostino Tassi, one of Orazio's pupils. After a seven-month trial, Tassi served a short jail sentence and was ultimately acquitted. Some have viewed the Judith paintings as Artemisia's imagined revenge against her assailant. After the trial, Artemisia was married off to the **Florentine** artist Pietro Antonio di Vincenzo Strattesi, the relative of a key witness who testified on her behalf. The marriage did not last and soon Artemisia is documented living alone with her daughter Prudentia.

In Florence, she worked for Grand Duke Cosimo II de' **Medici** and, by 1620, she was back in Rome receiving commissions from both local and foreign patrons. She created her *Lucretia* (c. 1621; Genoa, Palazzo Cataneo-Adorno) for Pietro Gentile, a Genoese nobleman and collector. Like Artemisia, Lucretia was a victim of rape and chose to commit suicide rather than bring shame to her family. While most depictions of her story presented her plunging the knife into her chest, Artemisia preferred to capture her psychological struggle as she chooses between life and death. Artemisia's *Self-Portrait as the Allegory of Painting* (1630; Windsor, Royal Collection) is just as innovative. Rendered in Naples where she moved sometime before 1630, the work shows the artist caught in the frenzy of creation, leaning over to see her reflection in a mirror outside the painting.

While in Naples, Artemisia came into contact with the works of **Domenichino** and **Giovanni Lanfranco** who had introduced the **classical** vocabulary of **Bologna** to the region. This resulted in a change in her style. Her *Lot and His Daughters* (1640s; Toledo, Museum of Art) and *Corsica and the Satyr* (1640s; private collection) belong to this phase in her career. In these works, the figures, now slimmer and more graceful, are pushed back to reveal a fully developed background. Artemisia never left Naples, save for a three-year stay in the court of **Charles I** of England where her father was working. In a letter to one of her patrons she wrote, "And I will show Your Lordship what a woman can do!" This reflects her ambition in wanting to achieve the same fame as some of her male predecessors. Artemisia certainly attained her goal. While living, she became an international celebrity, a status she quickly lost after her death when she

fell into a long period of obscurity that lasted until 1989 when interest in her oeuvre was resurrected.

GENTILESCHI, ORAZIO (1563–1639). Italian painter, born in Pisa to a **Florentine** goldsmith. Orazio's first known work he executed at the age of 30, a **fresco** in the **nave** of Santa Maria Maggiore, **Rome**, where he moved in c. 1576–1578. He painted in the **Mannerist** style until c. 1600 when he was exposed to the art of **Caravaggio**. His *St. Francis Supported by the Angel* (c. 1605; Madrid, Prado), *Crowning of Thorns* (c. 1610; Braunschweig, Herzog Anton Ulrich-Museum), and *St. Cecilia and an Angel* (c. 1610; Washington, National Gallery) show mundane figures, pushed so close to the foreground that they occupy most of the pictorial space, with dramatic **chiaroscuro**—all Caravaggist elements. By the 1620s, Caravaggio's popularity in Rome had waned, and the **Bolognese** painters had taken the forefront. As a result, Orazio changed his style to conform to the taste of his patrons. He relocated to Genoa where he painted his famed *Annunciation* (c. 1623; Turin, Galleria Sabauda) that takes place in a fully developed domestic interior and grants greater delicacy and elegance to the figures. In 1624, Orazio worked in the French court of **Marie de' Medici** and, in 1625, he went to England to serve as court painter to **Charles I**. There he created for Queen Henrietta Maria, Charles' consort, an *Allegory of Peace* on the ceiling of the Great Hall in the Queen's House at Greenwich (1638–1639). Gentileschi died in England in 1639. *See also* GENTILESCHI, ARTEMISIA.

GEORGE, SAINT. A Christian knight who went to Libya to liberate its people from the dragon that terrorized them. To appease the dragon, the Libyans offered the daughter of King Servius as sacrifice. Saint George saved the princess, killed the dragon, and, in exchange, the Libyans agreed to be baptized. **Donatello**'s *St. George Killing the Dragon* (1415–1417; **Florence, Orsanmichele**), **Giovanni Bellini**'s scene of the same subject on the *predella* of the *Pesaro Altarpiece* (1470s; Pesaro, Museo Civico), and **Antonio Pisanello**'s *St. George and the Princess* (c. 1437–1438; Church of Sant' Anastasia, Verona) depict the moment when the saint rescues the woman from the beast. St. George endured a number of tortures for refusing to renounce his Christian faith. Each time, he miraculously emerged unscathed, until

his final martyrdom when he was dragged and beheaded. **Altichiero's frescoes** in the **Oratory of St. George** in Padua (1377) depict the life of the saint, including his baptizing King Servius and torture on the wheel.

GERUSALEMME LIBERATA. Epic poem written by **Torquato Tasso** between 1559 and 1575 while in the service of Duke Alfonso II d'**Este** of Ferrara; first published in 1581. It relates the recovery of Jerusalem by Christian knights from the Turks in 1099 during the First Crusade. Its main characters are the heroes Rinaldo and Tancredi, who are torn between fulfilling their duties and indulging in their love for Armida and Clorinda, respectively. Rinaldo is the son of Bertoldo, who established the d'Este clan; hence, the poem becomes a celebration of the Ferrarese ducal family's ancestry. The *Gerusalemme Liberata* enjoyed great success and became a source for artists. Both **Anthony van Dyck** (1629; Baltimore Art Museum) and **Nicolas Poussin** (1629; London, Dulwich Picture Gallery) painted a *Rinaldo and Armida*; **Guercino** (1618–1619; Rome, Galleria Doria Pamphili) and Poussin (1630; St. Petersburg, Hermitage; second version 1634, Birmingham, Barber Institute of Fine Arts) rendered *Tancredi and Erminia,* another character from the story who loves Tancredi; and Guercino painted *Erminia and the Shepherds* (1649; Minneapolis Institute of Arts).

GHENT ALTARPIECE **(c. 1425–1432; Ghent, Cathedral of St-Bavon).** The *Ghent Altarpiece* bears an inscription that states that Hubert van Eyck, "greater than whom none was found," began the work, and his brother **Jan,** "second in art," completed it on 6 May 1432. It also identifies the donor, Jodocus Vijd, the burgomaster of Ghent who is shown with his wife, Isabella Borluut, kneeling on the altarpiece's cover. They adore Sts. **John the Baptist** and **John the Evangelist,** both painted in **grisaille.** Above is the *Annunciation,* with **prophets** and **sibyls** on the **lunettes,** proper inclusions as these individuals foretold the coming of Christ. Mary and the angel wear white robes set against the natural flesh tones of their hands and faces, as if to denote that a slow transformation from sculpture to real flesh and blood is unfolding before our eyes. In its opened state, the altarpiece presents a rendering in brilliant colors that contrast with

the subdued tones of the exterior. The **apocalyptic** *Adoration of the Lamb* is featured below, and above are the enthroned God the Father, who wears the papal tiara; the **Virgin**; and St. John the Baptist, who are flanked by angels and the nude Adam and Eve, whose sin caused the need for Christ's incarnation. Inscriptions above Mary and John extol their virtues respectively as mother and forerunner of Christ, while God's benevolence toward humanity is communicated through the inclusion of pelicans in the cloth of honor behind him that tear their chests open to feed their young—a parallel to God giving up his own son for sacrifice to grant humans salvation. Above these figures are the *Offering of Cain and Abel* and *Cain Killing Abel* in grisaille, further references to sacrifice and the sin of mankind. The obsession with rendering every strand of hair, jewel, and other details point to the van Eycks' close tie to the miniaturist tradition. The discrepancy in the scale of the figures suggests the involvement of two different hands in the rendering of the work. Laboratory analysis has revealed that the panels were reworked (by Jan, if we take the inscription at face value) to provide visual unity.

GHENT, JOOS VAN (JOOS VAN WASSENHOVE; c. 1430– c. 1480). Netherlandish painter active in Italy. It is not clear where Joos was born or trained. He is known to have entered the painters' **guild** of Antwerp in 1460, to have moved to Ghent in 1464, where in 1467 he sponsored **Hugo van der Goes**' entry into the guild, and to have left for Italy sometime after 1468, where he remained for the rest of his life. In Italy, he worked as Giusto da Guanto, an Italian translation of his name. Joos' *Communion of the Apostles* (1472– 1474; Urbino, Galleria Nazionale delle Marche) is a work he painted in Urbino that is documented as having been commissioned by the **Confraternity** of Corpus Domini for the Church of St. Agatha and financed by Duke **Federico da Montefeltro**, the city's ruler. In fact, the duke and his son are included in the painting, in the right background. Based on this documented painting and its visual qualities, others have been attributed to Joos, including the *Adoration of the Magi* (c. 1460–1465; New York, Metropolitan Museum) and the *Crucifixion Triptych* (Ghent, Cathedral of St. Bavon).

GHIBELLINES. *See* GUELFS AND GHIBELLINES.

GHIBERTI, LORENZO (1378–1455). One of the leading sculptors of the Early Renaissance. Trained as a goldsmith, Ghiberti was also a writer. His *Commentarii* of c. 1447–1448 is an autobiography, the first written by an artist, that also includes analysis of earlier artwork. Ghiberti's career was launched when he entered the competition in 1401 for the execution of the **east doors** of the **Baptistery of Florence** (1403–1424) meant to harmonize with the south doors created earlier by **Andrea Pisano**. Ghiberti's *Sacrifice of Isaac* won him the competition as its **classicized** visual vocabulary was well suited for current tastes. Ghiberti spent two decades executing the east doors, now the north portals of the Baptistery.

From c. 1412 to 1416, Ghiberti was occupied with the statue of *St. John the Baptist* for one of the niches of **Orsanmichele**, **Florence**, a commission he received from the Arte della Calimala, the **Guild** of Refiners of Imported Woolen Cloth. Then the largest statue to be cast in bronze in Florence, the figure combines classical and Gothic elements. Here, Ghiberti depicted the saint to look like a living, breathing individual who stands in *contrapposto*, his intense gaze adding an aura of spiritual strength. While its verism was inspired by Greco-Roman prototypes, the sway in the saint's pose, the massive, undulating folds of his drapery, and the large clumps of hair and beard, all point to Gothic precedents. Not to be outdone by the Calimala, the Arte di Cambio (the Florentine Guild of **Bankers**) commissioned Ghiberti to execute for them the statue of *St. Matthew* also at Orsanmichele (1419–1421), stipulating that its size should equal that of the *St. John the Baptist*. Like Ghiberti's earlier statue, *St. Matthew* stands in elegant *contrapposto*, wears classical garb, and features an intense gaze, his Gospel book opened and turned to the viewer.

From 1417 to 1427, Ghiberti was also working on **relief** panels for the baptismal font in the **Cathedral of Siena** to which **Donatello** and **Jacopo della Quercia** also contributed scenes from the story of the Baptist. Ghiberti's *Baptism of Christ* for the font presents an *all' antica* rendition of the subject. All vestiges of Gothicism have been shed, including the heavy, undulating folds of the drapery. Instead, the figures are idealized, their draperies clinging to reveal the details of their anatomy. The extended arm of the Baptist, the clouds above the figures, and the angels who witness the event form an arched canopy above Christ to denote the religious significance of the event

depicted that resulted in the establishment of baptism as a sacrament. The depth of carving in this work diminishes as the compositional elements move away from the foreground, as they do in the ancient Greco-Roman reliefs Ghiberti evidently studied.

In 1425, Ghiberti received the commission for the final set of doors for the Baptistery of Florence. These are usually referred to as the *Gates of Paradise* (1425–1452) as they face the walkway leading to the **cathedral**, called the *paradiso* in Italian. The term was coined by **Michelangelo** who felt that Ghiberti's work was worthy of such an appellation. Ghiberti was responsible for inaugurating a new phase in Renaissance sculpture, one that depended on classical precedents and that established the visual language of the era.

GHIRLANDAIO, DOMENICO DEL (DOMENICO DI TOMMASO BIGORDI; 1449–1494).

Ghirlandaio was the son of a goldsmith who was noted for his ability to create gold garlands (*ghirlande*) worn by wealthy women, hence the nickname. Little is known of his training, though it is supposed that he learned metalwork from his father. By the 1480s his own workshop included the young **Michelangelo**. Ghirlandaio catered mainly to the **Florentine** merchant community. Early in his career, his protectors were the Vespucci, who in 1471 commissioned him to decorate their funerary chapel in the Church of Ognissanti, Florence. Among the **frescoes** in this chapel is the *Madonna della Misericordia* who shelters in her mantle members of the patron family, including the explorer Amerigo Vespucci. In 1480, the Vespucci again approached Ghirlandaio to paint a *St. Jerome* in the Ognissanti to compete with **Sandro Botticelli**'s *St. Augustine* (1480) in the same location. At the same time, Ghirlandaio painted a *Last Supper* in the church's **refectory**, a subject he was to repeat on a number of occasions, including in 1486 in the refectory at the hostel of the **San Marco Monastery**.

His reputation well established, in 1482 Ghirlandaio was called to **Rome** by Pope **Sixtus IV**, along with Botticelli and **Pietro Perugino**, to work on the wall frescoes in the **Sistine Chapel**. Ghirlandaio contributed the *Calling of Sts. Peter and Andrew*, when Christ asks the saints to follow him as his **apostles**. He also contributed a *Resurrection*, destroyed to make way for Michelangelo's frescoes on the **Sistine ceiling** (1508–1512). Upon his return to Florence, Ghirlandaio was

asked by Francesco Sassetti, a wealthy **banker**, to decorate his family chapel at Santa Trinità with scenes from the life of his namesaint, **Francis**. The **altarpiece** in the **Sassetti Chapel** depicts the Annunciation and Adoration of the Shepherds with Francesco and his wife, Nera Corsi, kneeling at either side. In 1485–1490, Ghirlandaio painted for Giovanni Tornabuoni, related by marriage to the **Medici**, a series of large frescoes in the Cappella Maggiore at **Santa Maria Novella**, Florence, depicting scenes from the lives of the **Virgin** and **St. John the Baptist** that include members of the Tornabuoni family. Among them, the *Massacre of the Innocents* is somewhat of an anomaly in Ghirlandaio's oeuvre. While most of his work is subdued and rather dispassionate, this scene is dramatic and full of movement. Inspired by battle scenes on Roman sarcophagi, the work presents an effective contrast between the brutality of the soldiers and the desperation of the victims.

Another work by Ghirlandaio with emotional content, though not as poignant as the *Massacre of the Innocents*, is his *Old Man and Young Boy* in the Louvre, Paris (c. 1480). The sitters in this painting have not been identified, though clearly it is a man and his grandson. Though the man's nose is deformed from rhinophyma, a condition that results in the build-up of excessive tissue, the child accepts him and shows his affection unreservedly. The honest portrayal of the figures, with every imperfection denoted, as well as the crisp landscape behind them, bears the influence of Early Netherlandish art that by now was well represented in Italian collections. *See also* ANNUNCIATION TO THE SHEPHERDS.

GIORGIONE (GIORGIO DA CASTELFRANCO; c. 1477–1510). Leading painter of the **Venetian** School. Little is known of Giorgione's career and only a handful of his works have been attributed to him firmly. He is thought to have studied with **Giovanni Bellini** and to have begun his solo career as a painter of small devotional representations of the Madonna and Child. This information comes from **Giorgio Vasari** who also related that Giorgione was influenced by **Leonardo da Vinci**, who had visited Venice in 1500, and that he was an accomplished singer and lute player, as well as a great lover and conversationalist.

The few works known with certainty to have been executed by Giorgione reveal his ability to place figures in poetic landscapes and

to grant an ethereal quality through his lush brushwork. In his *Allendale Nativity* (c. 1505; Washington, National Gallery), the landscape dominates the figures. Pockets of light illuminate the winding road taken by the shepherds who have come to adore the Christ Child, a feature that recalls **Andrea Mantegna**'s *Adoration of the Magi* (c. 1464; **Florence, Uffizi**) painted for Ludovico **Gonzaga** for his private chapel. As in Mantegna's example, the Holy Family is shown at the mouth of a dark cave, a reference to the Holy Sepulcher where Christ will be buried after the **Crucifixion**. Giorgione's *Enthroned Madonna with Sts. Liberalis and Francis*, also known as the *Castelfranco Altarpiece* (c. 1500–1505; Castelfranco, Cathedral), is his only surviving altarpiece. It again shows the influence of Mantegna, as well as that of Giovanni Bellini, in that the **Virgin** and Child are elevated on a high throne, with a cloth of honor that pushes them forward and separates them from the background landscape. The work also demonstrates Giorgione's awareness of **Pietro Perugino**'s art, particularly the serene quality of his scenes, his pyramidal compositions, and the elegant poses of the figures with their exaggerated sway.

Giorgione's *The Tempest* (1500–1505; Venice, Galleria dell' Accademia) is one of his best-known works and also the most enigmatic. Art historians have offered interpretations that vary from mythological to allegorical to political. What is recognized unanimously is that this is the earliest known example of a sensuous nude figure in a landscape, a subject that would be favored by later Venetian masters. Giorgione's *Fête Champetre* (c. 1510; Louvre, Paris) and *Sleeping Venus* (c. 1510; Dresden, Gemäldegalerie) also present examples of the nude in the landscape. These two works are believed by some to have been completed or completely rendered by **Titian**, Giorgione's pupil. The *Sleeping Venus* is the first of many reclining female nudes and would inspire similar compositions not only by Titian but also **Lucas Cranach the Elder**, **Diego Velázquez**, **Peter Paul Rubens**, François Boucher, Francisco Goya, Jean-Auguste-Dominique Ingres, Edouard Manet, and others.

GIOTTO DI BONDONE (c. 1267–1337). The first Italian painter to attain international fame, Giotto is considered the father of the Renaissance. He was born to a peasant family in the village of Colle di Vespignano in Tuscany. **Lorenzo Ghiberti** wrote that, as a young

shepherd boy, Giotto drew a sheep on a rock when **Cimabue**, then the most prominent artist of **Florence**, passed by. Recognizing the boy's skill, Cimabue asked Giotto's father permission to take him in as his pupil. The exact dates of Giotto's apprenticeship with Cimabue are unknown, though it must have ended in c. 1280 when Cimabue was called to Assisi to work on the **apse** and **transept frescoes** in the Upper Church of **San Francesco**.

In the mid-1280s Giotto was in **Rome** creating the *Crucifixion* for the Church of Aracoeli (c. 1285–1287), painted in the manner of Cimabue with Christ's body sagging and bleeding, and, on the **apron**, the **Virgin** and **St. John** grieving. While in Rome, Giotto also painted a fresco in the right transept at Santa Maria Maggiore depicting a floral frieze, medallions showing the busts of **prophets** holding scrolls, and an arcade with small **foreshortened** arches. In c. 1287, probably at Cimabue's recommendation, Giotto went to work at San Francesco, Assisi, where he contributed 28 scenes from the life of **St. Francis** (some have debated the attribution and chronology of these scenes). Then, in c. 1300, he returned to Rome to work for **Boniface VIII**, rendering a fresco, now badly damaged, of the pope addressing the crowds. By 1301, he was back in Tuscany, and in 1305 he received the **Arena Chapel**, Padua, commission from Enrico Scrovegni, his best-known and best-preserved work.

In 1306, the pope moved to **Avignon**, France, and Giotto lost his papal patronage. The Roman Cardinal Jacopo Stefaneschi, who continued the patronage of works of art destined for Old **St. Peter's** in spite of the pope's absence, provided the artist with further commissions. In c. 1307, Giotto designed for the cardinal a large **mosaic** for the façade of the courtyard in front of the basilica that depicted the *Navicella* (only fragments have survived), the scene where Christ walks on water to save **St. Peter** from drowning. He also rendered the *Stefaneschi Altarpiece* (c. 1307; Vatican Museum) for the canon's **choir** in the basilica. In the 1320s Giotto was back in Florence painting frescoes in four chapels in the **Franciscan** Church of **Santa Croce**. Of these, only the **Bardi** and **Peruzzi** remain. The Bardi Chapel depicts scenes from the life of St. Francis, arranged along the walls in three levels. The Peruzzi Chapel shows the lives of Sts. **John the Baptist** and John the Evangelist. From 1328 to 1334, Giotto was in Naples in the court of King **Robert D'Anjou**. Chronicles inform

us that his work there centered on the decorations of Castel Nuovo, the king's residence, that are no longer extant.

A late work by Giotto (and assistants) is the ***Baroncelli Polyptych*** (c. 1332–1338; Florence, Santa Croce), a five-paneled altarpiece commissioned by the Baroncelli family for their chapel at Santa Croce that features the ***Coronation of the Virgin*** in the center and saints and musical angels on the lateral panels. To this same period belongs Giotto's design for the **Campanile** of the **Cathedral of Florence** (1334–1337), recorded in a tinted drawing on parchment in the Museo dell' Opera del Duomo in Siena. When Giotto returned to Florence from Naples in 1334, he was appointed Director of the Cathedral Works, considered a great honor, and immediately set out to work on the Campanile. Under Giotto's direction, the foundation was laid and the first story built. The project was temporarily halted in 1337 when Giotto died.

Giotto is buried in the Cathedral of Florence, then an unprecedented honor for an artist. An epitaph written by the poet Angelo Poliziano on his tomb reads: "I am the man who brought painting to life . . . whatever is found in nature may be found in my art." This epitaph truly expresses the genius of Giotto. In an era when the ***Maniera Greca*** was the style of choice, Giotto introduced a new mode of painting that required the empirical observation of nature and its phenomena, and its replication on the pictorial surface. Cennino Cennini in *Il libro dell' arte*, written in c. 1400, rightly proclaimed that "Giotto translated the art of painting from Greek to Latin."

GIUSTINIANI, MARCHESE VINCENZO (1564–1637). Italian art collector and connoisseur, best known as the patron of **Caravaggio**, a number of whose works he owned. Among these was the rejected version of Caravaggio's *St. Matthew and the Angel* (1602; destroyed in 1945) painted for the **Contarelli Chapel**, **Rome**, and the *Amor Vincit Omnia* (1601–1602; Berlin, Gemäldegalerie). Of Genoese descent, Giustiniani's family were the sovereigns of Chios, a station they lost in 1566 when the island was overtaken by the Turks. In that year, the young Giustiniani and his family moved to Rome where he eventually took up **banking** and became treasurer to the papacy. By the early decades of the 17th century, he and his brother, Cardinal Benedetto, had amassed a vast art collection that included approxi-

mately 600 paintings and 1,200 ancient sculptures. Giustiniani was also a writer whose essays on painting, sculpture, architecture, music, travel, and other topics were quite influential. In his expositions on painting, he was more democratic than **Giovan Pietro Bellori** when it came to assessing the merits of contemporary masters. While Bellori adulated the **classicism** of **Annibale Carracci** and balked at Caravaggio's naturalism and the **Mannerists'** distortions and ambiguities, Giustiniani felt that they all had something important to contribute to the art world.

GLORIFICATION OF THE REIGN OF URBAN VIII, **PALAZZO BARBERINI, ROME (1633–1639).** Commissioned by the **Barberini** from **Pietro da Cortona**, the *Glorification of the Reign of Urban VIII* shows Divine Providence commanding Immortality to crown the Barberini escutcheon, composed of bees contained in a laurel wreath held by Faith, Charity, and Hope. This main scene is enclosed in an illusionistic *quadratura* framework, partially concealed by fictive garlands, shells, masks, and other decorative elements. The scenes on the outer parameters of the **fresco** are mythological representations that refer to the pope's deeds: *Minerva Destroying Insolence and Pride* for his courageous fight against heresy, *Silenus and the Satyrs* for his ability to overcome lust and intemperance, *Hercules Driving out the Harpies* for his sense of justice, and *The Temple of Janus* for his prudence. The scene graces the ceiling of the Barberini Palace's grand salon and was meant to awe visitors and impart upon them its propagandist message. The dynamism of the scene, with its heavy **foreshortening** and elaborate allegorical content, had not been seen in art before. With this work, Cortona opened a new universe of possibilities in the field of ceiling fresco painting.

GOES, HUGO VAN DER (c. 1440–1482). Considered the most important Flemish master of the second half of the 15th century, Hugo van der Goes is believed to have been born in Ghent where he entered the painters' **guild** in 1467, with **Joos van Ghent** acting as his sponsor. In 1474, van der Goes became dean of the guild, and in 1478 he entered the Monastery of the Red Cloister in Soignes, near Brussels, as a lay brother. It is known that before entering the monastery van der Goes was involved in the designing of processional banners and

ephemeral commissions related to such events as the funeral of Philip the Good, the entry into Bruges of Charles the Bold, and Charles' marriage to Margaret of York.

Only approximately 15 paintings have been attributed to van der Goes and only the *Portinari Altarpiece* (c. 1474–1476; **Florence, Uffizi**) is firmly authenticated (by **Giorgio Vasari**). This work was commissioned by Tommaso Portinari, an Italian representative of the **Medici bank** in Bruges, who took the work with him upon his return to Florence, placing it in his chapel in the Church of S. Egidio. There, the work provided inspiration for Italian masters and an example of the Northern **oil painting** technique and vocabulary. It represents an *Adoration of the Shepherds* witnessed by members of Portinari's family. Hierarchic in the placement of the figures and their scale and filled with contrasting idealized and crude figures, the work presents an emotional rendition of the event. No less dramatic is the *Dormition of the Virgin* (c. 1481; Bruges, Groeningemuseum). Surrounded by the **apostles**, Mary, in the last moments of earthly existence and with eyes half opened, sees a vision of Christ surrounded by angels in a brilliantly lit spherical *mandorla*. Van der Goes suffered a mental breakdown in 1481, which made him melancholic and lethargic, and he died the following year. A fellow brother at the monastery named Gaspar Ofhuys left a written account of van der Goes' illness. Some scholars have attributed the emotive power of the master's paintings to his depression, which must have already manifested itself prior to his attack.

GOLDEN LEGEND BY JACOBUS DA VORAGINE (*LEGENDA AUREA*).

Jacobus da Voragine's *Golden Legend* is a collection he compiled in c. 1260 of legends of the saints worshiped during the Middle Ages. Its importance lies in the fact that it provides a glimpse of popular medieval religious thought. That the *Golden Legend* was read widely is attested by the approximately 900 manuscripts to have survived. With the introduction of the printing press, it became the most often printed book in Europe until the early 16th century. It has been suggested that the *Golden Legend* may have contributed to the **Reformation** because it revealed that many of the lives of the saints follow a formulaic narration. This led some to not only question whether these legends are in fact true but

also, therefore, the validity of sainthood as taught by the Catholic Church. For artists, the text provided a source for the depiction of saints, their stories, and attributes.

GONÇALVES, NUNO (active 1450–1471). The leading painter of Portugal in the 15th century and possibly the teacher of **Bartolomé Bermejo**, Gonçalves was appointed court painter to Alfonso V in 1450 and, in 1471, he was made the official painter of Lisbon. The only work known by him is the *Retable of St. Vincent* (c. 1460–1470; Lisbon, Museu Nacional de Arte Antiga), painted for the Convent of St. Vincent in Lisbon and financed by Prince Henry "the Navigator," son of King John I. The monumentality of the figures, their individualization, the brilliance of color, and the meticulousness in the rendering of details are all elements that influenced painting in Portugal until the 16th century.

GONZAGA FAMILY. The Gonzaga ruled Mantua from 1328, when Luigi Gonzaga was elected Captain General of the People, until 1708, when Mantua was seized by the Austrian **Hapsburgs**. In 1433, Holy Roman Emperor Sigismund gave Gianfrancesco Gonzaga the title of marquis, while in 1530 Emperor **Charles V** conferred the title of duke to **Federigo Gonzaga**. In 1531, Federigo married Maria Palaeologo, daughter of the Marquis of Monferrato, a territory Charles V ceded to Federigo in 1536 when the Palaeologo line ended. A branch of the Gonzaga family settled in France where they became the Dukes of Nevers and Rethelois. Upon the extinction of the Italian line in 1627, the French Gonzaga took over the rule of Mantua, but not before the French monarchs and the Hapsburgs contested the succession. The war between the two factions ended in 1631 with the Treaty of Cherasco, and the Dukes of Nevers and Rethelois were able to rule Mantua until their own extinction in 1708. The Gonzaga court was a major center of arts and culture. Among the artists who served the family were **Leon Battista Alberti**, **Andrea Mantegna**, **Correggio**, **Giulio Romano**, and **Peter Paul Rubens**. Among the literary figures were **Pietro Aretino** and **Torquato Tasso**.

GONZAGA, FEDERIGO II (1500–1540). Federigo **Gonzaga** succeeded his father, Francesco II, as Marquis of Mantua in 1519, and,

in 1530, he was conferred the title of duke by Emperor **Charles V**. In 1531, he married Maria Palaeologo, daughter of the Marquis of Monferrato, which gained Mantua that territory in 1536. Federigo was an able military commander. In 1521, as Captain of the Church, he was involved in the siege of Pavia and, in 1529, was appointed captain to the Imperial troops in Italy. Federigo was also a major patron, his passion for the arts inherited from his mother, **Isabella d'Este**, who was an avid art collector. As a child, Federigo was kept hostage at the Vatican in the court of **Julius II**, along with his father whose political inclinations did not accord with those of the pope. This coincided with the time when **Michelangelo, Raphael**, and **Donato Bramante** were working at the Vatican, which would have piqued Federigo's interest in art. Federigo was the patron of **Correggio** who rendered for him mythologies depicting the loves of **Jupiter**, including **Danaë** (c. 1531; **Rome**, Galleria **Borghese**), Ganymede, and Io (both early 1530s; Vienna, Kunsthistorisches Museum). **Giulio Romano** built for him the **Palazzo del Tè** (1527–34) and **frescoed** the Sala dei Giganti with his greatest painted masterpiece, the *Fall of the Giants* (1530–1532).

GOOD AND BAD GOVERNMENT, PALAZZO PUBBLICO, SIENA (1338–1339).

The *Allegory of Good and Bad Government* is a **fresco** in the Sala della Pace in the **Palazzo Pubblico**, Siena, painted by **Ambrogio Lorenzetti**. A fresco of huge proportions—so huge in fact that it cannot be photographed all at once—it was meant as admonition for the members of the Great Council, the Nine, who governed Siena from 1287 until 1355 and who met in this room. The fresco is composed of three scenes: the *Allegory of Good Government*, the *Peaceful City and Peaceful Country*, and the *Effects of Bad Government*. The *Allegory of Good Government* is on the wall that receives the most light. Here, an allegorical figure with orb and scepter, the Commune of Siena, is dressed in the city's black and white heraldic colors and enthroned. The **Virtues**, identified by inscriptions, surround him. Ambrogio utilized the same compositional arrangement as in **Last Judgment** scenes, with the allegorical Commune of Siena taking the place of the judging Christ and bound criminals to his left and good citizens to his right taking on the role of the

blessed and the damned. The figure of Justice, also enthroned and accompanied by Wisdom and Concord, stands out from the rest of the Virtues to stress the importance of governing justly and wisely. The scene leads to the *Peaceful City and Peaceful Country* where the effects of good government are clearly elucidated. The city, a portrait of Siena, is shown as a prosperous place where commerce, new construction, and education thrive. Men and their loaded mules pass through the city gates to bring produce for sale, houses are built, a school is in session, and citizens dance in the streets. On the city gates is the she-wolf suckling Romulus and Remus, denoting Sienese claim of descent from Remus. A hunting party passes through the gates that lead to the countryside, the first landscape to be rendered since the ancient era. It offers a panoramic view of cultivated, fertile lands filled with grain, olive trees, and grapevines. Above hovers Security with a man who hangs from the gallows for having disturbed the peace in one hand and a scroll that promises safety to those who live under the rule of the law in the other. On the darkest wall in the Sala della Pace is the *Effects of Bad Government*, now in poor condition. Utilizing the same formula as for the *Allegory of Good Government*, the demonic figure of Tyranny is enthroned and surrounded by War, Cruelty, Treason, Frenzy, and Discord. The city is shown pillaged, with criminals roaming, and the countryside as barren—the effects of poor rulership. The cycle's message to the Council of Nine could not have been conveyed more clearly. The Sienese expected their governing body to rule wisely to ensure prosperity in their city.

GOSSART, JAN (MABUSE; c. 1478–1532). Flemish painter from Maubeuge. Gossart may have trained in Antwerp where he is documented in 1503, the year he became an independent master. In 1507, he entered in the service of Philip of Burgundy in Walcheren, near Middleburg. In the following year, he went with Philip on a mission to the Vatican and, in 1517, to Utrecht where Philip was appointed bishop. While in **Rome**, Gossart sketched the ancient ruins and learned the Italian mode of painting, which was to have an immense impact on his art. This made him the first artist in Flanders to construct his images through the use of **one-point linear perspective** and to base his figures on ancient statuary and anatomical study.

Gossart's *St. Luke Painting the Virgin* (c. 1515; Prague, National Gallery) for the Church of St. Ronbout at Malines shows the protagonists in a fantasy architecture that is visibly **classical** in form, as are the reliefs and statuary decorating the backdrop. The heavy contrasts of light and dark and crisp outlines are part of the Italian vocabulary, even though the treatment of drapery still retains its Flemish flavor. Gossart's *Neptune and Amphitrite* (1516; Berlin, Staatliche Museen) is part of a mythological series he and the Italian Jacopo de' Barbari painted for Philip's castle of Suytborg. It represents the first classicized, idealized depiction of nudes in Flemish history. The work betrays the influence not only of Greco-Roman statuary but also of **Albrecht Dürer** and Philip's court sculptor, **Conrad Meit**, both influenced by Italian art and interested in the depiction of the sensuous nude form. Gossart's *Danaë* (1527; Munich, Alte Pinakothek) is a seminude figure occupying an apsidal **loggia**, the shower of gold falling upon her as she watches in amazement.

Gossart was also an accomplished portraitist. His portrait *Baudouin de Bourgogne* (c. 1525; Berlin, Staatliche Museen) shows the same clarity and plays of light and dark found in Italian portraits of the same period. The figure is set against a dark, undefined background, his form casting a shadow behind. His monumentality, coupled with the details of the costume and richness of textures, speak of the man's high social position. After Philip's death in 1524, Gossart entered in the service of Adolph of Burgundy. He died in 1532 in Middleburg where he had become a member of the city's religious brotherhood in 1509, and where he returned in the last years of his life to set up his own workshop. Gossart was a pioneer of Flemish art. The first to introduce the Italianate style to Flanders, he inaugurated the custom among Flemish masters to travel to Italy and learn from the art the region had to offer.

GOUJON, JEAN (c. 1510–c. 1565). Sculptor who dominated the field in 16th-century France. Goujon was deeply influenced by the Fontainebleau School established by **Rosso Fiorentino** and **Francesco Primaticcio**, as well as the art of **Benvenuto Cellini**, who was active in France from 1540 until 1545. Goujon arrived in Paris in 1544, and there he worked in collaboration with the architect Pierre Lescot. His *Pietà* (1544–1545; Paris, Louvre), originally part

of the rood screen in the Church of St. Germain l'Auxerrois, belongs to this period. The Fontainebleau **Mannerist** vocabulary is clearly seen in this work, particularly in the use of elegant elongated forms. The deep emotional content of the work is typical of Rosso's art, and the thin, closely arranged folds stem from Cellini. Goujon would again collaborate with Lescot at the Louvre in the 1550s, rendering the caryatids in the *Salle des Cariatides* and the sculptural decoration on the palace's west façade. Among Goujon's most celebrated works are the **nymphs** from the *Fountain of the Innocents* (1547–1549; Paris, Louvre), no longer in situ. The fluid lines and **classicized** forms in these **reliefs** again recall the art of the Fontainebleau artists. By the early 1560s, nothing else is heard of Goujon. He is believed to have traveled to **Bologna** and to have died there in c. 1565.

GOZZOLI, BENOZZO (1420–1497). A pupil of **Fra Angelico** whom he assisted in the **Chapel of Nicholas V** (1448) at the Vatican. Gozzoli was born in **Florence** to a tailor. In the 1450s, he worked in Montefalco, near Perugia, where he painted a cycle in the Church of San Fortunato, now in fragments. The **altarpiece** for the church's main **apse**, the *Madonna della Cintola* is now in the Pinacoteca Vaticana. Gozzoli also rendered **frescoes** at San Francesco di Montefalco that depicted the life of **St. Francis**, the church's patron saint. In 1456, he was in Perugia creating the *Madonna and Child with Saints* (Perugia, Galleria Nazionale dell' Umbria), and two years later in **Rome** rendering the frescoes in the Albertoni Chapel at Santa Maria d'Aracoeli (late 1450s), of which only a damaged *St. Anthony of Padua* has survived.

Gozzoli's most important commission is the fresco of the *Procession of the Magi* in the chapel at the **Palazzo Medici**, Florence (c. 1459). It reenacts a procession that took place once a year through the streets of Florence carried out by members of the city's most aristocratic **confraternity**, the Compagnia de' Re Magi, of which the **Medici** were members. In the work, the young **Lorenzo de' Medici** and his father, Piero de Gouty, are shown on horseback, and Gozzoli himself is included. He is the man with an inscription on his hat that reads *Opus Benotti* (*the work of Benozzo*). After this, Gozzoli went to Pisa and there he rendered a series of frescoes from the Old Testament in the Campo Santo (beg. 1469), damaged by bombing in 1944.

Gozzoli's works show his full command of **perspective** and his interest in rendering courtly scenes and in describing all the fine details of figures, objects, and backdrops. Also, the emphasis is on brilliant colorism and heavy gilding. Gozzoli died in 1497 while working in Pistoia, perhaps from the **plague**.

GRANDE MANIERA. The *grande maniera* (*grand manner*) was a term used by **Nicolas Poussin** to refer to the painting method he created based on his use of the **classical** Greek modes of music to express different moods. He developed this Theory of Modes in the 1640s, known from a letter he wrote to **Paul Fréart de Chantelou** explaining it. For him, the Phrygian mode was well suited for violent scenes such as battles, the Lydian for tragedies, the Ionic for joyous renditions such as festivals and bacchanals, and the Hypolidian for religious subjects. With this, Poussin systematized the depiction of emotions through facial expressions and body movement, resulting in well-planned and, at times, formulaic representations that, contrary to his intentions, lacked the expressiveness of his earlier paintings.

GREEK CROSS PLAN. This is a type of **central plan** shaped like a cross with four arms of equal length. The first Greek cross building of the Renaissance was **Leon Battista Alberti**'s *San Sebastiano* in Mantua (1460), built for Duke Ludovico **Gonzaga**. It was followed by **Giuliano da Sangallo**'s Santa Maria delle Carceri, Prato (1484–1492), and **Antonio da Sangallo the Elder**'s Church of the Madonna di San Biagio, Montepulciano (1518–1534). The ultimate Greek cross structure of the Renaissance was New **St. Peter's**, **Rome**, completed by **Michelangelo** in 1564 and inspired by **Donato Bramante**'s plan of 1506.

GREGORY XV (ALESSANDRO LUDOVISI; r. 1621–1623). Gregory XV was from a noble family from **Bologna**, where he was born in 1554. He received his doctorate in law from the University of Bologna in 1575. In 1612, he was appointed the city's archbishop and, in this capacity, he negotiated peace between Charles Emmanuel I of Savoy and Philip III of Spain, for which he was rewarded with the cardinalate in 1616. When he ascended the papal throne in 1621, he appointed his nephew, **Ludovico Ludovisi**, to the cardinalate, increasing

the family's income in great measure. It was Gregory who decreed that voting during papal elections be kept secret by using written ballots in an effort to eliminate external political pressures. He also was the founder of the Sacred Congregation of the Propaganda Fide, responsible for propagating the faith through missionary work, and for carrying out the **Counter-Reformation**. Gregory canonized **St. Theresa of Avila**, who had founded the Order of the Discalced Carmelites; **Ignatius of Loyola**, the founder of the **Jesuit Order**; Philip Neri of the Oratorians; and Francis Xavier, the disciple of Ignatius and an ardent Christian missionary.

Gregory did much to change the course of art in the 17th century. He favored the masters of the Bolognese School, which resulted in the popularization of their style at the expense of **Caravaggism**. Among the works created for Gregory and the Ludovisi are **Guercino**'s *Aurora* in the Casino Ludovisi, **Rome** (1621), a painting that symbolizes the dawn of a new era under the new pope's rulership. **Domenichino**'s portrait *Pope Gregory XV and Cardinal Ludovico Ludovisi* of 1621–1623 (Béziers, Musée des Beaux-Arts) he commissioned to commemorate the family's good fortune effected by his ascent to the throne.

GREGORY, SAINT (GREGORY THE GREAT; c. 540–604). St. Gregory was the son of a wealthy Roman patrician. He acted as prefect of **Rome** until 574 when he converted his home into a monastery (St. Andrew) and became a monk. In 578, Pope Pelagius II appointed him one of the seven papal deacons. Pelagius died of the **plague** in 590 and Gregory was elected in his place. Well known for his charitable acts, Gregory negotiated peace with the Lombards and persuaded them to spare Rome from invasion. He effected the conversion of England to Christianity and was among the first to assert the supreme authority of the papacy. Gregory was the author of various treatises, most notably the *Dialogues*, which relates the lives of Italian saints as well as visions and miracles. The Gregorian chant is a product of his additions to church liturgy. Considered one of the Latin Doctors of the Church, Gregory was canonized by public demand immediately upon his death. He is included among the Doctors of the Church in the lower panels of the **east doors** of the **Baptistery of Florence**, executed by **Lorenzo Ghiberti** in 1403–1424. He is also

the subject of **Andrea Sacchi**'s *St. Gregory and the Miracle of the Corporal* (1625–1626; Vatican, Pinacoteca) where the cloth used to wipe the chalice bleeds when he pierces it with a dagger and a bewildered nonbeliever sinks to his knees as he witnesses the miraculous event. **Francisco de Zurbarán** rendered Gregory (1626–1627; Seville, Museo Provincial de Bellas Artes) standing against a dark background wearing his ecclesiastic vestments and reading from an **illuminated manuscript**, the ideal picture of the scholar saint.

GRIEN, HANS BALDUNG (c. 1484/1485–1545). German painter who received his training in Nuremberg from **Albrecht Dürer**. Grien was born into a family of academics from Schwäbisch-Gmünd. By 1500, he is documented in a workshop in Strasbourg, and in Nuremberg by 1503. He is known to have completed two **altarpieces** for the Cathedral of Halle (1507), specifically the *Three Kings Altarpiece* (Berlin, Gemäldegalerie) and *St. Sebastian* (Nuremberg Museum), as well as stained glass and book illustrations in Freiburg, where he spent five years. In Freiburg, he also was charged with the cathedral's altarpiece (1512), a polyptych with scenes from the infancy of Christ and his **Passion**. The macabre figures prominently in Grien's art, as exemplified by his *Three Ages of Woman and Death* (1509–1511; Vienna, Kunsthistorisches Museum) and *Death and the Woman* (c. 1517; Basel, Kunstmuseum). Grien's interest in the supernatural is best revealed in his woodcuts, including his *Witches* of 1510, one of many representations of these characters of the occult.

GRISAILLE. A painting executed in monochrome (usually gray) to replicate the appearance of stone sculpture. In Netherlandish **altarpieces**, saints painted in grisaille usually figure on the shutters. When the altarpiece is opened, these exterior panels provide a contrast to the brilliantly colored interior scenes. An example is the *Ghent Altarpiece* by **Jan van Eyck** and his brother Hubert (c. 1425–1432; Ghent, Cathedral of St.-Bavon) where Sts. **John the Baptist** and **John the Evangelist** are painted in grisaille and therefore made to look like statues occupying Gothic niches. Similarly, **Hans Memlinc**'s *Last Judgment Triptych* (1473; Danzig, Muzeum Pomorskie) shows the donors on the outer panels kneeling in front of grisaille figures of the **Virgin**, Child, and St. Michael. In Italy, *quadratura* ceil-

ings often include figures in grisaille to imitate the sculpture that then adorned contemporary architecture. In **Annibale Carracci**'s **Farnese ceiling** (c. 1597–1600; **Rome**, **Palazzo Farnese**), for example, herms painted in grisaille support fictive lintels adorned with shelled motifs to give the appearance of real architectural elements separating the various scenes.

GROTESQUES. Sculptural or painted decorations based on antique Roman prototypes used for the ornamentation of **grottoes**, hence their name. They are usually composed of human, plant, or animal forms that can be either fantastic, playful, or ominous. This type of decoration was reintroduced in the 1490s when Emperor Nero's *Domus Aurea* [*Golden House*] in **Rome**, decorated with fantastic grotesques rendered in brilliant colors and gilded, was rediscovered. Several artists, including Pinturicchio, **Alexander VI**'s favorite painter, lowered themselves with ropes to view the Neronian decorations. Pinturicchio then decorated Alexander's apartments in the Vatican Palace with grotesque ornamentations (1492–1494).

GROTTO. Fantasy-type structure used to decorate a garden, as exemplified by the grotto in the Boboli Gardens, **Florence**, created for the **Medici** by **Giorgio Vasari** and Bernardo Buontalenti (1556–1560; façade 1583–1593). This **Mannerist** edifice presents a fusion of art and nature. Pumice stalactites mingle with **classical** motifs to create a structure that seems to have grown on the site rather than having been constructed. The interior is dark and cavelike. Again, pumice stone formations appear throughout. To enhance the effect of natural and man-made forms, outdoor scenes were **frescoed** on the walls while **Michelangelo**'s caryatid-like figures support the weight of the **vault**. In the deepest portion of the interior is a fountain with a statue of a nude **Venus** by **Giovanni da Bologna** that seeks to recreate the birth of the goddess from the sea foam. The bizarre forms of Renaissance grottoes have earned them the appellation in Italian of *bizzarrie*.

GRÜNEWALD, MATTHIAS (MATHIS GOTHART NEITHART; c. 1470/1475–1528). Along with **Albrecht Dürer**, Grünewald was the greatest artistic genius of Renaissance Germany. He was practically unknown until the 20th century when his identity and works

were finally rediscovered. Of his paintings, only approximately a dozen have survived. Grünewald was court painter to Uriel von Gemmingen, the archbishop of Mainz, and his successor, Albrecht von Brandenburg. A document of 1510, the earliest relating to the artist, refers to him as a designer of waterworks. In the following year, Grünewald was supervising the building of Aschaffenburg Castle for Archbishop Uriel, and, in 1517, he was painting an **altarpiece** for Heinrich Reitzmann, canon of the Church of Aschaffenburg. Other known documents on Grünewald are records of payment for three altarpieces he painted in Mainz in 1524–1525, lost in a storm when the Swedes carried them off by boat after their conquests in Germany. In 1525, Grünewald left von Brandenburg's service and went to Halle where he died in 1528.

The *Mocking of Christ* (1503; Munich, Alte Pinakothek) is Grünewald's earliest dated work. Rendered for the Church of Aschaffenburg, it already features what will become one of the main characteristics of the master's style—deep emotionalism that evokes pity toward the victimized Christ, here achieved through the crowding of figures and the scornful expressions of the tormentors. Grünewald's *Isenheim Altarpiece* (fin. 1515; Colmar, Musée d'Unterlinden) epitomizes his ability to evoke emotive responses from viewers. In its closed state, the work presents the **crucified**, broken, and bloodied body of Christ with **St. Mary Magdalen** kneeling at his feet in desperate agony. In its open state, the altarpiece includes the *Resurrection*, where Christ is shown as having recovered from his wounds, now a handsome, healthy figure rising to heaven while surrounded by a magnificent halo of yellow and red. The image clearly provides a ray of hope to those who suffer, a fitting subject as the altarpiece originally stood in the chapel of the commandery of the Hospital Order of St. Anthony in Isenheim. Grünewald's *Stuppach Madonna* (c. 1517–1520; Stuppach, Parish Church) may be the central panel for Reitzmann's altarpiece. It presents the **Virgin** and Child in a playful moment, their faces lit by the joy they experience. Next to them are prominently displayed lilies, symbols of the Virgin's purity. Behind are a garden, rainbow, and cathedral, this last denoting that Mary is here depicted as *Ecclesia*, the Church.

Grünewald's works convey meaning through gestures, distortions, grimaces, and resplendent colorism and light. His back-

grounds are there not to locate the work in a certain specific setting but rather to add to the spiritual drama of his scenes. His works are either full of tragedy or full of joy. He was among those few masters who was able to communicate through visual language the complexities of human emotion and hope for an afterlife that offers succor from the pain of living.

GUELFS AND GHIBELLINES. The names of Italian political factions deriving from the German *Welf*, the family name of the Dukes of Bavaria, and *Waiblingen*, the name of the castle of the Hohenstaufen Dukes of Swabia. The terms were first used in 1235 during the conflict between Pope Gregory IX and Emperor Frederick II Hohenstaufen. The Guelfs were supporters of the papacy and belonged to the merchant class, while the Ghibellines, feudal land owners, sided with the emperor. The rivalry of these two factions is of particular significance to the history of **Florence** where the Guelfs succeeded in removing the Ghibellines from power in the 1260s. The Guelfs destroyed the palace of the Ghibelline Uberti family and built on its site the **Palazzo Vecchio** (1299–1310) as their seat of government.

GUERCINO (GIOVANNI FRANCESCO BARBIERI; 1591–1666). The youngest member of the **Carracci** School. Guercino's appellation (in English, *squinter*) stems from the fact that he was slightly cross-eyed, which caused him to squint. He was born in Cento, not far from **Bologna**, and was essentially self-taught. In fact, contemporary sources indicate that Guercino had an academy of his own. In his formative years, he had the opportunity to study **Ludovico Carracci**'s *Cento Madonna* (1591; Cento, Museo Civico) and he also may have traveled to Bologna where he would have seen other works by the members of the Carracci School. Surprisingly, however, Guercino's early works show interest in **Caravaggist** naturalism, as his *Et in Arcadia Ego* (c. 1618; **Rome**, Galleria Nazionale d' Arte Antica) and *Samson Arrested by the Philistines* (1619; New York, Metropolitan Museum) exemplify.

In 1621, Guercino went to Rome, where he remained until 1623, working for the **Ludovisi**, Pope **Gregory XV**'s family. For them he painted his famed *Aurora* in the Casino Ludovisi (1621), a **vault**

fresco in a *di sotto in sù* technique and *quadratura* framework inspired by **Annibale Carracci's** *Triumph of Bacchus* in the center of the **Farnese ceiling** (c. 1597–1600; **Palazzo Farnese**). Completely dependent on the *Iconologia* by Cesare Ripa for the attributes of its allegorical figures, the work speaks of the dawn of a new era in the papacy under Gregory XV's rule. In 1623, Guercino also received the commission from the pope to paint one of his most important **altarpieces**, the *Burial of St. Petronilla* (1623; Rome, Capitoline Museum). A few months after its completion, the pope died and, having lost his patronage, Guercino returned to Cento.

Guercino's return to his hometown coincided with an abrupt change in his style. He abandoned all vestiges of the Caravaggesque mode and began utilizing a more **classicizing** vocabulary. His application of paint became less spontaneous, his blues and reds more intense, and his figures more idealized. His *Presentation in the Temple* (1623; London, National Gallery) and *Christ Appearing to the Virgin* (1628–1630; Cento, Pinacoteca Comunale) belong to this phase in his career. When **Guido Reni** died in 1642, Guercino, hopeful to take his place, moved to Bologna, where he did in fact become the leading master of the city. In Bologna, Guercino's art became even more idealized and permeated with a stillness that evokes meditation and devotion from the viewer, his *Circumcision* (1646; Lyon, Musée des Beaux-Arts) and *Marriage of the Virgin* (1649; Fano, Fondazione Cassa di Risparmio) providing two of the most outstanding examples. Guercino died in Bologna in 1666 after a long and fruitful career.

GUIDALOTTI CHAPEL, SANTA MARIA NOVELLA, FLORENCE (SPANISH CHAPEL; 1348–1355).

Used by the **Dominican** monks who lived in the monastery adjacent to the Church of **Santa Maria Novella** as their chapter house, this chapel was the burial site for members of the merchant Guidalotti family who charged **Andrea da Firenze** with its decoration. As they shared it with the monks, the **frescoes** depict scenes of significance to their order. In the center of the altar wall is a large *Crucifixion* flanked by the *Road to Calvary* and *Christ in Limbo*, while on the opposite entrance wall are scenes from the life of St. Peter Martyr, a 13th-century Dominican from **Florence** particularly venerated by the lo-

cals. One of these scenes presents the saint preaching in front of Santa Maria Novella. On the left wall is the *Apotheosis of St. Thomas*, also a Dominican, with the saint shown enthroned and flanked by **prophets** and **apostles**. At his feet are trampled heretics; below them are learned men from history, including Pythagoras and Euclid; above are the **Virtues**. On the right wall is the *Way to Salvation*, a fresco depicting Dominican doctrine and the activities its monks normally engage in, including preaching and converting nonbelievers. The **Cathedral of Florence** is prominently displayed within the composition with Pope Innocent VI, Emperor Charles IV, and Cardinal Giles Albornoz, a papal diplomat and Dominican, in front of it. Also included are black-and-white dogs, the *Domini canes* (God's dogs) who chase the wolves of heresy, a reference to the derivation of the name of the Dominican order. With these frescoes, the monks of Santa Maria Novella were reminded of their duties and provided with proper models to emulate.

GUILDS. Associations of individuals who practice specific trades, their purpose to control standards and maintain the monopoly of their activities. Although the concept of forming associations with members who share a particular interest had existed since antiquity, it was not until the late Middle Ages that guilds came to play a key role in the urban economy. In England, France, the Low Countries, Germany, and Italy the earliest medieval guilds were related to the textile industry. By the 13th century, France was completely dominated by the guild system, with every trade, including prostitution, well represented. In **Florence**, guilds were ranked according to the occupations of its members. The 7 Greater Guilds were those in prestigious professions, such as **banking**, law, and wool merchantry, while the 14 Lesser Guilds represented the smaller craftsmen and businessmen. In processions, the order in which these guilds participated depended on this hierarchy. In some cases, members of guilds took part in government. In 14th-century Florence, for instance, only guild members were eligible for civic office and, in **Venice** in 1310, members of the painter's guild were involved in the crushing of a rebellion against their government.

Guilds often generated art commissions. The Florentine Guild of Refiners of Imported Woolen Cloth, the Arte della Calimala, for

example, asked **Lorenzo Ghiberti** to render the statue of *St. John the Baptist* (1412–1416) for one of the exterior niches at **Orsanmichele**. The Guild of Linen Drapers and Peddlers, the Arte dei Linaiuoli e Rigattieri, commissioned from **Donatello** the *St. Mark* (1411–1413), and the Guild of Armorers and Swordmakers, the Arte dei Corazzai e Spadai, paid for his *St. George* (1415–1417), both in the same location. In the North, **Frans Floris** painted the *Fall of the Rebel Angels* (1554; Antwerp, Musée Royal des Beaux-Arts) for the Fencer's Guild of Antwerp and **Rembrandt** the *Anatomy Lesson of Dr. Tulp* (1632; The Hague, Mauritshuis) for the Surgeon's Guild of Amsterdam.

GUILLAIN, SIMON (1589–1658). The French sculptor Simon Guillain was born in Paris and trained with his father, Nicolas Guillain. He is known to have visited Italy where he remained for a while, returning to Paris in 1612. Very few works by Simon have survived. Of these, the most important is the royal monument he erected on the Pont-au-Change, Paris, in 1647 to serve as statement of French monarchic succession. Now dismantled, its principal figures housed in the Paris Louvre, the monument depicted the deceased **Louis XIII of France** ceding the regency to his wife, Anne of Austria, their young son Louis XIV standing between them and being crowned by Fame. The heavy draperies worn by the figures and the varying textures that add richness to the work are characteristic of Guillain's style.

– H –

HALS, FRANS (c. 1582–1666). Leading Dutch **Baroque** master who specialized in portraiture. Little is known of Frans Hals' life. He was born in Haarlem to a Flemish cloth worker from Mechelen who had moved to Holland when the Spaniards recaptured Flanders. Hals spent most of his life in his native city and there he trained with **Karel van Mander**. By 1610, he was a member of the **Guild** of St. **Luke** and an independent master. His *Shrovetide Revellers* (c. 1615; New York, Metropolitan Museum) presents a comical rendition of colorful theater characters who celebrate Mardi Gras by indulging in

food and drink. The three-quarter figures compressed into the foreground, their gesticulations, and the still-life elements on the table betray Hals' knowledge of the **Caravaggist** vocabulary. His *Banquet of the Officers of the St. George Civic Guard Company of Haarlem* (1616; Haarlem; Frans Halsmuseum) follows a well-established tradition of militia company portraiture, yet Hals infused the work with a dynamism never before seen in these types of representations. His *Married Couple* (1622; Amsterdam, Rijksmuseum) is thought to depict the artist himself and his wife, though some have suggested it is his brother Dirck Hals or his patron Isaac Massa and their respective brides. The work is based on **Peter Paul Rubens'** *Honeysuckle Bower* (1609–1610; Munich, Alte Pinakothek), which Hals might have seen during a brief trip to Antwerp in 1616. The *Laughing Cavalier* (1624; London, Wallace Collection) is an animated portrait rendered with choppy brushstrokes and seen from a worm's-eye perspective, typical of Hals' works. The *Officers and Sergeants of the St. Hadrian Civic Guard Company of Haarlem* (1633; Haarlem; Frans Halsmuseum) marks Hals' high point in his career as portraitist. As in his earlier militia portrait, the figures have been interrupted by the presence of the viewer, yet the vibrancy of the scene has increased in great measure, mainly due to the loose brushwork, the complex draperies, and the repetitive punctuations of color. By the time Hals rendered this work, he was one of the most sought-after portraitists in the Netherlands. A large number of works recording the likeness of members of the Dutch bourgeoisie by Hals have survived, among them *Nicolas Hasselaer* (1630–1635; Amsterdam Rijksmuseum), *Nicolas Woutersz van der Meer* (1631; Haarlem, Frans Halsmuseum), *Pieter van den Broecke* (c. 1633, London, Kenwood House), and *Isabella Coymans* (1650–1652; private collection). As Hals aged, his palette became more subdued, though the richness of his pictorial surfaces as a result of his choppy brushstrokes continued. Hals held his prominent artistic position until his death in 1666.

HAPSBURG, HOUSE OF. One of the major ruling houses of Europe whose history dates back to the 11th century. Their name derives from the Habichtsburg Castle in the former Duchy of Swabia, now Switzerland, where the family originated. In 1273, the Hapsburgs attained imperial power when Rudolf I was elected king of Germany.

By the 15th century, marriage alliances expanded the Hapsburg's monarchic rule to Austria, Spain, Portugal, the Low Countries, and Southern Italy. In 1521, Emperor **Charles V** split the Hapsburg empire into two, giving his brother Ferdinand I his Austrian dominion. The rest went to his son and successor, King **Philip II** of Spain. **Titian, Pieter Coecke, Bernard van Orley, El Greco, Juan Fernández de Navarrete, Alonso Sánchez Coello, Diego Velázquez**, and **Peter Paul Rubens** are among the artists who benefited from Hapsburg patronage.

HAWKWOOD, SIR JOHN (1320–1394). Known in Italy as Giovanni Acuto, Hawkwood was a British mercenary who commanded the **Florentine** army against Pisa. He was born in Essex, England, and began his military career in France. In 1364, he led the Pisan army in the war against Florence but, in 1377, after having served in the papal troops, he switched to the Florentine side, only to lose his life. While leading the Florentine army, Hawkwood was granted tax exemption and citizenship and, upon his death, he received the state funeral reserved for Florentine heroes. The Florentines also planned a large marble monument in his honor but the idea was abandoned when England reclaimed Hawkwood's remains. Hawkwood was finally memorialized in 1436 when **Paolo Uccello** painted a **fresco** in the **Cathedral of Florence** depicting the hero on horseback. The monochromatic palette Uccello used grants the illusion of a bronze monument, a fitting substitution for the earlier marble project. An inscription Uccello included in the fresco lauds Hawkwood as an able military commander. The work served to ascertain that Florence valued those who served it and bestowed upon them the highest honors.

HEEMSKERCK, MAERTEN VAN (1498–1574). Dutch master born in Heemskerck who worked with **Jan van Scorel** in Haarlem and Utrecht and who, like his master, traveled to **Rome** (1532) where he spent several years studying the works of the Italians. There, van Heemskerck created a number of drawings of antiquities and contemporary art that are invaluable as they record lost monuments, as well as the construction of New **St. Peter's**, which took place during his stay. In 1537, van Heemskerck settled in Haarlem where three years later he was appointed dean of the local **guild**. He remained

there for the rest of his life, save for a stay in Amsterdam from 1572
to 1573 when the Spaniards seized Haarlem. His *Family Portrait*
(c. 1530; Kassel, Staatliche Kunstsammlungen) he painted before his
departure to Rome and denotes the influence of van Scorel, so much
so that at one time it was attributed to the latter. His *St. Luke Paint-
ing the Virgin* (1532; Haarlem, Frans Halsmuseum), also created be-
fore his departure to Italy, presents **classicized** figures, though it was
not until van Heemskerck was exposed to Italian art firsthand that he
truly mastered this vocabulary. His *Entombment Triptych*
(1559–1560; Brussels, Musées Royaux des Beaux-Arts) demon-
strates his assimilation of the Italian **Mannerist** style, in particular
that of **Agnolo Bronzino.**

HELENA, SAINT (c. 250–c. 330). Saint Helena was the mother of Em-
peror Constantine the Great who, in 313, issued the Edict of Milan
that allowed Christians to practice their faith freely in the Roman Em-
pire. Helena converted to Christianity at the age of 63, built a number
of churches, and helped the poor and the sick. She also traveled to
Palestine, where she discovered the true cross on which Christ was
crucified. In **Piero della Francesca's** *Legend of the True Cross* in
the Cappella Maggiore at San Francesco, Arezzo (c. 1454–1458), St.
Helena is one of the main protagonists. **Cornelis Engelbrechtsz** de-
picted her in his *Constantine and St. Helena* (c. 1510–1520; Munich,
Alte Pinakothek) with youthful features and holding the cross as her
attribute, as did Andrea Bolgi in his sculpture for the crossing (where
the **nave** and **transept** cross) of **St. Peter's** (1629–1630), **Rome.**
Paolo Veronese rendered the *Dream of St. Helen* (c. 1580; Vatican,
Pinacoteca) that led to the finding of the cross, an unconventional de-
piction that inspired the heroic female saints of the **Baroque** era.

HEMESSEN, JAN SANDERS VAN (c. 1500–c. 1564). Netherlandish
artist from the region of Antwerp who became dean of the **Guild** of
Painters in that city in 1548. In 1551, van Hemessen moved to Haar-
lem where he spent the rest of his life. He is the father and teacher of
Caterina van Hemessen who specialized in portraiture and religious
subjects. Jan is best known for his crude, often comical figure types
that are crowded into the pictorial space. One of his favorite subjects
was the story of the prodigal son, with the version in the Brussels

Musées Royaux of 1536 providing one of the best examples. He also painted **genre** scenes, such as *The Surgeon* (c. 1555) in the Prado Museum, Madrid. Other works by van Hemessen include *Jesus Summons* **Matthew** *to Leave the Tax Office* (1536; Munich, Alte Pinakothek), the *Mocking of Christ* (c. 1560; Douai, Museé de la Chartreuse), and *Christ Driving the Merchants from the Temple* (1556; Nancy, Musée des Beaux-Arts).

HENRY IV OF FRANCE (1553–1610). Henry IV was the first French monarch from the Bourbon dynasty. Raised a Protestant, he converted to Catholicism in 1593 and was crowned king of France in the following year. He ended the Wars of Religion in 1598 when he signed the Treaty of Nantes that guaranteed religious freedom to the Protestant Huguenots in France. In 1600, Henry married **Marie de' Medici** and, in 1610, he was assassinated by a Catholic fanatic who opposed his policies. One of Henry's great concerns was the improvement of the city of Paris. He widened and paved its streets, built new quarters, and renovated old ones. The Pont Neuf and Place Dauphine (both beg. 1598), projects begun by Henry III and interrupted by civil strife, were completed under Henry IV's reign. Henry conceived the Place Royale (now Place des Vosges; 1605) as the locus for Parisians to gather during feasts and as suitable housing for the aristocracy. The Place's urban planning became the prototype to emulate in other cities of France and the rest of Europe. Covent Garden in London (c. 1630) is one of those projects based on the French urban model.

HERCULES. The mythological hero whose attributes are the club and lion skin and who is well known for his 12 labors. **Juno**, jealous of Hercules' mother Alcmena, sent two serpents to kill the infant hero. Blessed with great strength from birth, Hercules crushed the serpents to death. He married Megara and killed his three children in a fit of madness caused by Juno. To atone his actions, he accomplished his 12 labors: killing the Nemean lion, the Lernean Hydra, and the man-eating Stymphalian birds; capturing the Cerynean stag, the Erymanthian boar, the man-eating mares of Diomedes, and the Cretan bull; cleaning the stables of Augeas; obtaining the girdle of Hippolyta, queen of the Amazons, and the three apples from the Garden of Hes-

perides; fetching the cattle of Geryon; and bringing Cerberus from the underworld to earth. These labors brand him as the symbol of courage and strength.

Hercules is a favored mythological subject in art. **Tintoretto** depicted him as a child suckling on Juno's breast in the *Origin of the Milky Way* (c. 1570; London, National Gallery). **Peter Paul Rubens** painted *Hercules Fighting the Nemean Lion* (1608; Bucharest, Muzeul National), and **Albrecht Dürer** presented *Hercules Killing the Stymphalian Birds* (1500; Nuremberg, Germanisches National Museum). **Lucas Cranach the Elder** (1537; Brunswick, Herzog Anton Ulrich-Museum) and **Laurent de La Hyre** (c. 1638; Heidelberg, Kurpfälzisches Museum) painted *Hercules and Omphale*, with the queen of Lydia, who took him as her slave, donning his clothes and dressing him as a woman. *See also* HERCULES AND ANTAEUS; *HERCULES AT THE CROSSROADS.*

HERCULES AND ANTAEUS. On his way to obtain the apples of Hesperides, one of his 12 labors, **Hercules** was challenged by Antaeus, the son of Gaia and **Neptune**, to a fight. As the son of the earth goddess, Antaeus' strength increased each time Hercules threw him to the ground. Having discovered the giant's secret, Hercules lifted Antaeus and crushed him. **Antonio del Pollaiuolo** depicted the scene twice. His earliest rendition is the painting of c. 1460 (**Florence, Uffizi**), among the first large-scale mythological renderings of the Renaissance. The second is a sculpture in bronze (1470s; Florence, Museo Nazionale del Bargello) that elaborates further on the violent movements and Antaeus' agony as he is defeated by Hercules.

HERCULES AT THE CROSSROADS (c. 1596; Naples, Museo di Capodimonte). Cardinal Odoardo **Farnese** summoned **Annibale Carracci** to **Rome** from **Bologna** in c. 1595 to decorate his newly built **Palazzo Farnese**. *Hercules at the Crossroads* is the first major work Annibale carried out in the palace. The scene, painted on canvas, was intended to be mounted on the ceiling of the cardinal's *camerino* (studio) and shows Hercules at the crossroads pondering the proper path to take. **Virtue**, on the left, points to a trail up a mountain while a poet next to her prepares to sing Hercules' praises should he accept what she has to offer. On the right, Pleasure entices the hero

to a life of vice by presenting to him playing cards, theater masks, and musical instruments. The scene is based on the story by Prodicus, the fifth-century BCE sophist philosopher, as recorded by Xenophon in the *Memorabilia*, meant to guide young men to choose virtue over vice. As such, the image points to the proper choice Cardinal Farnese made when he took the religious path.

HERLIN, FRIEDRICH (active 1459–1499). German artist from Nördlingen where he can be traced in 1459. Herlin's name is listed in the city's tax rolls from that date until 1499, save for 1467 when he was in Rothenburg working on an **altarpiece** for the Church of St. James. The *St. George Altarpiece* he rendered for Nördlingen's city church in 1462–1465 and the *St. Blasius Altarpiece* for the Church of St. Blasius in Bopfingen in 1472. These paintings reveal Herlin's debt to the Flemish School, and particularly **Rogier van der Weyden**. Herlin's strongest work is the *Family Altarpiece* (1488; Nördlingen, Städtisches Museum), which shows the enthroned **Virgin** and Child against a brocaded cloth of honor. To their right, **St. Margaret** presents a female donor and her daughters while, to the left, **St. Luke** sponsors her husband and sons. In the distance is a cityscape seen through an archway, with every detail clearly rendered. This, the heavy draperies with angular folds, hierarchic proportions, and non-idealized figure types were all borrowed from Flemish examples. The posture of the Christ Child makes specific reference to the art of **Hans Memlinc**.

HOLBEIN THE YOUNGER, HANS (1497/1498–1543). German painter from Augsburg, trained by his father Hans Holbein the Elder, who was also a painter. In c. 1514, Holbein the Younger went to Basel where he entered the workshop of Hans Herbster. There he gained a reputation as a book illustrator, becoming employed by the publisher Johann Froben in 1516. In the years that Holbein was active, the **Reformation** had eliminated the need for **altarpieces** in the North because Protestants do not decorate their churches. Though Holbein did execute some religious works, he adapted to this situation in the art market by specializing in portraiture. In 1516, he painted the diptych portrait *Jakob Meyre and His Wife Dorothea Kannengiesser* (Basel, Kunstmuseum). Here the figures are set in an

Italianate architectural backdrop, their faces modeled in great detail. In 1521, the humanist Erasmus of Rotterdam visited Basel and Holbein painted his portrait (c. 1523; Paris, Louvre), showing him in profile at a desk writing. In 1526, prompted by the worsening art market in Basel, Holbein left for England where, armed with letters of recommendation from Erasmus, he was able to obtain commissions from Sir Thomas More. For More, Holbein painted a family portrait, now known only through a drawing (1526; Basel, Kupferstichkabinett) he sent back to Erasmus in Basel—the earliest informal group portrait so far recognized. From this, Holbein created various single portraits of the More family, including the famed *Sir Thomas More* (1527) in the Frick Collection, New York. During a second trip to England (1532), Holbein painted one of his most remarkable portraits, *The Ambassadors* (1533; London, National Gallery), which depicts the French Jean de Dinteville and Georges de Selve, bishop of Lavour surrounded by books and instruments that cast the sitters as intellectuals. The most remarkable feature in this work is the anamorphic skull that floats in the foreground, thought to refer perhaps to Dinteville's heraldic device. In 1536, Holbein became court painter to Henry VIII of England. His portrait of the king in wedding attire is in the Galleria Nazionale d'Arte Antica, **Rome**, and dates to 1539–1540. Not only did Holbein work for the king as portraitist but also as mural painter, miniaturist, engraver, and jewelry and costume designer. Holbein died in England in 1543 from the **plague.**

HOLY TRINITY. The Holy Trinity is the encapsulation of God the Father, the Son, and the Holy Ghost into one being. In the Renaissance, the Holy Trinity came to be represented as a figure of God holding the **crucified** Christ, between them the Holy Ghost in the form of a dove. **Masaccio's** *Holy Trinity* at **Santa Maria Novella** in **Florence** (1427) provides an exceptional example of this subject type. **Albrecht Dürer's** *Adoration of the Holy Trinity* (1508–1511; Vienna, Kunsthistorisches Museum) and **El Greco's** *Holy Trinity* (1577–1579; Madrid, Prado), a painting inspired by Dürer's version, also provide noteworthy examples of the theme.

HOLY TRINITY, SANTA MARIA NOVELLA, FLORENCE (1427). Painted by **Masaccio** utilizing **one-point linear perspective**,

the work is one of the earliest examples to make use of this technique. The scene unfolds in a chapel that convincingly recedes into space, with the vanishing point in the center of the masonry altar below it. The **crucified** Christ is presented as the Savior by God the Father who stands on a platform. At either side are the **Virgin**, who brings her son to our attention, and **St. John** who clasps his hands together. The work was commissioned by the Lenzi, included at either side of the painted chapel kneeling in prayer. Here Masaccio introduced the pyramidal composition that would become standard in Renaissance art. His placement of the figures follows a hierarchic order, with God the Father at the highest point, below him his son, then the Virgin and St. John, and finally the donors who occupy the space outside the painted chapel. Below the scene is a fictive tomb with a skeleton and inscription that reads: "I once was what you are, what I am you will become." With this, the image warns the viewer that life is temporary and only through Christ can salvation be attained. The work incorporates into painting the architectural principles of rationality, order, symmetry, and balance introduced by **Filippo Brunelleschi**, Masaccio's contemporary.

HONEYSUCKLE BOWER (1609–1610; Munich, Alte Pinakothek). In 1609, **Peter Paul Rubens** was appointed official court painter to Albert and Isabella, Archdukes of Flanders. In the same year, he married Isabella Brant and rendered the *Honeysuckle Bower* to commemorate the event. The painting represents the first life-size self-portrait of an artist and his wife in history. It is based on traditional medieval representations of lovers, as well as **Andrea Alciato**'s depiction of marital fidelity in his *Liber Emblemata*. Rubens was inspired as well by **Jan van Eyck**'s *Arnolfini Wedding Portrait* (1434; London, National Gallery), particularly in the holding of hands, though his composition lacks the formality of this earlier work. Instead, husband and wife are shown in a casual, intimate moment, with Isabella sitting on the ground, her skirt draping over Rubens' foot, and her hat touching his arm. The holding of hands symbolizes concord in marriage and the garden is the locus of love.

HONTHORST, GERRIT VAN (1590–1656). Dutch painter; member of the **Utrecht Caravaggist** group. Honthorst was born in Utrecht and

went to **Rome** in c. 1610–1612 where he entered in the service of Marchese **Vincenzo Giustiniani**. He also worked for the **Medici** Grand Dukes of Tuscany, and Cardinal **Scipione Borghese**. While in the papal city, Honthorst painted mainly religious subjects in the Caravaggist mode. He was particularly fond of nocturnal scenes, with *Samson and Delilah* (c. 1615; Cleveland Museum of Art) and *Christ before the High Priest* (c. 1617; London, National Gallery) providing two examples. Upon his return to Utrecht in 1620, he changed to **genre**, as did most of the Utrecht Caravaggists. His *Merry Fiddler* (1623; Amsterdam, Rijksmuseum) derives from **Caravaggio**'s single male figures and musicians. Like Caravaggio's *Bacchus* (1595–1596; **Florence, Uffizi**), he offers the viewer a drink. This representation, however, lacks Caravaggio's erotic undertones, instead presenting a jolly, festive mood. The single musician type was popularized by Honthorst and the Utrecht Caravaggists in the Netherlands.

HUGUET, JAIME (c. 1414–1492). Spanish painter from Tarragona whose manner is closely tied to the **International Style**. Jaime was trained by his uncle, Pere Huguet, who moved with him to Barcelona in 1434 near the studio of **Bernardo Martorell**. He was active in Zaragoza and Tarragona until 1448 when he returned to Barcelona, becoming the city's leading master in the years before his death. His influence spread to other parts of Spain, including Gerona, Lérida, and Aragon. Among his works are the *Flagellation of Christ* (1450s; Paris, Louvre), painted for the Cathedral of Barcelona; the *St. Vincent Altarpiece* (late 1450s; Barcelona, Museu Nacional d'Art de Catalunya), originally meant for the Church of Sarriá, Barcelona; and the *Retable of Sts. Abdón and Senén* (1459–1460) in the Church of Santa María, Tarrasa.

HUYGENS, CONSTANTIJN (1596–1687). Dutch poet, musician, and statesman from The Hague. Huygens was secretary to Stadholder Frederik Hendrik, prince of Orange, from 1625 to 1647, serving as well as his artistic advisor. He also worked for William II, Frederik's successor. His father Christiaan, secretary of the Council of State of the Dutch Republic, had encouraged a broad education for his young son. Huygens therefore was exposed to art, music, science, and languages. He was also well traveled. Among the places he visited were

London, Brussels, Paris, and **Venice**, where he went on a diplomatic mission. King James I of England knighted him in 1621 for his musical talents. It was Huygens who sought out the young **Rembrandt** in 1629. In his autobiography, he praised the master's *Judas Returning the Thirty Pieces of Silver* (1629; Yorkshire, Mulgrave Castle) for its effective conveyance of deep emotion. He also referred to Rembrandt as the greatest of history painters.

HYPNEROTOMACHIA POLIFILI (1499). In English, *The Dream of Polyphilus.* Thought to have been written by the **Dominican** friar Francesco Colonna and published in **Venice** in 1499, the *Hypnerotomachia Polifili* is an architectural work of fiction amply illustrated with woodcuts. The hero in the story is Polyphilus who wanders through fantastic places in search of his love, Polia, whom he finally finds in the gardens of Adonis. The book is of particular interest to architectural historians as the woodcuts illustrate monuments from antiquity, revealing Renaissance attitudes toward them. The woodcut of the Island of Cythera, for example, includes a colosseum similar to that in **Rome**, and the temple of **Venus** is based on the Early Christian Santa Costanza, also in the papal city. The temple of the sun is a replica of the Greek Mausoleum of Halicarnassus, and the Polyandron necropolis for dejected lovers relies completely on a survey of the Greek ruins in Delos composed by Ciriaco d'Ancona in 1445. As Polyphilus wanders through these sceneries, he measures the structures and studies their inscriptions, hoping to learn the mysteries of the ancient past. The *Hypnerotomachia* gained great popularity at the end of the 16th century, as attested by the fact that it was translated into various languages.

HYRE, LAURENT DE LA (1606–1656). French painter; one of the founding members of the **French Academy** (1648). La Hyre's early works were influenced by **Francesco Primaticcio** and the Fontainebleau School, this followed by a **Caravaggist** phase. In his mature years, he adopted a more **classicized** style similar to that of **Nicolas Poussin** and **Eustache Le Seur**, his competitor. The elongated forms of his *Hercules and Omphale* (c. 1638; Heidelberg, Kurpfälzisches Museum) and their overstated poses belong to La Hyre's **Mannerist** stage. His *Allegory of the Regency of Anne of Aus-*

tria (1648; Versailles, Musée du Château) is a mature work with rich tones of blue, red, and gold common to his art. The work is an allegory of the Peace of Westphalia that ended the Thirty Years' War. It shows France seated and crowned by Victory. Peace, depicted as a young boy, burns the weapons and armors of war, while the hovering Fame blows her trumpet to announce the end of hostilities and France's victory. To the same period belongs his *Cornelia Refusing the Crown of Ptolemy* (1646; Budapest, Museum of Fine Art), a scene filled with classicized figures and setting, the story told through elegant rhetorical gestures. La Hyre also rendered a number of poetic landscapes, among them **Diana and Her Nymphs** (1644; Los Angeles, J. Paul Getty Museum) and *Laban Searching Jacob's Baggage for the Stolen Idols* (1647; Paris, Louvre). These works were rendered at a time when landscape was becoming as important as other genres, and La Hyre did much to contribute to its rise.

– I –

***ICONOLOGIA* BY CESARE RIPA.** An emblem book first published in 1593 that became the standard text consulted by artists when rendering allegorical figures and scenes. Ripa used various mythological, emblematic, and archaeological manuals to compose his text, including Vincenzo Cartari's *Le imagini de i dei* and Piero Valeriano's *Hieroglyphica*. An example of a work that relies on Ripa's text is **Guercino**'s *Aurora* in the Casino **Ludovisi, Rome** (1621), down to her rolled-up sleeves and the flowers she scatters about. **Valentin de Boulogne**'s *Allegory of Rome* (1628; Rome, Villa Lante) depends on Ripa's prescription for Rome as a female with shield, lance, and a towerlike headdress.

IGNATIUS OF LOYOLA, SAINT. *See* LOYOLA, ST. IGNATIUS OF.

IL GESÙ, ROME (1568–1584). Il Gesù was the first **Counter-Reformation** church ever built. Financed by Cardinal Alessandro **Farnese**, it was to function as the mother church of the **Jesuit Order**. Its architect, Giacomo da Vignola, used **Leon Battista Alberti**'s **Sant'Andrea** in Mantua (beg. 1470) as his prototype. As in Alberti's

structure, Il Gesù is an aisleless, barrel-**vaulted** church with a broad **nave**, granting an unobstructed view of the altar where the rituals of the mass take place. The façade, which borrows elements from Alberti's façade at **Santa Maria Novella, Florence** (c. 1456–1470), was completed by Giacomo della Porta, **Michelangelo**'s pupil, in 1575–1584. Here, doubled engaged pilasters define the bays of the lower story and step forward as they move closer to the entrance. The doorway is marked by a triangular and segmented **pediment**, as well as the pedimented window of the second story. Scrolls provide a rhythmic transition from the narrower upper level to the lower, an amplification of Alberti's idea in the Santa Maria Novella façade. Il Gesù became the standard for all longitudinal churches built in **Rome** during the Counter-Reformation and for Jesuit churches around the world.

ILLUMINATED MANUSCRIPT. A manuscript hand-written on parchment with the text complemented by miniature painted scenes, decorated initials, and borders. The earliest illuminated manuscripts date from the Early Christian era. Most were created by monastic communities who, through the medium, were able to preserve the Greco-Roman literary culture and disseminate religious doctrine. With the invention of the printing press in the 15th century, the need for illuminated manuscripts was eliminated as printed books became a more practical and economical way to disseminate information. Examples of illuminated manuscripts created in the Renaissance are the *Psalter of the Duke of Berry* (c. 1380–1385; Paris, Bibliothèque Nationale) for which **André Beauneveu** painted a series of **prophets** and **apostles**, the *Book of Hours of Jean le Meingre, Maréchal de Boucicaut* (beg. c. 1409; Paris, Musée Jacquemart-André, Ms. 2) by the **Boucicaut Master**, the **Limbourg brothers**' *Les Très Riches Heures du duc de Berry* (1416; Chantilly, Musée Condé), and the *Rohan Hours* (c. 1414–1418; Paris Bibliothèque Nationale). *See also* JEAN, DUC DE BERRY.

IMMACULATE CONCEPTION. A theological doctrine that asserts that the **Virgin Mary** was conceived without sin. This doctrine did not become dogma until 1854, although Pope **Sixtus IV** gave it official approval in 1475. The doctrine was passionately defended for centuries, particularly in Spain where the monarchy took up the cause. **Francisco Pacheco, Diego Velázquez**'s father-in-law, wrote

in his treatise on art that the Immaculate Conception should be depicted by showing a youthful and beautiful Mary with long blond hair, a white tunic, blue mantle, with rays of light emanating from her head culminating in 12 stars. She should be standing on the moon, with its upper part forming a crescent. This, in fact, is how Velázquez painted his *Immaculate Conception* (1619; London, National Gallery), except that his Virgin's tunic is pink, not white—one of many representations of the kind in the history of Spanish art, including **Francisco de Zurbarán**'s version of 1630–1635 (Madrid, Prado), Alonso Cano's of 1648 (Vitoria, Museo Provincial) and Bartolomé Esteban Murillo's of 1665–1670 (Madrid, Prado). In Italy, images of the *Immaculate Conception* are not as common as in Spain, though some splendid examples do exist, including **Guido Reni**'s of 1627, now at the Metropolitan Museum in New York.

IMPASTO. Paint applied thickly to the surface of a panel or canvas. Usually the marks from the brush or palette knife used to apply the paint remain visible when using this technique. The use of heavy impasto became a common feature of **Baroque** art, with artists such as **Rembrandt** and **Frans Hals** creating some of the most notable examples.

INSTRUMENTS OF THE PASSION. Objects related to the **Passion of Christ**. These include the column on which he was beaten; the whips used for his **flagellation**; the crown of thorns placed on his head; the cross, nails, and hammer of his **Crucifixion**; the sponge saturated with vinegar administered to him in the last moments of life; the lance of St. Longinus that pierced his side; and the chalice used to collect his blood.

INTERNATIONAL STYLE. The term *International Style* refers to an art mode of the 14th and 15th centuries that blends Italian and Northern Gothic elements. The International Style became the preferred mode of the rulers and aristocrats of Europe for its elegance. It is characterized by the use of brilliant colors; graceful, courtly figures; heavy gilding; and emphasis on patterned surfaces. The style developed when **Simone Martini**, a pupil of **Duccio**, moved to the papal court

of **Avignon** (1335) and brought with him the Sienese vocabulary. As the papal court was frequented by foreigners, the style soon spread to other parts of Europe, hence the appellation "International Style." Among the exponents of this mode were the **Limbourg brothers, Melchior Broederlam, Jean Malouel, Gentile da Fabriano, Luis Borrassá**, and **Jaime Huguet**.

ISENHEIM ALTARPIECE (fin. 1515; Colmar, Musée d'Unterlinden). Painted by **Matthias Grünewald** for the chapel of the commandery of the Hospital Order of St. Anthony in Isenheim, the *Isenheim Altarpiece* includes in its closed state a *Crucifixion*, with Sts. Anthony and **Sebastian** in the outer wings and the *Lamentation* on the *predella*. In its first opened position, it depicts the **Annunciation**, Angel Concert and Nativity, and **Resurrection**. In the second opened position, the altarpiece presents the figures of Sts. Athanasius, Anthony, and **Jerome** (carved by Nicholas von Hagenau) flanked by panels of the *Temptation of St. Anthony* and the *Meeting of Sts. Paul and Anthony in the Desert*. As a work seen daily by patients cared for at the commandery, many of whom were treated for the new disease of syphilis, Sts. Anthony and Sebastian were included for their association with illness and **plague**. St. Anthony, of course, was also the patron saint of the order, hence the two scenes from his life flanking the carved standing saints. In the *Crucifixion*, Christ is covered with skin lesions so that the intended viewers could parallel their suffering to that of the Savior. The agony experienced by **Mary Magdalen** at the foot of the cross adds to the poignancy of the scene. When the altarpiece was opened to reveal the *Annunciation*, *Angel Concert and Nativity*, and *Resurrection* to patients, the sense of misery and suffering was replaced by a sense of hope. The message provided was that the Savior came into the world to bring the rewards of an afterlife for the suffering experienced here on Earth.

– J –

JEAN, DUC DE BERRY (1340–1416). The duc de Berry was the son of King Jean II the Good of France and the brother of **Philip the Bold** of Burgundy. In 1356, he was made Count of Poitiers and, during his

father's captivity in England two years later, he was appointed lieutenant of Auvergne, Languedoc, Périgord, and Poitou, which gave him control of a large portion of France. In 1360, his father also gave Jean the duchies of Berry and Auvergne. From 1380 until 1388, Jean acted as member of the regency council of his nephew and heir to the throne, Charles VI. In that capacity, he negotiated for peace with John of Gaunt, Duke of Lancaster. In 1405, he also negotiated the temporary reconciliation between John the Fearless, Duke of Burgundy, and Louis, Duke of Orléans, both of whom were vying for control of France. Louis was murdered in 1407 and, three years later, Jean allied himself with the Orleanists. Jean's mediations effected the Peace of Auxerre (1412). However, hostilities soon resumed and, in the following year, he also negotiated the Peace of Pontoise, which resulted in Orleanist victory. Jean is best remembered for his lavish spending on the arts. He left a collection of no less than 150 **illuminated manuscripts**, among them *Les Très Belles Heures du duc de Berry* (c. 1410; New York; The Cloisters) and *Les Très Riches Heures du duc de Berry* (1416; Chantilly; Musée Condé), both executed by the **Limbourg brothers**.

JEROME, SAINT (EUSEBIUS HIERONYMOUS SOPHRO-NIUS; c. 342–420). One of the Latin Doctors of the Church. Born in Dalmatia to a wealthy pagan family, St. Jerome went to **Rome** to acquire an education and there he was baptized by Pope Liberius in 360. A vision of Christ convinced him to settle in the Syrian Desert where for four years he engaged in fasting, prayer, meditation, and the study of the Hebrew language. This is the subject of **Andrea del Castagno**'s *Vision of St. Jerome* (c. 1454–1455) in the Church of Santisima Annunziata, **Florence**, where the saint is shown as an ascetic character who beats his chest with a rock, the vision of Christ above him, the lion whose thorn he removed at his side, and his followers Sts. Paola and Eustochium bearing witness to the event. When Jerome emerged from the desert, he went to Antioch where he was ordained by St. Paulinus. His newly acquired knowledge allowed him to translate the Bible from the true Hebrew version into Latin, which the **Council of Trent** declared to be the official Vulgate of the Catholic Church. It remained as such until 1979 when Pope John Paul II replaced it with the New Vulgate.

As a result of the Tridentine council's declaration, St. Jerome became one of the preferred subjects of **Baroque** art. **George de La Tour** rendered the *Penitent St. Jerome* (1628–1630; Stockholm, Nationalmuseum) on one knee, his whip in one hand, his **crucifix** in the other, and his ecclesiastic vestments prominently displayed. **Jusepe de Ribera** (1626; Naples, Museo Nazionale di Capodimonte) and **Simon Vouet** painted *St. Jerome and the Angel of Judgment* (c. 1625; Washington, National Gallery) where the saint (and the viewer) is reminded of the **Last Judgment** and transience of life. **Agostino Carracci** (c. 1592–1593; **Bologna**, Pinacoteca Nazionale) and **Domenichino** (1614; Vatican, Pinacoteca) rendered the *Last Communion of St. Jerome* where he is administered the last rites.

JESUIT ORDER. A mendicant religious order founded by **St. Ignatius of Loyola** in 1534 when he gathered a group of fellow students of theology from the University of Paris. Ordained in **Venice** in 1537, after a year of pilgrimage in Spain, Ignatius and his followers also resolved to do pilgrimage in Jerusalem. As war impeded their travel, they instead went to **Rome** to offer their services to **Paul III** who approved their order in 1540. Their main objective was missionary work meant to spread the Catholic faith around the world. St. Francis Xavier, a member of the original group, went to India, Indonesia, and Japan, and Matteo Ricci to China. By the 17th century, the Jesuits were also performing missionary work in North and Latin America. During the **Counter-Reformation**, the Jesuits became the leading force in the fight against the spread of Protestantism. Until the 18th century, when the order was suppressed by Clement XIV (1773), they were also leaders in education, establishing schools in all the major urban centers of Europe. Pius VII reinstated the Jesuits in 1814 and to this day they enjoy a solid reputation as educators. The mother church of the order is **Il Gesù** in Rome.

JOACHIM, SAINT. Joachim is the father of the **Virgin Mary**. While in Jerusalem, where he and his wife **Anne** went to sacrifice to God, Joachim was expelled from the temple by the high priest for not having been blessed with children. Shamed, he went into the mountains and there he prayed, asking for his barrenness to be lifted. In a dream, an angel informed him that God had heard his prayers and that his

wife was now with child. This was deemed a miracle as Joachim and Anne were of advanced age. Joachim returned to Jerusalem to meet his wife at the city gates, as commanded by the angel. The story, which stems from the **Apocrypha**, was depicted in various scenes by **Giotto** in the **Arena Chapel, Padua** (1305), and **Taddeo Gaddi** in the **Baroncelli Chapel** (1332–1338) at **Santa Croce, Florence**.

JOHN THE BAPTIST, SAINT. Son of Zacharias, a priest of the Temple of Jerusalem, and Elizabeth, the **Virgin**'s cousin, who conceived him in old age. St. John lived as a hermit in the desert of Judea until the age of 30 when he chose to preach in the banks of the Jordan River against the evils of the world and to persuade his listeners to engage in penance and submit to baptism. There, he recognized Christ as the Messiah and **baptized** him, a scene depicted by **Piero della Francesca** in the 1450s (London, National Gallery), **Andrea del Verrocchio** in 1472–1475 (**Florence, Uffizi**), and **El Greco** in 1608–1614 (Toledo, Hospital de San Juan Bautista de Afuera). As St. John had attracted large crowds, Herod, fearful of his power, had him arrested. Also contributing to his arrest was the fact that John denounced Herod's marriage to his sister-in-law, Herodias, who retaliated by effecting the saint's execution. Herod held a banquet and asked Salome, Herodias' daughter, if she would dance for him. Persuaded by her mother, Salome retorted that she would do so if he gave her the head of the Baptist, to which Herod agreed. The story is the subject of **Fra Filippo Lippi**'s **frescoes** in the **choir** of the **Prato Cathedral** (1452–1466) and **Benozzo Gozzoli**'s painting in the Washington National Gallery (c. 1461–1462). **Caravaggio** depicted the Baptist's decollation in 1608 (Malta, Church of St. John in Valetta) and **Titian** painted Salome holding his severed head on a platter in c. 1515 (**Rome**, Galleria Doria-Pamphili).

JOHN THE EVANGELIST, SAINT. St. John the **Evangelist**, the youngest of the **apostles**, was called along with his brother James by Christ at Lake Genesareth. John was present at the **Transfiguration**, **Agony in the Garden**, and **Crucifixion**. After Christ's death, he went to **Rome** where Emperor Domitian submitted him to martyrdom. Having escaped unscathed from a pot of boiling oil, he was exiled to the island of Patmos where, after experiencing visions, he

wrote the Revelations, the final book in the Bible. **Correggio** depicted St. John in one of those mystical moments in 1520–1524 in the **dome fresco** of San Giovanni Evangelista in Parma, and **Hans Memlinc** (1479; Bruges, Hospital of St. John) did the same in one of the lateral panels of his *Altarpiece of the Virgin and Angels*. After Domitian's death, St. John went to Ephesus where he also wrote his Gospel. He died there, the only apostle to do so of natural causes. Scenes from St. John's life are included in the **Peruzzi Chapel** at **Santa Croce, Florence**, rendered by **Giotto** in the 1320s, and in the chapel of Filippo Strozzi at **Santa Maria Novella**, Florence, painted by **Filippino Lippi** in 1502. *See also* APOCALYPSE.

JOHNSON, CORNELIUS (1593–1661). Leading portraitist of the **Baroque** era in England. Cornelius Johnson was the son of Dutch immigrants who settled in London, and worked for kings James I and **Charles I**, as well as members of the court. His popularity waned after **Anthony van Dyck** arrived in England in 1632. When civil war broke out in 1643, Johnson moved to Holland where he remained for the rest of his life. Johnson's portraits are closely tied to Dutch portraiture. His figures are usually placed in front of dark, undefined backgrounds with focus on their faces and elaborate costumes that denote their social standing. His portrait *Sir Thomas Hanmer* (1631; Wales, National Museum) depicts a member of King Charles' court who retired from politics after the civil war to devote himself to gardening, becoming one of the most distinguished horticulturists of his era. Here, he is depicted at the age of 19 when he served Charles as page and cupbearer, wearing an aristocratic black silk costume with lace collar and gazing out at the viewer without expression. Johnson's portrait *Baron Thomas Coventry* (1639; London, National Portrait Gallery), which depicts a prominent lawyer, politician, and judge, shows the sitter with the signs of his parliamentary office: the bag, great seal, and mace. A comparison of these two works demonstrates the impact of van Dyck's art on Johnson's style as the later portrait presents a softening of forms, particularly in the details of the drapery, and greater accuracy of proportions than the earlier example.

JONES, INIGO (1573–1652). Inigo Jones is credited with bringing Palladianism to England. He was born in Smithfield to a cloth worker

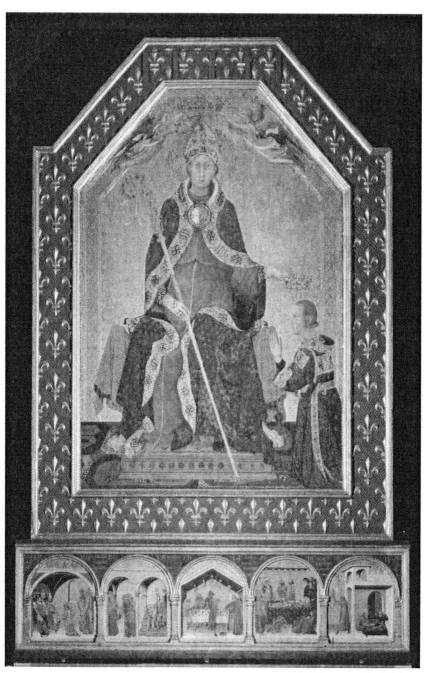

Simone Martini, Altarpiece of St. Louis of Toulouse, *1317, tempera on wood, Naples, Museo Nazionale di Capodimonte. Photo: Scala/Art Resource, NY.*

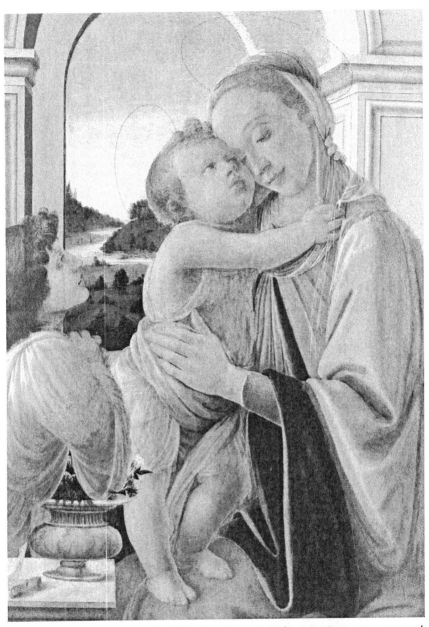

Sandro Botticelli, Madonna and Child with Adoring Angel, *c. 1468, tempera on panel, Norton Simon Art Foundation.*

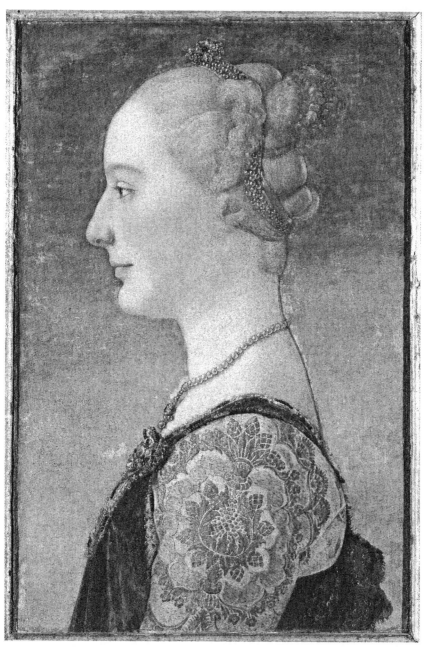

Antonio del Pollaiuolo, Portrait of a Woman, c. 1475, tempera on wood, Florence, Uffizi. Photo: Scala/Art Resource, NY.

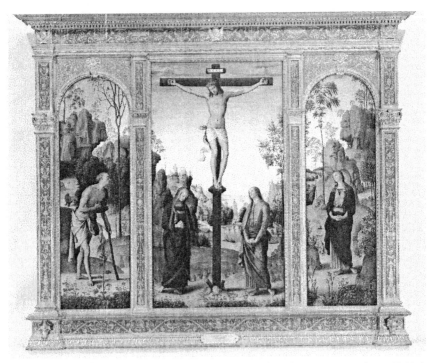

Pietro Perugino, Crucifixion, 1481, oil on panel transferred to canvas. Andrew W. Mellon Collection, Image © 2007 Board of Trustees, National Gallery of Art, Washington.

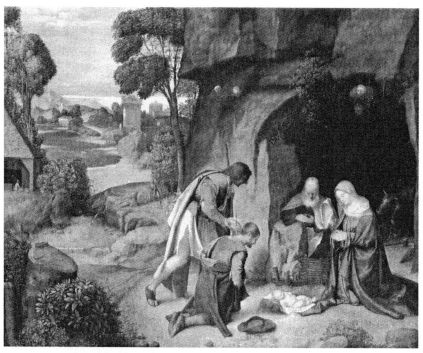

Giorgione, The Allendale Nativity, *c. 1505, oil on panel. Samuel H. Kress Collection, Image © 2007 Board of Trustees, National Gallery of Art, Washington.*

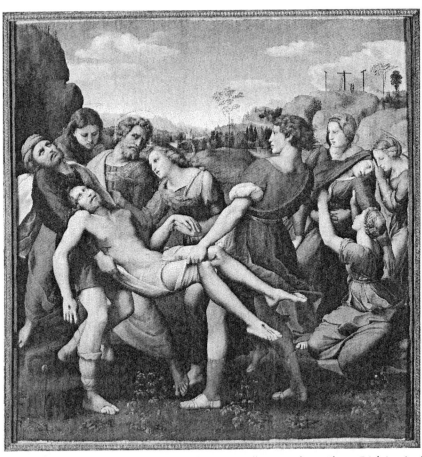

Raphael, Entombment, *1507, oil on wood, Rome, Galleria Borghese. Photo: Erich Lessing/ Art Resource, NY.*

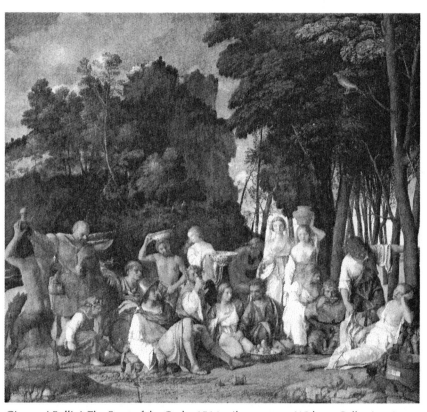

Giovanni Bellini, The Feast of the Gods, *1514, oil on canvas. Widener Collection, Image © 2007 Board of Trustees, National Gallery of Art, Washington.*

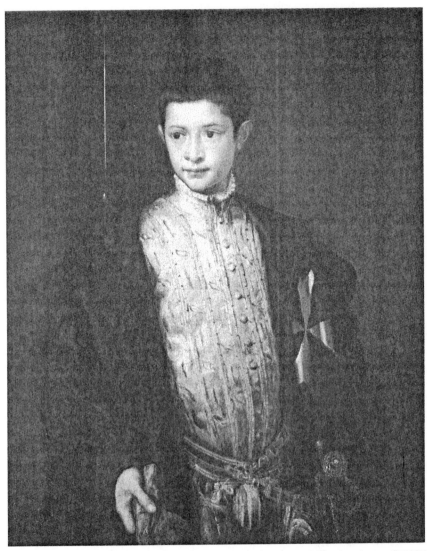

Titian, Ranuccio Farnese, 1542, oil on canvas. Samuel H. Kress Collection, Image © 2007 Board of Trustees, National Gallery of Art, Washington.

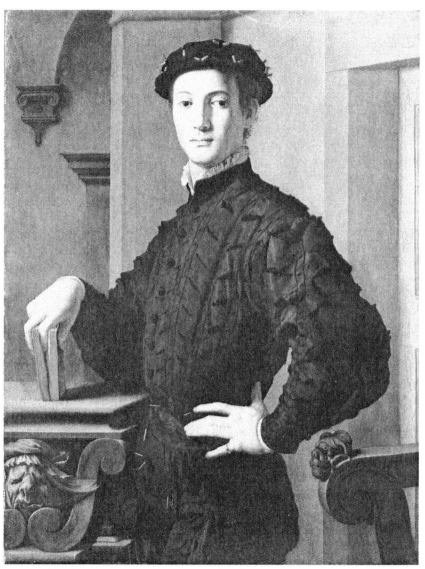

Agnolo Bronzino, Portrait of a Young Man, c. 1550, oil on wood. The Metropolitan Museum of Art, H. O. Havemeyer Collection, Bequest of Mrs. H. O. Havemeyer, 1929 (29.100.16) Image © 2007 The Metropolitan Museum of Art.

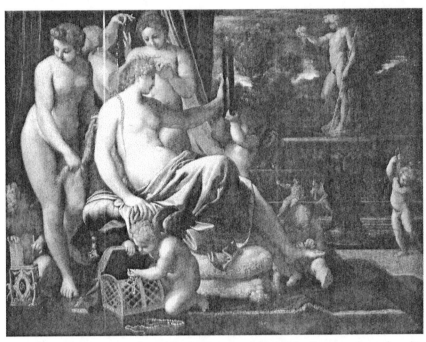

Annibale Carracci, Venus Adorned by the Graces, 1594–1595, oil on panel transferred to canvas. Samuel H. Kress Collection, Image © 2007 Board of Trustees, National Gallery of Art, Washington.

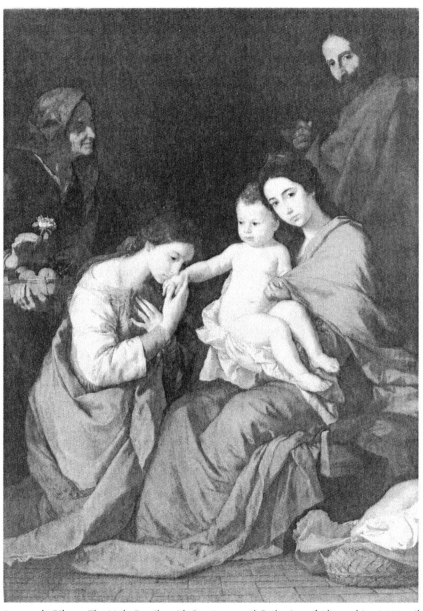

Jusepe de Ribera, The Holy Family with Sts. Anne and Catherine of Alexandria, *1648, oil on canvas. The Metropolitan Museum of Art, Samuel D. Lee Fund, 1934 (34.73) Image © 2007 The Metropolitan Museum of Art.*

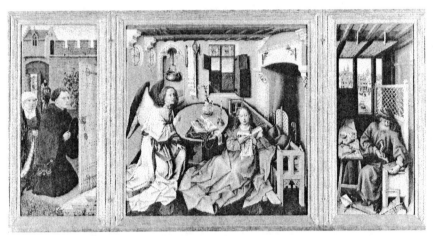

Robert Campin, Mérode Altarpiece, c. 1426, oil on wood. The Metropolitan Museum of Art, The Cloisters Collection, 1956 (56.70) Image © 2007 The Metropolitan Museum of Art.

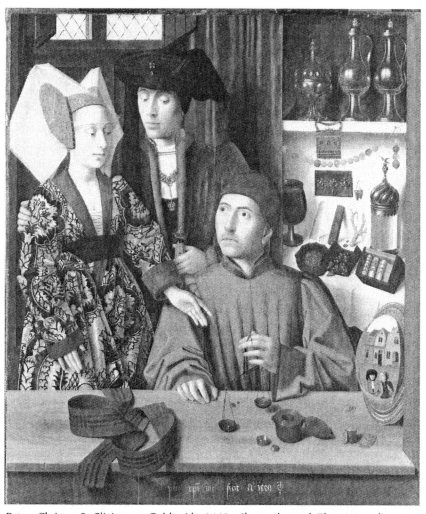

Petrus Christus, St. Eligius as a Goldsmith, 1449, oil on oak panel. The Metropolitan Museum of Art, Robert Lehman Collection, 1975 (1975.1.110) Image © 2007 The Metropolitan Museum of Art.

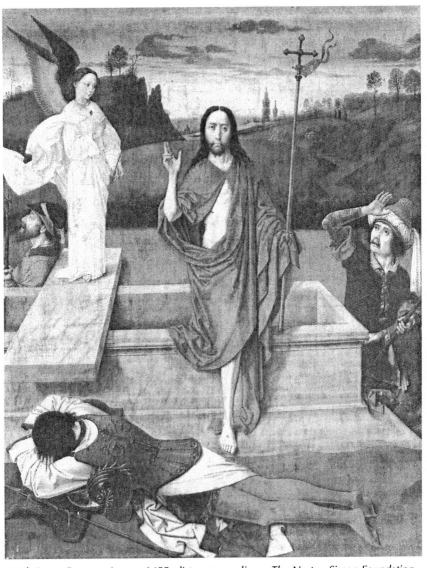

Dirk Bouts, Resurrection, *c. 1455, distemper on linen. The Norton Simon Foundation.*

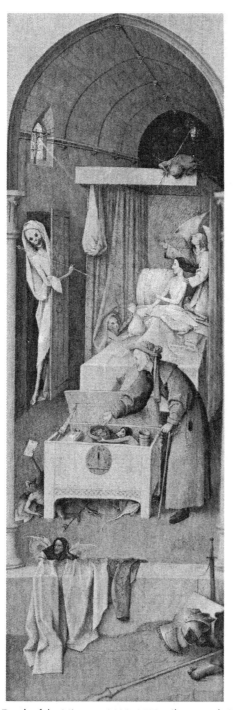

Hieronymus Bosch, Death of the Miser, *c. 1485–1490, oil on panel. Samuel H. Kress Collection, Image © 2007 Board of Trustees, National Gallery of Art, Washington.*

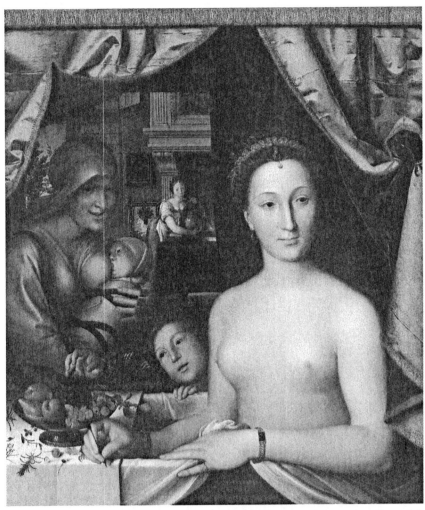

François Clouet, A Lady in Her Bath, c. 1550–1570, oil on panel. Samuel H. Kress Collection, Image © 2007 Board of Trustees, National Gallery of Art, Washington.

and is mentioned in documents dating to 1603 as a picture maker. Soon thereafter, he went to Italy where he must have seen **Andrea Palladio**'s buildings. By 1605, he is recorded in London working for Queen Anne of Denmark, James I's wife, designing costumes and sceneries for masks in a Palladian style. In 1610, Inigo was working for Prince Henry, James' son, as his official surveyor and, following Henry's death (1612), he became the Surveyor of the King's Works (1613). At this time, Inigo returned to Italy as the escort to Thomas Howard, Earl of Arundel, visiting Milan, Parma, **Venice**, **Bologna**, Siena, **Florence**, and **Rome**. Inigo brought with him his copy of Palladio's *Quattro Libri* and made notations on the margins as he studied his buildings.

Having returned to England in 1615, in the following year he received the commission to build the Queen's House in Greenwich for Henrietta Maria, **Charles I**'s wife, a commission he completed in 1635. The structure, composed of two equal squares connected by a covered bridge, utilized a Palladian vocabulary, mathematical proportions, and emphasis on symmetry—features that up to that point had not been seen in England. In 1619–1622, Inigo was also occupied with the building of the Banqueting House in Whitehall Palace, London, meant to function as the reception hall for foreign dignitaries, to host official ceremonies, and to replace the previous banqueting hall that had burned down in 1619. Here too the design derived from Palladio, and specifically the Palazzo Thiene, illustrated in the *Quattro Libri*, and the Basilica in Vincenza, the Venetian architect's reinterpretation of an ancient basilican plan as described by **Vitruvius**. Inigo's façade is raised on a podium and utilizes the **Colosseum principle**. Originally, each level was faced with a different colored stone, replaced in the 19th century with a stark white front. The frieze still carries the swags and masks intended by Inigo to denote the function of the building. The interior is in essence a large, open hall, meant to house large numbers of peoples, its ceiling decorated with a magnificent painting by **Peter Paul Rubens** depicting the Apotheosis of James I (1629), installed there in 1635. Charles I was beheaded in front of the Banqueting House in 1649.

JORDAENS, JACOB (1593–1678). After the death of **Peter Paul Rubens** and **Anthony van Dyck**, Jacob Jordaens became the leading

painter of Flanders. But unlike his predecessors, he was never a court painter, instead catering to bourgeois customers. Like Rubens, Jordaens trained with Adam van Noort, whose daughter he married. He spent most of his life in Antwerp, save for short visits to Southern and Northern Netherlands. Though the influence of Rubens is clearly seen in his works, particularly in the loose brushwork and the monumentality and energy of his scenes, he differs from the older master in that his figures are vulgar peasant types with exaggerated rosy cheeks and saggy flesh highlighted with blue-gray tones. Examples of his paintings are the *Satyr and Peasants* (c. 1620; Munich, Alte Pinakothek), the *Allegory of Fertility* (c. 1622; Brussels, Musées Royaux des Beaux-Arts), *Pan and Syrinx* (c. 1625; Antwerp, Royal Museum of Fine Arts), the *Four Evangelists* (c. 1625; Louvre, Paris), and the *Martyrdom of St. Apollonia* (1628; Antwerp, Augustinian Church). Jordaens' most important work is the *Triumph of Stadholder Frederik Hendrik* (1652), commissioned by Frederik's wife, Amalia van Solms, for the Oranjezaal at the Huis ten Bosch in The Hague to commemorate the deeds of her deceased husband.

JOSEPH, SAINT. St. Joseph was one of the suitors who brought rods to the temple to determine who would wed the **Virgin Mary**. That Joseph's rod flowered made clear that he was the one chosen. **Pietro Perugino** depicted the **Marriage of the Virgin** to Joseph in 1500–1504 (Caen, Musée des Beaux-Arts) and **Raphael** in 1504 (Milan, Brera). Joseph was alarmed to hear that Mary was pregnant, as they had not consummated their relationship. An angel appeared to him and dissuaded him from divorcing her, explaining that her pregnancy was the work of the Holy Spirit. Joseph was present at Christ's birth and took his family to Egypt to escape the **massacre of the innocents**. He was also at Christ's **Presentation in the Temple**, as exemplified by **Ambrogio Lorenzetti**'s painting of the subject of 1342 (**Florence, Uffizi**). After he and Mary find the 12–year-old Christ disputing with the doctors in the temple, Joseph disappears from the New Testament, save for a brief mention in the Gospel of **Luke**.

The cult of St. Joseph had existed in the East since the fourth century. In the West, however, his veneration was not popularized until the 15th century and his feast was only introduced into the Roman calendar in 1479. In art, he gradually took on a more active role in

images of the Holy Family. Examples include **Michelangelo**'s *Doni Tondo* (c. 1503, Florence, Uffizi) where he helps the Virgin balance the Christ Child on her shoulder, **Ludovico Carracci**'s *Cento Madonna* (1591; Cento, Museo Civico) where he leans his elbow on the Virgin's throne, **Caravaggio**'s *Rest on the Flight into Egypt* (c. 1594; **Rome**, Galleria Doria-Pamphili) where he holds the music score for the music-playing angel who sooths the Christ Child to sleep, and **La Tour**'s *Christ and St. Joseph* (1645; Paris, Louvre) where he engages in carpentry with the young Christ.

JUDAS RETURNING THE THIRTY PIECES OF SILVER **(1629; Yorkshire, Mulgrave Castle).** Christ was arrested after Judas led the Roman soldiers to him, for which he was paid 30 pieces of silver. After the arrest, Judas, overwhelmed by a sense of remorse, attempted to return the money, but the high priests and elders refused it. This is the scene depicted by **Rembrandt** in this work. Judas is shown on his knees with hands clasped as he explains to the priests and elders that he has betrayed innocent blood. This gesture is so powerful that, upon seeing the work, **Constantijn Huygens**, secretary to Stadholder Frederik Hendrik, praised Rembrandt's ability to convey great emotion and predicted that he would soon surpass the famous masters of his era, which in fact he did. Huygens also called Rembrandt the greatest of history painters.

JUDITH AND HOLOFERNES. A story from the **Apocrypha** that relates how Judith saved the Israelites from the Babylonians, who had cut off their water supply. Judith entered the Babylonian camp and agreed to dine with Holofernes, their commander. She gave him so much to drink that he fell into a stupor. Then she grabbed his sword and beheaded him. In the morning, the Babylonians, confused by the event, were defeated by the Israelites. In art, the image of Judith and Holofernes became a symbol of **virtue** overcoming vice. **Andrea Mantegna** depicted Judith placing the head of Holofernes in a bag held by her servant Abra, while the beheaded corpse lies on a bed behind them (c. 1495; Washington, National Gallery). **Donatello** (1459; **Florence, Palazzo Vecchio**), **Caravaggio** (c. 1598; **Rome**, Galleria Nazionale d'Arte Antica), and **Artemisia Gentileschi** (1612–1613;

Naples, Museo Nazionale di Capodimonte) chose to portray the moment when Judith cuts off Holofernes' head.

JULIUS II (GIULIANO DELLA ROVERE, r. 1503–1513). Nephew of Pope **Sixtus IV** who raised him to the cardinalate upon ascending the throne in 1471. Elected to the papacy in 1503, Julius set out to expand the Papal States by capturing the Romagna, Perugia, and **Bologna** territories the papacy had once owned. In 1508, he joined the **League of Cambrai** against **Venice**, which resulted in the recovery of Rimini and Faenza. His other major political concern was to free Italy from the French. In 1511, he formed the Holy League with Venice, Spain, England, Switzerland, and the Holy Roman Emperor. In 1512, the Swiss defeated the French in Novarra, and Parma, Piacenza, and Reggio Emilia were annexed to the Papal States. The victory was short-lived as Julius died in the following year. The league was dissolved, and the French captured Lombardy. Julius is best remembered for his art patronage. **Michelangelo** painted the **Sistine ceiling** (1508–1512) under his papacy and **Raphael** the **Stanza della Segnatura** (1510–1511), both at the Vatican. **Donato Bramante** submitted his design for New **St. Peter's** under Julius' patronage (1506), and Michelangelo rendered the pope's **tomb** (1505–1545) originally intended for St. Peter's, but eventually placed in the pope's titular Church of San Pietro in Vincoli, **Rome**.

JUNO. Jupiter's consort, Juno is the mother of Vulcan and **Mars** and the protectress of marriage and childbirth. Her sacred bird is the peacock, often seen in paintings related to the goddess, such as **Tintoretto**'s *Origin of the Milky Way* (c. 1570; London, National Gallery) where the infant **Hercules** suckles from her breast, the galaxy formed by the milk that drips from his mouth. The peacock is also included in **Andrea Mantegna**'s ceiling in the *Camera Picta* at the Ducal Palace in Mantua (1465–1474), also known as the Camera degli Sposi (Room of the Married Couple), as reference to Juno's role as patroness of marriage. Juno persecutes the many loves of Jupiter to avenge his infidelity, and she is also ruthless toward the offspring resulting from these illicit affairs. In the *Judgment of Paris*, she is one of the goddesses in the contest, the scene **Lucas Cranach the Elder**

depicted in 1530 (Karlsruhe, Staatliche Kunsthalle) and **Peter Paul Rubens** in 1602 (London, National Gallery).

JUPITER. The god of gods, Jupiter is the ruler of heaven and Earth. In his infancy, he was hidden so his father Saturn would not devour him and was nurtured by the goat Amalthea, a scene sculpted by **Gian Lorenzo Bernini** in 1615 (**Rome**, Galleria **Borghese**). As an adult, he battled his father, defeated him, and established order in the cosmos. The giants rose up against him, but Jupiter defeated them and cast them to the underworld, the scene depicted in **Perino del Vaga**'s *Fall of the Giants* (c. 1529) in the Palazzo del Principe, Genoa, and **Giulio Romano**'s (1530–1532) in the **Palazzo del Tè**, Mantua. **Juno** became Jupiter's consort, yet, for him, fidelity to her was not a priority. He was notorious for his many affairs and illegitimate children. He appeared to **Danaë** in the form of a gold shower, to Leda as a swan, and to Europa as a bull. He fathered **Apollo** with Letona, Proserpina with Ceres, and **Bacchus** with Semele. His many loves are common subjects in art. **Correggio** alone painted *Jupiter and Ganymede*, *Jupiter and Io* (both 1530s; Vienna Kunsthistorisches Museum), and *Jupiter and Danaë* (c. 1531; Rome, Galleria Borghese). **Titian** (1554; Vienna, Kunsthistorisches Museum) and **Jan Gossart** (1527; Munich, Alte Pinakothek) also rendered his indiscretion with *Danaë*, and **Paolo Veronese** painted the *Rape of Europa* (1580; **Venice, Doge's Palace**).

– K –

KOERBECKE, JOHANN (c. 1420–1491). German painter from Münster where he is first recorded in 1446. Koerbecke exemplifies the rejection in Germany of the **International Style** during the first half of the 15th century in favor of greater naturalism and solidity of forms. His most important masterpiece is the *Marienfeld Altarpiece*, painted for the high altar of the Cistercian Abbey Church of Marienfeld, Münster (1457). Now dismantled and its pieces scattered through various museums, the work includes scenes of the life of the **Virgin** and Christ's **Passion**. *Christ before Pilate*, now in the Landesmuseum in Münster, is one of those scenes and shows the figures

in contemporary garb against a German cityscape to appeal to local 15th-century viewers. Others are the *Road to Calvary*, also in Münster, and the *Crucifixion* in the Berlin Staatliche Museen. These works reveal Koerbecke's dependence on Flemish prototypes, particularly in the treatment of drapery, the vibrancy of colors, and deep emotionalism. His figures, however, are not as voluminous as the Flemish prototypes.

KULMBACH, HANS VON (HANS SÜSS; c. 1480–1522). German painter from **Albrecht Dürer**'s workshop where he was active in c. 1500. Kulmbach became a citizen of Nuremberg in 1511 and in 1514–1516 he is documented in Krakow, Poland, where he painted several **altarpieces**. His *Tucher Altarpiece* (1513; Nuremberg, Church of Sebald) shows Dürer's influence in the solidity and monumentality of the figures. The work is a *sacra conversazione* type with the **Virgin** and Child surrounded by saints. **Venetian** influence, learned through Dürer, is clearly discerned in the work, particularly in the inclusion of the landscape as backdrop, the isolation of the Virgin and Child from the other figures through architecture, and the **Bellini**-like musical angels at their feet. A versatile master, Kulmbach also rendered landscapes and portraits. An example of the former is the *Calling of St. Peter* in the **Florence Uffizi** (1514–1516), an evocative work filled with **atmospheric** effects. An example of his portraiture is the *Margrave Casimir of Brandenburg* (1511; Munich, Alte Pinakothek), with the sitter's heraldic devices prominently displayed to articulate clearly his social standing.

– L –

L'ORME, PHILIBERT DE (c. 1510–1570). French architect responsible for proliferating the Italian architectural vocabulary in France. Trained by his father in Lyon, L'Orme went to Italy in 1533 to study Italian architecture firsthand. Upon his return to France, he was appointed official architect to King **Francis I**, and when Francis died, L'Orme continued his official charge under Henry II. Much of his work is no longer extant. His masterpiece is the Château d'Anet (beg. 1550) in Paris, a commission he received from Henry's mis-

tress, Diane de Poitiers. Only the building's frontispiece, entrance gate, and parts of the chapel have survived and are now incorporated into the grounds of the Ecole des Beaux-Arts. The frontispiece shows a melding of Italian and Gothic elements with the **classical** orders applied utilizing the **Colosseum principle**, but superimposed with a triangular form that is too pitched to be qualified as a **pediment**. The applied ornamentation on the various surfaces is typically Northern. L'Orme was also an author. He published the *Nouvelles inventions pour bien bastir et à petits frais* in 1561, in essence a building manual, and *Le premier tome de l'architecture* in 1567, a theoretical architectural treatise.

LA TOUR, GEORGE DE (1593–1652). French **Caravaggist** painter from Vic-sur-Seille, but active in Lunéville in the Lorraine region. Little is known about the details of La Tour's life or how he became acquainted with the Caravaggist style. The available documentation on him reveals that in 1623–1624 he received two commissions from the Duke of Lorraine and that in 1639 he was painter to King **Louis XIII**, who is known to have owned a *St. Sebastian* by La Tour. A gap in the documentation from 1610–1611 and 1639–1642 has led some scholars to suggest that La Tour may have traveled on those occasions to Italy, where he would have seen Caravaggio's works, or perhaps to the Netherlands, where he would have become acquainted with the Italian master's style through the works of the **Utrecht Caravaggists**. His *Fortune Teller* (1636–1639; New York, Metropolitan Museum) is, in fact, more closely related to the art of the Dutch masters. It shows five half-length figures in elaborate costumes set against a dark background. The story is told through glances and gestures, the colors as brilliant as those utilized by the Utrecht Caravaggists. La Tour's *Christ and St. Joseph* (1645; Paris, Louvre), where the Savior holds a candle so the saint may engage in carpentry, relates to **Gerrit van Honthorst**'s nocturnal scenes. The candle gave La Tour the opportunity to study the flickering effects of the flame on the various surfaces. The tools used by Joseph prefigure the **instruments of the Passion** and the wood refers to the cross on which Christ was **crucified**.

La Tour was living at a time when the **Franciscans** were experiencing a religious revival in the Lorraine region and their influence

is clearly felt in the religious works created by the artist as they evoke piety from viewers and contemplation advocated by the members of the order. La Tour's *Nativity* (1650; Rennes, Musée des Beaux-Arts), exemplifies this. It again presents a nocturnal scene, yet the figures have become simplified and geometric while retaining their visual impact. The **Virgin**, with **St. Anne** at her side, holds a tightly swaddled Christ Child, a reference to the future covering of his dead body with the holy shroud. The painting stresses the humble life of Christ and his family, a reflection of Franciscan humility and vow of poverty. La Tour had more in common with Caravaggio than just his style. Like the Italian master, he was an arrogant and violent individual, as attested by the several court cases in which he was embroiled—a huge contrast to his humble, serene, pious scenes.

LAMENTATION. After the **Crucifixion**, Joseph of Arimathea received permission from Pontius Pilate to retrieve and bury Christ's body. The Lamentation refers to the moment when, after having been lowered from the cross, Christ is mourned by those present. The Lamentation is one of the most popular episodes in religious art as it presents one of the central moments in the story of salvation. Examples in Italy include **Giotto**'s version in the **Arena Chapel** in Padua (1305), **Andrea Mantegna**'s foreshortened rendition in the Milan Brera (c. 1490), **Sandro Botticelli**'s versions in the Museo Poldi Pezzoli in Milan and the Alte Pinakothek in Munich (both 1490s), and **Andrea del Sarto**'s *Lamentation* in the **Florence** Palazzo Pitti (1524). Northern examples include the version by **Petrus Christus** in the Brussels Musées Royaux des Beaux-Arts (c. 1448) and **Albrecht Dürer**'s in the Alte Pinakothek in Munich (1500–1503).

LANFRANCO, GIOVANNI (1582–1647). Lanfranco studied with **Agostino Carracci** in his native city of Parma and, when his teacher died in 1602, he moved to **Rome**. There he worked as one of **Annibale Carracci**'s assistants on the **Farnese ceiling** commission (c. 1597–1600). From 1610 until 1612, Lanfranco was in Piacenza and, upon his return to Rome, his career suddenly soared. He received work from Pope **Paul V** in the Sala Reggia of the Palazzo Quirinale where his *Presentation in the Temple* stands out (c. 1616). The work owes a debt

to Carracci in the lucid spatial construction, solidity of the figures, and appealing pastel tones. His *Madonna and Child with Sts. Charles Borromeo and Bartholomew*, painted for the Church of San Lorenzo in Piacenza (c. 1616), features a Carraccesque hourglass composition and St. Charles' gesture faithfully copies that of **St. Dominic** in **Ludovico Carracci**'s *Bargellini Madonna* (1588; **Bologna**, Pinacoteca Nazionale). Lanfranco's *Ecstasy of St. Margaret of Cortona* (1622; **Florence**, Palazzo Pitti) he painted as the **altarpiece** in the Church of Santa Maria Nuova in Cortona for Niccolò Gerolamo Venuti whose coat of arms is included in the lower left. The swooning St. Margaret, who experiences the vision of Christ with wounds hovering above the clouds, became the prototype for **Gian Lorenzo Bernini**'s *Ecstasy of St. Theresa* in the **Cornaro Chapel** in the Church of Santa Maria della Vittoria, Rome (1645–1652). Lanfranco's most notable commission is the **dome** of Sant' Andrea della Valle, which depicts the **Virgin** in Glory (1625–1627). The work is based on **Correggio**'s *Assumption of the Virgin* in the Cathedral of Parma (1526–1530). A spectacular *di sotto in sù* image with figures arranged in concentric circles, the **fresco** grants the illusion of a sudden apparition in the heavens. With this dome, Lanfranco introduced Correggio's dramatic illusionistic techniques to Rome.

LAST COMMUNION OF ST. JEROME **(c. 1592–1593, Bologna, Pinacoteca Nazionale).** This is **Agostino Carracci**'s most celebrated work. Painted upon his return from his first trip to **Venice**, the work demonstrates the influence of Venetian art, particularly in the use of a **classical** arch and columns to enframe the event, the landscape in the background, and the treatment of the putti who hover above. As the title indicates, the work shows **St. Jerome** receiving the Eucharist right before his death. This is a subject that had already been tackled by **Sandro Botticelli** (c. 1495; New York, Metropolitan Museum) in a painting he created for the **Florentine** wool merchant Francesco del Pugliese. Agostino's approach is, however, different from Botticelli's. The scene, described by St. Eusebius in his writings, is supposed to have taken place in St. Jerome's humble cell, which is how Botticelli rendered it. Agostino, on the other hand, placed the event in a classical, upscale setting, contrasting the old,

emaciated figure of the saint with the men garbed in impeccable ecclesiastic vestments. Agostino's choices may have had to do with the fact that he was painting at the time of the **Counter-Reformation**. The Protestants had questioned transubstantiation, the moment when, according to Catholic doctrine, the Eucharist is turned into the actual body and blood of Christ after the priest blesses it. The inclusion of the putti hovering above the scene and the **triumphal arch** in the background visually indicate divine approval of the doctrine and triumph of the true faith. Agostino's *Last Communion of St. Jerome* was highly praised by 17th-century theorists and admired by a number of artists, including **Peter Paul Rubens** and **Domenichino**, who painted his own version of the scene (1614; Vatican, Pinacoteca) for the Congregation of San Girolamo (Jerome) della Carità in **Rome**, prompting accusations of plagiarism against him.

LAST JUDGMENT. The term refers to the Christian tenet that, at the end of time, Christ will return to judge mankind. The blessed will be taken up to heaven and the sinners sent to hell, where they will be punished for eternity. The subject, common in art, lends itself to the depiction of the nude in expressive gestures and poses. It also affords an opportunity for the depiction of the macabre, which was more common in Northern Europe than in the South. The most spectacular *Last Judgment* is **Michelangelo**'s on the altar wall of the **Sistine Chapel** at the Vatican (1536–1541). It features a profusion of muscular nudes in complex poses, typical of the master's style. In the center is Christ, his mother at his side, commanding the blessed to rise up to heaven, while the damned, clearly troubled, are pushed down by demons toward Charon, the character from **Dante**'s *Inferno* who will transport them on his boat to the underworld. In Hubert and **Jan van Eyck**'s version (1430–1435; New York, Metropolitan Museum), the blessed are lined up as they await entry into paradise, while a pile of tortured bodies cast into hell by St. Michael occupy the painting's lower portion. **Hieronymus Bosch**'s *Last Judgment* (1504; Vienna, Akademie der Bildenden Künste) includes the blessed whom Christ presides over in a blue sphere that hovers above a fantastic landscape where the damned are tormented by monstrous demons in strange and inventive ways. *See also* LAST JUDGMENT, SISTINE CHAPEL, VATICAN.

LAST JUDGMENT, **SISTINE CHAPEL, VATICAN (1536–1541).**
In 1534, Pope **Clement VII** commissioned **Michelangelo** to paint
a **fresco** on the altar wall in the **Sistine Chapel** depicting the **Resurrection of Christ**. But, when Clement died, **Paul III**, his successor, changed the subject to the **Last Judgment**. To execute the
fresco, Michelangelo had no choice but to destroy the works on the
altar wall carried out by **Pietro Perugino** in the previous century
and some of the portraits of the earlier popes, as well as his own
lunettes over the windows he included in 1508–1512 when he executed the **Sistine ceiling**.

The Last Judgment was a common scene, yet it had never been depicted in such a grand manner. Instead of the compartmentalized renditions of earlier centuries, Michelangelo created a unified scene with
Christ as judge in the center dramatically commanding the souls to
rise from their graves. To his right is the **Virgin Mary** and surrounding him are the **apostles** and martyred saints. The blessed are aided
by wingless angels on their climb up to heaven, while demons torment the damned and push them into hell. Charon, a character from
Dante's *Inferno*, navigates the boat that leads the damned through the
River Styx and into the underworld. For dramatic effect, Michelangelo changed the figures' scales. Christ and those around him are almost twice as large as the figures below them and the angels above
who hold the **instruments of the Passion**. Each figure is posed differently, and their nudity reveals Michelangelo's keen understanding
of anatomy. This proved to be a curse. Michelangelo was severely
criticized for having included so many bare figures. No sooner had he
completed the fresco than his pupil, Danielle Volterra, was instructed
to paint draperies in all the right places to cover some of the nudity.
Michelangelo documented his frustration over the incident in the
fresco. The skin held by St. Bartholomew, martyred by flaying, is a
sagging self-portrait that speaks clearly of Michelangelo's dejection
over the controversy.

LAST SUPPER. On the eve of his arrest, Christ took his last meal with
his **apostles**. Since on the occasion he declared that the wine they
were consuming represented his blood and the bread his body, the
event marks the institution of the Eucharist as a holy sacrament. It
was also the moment when Christ announced to his disciples that one

of them would betray him. In depictions of the scene, Judas, the one to give up Christ to the Roman authorities, is usually isolated from the rest of the figures. In **Andrea del Castagno**'s *Last Supper* in the **refectory of Sant' Apollonia, Florence** (1447), **Domenico del Ghirlandaio**'s in the refectory of the Church of Ognissanti, Florence (1480), and **Tintoretto**'s at San Giorgio Maggiore, **Venice** (1592–1594), Judas is placed on the opposite side of the table, while in **Leonardo da Vinci**'s *Last Supper* (1497–1498) at Santa Maria delle Grazie in Milan he clutches the money bag containing the 30 pieces of silver he was paid for his betrayal. **Dirk Bouts** (1464–1467; Louvain, Church of St. Pierre) chose to concentrate on the solemnity of the event rather than Judas' duplicity. Other Last Suppers include the versions by **Pieter Coecke** (1531; Brussels, Musées Royaux des Beaux-Arts) and **Francisco Ribalta** (1606), this last painted for the College of Corpus Christi in Valencia, Spain. *See also LAST SUPPER*, REFECTORY, SANTA MARIA DELLE GRAZIE, MILAN; *LAST SUPPER*, SAN GIORGIO MAGGIORE, VENICE.

***LAST SUPPER*, REFECTORY, SANTA MARIA DELLE GRAZIE, MILAN (1497–1498).** Painted by **Leonardo da Vinci**, the scene portrays the moment when Christ declares to his disciples that one of them will betray him. They react by gesticulating and discussing the announcement with each other. Some point to themselves as if to ask "Lord, is it I?" while others raise their hands in astonishment. The only figure who does not react is Judas, placed by Leonardo in the shadows and clutching his money bag. Though Leonardo eliminated the figures' halos to bring them to the viewer's realm, he placed a segmented (semicircular) **pediment** above Christ to isolate him from the rest of the figures. The **vanishing point** is at Christ's head to define him as the physical and spiritual center of the work. Leonardo's interest in numerology and mathematical order is reflected in this painting. The 12 **apostles** are divided into four groups of three. Also, there are three windows behind the figures and four doorways on the lateral walls. The number three refers to the **Holy Trinity** and the Theological **Virtues**. Four are the elements, the seasons, the Gospels, the Cardinal Virtues, and the rivers of paradise. Seven, the sum of these two numbers, refers to the gifts of the Holy Spirit and the joys

and sorrows of the **Virgin**. The product of the two when multiplied is 12, the number of apostles, the months of the year, the hours of the day, the hours of the night, and the gates of Jerusalem. With this, Leonardo sought to demonstrate the perfection of the universe and its spiritual and material components, as created by God.

Supposedly, the prior of Santa Maria delle Grazie complained to **Ludovico "il Moro" Sforza**, Duke of Milan, that Leonardo was not working fast enough to complete the *Last Supper*. Leonardo explained to Ludovico that, although he had not been to the monastery in a while, he had been at the Borghetto every day searching for a suitable model for Judas from among the riffraff. He then added that if he could not find an individual whose physiognomy showed the wickedness of the traitor apostle, he would then use the features of the prior who had complained. Though this may be nothing more than an anecdote, Leonardo did plan his work very carefully, as attested by the large number of surviving sketches. In his *Trattato della Pittura* [*Treatise on Painting*], Leonardo described the poses and gestures he intended to include in the **fresco** and then proceeded to identify the models he used for each figure. So, for example, Christ's head was based on that of a Count Giovanni who lived in the house of the Cardinal of Montaro, and his hand was that of Alessandro Carissimo of Parma.

The fresco, though recently restored, continues to deteriorate. Leonardo, who incessantly engaged in experimentation, used an **oil tempera** medium applied over dry wall plaster. Almost immediately, the paint began to flake off. The fresco has also suffered several travesties. In 1652, the monks of Santa Maria delle Grazie cut a door through its lower portion. In 1796, Napoleon's army used the **refectory** as a stable and his soldiers amused themselves by throwing bricks at Leonardo's figures. In 1800, a flood in the refectory caused further damage and little effort was made to bail out the water. The work was heavily repainted in both the 18th and 19th centuries. Then, in 1943, the Allies bombed Milan and most of the refectory was destroyed. The fresco survived because it had earlier been braced with steel and sandbags. In spite of these major issues of conservation, Leonardo's *Last Supper* remains as one of the great icons of Renaissance art.

LAST SUPPER, **SAN GIORGIO MAGGIORE, VENICE (1592–1594)**. One of **Tintoretto**'s best-known works, the *Last Supper* belongs to the last stages of his career when he incorporated supernatural elements into his renditions. The dining table in this scene is placed on the left in a diagonal that recedes rapidly into space. There, Christ administers the Eucharist to one of the **apostles**, while the other men gesticulate as they converse. Judas, at the opposite side of the table, is the only figure without a halo. Above the men are angels painted as spectral beings. They provide a contrast to the mundane servants who clear the dishes, the cat who tries to get at the leftovers, and the dog who chews on a bone. The concurrence of divine and mundane, the dynamism of the scene punctuated by the diagonal positioning of objects and figures, and the commotion caused by the clanking of dishes and loud conversation are what set this work apart from earlier renditions of the Last Supper.

LATIN CROSS PLAN. An architectural plan for a church that is shaped like the cross on which Christ was **crucified**, the central event in the Christian story of salvation. Latin cross plans are composed of a **nave**, usually flanked by aisles, chapels, or both, a **transept** that serves as the arms of the cross, and an **apse** where the main altar is placed. Some Latin cross churches also have a narthex, a vestibule that precedes the nave. The **Council of Trent** declared that the Latin cross plan was the best suited to the liturgy of the mass as it allowed all focus to be placed on the altar where the ceremonies take place. As a result, architects active in the early years of the **Baroque** era rejected the Renaissance experiments with the **central plan** type and instead built longitudinal churches, as advocated by the council.

LAUGHING CAVALIER **(1624; London, Wallace Collection).** It is not clear who the sitter in this portrait by **Frans Hals** is, though the inscription on the upper right corner specifies that the man was 26 years old when the artist rendered the work. The title of the painting is a 19th-century invention unrelated to the subject. In fact, the sitter is not shown laughing. Instead he smiles self-assuredly. His jacket is adorned with emblems that refer to manly **virtues** and amorous pursuits, which has led some to believe that the portrait marks his wedding day. Among the embroideries of his costume are **Mercury**'s cap

and caduceus (rod with intertwined snakes), taken from **Andrea Alciato**'s *Liber Emblemata* where these objects are accompanied by the motto: "Fortune, companion of manly effort." The bees, winged arrows, flames, and cornucopias are all references to **Cupid's** sting. Typical of Hals' style are the loose, choppy brushstrokes that lend great animation to the work and the low vantage point that confers an air of monumentality.

LAURENTIAN LIBRARY, SAN LORENZO, FLORENCE (1524–1534). In 1524, Pope **Clement VII** commissioned **Michelangelo** to build the Laurentian Library for the purpose of housing the collection of books and manuscripts owned by his family, the **Medici**. The project was interrupted in 1527 when the **sack of Rome** resulted in the exile of the Medici from **Florence**. It resumed in 1530 when their banishment was lifted, and abandoned again in 1534 when Michelangelo was working in **Rome**. It was not until 1559 that the staircase for the library's vestibule was completed by Michelangelo's assistants, **Giorgio Vasari** and **Bartolomeo Ammannati**, who followed a model the master had sent from the papal city.

The vestibule is among the most innovative of Michelangelo's architectural designs as here he experimented with an anti**classical** vocabulary that led to the development of the **Mannerist** style. The stairs that lead to the library's reading room jut out in a rhythmic curvilinear motion. Niches are too shallow to hold statues, the windows above them are blind, and the paired columns flanking them are recessed and supported by scroll brackets—features never before employed in architecture. The library's reading room is in essence a long rectangle pierced by windows on the long walls. These are capped with protruding lintels supported by brackets and enclosed in quadrangular moldings above which the blind windows of the vestibule are repeated—again Michelangelo's inventions. The innovative vocabulary Michelangelo introduced in this commission not only inspired the Mannerist architects but continued to have an impact on the 17th century as **Francesco Borromini**'s experiments with unconventional rhythmic forms prove.

LAWRENCE, SAINT (d. 258). One of the deacons of **Rome**, St. Lawrence was martyred for selling the Church's possessions and

giving the money to the poor. When Emperor Valerian heard of the saint's actions, he demanded the return of the sold items. Lawrence gathered the blind, crippled, orphans, and poor and told Valerian that these were the treasures of the Church. In retaliation, Valerian condemned Lawrence to burn on a hot griddle. As the saint bore the agony of his martyrdom, he asked his executioners to turn him over for he was already well-cooked on one side—the scene depicted by **Titian** (1548–1559) in the Chiesa dei Gesuiti in **Venice** and **Agnolo Bronzino** (1569) in the Church of San Lorenzo, **Florence**. Key episodes from the saint's life are included in the **Chapel of Nicolas V** at the Vatican **frescoed** by **Fra Angelico** in 1448 and the *Sancta Sanctorum* at the Lateran Palace, Rome, a chapel dedicated to the saint. **Michael Pacher**'s *St. Lawrence Distributing Alms* (1465–1470; Munich, Alte Pinakothek) is part of the dismantled *St. Lawrence Altarpiece* of St. Lorenzen near Bruneck, now dispersed in various museums.

LE NAIN BROTHERS (ANTOINE, 1588–1648; LOUIS, c. 1593–1648; MATHIEU, c. 1607–1677). The Le Nain brothers were painters from Laon, where their father Isaac owned property. Scholarship on these individuals is complicated by the fact that they often collaborated on commissions, which has made it difficult to identify the contributions of each. Also, they signed their works only by surname and only their paintings from the 1640s are firmly dated. In the late 1620s, the Le Nain were in Paris where Mathieu is documented in 1633 as the city's official painter. There, the Le Nain were among the artists who established the **French Academy** in 1648. Antoine and Louis died in that year, two days from each other. In 1652, Mathieu was named painter to the king and, in 1662, he was granted the title of Cavalier of the Order of St. Michael, a title he lost for his inability to prove his birth into nobility.

In spite of the problems of attribution posed by the Le Nain's collaboration, there are three main styles that emerge in the body of works they left. One is a group of small pictures on copper rendered with strong colors that portrays bourgeois individuals in their homes. These are normally given to Antoine, as in the case of the *Musical Gathering* of 1648 (Paris, Louvre). To Louis are attributed the peasant scenes with subdued colors that relate to the work of the Bam-

boccianti, a group of Dutch painters led by Pieter van Laer, called Bamboccio, who were active in Italy and specialized in **genre** scenes. Louis would have become acquainted with the Bamboccianti during his stay in **Rome** in 1626–1630, or in Paris in 1626 when Laer visited briefly. Of the works given to Louis, the best-known is the *Peasant Family in an Interior* (1645–1648; Paris, Louvre), a scene that depicts the working class in all its dignity. The final group of paintings, of military officers, is usually ascribed to Mathieu as he was a lieutenant in the Parisian militia. One such work is *La Tabagie* of 1643 in the Louvre. Barring the difficulties in Le Nain scholarship, the brothers stand out in the history of French art for having popularized genre in the region and for providing a refreshing contrast to the **classicist** renderings of their French contemporaries.

LE ROI À LA CHASSE **(PORTRAIT OF CHARLES I) (1635; Paris, Louvre).** This portrait of **Charles I** of England was painted by **Anthony van Dyck** and represents a major innovation in the history of portraiture as it shows the king in an informal, leisurely moment. He wears hunting attire and stands in profile, his head turning toward the viewer, his left arm akimbo, and his elbow jutting forward. The set is **Venetianized**, with a landscape inspired by **Titian**'s portrait *Charles V on Horseback* (1548; Prado, Madrid). Though the scene is informal, the king's status is nevertheless stressed. His costume is of silk and lace, his activity that of an aristocrat, his face with a melancholic expression—then considered the attribute of men who are well above all others—and his horse bowing to him in reverence.

LE SEUR, EUSTACHE (1616–1655). French **Baroque** painter who entered **Simon Vouet**'s workshop at the age of 15. In 1645, Le Seur left his master's studio and became an artist in his own right. His works are characterized by a graceful **classicism**, delicate figures, and luminous surfaces. Among his most important paintings are the *Marine Gods Paying Homage to Love* (c. 1636–1638; Los Angeles, J. Paul Getty Museum), taken from the *Hypnerotomachia Polifili*; *Sleeping Venus* (c. 1640; San Francisco, Fine Arts Museum), based on the **Venetian** reclining nude type; and the *St. Bruno Series* (1648–1650; Paris, Louvre) painted for the Chartreuse de Paris.

LEAGUE OF CAMBRAI (1508–1510). A league formed by Pope **Julius II**, King Louis XII of France, and Holy Roman Emperor **Maximilian I** to curtail **Venice**'s territorial expansion and influence in Northern Italy. This resulted in Venice's loss of much of its territory and its financial ruin. Friction between Julius and Louis XII caused the league's collapse in 1510 and an alliance between the pope and Venice against France. In 1512, they drove the French out of Italy, but disagreements regarding the distribution of spoils caused a rift between the two allies. The Venetian Republic changed sides and, in 1515, the French, now led by Louis' successor, **Francis I**, regained their territories in Italy and, in 1517 the lands taken from the Venetian Republic were returned.

LEGEND OF THE TRUE CROSS*, SAN FRANCESCO, AREZZO (c. 1454–1458).** This **fresco** cycle was commissioned from **Piero della Francesca** by the Bacci family for the Cappella Maggiore of San Francesco. The main scenes follow **Jacobus da Voragine**'s story in the ***Golden Legend of the wood used for the cross on which Christ was **crucified**. According to the account, Seth placed the seedlings from the Tree of Knowledge in Adam's mouth at the time of his death. These grew into a new tree that King Solomon cut for use as a bridge over a stream. When the Queen of Sheba crossed the bridge to meet the king, she learned that this would be the wood on which Christ would be crucified and announced that it would bring about the obliteration of the Jewish people. Solomon buried the wood to prevent such tragedy, but centuries later it resurfaced and the Romans used it for the crucifixion. **Helena**, Constantine the Great's mother, traveled to Jerusalem to recover the true cross, which was recognized when it effected the miraculous resurrection of a dead boy. In the seventh century, the Persian King Chrosoes stole the wood, and the Byzantine Emperor Heraclius recovered it, carrying it back to Jerusalem as Christ had done on the **road to Calvary**. Among these scenes in San Francesco, an **Annunciation** is included as reminder that the cycle tells the story of the relic on which the incarnated Christ shed his blood to grant salvation to the faithful. Piero's frescoes symbolize the historical triumph of Christianity against its enemies.

LEMERCIER, JACQUES (c. 1585–1654). French architect who worked for King **Louis XIII.** Little is known of Lemercier's training. He was the son of a mason and may have learned the principles of building from his father. In c. 1607, he went to **Rome**, where he remained until 1612. Upon his return to Paris, he entered in the service of Cardinal **Armand Richelieu**, first minister to the king, a move that launched his career. For the cardinal he built the Church of the Sorbonne (beg. 1635) on the grounds of the university of the same appellation—a structure of the **Il Gesù** sort, though Lemercier's design includes a large **dome** and two façades. In c. 1639, Lemercier was commissioned by Louis XIII to extend the west wing of the Louvre Palace, his most important commission. He also erected three country houses: the hôtels de Rueil, Liancourt, and Richelieu. Unfortunately, little survives of these buildings, though their designs are recorded in engravings. Lemercier is credited as one of the architects to introduce the Italian vocabulary to France.

LEO X (GIOVANNI DE' MEDICI; r. 1513–1521). Leo X was the second son of **Lorenzo "the Magnificent" de' Medici**, tonsured at the age of seven, and made cardinal at 13. Like his father, Leo presided over a court that included artists, poets, and musicians but also clowns, animal tamers, and other odd individuals—and that, coupled by his extravagant behavior, gave added fuel to the leaders of the **Reformation.** It was under Leo's rule that Martin Luther posted his Ninety-Five Theses on the portals of Wittenberg Cathedral (1517), resulting in his excommunication in 1521. As pope, Leo's main concern was to prevent foreign domination of Italy, and particularly **Florence**, and to advance his family's interests. In 1516, he expelled the **della Rovere** from Urbino and installed his nephew Lorenzo II de' Medici as its duke. With this, Leo set in motion the events that would lead to the Medici's attainment of the title of Dukes of Tuscany in 1530. Leo was the patron of **Raphael**, who under his rule completed the **Stanza** at the Vatican, and **Donato Bramante**, who worked on New **St. Peter's.** Raphael also painted the *Portrait of Pope Leo X with Cardinals Giulio de' Medici and Luigi de' Rossi* (c. 1517; Florence, **Uffizi**), which shows the pope at his desk examining an **illuminated manuscript**

with a magnifying glass, a fitting tribute to the man who profoundly valued such art objects.

LEONARDO DA VINCI (1452–1519). Leonardo da Vinci is the artist who inaugurated the High Renaissance. He was among the great luminaries of the period not only in art but in a number of fields. His inquisitive nature led him to experiments in optics, astronomy, aviation, anatomy, botany, and hydraulics. He was a painter, sculptor, architect, engineer, mathematician, and scientist, to name a few of the fields in which he involved himself. Leonardo was also instrumental in elevating the artist's status from artisan to genius. In his *Trattato della Pittura* [*Treatise on Painting*] he expressed his view that the creative powers of the artist are like those of God. The artist is not a mere manual laborer but also a thinker and theorist. Therefore, painting should be considered a liberal art, higher still than music or poetry, as these two depend on the ear, while painting depends on the eye, a more noble organ.

Leonardo was the illegitimate son of a Tuscan notary from the town of Vinci, near **Florence**. He was taken away from his mother at a very young age to be raised by his father and his father's wife. The trauma this event caused, as well as the fact that he had diminished rights from those of legitimate children and that he was stigmatized for being left-handed, resulted in his detachment from humans and complete immersion in the arts and scientific experimentation. He is known to have dissected more than 30 corpses, scrupulously recording his findings in his notebooks and drawings. He invented a number of military weapons, tanks, flying machines, a grinder to create concave mirrors that resulted in the production of a telescope in 1509, and many other such objects.

Leonardo received his training as artist in the studio of **Andrea del Verrocchio** from whom he acquired his interest in anatomy and physiognomy. In 1472–1475, he assisted his master with the *Baptism of Christ* (Florence, **Uffizi**) where the kneeling angel on the left and the background landscape have been attributed to him, as they exhibit the same softness and lush brushwork of his autographed works. His earliest solo commission was the *Annunciation* (late 1470s; Florence, Uffizi), a unique composition he painted for the Monastery of Monte Oliveto outside of Florence. Here the scene

takes place outdoors, in front of the **Virgin**'s home, instead of the usual domestic setting. Her book of devotions is set on an elaborately carved Roman funerary urn, perhaps to denote the future death of her son. The wind created by the archangel Gabriel as he alights causes the flowers in the garden to bend. These are botanically accurate, as are the lilies held by the angel, symbols of the Virgin's purity. Leonardo's palette, with emphasis on earth tones, olives, blues, and deep reds, is common in his art, as are the varied drapery folds placed close together in animated arrangements. Leonardo's *Benois Madonna* (St. Petersburg, Hermitage) also falls in this period. The Virgin here is a youthful figure, and the pudgy child looks and behaves the way an infant would. Leonardo's close study of the human form and physiognomy are what led to his lifelike rendition of the figures and their facial expressions. In this work, he began experimenting with **sfumato**, a shading technique he devised that grants the figures a smoky, mysterious quality.

In 1481, Leonardo was commissioned to paint the ***Adoration of the Magi*** (Florence, Uffizi) for the Monastery of San Donato a Scopeto, just outside of Florence, a work he left unfinished when he moved to Milan. He only managed to create the underdrawing, leaving us with some understanding of his painting method. He first used ocher tones to sketch the overall composition, and then added his other colors in layers over the underpainting. This means that for Leonardo, dark tones took preeminence. In spite of its unfinished state, the work divulges Leonardo's intention to capture the frenzied excitement of those who have come to adore the Christ Child.

Leonardo went to Milan in 1481 or 1482 to work for the **Sforza** as artist and military and civil engineer. While in Milan, he painted the ***Madonna of the Rocks*** (1483–1486; Paris, Louvre) for the chapel of the **Confraternity** of the **Immaculate Conception** in the Church of San Francesco Grande, his famed ***Last Supper*** (1497–1498) in the **refectory** of the Monastery of Santa Maria delle Grazie, and the *Portrait of a Woman with an Ermine* (c. 1485; Cracow; Czartoryski Museum). In 1499, Milan was invaded by the French, forcing Leonardo to leave the city. In 1500 he is recorded in **Venice** and then in Florence where he painted the ***Madonna and Child with St. Anne*** (c. 1508–1513; Paris, Louvre) for the high altar of the Church of Santisima Annunziata and the ***Mona Lisa*** (1503), now in the Paris Louvre.

In 1503, the Florentine Republic asked Leonardo to render the *Battle of Anghiari* (1503–1506) in the Council Chamber of the **Palazzo Vecchio** at the same time as **Michelangelo** created the *Battle of Cascina* (1504–1506). In 1506, Leonardo returned to Milan where he remained until 1513 when he was invited by Pope **Leo X** to **Rome**. At the Vatican he engaged in scientific research until 1517 when he was called by **Francis I** to the French court. Francis provided the queen's manor house (the Château de Cloux) for Leonardo to use as his home, and engaged him in the staging of pageants, allowing him to also continue his scientific investigations. Leonardo died in France in 1519.

LEYDEN, LUCAS VAN (1494–1533). Dutch painter and engraver who was deeply influenced by **Albrecht Dürer** and the Italians. Lucas van Leyden was first trained by his father, Hugo Jacobsz van Leyden, and, when Hugo died, Lucas moved to the studio of **Cornelis Engelbrechtsz**. His earliest dated work is an engraving titled *Mohammed and the Monk Sergius* (1508), an image with Dürer-like qualities much admired by his contemporaries. In fact, Marcantonio Raimondi used van Leyden's background for his own engraving of **Michelangelo**'s *Battle of Cascina*. Then followed van Leyden's engraving of *Adam and Eve* (1510) where the theme of mother and child is borrowed from Dürer, as are the deep pockets of dark that contrast with open areas free of crosshatching. Even van Leyden's signature, composed simply of the upper case letter "L," recalls the signature of Dürer.

Van Leyden's ***Adoration of the Magi*** (c. 1500–1510; Merion Station, the Barnes Collection) is one of his early paintings. It shows a spacious, logically constructed manger populated by figures that are dwarfed by the ample setting. The construction of space in this work denotes van Leyden's understanding of Italian methods of **perspective**. So does his engraving of the *Ecce Homo* (1510), a work that recalls **Jacopo Bellini**'s drawings of religious scenes presented as mere incidentals within elaborate cityscapes in convincing perspective. By c. 1514–1515, van Leyden adopted a more monumental style, as seen in his *Card Players* (c. 1514; Salisbury, Wilton House Collection), a **genre** scene that moralizes on the ills of gambling. His *Madonna and Child with Angels* (c. 1518; Berlin, Staatliche Museen), like the *Card*

Players, brings the half figures closer to the picture plane, the musical angels recalling those of Italian masters such as **Andrea Mantegna**. Also Mantegnesque are the garlands above the **Virgin** and Child, which mimic those in the Italian master's *San Zeno Altarpiece* (1456–1459; Verona, San Zeno).

Van Leyden's *Adoration of the Golden Calf* (c. 1525; Amsterdam, Rijksmuseum) presents another moralizing theme of inappropriate conduct. Here, the Israelites engage in the **vices** of gluttony, intemperance, and luxuria. In the middle ground, Moses descends from the mountain with the law tablets, only to find the Israelites committing idolatry. The *Healing of the Man of Jericho* (1531; St. Petersburg, Hermitage) presents a more successful integration of figures within the landscape as they no longer seem overwhelmed by it. It depicts one of the miracles effected by Christ while on his way to Jerusalem, the drama enhanced by the emphatic gestures and poses of those who witness.

Karel Van Mander wrote that at 35 van Leyden traveled by boat through the Netherlands and entertained fellow painter **Jan Gossart** and others. After the trip, van Leyden fell ill and, convinced that he had been poisoned, spent the last years of his life in bed, though he continued to work until his death in 1533. Van Leyden left 172 engravings, which facilitated the spread of his style through Europe and particularly Italy, where his influence was significant.

LIBRARY OF ST. MARK, VENICE (1537–1580s). Jacopo Sansovino's greatest masterpiece. The Library of St. Mark was built to house the Greek manuscripts Cardinal **Basilius Bessarion**, the Patriarch of Constantinople, bequeathed to the Republic of **Venice** in 1468. Sansovino was faced with the problem of creating a design that would not minimize the importance of the **Doge's Palace**, Venice's seat of government, which the library faces. Sansovino opted for a long façade, making sure that it would not overtower the palace, and he added a great deal of decorative sculpture for texture that gave the building an imposing design. The lower level provides a passageway for Venetians to shield themselves from the elements, as well as shops. The reading room is in the upper story to prevent damage to the books during floods. The arches of the passageway and the upper windows create a play of light on the surface and of voids and solids

that grant the structure a rhythmic quality. Sansovino applied the **Colosseum principle** to the exterior, with the Doric order in the lower story and the Ionic in the upper level. He was, in fact, the first to introduce this motif to Venice.

LIMBOURG BROTHERS (POL, HERMAN, AND JEAN; all d. 1416). Netherlandish manuscript illuminators, active in Paris; the nephews of **Jean Malouel**. The Limbourg brothers first appeared in Paris in the late 1390s when we find Herman and Jean working as apprentices in the shop of a local goldsmith. In 1402, Pol, who is believed to have acted as group leader, and Jean were employed by **Philip the Bold**, Duke of Burgundy, as illuminators, a position they may have received at the recommendation of their uncle who from 1396 had been working as the duke's court painter. Philip died in 1404, and the brothers went to work for **Jean, duc de Berry**. Their most important works they created for their new patron. These are *Les Très Belles Heures du duc de Berry* (c. 1410; New York; The Cloisters), added illuminations for *Les Petites Heures du duc de Berry* (beg. c. 1372 by Jean Le Noir and Jacquemart de Hesdin; Paris, Bibliothèque Nationale de France), and *Les Très Riches Heures du duc de Berry* (1416; Chantilly; Musée Condé), this last considered one of the greatest examples of the **International Style**. All three brothers died of the **plague** in 1416. *See also* ILLUMINATED MANUSCRIPT.

LINAIUOLI ALTARPIECE **(1433, Florence, Museo di San Marco).** Commissioned by the Arte dei Linaiuoli, the **Guild** of Linen Merchants, from **Fra Angelico** for their meeting house in the Piazza Sant' Andrea in **Florence**, this **triptych** is the artist's first dated work and major commission (the frame was executed by **Lorenzo Ghiberti**). When closed, the triptych shows Sts. **Peter** and Mark, this last the guild's patron, standing against dark backgrounds. Both figures are solid, with heavy draperies, and stern expression, rendered in the style of **Masaccio**. When opened, the triptych presents an *Enthroned Virgin and Child* with St. Mark again appearing in the right panel and **St. John the Baptist**, patron saint of Florence, occupying the left. Here, Fra Angelico provided a contrast between the homely saints and the delicate, graceful Virgin. As customary, the *predella* features

narratives that relate to the altarpiece's main scenes. These are *St. Peter Preaching*, the ***Adoration of the Magi***, and the *Martyrdom of St. Mark*. In this triptych, Fra Angelico introduced a more believable setting than those of his predecessors by substituting curtain panels for the usual gilded background, thereby granting the impression of a fully defined interior space.

LIPPI, FILIPPINO (c. 1457–1504). Filippino was the son of **Fra Filippo Lippi** and the nun Lucrezia Buti. He first trained as painter with his father, but when his father died in 1469, **Sandro Botticelli** cared for him and completed his training. Filippino's first important commission was the completion of the decoration of the **Brancacci Chapel** at Santa Maria del Carmine, **Florence**, where **Masaccio** and **Masolino** had worked. To add to the scenes already in the chapel, in 1481–1482 Filippino **frescoed** further episodes from **St. Peter**'s life. In 1489, Filippino began work in the Carafa Chapel at Santa Maria sopra Minerva, **Rome**, belonging to Cardinal Oliviero Carafa who in 1472 had commanded the papal fleet against the Turks. The scenes depict the life of **St. Thomas Aquinas**, as well as the **Assumption** and **Annunciation** where the saint presents Cardinal Carafa to the **Virgin**. By 1502, Filippino was back in Florence working for Filippo Strozzi on his chapel in the Church of **Santa Maria Novella**, frescoing scenes from the lives of Sts. Philip and **John the Evangelist**. These include *St. Philip Driving the Dragon from the Temple of Hieropolis*, the *Crucifixion of St Philip*, *St. John the Evangelist Resuscitating Druisana*, and the *Torture of St. John the Evangelist*. Filippino's *Vision of St. Bernard* (c. 1485–1490), now in the Church of the Badia in Florence but originally intended for the Monastic Church of Le Campora at Marignolle, demonstrates his close affinity to the style of Botticelli. His figures, like Botticelli's, are elongated, with emphasis on linearity, and rendered in intense blues, reds, and oranges.

LIPPI, FRA FILIPPO (FILIPPO DI TOMMASO DI LIPPO; 1406–1469). An unwanted child placed in the Carmelite Monastery of Santa Maria del Carmine, **Florence**, where he took the monastic vows in 1421, Fra Filippo Lippi may have witnessed **Masaccio** and **Masolino** working on the **Brancacci Chapel frescoes** in the adjacent church. The lyricism and sweetness of Lippi's figures do not reflect

his colorful personality. Forced by circumstance to take his monastic vows, Lippi did not follow them seriously. He had a relationship with a nun with whom he fathered two children, one of them the artist **Filippino Lippi**. Accusations of embezzlement and forgery also punctuate his life. On more than one occasion, **Cosimo de' Medici** intervened on his behalf, including the negotiations to have the artist and his mistress released from their vows so they could marry.

The *Tarquinia Madonna* (1437; **Rome**, Galleria Nazionale) is Lippi's earliest known work. Commissioned by the authorities of the city of Tarquinia, near Florence, it shows the influence of Masaccio in its use of **one-point linear perspective** and the solidity of the figures. Typical of Lippi is the humanization of the scene. The figures do not wear halos, nor do they occupy a heavenly realm. Instead, the scene takes place in an intimate domestic interior with Gothic **vaulting**, a bed, and window. The pudgy Christ Child frets as would any infant seeking the security of his mother's embrace. In the same year, Lippi began work on the *Barbadori Altarpiece* for the Barbadori Chapel in the Church of **Santo Spirito**, Florence, an unconventional depiction of the **Virgin** and Child who stand in front of a throne, instead of sitting in it. The *Coronation of the Virgin* for the main altar of Sant' Ambrogio, Florence (1441–1447; Florence, **Uffizi**) is also unconventional in that the Virgin kneels in prayer while God the Father, not Christ, crowns her. The solemn occasion is witnessed by saints and angels holding white lilies, the symbol of the Virgin's purity. In the 1440s, Lippi's figures became increasingly more appealing and he developed a marked interest in rendering draperies of various thicknesses in undulating patterns. His *Madonna and Child* tondo (round pictorial field) in the Palazzo Pitti, Florence, of c. 1452 and the version of c. 1455 in the Uffizi exemplify this stage in his career. In 1452–1466, the artist created frescos for the Datini family in the **choir** of **Prato Cathedral** that depict the lives of Sts. **Stephen** and **John the Baptist**. His last work was the fresco cycle in the **apse** of the Cathedral of Spoleto (1466–1469) of the life of the Virgin. These were completed by his son Filippino after his death in 1469.

LIPSIUS, JUSTUS (1547–1606). Flemish philosopher and humanist who revived the ancient Stoic philosophy of Seneca and Tacitus and tried to reconcile it with Christianity. The founder of Neo-Stoicism,

Lipsius articulated in his *De Constantia* (1584) and *Politicorum sive civilis doctrinae* (1589) the mastery of emotions and the values of choosing **virtue** over pleasure as the proper paths. For Lipsius, the evils of society can only be resolved through constancy, which he defined as strength of mind, invulnerable to external events. **Peter Paul Rubens**' brother, Philip, was a pupil of Lipsius. When Philip died, the artist commemorated the event by painting *The Four Philosophers* (1612; **Florence**, Palazzo Pitti), a work that shows Lipsius surrounded by three of his pupils, including Philip. The artist stands behind the main figures, opposite a bust of Seneca. The four tulips in front of the bust, two opened and two closed, denote that both Philip and Lipsius had already died when the portrait was created. As further homage to those depicted, Rubens added the Roman Palatine Hill in the background, in antiquity the locus of learned discussion.

LOCHNER, STEPHAN (c. 1400–1451). Stephan Lochner was a native of Meersburg, near Lake Constance. At an unknown date, he moved to Cologne, where in 1442 he was paid for ephemeral decorations meant to celebrate Emperor Frederick III's visit to the city. In 1447, and again in 1451, he was elected councilor of the painter's **guild** in Cologne. Soon after receiving this honor for the second time, he died of the **plague**.

The ***Last Judgment Altarpiece*** (c. 1435–1440; central panel in Cologne, Wallraf-Richartz-Museum) Lochner painted for the local Church of **St. Lawrence**. It presents Christ in a ***mandorla***, with the **Virgin** and **St. John** kneeling at his feet pleading for the souls of those being judged. Below, the blessed line up to enter the gates of heaven, while the damned are tormented by demons as they are led into hell. One of the side panels (Frankfurt, Kunstinstitut) shows the *Martyrdom of St. Bartholomew*, the saint who was flayed alive. Here, the scene is set against a gold background that does little to soften the horror of the event. One of the executioners grabs his knife with his teeth as he forcefully pulls the skin off the saint's arm.

The *Last Judgment Altarpiece* is closely connected to medieval conventions that Lochner eventually shed in favor of rounder, more delicate, sweeter figure types. Examples include the *Madonna in the Rose Bower* (c. 1438–1440; Cologne Wallraf-Richartz-Museum) and

Presentation in the Temple (1447; Darmstadt, Hessisches Landesmuseum). The first shows the Virgin and Child surrounded by musical angels, the rose bower behind symbolizing Mary's charity and the gold background the divine nature of the scene. The solidity and linear qualities of his previous works have now been replaced by softened contours. Flemish influence is seen in the angularity of Lochner's drapery folds, previously lacking in his works. The second painting, which also features sweet types, Lochner signed in the letter held by one of the figures who is dressed like a knight of the Teutonic Order (a medieval military order). The scene is further softened by the appealing children in the foreground who hold candles, granting a greater sense of solemnity to the painting. Lochner's tender figures and vivid colorism place him among the most highly regarded German masters of his era.

LOGGIA. A loggia is a roofed gallery attached to the façade of a structure and opened to a garden or other exterior space. The openings are normally achieved through the use of arches supported by columns, as in the **Ospedale degli Innocenti** in **Florence** (1419–1424) designed by **Filippo Brunelleschi** and the *Loggetta* in **Venice** (beg. 1538) by **Jacopo Sansovino**. Loggie are sometimes decorated with **frescoes**, as in the Villa Carducci in Legnaia (1448) rendered by **Andrea del Castagno** with images of illustrious men and women, and in the **Villa Farnesina** decorated with mythologies by Baldassare Peruzzi, **Raphael**, and Sebastiano del Piombo (1513–1518).

LORENZETTI, AMBROGIO (c. 1290–1348). Painter of the Sienese School who, along with his brother **Pietro Lorenzetti**, foreshadowed the 15th-century developments in **one-point linear perspective** that would change the course of art. Documents indicate that Ambrogio was in **Florence** on two occasions, which would have given him firsthand knowledge of the new mode introduced by **Giotto**, well represented in the **Bardi** and **Peruzzi** chapels at **Santa Croce**. In 1319 Ambrogio painted an **altarpiece** of the Madonna for the Pieve in Vico l'Abate in the Florentine outskirts, and in 1332–1334 he created a polyptych for the Church of San Procolo in Florence proper, when he had no choice but to join the Florentine painter's **guild** in order to work in that city.

The *Virgin and Child with Saints **Mary Magdalen** and Dorothy* (1330s; Siena, Pinacoteca), commissioned for the Convent of St. Petronilla in Siena, is one of Ambrogio's earlier extant works. Here, the Virgin and Child are not enthroned as tradition dictated but rather represented as three-quarter-length figures placed against a gilded background. In c. 1335–1337, Ambrogio painted the *Maestà Altarpiece* for the high altar of the Church of Sant' Agostino in Massa Marittima, then under Sienese dominion. As a subject often represented by Sienese masters, the work was meant to assert the dominance of Siena over the city. Only the main panel of this altarpiece survives; the *predella*, frame, and other decorative elements are missing.

Ambrogio's most significant commission is the allegory of *Good and Bad Government* (1338–1339) in the Sala della Pace of the **Palazzo Pubblico** in Siena, the most ambitious **fresco** of the 14th century. In 1342, Ambrogio painted the *Presentation in the Temple* for the **Cathedral of Siena** (now in Florence, **Uffizi**), which shows a row of columns convincingly receding into space and toward the center of the work. The figures are placed behind the columns that, along with the glimpse of the **vaulted** ceiling, enhances the sense of three-dimensionality. Ambrogio and his brother are thought to have succumbed to the **Black Death** that struck Europe in 1348.

LORENZETTI, PIETRO (c. 1290–1348). Italian painter who, along with his brother **Ambrogio Lorenzetti** and **Simone Martini**, dominated the art scene in Siena. Pietro's *Virgin and Child with Saints*, *Annunciation*, and *Assumption*, the **polyptych** he created for the Pieve di Santa Maria in Arezzo, is signed and dated 1320 in an accompanying inscription where he declares himself to be a mature artist, in complete control of the new style of painting. This new style to which he refers is the naturalism **Giotto** introduced in the early years of the 14th century. In this altarpiece, the Virgin wears a mantle lined with ermine fur, rather than the customary red and blue cloak, and she and the Christ Child are no longer enthroned as in earlier altarpieces, but rather they stand in front of a gilded background. The Christ Child, normally shown in a blessing gesture, here interacts with his mother. While the volume of the figures and draperies depend on Giotto's art, the emphasis on luxurious costumes, brilliant

colors, and heavy gilding, are characteristics particular to the Sienese School of painting.

In 1325–1330, Pietro was in Assisi, painting **frescoes** of the **Passion of Christ** in the **transept** of the Lower Church of **San Francesco**. Of these, the *Crucifixion* is the most poignant. Though Pietro followed Byzantine and 13th-century representations of the scene, his version is filled with a pathos not found in earlier examples—a convincing representation of a tragic event. Pietro's most famous work is the ***Birth of the Virgin*** (Siena, Museo dell' Opera del Duomo), painted in 1342 for the **Cathedral of Siena**, a truly innovative altarpiece in that the frame becomes an outward projection of the painted architecture. To further enhance the sense of depth, Pietro showed the three four-partite **vaults** of the upper-class Sienese setting in which the scene takes place and he positioned his figures behind two columns. With this, he foreshadowed the developments of **one-point linear perspective** that would be introduced in painting and relief sculpture in Italy in the 15th century.

LOTTO, LORENZO (1480–1556). According to **Giorgio Vasari**, Lorenzo Lotto trained with **Giovanni Bellini** alongside **Giorgione** and **Titian**. He was active in **Venice**, **Rome**, Bergamo, the Marches, and perhaps also the Tuscan region. His life is only documented after 1538 when he began keeping a record book of his financial activities. One of his notable works is the portrait of newlyweds *Master Marsilio and His Wife* (1523; Madrid, Prado), the groom placing a ring on his bride's finger and a putto behind fixing a yoke, symbol of marriage, on their necks. The monumental figures are pushed to the foreground so they occupy a large portion of the pictorial space and the draperies are sculptural, both characteristic of Lotto's style. The same elements are included in his *Sacra Conversazione* of the 1520s (Vienna, Kunsthistorisches Museum), which utilizes a Venetian format of figures set against a luscious landscape, as well as the rich colorism of the Venetian School. Other works by Lotto include *Christ Taking Leave of His Mother* (1521; Berlin, Staatliche Museen), the *Annunciation* (c. 1527; Recanati, Pinacoteca Comunale), *Lucretia* (1528–1530; London, National Gallery), and the *Portrait of Andrea Odoni* (1527; Hampton Court, Royal Collection).

LOUIS OF TOULOUSE, SAINT (LOUIS D'ANJOU; 1274–1297).
St. Louis of Toulouse was the son of Charles II D'Anjou, king of Naples and Sicily, and Mary, daughter of King Stephen V of Hungary. When Alfonso III of Aragon captured Charles in 1288, Louis and his brothers were sent as hostages to Barcelona in exchange for their father's release. The boys spent seven years in captivity while Charles negotiated for their return. Louis surrendered his rights to the throne when Charles arranged for his marriage to the sister of King James II of Aragon, a liaison he opposed. Instead, with great resistance from his father, he was ordained a **Franciscan** at the age of 23, and, in spite of his royal lineage, he embraced an ascetic life. He was soon appointed bishop of Toulouse, a position he resigned after only a few months. He died six months later in Brignolles and was canonized in 1317, an event commemorated by his brother, **Robert D'Anjou**, by commissioning **Simone Martini** to paint the *Altarpiece of St. Louis of Toulouse* (1317; Naples, Museo Nazionale di Capodimonte). St. Louis is included among the Franciscan saints **Taddeo Gaddi** depicted in the **refectory of Santa Croce, Florence**, in c. 1340. He is also one of the saints in the *San Ludovico Altarpiece* by **Annibale Carracci** (c. 1589; **Bologna**, Pinacoteca Nazionale), painted for the Church of Santi Ludovico (in English, *Louis*) e Alessio in Bologna.

LOUIS XIII OF FRANCE (1601–1643). The eldest son of King **Henry IV** of France and **Marie de' Medici**, who acted as his regent after Henry's assassination in 1610. In 1615, Marie arranged for Louis' marriage to Anne of Austria and, in 1617, Louis exiled his mother to Blois for having prompted the rebellion of the nobility against the regency. Two years later, Marie escaped and allied herself with her younger son, Gaston d'Orleans, against Louis, only to be defeated. In 1622, Cardinal **Armand Richelieu**, then Louis' secretary of state and later first minister, reconciled the king with his mother, but this was not to last. A conspiracy to overthrow Richelieu resulted in Marie's permanent banishment from the French court. With the help of Richelieu, Louis was able to achieve religious unity in France and to move closer to absolutist power by diminishing the power of the nobility.

Louis was a notable patron of the arts. He is known to have owned a *St. Sebastian* by **George de la Tour** and to have commissioned **Simon Vouet**'s *Allegory of Wealth* (c. 1630–1635; both Paris, Louvre). Vouet's studio, in fact, became the place of dissemination of the king's artistic ideology. In c. 1639 **Jacques Lemercier** extended for him the west wing of the Louvre Palace. **Peter Paul Rubens**, who worked primarily for Marie, painted the portrait *Anne of Austria* (1621–1625; Paris, Louvre) under Louis' patronage, as well as 12 cartoons for tapestries recounting the main episodes of Constantine the Great's life (1620–1621). Louis is also the one to have called **Nicolas Poussin** to France to work on the decorations of the Louvre Palace, a commission that proved to be disastrous as Poussin lacked the expertise to work in the large scale the king demanded.

LOYOLA, ST. IGNATIUS OF (1491–1556). A native of Gúipuzcoa, in the Basque region of Spain, St. Ignatius was born to a noble family. In 1521, he was wounded in the leg in the siege of Pamplona while serving in the Duke of Nagara's army. While recovering, he read stories from the life of Christ and the saints and was so taken by the readings that he decided to devote himself to the religious life. From 1522 until 1523, he was on retreat in Manresa where he experienced visions and wrote the *Spiritual Exercises*, a text he published in 1548 meant to inspire devotion through prayer, meditation, and other prescribed practices. In 1534, St. Ignatius established the **Jesuit Order**. He was ordained in **Venice** in 1537, after a year of pilgrimage in Spain. He and his followers had vowed to also do pilgrimage in Jerusalem. Unable to do so, they instead went to **Rome** to offer their services to the pope. In Rome, St. Ignatius experienced another vision where Christ appeared to him and assured him that all would go well. All did in fact go well as Pope **Paul III** gave the Jesuit Order his approval in 1540. St. Ignatius was canonized in 1622 by **Gregory XV**.

LUCY, SAINT (d. 304). The daughter of noble parents from Syracuse, Sicily, St. Lucy refused to marry one of her suitors who, in retaliation, denounced her as a Christian to Governor Paschasius. She was sentenced to a brothel but, when guards attempted to take her there, they could not move her. Then, she was ordered to die at the stake,

but the flames did not harm her. In the end she was stabbed successfully in the throat. Saint Lucy is the patron saint of eye ailments as she supposedly tore out her own eyes to give to a suitor who admired them, but these were miraculously restored. Another version of her life story claims that the tearing out of her eyes was part of her martyrdom. The saint figures in the *St. Lucy Altarpiece* by **Domenico Veneziano** (c. 1445–1447, **Florence, Uffizi**), with her martyrdom by stabbing on the *predella* (now in Berlin, Gemäldegalerie). **Lorenzo Lotto** painted *St. Lucy before the Judge* (1532; Jesi, Pinacoteca Comunale) and **Caravaggio** rendered her burial (1608; Syracuse, Museo Bellomo). One of the most aesthetically pleasing representations of the saint is by **Francisco de Zurbarán** (c. 1635–1640; Chartres, Musée des Beaux-Arts), painted for the Monastery of the Merced Descalza in Seville, Spain.

LUDOVISI, CARDINAL LUDOVICO (1595–1632). A native of **Bologna**, Cardinal Ludovisi was the nephew of Pope **Gregory XV**. He was educated in the Collegio Germanico in **Rome** and at the University of Bologna where he graduated in 1615 with a degree in canon law. In 1621, upon his uncle's ascent to the papal throne, Ludovico obtained the cardinalate, with Santa Maria in Traspontina as his titular church. Ludovico also served as archbishop of Bologna, prefect of the Congregation of the Propaganda Fide, and vice-chancellor of the Holy Roman Church. He is best known for his collection of antiquities, which included the famed *Dying Gaul* now in the Capitoline Museum and *Ares* in the Palazzo Altemps, both in Rome. He was the patron of **Gian Lorenzo Bernini**, **Alessandro Algardi**, and **Guercino** and is portrayed in **Domenichino**'s portrait *Pope Gregory XV and Cardinal Ludovico Ludovisi* (1621–1623; Béziers, Musée des Beaux-Arts).

LUKE, SAINT. St. Luke is one of the **Evangelists** who wrote the Gospels. He is believed to have been a Greek born in Antioch and to have trained as a physician. Nothing is known of his conversion to Christianity, though perhaps **St. Paul** may have had a hand in this as Luke accompanied him to Troas in c. 51 CE, and then to Samothrace, Neapolis, and Philippi. Luke remained in Philippi where he acted as leader of the local Christian community. In 57 CE he rejoined Paul in

Troas and together they traveled to Miletus, Tyre, Caesarea, and finally Jerusalem. In 61 CE Luke and Paul were in **Rome**, where the latter was imprisoned and martyred. Luke is believed to have died in Boetia at the age of 84 of natural causes. His Gospel is unique in that it emphasizes the poor, forgiveness of sins, and social justice. It is also the only Gospel to present the story of the **Annunciation, Visitation, Presentation in the Temple**, and **Mary Magdalen**'s washing of Christ's feet with her tears. One tradition claims that St. Luke painted a number of portraits of the **Virgin**. For this, he is considered the patron saint of painters and most early guilds or academies of painting in Europe were named after him. **El Greco** presented *St. Luke* (c. 1605–1610; Toledo, Cathedral) in this light as a three-quarter figure with pen in hand and holding opened his book where his portrait of the Madonna and Child is included. **Jan Gossart** (c. 1515; Prague National Gallery) and **Maerten van Heemskerck** (1532; Haarlem, Frans Halsmuseum) showed the saint in the act of painting the Virgin. *See also* ACCADEMIA DI SAN LUCA, ROME.

LUNETTE. A semicircular wall area enframed by an arch over a door or window. Lunettes become pictorial fields onto which a painting, **mosaic**, or **relief** sculpture can be placed. **Annibale Carracci**, for example, painted a series of religious landscapes in c. 1604 to be installed in the lunettes of the chapel in the Aldobrandini Palace, **Rome**. Davide **Ghirlandaio**, Domenico's brother, rendered a mosaic of the **Annunciation** (1509) on the lunette above the main portal of the Church of Santisima Annunziata, **Florence**, and **Benvenuto Cellini** provided a relief of **Diana**, goddess of the hunt, for one of the doorway lunettes in the Palace of Fontainebleau near Paris (1542–1544; now Paris, Louvre). Lunettes are also sometimes part of wall tombs, as the *Tomb of Chancellor Carlo Marsuppini* (1453; **Santa Croce**, Florence) by **Desiderio da Settignano** exemplifies.

– M –

MADERNO, CARLO (1556–1629). Architect from Capolago, now Switzerland, who was active in **Rome** where he arrived in c. 1576. There Maderno worked for his uncle, Domenico Fontana, Pope Six-

tus V's favored architect. In 1594, Fontana moved to Naples and Maderno became an independent master. His façade for the Church of Santa Susanna, Rome, he created in 1597–1603, a design based on Giacomo da Vignola's **Il Gesù** (1568–1584) with a gradual crescendo from the lateral bays to the central portal aimed at placing all focus on the entrance. In 1602, Maderno also designed the Water Theater in the Villa Aldobrandini at Frascati for Cardinal **Pietro Aldobrandini**. In the following year, he was appointed the official architect of **St. Peter's** and, in 1606–1612, he worked on the conversion of the structure into a longitudinal basilica and added a new façade. In 1628–1633, Maderno worked for the **Barberini** on the design of their palazzo, his most important secular commission. Maderno died in 1629, and the Palazzo Barberini was completed by **Gian Lorenzo Bernini**.

MADERNO, STEFANO (1576–1636). Sculptor possibly from Lugano who was active in **Rome**. Early in his career, Maderno restored antique statues for collectors, but soon began executing small terracotta sculptures inspired by ancient prototypes. His most important commission is the life-size statue of *St. Cecilia* (1600) in the Church of St. Cecilia in Trastevere, Rome. In 1599, the saint's body was found intact in a coffin under the church's high altar. Pope Clement VIII commemorated the miraculous event by commissioning Maderno to create a recumbent sculpture of the saint as she had been found, with hands bound, her neck partially severed, and wearing an embroidered dress. Once Maderno completed the work, it was incorporated into the high altar, under which the saint was reburied. It became the prototype for the depiction of recumbent saints in art.

MADONNA AND CHILD WITH ST. ANNE **(c. 1508–1513; Paris, Louvre).** Painted by **Leonardo da Vinci** for the high altar of the Church of Santisima Annunziata in **Florence**, the commission for this **altarpiece** originally went to **Filippino Lippi**, but Leonardo persuaded the friars of the Annunziata to give him the charge instead. In 1501, Leonardo provided a cartoon for the composition (original lost; another version in London, National Gallery) that proved too large for the altarpiece's intended frame. The cartoon was exhibited in the Annunziata monastery and Florentines flocked

to see it, including **Michelangelo** and **Raphael**, both of whom were deeply affected by it.

In the final composition, Leonardo arranged the figures to form a pyramid against an **atmospheric** landscape, the **Virgin Mary** sitting on **St. Anne**'s lap and holding onto the Christ Child, who grabs a lamb by the neck and ear. Clearly, Christ's genealogy is one of the painting's main theme. Christ grabs the sacrificial lamb to herald the **Passion**, which Mary tries to prevent by holding him back. In the cartoon, St. Anne points upward as if to indicate to her daughter that Christ's sacrifice is the will of God and that it would be futile to intervene. In the painting, Leonardo omitted St. Anne's pointing gesture, though the melancholic tinge in her smile implies her recognition of Christ's future suffering. The cascade of movement from upper left to lower right, enhanced by Mary's graceful bend, is an enhancement to the original composition where mother and daughter sat almost side by side. Leonardo did not complete the work and, when he moved to France in 1517 to serve **Francis I**, he took the painting with him, along with his *Mona Lisa* (1503) and *St. John the Baptist* (c. 1513–1516; both Paris, Louvre), keeping it until his death in 1519 when it entered the French royal collection.

MADONNA DEL POPOLO **(1575–1579; Florence, Uffizi).** Painted by **Federico Barocci** for the **Confraternity** of the Misericordia in Arezzo, the work shows the people of Arezzo below an apparition of the **Virgin** who intercedes on their behalf. Some of the figures point to the vision, while others go about their daily routines without noticing the event. A woman returns from the market with a child in her arms; a beggar lies on the ground while a man offers him alms. The Virgin seems to be asking her son to illuminate those who are blind to the true faith and, in response, he sends the Holy Spirit so they may be saved. Barocci enhanced the figures' appeal by adding touches of pink throughout the pictorial surface, common to his art. This work represents the artist's early **Mannerist** phase. Consequently, the composition is oval with a void in the center and a large number of figures populating the picture, most in contorted poses. Barocci would eventually shed the Mannerist style in favor of greater clarity and deeper emotional content in response to the demands of the **Council of Trent** and the **Counter-Reformation**.

MADONNA OF THE HARPIES (1517; Florence, Uffizi). This work was painted by **Andrea del Sarto** for the Convent of San Francesco dei Macci in **Florence**. An unconventional representation, the **Virgin** is shown standing on a pedestal that is decorated with harpies, mythological monsters who carry away the souls of the dead and minister punishment. Also on the pedestal are inscribed the first lines of the hymn to the Virgin of the **Assumption**, which explains why the two putti at Mary's feet seem to be pushing her upward. The work has been the subject of much discussion because the inclusion of the harpies is not well understood. Identified variously as harpies, sphinxes, sirens, and other mythical creatures, they have inspired readings that range from symbols of paganism superseded by the triumph of Christianity to sin conquered by the Virgin's purity. Some believe that del Sarto's Mary is the woman of the **Apocalypse** described in the Book of Revelations who engages in a spiritual battle against demons or the embodiment of the **Immaculate Conception** who tramples the dragon of evil. In the painting, Mary is flanked by Sts. **Francis** and **John the Evangelist**, this last figure based on one of the males holding a book in **Raphael**'s *School of Athens* in the **Stanza della Segnatura** (1510–1511) at the Vatican. Saint John is there because he authored one of the Gospels where the story of salvation is told, and St. Francis is the patron of the Poor Claires who resided in the monastery for which the work was painted.

MADONNA OF THE PESARO FAMILY, **SANTA MARIA DEI FRARI, VENICE (1519–1526).** Painted by **Titian**, the *Madonna of the Pesaro Family* was commissioned by Jacopo Pesaro, Bishop of Paphos, Cyprus. Following the prescriptions of **Giovanni Bellini** and **Giorgione** for the depiction of the enthroned **Virgin** and Child, Titian placed these saintly figures on an elevated throne against a landscape, with two large columns flanking them. Titian, however, elaborated on the format by relegating the throne to the side and placing **St. Peter**, not the customary musical angels, at the foot of the throne—his key to heaven's gate prominently displayed. The armored figure on the lower left presents a Turkish captive to the Virgin and Child to refer to Jacopo's triumph over the Turks in 1502 at Santa Maura while commanding the papal naval ships. The diagonal formed by the throne, saint, and armored and captive figures makes

for a dynamic rendition. At either side of the Virgin are members of the Pesaro family kneeling, with **St. Francis**, the founder of the **Franciscan Order** to which the Church of Santa Maria dei Frari belongs, on the right petitioning the Virgin to view the Pesaro family favorably. Above, heavily **foreshortened** putti support the cross on which Christ will be **crucified**, yet the Christ Child seems oblivious to his future fate as he plays with his mother's veil. This playful detail shows Titian's interest in stressing the human aspect of his religious characters.

MADONNA OF THE ROCKS (1483–1486; Paris, Louvre). Leonardo da Vinci painted this work for the Church of San Francesco Grande in Milan and received the commission from the **Confraternity** of the **Immaculate Conception**. Two of his pupils and an independent sculptor were also involved in the project, which was to include side panels depicting musical angels and a sculpture of the *Immaculate Conception* to be placed either above or below the **altarpiece**. Leonardo's figures form a pyramidal composition with the **Virgin** in the center embracing the young **St. John the Baptist** and holding up her **foreshortened** hand in a protective gesture above her son's head. The Christ Child, in turn, blesses his cousin, the Baptist, while the angel on the right points to St. John and looks in our direction. The scene takes place in a **grotto**, a reference to the Holy Sepulcher where Christ was buried after the **Crucifixion**. The light that seeps through the rocks in the background denotes the salvation Christ will bring to humanity, made possible by Mary, the immaculate vessel who brought on his incarnation. Here, Leonardo adds a sense of mystery to the work by using his characteristic **sfumato** technique, while his interest in botany is reflected in the accurate rendering of the plants in the foreground. A second version of this painting exists (fin. c. 1506; London, National Gallery) that lacks the subtleties of the earlier composition, betraying the heavy intervention of assistants. The *Madonna of the Rocks* presents the poetic beauty for which Leonardo is so well known and reflects his keen observation of the nuances of nature and desire to replicate them faithfully on the painted surface.

MADONNA OF THE ROSARY, ORATORIO DEL ROSARIO, PALERMO (1624–1627). Painted by **Anthony van Dyck**, the

Madonna of the Rosary is part of a series he rendered on the life of St. Rosalie, patron saint of Palermo, Sicily. It is the largest work the artist created during his stay in Italy and one of his finest **altarpieces**. Commissioned in 1624 to celebrate the recovery of the saint's remains, the work also was meant as appeal on behalf of the people of Palermo for deliverance from the **plague** that was devastating their city. The *Madonna of the Rosary* shows the **Virgin Mary** and Christ Child appearing to Rosalie and her companions in a heavenly burst of clouds and angels. Below, a nude child holds his nose, a traditional reference to death and decay, and points to those who are stricken. The overall composition borrows heavily from **Peter Paul Rubens'** *St. Gregory Surrounded by Saints* (c. 1608; Grenoble, Musée), a work he placed on his mother's tomb in the Abbey of St. Michael in Antwerp where van Dyck would have seen it. The lush brushwork and vivid colorism come not only from Rubens but also from van Dyck's direct study of the works of the **Venetians**, and particularly **Titian**. When van Dyck painted this work, no precedents on the depiction of St. Rosalie existed. Therefore, it shows his inventiveness in formulating a new standard of visual representation.

MADONNA OF THE STAIRS (1489–1492; Florence, Casa Buonarroti). This work, executed by **Michelangelo** while training in the **Medici** household, illustrates his admiration for **Donatello**. Not only does it recall Donatello's *Pazzi Madonna* (1420s–1430s; Berlin; Staatliche Museen), but it also uses the older sculptor's *relievo schiacciato* technique. Michelangelo also looked to ancient statuary and particularly funerary *stelae*, a proper choice as his scene foreshadows the future death of Christ. As in the ancient examples, Michelangelo's **relief** is permeated by a quiet, somber mood. In the foreground, the **Virgin**, here presented as the "Stairway to Heaven" by her juxtaposition to the stairs, partially covers the Christ Child with her mantle to denote the future wrapping of his body with the shroud in preparation for burial. In the background, wingless angels spread the shroud in anticipation of the event. Executed by Michelangelo while in his teens, the *Madonna of the Stairs* demonstrates that he already was capable of rendering anatomy and drapery folds accurately and that his interest in challenging himself to render complex poses began at an early age.

MADONNA WITH THE LONG NECK (1534–1540; Florence, Uffizi). The *Madonna with the Long Neck* was rendered by **Parmigianino** for Elena Baiardi to be placed in her family chapel in the Church of Santa Maria dei Servi, Parma. This is the artist's best-known work and exemplifies his mastery at rendering graceful, elegant scenes. The elongations, ambiguities, and incompatible proportions are what qualify the work as **Mannerist**. The large **Virgin** in the center of the composition is reminiscent of the monumental, powerful **sibyls** rendered by **Michelangelo** on the **Sistine ceiling**, Vatican (1508–1512). Her opened toes, shown prominently in the foreground, in fact replicate those of Michelangelo's Libyan Sibyl. The sleeping Christ Child, in turn, is based on the pose of the dead Christ sprawled across Mary's lap in Michelangelo's Vatican *Pietà* (1498/1499–1500), his grayish, corpselike complexion alluding to his future death on the cross. The row of **classical** columns in the background parallel the columnar posture and neck of the Virgin and possibly refer to the Old Law of Moses now superseded by the New Law of Christ. The diminutive male figure in the background holding an opened scroll is believed to be one of the **prophets** who foretold the coming of the Lord. This emphasis on symbolic elements that at times prove difficult to decipher is part of the Mannerist style and categorizes the work as one of the movement's grand masterpieces.

MAESTÀ ALTARPIECE (1308–1311; Siena, Museo dell' Opera del Duomo). Created by **Duccio**, then leading painter of the Sienese School, the *Maestà Altarpiece* was intended for the main altar of the **Cathedral of Siena**. A freestanding polyptych painted on both sides, the altarpiece was removed from its original site in 1506 and dismantled to make way for a new decorative program. The scenes from the *predella* and **pinnacles** were scattered and are now in various museums around the world; some, regrettably, were cut down and two are missing. This has fueled much debate as to the original order of placement of the scenes and the subjects represented in the lost panels.

In the central panel is an *Enthroned Virgin and Child* in majesty (hence the appellation *Maestà*) surrounded by angels, appropriate to the cathedral of a city whose patroness is the Virgin. Saints Ansanus, Savinus, Crescentius, and Victor, also patrons of Siena, kneel at

Mary's feet, while an inscription at the foot of her throne reads, "Holy Mother of God, be the cause of Siena, of life to Duccio as he has painted you in this manner." Behind the figures are three-quarter-length representations of **prophets** holding scrolls. The back of the main panel features the **Passion of Christ**, while the *predella* scenes are from Christ's infancy and the pinnacles from the life of the Virgin. The almond-shaped faces of the figures, the use of black to denote shadows, and the heavy gilding betray the dependence on the *Maniera Greca* tradition established in the region by **Coppo di Marcovaldo** and **Guido da Siena**.

In 1311, when the altarpiece was completed, the Sienese citizens carried it from Duccio's workshop to the cathedral in a grand procession led by the bishop and other members of the clergy. Candles were lit around it, bells rung, bagpipes and trumpets played, and prayers carried out in front of it. Siena could now boast of an artist as grand as **Giotto**, active in the enemy Republic of **Florence**.

MAGDALENA VENTURA WITH HER HUSBAND AND CHILD **(1631; Toledo, Museo Fundación Duque de Lerma).** Painted by **Jusepe de Ribera** for the Duke of Alcalá, Viceroy of Naples, who was fascinated by Magdalena Ventura, a resident in the city cursed with a heavy beard. In the painting, Magdalena stands next to her husband and suckles one of her many children, her breast predominantly displayed to denote her ability to bear and nurture children in spite of her condition. A long inscription on the stones stacked to the right speaks of her situation and hails her as "a miracle of nature." Above the stones are the spindle and distaff, implements used for weaving and considered signs of domesticity and female virtuosity. Though a depiction of what some would classify as a freak of nature, Ribera depicted the woman in all her dignity. The work speaks of the interest in the Spanish court and its territories in the rarities of nature and the desire to record them.

MAINO, JUAN BAUTISTA (1578–1641). Of Milanese and Portuguese descent, Maino was active in Spain in the courts of Philip III and **Philip IV**. The details of his training are not completely clear. Considered by most to have been one of **El Greco**'s pupils, one

17th-century source states that Maino was a student and friend of **Annibale Carracci**, as well as a close companion to **Guido Reni**. By 1611, Maino is documented in Toledo where two years later he took vows at the **Dominican** Monastery of St. Peter Martyr. In 1614, Philip III called him to Madrid and appointed him drawing master to his son, the future King Philip IV. At court, he excelled in the area of portraiture, though he is best known for the religious canvases he created. Among these are the *Adoration of the Magi* and *Adoration of the Shepherds* (both 1612–1613; Madrid, Prado), both rendered for the Monastery Church of St. Peter Martyr. His most important commission is the *Recapture of Bahia* (1634–1635; Madrid, Prado) for the Hall of Realms in the king's Palace of El Buen Retiro, an event that took place in 1625 led by Count Duke of Olivares, whom Maino included in the painting. Here, Bahia is recovered from the Dutch who kneel in front of Philip IV's portrait. The wounded tended to in the foreground, modeled after traditional images of the *Pietà*, add an aura of sentimentalism and cast the victors as benevolent toward their enemies. In these works, Maino's style is closely tied to that of the members of the Carracci School in its choice of colors and idealization of forms, giving credence to the contemporary reports on his training in Italy.

MAITANI, LORENZO (c. 1270–1330). Italian sculptor and architect from Siena. In 1308, Maitani was summoned to Orvieto to reinforce the **apse** and **transept** of the city's cathedral, which had weakened. In 1310, he was appointed Director of Cathedral Works, a position he held until his death in 1330. In this capacity, he was charged with the design of the cathedral's façade and its **reliefs**, which include scenes from the Book of Genesis (from the Creation to the descendants of Cain), the Tree of Jesse, the prophecies of the coming of Christ and his sacrifice for humanity, the story of salvation, **Last Judgment**, **Resurrection**, and paradise. Also attributed to Maitani is the *Enthroned Virgin and Child* revealed by angels who part the curtains of the canopy that contains them above the cathedral's west portal. Maitani's style in these reliefs is closely tied to the medieval tradition and is characterized by busy scenes with figures in contorted poses. For this, he is classified as one of the most expressive sculptors of the Proto-Renaissance era.

MALATESTA, SIGISMONDO (1417–1468). Tyrant ruler of Rimini, a charge he obtained in 1432, at the age of 14. Sigismondo was excommunicated in 1462 by Pope Pius II and cast to hell in front of **St. Peter's** on charges of impiety and sexual misconduct related to the suspicious death of his wife, Polissena **Sforza** (1449), probably from poisoning. In 1450, Sigismondo had commissioned **Leon Battista Alberti** to complete the ***Tempio Malatestiano***, begun by Matteo de' Pasti as a renovation of a church already on the site that housed the funerary chapels of his ancestors. By the time Alberti became involved in the project, Sigismondo had decided to convert the structure into some sort of pagan shrine that spoke of his glory as ruler. He retrieved the remains of famous men, including the Greek humanist and **Neoplatonist** Gemistus Pletho, an advocate of paganism whose body Sigismondo discovered during the 1465 campaign against the Turks in the Morea when he commanded the **Venetian** army. The project gave the pope added ammunition in his defamation campaign against Sigismondo. Sigismondo was also the patron of **Antonio Pisanello** and **Piero della Francesca**.

MALOUEL, JEAN (c. 1365–1415). Jean Malouel, a painter from the town of Nijmegen, now Holland, was the uncle of the **Limbourg brothers**. He is known to have worked for Isabella of Bavaria, wife of Charles VI of France (d. 1435), and then, in 1396, he is recorded as court painter to **Philip the Bold**, Duke of Burgundy, a charge he fulfilled until his death in 1415. For Philip he rendered five large panels for the Chartreuse de Champmol in Dijon, where he also was charged with painting and gilding **Claus Sluter**'s *Well of Moses* (1395–1406; Dijon, Musée Archéologique). One of the five panels is perhaps the *Martyrdom of St. Denis* (fin. c. 1416; Paris, Louvre), believed to be the painting for which Henri Bellechose, Malouel's pupil, received pigments to complete it after his master's death. The work shows Denis, patron saint of France and first bishop of Paris, receiving his last communion on the left and undergoing his decapitation on the right, with Christ's **Crucifixion** in the center, the cross held by God the Father. Also attributed to Malouel is the *Pietà* in the Louvre (c. 1400), a tondo (circular panel) that brings the scene close to the picture plane to evoke piety from viewers. The work combines the *Pietà* theme with the **Holy Trinity** as it is God

the Father who supports the bloodied body of Christ while the Holy Dove hovers between them. The coat of arms of France and Burgundy painted on the panel's reverse denotes that this work was also rendered for Philip, and perhaps the Chartreuse de Champmol. Malouel was among the artists who translated the French Gothic miniaturist tradition to large-scale painting. His gilded backgrounds, rich patternings, and elongated forms qualify him as one of the luminaries of the **International Style**.

MALVASIA, CARLO CESARE (1616–1693). The author of the *Felsina Pittrice* (1678), a history of **Bolognese** painting and collection of biographies of Bolognese artists. Malvasia was born into an aristocratic family. In 1639, he went to **Rome** where he became a member of several literary academies, among them the Accademia degli Umoristi. Through these, he made the acquaintance of important patrons, among them cardinals Giovanni Francesco Ginetti and Bernardino Spada, as well as the sculptor **Alessandro Algardi**. By 1647 he was back in Bologna teaching law at the local university and, in 1662, he was appointed canon in the Cathedral of Bologna, after obtaining a degree in theology. His charge provided travel opportunities that gained him the acquaintance of the likes of Cardinal Leopoldo de' **Medici**, whom he served as artistic advisor, as well as Pierre Cureau de la Chambre, who facilitated his access to the court of Louis XIV of France and the **French Academy**. All the while, Malvasia conducted his research on the artists of Bologna. His *Felsina Pittrice* is one of the most important historical sources on the Bolognese reform movement effected by the **Carracci** and their followers.

MAN WITH BLUE SLEEVE **(c. 1511–1515; London, National Gallery).** This portrait is an early work by **Titian**. It is not clear who is depicted, though art historians have suggested that it may be the poet Ludovico Ariosto. Some view the work as a self-portrait, while others believe the man to be a member of the Barbarigo family, among Titian's earliest patrons. Regardless of the sitter's identity, the work represents a major step forward in the development of portraiture. Previously, sitters were presented in a formal, static pose and the emphasis was on opulence and social status. Titian exchanged luxury

for visual richness by loosening his brushwork and placing the man's body in an informal profile pose with a sharp turn of the head toward the viewer and a self-assured facial expression. His arm, clad in a blue sleeve, hangs over a parapet and seems to break into the viewer's space. The **foreshortenings**, lively pose, and character of the man depicted infuse the work with a dynamism never before seen in this genre. With this, Titian broke away from the Renaissance emphasis on permanence and opened the doors for future experiments in portraiture on the capturing of a moment in time on the pictorial surface.

MANCINI, GIULIO (1588–1630). The private physician to Pope **Urban VIII**, Mancini was also an amateur art critic and patron. His *Considerazioni sulla Pittura* [*Thoughts on Painting*], written largely between 1617 and 1621, is a guide for collectors on connoisseurship, conservation, and the proper display of art. For him, beauty in art had little to do with **Neoplatonic** concepts, as his contemporary theorists **Giovanni Battista Agucchi** and **Giovan Pietro Bellori** believed, and more with proportions, color, and expression. He felt that beauty exists in all things in nature and that even the deformed can be depicted in a pleasing manner as long as decorum is preserved. He severely criticized **Caravaggio** for using the corpse of a prostitute as his model for the *Death of the Virgin* he painted for the Church of Santa Maria della Scala, **Rome** (1605–1606). It was not Caravaggio's naturalism that bothered Mancini but rather the way he had disrespected the **Virgin Mary** in this particular work. Also interesting is the fact that Mancini was deeply opposed to censorship—this in an era when the **Counter-Reformation** Church was attempting to control art to use as weapon against the spread of Protestantism. Mancini specifically mentioned **Girolamo Savonarola**, who burned precious works of art in **Florence**, calling him an extremist. In his view, erotic art also had its place in collections, as long as they were covered and only shown by the owner to his wife or a person of confidence. Mancini's *Considerazioni sulla Pittura* reveals much about attitudes on art in the **Baroque** era and provides insight into patronage, collecting, and display practices.

MANDER, KAREL VAN (1548–1606). Dutch **Mannerist** painter who authored the *Schilderboeck* (first published in 1604), a biographical

compendium of artists and their works from the ancient era to the author's days. For art historians, this book is one of the major sources of information on the lives of the Northern masters of the 15th and 16th centuries. For this, van Mander has been called the "**Vasari** of the North." Van Mander was in **Rome** from 1573 to 1577 and it is there that he became aware of Giorgio Vasari's *Lives of the Artists*, which inspired him to write the *Schilderboeck*. It is also there that he was exposed to the Mannerist mode he adopted as his own. He spent some years wondering through the Netherlands, finally settling in Haarlem in 1583 where, together with Hendrik Goltzius and Cornelis van Haarlem, he established an academy and developed a Dutch Mannerist style. Van Mander died in Amsterdam where he spent the last two years of his life. Among his most notable works are *The Flood* (c. 1583; Haarlem, Frans Halsmuseum), the *Continence of Scipio* (1600; Amsterdam, Rijksmuseum), and the *Garden of Love* (1602; St. Petersburg, Hermitage Museum).

MANDORLA. In English, *almond*. An almond shape used in art to surround saintly figures, like the **Virgin Mary** or Christ, to denote their divinity. The device is more common in works belonging to the Proto-Renaissance era, for example, the *Strozzi Altarpiece* (1354–1357) in the **Strozzi Chapel** at **Santa Maria Novella**, **Florence**, by **Andrea Orcagna**, where Christ is centered in a *mandorla* and surrounded by seraphim. In the Baptistery of Padua, the Virgin is enclosed in a *mandorla* in Giusto de' Menabuoi's **fresco** (c. 1378) and hovers above the entrance to the tomb of Fina Buzzacarini, the patron. A work that belongs to the Early Renaissance that utilizes the device is the *Sansepolcro Altarpiece* by **Sassetta** (1437–1444; Borgo di Sansepolcro, Church of San Francesco) where **St. Francis**, enclosed in a *mandorla*, hovers above the sea with the **Franciscan Virtues** of Charity, Poverty, and Obedience above him.

MANDYN, JAN (1502–c. 1560). Painter from Haarlem whose fantastic works are closely related to those of **Hieronymus Bosch**. Mandyn is recorded in Antwerp in 1530, with Gillis Mostaert and Bartholomew Spranger figuring among the pupils in his workshop. His *Temptation of St. Anthony* (1547; Haarlem, Frans Halsmuseum) is his only signed work and has served as the basis for reconstructing

his career. Like Bosch's fantasies about the follies of humanity, Mandyn's painting presents a landscape littered with bizarre objects and monstrous creatures who hassle the saint as he prays for strength. Mandyn was somewhat more conservative than Bosch in the peculiarities of his scenes, though they possess as much visual richness as Bosch's compositions. Other works by Mandyn include the *St. Christopher with the Christ Child* (c. 1550) at the Los Angeles County Museum and the *Landscape with the Legend of St. Christopher* (early 16th century) at the St. Petersburg Hermitage.

MANFREDI, BARTOLOMEO (c. 1580–1621). Little is known of Bartolomeo Manfredi's career as painter. He was born in Ostiano near Mantua and went to **Rome** sometime between 1600 and 1606, where he became one of **Caravaggio**'s closest followers. **Giovanni Baglione** wrote that Manfredi in fact worked in Caravaggio's studio as his assistant and servant. His *Gypsy Fortune Teller* (c. 1610–1615; Detroit Institute of Arts) depicts a subject also tackled by Caravaggio (c. 1596; Rome, Capitoline Museum). Like his master, Manfredi used half-figures set against a dark, undefined background and lit through the use of theatrical **chiaroscuro**. His *Cupid Punished by **Mars*** (1605–1610; Chicago, Art Institute) relates compositionally and thematically to Caravaggio's *Amor Vincit Omnia* (1601–1602; Berlin, Gemäldegalerie) and his *Guardroom* (c. 1608; Dresden, Gemäldegalerie) borrows from Caravaggio's *Cardsharps* (1595–1596; Forth Worth, Kimball Museum of Art). Manfredi was responsible for transmitting the Caravaggist mode of painting to the foreign masters who visited Rome in the early decades of the 17th century, particularly from France and the Netherlands.

MANIERA GRECA. A term used to describe the Greek or Byzantine mode of painting adopted in Italy by artists of the Proto-Renaissance era. It is characterized by the heavy use of gilding, brilliant colors, striations to denote the folds of fabric, and segments for the figures' anatomical details. Among the artists who adopted the *Maniera Greca* style are **Berlinghiero** and **Bonaventura Berlinghieri**, **Coppo di Marcovaldo**, **Guido da Siena**, and **Cimabue**, who is said to have brought it to its greatest refinement. **Giotto** is the first master to have rejected the *Maniera Greca* mode

in favor of greater naturalism and convincing emotive content, thereby revolutionizing the art of painting.

MANNERISM. An art movement that emerged in roughly the 1520s inspired by the unprecedented architectural forms **Michelangelo** introduced in the vestibule of the **Laurentian Library** (1524–1534) and **Medici** Chapel (**New Sacristy of San Lorenzo, Florence,** 1519–1534), and the sculptural figures in this last commission with their exaggerated musculature and unsteady poses. Mannerists purposely denied the strict **classicism** and emphasis on the pleasing aesthetics of the High Renaissance and instead embraced an anticlassical mode of representation that entailed the use of illogical elements, jarring colors and lighting, contorted figures, and ambiguous iconographic programs. The early exponents of this movement were **Jacopo da Pontormo** and **Rosso Fiorentino** who favored circular compositions with a void in the center, scenes that move up instead of logically receding into space, abrupt color combinations, and harsh lighting that ignores the subtle Renaissance gradations from light to medium to dark. Rather than looking to nature for inspiration, these masters looked to Michelangelo, the result being an art that can be categorized as self-consciously artificial, highly sophisticated, and cerebral.

The pioneer of Mannerist architecture was **Giulio Romano** who designed for Duke **Federigo Gonzaga** of Mantua the **Palazzo del Tè** (1527–1534), a structure with asymmetrical placement of pilasters, stringcourses that are interrupted by massive keystones, and pronounced **rustications** on all the exterior surfaces. Mannerism soon spread to other parts of Italy and Europe. **Perino del Vaga** brought the vocabulary to **Rome** and Genoa, **Domenico Beccafumi** to Siena, **Correggio** to Parma, and **Parmigianino** to Parma, Rome, and **Bologna**. A second waive of Mannerist artists emerged toward the middle of the 16th century, including **Agnolo Bronzino, Giorgio Vasari**, and **Federico Barocci. Benvenuto Cellini, Bartolomeo Ammannati**, and **Giovanni da Bologna** translated the Mannerist idiom into sculpture, and Ammannati and Vasari also applied it to architecture. Rosso and **Francesco Primaticcio** traveled to France to work in the court of King **Francis I**. At the Palace of Fontainebleau, they invented a new type of decoration that combined stucco, metal,

and woodwork with painting and sculpture, establishing what today is known as the Fontainebleau School, a French version of Mannerism. In the Low Countries, Mannerism was adopted by a group of masters known as the Romanists, among them **Jan Gossart**, **Joos van Cleve**, **Bernard van Orley**, and **Jan van Scorel**.

MANSART, FRANÇOIS (1598–1666). French architect, first trained by his father who was a carpenter. When his father died in 1610, Mansart completed his training with his brother-in-law, the architect Germain Gaultier who had collaborated with **Salomon de Brosse**. No evidence exists to confirm that Mansart was in Italy, yet he was familiar with the Italian architectural vocabulary, already fairly well represented in France through the work of de Brosse and **Jacques Lemercier**. By now, the treatises of **Vitruvius**, **Andrea Palladio**, and Giacomo da Vignola had been translated into French and made available to local masters. Also available were books with reproductions of the monuments from antiquity on which the Renaissance architectural vocabulary of Italy was based.

Mansart's first recorded commission was the façade of the Church of Feuillants in Paris (1623–1624; destroyed; known only through engravings), a work based on de Brosse's Church of St. Gervais. Mansart added a tall screen above the segmented **pediment** in the manner of **Jean du Cerceau** and volutes (spiral scrolls) at either side of the upper story with **rusticated** pyramids at either end to differentiate his work from that of de Brosse. Mansart correctly applied the **Colosseum principle** to the structure, with the Ionic order below the Corinthian. The commission was followed by the Château de Berny (1623–1624), of which only a portion of the court façade survives. Here, Mansart provided a freestanding structure with independent roofs, at the time a major departure from the usual French château type. He also added some curvilinear forms along the court to add movement to the structure and flanked it with quadrant colonnades.

The Château de Balleroy (c. 1631) is one of the few buildings by Mansart to have survived in its original condition. Built for Jean de Choisy, chancellor to the Duke of Orleans, the structure is fairly small in size, so Mansart emphasized its vertical axis to add to its monumentality. The building sits on a terrace accessed by semicircular stairs that break the monotony of the rectilinear forms. The central

block is composed of three stories and crowned by a pitched roof with dormers. The side blocks mimic these forms, yet their height is decreased so as not to compete with the central block.

Other domestic structures by Mansart include the Château de Blois (1635–1638) built for Gaston d'Orléans, **Louis XIII**'s brother, and the Château de Maisons (1642–1646) for René de Longueil, the king's Président des Maisons. In the mid-1640s, Mansart also provided a design for the Church of Val-de-Grâce commissioned by Anne of Austria, Louis XIII's wife, who passed the work on to Lermercier after a year as Mansart ignored budgetary constraints and kept making changes to his plans. Mansart, in fact, is known to have had a belligerent personality that cost him not only this commission but many others. Toward the end of his life, he fell into oblivion, receiving only sporadic work from patrons. Today, Mansart is considered one of the most proficient and influential architects of 17th-century France.

MANTEGNA, ANDREA (c. 1431–1506). The leading painter of the Early Renaissance in Northern Italy; a master of **perspective** and **foreshortening**. Mantegna was born near Padua where he was trained by the painter Francesco Squarcione, who was also an art collector and dealer. From Squarcione Mantegna developed a keen interest in antiquity and learned to read Latin. His interest in the ancient world peaked when he became a member of a group in Verona who engaged in archaeological studies and often took boat rides on Lake Garda to read the classics. In 1453, Mantegna married Nicolosia, the daughter of **Jacopo Bellini**, becoming a member of the Bellini dynasty of painters. His earliest commission is the Ovetari Chapel in the Church of the Eremitani in Padua (1454–1457). The contract for the work had to be signed by his brother, as Mantegna was considered too young to do so himself. The patron was Imperatrice Capodilista, wife of Antonio di Biagio degli Ovetari, who left funds in his will for the project. The scenes chosen were from the life of St. James. Unfortunately, these were lost to Allied bombing during World War II and are only known through the few remaining fragments and photographs taken before their destruction. The photos reveal Mantegna's understanding of the **Florentine** vocabulary and technical advancements in perspective. They also disclose the influence of **Donatello**, as Mantegna's figures are as solid as the sculptor's. In Mantegna's *St.*

James Led to His Execution, one of the soldiers is in fact based on Donatello's *St. George* from **Orsanmichele**, Florence (1415–1417).

In 1456–1459, Mantegna painted the ***San Zeno Altarpiece*** for the Church of San Zeno in Verona. Here the elaborate architectural framework, created in a **classical** vocabulary, interacts with the painted image in that its columns are made to match precisely the painted piers in the foreground. Mantegna carried the classical idiom into the image itself by placing the enthroned **Virgin** and Child, musical angels, and saints in a chamber with piers that support a continuous **all' antica** frieze with garlands and putti. Here again, Donatello's influence is noted in the overall composition. The architectural and figural arrangements depend on Donatello's altar in the Church of San Antonio (il Santo) in Padua. Mantegna's ***Agony in the Garden*** (mid-1450s; London, National Gallery) is based on one of the drawings Jacopo Bellini created for teaching purposes. The work reveals Mantegna's mastery at rendering foreshortened figures, specifically the sleeping **apostles** in the foreground. In the middle ground, Judas leads the Romans to Christ and, in the background, the city of Jerusalem is shown as an ancient Roman city. To this period also belongs Mantegna's ***St. Sebastian*** (1457–1458; Vienna, Kunsthistorisches Museum), which shows the saint amidst Roman ruins. A foot fragment from an ancient statue is juxtaposed to the saint's foot to denote that Mantegna learned well his lessons from the ancient masters.

In 1459, Mantegna moved to Mantua where he became court painter to Duke Ludovico **Gonzaga**. There he remained until his death, painting **altarpieces** and **frescoes** and designing pageants. The most significant work Mantegna carried out in these years is the decoration of the ***Camera Picta*** [*Painted Chamber*] in the Mantuan Ducal Palace (1465–1474). Also known as the Camera degli Sposi (Room of the Married Couple), the frescoes in this chamber record contemporary events in the Gonzaga's lives. The architecture in the scene continues that of the actual room and figures climb fictive steps to reach the real mantel above the fireplace. The most illusionistically successful scene is on the ceiling where a painted oculus (rounded opening) provides a view of the sky. On a balustrade around the oculus putti and servants in exaggerated foreshortening look down at the viewer and smile. Even more remarkable is Mantegna's ***Lamentation over the Dead Christ*** (c. 1490; Milan, Pinacoteca di Brera), also

painted in Mantua. Here, the corpse lies on a slab that is perpendicu-
lar to the picture plane, permitting a clear view of Christ's wounds.
At his side, Mary and **St. John** weep uncontrollably, inviting viewers
to do the same. This work was inspired by **Andrea del Castagno**'s
Death of the Virgin in the Church of San Egidio, Florence (destroyed
in the 17th century), which Mantegna saw when he traveled to that
city in 1466 and again in 1467.

The engravings Mantegna produced from the 1490s on dissemi-
nated his style in Northern Europe where **Albrecht Dürer** is known
to have copied them to perfect his own skills. For Dürer, Mantegna
represented an example of classicism. In Italy, however, Mantegna
touched future masters mainly for his illusionistic devices. His fore-
shortenings in the *Camera Picta* became the catalyst for the illusion-
istic ceilings of the next three centuries.

MARCOVALDO, COPPO DI. *See* COPPO DI MARCOVALDO.

MARGARET OF ANTIOCH, SAINT. St. Margaret was the daughter
of a pagan priest from Antioch who banished her when she converted
to Christianity. Margaret went to the countryside where she became a
shepherdess and there she was able to practice her faith freely. She re-
jected the advances of Governor Olybrius who, in retaliation, ordered
her torture and imprisonment. While captive, the devil appeared to
her in the form of a dragon and swallowed her. Margaret carved her
way out of the belly of the beast with a small **crucifix** she always car-
ried with her. The following day, attempts were made to end her life
by fire and drowning, but both efforts were futile as she miraculously
emerged unscathed from the flames and water. The thousands of in-
dividuals who witnessed the event were immediately converted and
executed. Margaret herself was finally beheaded. Because she carved
her way out of the dragon's belly, Margaret is the patron saint of
childbirth. She is included in that capacity on the bedpost in **Jan van
Eyck**'s *Arnolfini Wedding Portrait* (1434; London, National
Gallery). In **Francisco de Zurbarán**'s depiction of the saint (1634;
London, National Gallery), she stands alongside the dragon, her dress
and hat that of a shepherdess. She is also included in **Friedrich Her-
lin**'s *Family Altarpiece* (1488; Nördlingen, Städtisches Museum)
where she presents female donors to the **Virgin** and Child.

MARGARET OF AUSTRIA (1480–1530). A **Hapsburg**, Margaret of Austria was the daughter of Holy Roman Emperor **Maximilian I**. At the age of two, she was betrothed to the future King Charles VIII of France. Instead, in 1489, Charles married Anne of Brittany and sent Margaret back to her father's court. In 1497, she married the Infante Juan, heir to Isabella of Castile and Ferdinand of Aragon. Widowed a few months later, in 1501, she wed Philibert II, Duke of Savoy, who also died (1504). Her father then appointed her regent to the Netherlands 1507) and guardian to **Charles V**, whom she made her universal heir.

Margaret was a major collector and patron of the arts. **Bernard van Orley** and **Jan Mostaert** were her court painters, and **Conrad Meit** her sculptor. A portrait of Margaret rendered by van Orley in the Musées Royaux des Beaux-Arts, Brussels, records her likeness. Mostaert's *Portrait of an African Man* (1520–1530; Amsterdam, Rijksmuseum) is thought to represent an individual from her court in Malines. Meit created a number of small- and large-scale sculptures for her, as well as portraits. He was charged with overseeing the execution of the tombs of Margaret and her husband Philibert in the Church of Brou in Bourg-en-Bresse (1526–1532). Margaret's collection included such notable works as **Jan van Eyck's** *Arnolfini Wedding Portrait* (1434; London, National Gallery) and **Jan Gossart's** *Metamorphosis of Hermaphrodite and Salmacis* (c. 1505; Rotterdam, Museum Boymans-van Beuningen).

MARMION, SIMON (c. 1420/1425–1489). French painter and manuscript illuminator from Amiens who was praised by the poet Jean Lemaire de Belges as the "prince of illuminators." As a member of a family of painters, Marmion probably received his training from his father. He settled in Valenciennes sometime in the 1540s and there he established his own independent workshop. In 1454, he was summoned by Philip the Good to work for him on the decorations of a lavish banquet. From this point on, Marmion regularly worked for the Burgundian court, also serving Philip's son, Charles the Bold, and Charles' wife, Margaret of York. Though a number of manuscript illuminations, including the *Crucifixion* in the *Pontifical of Sens* (c. 1467; Brussels, Bibliothèque Royale, Ms. 9215, fol. 129), can be given to Marmion with certainty, his large-scale paintings are

not as well documented. Among these is the **Lamentation** (early 1470s) at the New York Metropolitan Museum, which bears the arms and interlaced initials of Charles and Margaret on the verso. The painting's small scale denotes that it was meant for use in private devotion. Other works by Marmion are in the Philadelphia Museum of Art, namely his **Pietà** and *St. Jerome and a Cardinal Praying*, both dating to the last quarter of the 15th century. The angular forms of Marmion's draperies, the brilliant colors, emphasis on details, and drama define his works as Flemish. *See also* ILLUMINATED MANUSCRIPT.

MARRIAGE AT CANA, REFECTORY, MONASTERY OF SAN GIORGIO MAGGIORE, VENICE (1563). Paolo Veronese painted the *Marriage at Cana* for the same monks who commissioned **Tintoretto** to paint the **Last Supper** (1592–1594) in their monastery church. The marriage at Cana represents the first miracle effected by Christ. He and the **Virgin Mary** were invited to a wedding. When the hosts ran out of wine, Christ turned water from the jugs, seen on the right foreground, into wine. The scene is a noisy, dynamic composition similar to Tintoretto's *Last Supper*. However, while Tintoretto rendered humble figures, Veronese instead emphasized the opulence of brocade silks and tableware. The result is a scene that looks more like a contemporary **Venetian** wedding celebration than a solemn representation of a miraculous event. Christ and Mary sit in the center of the table and are the only figures who neither move nor engage in conversation. They are also the only to feature halos. The foreground includes a playful cat and several dogs patiently waiting for a morsel to fall. In front of the table are musicians who entertain the guests. These are portraits (from left to right) of the artist Jacopo Bassano, Veronese himself, and **Titian**. With their inclusion, Veronese made his case for painting as a liberal art comparable to music.

MARRIAGE OF THE VIRGIN. The scene stems from **Jacobus da Voragine**'s *Golden Legend*. Mary had many suitors, so the high priest in the temple asked them to present rods to him. **Joseph**, who held the rod that bloomed, was granted Mary's hand in marriage. In versions by both **Pietro Perugino** (1500–1504; Caen, Musée des

Beaux-Arts) and **Raphael** (1504; Milan, Brera), the marriage takes place in front of the temple and is officiated by the high priest. Joseph holds the blooming rod in one hand, and he puts the ring on the **Virgin**'s finger with the other. Among the other suitors, the one next to Joseph breaks his rod over his knee in frustration, while next to Mary stand the other maidens from the temple. **Guercino** painted the marriage (1649; Fano, Fondazione Cassa di Risparmio) as a more intimate event inside the temple with only the Virgin, Joseph, high priest, and two women present. The temple's tabernacle behind the high priest and the canopy above the figures, places the work in its proper historical setting. The scene was also depicted by **Giotto** (1305; Padua, **Arena Chapel**), **El Greco** (c. 1612, Bucharest Art Museum), and **Nicolas Poussin** (1640; Grantham, Belvoir Castle; second version Edinburgh, National Gallery of Scotland).

MARS. The mythological god of war, Mars is the son of **Jupiter** and **Juno** and his attributes are the helmet, shield, and spear or sword. His illicit affair with **Venus** was discovered by Vulcan, her consort. In retaliation, Mars punished **Cupid** for causing him to fall in love with the goddess, an episode rendered by **Bartolomeo Manfredi** in his *Cupid Punished by Mars* (1605–1610; Chicago, Art Institute). In **Sandro Botticelli**'s *Mars and Venus* (c. 1482; London, National Gallery), the god is shown asleep, perhaps to denote the power of love over war. In **Paolo Veronese**'s *Mars and Venus United by Love* (c. 1570; New York, Metropolitan Museum), the coupling of these two figures carries similar connotations, in this case of political significance to Emperor Rudolph II of Prague, who commissioned the work. **Diego Velázquez** (c. 1639–1641; Madrid, Prado) showed Mars at the foot of the bed after his amorous encounter with Venus and discovery by Vulcan, while **Annibale Carracci** presented him paying the adulterer's fee in the background of his *Venus Adorned by the Graces* (1594–1595; Washington, National Gallery).

MARTHA, SAINT. Martha is the sister of **Mary Magdalen** and Lazarus. Christ often visited their home and, on one such occasion, Martha complained to him that her sister was listening to his words rather than tending to her chores. Christ retorted that it was Mary who had chosen "the better part." This is the scene **Diego Velázquez**

depicted in his *Christ in the House of Mary and Martha* (c. 1620) at the London National Gallery. With this episode Martha came to symbolize the active Christian way of life and her sister Mary the contemplative existence. Martha is usually included in scenes of the *Raising of Lazarus*, as in **Giotto**'s rendition in the **Arena Chapel**, Padua, of 1305 and **Caravaggio**'s of 1609 (Messina, Museo Nazionale). In fact, she is the one who called on Christ after her brother's death to bring him back to life. Martha and her siblings went to France after Christ's death. There in the woods between Arles and **Avignon**, a dragon threatened the inhabitants of the region. Martha found the creature in the woods hurting a male youth. She doused the dragon with the holy water she carried in an aspersorium (vessel used to contain holy water) and held her cross in front of it. The dragon was appeased and allowed St. Martha to bind it with her girdle. **Francesco Mochi**'s *St. Martha* in the **Barberini** Chapel at Sant' Andrea della Valle, **Rome** (1609–1628), shows her bending down to place the aspersorium in the monster's mouth.

MARTIN V (ODDO COLONNA; r. 1417–1431). Martin V's election to the papal throne ended the Great Schism. At the Council of Constance, John XXII and Benedict XIII were deposed, Gregory XII was forced to abdicate, and Martin was elected as sole occupant of the papal throne. Martin was a Colonna, the member of one of the oldest and most powerful families of **Rome**. He was educated in law at the University of Perugia, and appointed protonotary by Urban VI and cardinal deacon by Innocent VII. Having attained the papacy, Martin was able to reestablish its seat in Rome in 1420 through his family's backing. He granted concessions to Queen Joanna II of Naples to effect the removal of the Neapolitan troops that occupied Rome, and to the **condottiere** Braccione di Montone who then dominated central Italy. Martin recognized Braccione as Lord of Perugia, but then defeated him in the Battle of L'Aquila in 1424. In Rome, Martin sought to reaffirm the power and prestige of his office and to rescue the city from the disrepair into which it had fallen during the schism. To this effect, he began a reconstruction campaign of the major pilgrimage sites, including St. John Lateran, Santa Maria Maggiore, and the portico of Old **St. Peter's**. He also commissioned from **Masolino** the **altarpiece** for Santa Maria Mag-

giore that depicts the church's founding (*Miracle of the Snow*, c. 1423; Naples, Museo Nazionale di Capodimonte) and from **Gentile da Fabriano frescoes** depicting the life of **St. John the Baptist** and **prophets** (now destroyed) for the walls of St. John Lateran. With this, Martin laid the foundations for the development of the Renaissance in Rome.

MARTINI, SIMONE (active 1315–1344). One of the most important pupils of **Duccio**, instrumental in the development of the **International Style**. Simone Martini is known to have assisted his master in the execution of the *Maestà Altarpiece* (1308–1311; Siena, Museo dell' Opera del Duomo) and to have been active in Siena, Naples, Sicily, Assisi, and the papal court of **Avignon** in Southern France. His first documented commission is the *Maestà* for the Council Chamber in the **Palazzo Pubblico**, Siena (1311–1317; partially repainted in 1321), meant to inspire the rulers of the city who convened in this room to engage in wise government. In 1317, Martini was invited by **Robert D'Anjou**, king of Naples, to work for him at his court. There he painted the **altarpiece** *St. Louis of Toulouse* (Naples, Museo Nazionale di Capodimonte), of Robert's brother, to commemorate his canonization in that year and to assert divine sanction of Anjou rule. In c. 1328 Martini was in Assisi painting **frescoes** in the **Montefiore Chapel** in the Lower Church of **San Francesco**. The commission came from the **Franciscan** Cardinal Gentile Partino da Montefiore who had close ties with the House of Anjou as he had negotiated the attainment of the Hungarian throne for Robert's nephew, Charles I Carobert. These frescoes depict the life of St. Martin of Tours, who lived in the 4th century and to whom the Church of San Martino ai Monti, **Rome**, Cardinal Montefiore's titular church, is dedicated. Among Martini's altarpieces are the polyptych he created for the Church of Santa Caterina in Pisa (Pisa, Museo Nazionale di San Matteo), called the *Pisa Polyptych* (1319), and the *Annunciation* for the **Cathedral of Siena** (1333; **Florence, Uffizi**), this last work with the assistance of **Lippo Memmi** who rendered the figures of Sts. Ansanus and **Margaret** on the outer leaves.

In 1335, Martini went to France to work in the papal court of Avignon where he spent the rest of his life. There he befriended **Petrarch**, who was also working for the papacy. In c. 1340–1344,

Martini executed the *Road to Calvary* (Paris, Louvre), originally part of a polyptych depicting the **Passion of Christ**. In the same time period, he received the commission from Cardinal Jacopo Stefaneschi to fresco the Church of Notre-Dame-des-Doms in Avignon. These frescoes included a *Blessing Christ* and a *Madonna of Humility* that have deteriorated considerably. The **sinopie** for these two scenes are now housed in the Papal Palace in Avignon. As the French papal court was frequented by delegates and other individuals from various realms, Martini's Sienese visual vocabulary soon spread to other parts of Europe where it developed into what is aptly called the International Style.

MARTORELL, BERNARDO (c. 1400–1452). Spanish painter and miniaturist who embraced the **International Style**. Martorell was probably trained by **Luis Borrassá** in Barcelona where he is documented from 1427. There he became the leading artist of the region. His *Altarpiece of St. Vincent* (c. 1435–1440; Barcelona, Museu Nacional d'Art de Catalunya), *Retable of St. George* (c. 1437; Chicago, Art Institute, and Paris, Louvre), and *Retable of the Transfiguration* (c. 1445–1452; Barcelona, Cathedral) show the emphasis on the details of costumes and architecture, liberal use of gilding, and crowding characteristic of the International Style. These works also demonstrate Martorell's gradual move toward greater realism and simplification.

MARTYRDOM OF ST. MAURICE AND THE THEBAN LEGION (1580; El Escorial, Monastery of San Lorenzo). El Greco painted the *Martyrdom of St. Maurice and the Theban Legion* for King **Philip II** of Spain as the **altarpiece** to the Royal Church of El **Escorial**. The Theban Legion was composed of 6,000 Christian men from Upper Egypt from the third century who were led by St. Maurice. When the saint and his men refused to sacrifice to idols as commanded by Emperor Maximian Herculius, all were decapitated. Maurice and two fellow officers encouraged their soldiers not to lose faith as they were being martyred, which is the moment depicted by El Greco. In the painting, angels above hold palms of martyrdom and await the men's souls in heaven. El Greco deemphasized the horror of the scene by

placing the executions in the middle ground and decreasing considerably the scale of the figures in that portion of the painting. Philip II rejected the work, though El Greco was paid for his services, and the painting was placed in storage in the Escorial basement. El Greco did not obtain further royal commissions; his unique style may have proved too progressive for his patron.

MARY MAGDALEN, SAINT. A follower of Christ who became one of the great examples of the repentant sinner. Mary Magdalen's legend seems to be a conflation of various episodes from the lives of more than one woman. Prior to her acceptance of Christ, she was a prostitute. She gave up her sinful life when she and her sister **Martha** received the Lord in their home. While Martha was busy preparing dinner, Mary Magdalen listened to his words, which caused her renunciation of sin—the scene depicted by **Diego Velázquez** in his *Christ in the House of Mary and Martha* (c. 1620) at the London National Gallery. In the house of Simon the Pharisee, Mary Magdalen washed Christ's feet with her tears, dried them with her hair, and anointed them with costly oils—a prefiguration to the anointment of Christ's body after the **Crucifixion**. This is the scene depicted by **Dirk Bouts** in *Christ in the House of Simon the Pharisee* of the 1440s (Berlin, Staatliche Museen). Mary Magdalen usually weeps at the foot of the cross during the Crucifixion, as in **Matthias Grünewald**'s *Isenheim Altarpiece* (fin. 1515; Colmar, Musée d' Unterlinden). She was the first to visit Christ's sepulcher, only to find it empty. Christ appeared to her and, at first, she took him for a gardener. When she realized who he was, she tried to touch him, but he cautioned her against it as he had not yet ascended to heaven. In art, the scene is called *Noli me tangere* (*Do not touch me*) and shows Christ carrying a hoe. Examples are **Titian**'s version of c. 1510 in the London National Gallery and **Correggio**'s of c. 1525 in the Madrid Prado. After Christ's death, Mary Magdalen went to Provence in France where she spent the rest of her life in the wilderness engaging in penance. In art, this period in her life was also a common subject. **Donatello**'s *Mary Magdalen* in her last years is by far the most expressive as he rendered the saint in polychromed wood as an emaciated, toothless figure covered by her long red tresses (1430s–1450s; **Florence**, Museo dell' Opera del Duomo).

MARZAL DE SAX, ANDRÉS. *See* SAX, ANDRÉS MARZAL DE.

MASACCIO (TOMMASO DI SER GIOVANNI DI MONE; 1401–c. 1428). Masaccio was born in San Giovanni Valdarno, near **Florence** where he is recorded as having joined the painters' **guild** in 1422. "Masaccio" was his nickname, a derogatory appellation that referred to his uncomely physical appearance. **Giorgio Vasari**, in fact, wrote that Masaccio was so completely engrossed in his art that he dedicated little time for his own grooming or the tidying of his home. Little is known of his training, but it is clear that his contemporaries **Donatello** and **Filippo Brunelleschi** were a major force in his artistic development, as was **Giotto**. Like Giotto, Masaccio rejected the ornamental style of the Sienese and **Venetian** Schools and instead opted for a more naturalistic mode of expression. From Donatello he borrowed the solidity of forms and from Brunelleschi the new **classical** architectural vocabulary to use in the backgrounds of his paintings. Also, Masaccio was the first to experiment with **one-point linear perspective**, a scientific method thought to have been developed by Brunelleschi.

Masaccio's *Madonna and Child with Saints* (1422; Florence, **Uffizi**), painted for the Church of San Giovenale in Cascia di Reggello, provides an early example of his art. Here the figures occupy a believable, rational space, they are more voluminous than the figures rendered by masters from the previous century, they overlap to further enhance the sense of space, and the shading of their draperies is more emphatic than in earlier examples. Two years later, Masaccio collaborated with **Masolino** in the execution of the *Virgin and Child with St. Anne* (Florence, Uffizi), a painting that stresses Christ's genealogy by placing the figures one behind the other to form a pyramid. In c. 1425, Masaccio and Masolino again collaborated, this time in the **Brancacci Chapel** at Santa Maria del Carmine where they painted scenes from the life of **St. Peter**. In the following year, Masaccio rendered the *Enthroned Virgin and Child*, part of the *Pisa Polyptych* commissioned by Giuliano di Ser Colino degli Scarsi for Santa Maria del Carmine, at one point dismantled and its pieces scattered. In 1427, Masaccio created one of his most important masterpieces, the *Holy Trinity* at **Santa Maria Novella**. Masaccio's importance lies in the fact that he introduced new technical innovations to painting that al-

lowed for believable renditions of space. Though he died while still in his twenties, the impact of his art was immense.

MASO DI BANCO (active c. 1320–1350). Florentine painter who trained with **Giotto**. Maso di Banco's masterpiece is the series of five **frescoes** he created in c. 1340 in the **Bardi di Vernio Chapel** at **Santa Croce**, Florence. These scenes are from the life of St. Sylvester who reigned as pope in 314–335 and who persuaded Emperor Constantine the Great to convert to Christianity. The monumentality of Maso's figures in these frescoes, the volume of their faces, hands, and drapery folds, and the diagonal placement of the background architecture to show two sides at once, are all elements he borrowed from his master. The elaborate backdrops, refined costumes and figure types, meticulous rendering of details, and careful application of paint, however, are very much his own.

MASOLINO DA PANICALE (MASO DI CRISTOFANO FINI; active c. 1423–1447). Masolino has been overshadowed by **Masaccio** with whom he often collaborated. Studies on his art unfortunately have centered mainly on identifying his intervention in these commissions he shared. One of his early works is the *Miracle of the Snow* (c. 1423; Naples, Museo Nazionale di Capodimonte), part of the *Santa Maria Maggiore Triptych* commissioned by Pope **Martin V** for the Church in **Rome** bearing the same appellation. In c. 1425, Masolino worked with Masaccio on the **frescoes** of the **Brancacci Chapel** at Santa Maria del Carmine, **Florence**, commissioned by Felice Brancacci. Among the scenes he contributed are the *Healing of the Lame Man and the Raising of Tabitha* and the *Temptation*. The scenes on the **vault** and **lunettes**, destroyed in the 18th century, are also thought to have been by his hand. In c. 1428–1430, Masolino was again in Rome painting frescoes from the life of **St. Catherine of Alexandria** in the Castiglione Chapel at San Clemente for Cardinal Branda Castiglione. This commission is one of the best examples of the period of propagandist chapel decoration. Masolino's works show that he adopted techniques he learned while working alongside Masaccio, including **one-point linear perspective**, a single source of light, and cast shadows that enhance the three-dimensionality of forms. Masolino's art is distinguished from Masaccio's, however, in

that his figures are more elegant and slender, yet lack the visual impact and emotive power of those rendered by his fellow master.

MASSACRE OF THE INNOCENTS. When the three magi set off to find the newborn Christ, they asked Herod, king of Judea, if he knew where the child could be found. Upon hearing of the birth of the new king of the Jews, Herod felt his position threatened and ordered the killing of all the children in his kingdom aged two or younger. The story gave artists the occasion to paint a complex scene of violence and desperation that highlighted their artistic abilities. Among the most poignant examples are **Giotto**'s in the **Arena Chapel** in Padua (1305), **Domenico del Ghirlandaio**'s in the Cappella Maggiore at **Santa Maria Novella, Florence** (1485–1490), **Guido Reni**'s in the Pinacoteca Nazionale in **Bologna** (1611), and **Peter Paul Rubens**' in the London National Gallery (1611–1612).

MASTER OF FLÉMALLE (ROBERT CAMPIN; active 1406–1444). Flemish master, now identified as Robert Campin from Tournai. Campin was the teacher of **Rogier van der Weyden** and, along with **Jan van Eyck**, is considered the father of Early Netherlandish art. The name *Master of Flémalle* derives from three panels, now in the Städelsches Kunstinstitut in Frankfurt, that came from an abbey in Flémalle, near Liège. Campin was born in Valenciennes, possibly in 1375, and became a citizen of Tournai in 1410. In 1423, he was elected dean of the painter's **guild** and served in one of the city's councils until 1428. In 1432, he was banished from Tournai for immoral conduct and forced to go on pilgrimage to St. Gilles in Provence. The sentence was reduced to payment of a fine thanks to the intervention of Jacqueline of Bavaria, daughter of Count William IV of Holland, which reflects the esteem with which Campin was regarded.

Scholars usually place the *Entombment Triptych* (c. 1415–1420; London, Collection of Count Antoine Seilern) among Campin's earliest works. It presents everyday figure types engaged in the drama of the moment, the angularity of their draperies offering an alternative to the fluid rhythms of the works of contemporaries. The shallow background and compression of the figures into a tight space suggest that Campin looked to sculpted religious imagery for which Tournai

was well known, while the weeping angels and heads of the **Virgin** and the dead Christ pressed together suggest an awareness of the works of **Giotto**, the one to introduce these motifs into art. Campin's *Nativity* (c. 1420; Dijon, Musée des Beaux-Arts) develops further the naturalistic tendencies of the *Entombment*. Here, a road leads into a landscape, the recession into space convincingly achieved by empirically observing nature and imitating it on the panel. The work is full of symbolism, typical of Campin's art. **St. Joseph**, for instance, shields the flame of a candle with his right hand to denote, as the Bible instructs, that Christ is the light, a point reiterated by the rising sun behind the manger. Also, the midwife with the withered hand refers to the **apocryphal** account of the Nativity where one of the midwives who attended Mary during childbirth doubted Christ's virgin birth—her irreverence resulting in the problem with her hand, which was cured at the touch of the Christ Child.

Campin's most celebrated painting is the *Mérode **Altarpiece*** (c. 1426; New York, The Cloisters). The central panel in this work shows the ***Annunciation*** in an interior domestic setting, with the Virgin seated on the ground to denote her humility. A miniaturized Christ Child carrying the cross enters the room through a window and flies toward his mother's womb, marked by the star pattern formed by the folds of her drapery. The fact that the child has passed through the glass without breaking it refers to his mother's virginity preserved regardless of conception. The background niche represents the tabernacle in the temple and the towel the washing of the hands by the priest before the mass. The smoke rising from the extinguished candle confirms the presence of God in the room, while the scroll and book on the table refer to the Old and New Testaments, respectively, and the vase with lilies to the Virgin's purity. On the left wing of the altarpiece are the donors, identified as members of the Ingelbrechts and Calcum families by the coat of arms on the back window in the central panel. On the right wing is St. Joseph in his carpentry shop working on a mousetrap, an allusion to **St. Augustine**'s statement that the Incarnation of Christ was the trap used by God to ensnare the devil. Campin followed his famed altarpiece with the *Virgin and Child before a Fire Screen* (c. 1428; London, National Gallery) and the *Virgin in Glory* (c. 1428–1430; Aix-en-Provence, Musée Granet). In the first, the fire screen behind the nursing Mary forms a halo

around her head. The second presents Mary and the Christ Child seated on a bench, a crescent moon at their feet, and floating above **St. Peter**, St. Augustine, and a donor—a scene based on the account of the **Apocalypse**. Both paintings show a more successful recession into space and greater unity among the compositional elements than in Campin's earlier works.

Campin used **oil** as his medium, which allowed him to apply layer upon layer of color and resulted in a brilliance never before seen in panel art. He was also the first master in the North to reject the elegant, courtly scenes of the **International Style** in favor of the representation of the natural world and the drama of human existence. Though heavily dependent on the Northern miniaturist tradition and the sculpture of Tournai, Campin was the pioneer who established the visual conventions that would reign in the North until the end of the 15th century.

MATTHEW, SAINT. Matthew is one of the **Evangelists** who authored the Gospels and the patron saint of **bankers** as he was a tax collector from Capernaum when Christ called him to become one of his **apostles**. After Christ's **Crucifixion**, Matthew went to Judea where he preached, and then to Ethiopia where he was martyred by sword for thwarting the king's attainment of the virgin Ephigenia. Matthew's story was masterfully illustrated by **Caravaggio** in the **Contarelli Chapel**, **Rome** (1599–1600, 1602), including his calling by Christ, his writing of the Gospel while guided by an angel, and his martyrdom. **Hendrick Terbrugghen** also painted the *Calling of St. Matthew* in 1621 (Utrecht, Centraal Museum) and **Nicolas Poussin** rendered the *Landscape with St. Matthew* in 1640 (Berlin, Gemäldegalerie) where the angel dictates to the saint the word of God.

MAXIMILIAN I, HOLY ROMAN EMPEROR (1459–1519). Born in Wiener Neustadt into the **Hapsburg** line, Emperor Maximilian I was the son of Frederick III and Eleonora of Portugal. His marriage to Mary of Burgundy (d. 1482), daughter of Charles the Bold, in 1477 led to his obtaining the Burgundian Netherlands and his involvement in war against France over the territory. Maximilian also became involved in the Italian wars carried out by the great European powers to control the Italian independent cities, his purpose being to prevent

French territorial expansion and to extend the Hapsburg dominion. His association with **Ludovico Sforza** during this conflict led to his marriage in 1493 to Bianca Maria Sforza, Ludovico's niece. At the time, he invested Ludovico with the Duchy of Milan to which Louis XII of France also laid claim. In 1508, he allied himself with Pope **Julius II** and France, forming the **League of Cambrai**, to curtail **Venice**'s territorial expansion. In 1511, however, Maximilian and the pope formed the Holy League to expel Louis XII from Italy.

Maximilian was the patron of **Hans Burgkmair**, who created a series of woodcuts for him, and **Albrecht Dürer**, whose portrait in the Kunsthistorisches Museum in Vienna (1519) records the emperor's likeness. Maximilian is also included in Dürer's *Rozenkranz Madonna* (1505–1506; Prague; National Gallery) for the Church of San Bartolomeo, commissioned by the Fondaco dei Tedeschi, the association of German merchants in Venice. There he kneels to be crowned with roses by the **Virgin**.

MECKENEM THE YOUNGER, ISRAHEL VAN (c. 1450–1503).
German engraver from Bocholt who was trained by his father, also an engraver and goldsmith. Sixteen early prints by Meckenem are in fact copies of his father's works. Meckenem is documented in Cleves in 1465 and in Bamberg in 1470, returning to Bocholt in 1480 where he was elected to the town council in 1503. A prolific engraver, he left over 600 plates, many of which provide insight into everyday life and lore. Among these are the *Morris Dance* (c. 1475), a form of comical acrobatic dance performed during carnival; *The Lute Player and the Harpist* (c. 1490), which has left a visual record of the musical instruments and costumes of the day; and *The Visit to the Spinner* (c. 1495), which presents a middle-class interior domestic setting. Meckenem's *Self-Portrait with His Wife Ida* (c. 1490) is among the earliest self-portraits in an engraving to have survived. Meckenem's style is characterized by sharp contrasts of light and dark, an emphasis on textures, and sharp contours that add visual richness to his images.

MEDICI CYCLE (1622–1625; Paris, Louvre).
In 1615, **Marie de' Medici**, wife of **Henry IV** of France, commissioned **Salomon de Brosse** to build for her the Luxembourg Palace in Paris based on the

Palazzo Pitti, the residence in **Florence** where she had lived as a child. Once completed, Marie took the task of decorating it. She commissioned **Peter Paul Rubens** to create a cycle of over 40 works to commemorate her and her husband's deeds to be placed in the palace's two galleries. Rubens had already worked for her son, **Louis XIII**, in 1620–1621, creating cartoons for 12 tapestries depicting the life of Emperor Constantine the Great. Familiar with the master's talent, Marie felt confident that he would provide works of great quality for her as well.

Only approximately 20 paintings were completed by Rubens, all from the life of Marie. The cycle begins with her childhood and education, continues with her arrival in Marseilles, her marriage to Henry, his assassination in 1610, her regency and exile to Blois, and her reconciliation with her son and vindication. The cycle glorifies a life that was not as exalted as Marie professed. The misery of her childhood had to do with her mother's early death and her father's remarriage to a commoner. He sent his children, including Marie, away to the Palazzo Pitti. Two of them died in childhood and a third was married off at an early age to the Duke of Mantua, leaving Marie on her own. Henry IV only married her for her hefty dowry. In 1610, he was stabbed to death and Marie became the regent to her son because Salic laws prohibited women from serving as queens. Her relationship with her son was fraught with conflict and, though they reconciled after Louis exiled her to Blois thanks to the intervention of Cardinal **Armand Richelieu**, in 1630 he exiled her for good. She escaped to the Low Countries and then Germany, where she died. The Luxembourg Palace was closed and Rubens' cycle forgotten until the late 17th century when it was reopened. The rediscovery of Rubens' *Medici Cycle*, with its lush brushwork and rich colorism, caused a major sensation. Debates among **Poussinists** and Rubenistes ensued, forever changing the course of art in France.

MEDICI FAMILY. The Medici originated in the valley of the Mugello and moved to nearby **Florence** in the 13th century. In 1397, Giovanni di Bicci de' Medici established a **bank**. Soon he opened branches all over Italy and Europe and became involved in papal finances, enterprises that resulted in his amassing a large fortune. With wealth came power and, in 1402, Giovanni was elected to serve as one of the pri-

ors of Florence's legislative body, the *Signoria*. His son **Cosimo** is the one who sealed the family's political hegemony when in 1434 he was able to effect the removal of the **Albizzi** from power and to take over their position as the city's leading political figure. Medici rule was to last until the 18th century, when the family died out, save for exile in 1494 and again in 1527. In 1530, the Medici took absolute control of Tuscany as dukes and, in 1569 as grand dukes, titles they obtained through the efforts of two Medici popes: **Leo X** and **Clement VII**. Marriage alliances linked them to the royal houses of France and Spain, further strengthening their position of power.

It is not unreasonable to say that the Medici were one of the central forces that enabled the Renaissance to take place as they contributed greatly to the cultural and intellectual fabric of Florence, the birthplace of the movement. Without their patronage the philosophers **Marsilio Ficino** and Pico della Mirandola, the artists **Donatello**, **Filippo Brunelleschi**, **Sandro Botticelli**, and **Michelangelo**, the poet Angelo Poliziano, and the astronomer Galileo Galilei might not have had the opportunity to achieve the endeavors for which they are so well known. *See also* MEDICI, LORENZO "THE MAGNIFICENT" DE'; MEDICI, MARIE DE'.

MEDICI, COSIMO DE' (1389–1464). The son of Giovanni di Bicci de' **Medici**, Cosimo was exiled from **Florence** by the **Albizzi**, who headed the city's oligarchic regime, for leading an opposing political faction. That faction was powerful enough to have Cosimo recalled in 1434 and the Albizzi removed from power. Cosimo became the leader of a republican system he quietly governed from behind the scenes. To ensure his hegemony, he banished his opponents and appointed magistrates from among his supporters. He also forged alliances with Milan, Naples, **Rome**, and **Venice**. His court is considered to have been key to the development of the Renaissance as he supported scholars such as Argyropoulous and **Marsilio Ficino**, who opened the Platonic Academy in Florence with his backing. He also was the patron of **Donatello** and **Michelozzo**, who designed his **Palazzo Medici** (beg. 1436). Cosimo also affected the Florentine religious fabric as he was a major supporter of the **Dominicans**. He gave them the **San Marco Monastery** in Florence after expelling the Sylvestrine monks who had occupied the building and had allowed it

to fall into disrepair. Cosimo had Michelozzo renovate the structure and add a library, the first to be built in the Renaissance. Once completed, he donated 400 Latin and Greek manuscripts as the core of its collection, establishing San Marco as one of the most important public libraries of Europe. In 1438–1445, he also financed the **frescoes Fra Angelico** painted in the monastery's cells.

MEDICI, LORENZO "THE MAGNIFICENT" DE' (1449–1492).
Lorenzo "the Magnificent" was the grandson of **Cosimo de' Medici**. He was 20 years old when he took the reigns of government in **Florence** from his invalid father, Piero the Gouty. Like his predecessors, Lorenzo chose to control the city from behind the scenes. He also continued their policy of forging alliances with the major Italian city-states and of contributing to the cultural and intellectual life of Florence. In 1478, Lorenzo fell victim to the **Pazzi Conspiracy** to oust the Medici from power. On that occasion, he was wounded and his brother Giuliano murdered, an act he retaliated by hunting down and severely punishing the conspirators.

Lorenzo was the patron of the poet Angelo Poliziano. Under him, **Marsilio Ficino** translated the works of Plotinus and Proclus, thus bringing **Neoplatonism** to the forefront of philosophy. It was Lorenzo who took the young **Michelangelo** under his protective wing and nurtured his talent and persona and who commissioned **Andrea del Verrocchio** to create his famed bronze *David* (early 1470s; Florence, Museo Nazionale del Bargello). **Giuliano da Sangallo** built for him a magnificent villa at Poggio a Caiano (early 1480s), the first attempt to recreate an ancient suburban villa based on the descriptions provided by **Vitruvius** and Pliny the Younger. Sangallo also built the Church of Santa Maria delle Carceri at Prato (1484–1492) with funds provided by Lorenzo.

MEDICI, MARIE DE' (1573–1642). Marie de' **Medici** was the daughter of Grand Duke Francesco I de' Medici of **Florence** and Johanna of Austria, daughter of the **Hapsburg** Holy Roman Emperor Ferdinand I. In 1600, she was betrothed to **Henry IV** of France whose poor finances necessitated a lucrative marriage alliance, which the Medici were willing to provide. In the following year, she gave birth to her son, the future **Louis XIII**. Her mother's untimely death,

her father's remarriage, and his almost complete abandonment of his children had caused great misery in Marie's early life. Her marriage did not fare any better. Henry had a number of mistresses who resented her presence at court. When he was assassinated by a religious fanatic in 1610, Marie was immediately appointed regent to her son because Salic laws prevented her from assuming the role of queen. No sooner had she obtained this charge than she banished Henry's mistresses. As regent, she fell under the influence of Concino Concini, Marquis of Ancre, who dismissed Henry's minister duc de Sully and created such resentment that the nobility rebelled against the regency. In 1617, Concini was assassinated. Having attained his majority, Louis XIII assumed his position as king of France and exiled his mother to Blois. In 1619, she escaped and allied herself with her younger son, Gaston d'Orleans, against the king, only to be defeated. In 1622, Cardinal **Armand Richelieu**, Louis' first minister, reconciled Marie with the king. The reconciliation, however, did not last. A conspiracy to overthrow Richelieu for his anti-Hapsburg policies caused Marie's permanent banishment from the French court. She escaped to the Low Countries and then Germany, where she spent the last years of her life. **Peter Paul Rubens** created for Marie in 1622–1625 the *Medici Cycle* for the Luxembourg Palace, built for her by **Salomon de Brosse** (beg. 1615), to record the most important events of her life and to glorify her position as the wife of Henry and mother of Louis. Another artist patronized by Marie was **Orazio Gentileschi**, who was present at her court in 1624.

MEIT, CONRAD (c. 1480–1550). German sculptor who from 1506 until 1510 worked in the court of Frederick the Wise, Elector of Saxony, in Wittenberg. In 1514, Meit entered in the service of **Margaret of Austria**, creating for her large- and small-scale statues and overseeing the execution of her tomb and that of her husband Philibert II, Duke of Savoy, in the Church of Brou, Bourg-en-Bresse (1526–1532). Meit is thought to have been trained by **Lucas Cranach the Elder** who worked alongside him and **Albrecht Dürer** in Frederick's court. Meit is best known for his small-scale freestanding sensuous nude figures inspired by Italian and ancient prototypes. Among them are his *Judith with the Head of Holofernes* (1510–1515; Munich, Bayerisches Nationalmuseum), *Lucretia* (c. 1510; Braunschweig,

Herzog Anton Ulrich Museum), *Mars and Venus* (1520; Nuremberg, Germanisches Nationalmuseum), and *Eve* (c. 1520; Vienna, Kunsthistorisches Museum).

MEMENTO MORI. A Latin phrase used to remind humans of the inevitability of death. Since one of the major purposes of Christianity is to provide relief from the fear of death by promising salvation, the memento mori serves to emphasize the transitory nature of life and its pleasures and the importance of preparing for the everlasting afterlife. In art, a memento mori can be as overt as showing a dead corpse or skeleton in a funeral setting, or disguised as a *vanitas* motif such as a wilting flower, decomposing fruits, skulls, and hourglasses. The juxtaposition of old and young figures can also serve as a reminder of the transience of human existence.

MEMLINC, HANS (c. 1440–1494). Hans Memlinc was **Rogier van der Weyden**'s most faithful follower. A native of the town of Seligenstadt on the Main, Germany, he moved to Bruges, Flanders, sometime around 1465. By the following year, he was a member of the Bruges **Guild** of Painters and, by 1480, he was among the city's wealthiest citizens who were required to pay an added tax to support the war against France. Though stylistically his art emulates that of van der Weyden, Memlinc lacks the passion and drama of the older master. Instead, his works are serene and graceful, with an emphasis on order and balance.

Among his early works, the *Donne Triptych* (1468–1469; London, National Gallery) stands out. Created for Sir John Donne of Kidwelly, a Welshman who lived in Calais and who was probably in Bruges for the celebration of Charles the Bold's marriage to Margaret of York, the work shows the enthroned **Virgin** and Child flanked by angels and Sts. **Catherine** and Barbara, with the donor, his wife, and children kneeling at their feet. On the wings are Sts. **John the Evangelist** and **John the Baptist**, Donne's namesaints. The slender, delicate figures pose emotionless in a tight composition that connects the three panels through the extension of the central space into the **altarpiece**'s side wings. Memlinc's *Martyrdom of St. Sebastian* (c. 1470; Brussels, Musées Royaux des Beaux-Arts), rendered soon after the *Donne Triptych*, afforded the opportunity to experiment with the hu-

man nude form. The saint is presented as a slender, youthful figure who remains calm in the face of adversity. His delicate, graceful features provide a marked contrast to the brutish Roman archers who prepare their bows to effect the saint's martyrdom. Memlinc's *Passion Panel* (c. 1470; Turin, Galleria Sabauda) also belongs to this period, the patron Tommaso Portinari, the **Medici bank**'s representative in Bruges who also patronized **Hugo van der Goes** and who appears in the work in the foreground along with his wife. Here Memlinc cleverly resolved the problem of unifying multiple scenes on one pictorial surface by inserting them into the various buildings he enclosed within the walls of Jerusalem. Memlinc would again include multiple scenes in the *Life of the Virgin and Christ Panel* (1480; Munich, Alte Pinakothek), utilizing architecture and mountainous forms to organize and separate each event from the rest. Painted for Pieter Bultinc, a member of the tanners' guild, this work, and the one for Portinari, anticipate the landscapes by **Joachim Patinir**.

For Angelo di Jacopo Tani, another representative of the Medici bank in Bruges, Memlinc created the *Last Judgment Triptych* (1473; Danzig, Muzeum Pomorskie), a work seized by pirates on its way to **Florence** and placed in the Church of St. Mary in Danzig. In its closed state, the altarpiece shows Jacopo and his wife Caterina kneeling in front of **grisaille** figures of the Virgin, Child, and St. Michael. When opened, the viewer is surprised by the unexpected burst of color and action, particularly given the serenity and pale colors of the exterior. In the interior's center is Christ as judge, below him St. Michael weighing the souls, and at the sides the blessed entering heaven and the damned cast into hell. Here again, Memlinc worked with the nude form, now in action. Memlinc once again tackled the nude in his *Bathsheba* (1484; Stuttgart, Staatsgalerie), an episode from the biblical story of **David**. She, a soft, delicate woman of the Northern type (small breasts, rounded belly) steps out of her bath, her servant wrapping her in a towel that does little to cover her nudity. In the left background is the roof from which David saw Bathsheba in the nude. The **reliefs** on the church portals, also in the background, relate the death of Bathsheba's husband, Uriah, sent to battle by David so he could rid himself of his contender.

Other works by Memlinc that deserve mention are the *Chasse of St. Ursula* (1489; Bruges, Hospital of St. John), a reliquary casket

constructed to look like a miniature Gothic church and decorated with scenes from Ursula's life based on **Jacobus da Voragine**'s *Golden Legend*, as well as his portrait *Man with a Medal* (c. 1475–1480; Antwerp, Musée Royal des Beaux-Arts), one of the many portraits by Memlinc to have survived. His sitter in this example is shown in bust length, set against a landscape, and holding a coin with Emperor Nero's profile. His identification as either Niccolò Spinelli or Giovanni di Candida, two Italian medalists, have been proposed, though neither is certain.

Memlinc held his position as the most important master of Bruges until his death in 1494, when he was succeeded by **Gerard David**. His influence carried through other regions. Italians, among them **Pietro Perugino**, were exposed to his art via the merchants who worked in Bruges and then shipped his paintings to their native cities. Memlinc's *Last Judgment*, which ended up in Danzig, was emulated by local masters. Finally, contacts between Spain and Flanders brought Memlinc's delicate, graceful style to the attention of **Bartolomé Bermejo** and other Hispano-Flemish masters.

MEMMI, LIPPO (c. 1285–c. 1361). Italian painter from the Sienese school. Lippo Memmi was the brother-in-law of **Simone Martini**, whom he assisted and whose painting style he adopted. The lateral panels showing Sts. Ansanus and **Margaret** in the **Uffizi** *Annunciation* (1333) by Martini have been attributed to Memmi. Memmi's most important commission is the *Maestà* in the Palazzo Comunale at San Gimignano (1317). This **fresco**, based on Martini's of the same subject (1311–1317) in the **Palazzo Pubblico**, Siena, was commissioned by Nello di Mino Tolomei, Captain of the People of San Gimignano. Tolomei is included in the scene, kneeling in front of the enthroned **Virgin** and Child in the center of the composition, as is his coat-of-arms on the canopy above the figures. Not coincidentally did Memmi use a similar format to Martini's fresco in the Palazzo Pubblico. San Gimignano was controlled by Siena, and Memmi's fresco made clear that Tolomei was in charge of enforcing Sienese rule. Also attributed to Memmi is the *Madonna dei Raccomandati* (c. 1320) in the Chapel of the Corporal in the Orvieto Cathedral, a work that presents the Virgin offering her protection to the city's inhabitants who kneel in prayer under her mantle. The at-

tribution has been an issue of debate among art historians, though a signature accompanies the work that identifies its author as "Lippus de Sena."

MERCURY. The son of **Jupiter** and Maia and father of **Cupid**, Mercury is the messenger of the gods and protector of commerce whose attributes are the caduceus (a rod with two snakes coiled around it), the winged sandals, and the petasus (winged helmet). Hours after his birth, Mercury stole the bulls of Admetus that **Apollo** was guarding, a scene rendered by Claude Lorrain in his *Landscape with Apollo Guarding the Herds of Admetus* (1645; **Rome**, Galleria Doria-Pamphili). Apollo recovered the animals and Mercury gave him the lyre he had devised from a tortoise shell for which the sun god appointed him divine messenger. Mercury helped Jupiter rescue Io from Argus, the multi-eyed monster whom he lulled into a deep sleep by playing his pipes, the scene depicted by **Peter Paul Rubens** in his *Argus and Mercury* of 1635–1638 (Dresden, Alte Meister Gallerie). In **Sandro Botticelli**'s *Primavera* (c. 1482; **Florence**, **Uffizi**), Mercury stirs the clouds with his caduceus, a fitting inclusion for a work commissioned by the **Medici** whose wealth relied on **banking** and commerce. **Giovanni da Bologna**'s bronze statue of *Mercury* (1580; Florence, Museo Nazionale del Bargello) balances on the mouth of Zephirus, the west wind, to denote that he is in flight, while on the **Farnese ceiling** by **Annibale Carracci** (c. 1597–1600; Rome, **Palazzo Farnese**), the **classicized** Mercury floats in midair and hands the apple of Hesperides to Paris so he may judge the contest between **Minerva**, **Juno**, and **Venus**.

MESSINA, ANTONELLO DA (active c. 1445–1479). Originally from Messina, Sicily, Antonello was trained by a Neapolitan artist named Colantonio. Little had taken place in Southern Italy in terms of artistic development since **mosaicists** from the 12th century had worked in the region and **Giotto** had served **Robert D'Anjou** from 1328 to 1334. Therefore, Antonello's stylistic formation depended not on contemporary developments but on the art owned by Southern Italian collectors, such as King Alfonso of Naples. Alfonso owned works by **Jan van Eyck**, **Rogier van der Weyden**, and other Flemish masters that Antonello may have studied, as indicated by the

strong Early Netherlandish influence in his art. In 1456, Antonello is recorded working in the court of Galeazzo Maria **Sforza** in Milan at the same time as a Northern master thought to be **Petrus Christus**, van Eyck's follower. From his exposure to Flemish art, Antonello learned the **oil painting** technique of applying various layers of glaze to achieve a rich, velvety surface—a technique he is credited with introducing to **Venice** when he moved there in 1475.

Antonello's *St. Jerome in His Study* (c. 1450–1455; London, National Gallery) shows the Flemish influence in his art, so much so that, in 1529, a Venetian who saw the work confused it with a van Eyck or a **Hans Memlinc**. Not only is the rich palette taken from Early Netherlandish prototypes but so is his interest in describing every object in great detail. Antonello's *Virgin Annunciate* (c. 1465; Palermo, Museo Nazionale) and *Portrait of a Man* (c. 1465; London, National Gallery) both follow the Early Netherlandish portrait format of using a half-figure set against a dark, undefined background. While Antonello influenced the Venetian masters, they taught him some lessons as well. His *St. Sebastian* (1476–1477; Dresden, Gemäldegalerie) demonstrates the influence of **Andrea Mantegna**. Here, his palette has changed from deep reds, ochers, and golden tones to soft pastels. His figure is idealized and set against a well-developed background. In this work, Antonello also shows a greater understanding of anatomy and **perspective**.

METSYS, QUINTEN (1465/1466–1530). Painter born in Louvain who in the first decades of the 16th century became the leading master of Antwerp. **Karel van Mander** wrote that Metsys learned painting by coloring prints while recovering from an illness. Originally a blacksmith, Metsys fell in love with a woman who disapproved of his trade so, to win her over, he changed his career to painter, the trade of a rival suitor. There may be some truth to van Mander's anecdote, though documents only record Metsys' father as a blacksmith but not the artist. Documents also record that Metsys entered the painter's **guild** in Antwerp in 1491 and that he purchased a house in the city, attesting to his success. **Albrecht Dürer**, in fact, visited Metsys' home and recorded that it housed an impressive collection of paintings.

Early in his career, Metsys painted in the style of **Jan van Eyck**, **Robert Campin**, **Hugo van der Goes**, and **Hans Memlinc**, as his

Madonna and Child (c. 1495–1505; Lyons, Musée des Beaux-Arts) attests. A few years later, however, he began incorporating Italianate elements into his art. His *St. Anne Altarpiece* (1507–1509; Brussels, Musées Royaux des Beaux-Arts), painted for a chapel in the Church of St-Pierre, Louvain owned by the **Confraternity** of St. Anne, displays a greater monumentality than his earlier works and softer, less angular draperies, as well as a triple-arched **loggia** with a domed central bay inspired by Northern Italian precedents. Metsys' other major altarpiece of this period is the *Deposition* (1508–1511; Antwerp, Musée Royal des Beaux-Arts), painted for the Chapel of the Carpenters' Guild in Antwerp Cathedral. This **triptych** features the emaciated body of Christ laid out in the foreground on a shroud, with Mary kneeling in prayer next to him instead of swooning as she is customarily represented. On the wings are scenes from the lives of the guild's patron saints. Salome presents the head of **St. John the Baptist** to Herod and **St. John the Evangelist** is shown in a caldron.

Portraits and **genre** scenes were also part of Metsys' oeuvre. An example of the first is the *Portrait of a Lady* (c. 1510–1515; New York, Metropolitan Museum) who marks the page of her book of devotions with her index finger and pauses for a moment to ponder on the passage she has just read. The play of light on her crisp white headdress, forehead, cheek, and neck add to the work's visual appeal. The *Banker and His Wife* (1514; Louvre, Paris) and *Unequal Pair* (c. 1515–1520; Washington, National Gallery) are two moralizing genre scenes. The first, a work that recalls **Petrus Christus'** *St. Eligius as a Goldsmith* (1449; New York, Metropolitan Museum) contrasts the wife's piety, indicated by the book of devotions she peruses, to her husband's usury, denoted by the money in front of him and the scales he holds. Here the convex mirror in the foreground, which is believed to reflect the painter himself, invokes the mirror in van Eyck's *Arnolfini Wedding Portrait* (1434; London, National Gallery). The second painting illustrates the adage that a fool and his money are soon parted. As the woman caresses the old man with whom she flirts, she hands his purse to her accomplice. These works show that Metsys was particularly interested in the art of **Leonardo da Vinci** and borrowed from him the solidity of figures and draperies as well as the **sfumato** device, softening it so as to retain the characteristically Northern brilliance of colors.

MICHELANGELO BUONARROTI (1475–1564). Michelangelo was born in Caprese near Arezzo, where his father, Simone Buonarroti, was governor. Once Simone's tenure ended, the family returned to their native **Florence**. Michelangelo, still an infant, was sent to a wet nurse in Settignano, the village of stonecutters where **Desiderio da Settignano** and the **Rossellino** brothers were born. Michelangelo used this detail of his life to explain his passion for sculpture. He often joked that he had swallowed the tools of his trade when suckled by his wet nurse. Though his favored activity was sculpting, Michelangelo was also an accomplished painter, architect, and poet. At a young age, he had decided to become an artist. His father was opposed to this as he felt that art, then considered a manual labor, was an activity at odds with their noble status. Eventually, however, Simone gave in and placed the 13-year-old Michelangelo in the workshop of **Domenico del Ghirlandaio**. A year later, having recognized the boy's talent, **Lorenzo "the Magnificent" de' Medici** invited him to join the informal sculpture school he set up in his garden. There Michelangelo worked with Bertoldo di Giovanni, a pupil of **Donatello**. Bertoldo proved to be a nurturing teacher who exposed the boy to the works of his master, as well as **Giotto** and **Masaccio**, as surviving sketches by Michelangelo prove. Not only did Michelangelo receive a solid artistic education, but he was also surrounded by the intellectual luminaries that formed part of Lorenzo's court, including the poet Angelo Poliziano and the philosopher **Marsilio Ficino**.

Among the works Michelangelo created in these years were his *Madonna of the Stairs* (1489–1492), begun at the age of 14, and the *Battle of the Lapiths and the Centaurs* (c. 1492), both now in Casa Buonarroti, Florence. These works demonstrate Michelangelo's deep understanding of human anatomy and interest in depicting the male figure in complex poses, with muscles, tendons, and bones responding to pressure and movement. By the time Michelangelo worked on the *Battle of the Lapiths and the Centaurs*, he had already engaged in human dissections at the Hospital of **Santo Spirito**. In fact, he gave a *Crucifixion* to the prior of Santo Spirito in gratitude for allowing him to carry out the dissections.

In 1492, Lorenzo "the Magnificent" died and Michelangelo moved from the **Medici** household. In 1494, the Medici were exiled from

Florence, so Michelangelo took the opportunity to travel to **Venice** and **Bologna** where he saw the works of **Jacopo della Quercia**. These would influence his own work and become the prototypes for some of the scenes in his **Sistine ceiling** (1508–1512; Vatican). By 1496 he was in **Rome**, where he executed his *Bacchus* (1496–1497; Florence, Museo Nazionale del Bargello) and *Pietà* (1498/1499–1500; Rome, **St. Peter's**). The first reflects his study of ancient statuary in the Vatican collection. Commissioned by Jacopo Galli, a wealthy Roman nobleman, it was meant for a garden where some contemporaries confused it for an ancient piece. The *Pietà* Michelangelo executed for the French Cardinal Jean de Bilhères Lagraulas to be placed in his funerary chapel in St. Peter's. Back in Florence, Michelangelo worked on the *Taddei Tondo* (c. 1500–1502; London, Royal Academy of Fine Arts) for Francesco Taddei, his famous *David* (1501–1504; Florence, Accademia) for one of the buttresses of the **Cathedral of Florence**, and the *Doni Tondo* (c. 1503; Florence, **Uffizi**) for Angelo Doni and his wife Maddalena Strozzi, his earliest known painting.

In 1504–1506, Michelangelo worked alongside **Leonardo da Vinci** in the Sala del Consiglio (Council Chamber) of the **Palazzo Vecchio**, where he painted his *Battle of Cascina* and Leonardo the *Battle of Anghiari*. The work was left unfinished when he was called back to Rome by Pope **Julius II** to work on his tomb. By the end of 1516, Michelangelo was back in Florence working on the façade of the Church of San Lorenzo, built in the previous century by **Filippo Brunelleschi**. He provided a wood model, but in 1520, much to his indignation, the contract he signed for this commission was annulled and instead he was asked to work on the Medici Chapel (**New Sacristy**) at San Lorenzo (1519–1534). At the same time, he was commissioned by **Clement VII**, a Medici, to work on the **Laurentian Library** (1524–1534).

In 1527, the Medici were again exiled from Florence and Michelangelo resumed work on the **Tomb of Pope Julius II**. In 1536, he returned to Rome to paint the *Last Judgment* (1536–1541) in the **Sistine Chapel** for Pope **Paul III**, and in 1538 he also worked on the *Piazza del Campidoglio* (1538–1564). In 1542–1550, he **frescoed** the Pauline Chapel with the *Crucifixion of St. Peter* and *Conversion of St. Paul*, and in 1545, he also brought Julius II's tomb to completion

after being hounded by the pope's family. In the following year he began work on St. Peter's, a commission he carried out without pay because he thought it would ensure his salvation after death.

Michelangelo died in 1564 and was buried in the Church of **Santa Croce** in Florence. Hordes of people turned out to pay their final respects to the man who had brought the city much glory. As **Giorgio Vasari** wrote, Michelangelo reached the pinnacle of artistic accomplishment. He triumphed over nature and surpassed the achievements of the ancients. Though he considered himself primarily a sculptor and believed in its superiority over painting, Michelangelo excelled in every field he tackled.

MICHELOZZO DI BARTOLOMEO (1396–1472). A follower of **Filippo Brunelleschi**, Michelozzo was responsible for completing the lantern that caps the **dome** of the **Cathedral of Florence**. He was the son of a tailor and began his artistic career as a sculptor. Documents indicate that he worked as **Lorenzo Ghiberti**'s assistant in that capacity. By 1425, Michelozzo was collaborating with **Donatello** on several tombs, providing the architectural components and some of the sculpture. An example is the *Tomb of John XXII* (c. 1435) in the **Baptistery of Florence** to which Michelozzo contributed the **Virtues** at the base and the **Virgin** and Child on the **lunette**. After 1428, he became increasingly active as architect, working mainly for **Cosimo de' Medici**. In the late 1430s, Cosimo financed the building of the **San Marco Monastery**, **Florence**, and its adjacent church. This monastery was occupied by the Sylvestrine Order until 1436 when the monks were expelled and the facilities given instead to the **Dominicans**, who enjoyed Cosimo's favor. The commission included a library, the first built in the Renaissance and the most successful room in Michelozzo's design. It features a Brunelleschian repetition of arches, columns, and corbels, and two-toned embellishments on wall surfaces. Also from Cosimo came the commission for the building of the **Palazzo Medici**, begun in 1436 and meant as the **Medici**'s principal residence. Michelozzo's design for this building became the prototype for Florentine palace design for the rest of the 15th century. Michelozzo is also known to have worked in **Venice**, Pistoia, Montepulciano, Milan, and even Dalmatia. Wherever he worked, he used

the architectural innovations he had learned from Brunelleschi, thereby spreading the new Renaissance style outside of Florence.

MILANO, GIOVANNI DA (active 1346–1366). Lombard painter who settled in **Florence** in the 1360s. His earliest signed work is the *Polyptych with Madonna and Saints* dated 1355 (the *Prato Polyptych)*, created for the Spedale della Misericordia, the most ancient charitable institution in Prato (now in the Prato Museo Civico). In 1365 he **frescoed** for Lapo di Lizio Guidalotti the Rinuccini Chapel in the Church of **Santa Croce, Florence,** with scenes from the lives of the **Virgin** and **Mary Magdalen,** each told in five episodes. Also in 1365, he painted the *Pietà* (Florence, Accademia), a work he signed and dated and that represents one of the earliest examples of the subject in Florence.

MINERVA. Minerva (Pallas) is the goddess of wisdom and daughter of **Jupiter** and Metis. She was born from her father's head an adult dressed as a warrior with helmet, shield, and breastplate. On her shield is the head of Medusa as she was the one who helped Perseus slay this snake-headed monster. Minerva values her chastity and avoids succumbing to passion. She is shown in this light in **Andrea Mantegna**'s *Expulsion of the Vices from the Garden of Virtue* (1497; Paris, Louvre), meant as part of the decorations of **Isabella d'Este**'s *studiolo*, where she is the one ridding the garden of sin. In **Sandro Botticelli**'s *Pallas and the Centaur* (c. 1482; **Florence, Uffizi**), she grabs the creature by the hair to tame his lustful nature. She was challenged to a weaving contest by Arachne. Having won, she transformed her conceited contender into a spider, the subject of **Diego Velázquez'** *Fable of Arachne* (1656; Madrid, Prado). Minerva is also included in **Lucas Cranach the Elder**'s *Judgment of Paris* (1530; Karlsruhe, Staatliche Kunsthalle) where she is involved in a beauty contest with **Juno** and **Venus.** In **Pietro da Cortona**'s *Glorification of the Reign of Pope Urban VIII* (1633–1639; **Rome,** Palazzo **Barberini**), she destroys Insolence and Pride, a way to denote the pope's fight against the heretic enemies of the Church. Lastly, Minerva is also featured in **Raphael**'s *School of Athens* in

the **Stanza della Segnatura**, Vatican (1510–1511) as the goddess of wisdom who inspires the philosophers from antiquity.

MIRACLE OF THE SNOW (c. 1423; Naples, Museo Nazionale di Capodimonte). In c. 1423, **Masolino** painted the *Miracle of the Snow*, also called the *Founding of Santa Maria Maggiore*, as the central scene of an **altarpiece** commissioned by Pope **Martin V** for the Church of Santa Maria Maggiore in **Rome**, now dismantled. It depicts Pope Liberius tracing the plan for the church on the ground when a miraculous snowfall occurred in August that outlined the shape of the structure. Above, Christ and the **Virgin**, enclosed in a blue circle of heaven, oversee the miraculous event. Below them, the clouds that brought the snow diminish in size as they move deeper into the background, while the arcade on the right is also rendered in **perspective**. For this, the painting represents a major breakthrough in the depiction of three-dimensional space on a two-dimensional surface. In the background, the pyramid of Gaius Cestius, the Aurelian walls, and other ancient landmarks situate the scene in Rome and assert the position of the pope as the heir to the emperors from antiquity. **Giorgio Vasari** wrote that Pope Liberius bears Martin's likeness, at his side Holy Roman Emperor Sigismund II who convoked the Council of Constance that elected Martin pope. The altarpiece's side panels are now in the National Gallery in London and the Philadelphia Museum and depict Sts. **Jerome** and **John the Baptist** (left) and **John the Evangelist** and Martin of Tours (right), respectively. The left panel is believed to have been executed by **Masaccio** who often collaborated with Masolino, as the saints are more massive and crude than the rest of the figures. A double-sided altarpiece, the central panel's verso depicts the **Assumption of the Virgin** with a foreshortened Christ welcoming her into heaven. On the reverse of the lateral panels are Sts. **Peter** and **Paul** (left) and Pope Liberius and St. Matthias (right), this last's relics housed at Santa Maria Maggiore. The *Santa Maria Maggiore Altarpiece* was commissioned at a time when Pope Martin V wished to rebuild the city of Rome after it had fallen in disrepair from the absence of the papal court during the Great Schism. The altarpiece therefore, marks a moment in history when pope and artist set in motion the forces that would eventually transform the papal city into the principal artistic center of the Renaissance and **Baroque** eras.

MISERICORDIA ALTARPIECE (beg. 1445; San Sepolcro, Museo Civico). The *Misericordia Altarpiece* was commissioned from **Piero della Francesca** by the **Confraternity** of the Misericordia of San Sepolcro, some of whose members were part of the artist's family. The contract stipulated that the work was to be carried out by Piero alone and completed within three years. Piero ignored both stipulations and the altarpiece was completed by his assistants a decade later. Dismembered in the 17th century, the work originally featured 23 panels, the central scene presenting a Madonna of the Mercy (in Italian, *Misericordia*) type who opens her mantle in a protective gesture. At her feet in prayer are the people of San Sepolcro, the hooded figure a member of the confraternity. His face is covered because these individuals wished to engage in charity in anonymity. On the lateral panels were Sts. **Sebastian**, associated with illness and hence a suitable inclusion as the confraternity cared for the sick; **John the Baptist**, patron saint of **Florence**, which then ruled the town of San Sepolcro; **John the Evangelist**, the local patron saint; and Bernardino da Siena, recently canonized and a major promoter of the Madonna of the Mercy cult. A Virgin **Annunciate** and Gabriel occupied the central panels on the **pinnacles** while a **Crucifixion** surmounted the polyptych. Other saints of significance to the confraternity and the city occupied the rest of the pinnacles and small border panels, while the *predella* featured narratives from the **Passion** and **Resurrection**. This last occupied the center of the *predella* as legend has it that San Sepolcro (*Holy Sepulcher*) was founded in the 10th century by Sts. Arcanus and Giles who brought relics from Christ's tomb in Jerusalem and deposited them in the Benedictine abbey they established in the region. Clearly, the work reflects both the civic and religious aspects of life in the community of San Sepolcro and how the two were enmeshed in the minds of its citizens.

MOCHI, FRANCESCO (1580–1654). Tuscan sculptor from Montevarchi who trained with the **Mannerist** painter Santi di Tito and then moved to **Rome** to complete his training with the sculptor Camillo Mariani. Mochi's most important patrons were the **Farnese**. In fact, a letter written by Mario Farnese recommending Mochi for a commission in the Cathedral of Orvieto is the earliest known document on the artist. The work for which he was recommended was the

Annunciation (1603–1608), with a **Virgin** and angel in vigorous poses that capture the psychological depth of the event depicted. Mochi's equestrian portraits *Ranuccio* and *Alessandro Farnese* (1620–1625) for the Piazza Cavalli in Piacenza show the same dynamism and dramatic depiction of drapery as the *Annunciation*. These two monuments were created for the formal entry into Piacenza of Ranuccio Farnese, Duke of Parma, and his wife on the occasion of their son's baptism. Mochi's *St. Martha* (1609–1628) forms part of the **Barberini** Chapel decorations at Sant' Andrea della Valle, Rome, commissioned by Cardinal Maffeo Barberini, later Pope **Urban VIII**. Mochi would again work for Urban at the crossing of **St. Peter's** for which he contributed his statue of a frantic *St. Veronica* (1629–1630) displaying the imprint of the Holy Face on the *sudario*, a relic enshrined in the pier by the statue. This sculpture is further evidence of Mochi's ability to render elegant figures in highly complex, expressive poses.

MONA LISA (1503; Paris, Louvre). The *Mona Lisa* is **Leonardo da Vinci**'s most recognized masterpiece and the central icon of the Renaissance. According to **Giorgio Vasari**, the female depicted in this portrait is Mona Lisa di Antonio Maria Gherardini, wife of Francesco del Giocondo, a wealthy **Florentine banker**. This identification has been accepted by most, though some scholars have suggested other possible sitters, including Isabella of Aragon, Duchess of Milan; a mistress of Giuliano de' **Medici**; and even Leonardo himself. Speculation as to why she smiles has also been raised, with suggestions varying from a woman following the aristocratic conventions of the day to Leonardo's fixation on his mother. A diagnosis of bruxism, the grinding of teeth resulting from anxiety, has also been made. Vasari wrote that Leonardo hired musicians and singers to amuse Mona Lisa as she sat for the portrait, which might provide another logical explanation. The work has been cut down. Originally, the figure was flanked by columns that attached to the still partially visible balustrade on which she rests her hands, this known from early copies of the painting. The importance of this work lies in the fact that, with it, Leonardo established a new portrait type. Previously in Italy, the likenesses of women were captured in profile in a nonrealistic manner, the emphasis on the sitter's social standing and luxuri-

ous costumes and jewelry. Mona Lisa is a frontal, naturalistically rendered figure set against a detailed landscape that echoes the curves of her hair and garments. There are no hints of luxury. Instead the focus is on the woman and her psyche. She is a living, breathing individual, a far cry from the flattened representations of the past. Her verism prompted Vasari to comment that when glancing at the figure one could swear her pulse was beating on the pit of her throat.

MONACO, LORENZO (PIERO DI GIOVANNI; c. 1370–1424). Italian painter whose life and career are not well documented. He was active in **Florence** where in 1391 he entered the Camaldolese Monastery of Santa Maria degli Angeli. His best-known work is the *Coronation of the Virgin* (1414; Florence, **Uffizi**), painted for the high altar of the monastery's church. Monaco painted a smaller version, now in the National Gallery in London (1407–1409), for the local Monastery of San Benedetto Fuori della Porta a Pinti that also belonged to the order. The *Adoration of the Magi* in the Uffizi (c. 1421–1422) he originally rendered for the Church of Sant' Egidio, while the **frescoes** in the Bartolini-Salimbeni Chapel in the Church of Santa Trinità (1420–1425) that depict the life of the **Virgin Mary**, saints, and **prophets** is his most extensive commission. The opulent pageantry in these works, the brilliant colors, and heavy gilding mark Monaco as one of the notable exponents of the **International Style**.

MONTAÑÉZ, JUAN MARTINEZ (1568–1649). Spanish sculptor who specialized in religious figures rendered in polychromed wood. Montañéz was a native of Seville who studied with the sculptor Pablo de Rojas in Granada. In 1635 he was summoned to Madrid to render a sculpted head of **Philip IV** of Spain to be sent to Italy so Pietro Tacca could render the king's equestrian portrait (1640; Madrid, Plaza de Oriente). This is Montañéz's only documented secular commission. While at court, **Diego Velázquez** painted his portrait (c. 1635; Madrid, Prado), showing the sculptor at work on the bust. The types of sculptures Montañéz created were meant to be carried during religious processions and displayed in the interior of churches to stir up deep emotions in viewers, among them his *St. Ignatius of Loyola* (1610; Seville, University Chapel), paraded during the celebrations of the saint's beatification, and the *Penitent St. Jerome* in the

Monastery of San Isidro del Campo, near Seville (1612). One of the greatest examples of Montañéz's work is the *Christ of Clemency*, now in the Cathedral of Seville (1603–1606), commissioned by Mateo Vázquez de Leca, the archdeacon of Carmona, for his private chapel. As in most Sevillian depictions of the **Crucifixion** from this era, Montañéz used four nails, instead of three, to augment the sense of Christ's suffering. Montañéz's renderings were tremendously influential in the development of Spanish art, especially that of **Francisco de Zurbáran** whose own *Crucified Christ* (1627; Chicago, Art Institute) translates to painting Montañéz's sculptures.

MONTEFELTRO, FEDERICO DA (1422–1482). Ruler of Urbino from 1444; appointed duke in 1474 by Pope **Sixtus IV**. Federico was the illegitimate son of Guidantonio, Count of Montefeltro and Urbino, who in 1435 turned him over as a hostage to **Venice** to guarantee the peace of Ferrara signed between Pope Eugenius IV and the **Visconti**, then rulers of Milan. In the following year, Federico was transferred to the **Gonzaga** court in Mantua where he received a humanistic education and where he was knighted by Emperor Sigismund. He took the rulership of Urbino in 1444 when his half-brother Oddantonio was murdered. To support Urbino's economy, Federico served as **condottiere** to the papacy, the king of Naples, and several Italian princes, including the **Sforza** of Milan for whom he obtained the territory of Pesaro. For himself, he took Fossombrone and married Battista Sforza in 1450. His daughter Giovanna's marriage to Sixtus IV's nephew, Giovanni **della Rovere**, resulted in the pope raising Urbino to a duchy (1474). Federico died in Ferrara in 1482 while fighting for the Venetian Republic.

For over 30 years, Federico expended great effort in the building and decoration of his Ducal Palace. As a result, Urbino became one of the most important artistic centers of the Renaissance where sculptors, painters, and architects from other regions came to work. The Tuscan **Piero della Francesca** painted the portraits of Federico and his wife Battista Sforza in 1472 (both in **Florence, Uffizi**). Luciano Laurana, from Dalmatia, executed a posthumous bust of Battista in about the same year. He is also credited with some of the architectural design of the Ducal Palace as he is named its chief architect in a doc-

ument of 1468. The Sienese architect Francesco di Giorgio Martini, who arrived in Urbino in 1476, continued work on the palace. He also built a number of fortresses in Urbino and worked for Montefeltro as sculptor. His *Deposition* in bronze **relief** (c. 1477; Venice, Santa Maria del Carmine) originally formed part of an **altarpiece** in the Oratory of Santa Croce, Urbino. The Spanish painter **Pedro Berruguete** and the Netherlandish **Joos van Ghent** worked for the duke on the decoration of his study and library (1477). In 1480–1481, Berruguete also rendered a portrait of Federico and his son, now in Urbino's Galleria Nazionale. *See also BATTISTA SFORZA AND FEDERICO DA MONTEFELTRO, PORTRAITS OF.*

MONTEFIORE CHAPEL, SAN FRANCESCO, ASSISI (c. 1328). The Montefiore Chapel, located in the Lower Church of **San Francesco** in Assisi, was executed for the **Franciscan** Cardinal Gentile Partino da Montefiore whose titular church was San Martino ai Monti, **Rome**. He had close ties to the House of Anjou, and played a key role in obtaining the throne of Hungary for Charles I Carobert, nephew of **Robert D'Anjou**, king of Naples. The **frescoes** in his chapel were executed by **Simone Martini**, one of **Duccio**'s most important pupils and one of the artists to work for Robert in Naples. The scenes depicted relate the story of St. Martin of Tours who lived in the fourth century and to whom Montefiore's titular church is dedicated. Born in Pannonia, St. Martin converted to Christianity at an early age against his parents' wishes. As a soldier in Amiens, he came across a beggar and offered him half his cloak. That night Christ appeared to him in a dream and thanked him for it. For 10 years he lived as a hermit in Ligugé where he preached and meditated until, in 372, he was appointed Bishop of Tours by popular acclaim. He died there in 397 just after having had a premonition that the end was near, which he announced to his followers. In the scenes by Martini, the saint's charity, miraculous deeds, investiture, premonitions, and death are the main subjects. The stories unfold in luxurious courtly settings rendered in convincing perspective, with elegant patterning on the various surfaces. The emphasis on courtly splendor is characteristic of the **International Style** Martini helped establish when he worked in the papal court of **Avignon**.

MOR VAN DASHORST, ANTHONIS (ANTONIO MORO; c. 1517–1577). Dutch painter, known primarily for his skill as portraitist. Anthonis Mor was born in Utrecht where he was trained by **Jan van Scorel**. In c. 1545, he moved to Antwerp where he entered the **guild** two years later. By 1549, he was working in Brussels, and, in 1550, he traveled to Italy. For the rest of his career he worked primarily for the **Hapsburgs** in England, Spain, Portugal, and Germany. His portrait *Antoine Perrenot de Granvelle, Bishop of Arras* (1549; Vienna, Kunsthistorisches Museum), counselor to Margaret of Austria, shows his mature style. The work owes particular debt to the portraits of **Titian** in that the figure is presented in three-quarter length against an undefined background glancing confidently at the viewer and wearing an elaborate costume with particular emphasis on the various textures. He leans on a desk and holds a letter in his hand, denoting the official nature of the portrait. Other portraits by Mor of note are his *Fernando Alvarez de Toledo, Third Duke of Alba* (1549; New York, The Hispanic Society of America), Spanish general and later governor of the Netherlands; *Queen Mary Tudor of England* (1554; Madrid, Prado), wife of **Philip II**; and *Thomas Gresham* (1564; Amsterdam, Rijksmuseum), a representative of the English crown in the Netherlands. His standing portrait *Philip II in Armor* (1557; El **Escorial**, Monasterio de San Lorenzo) is one of the works that set the standard for Hapsburg portraiture in Spain.

MOSAIC. A technique invented by the ancients to decorate the interior surfaces of domestic and public spaces. It entails gluing the minute **tesserae** produced by cutting colored stones or glass onto wall, ceiling, or floor surfaces to create decorative patterns or fully developed scenes. In public spaces, such as the **apses** of pagan basilicas, mosaics served as a regal backdrop for the enthroned emperor. These scenes were usually mythological, though at times political images were also produced. With the introduction of Christianity as the Roman Empire's official religion, the need arose for decorations for newly built churches and other sacred structures. The sparkling effects created by the colored tesserae in the mosaics became symbolic of heaven—the reward granted to the faithful after death. Church apses became the main focus of mosaic decoration since it is here where the mass takes place and where the host is consecrated. Mo-

saics, however, also were used to cover the **triumphal arch** preceding the apse, and the solid walls above the **nave** arcade. The scenes depicted were usually religious narratives that instructed the faithful on Christian doctrine, including the story of salvation through Christ, the life of the **Virgin Mary**, or the cults of the saints. The use of mosaics as religious decorations continued well into the 13th century. **Jacopo Torriti** was responsible for the mosaics in the Basilica of St. John Lateran (c. 1291) and Santa Maria Maggiore (c. 1294), both in **Rome. Coppo di Marcovaldo** is credited with the mosaics of the **Last Judgment** on the **vault** of the **Baptistery of Florence,** and **Giotto** is known to have created a large mosaic for the courtyard façade of Old **St. Peter's** in c. 1307 depicting the scene where Christ walks on water to save **St. Peter** from drowning, the *Navicella* (destroyed in the 16th century). *See also* COSMATESQUE STYLE.

MOSTAERT, JAN (c. 1472–1555). Dutch painter from Haarlem who was trained by Jacob Janszen and influenced by **Geertgen Tot Sint Jans**. In 1507, and again in 1543–1544, Mostaert served as dean of the painter's **guild** in Haarlem. In 1519, he is also documented working in the court of **Margaret of Austria**. His *Passion Triptych* (c. 1510; Brussels, Musées Royaux des Beaux-Arts) shows Geertgen's influence, particularly in the elongation and stiffness of the figures, the ovoid faces, and the gentleness that permeates the painting, features also found in his *Adoration of the Magi* (1515–1520; Amsterdam, Rijksmuseum). His *Tree of Jesse* (1485; Amsterdam, Rijksmuseum) presents the genealogy of Christ, with Jesse reclining on the ground, a tree growing out of him, Christ's male ancestors climbing on it, and the **Virgin** and Child at the apex. This scene translates visually the prophecy of Isaiah that a Messiah would be born from the family line of Jesse, father of King **David**, a scene common to the North, particularly in **illuminated manuscripts**. Mostaert's skill as portraitist is demonstrated by his *Portrait of a Man* (c. 1515–1520; Brussels, Musées Royaux des Beaux-Arts) which includes in the background another prophecy about the coming of the Lord, in this case made by the Tiburtine **Sibyl** to Emperor Caesar Augustus. One of Mostaert's most unusual paintings is the *West Indian Landscape* (c. 1540; Haarlem, Frans Halsmuseum), which depicts nude natives, huts, and animals indigenous to the Americas. Though seemingly a

pastoral setting, peace is disturbed by a group of armed European invaders. While the significance of the subject is not clear, it has been suggested that the work may symbolize the colonization efforts in the Dutch territory by the tyrannous Spaniards.

MUSEO CARTACEO (THE PAPER MUSEUM). The Museo Cartaceo was a collection of approximately 7,000 drawings created by the leading **Baroque** masters of **Rome**, among them **Pietro da Cortona, Nicolas Poussin,** and **François Duquesnoy,** for the patron and collector Cassiano dal Pozzo to record the natural and man-made world. The collection included a significant number of archaeological renderings that recorded the monuments from antiquity that proved to be of great use to artists of the period, who were given access to view them and who borrowed elements from them to include in their own compositions. The collection also provided visual documentation in the botanical, geological, ornithological, and zoological fields. The drawings were catalogued by category and bound to facilitate their use for research. The Museo Cartaceo provided the foundations for today's research and classification methodology and a gauge with which to measure the scientific and archaeological concerns of the period. When dal Pozzo died in 1657, the volumes were inherited by his brother Carlo Antonio. They later became the property of Pope Clement XI, who purchased them in 1704. His family, the Albani, sold the collection to George III of England and most of the drawings are now housed in the London Royal Library.

MUSES. In mythology, muses are the goddesses of art and science, and they provide inspiration to those who engage in the practice of these fields. The daughters of **Jupiter** and Mnemosyne, their birthplace is Pieria at the foot of Mount Olympus where the gods reside. They usually convene in Parnassus presided over by **Apollo.** Though their numbers have varied in the surviving ancient accounts, eventually nine of them came to be worshiped. They are Calliope, Clio, Erato, Euterpe, Melpomene, Polyhymnia, Terpsichore, Thalia, and Urania. Muses often appear in art. In **Giorgione**'s *Fête Champetre* (c. 1510; Louvre, Paris) they provide the poets with inspiration. In the **Stanza della Segnatura** (1510–1511) at the Vatican, **Raphael** placed them in Parnassus, as did **Nicolas**

Poussin in his *Apollo and the Muses* (1631–1632; Madrid, Prado). **Simon Vouet** painted the *Muses Urania and Calliope* (c. 1624; Washington, National Gallery), believed to have been part of a series that showed all nine muses along with Apollo, and **Eustache Le Seur** decorated the Cabinet of the Muses in the Hotel Lambert, Paris (1652–1655; now Paris, Louvre) with paintings showing the women in groups of three, each with her respective attribute.

MYSTIC MARRIAGE OF ST. CATHERINE. This event, a common subject in art, is a vision experienced by **St. Catherine of Alexandria** where the Christ Child placed a gold ring on her finger, resulting in her conversion to Christianity. The scene is usually depicted as an intimate moment, with Christ sitting on his mother's lap and leaning toward the saint to give her the ring. This is how **Lucas Cranach the Elder** presented the scene in c. 1516 (Budapest, Szepmuveszeti Muzeum) and **Correggio** in c. 1520 (Paris, Louvre). **Gerard David** rendered the mystic marriage as a more solemn and less intimate moment (c. 1505; London, National Gallery). In his version, the **Virgin** and Child are enthroned in the center of the composition, separated from the cityscape in the background by a brocaded cloth of honor, and flanked by two saints at either side, including St. Catherine who receives the ring from Christ. Fra Bartolomeo rendered the scene as a major miraculous event (1512; **Florence**, Galleria dell' Accademia), with the Virgin and Child standing beneath an elaborate baldachin supported by putti, musical angels at their feet, and a number of witnesses.

– N –

NASTAGIO DEGLI ONESTI. A character from **Giovanni Boccaccio**'s *Decameron* whose story became a popular subject in painting during the 15th century, appearing mainly in domestic furnishings that provided didactic narratives. In the *Decameron*, Nastagio falls in love with a woman who rejects him. Disheartened, he squanders his fortune and spends his days in the woods drinking and dining with his friends. One day he witnesses a naked woman being chased by a knight. The knight kills her, feeds her innards to his hounds, and then explains to Nastagio that he was once in love with the woman but

was rejected, so he committed suicide. When the woman also died, the two were condemned to eternally reenact her murder and the feeding of her entrails to the dogs. Then, the woman gets up, and the scene is replayed. Shaken, Nastagio invites the object of his affection to a banquet in the woods where they both witness the knight killing the woman. Horrified by the event, Nastagio's love decides to accept him as her husband. **Sandro Botticelli** rendered the story in four panels, three of which are now in the Prado, Madrid, and the other in a private collection. Executed in 1483, they were commissioned by the **Medici** for the wedding of Gianozzo Pucci, **Lorenzo "the Magnificent's"** nephew, to Lucrezia Bini. A panel by **Domenico del Ghirlandaio** in the Brooklyn Museum (after 1483) shows the chase of the nude woman by the knight and his dogs. These works were meant to elucidate the pivotal role of marriage and the family as one of the pillars of society.

NAVARRETE, JUAN FERNÁNDEZ DE (1526–1579). Called *El Mudo* (*The Mute*) because he was a deaf-mute, Navarrete is best known for the **altarpieces** he contributed to the decoration of the Monastery of El **Escorial** for **Philip II** of Spain, whom he served as court painter from 1568 until his death in 1579. He was originally from Logroño and traveled to Italy where he was influenced by the art of the Renaissance masters, and particularly **Titian** with whom he may have studied. His earliest known painting is the *Baptism of Christ* (c. 1565, Prado, Madrid), a work that shows his assimilation of the Italianate style. Not only are the anatomical details of Christ's nude torso and his pose borrowed from **Michelangelo**, but the foreshortened God the Father hovering above Christ is taken directly from the scenes of Creation in Michelangelo's **Sistine ceiling** (1508–1512; Vatican). The Michelangelesque features in Navarrete's art are also manifested in his *Christ Appearing to His Mother* (1578–1579), one of the altarpieces he contributed to the decoration of El Escorial, where a seminude foreshortened Christ floats in midair. Navarrete's loose brushwork and vivid colorism are what earned him the sobriquet "Spanish Titian." His other works include *Abraham and the Three Angels* (1575; Dublin, National Gallery of Ireland), *Martyrdom of St. James* (1571), *Christ at the Column* (1572–1575), and *Burial of St. Lawrence* (1578–1579; all at El Escorial, Monastery of San

Lorenzo), this last a lugubrious rendition with dramatic lighting effects. These were part of the 32 altarpieces commissioned from the artist for the Escorial monastery. Having completed about a third of the works, Navarrete died suddenly, leaving Philip to scramble to find a substitute master. Navarrete's Italianate style would affect future Spanish painters, among them **Francisco Ribalta** and particularly **Diego Velázquez**.

NAVE. The central space of a church, running from the entrance to the **choir**, where the faithful congregate to hear the mass. It is called a nave as the church at times is likened to the ship that symbolically will transport the faithful from this life to the next. It is usually flanked by aisles and separated from them by the nave arcade. The nave elevation in Gothic churches usually includes the arcade, triforium, and **clerestory**, granting a delicate skeletal appearance. In Italy, the nave elevations are usually only two stories high, with arcade and clerestory, and feature lesser piercings. This type of construction is better suited for the hot and humid climate of the region. The continuous walls above the nave arcades in these churches provide a surface for **fresco** or **mosaic** decorations, normally absent in French Gothic prototypes. In some of the longitudinal churches built during the **Counter-Reformation**, among them **Il Gesù** in **Rome** (1568–1584), the nave was widened and the side aisles eliminated to avoid the visual interruptions created by the arcade and to place all focus on the main altar during the rituals of the mass.

NEOPLATONISM. A school of philosophical thought founded by Plotinus in the sixth century. Inspired by the writings of **Plato**, Plotinus concluded that it is from the One, Intelligence, and the Soul that all existence emanates. For him, it is through intellectual contemplation that these three can be united as a single, all-encompassing reality. The soul possesses a higher, purer form and a lower corrupt part that causes mundane individuals to give into their passions and **vices**. Those who are enlightened achieve their soul's ascent to the highest level through contemplation. Neoplatonism greatly influenced Christianity. The three hypostases of the One, Intelligence, and the Soul parallels the doctrine of the **Holy Trinity** and the concept of attaining greater heights through contemplation translates to the ascent of

the soul to heaven as reward for proper Christian behavior through prayer and meditation.

The recovery of Greek manuscripts in the 13th century from Byzantium by the Crusaders and their systematic translation into Latin in the 15th century occasioned the revival of Neoplatonism. **Marsilio Ficino**'s founding of the Platonic Academy in **Florence** under the auspices of the **Medici** and the writings in which he tried to reconcile Neoplatonism and Christianity sparked further interest in the philosophy. Eventually, every aspect of life was touched by Neoplatonism, including art, and theorists such as **Giovanni Battista Agucchi** and **Giovan Pietro Bellori** were soon instigating artists to improve upon what they viewed as the imperfect, corrupt nature by rendering it not as they saw it, but as the higher, more perfect version they envisioned. Among the artists whose works have been interpreted along the lines of Neoplatonism are **Sandro Botticelli**, **Michelangelo**, **Raphael**, and **Annibale Carracci**.

NEPTUNE. The god of the sea, son of Saturn and Cybele, and brother of **Jupiter**. Neptune's consort is Amphitrite who at first rejected his advances and fled, but was later persuaded to marry him. Neptune had almost as many loves as his brother Jupiter, including Medusa, from which union Pegasus and the giant Chrysaor were born, and Gaia who bore him Antaeus. Neptune is often depicted on fountains, as in **Bartolomeo Ammannati**'s *Neptune Fountain* (1563–1575) in the Piazza della Signoria in **Florence**. **Benvenuto Cellini** included the god reclining opposite Tellus in his famed salt cellar of **Francis I** of France (1540–1544; Vienna, Kunsthistorisches Museum) to denote the places of origin of salt and pepper. **Jan Gossart** depicted Neptune alongside Amphitrite as Italianate, **classicized** nudes (1516; Berlin, Staatliche Museen), the first rendition of its kind in Flanders. **Eustache Le Seur** painted the *Marine Gods Paying Homage to Love* (c. 1636–1638; Los Angeles, J. Paul Getty Museum), a work that shows Polyphilus and Polia, the characters of the *Hypnerotomachia Polifili*, being ferried to **Venus**' sacred island of Cythera by Neptune, Amphitrite, and their retinue.

NEW SACRISTY OF SAN LORENZO, FLORENCE (1519–1534). The New Sacristy of San Lorenzo was conceived as a funerary chapel

for members of the **Medici** family, namely Lorenzo, Duke of Urbino (d. 1519), Giuliano, Duke of Nemours (d. 1516), and the brothers **Lorenzo "the Magnificent"** (d. 1492) and Giuliano, the latter murdered during the **Pazzi Conspiracy** (1478). **Michelangelo** received the commission from Cardinal Giuliano de' Medici who later became Pope **Clement VII** (r. 1523–1534). Work was interrupted in 1527 as the **sack of Rome** resulted in Medici exile from **Florence**, though they were reinstated in 1530 by papal and imperial forces. As Michelangelo had aided in the fortification of the city during their absence to prevent them from retaking power, the Medici ordered Michelangelo's assassination. Soon however, Clement VII, who understood the uniqueness of Michelangelo's artistic abilities, pardoned the master and work on the New Sacristy resumed. In the end, Michelangelo left the project unfinished as Clement died in 1534 and Alessandro de' Medici was murdered in 1537. In that year, Michelangelo was in **Rome** and, having heard of the event, decided that it would not be safe for him to return to Florence to complete the work.

Michelangelo's monument to the Medici and **Filippo Brunelleschi**'s **Old Sacristy** stand at opposite sides of the transept of San Lorenzo. Therefore, Michelangelo consciously harmonized his design with that of his predecessor. He used *pietra serena* (a local stone) trims over whitewashed walls and echoed the arches and **pediments** of the earlier structure. Yet Michelangelo also added decorative elements that are unprecedented, such as blind niches that are too shallow to contain statues, niches that are deeper at the top than at the bottom to accommodate carved swags, and columns that do not belong to any identifiable order, these supported by scroll brackets. Drawings indicate that originally Michelangelo intended a freestanding monument for the tombs in the center of the room. In the end, however, he settled for wall tombs, completing only those of the Medici dukes. Their sarcophagi are shaped like segmented (semicircular) pediments and feature a reclining figure at either side. Night and Day are on Lorenzo's tomb and Dusk and Dawn on Giuliano's; these figures imply the passage of time. Above the central split in each sarcophagus is the sculpted portrait of the deceased. Giuliano, in an assertive stance, holds a baton of command, while Lorenzo is pensive, his left arm resting on a coffer to reference the family's **banking** activities. For this, the figures have been given a **Neoplatonic** reading,

with Giuliano seen as a representation of the active life and Lorenzo as its contemplative counterpart. Had Michelangelo executed the other tombs, the dukes would have gazed at their forbearers—an assertion of dynastic continuity.

Michelangelo's drawings indicate that he intended to include river gods at the lower level of each tomb, meant to represent the four rivers of paradise. **Frescoes** on the **lunettes** above the tombs of the *Resurrection* and the *Brazen Serpent*, an Old Testament episode that prefigures the **Crucifixion**, would have provided references to the Christian promise of salvation. With the New Sacristy, Michelangelo sought to unite concepts of time, memory, and spiritual transcendence through an expressive visual language that broke away from normative artistic conventions.

NICHOLAS IV (GIROLAMO MASCI; r. 1288–1292). Of humble background, Nicholas IV was created cardinal in 1278 and appointed bishop of Palestrina in 1281. He was the first **Franciscan** pope, his reign dominated by the influence of the Colonna, so much so that he was portrayed sardonically by the populace of **Rome** as a figure crowned in the papal tiara and encased in a column, the heraldic symbol of this feudal family. As pope, his efforts centered on restoring Sicily to the House of **Anjou** after having been lost to Aragon. Nicholas effected an alliance between France and Castile against Aragon, declared James of Aragon deposed, and crowned Charles II D'Anjou king of Naples and Sicily. He sent missionaries to the Balkan, Near East, and China, this last region seeing the representation of the Catholic Church for the first time. Nicholas restored the Church of Santa Maria Maggiore in Rome, adding a **transept** and rebuilding the **apse**. He then commissioned **Jacopo Torriti** to decorate the apse with **mosaics** depicting the **Coronation of the Virgin** (not executed until c. 1294). He also commissioned from Torriti the mosaics at St. John Lateran (c. 1291).

NICHOLAS V (TOMMASO PARENTUCELLI; 1447–1455). A native of Sarzana and the son of a physician, Nicholas was educated in **Bologna**. His father's death forced him to interrupt his studies and seek work in **Florence**. There, he refined his humanist interests in the

Strozzi and **Albizzi** households where he worked as a tutor and made the acquaintance of the leading humanists of the day. In 1419, he was able to return to Bologna and complete his studies, after which he entered in the service of the bishop of Bologna, Niccolò Albergati. In 1444, Albergati died and Nicholas assumed his position as bishop. Eugene IV sent him on diplomatic missions in Italy and Germany, which earned him the cardinalate in 1446. Eugene died in the following year and Nicholas became pope. He immediately set out to embellish the city of **Rome** and make it the worthy capital of Christianity. **Leon Battista Alberti** acted as his advisor in Rome's restoration campaign. Nicholas repaired the Acqua Vergine to improve the city's water supply, widened streets, and renovated bridges, the buildings of the Capitol, major basilicas, and smaller churches. He also made improvements to the port of Ostia, the city's harbor, and extended the Vatican Palace, including the addition of a library to house his extensive collection of books. His chapel in the Vatican (the **Chapel of Nicholas V**) was **frescoed** by **Fra Angelico** in 1448 with scenes from the lives of Sts. **Stephen** and **Lawrence**. Nicholas also hired a number of humanists to his court, including **Lorenzo Valla**, to enhance culture in Rome.

NIGHT WATCH **(1642; Amsterdam, Rijksmuseum).** Painted by **Rembrandt** in 1642, the *Night Watch* portrays officers of the Company of Captain Frans Banning Cocq and his Lieutenant William van Ruijtenburgh. The title of the painting is a 19th-century fabrication based solely on the fact that the scene takes place in a dark room. Unlike traditional portraits of militia company members where figures pose while seated around a table, this one shows the individuals in action. As they ready themselves to participate in a parade, Captain Cocq gives his lieutenant his final instructions, a young gunpowder boy waits in the foreground, a drummer practices, an officer raises the company flag, and others ready their muskets and lances. Left center, a girl runs across the room, surprisingly receiving the greatest amount of light in the painting. She is dressed in blue and gold, the company's colors, and from her waist dangles a dead bird with claws prominently shown, the company's emblem. With these particulars, she becomes the personification of the group's heraldic device. The dramatic **chiaroscuro** effects, oblique

arrangements of figures, banners, and weapons, and the excitement of the moment classify this work as decidedly **Baroque**.

NYMPHS. In Greek, *nymph* translates to *young woman*. In mythology, these creatures are lesser deities who often represent some aspect of nature, such as a tree, **grotto**, stream, or region. In art, they are usually depicted as beautiful, sparsely dressed, youthful figures who often hold a flower or some other attribute particular to their story. Some lust after handsome male youths while others are pursued by **satyrs**, male mortals, or even gods. Daphne is the wood nymph pursued by **Apollo** and turned into a laurel tree by Peneius to protect her, the theme of **Antonio del Pollaiuolo**'s *Apollo and Daphne* (1470–1480; London, National Gallery) and **Gian Lorenzo Bernini**'s sculpture of the same subject (1622–1625; **Rome**, Galleria **Borghese**). The sea nymph Galatea ridicules the Cyclops Polyphemus in **Annibale Carracci**'s **Farnese ceiling** (c. 1597–1600; Rome, **Palazzo Farnese**), and the wood nymph Chloris becomes Flora as reward for Zephirus' indiscretion in **Sandro Botticelli**'s *Primavera* (c. 1482; **Florence**, **Uffizi**). **Laurent de la Hyre** painted *Diana and Her Nymphs* in 1644 (Los Angeles, J. Paul Getty Museum), and **Artemisia Gentileschi** rendered *Corsica and the Satyr* in the 1640s (private collection), this last work showing the astute nymph who, tired of being pursued, donned a hairpiece that came off as the satyr tried to grab it.

– O –

OGNISSANTI MADONNA **(c. 1310).** Painted by **Giotto** for the Church of the Ognissanti in **Florence** (now in the **Uffizi**) belonging to the mendicant Order of the Umiliati, the panel follows the tradition of presenting an iconic image of the enthroned **Virgin** and Child surrounded by saints and angels set against a gilded background often depicted by masters of the *Maniera Greca* style. Giotto, however, rejected the flattened, simplified, abstracted forms of the earlier examples in favor of a more naturalistic mode of representation. The compartmentalization of anatomical parts of the Byzantine tradition are gone, as are the gold striations that denote the drapery's folds.

Giotto's figures have volume, their draperies fall naturally and define the contours of their bodies, and the Virgin and Child are enclosed within a three-dimensional throne. With this, Giotto humanized the divine characters depicted, therefore allowing for a more intimate connection between viewer and devotional art.

OIL PAINT. This painting medium is composed of pigments mixed with linseed, walnut, or other oils. Its advantage over **tempera** is that it can be applied as layered transparent glazes for a richer, more luminous effect. The **Master of Flémalle** and **Jan van Eyck** were among the first artists to use oil paints on panel. It was **Antonello da Messina** who introduced the oil glazing technique to Italy. He studied the works of van Eyck and **Rogier van der Weyden** in the collection of King Alfonso of Naples and he may have learned the technique firsthand from **Petrus Christus** in the **Sforza** court in Milan.

OLD SACRISTY OF SAN LORENZO, FLORENCE (1421–1428). Built by **Filippo Brunelleschi**, the Old Sacristy protrudes from the left arm of the Church of San Lorenzo's **transept**. Conceived as the final resting place for Giovanni di Bicci de' **Medici**, Brunelleschi's first patron, the Old Sacristy is in essence a cube of equal height and width capped by a **dome**. Attached to it is a rectangle divided into three parts; the central segment, meant to accommodate the altar, is also domed. This simple arrangement of quadrangular and circular forms follows a Pythagorean principle of proportions common to Brunelleschi's architecture. The sacristy's elevation is tripartite as well, with Corinthian pilasters that fold at the corners and carry the weight of the entablature. *Pietra serena*, a local tan-colored stone, trims the white stucco walls, another typical Brunelleschian feature. To allow light into the interior, the dome is capped by a lantern and pierced at the base by 12 oculi (round openings), meant to refer to the 12 **apostles** and the 12 gates of Jerusalem. Terracotta **reliefs** by **Donatello** fill the roundels on the arches and **pendentives** that support the dome, as well as the semicircular fields above the doorways. Brunelleschi is said to have complained that Donatello's contributions to the sacristy were too busy and disrupted the harmony of his architectural design. The Old Sacristy reflects Brunelleschi's rational approach to building. The first Renaissance master to introduce

classical elements to architecture, his Old Sacristy echoes the balance, symmetry, and harmonious proportions of the ancients.

ONE-POINT LINEAR PERSPECTIVE. A mathematical method thought to have been devised by **Filippo Brunelleschi** and used to render convincing three-dimensional spaces on two-dimensional surfaces. In this method, all orthogonal lines converge at a single vanishing point placed on the horizon line. According to Antonio Manetti, Brunelleschi's biographer, the architect demonstrated the method by using it to paint the **Baptistery of Florence**. He drilled a hole in the center of his composition so the real building could be seen through it. Placing a mirror in front of the viewer who peeked through the peephole to reflect his painting and then removing it to reveal the Baptistery, Brunelleschi was able to prove that his rendering was indistinguishable from the actual building. The first to introduce one-point linear perspective to painting was **Masaccio** in works such as the *Holy Trinity* (1427) at **Santa Maria Novella**, **Florence**. **Donatello** was the first to use it in **relief** sculpture, with the panels he executed for the altar of San Antonio, Padua (1444–1449), serving as some of his best examples. Until 1435, the method was only spread by word of mouth. In that year **Leon Battista Alberti**'s treatise on painting, which includes discussion on one-point linear perspective, was published, allowing for its wider dissemination.

ORATORY OF ST. GEORGE, PADUA (1377). In the 1370s, **Altichiero** had worked in the Church of San Antonio in Padua, painting **frescoes** in the St. James Chapel for Bonifazio Lupi, from a family of **condottieri** who served the Carrara, the city's rulers. These were such a major success that Raimondino Lupi, Bonifazio's relative, asked the artist to work for him in the Oratory of **St. George**, his funerary chapel. Of the scenes Altichiero executed, *St. George Baptizing King Servius*, the *Martyrdom of St. George*, and the *Execution of St. George* stand out. In the first, elaborate architecture serves as the backdrop for the baptism of the Libyan King Servius, his family, and members of his court agreed upon after the saint saved Servius' daughter from the dragon. The event takes place in the center of the composition, with the royal family kneeling and courtiers witnessing along the buildings' arcades. Their demeanor and facial expressions

elucidate the solemnity of the moment depicted. In the *Martyrdom of St. George*, the saint is shown in the center stretched on a wheel, one of the many tortures from which he was delivered. In the saint's legend it is specified that, between torments, George converted others to Christianity. On the **logge** at either side of the massive building that serves as backdrop, he is shown engaged in this activity. His final martyrdom by decapitation is depicted in the *Execution of St. George* where, surrounded by a crowd of onlookers, the executioner prepares to carry out the saint's beheading. To add to the horror, a man removes his child to prevent him from witnessing the gruesome event. The frescoes in the Oratory of St. George show Altichiero's dependence on the naturalism introduced by **Giotto** whose frescoes in the **Arena Chapel**, Padua (1305), were readily available for study. Altichiero's figures are as massive and solid as those of the **Florentine** master, though the individualized features, complex architecture, believable depth, and sense of movement are his own elaborations.

ORATORY OF ST. PHILIP NERI, ROME (1637–1650). The Oratory of St. Philip Neri is next door to the Chiesa Nuova in **Rome**. The commission to build the structure came from the Order of the Oratorians established by the saint and was given to **Francesco Borromini** after an architect of little note had been working on it for 13 years and yielding little results. The purpose of the building was to accommodate the throngs of individuals who came to the Chiesa Nuova for informal religious discussions and to hear sacred music. Borromini's genius is reflected in the play of concave and convex forms on the building's façade, characteristic of his style. While the overall shape of the façade is concave, the central bay on the lower level juts out to emphasize the building's entrance. Above this is a semicircular balcony and doorway contained in a **coffered** niche that is rendered in **perspective** to create the illusion of depth in spite of its flattened form. Borromini stylized the articulations on windows and **pediments** to echo these curves, though attached pilasters between the bays serve to contain the façade's overall undulating rhythms. The interior also presents a play of contracting and expanding movements. From pilasters on the walls that cannot be classified among the **classical** orders rises a series of ribs that crisscross to form an intricate pattern on the ceiling, culminating in the center with an enframed

fresco. The work demonstrates Borromini's mastery in inventing new architectural forms and in according an organic motility to his spaces.

ORCAGNA, ANDREA (ANDREA DEL CIONE; c. 1308–1368). **Florentine** painter, sculptor, and architect who, along with his brother Nardo del Cione, decorated the **Strozzi Chapel** at **Santa Maria Novella**, Florence. Orcagna's contribution consisted of an **altarpiece** titled the *Enthroned Christ with Madonna and Saints* (the *Strozzi Altarpiece*), which he executed in 1354–1357. In 1359, Orcagna executed the massive tabernacle at **Orsanmichele**, Florence, in marble, **mosaic**, gold, and lapis lazuli. This elaborate work includes **reliefs** from the life of the **Virgin** and a painted panel by **Bernardo Daddi** of the *Enthroned Virgin and Child*. From 1358 to 1362, Orcagna is documented in Orvieto supervising the execution of the mosaics on the façade of the cathedral. His last work was the *St. Matthew Altarpiece* (Florence, **Uffizi**), commissioned by the Arte di Cambio, the **Guild** of Money Changers, in 1367 to be placed on one of the supporting pillars in Orsanmichele. Orcagna fell seriously ill while working on the commission and died. The task fell to his brother, Jacopo del Cione, who completed the altarpiece at the end of the 14th century.

ORLANDO FURIOSO. A poem written by Ludovico Ariosto while serving Duke Alfonso I d'**Este** of Ferrara, first published in 1516. The poem is a chivalric epic that centers on the figure of Charlemagne and borrows from Arthurian legend to celebrate the d'Este dynasty. Orlando is the hero who falls in love with the Cathayan princess Angelica and converts the pagan prince Ruggiero to Christianity. Ruggiero marries Bradamante and together they establish the d'Este line. The poem gained tremendous popularity soon after its publication and was often pitted against **Torquato Tasso**'s *Gerusalemme liberata* in debates related to the multiple, simultaneous scenes of epic poetry versus the use of only one dominant theme. *Orlando Furioso* became a source for painting, as **Dosso Dossi**'s *Melissa* (1520s), **Giovanni Lanfranco**'s *Norandino and Lucina Overcome by the Ogre* (c. 1624; both **Rome**, Galleria **Borghese**), and **Peter Paul Rubens**' *Angelica and the Hermit* (1626–1628; Vienna, Kunsthistorisches Museum) testify.

ORLEY, BERNARD VAN (1491/1492–1542). The leading painter in Brussels in the first half of the 15th century; influenced by the Northern **Mannerists**, particularly **Jan Gossart**. In 1515, van Orley was commissioned by Philip the Handsome to paint six portraits of his children to be given to the king of Denmark. This led to his appointment as court painter to **Margaret of Austria** in 1518 and, when Margaret died in 1530, van Orley worked as court painter to her successor as regent of the Netherlands, Mary of Hungary. From 1517, van Orley supervised the execution of tapestries made after **Raphael**'s cartoons, and with this he was exposed firsthand to the Italian manner. His *Job Altarpiece* (1521; Brussels, Musées Royaux des Beaux-Arts) is a Mannerist **triptych** painted for Margaret. The central panel shows the *Destruction of the Children of Job*, a violent scene contained in an Italianate architectural setting. His *Last Judgment* *Altarpiece* (1525; Antwerp, Musée Royal des Beaux-Arts) shows Italianate nudes in unusual poses, typical of the Mannerist style. Above is a domelike rendition of heaven, where Christ sits at the apex, recalling the semicircular sky in Raphael's *Disputà* in the **Stanza della Segnatura** (1510–1511) at the Vatican. On the side wings, van Orley depicted the **Seven Acts of Mercy** to elucidate the Christian belief that charitable acts can lead to salvation. Van Orley was also an accomplished portraitist. His portraits *Doctor Joris van Zelle* (1519; Brussels, Musées Royaux des Beaux-Arts), of a physician working in Brussels, and *Charles V* (1521; Budapest, Szepmuveszeti Muzeum) present two monumentalized figures placed in a confined setting. Along with Gossart, **Joos van Cleve**, and **Jan van Scorel**, van Orley was responsible for introducing to the Low Countries the latest Italian art developments.

ORSANMICHELE, FLORENCE. Orsanmichele is a church in **Florence** that also functioned as the wheat exchange and granary. The design of the building is normally given to Francesco Talenti, Neri di Fioravante, and Benci di Cione. It was originally conceived in 1337 as an open **loggia** built around a tabernacle containing an image of the **Virgin** and Child that had effected miracles. This structure was erected on the site of the city's grain market. The upper stories were added after 1348 to be used as a granary when famine resulting from the **Black Death** affected the city. Located in the heart of Florence

and used by the local **guilds** as their church, Orsanmichele became one of the pivotal centers of the city's civic and religious fabric.

In its present form, the building is a typical blocklike Italian Gothic structure reflective of its civic function, the grain chutes still in situ. It is in the interior that Orsanmichele takes on an ecclesiastic form, its four-partite **vaults** supported by heavy piers, its windows ornamented with Gothic **tracery**, and its wall surfaces covered with **frescoes** (by Giovanni del Biondo, Niccolò di Pietro Gerini, and others). **Andrea Orcagna**'s massive tabernacle with reliefs depicting the life of the Virgin (1359) is the church's centerpiece. It encloses a painted panel by **Bernardo Daddi**, his *Enthroned Virgin and Child*, that replaced the lost miraculous image around which the church was originally built. To fill the 14 Gothic niches that surround the exterior, a decorative campaign was initiated in 1411. Each niche was assigned to one of the local guilds, each expected to pay for a statue of its patron saint. The most important sculptors of Florence were involved in the commission, including **Lorenzo Ghiberti** who executed the *St. John the Baptist* (c. 1412–1416) for the Arte della Calimala (the Guild of Refiners of Imported Woolen Cloth), **Donatello** who executed the *St. Mark* (1411–1413) for the Arte dei Linaiuoli e Rigattieri (the Guild of Linen Drapers and Peddlers) and the *St. George* (1415–1417) for the Arte dei Corazzai e Spadai (the Guild of Armorers and Swordmakers), and Nanni di Banco who contributed the *Quattro Coronati* (c. 1411–1413) for the Arte dei Maestri di Pietra e Legname (Guild of Stone and Woodcutters).

OSPEDALE DEGLI INNOCENTI, FLORENCE (1419–1424). Designed by **Filippo Brunelleschi**, the Ospedale degli Innocenti was a foundling hospital financed by the architect's own **Guild** of Silk Merchants and Goldsmiths. Only the outside **loggia** faithfully follows Brunelleschi's design, as the rest of the structure was completed by his pupils. The loggia consists of a series of round arches supported by Corinthian columns, each containing a small **dome**. Along the hospital's walls, corbels lend further support while heavy pilasters at either end of the loggia provide a sense of completion. On the spandrels (the triangular spaces between the arches) are roundels filled with glazed terracotta **reliefs**, a common Brunelleschian feature. The second story includes **pedimented** windows, each centered above its

corresponding arch below. Brunelleschi's design called for pilasters between the windows, yet these were omitted by his pupils. The Ospedale degli Innocenti shows the impact of ancient Roman architecture on Brunelleschi. Not only is the vocabulary he utilized **classic** but so are the principles of construction he applied to the commission. The emphasis on rationality, balance, symmetry, and rhythmic repetitions all derive from his careful study of ancient prototypes.

OVID (PUBLIUS OVIDIUS NASO; 43 BCE–17/18 CE). Roman mythographer whose writings became major sources of inspiration to artists and patrons. His greatest masterpiece is the *Metamorphoses*, an account of the cosmos from its formation until Ovid's day that includes myths in which figures are metamorphosized in one form or another. His *Ars Amatoria* offers advice on the art of love, while his *Fasti* relates the Roman festivals in a mythological context. Popular in his lifetime, Ovid was highly praised by Emperor Augustus, yet in 8 CE, Augustus banished Ovid for unknown causes, and the poet ended his days in the port of Tomis on the Black Sea, now part of Romania.

– P –

PACHECO, FRANCISCO (1564–1644). Spanish painter, best known for his theoretical treatise, the *Arte de la Pintura*, published in 1649, key work for understanding the history of Spanish painting. It includes information on the proper depiction of religious subjects, discussion on technique, and, more importantly, biographical information on the Spanish painters of the era. Pacheco's studio in Seville became a center of culture where artists and intellectuals met to discuss learned topics. In this environment, **Diego Velázquez**, who trained with Pacheco and eventually married his teacher's daughter, spent his formative years.

PACHER, MICHAEL (c. 1435–1498). Austrian painter and sculptor who commingled Italian and Northern elements in his art, creating a new idiom of expression. He was from the Tyrol region, and was probably born in Neutstift, near Bressanone, Italy, hence the Italianate

elements in his works. A trip to Padua and **Venice** exposed Pacher to the art of **Andrea Mantegna**, from which he developed an interest in architectural forms viewed from below and figures pushed close to the foreground. In 1467, Pacher is documented as a citizen of Bruneck where he established a workshop. His best-known work is the ***Altarpiece of St.*** *Wolfgang* (1471–1481; Sankt-Wolfgang, Parish Church), which presents the carved ***Coronation of the Virgin*** as the central scene. Two sets of painted wings depict Sts. **George** and Florian in armor and narratives from the lives of St. Wolfgang and Christ. The altarpiece is crowned with elaborately carved Gothic **pinnacles** and a **crucifix** in the center, at its base a *predella*. The work constitutes one of the most impressive carved altarpieces of the 15th century.

PALAEOLOGAN STYLE. A mode of painting embraced by artists active in the Byzantine Empire during the Palaeologan Dynasty (1261–1453). Characterized by the realistic depiction of figures and draperies combined with deep expressions of emotion, this style seems to have influenced the art of **Pietro Cavallini**, from the Roman School, whose **apostles** at Santa **Cecilia** in Trastevere (c. 1290) closely resemble the figures of the Palaeologan **frescoes** in the Church of the Trinity at Sopočani in Serbia, painted for King Stefan Uroš in 1263–1268 by Greek masters. Palaeologan icons were available in Italy, yet it is possible that Cavallini may have visited Sopočani as exchanges between East and West were not uncommon. King Stefan's wife, in fact, was French, and his mother the **Venetian** granddaughter of **Doge** Enrico Dandolo.

PALAZZO DEL TÈ, MANTUA (1527–1534). The Palazzo del Tè in Mantua is a suburban villa on the Tè island built by **Giulio Romano** to be used by Duke **Federigo Gonzaga** and his family for recreation purposes and also as stables for Federigo's horse-breeding ventures. The work is a masterpiece of the **Mannerist** style. The main façade is composed of a long block with three equal arches in the center and four window bays at either side. A Doric frieze is carried by pilasters and the walls are **rusticated**. The various architectural elements, which High Renaissance masters such as **Donato Bramante** and **Antonio da Sangallo the Younger** would have kept separate, are here deliberately combined so that the keystones above the windows dis-

rupt the stringcourses. Giulio also rejected the order, symmetry, and balance of the High Renaissance, instead including asymmetrical spacings between the pilasters. The rustication on the walls is rather flat when compared to the aggressive rustications on the windows and arches. The rustication in the courtyard is more pronounced. Here, blind windows are capped by massive **pediments** and the keystone above the doorway is also large and breaks the pediment above in an anti**classical** manner. A Doric frieze that drops every so often is carried along the length of the structure and supported by engaged columns. Surprisingly, the garden façade is more subdued, without the heavy rustications and anticlassical elements of the main façade and courtyard. Instead, a soft rhythmic quality is established by the repetition of arches.

Giulio was also responsible for the **frescoed** decorations. In the Sala dei Cavalli (Room of the Horses) he portrayed Federigo's favorite horses on the walls overseen by the gods on Mount Olympus painted on the **vault** above them (1530–1532). In preparation for **Charles V**'s visit to Mantua, Giulio also frescoed in the Sala dei Giganti (Room of the Giants) the *Fall of the Giants* (1530–1532), a tour de force of illusionism as the image seems to collapse around the viewer. Like the architecture, the frescoes offer visitors moments of agitation alternating with serene pauses. For this reason, Giulio's commission has been read as an attempt to translate music, with its crescendos and varying rhythms, into visual form.

PALAZZO FARNESE, ROME (c. 1513–c. 1589). Commissioned from **Antonio da Sangallo the Younger** by Cardinal Alessandro **Farnese** who in 1534 was elected to the papal throne as **Paul III**. After his election, the pope asked Sangallo to modify the original design to create a more imposing structure that reflected his newly acquired position of power. As a result, the palace is the largest and among the most magnificent examples of Renaissance domestic structures. Sangallo designed a freestanding block built around a central courtyard with a **loggia** that affords a view of the Tiber River. Only the corners of the façade and its main entrance are **rusticated**, granting little texture to the building. The three stories are emphatically separated by entablatures and the windows of the lower story are capped by lintels supported by brackets. Those on the upper

stories are framed by columns and capped by **pediments** that alternate at the second level. The entrance vestibule, one of the most interesting features of the building, was designed *all' antica* as a barrel-vaulted tunnel with a **coffered** ceiling supported by granite columns. The space was inspired by the Theater of Marcellus in **Rome** and the Colosseum, as was the courtyard, which features superimposed arches that follow the **Colosseum principle**. When Sangallo died, the pope charged **Michelangelo** with the completion of the project. Michelangelo had already won the competition for the palace's heavy cornice, initiated by Paul III while Sangallo was still living. Not only was the cornice designed by Michelangelo but so was the central window of the façade, which is more recessed than the other windows and is crowned by the Farnese coat-of-arms. The third story in the courtyard is also Michelangelo's. After Michelangelo's death, his pupil Giacomo della Porta is the one who finally brought the palace to completion. In the interior, the Palazzo Farnese boasts **frescoes** by the **Carracci**, with the **Farnese ceiling** (c. 1597–1600) as its crowning jewel.

PALAZZO MEDICI-RICCARDI, FLORENCE (beg. 1436). The most important commission **Michelozzo** received from **Cosimo de' Medici** was to build for him a family palace to be used as his principal residence in **Florence**. Cosimo was exiled in 1433 and returned to Florence in the following year, becoming the city's ruler for the next three decades. He was careful to hide any outward manifestations of his position of power and this is reflected in the simplicity of the design chosen for the Palazzo **Medici**. **Giorgio Vasari** wrote that Cosimo first asked **Filippo Brunelleschi** to provide a design, but he rejected it for being too intricate, remarking that envy is a plant that should not be nurtured. Brunelleschi destroyed the model he made and the commission instead went to his follower, Michelozzo.

The building is three stories high, with an arcade in the lower level that was originally open but filled in the 16th century when the Riccardi purchased and extended the palace. The upper story is capped by a heavy cornice, giving the structure a sense of completion. The **rustications** on the façade, which diminish as the structure ascends, add a rugged appearance and grant the impression of a taller building. Michelozzo added a courtyard in the middle of the

structure, based on Brunelleschi's façade of the **Ospedale degli Innocenti** (1419–1424). Here, round arches supported by Corinthian columns carry an entablature. Above, windows are strategically lined with the arches below. Unlike Brunelleschi's design, however, Michelozzo's placement of the corner windows is somewhat awkward as they are too close to one another, breaking the harmony of the design. There is also a lack of definition at the corners of the arcade, a problem that could have been solved had Michelozzo added heavy pilasters similar to those used by Brunelleschi at the ends of the **loggia** in his Ospedale degli Innocenti. In spite of these problems, Michelozzo's design became the prototype for Florentine palace design for the rest of the century.

PALAZZO PUBBLICO, SIENA (beg. 1298). The Palazzo Pubblico was built to function as Siena's city hall. A fortified structure with a belvedere in the center, a massive tower, and crenellations, the structure bends slightly to accommodate the Piazza del Campo in front. Like the **Palazzo Vecchio** (1299–1310) in **Florence**, the Palazzo Pubblico housed the *priori*, members of the city's highest governing body. These individuals lived and worked in the Palazzo and were subject to physical attacks from a sometimes discontented Sienese population. Therefore, it was important to build a structure that gave these men protection, hence the fortified design. To further express visually this idea that the building safeguarded the governing body, the lower story is built in stone while the upper levels are in brick. Lined with the tower is the palazzo's chapel that juts into the piazza as if to denote the interconnections that then existed between religion and politics.

The Palazzo Pubblico's interior boasts a number of notable **frescoes**. In the Council Chamber is the *Maestà* by **Simone Martini** (1311–1317; partially repainted in 1321). Here, the **Virgin** is flanked by the city's patron saints who implore her to show goodwill toward Siena. The canopy above the figures includes the Sienese coat of arms and an inscription that reads, "The Virgin protects Siena which she has long marked for favor." At the base of the fresco a second inscription asks the men who convened in this room to please the Virgin by engaging in wise rulership. In the Sala della Pace (Room of Peace), where the members of the Great Council met, **Ambrogio**

Lorenzetti painted one of the most ambitious fresco decorations of the 14th century, the *Allegory of **Good and Bad Government*** (1338–1339), which expounds the principles of good government through wisdom and justice and the consequences of poor judgments. The Sala del Mappamondo (Room of the Maps) features a monochromatic fresco by Lippo Vanni that documents the victory of the Sienese troops against British mercenaries at the Val de Chiana (c. 1363), while Taddeo di Bartolo's scenes from the life of the Virgin, patroness of Siena, grace the walls of the building's chapel (1406–1407). To Taddeo di Bartolo also belong the scenes in the antechapel (1412–1414) of ancient Roman personages, such as Cato and Scipio Africanus, that communicate civic concepts of justice and magnanimity. Finally, the Sala dei Priori was frescoed by Spinello Aretino (1407) with scenes from the life of Sienese Pope Alexander III to indicate that Siena honors its citizens who achieve distinction.

PALAZZO VECCHIO, FLORENCE (PALAZZO DELLA SIGNO-RIA; 1299–1310). The architectural design of the Palazzo Vecchio in **Florence**, built to house the city's government body, the *priori*, has been attributed to **Arnolfo di Cambio**. The building was conceived as a fortified structure from which protrudes a crenellated tower. The main block is composed of three stories that diminish in height as they ascend, the two upper levels pierced by French Gothic windows with **tracery**. The block is capped by a crenellated arcade supported by corbels. To further emphasize the protective appearance of the structure, the architect **rusticated** the façade, a feature normally used in military architecture that consists of applying rough-cut stones to the exterior surfaces. The structure was built at a time when **Guelf and Ghibelline** rivalries in Florence had peaked. The Guelfs, composed of the merchant class, wrested power from the aristocratic Ghibellines, destroyed the palace of the Ghibelline Uberti family, and erected the Palazzo Vecchio on its site. They placed the Palazzo's tower off center, building it on the base of a former Ghibelline tower to denote symbolically their political triumph. That the building looks impenetrable was meant to reflect the strength of the Florentine Republic as a city capable of governing itself and maintaining order. *See also STUDIOLO* OF FRANCESCO I DE' MEDICI, PALAZZO VECCHIO, FLORENCE.

PALEOTTI, ARCHBISHOP GABRIELE (1522–1597). A key player in the **Council of Trent**, Gabriele Paleotti kept a diary during the council meetings, one of the great historic documents of the period. In 1565, he was granted the cardinalate and, in 1567, he was appointed archbishop of **Bologna**. In that capacity, he immediately set out to introduce the reforms enacted by the Council of Trent to his archdiocese, including the proper representation of religious subjects in art. His treatise, the *Discorso intorno alle imagini sacre e profane* (1582), became the catalyst for the Bolognese art reform. It criticized the ambiguities of **Mannerist** paintings and called instead for clarity of representation and works that appealed to the emotions of the faithful. The first to fulfill Paleotti's demands were the **Carracci** who, by following the archbishop's prescriptions, ushered in the **classicist Baroque** mode of painting.

PALLADIO, ANDREA (ANDREA DI PIETRO DELLA GONDOLA; 1508–1580). Architect and theorist from Vincenza who trained in Padua as a stonemason and was active in **Venice** and its outlying areas. The name *Palladio* derives from Pallas Athena (**Minerva**), goddess of wisdom, bestowed on him by his protector and earliest patron, the humanist and amateur architect Giangiorgio Trissino. Trissino took Palladio to **Rome** in 1541 so he could study the ancient remains and the works of the moderns. The work that established Palladio's reputation is the Basilica of Vincenza (beg. 1549), a commission he received after **Giulio Romano**'s design was rejected by the town council. Palladio's design for this structure borrows heavily from **Jacopo Sansovino's Library of St. Mark** in Venice (1537–1580s), particularly in the repetition of arches and the play of voids and solids that grant the structure a rhythmic quality. After this, Palladio became the favored architect of the aristocracy in Vincenza. Among the palaces he built for them are the *Palazzo Thiene* (beg. c. 1542), the *Palazzo Valmarana* (beg. 1565), and the *Villa Rotonda* (c. 1566–1570), this last among his greatest masterpieces. Built as a pleasure home for the wealthy patrician Paolo Almerico, the building features four **classical** porticoes situated on the cardinal points and a **dome** inspired by that of the Pantheon in Rome. The numerical proportions of the building's plan are based on ancient Greek musical

ratios, embracing a concept that had existed since antiquity that the same numerical relations that are pleasing to the ear can also be pleasing to the eye. Palladio's *Teatro Olimpico* (1580–1584), also in Vincenza, was an attempt to reconstruct an ancient Roman theater **Vitruvius** described in his architectural treatise. In Venice, Palladio built two major churches, *San Giorgio Maggiore* (beg. 1566) and *Il Redentore* (beg. 1577). Both present two interlocking temple façades to compensate for the different heights of the interior **nave** and aisles. Palladio's *Quattro Libri*, a treatise on architecture, caused wide diffusion of his works, particularly in England where **Inigo Jones** introduced the Palladian vocabulary, thereby initiating a new movement that was to last well into the 18th century.

PALOMINO, ANTONIO (1653–1726). Spanish painter from Bujalance, near Cordoba, best known for his *Museo pictórico y escala óptica* (1715–1724), a treatise on painting invaluable for its biographical material that has earned him the sobriquet *The Spanish Vasari*. In Cordoba, Palomino studied law, theology, and philosophy. He also took painting lessons from Juan de Valdés Leal, who figures in his treatise. In 1688, he became court painter to King Charles II of Spain and, in 1725, after his wife's death, he entered the priesthood, dying in the following year. The first and second volumes of his *Museo pictórico* expound his theory of painting and provide material on the processes involved in creating art. These two were of little impact, yet the third volume, subtitled *El Parnaso español pintoresco laureado*, today serves as one of the major biographical sources for the Spanish artists of the **Baroque** era.

PAOLO, GIOVANNI DI (active c. 1425–1483). One of the leading masters of the Sienese School of the 15th century; however, the details of his life are scarce. He may have studied with the local master Taddeo di Bartolo, though his works show the influence of **Gentile da Fabriano** who is known to have worked in Siena in c. 1425. Giovanni's *St. Catherine of Siena before the Pope* (c. 1460; Madrid, Thyssen-Bornemisza Collection) betrays his fealty to the Sienese tradition. The gilded background, brilliant colors, and courtly figures in this work are all typical of the Sienese style of painting. Giovanni's *Creation and Expulsion from Paradise* (c. 1445; New York, Metro-

politan Museum) is part of the *predella* to an **altarpiece** he rendered for the Church of San Domenico, Siena. It includes an unusual depiction of God the Father suspended in midair while creating the Earth. The world he has formed is surrounded by concentric circles meant to denote the elements, planets, and zodiac belt. Giovanni's *Madonna of Humility* (c. 1435; Siena, Pinacoteca Nazionale) presents the **Virgin** sitting on the ground amidst flowers, behind her a panoramic view of the landscape. She holds the Christ Child in a loving gesture, her facial expression denoting the sadness she feels over her son's future sacrifice. Giovanni was to use this Madonna type again in his *Virgin and Child in a Landscape* (1460s; Boston, Museum of Fine Arts) where Mary sits on a cushion. The substantial number of scenes by Giovanni to have survived—most *predella* panels now scattered in museums around the world—speak of the fruitful career the artist enjoyed.

PARMIGIANINO (FRANCESCO MAZZOLA; 1503–1540). Mannerist painter from Parma, where he had the opportunity to study the works of **Correggio**. In 1524 Parmigianino traveled to **Rome**, where he remained until 1527 when the city was **sacked**. From there, he fled to **Bologna** and by 1531 he was back in his hometown. His famed *Self-Portrait in a Convex Mirror* (Vienna, Kunsthistorisches Museum) he painted in 1524 prior to his visit to Rome. The work is rendered on a convex wooden panel and mimics the distortions one would see in an image reflected in a convex mirror, recalling the optical experiments of **Jan van Eyck** and **Petrus Christus**. Parmigianino's *Madonna with the Long Neck* (1534–1540; **Florence**, **Uffizi**) he created for the Church of Santa Maria dei Servi in Parma. It shows his exposure to the works of **Michelangelo** and **Raphael** in Rome as the figures possess the same monumentality as those rendered by these masters. The Christ Child, asleep on his mother's lap, in fact depends on Michelangelo's Christ in his Vatican *Pietà* (1498/1499–1500) and the position of Mary's left foot is taken directly from Michelangelo's Libyan Sibyl on the **Sistine ceiling**, Vatican (1508–1512). The influence of **Leonardo da Vinci** is also felt in this work, particularly in the use of **sfumato**, though perhaps Parmigianino adopted this technique from studying the art of Correggio. The disparate proportions and ambiguities, including columns that lead to

nowhere and angels who share one leg, mark this work as decidedly Mannerist. In 1535, Parmigianino painted *Cupid Carving His Bow* (Vienna, Kunsthistorisches Museum), a sensuous mythological work so admired by **Peter Paul Rubens** that he copied it. Parmigianino's *Pallas Athena* (c. 1539, Windsor Collection) is an example of his late phase. A bust portrait of the goddess of wisdom (**Minerva**), it shows her wearing an armor adorned with a cameo that depicts in **grisaille** a winged Victory with palm and olive branch in hand flying over the city of Athens, which she won in a contest with Poseidon (**Neptune**).

Parmigianino is known for his graceful forms and complex iconographic programs that in some ways reflect his own complex personality. Upon his return to Parma, he received a commission to render **frescoes** in the Church of Santa Maria della Steccata. But instead of fulfilling the commission, he spent most of his time engaged in alchemy. Having breached his contract, he was imprisoned for almost a decade until he escaped. He died at 37, yet in spite of his short career, he became the most influential painter of the Mannerist movement.

PASSION OF CHRIST. The Passion refers to the suffering of Christ during the last days of his life, culminating in his **Crucifixion** and burial. It begins with his entry into Jerusalem and continues with the **Last Supper**, **Agony in the Garden**, **betrayal of Judas** and Christ's arrest, his trial before Caiaphas, his sentencing by Pontius Pilate, his **Flagellation** and mocking, the **road to Calvary**, Crucifixion, **Deposition**, and **Entombment**. These events are commemorated by Christians throughout the world during Holy Week, with Easter marking Christ's **Resurrection**. As the basic tenet of Christianity, the scenes from the Passion are among the most often depicted in art as a way to translate visually the narratives from the Gospels to instruct the faithful.

PATINIR, JOACHIM (c. 1480–1524). Flemish painter, the first in history to have specialized in landscapes. Patinir was from Bouvignes and by 1515 he was an independent master enrolled in the painter's **guild** of Antwerp. Nothing is known of his training, though it has been suggested that he apprenticed either with **Gerard David** or **Hieronymus Bosch**. **Albrecht Dürer** mentioned in his journal that he

traveled with Patinir to the Netherlands in 1521 and commented on the artist's abilities as a landscapist.

Patinir's *Baptism of Christ* (c. 1515–1520; Vienna, Kunsthistorisches Museum) is a signed work. It presents a panoramic landscape with rock formations in the middle ground that serve to enframe the central scene. On the left, in the distance is **St. John the Baptist** preaching, this episode and the baptism of Christ united through the repetition of colors. Patinir's *Passage to the Infernal Regions* (c. 1520–1524; Madrid, Prado) presents a Bosch-like representation of hell with Charon, a character from **Dante**'s *Inferno*, transporting a soul to the underworld that is guarded by Cerberus, the three-headed dog. On the river's left bank, angels escort other souls who await their fate, the **atmospheric** and light effects on the sky and water surface lending particular visual interest to the work. His *Rest on the Flight into Egypt* (c. 1520–1524; Madrid, Prado) shows the Madonna nursing. On the right, peasants cut the wheat that, according to the **Apocrypha**, the Christ Child caused to grow to prevent his capture and premature death. On a rock sits a sphere upon which sculpture fragments rest as another apocryphal reference, in this case that of the fall of idols as Christ and his family traveled to Egypt.

Patinir's panoramic landscape constructions, composed of earth tones for the foreground, greens for the middle ground, and blues for the background, united by transitional hues and broad lighting and charged with atmospheric effects, were widely copied. This has caused an unfortunate overattribution to Patinir of any work that utilizes this formula, complicating the reconstruction of the master's career. Clear is the fact that Patinir was the first to give predominance to nature and to relegate the figures to a subordinate position, and the first to emphasize the sacredness of nature as God's creation, thereby enhancing the spiritual content of the religious scenes portrayed within it.

PAUL III (ALESSANDRO FARNESE; r. 1534–1549). Paul III was born in Canino in the province of Viterbo in 1468 and received a humanist education in **Rome, Florence**, and Pisa. He obtained the post of cardinal-deacon in 1493 from Pope **Alexander VI** whose mistress was Giulia **Farnese**, Paul III's sister. Paul himself had a mistress who bore him three sons and a daughter. Upon ascending the papal throne,

he set up a humanist court composed of artists, writers, and scholars. He also hosted masquerades and feasts, and in 1536 restored the practice of celebrating carnival. His appointment of his two teenage grandsons to the cardinalate in 1534 provoked protests within the curia. Nepotistic practices aside, Paul was a hard worker. He recognized the need to address the spread of Protestantism and to enact church reform. To this end he convoked a general council, revitalized the sacred college, and set up a commission to examine the state of the Church that became the basis for the work carried out by the **Council of Trent**. He also encouraged the reform of religious orders and the formation of new ones, including the Theatines and Ursulines. He was the one to approve the formation of the **Jesuit Order** and to establish the Congregation of the Roman Inquisition.

Paul was depicted on two occasions by **Titian**: in 1543 (Toledo, Cathedral Museum) and in 1546 with his grandsons Alessandro and Ottavio Farnese, Duke of Parma (Naples, Museo Nazionale di Capodimonte). Under Paul, **Michelangelo** painted the *Last Judgment* in the **Sistine Chapel** (1536–1541) and the **frescoes** in the Pauline Chapel at the Vatican (1542–1550), this last built by **Antonio da Sangallo the Younger** in 1537–1540. Sangallo also built for Paul the **Palazzo Farnese**, Rome (c. 1513–c. 1589) while still a cardinal, and Michelangelo built the **Piazza del Campidoglio** (1538–1564) and began the construction of New **St. Peter's** (1546).

PAUL V (CAMILLO BORGHESE; r. 1605–1621). Paul V was of Sienese origin. He studied law in Perugia and Padua and received the cardinalate in 1596 after a successful mission to Spain. In 1603, he was appointed vicar of **Rome** and inquisitor. As pope, Paul's outmoded views on papal supremacy led to collisions with Savoy, Genoa, **Venice**, and Naples. Venice imposed severe restrictions on the Church's acquisition of land and construction of new ecclesiastic buildings in its territory and brought two priests to trial to which the pope responded by excommunicating all of the Venetian senate and by placing the city under an interdict (suspension of public worship and withdrawal of the Church's sacraments). In return, Venice declared the interdict invalid and expelled the **Jesuits**. The issue was not settled until 1607 when France mediated between the papacy and Venice, though the Jesuits were not allowed to return and the whole

episode proved to be a major moral defeat for the pope. Paul's relations with England were also difficult. In 1605, he sent a letter to James I of England urging him to exonerate British Catholics from persecution resulting from the failed Gunpowder Plot carried out against the king and members of Parliament. When in the following year Parliament demanded from Catholics an oath denying the pope's right to depose princes, Paul forbade them to take it. This move caused the British Catholics to become divided as their archpriest, George Blackwell, urged them to ignore the pope's prohibition and swear as demanded by Parliament.

Paul was responsible for the canonization of St. Charles Borromeo and the beatification of Sts. **Ignatius of Loyola**, Philip Neri, **Theresa of Avila**, and Francis Xavier. He is also the one to have censured Galileo Galilei for teaching the heliocentric theory of the universe. Paul's pet art project was the Cappella Paolina in Santa Maria Maggiore where **Giovanni Baglione** and others were involved in its decoration (1611–1612). **Giovanni Lanfranco** worked for the pope in the Sala Reggia of the Palazzo Quirinale, Rome (c. 1616), and **Carlo Maderno** added the **transept** and façade to **St. Peter's** (1606–1612) under his patronage. It was Paul who, along with his nephew **Scipione Borghese**, acted as the protector of the young **Gian Lorenzo Bernini**, and the one to have pardoned **Caravaggio** for the murder charges levied against him.

PAUL, SAINT. Paul was born to Jewish parents who named him Saul and he was educated by the rabbi Gamaliel. As a native of Tarsus, now Turkey, he was considered a Roman citizen. He became a radical persecutor of Christians and, on his way to Damascus to arrest some of these faithful and to bring them back to Jerusalem for prosecution, he experienced a vision that caused his conversion to Christianity— a scene depicted dramatically by **Caravaggio** in the **Cerasi Chapel** (1600) at Santa Maria del Popolo, **Rome**. Rejected by his own people for converting, Paul spent three years in Arabia and then in Damascus where he preached. Back in Jerusalem, he met up with the **apostles** and was accepted into the Christian community. He set out to preach the Gospel in Cyprus, Perga, Antioch, and Lycaonia, and, during this journey, he changed his name from Saul to Paul. A second mission led him to Europe and he founded churches in Philippi, Thessalonica,

Beroea, and Corinth. After a third journey to evangelize the world, Paul was arrested in Jerusalem, tried, and beheaded in Rome on the same day as **St. Peter**'s crucifixion.

Since the martyrdoms of these two saints coincide, the two scenes are often paired in art, as the example of the Cerasi Chapel denotes. **Michelangelo** also paired them in the Pauline Chapel at the Vatican (1542–1550), while scenes from the lives of both saints are included in **Cimabue's frescoes** in the **transept** of the Upper Church of **San Francesco** in Assisi (after 1279). In 1515, **Leo X** commissioned **Raphael** to render cartoons for a series of 10 tapestries to be hung on the lower walls of the **Sistine Chapel**, Vatican, depicting the Acts of Sts. Peter and Paul (London, Victoria and Albert Museum). These include St. Paul preaching to the Athenians and the blinding of Elymas, a magus who prevented Proconsul Sergius Paulus from hearing the word of God from Paul, so the saint struck him with temporary blindness, effecting Sergius' immediate conversion to Christianity.

PAZZI CHAPEL, SANTA CROCE, FLORENCE (1433–1461). Filippo Brunelleschi received the commission to build the Pazzi Chapel from Andrea Pazzi, the **Medici**'s rival. It was to function as the chapter house for the convent attached to the Church of **Santa Croce, Florence**, as well as a place for the Pazzi to engage in private devotion. In 1433 part of Santa Croce's cloister was removed to make way for the new chapel. Some doubt whether the portico was built according to Brunelleschi's design, its Roman **triumphal arch** motif suitable for a religious structure as it speaks of the triumph of Christianity over paganism. The chapel's **central plan** is a more complex version of Brunelleschi's **Old Sacristy** at San Lorenzo (1421–1428). It consists of a central square capped by a **dome** and flanked at either side by rectangles that are half its width. A smaller square protrudes from the center to form the **apse**, a space that is also domed. This plan, completely based on geometric forms and a mathematical system of proportions, reflects Brunelleschi's rational approach to architecture. The domes are supported by **pendentives**, the largest pierced by a lantern and 12 oculi (rounded openings) that refer to the 12 **apostles** and the 12 gates of Jerusalem. When light enters the interior through these openings, it grants the illusion of a dome floating in midair as if supported by divine forces rather than actual architectural

elements. Brunelleschi stuccoed the walls in white and trimmed them with *pietra serena,* a local tan-colored stone. As added ornamentation, **Luca della Robbia** created terracotta **reliefs** of the **Evangelists** for the pendentives and of saints for the roundels below the entablature. Brunelleschi purposely picked della Robbia for the execution of the reliefs since he found him better suited to the task than **Donatello**, who had contributed the reliefs in the Old Sacristy and that, in Brunelleschi's view, were too busy and infringed upon his architectural design. Considered one of the architectural masterpieces of the Renaissance, the Pazzi Chapel rejects the ornamentations of the Gothic style, instead embracing the ancient principles of harmony, balance, and symmetry.

PAZZI CONSPIRACY (1478). A plot devised to rid **Florence** of the **Medici** for thwarting papal expansion. Pope **Sixtus IV** wished to acquire Imola for his nephew, Girolamo Riario. The Medici denied the financial backing needed for this purpose, so instead the pope obtained it from their rivals, the Pazzi. Further resentment between Sixtus and the Florentine rulers resulted when the pope appointed Cardinal Francesco Salviati, a staunch enemy of the Medici, archbishop of Pisa, resulting in **Lorenzo "the Magnificent" de' Medici**'s order that the cardinal be excluded from his see. In retaliation, Sixtus, the Salviati, and the Pazzi planned the murder of Lorenzo and his brother Giuliano in the **Cathedral of Florence** during the mass. This would take place at the moment when the priest raised the Eucharist in front of the congregation and then Girolamo Riario would be installed as the city's new ruler. On 26 April 1478, at the signal, Giuliano was stabbed multiple times and died. Lorenzo, who was also wounded, managed to escape. The conspirators were seized and executed. Jacopo Pazzi was tossed from a window, dragged naked through the streets of Florence, and thrown into the Arno River. His family's possessions were confiscated; Salviati was hung, and others who were involved were hunted down through Italy and murdered.

PEDIMENT. A common element of Greco-Roman architecture, a pediment is the triangular area on the façade of a temple formed by the slopes of its pitched roof. Greco-Roman pediments were usually filled with sculpture reliefs that illustrate the myths of the ancients.

In the Renaissance, the interest in the revival of **classical** antiquity resulted in the incorporation of the pediment into the architectural vocabulary of the period. Pediments were used not only on the façade of churches and other buildings but also to cap doors, windows, and niches. Rectilinear pediments many times alternated with segmented pediments, which are semicircular in form, to create a sense of rhythm and movement. Broken pediments became a common feature of **Mannerist** and **Baroque** architecture.

PENDENTIVE. Pendentives are the triangular curving segments that support a **dome** and transfer its weight to the pillars below. They were introduced by Byzantine architects who first used it on a large scale at Hagia Sophia in today's Istanbul. Its use allowed for more extensive unobstructed interior expanses as well as the enclosure of a square opening with a circular dome. Pendentives provide surfaces that can be decorated with either **mosaics**, **frescoes**, or sculpture **reliefs**. Examples of pendentive mosaics include the *Four Doctors of the Church* in the Gregorian Chapel at **St. Peter's** (1580s), executed by the **Mannerist** artist Girolamo Muziano. Pinturicchio frescoed the pendentives in the retro-choir of Santa Maria del Popolo, **Rome** (1508), with the same theme. Terracotta reliefs by **Donatello** in the pendentives of the **Old Sacristy**, San Lorenzo, **Florence** (1421–1428), and those by **Luca della Robbia** in the **Pazzi Chapel** (1433–1461) in the same city provide sculptural examples.

PENTECOST. Ten days after the **Ascension** of Christ, the **apostles** gathered for Shavout, a Jewish feast celebrated 50 days after Passover. Suddenly, they heard a noise and tongues of flame descended upon them. As each was filled by the Holy Spirit, they began to speak in foreign tongues. This gift allowed them to go into different parts of the world to preach the word of God. **El Greco** painted the scene in c. 1608–1610 (Madrid, Prado) with the **Virgin Mary** at the center and the Holy Dove descending upon her and the apostles, the tongues of flame already above their heads. The scene was depicted similarly by **Giotto** in the Arena Chapel, Padua (1305), **Duccio** in the *Maestà Altarpiece* (1308–1311; Siena, Museo dell' Opera del Duomo), **Andrea da Firenze** on the vault of the **Guidalotti Chapel** at **Santa Maria Novella**, **Florence** (1348–

1355), and **Juan de Flandes** on a panel at the Madrid Prado (1514–1518) that originally formed part of the **retable** of the Church of St. Lazarus in Palencia, Spain.

PENTIMENTI. Strokes of paint added by an artist to correct or modify the various elements of a composition. *Pentimenti* are invaluable for the art historian in that they reveal the act of creation. These can be observed with the naked eye as the surface layers of paint begin to fade, or through x-rays. A painting where the *pentimenti* provide a wealth of information is **Caravaggio**'s *Martyrdom of St. Matthew* in the **Contarelli Chapel, Rome** (1599–1600, 1602). Caravaggio painted *alla prima*, a method that results in many *pentimenti* as the artist who uses it works out the composition directly on the panel or canvas. The *pentimenti* in Caravaggio's work, seen through x-rays, reveal his lack of confidence in tackling the complex composition. The contract for this work called for a scene in a church interior with steps leading up to it and many figures. The x-rays show that the figures were originally smaller and that many modifications were also made to the overall arrangement of the interior space.

PERSPECTIVE. *See* ATMOSPHERIC PERSPECTIVE; ONE-POINT LINEAR PERSPECTIVE.

PERUGINO, PIETRO (PIETRO VANNUCCI; c. 1445–1523). Italian painter credited with bringing Perugia out of artistic obscurity; the teacher of **Raphael**. The details of Perugino's training are unknown, though it possibly took place in **Florence**, as indicated by the fact that in 1472 he was listed as a member of the Florentine Company of **St. Luke**, a fraternity of painters. In 1475, he is documented back in Perugia and in 1481 he had acquired enough of a reputation to have been called by Pope **Sixtus IV** to **Rome** to work on the wall **frescoes** in the **Sistine Chapel**. Art historians believe that Perugino may have been put in charge of directing the commission. Of the scenes he contributed, his *Christ Giving the Keys of the Kingdom of Heaven to St. Peter* (1482) represents one of the most successful frescoes in the chapel. He also contributed an *Assumption of the Virgin*, destroyed when **Michelangelo** created his *Last Judgment* (1536–1541) on the altar wall. The first shows the moment when Christ

commands St. Peter to establish the first Christian church in Rome and the papacy, visually verbalizing the concept of the pope's God-given right to rule since Peter received the appointment directly from Christ. The second, known through a drawing in the Albertina in Vienna by one of Perugino's assistants, showed Sixtus IV kneeling in front of the **Virgin**, his papal tiara prominently displayed at his side. Also at his side, St. Peter presented him to the Virgin, his keys touching the pontiff on the shoulder to again assert the divine nature of the papal office.

Perugino rendered his ***Crucifixion*** (1481; Washington, National Gallery) a year earlier, a work that bears the influence of Early Netherlandish art and, in particular, that of **Hans Memlinc**. The pale, delicate figure types, the undulating drapery worn by Christ, and the emphasis on every minute detail emulate Memlinc's style. The scene is calm, with figures passively witnessing the event—an image that invites contemplation. One of the characteristics of Perugino's art is his use of stock figures in an exaggerated sway that he repeated over and over. His **Mary Magdalen** in this painting echoes the pose of **St. John** down to the last detail. Also characteristic of Perugino is the plunging landscape in the center background. All of these elements also form part of his *Pazzi Crucifixion* (1494–1496) in the Church of Santa Maria Maddalena dei Pazzi, Florence, except that here Perugino included three **classical** arches to separate the witnessing saints from the crucified Christ and mourning Virgin. Perugino also turned to Memlinc for inspiration when engaging in portraiture. His portrait *Francesco delle Opere* (1494; Florence, **Uffizi**), of a Florentine craftsman, utilizes a formula often found in the Northern master's art that includes an unidealized half figure with face and hands emphasized, one hand resting on a parapet, and the other holding an object—here a scroll with the Latin motto *Timete Deum* (*Fear God*).

Among Perugino's late works are the *Virgin Adoring the Child with St. Michael and Tobias and the Angel* (c. 1499; London, National Gallery) commissioned for the Certosa di Pavia, the *Virgin and Child* at the Washington National Gallery (1501), and the ***Marriage of the Virgin*** (1500–1504; Caen, Musée des Beaux-Arts) for the Cathedral of Perugia where Mary's wedding ring is housed. In this late phase, Perugino's figures adopt a dreamy quality, achieved by softening the contours and rounding and shading the eyes with earth

tones. His style in these works so influenced his pupil Raphael that it is sometimes difficult to tell their works apart. In fact, Raphael might not have achieved the visual beauty of his figures and backdrops had it not been for the lessons he learned from Perugino.

PERUZZI CHAPEL, SANTA CROCE, FLORENCE (1320s). The Peruzzi Chapel was owned by one of the leading **banking** families of **Florence**. Donato di Arnoldo Peruzzi left funds in his will for the construction and decoration of the family chapel at **Santa Croce** and his grand-nephew, Giovanni di Rinieri Peruzzi, commissioned **Giotto** in the 1320s to carry out the **fresco** decorations. Located next to the **Bardi Chapel** owned by the wealthiest family of Florence and also decorated by Giotto, the Peruzzi Chapel was conceived in direct competition with it. The scenes chosen by Giovanni were the lives of Sts. **John the Baptist** and **John the Evangelist**, his namesaints, with the Baptist also acting as the patron saint of the city of Florence. Among the scenes is the ascension of the **Evangelist** where a floating God the Father pulls the saint up to heaven while astonished individuals with hands clasped in prayer witness the event. The *Birth and Naming of the Baptist* shows St. Elizabeth attended by the midwives during labor, while in the next room the newborn is presented to his father, Zacharias, who busily writes the boy's name on a tablet. Both the Bardi and Peruzzi chapels were whitewashed during the 18th century and restored in the 19th century by incompetent individuals who overpainted the frescoes. Eventually, the excess layers of paint were removed and, unfortunately, the Peruzzi Chapel frescoes are now in deplorable condition. One of the main reasons for this is that Giotto, who by now was in high demand, used a *fresco secco* technique to render the scenes more rapidly.

PESARO ALTARPIECE **(1470s; Pesaro, Museo Civico).** Commissioned from **Giovanni Bellini** by Costanzo **Sforza**, Lord of Pesaro, for the local Church of San Francesco, the work depicts the **Coronation of the Virgin** with saints. The throne on which the **Virgin** and Christ sit is of the type rendered by **Andrea Mantegna**, Bellini's brother-in-law, reliant on a **classical** vocabulary. Bellini's includes **reliefs** and *cosmatesque* marble inlays with the figures silhouetted against a landscape seen through its back opening that features

Costanzo's fortress of Gradara, part of his dominion since 1463. With this, the coronation is situated not in heaven as is customary, but on Pesaro's lands to denote that the region is blessed with divine favor. This message is made more poignant by the bursting vision of the Holy Dove on the top center. Mantegna's influence is also felt in the solidity of the figures, the crisp rendition of draperies, the bright colors, and the diagonal positioning of the saints to enhance the sense of depth. These and the saints along the left and right sides of the frame are of significance to the church and its patron. Among them are **Francis**, chosen because the **altarpiece** was rendered for a **Franciscan** church, Terence, patron saint of Pesaro, **Paul**, and **George**. Narratives from the lives of these saints are included in the *predella*. So, for example, Terence is shown holding up a model of the fortress of Gradara, St. George slays the dragon, and St. Paul experiences the vision that caused his conversion. Originally, the altarpiece was surmounted by a *Pietá*, now in the Vatican Museum. The details of the commission are not well known, though clearly the work was meant not only as religious celebration of Catholic doctrines but also as glorification of Costanzo Sforza's rulership.

PETER, SAINT. Introduced by his brother Andrew to Christ, Peter became one of the Lord's disciples. The calling of the two brothers to the apostolate was depicted by **Domenico del Ghirlandaio** in the **Sistine Chapel**, Vatican, in 1482. Peter is mentioned in the Gospels more than any other **apostle**. He was present at the **marriage at Cana** when Christ effected his first miracle—the turning of water into wine. Christ called him "the rock" upon which his church would be built, a statement used by the papacy to assert the divine sanction of their office, the scene depicted by **Pietro Perugino** in the Sistine Chapel (*Christ Giving the Keys of the Kingdom of Heaven to St. Peter*; 1482). He was present during the *Agony in the Garden*, as rendered by **Giovanni Bellini** (c. 1460; London, National Gallery). At Christ's arrest, he cut off Malchus' ear in anger, the scene presented by **Giotto** in his *Betrayal of Christ by Judas* in the **Arena Chapel**, Padua (1305). After Christ was arrested, three times Peter denied him but, after the **Crucifixion**, he was the first of the apostles to preach to the Gentiles, to effect conversions, and to perform miracles. He was imprisoned by Herod Agrippa, but an angel helped him escape

so he could continue preaching. **Raphael** included the *Liberation of St. Peter* in the decorations of the Stanza d'Eliodoro at the Vatican (1512–1514). Peter became the first bishop of **Rome** and was crucified there by Emperor Nero. His crucifixion is the subject of one of **Caravaggio**'s paintings in the **Cerasi Chapel**, Rome (1600). His remains are kept in the crypt of the Basilica of **St. Peter's**, directly under the altar, to assert papal succession from Peter.

PETRARCH (FRANCESCO PETRARCA; 1304–1374). Born in Arezzo, the Italian poet Petrarch was the son of an exiled **Florentine** notary. In 1311, his family moved to Provence, France, to benefit from the patronage of the papal court of **Avignon**. Petrarch remained there until 1353, though he traveled extensively during these years in Italy and France. He became one of the humanists at the papal court and spent his time studying the ancient texts, especially those written by Livy. It was in the Church of St. Claire in Avignon that he met his great love, Laura, the woman he celebrated in his *Canzionere*, written in the vernacular. In 1330, he took minor orders and came under the protection of the Colonna, among the most powerful feudal families of the era. At this time, Petrarch began to write. His biographies of famous Romans, *De viris illustribus*; his *Africa*, an account of the life of Scipio Africanus; and his *Rerum memorandarum libri*, on the cardinal **virtues**; all belong to this period in his life.

Petrarch recovered a number of ancient texts, including Cicero's *Pro Archia*, which he found in Liège in 1333, and his letters, which he obtained in Verona in 1345. His writings earned him a laurel crown from the pope, an honor he received on the Capitoline Hill in **Rome** in April 1341. This was a practice carried out by the ancients to honor their poets, and Petrarch was the first among modern poets to be granted that tribute. Among the works Petrarch composed in Rome is his *De vita solitaria* in which he sought to reconcile humanism with Christianity. In 1353, he went to work for the **Visconti** in Milan, but later moved to Padua, **Venice**, and Pavia. He died in Arquà where Francesco da Carrara, Lord of Padua, had given him some land.

Considered by many the father of the Renaissance, Petrarch was responsible for perfecting the Italian sonnet form, aptly called the Petrarchan sonnet. His belief in the value of studying the writings of the

ancients marked the course of Renaissance intellectual and philosophical thought, while the internal conflicts he expressed in his writings became the basis for humanist debate for the next 200 years.

PHILIP II OF SPAIN (1527–1598). The son of Holy Roman Emperor **Charles V** who appointed him ruler of Naples and Sicily in 1554, of the Netherlands in 1555, and of Milan and Spain in 1556. Upon Charles' death (1558), Philip also inherited the rulership of the Spanish colonies in the Americas. In 1567, he sent an army to squelch the Calvinist revolt in the Netherlands. The seven United Provinces of Holland, led by **William of Orange**, signed the Union of Utrecht in 1579 and declared their independence from Spain in 1581. In 1580, Sebastian I of Portugal died leaving no heirs to the throne. Philip seized the opportunity to lay claim to the Portuguese crown as he was the son of Isabella of Portugal. He met little resistance and as the new king he obtained Brazil and the Portuguese colonies in Africa and the West Indies, along with the riches these lands had to offer. In 1588, he sent the Spanish Armada to England, which he ruled briefly while married to Mary Tudor, a Catholic who sought to reinstate Catholicism in her kingdom. She died in 1558 before accomplishing her goal. Her Protestant sister, Queen Elizabeth, ascended the throne as her successor and Philip used the fact that the British had provided support to the Protestants in Holland during their revolt as an excuse to oust her from power. Heavy winds and large ships proved disastrous to the Spanish Armada as they tried to invade England in 1588. In 1590–1598, Philip also involved himself in the French wars of religion against the Huguenots (French Protestants). The French King **Henry IV**, a Protestant, ended the war when, in 1593 he converted to Catholicism and in 1598 he signed the Treaty of Nantes guaranteeing religious freedom to this group.

Philip was passionate about art and learning. In 1557, during the Battle of San Quentin against the French, he vowed that, if victory was achieved, he would build a monastery in honor of **St. Lawrence**. Having won, he commissioned the architect Juan Bautista de Toledo to build the Monastery of San Lorenzo in El **Escorial**, a structure continued by Juan de Herrera when Juan Bautista died in 1567. The decoration of the monastery occupied Philip for several years, with Bartolomé and **Vicente Carducho**, **Juan Fernández de Navarrete**,

Eugenio Cajés, and **El Greco** forming part of the group of artists involved in the task. **Juan Pantoja de la Cruz**, **Alfonso Sánchez Coello**, and **Anthonis Mor** were his official portraitists, and **Titian** also worked for him as he had done for Philip's father, Charles V.

PHILIP IV OF SPAIN (1605–1665). Philip IV was the son and heir of Philip III of Spain. He was a more capable ruler than his father but, like him, he relied on a minister to run the monarchy. The individual he chose was Gaspar de Guzmán y Pimentel, Count of Olivares, whom he had to dismiss in 1643 after several political and economic failures. Philip's priorities also matched those of his father: to uphold the Catholic faith against the threat of Protestantism, to assert Spanish control over the Dutch United Provinces, and to extend the **Hapsburg** dominion. However, these priorities could not be attained. In 1640, Portugal revolted against Spain, and Philip lost his position as their monarch. He had no choice but to recognize the independence of the Dutch Provinces in 1648 when the Peace of Westphalia was negotiated, and, in the following year, Spain lost Roussillon and part of the Spanish Netherlands to France in the Peace of the Pyrenees. While his realm declined politically and economically, artistically it experienced its golden age, mainly thanks to the presence of **Diego Velázquez** in his court. Also present at his court were **Peter Paul Rubens**, **Juan Bautista Maino**, and **Juan Martinez Montañéz**.

PHILIP THE BOLD, DUKE OF BURGUNDY (1342–1404). The son of King John II of France, Philip married Margaret, heiress of Flanders in 1369, a territory he inherited when his father-in-law, the Count of Flanders, died. Philip was made Duke of Touraine in 1360 and rewarded three years later with the Duchy of Burgundy for his participation in the Battle of Poitiers against England. Along with his brothers, **Jean**, **Duc de Berry**, and Louis I D'**Anjou**, he acted as regent to Charles VI of France. Philip moved his court to Dijon and embellished the city with works of art. One of his main focuses was the Chartreuse de Champmol, the Carthusian monastery he founded and where he established his mortuary chapel. There, **Claus Sluter** embellished the portals with sculptures (1385–1393), rendered his famed *Well of Moses* (1395–1406; Dijon, Musée Archéologique), and Philip's tomb (1390–1393). **Melchior Broederlam** painted his *Dijon*

Altarpiece (1394–1399; Dijon, Musée des Beaux-Arts) and **Jean Malouel** the *Pietà* (c. 1400; Paris, Louvre) and *Martyrdom of St. Denis* (fin. c. 1416; Paris, Louvre) for the same monastery. The **Limbourg brothers** also worked for the duke before entering in the service of Jean de Berry.

PIAZZA DEL CAMPIDOGLIO, ROME (1538–1564). The Campidoglio is the piazza on the Capitoline Hill in **Rome**. In the ancient era, this had been the seat of the Roman government, and Pope **Paul III** wanted to revive the site to function as the center of the new Rome of the popes. To this effect, he commissioned **Michelangelo** to design the piazza and refurbish two buildings already on the site, the Senators' and Conservators' palaces. These two structures formed an awkward 80° angle. Rather than feeling intimidated by the unusual layout, Michelangelo used the asymmetry to his advantage. He erected a third structure across from the Conservators' Palace, the Palazzo Nuovo, also placing it at 80° thus attaining a trapezoidal shape for the piazza. He then reworked the façades of the existing buildings to conform to the **classical** forms of the new structure. Within the trapezoid, Michelangelo added an oval design on the pavement that encloses a series of rhomboids. In the center of the oval, Paul III ordered Michelangelo to place the ancient equestrian statue of Emperor Marcus Aurelius, until then located near the Church of St. John Lateran and thought to represent Emperor Constantine the Great. Michelangelo designed a pedestal for the statue and complied with the pope's wishes. Constantine was the first Roman emperor to convert to Christianity and he therefore is symbolic of the triumph of the faith over paganism. Hence, such a figure was the proper choice for the piazza that was to become the new center of Christendom.

PIETÀ. A scene depicting the dead body of Christ supported by his mother, the **Virgin Mary**, or his followers. Among the earliest depictions of this sort from the Renaissance is **Giovanni da Milano**'s rendition of 1365 (**Florence**, Accademia), which shows the dead body of Christ supported by the Virgin and **St. John**. **Giovanni Bellini**'s *Pietà* (1460; Milan, Pinacoteca di Brera) shows the same three figures against a landscape, with Mary leaning her head on her

son's shoulder. The most famous *Pietà* is that by **Michelangelo** (1498/1499–1500; **Rome, St. Peter's**), where the Virgin spreads her left arm as if to present the Savior to the faithful. **Titian** rendered the *Pietà* (c. 1576; **Venice**, Galleria dell' Accademia) as a deeply emotional scene with the seated Virgin holding the dead body of Christ on her lap in the manner of Michelangelo, the distressed **St. Jerome** (his self-portrait) crawling toward the Savior, and **Mary Magdalen** in anguish running toward the viewer with right arm raised as if to proclaim his death. **Annibale Carracci** (1600; London, National Gallery) placed his figures in a pyramid of bodies leaning on each other to denote the extreme sense of sorrow felt by the mourners. *See also PIETÀ*, ST. PETER'S, ROME.

PIETÀ, ST. PETER'S, ROME (1498/1499–1500). Commissioned from **Michelangelo** by the French Cardinal Jean de Bilhères Lagraulas for his family chapel at **St. Peter's**. The contract stipulated that this was to be the most beautiful work in marble to exist in **Rome**, a stipulation Michelangelo may very well have achieved as his *Pietà* was greatly admired by his contemporaries and continues to serve as one of the prime examples of Renaissance sculpture. Michelangelo made a special trip to Carrara, well known for its white marble quarries, to find the perfect block for the execution of the work. He created a pyramidal composition with the dead Christ lying on his mother's lap, her crumpled drapery forming a backdrop for his corpse. She stretches her left arm as if revealing the Savior to the faithful. This motif stems from medieval German prototypes, usually heart-wrenching renditions that emphasize the brutality of the **Passion** and **Crucifixion**. Michelangelo instead created a restrained, quiet iconic image. **Giorgio Vasari** wrote in his *Lives* that a group of Lombards had thought that the work was carved by one of their compatriots. In the middle of the night, Michelangelo sneaked into St. Peter's and signed his name on the **Virgin**'s strap that runs across her chest to prevent any further confusion as to the authorship of the work. Originally meant for a niche, the sculpture is now encased in heavy glass and tucked in a dark corner of the basilica. The reason for this is that, in 1972, the work was attacked by a crazed individual who broke the Virgin's nose and some of her fingers. The work has since been restored.

PILON, GERMAIN (1525/1530–1590). French **Mannerist** artist who became the leading sculptor of France after **Jean Goujon**'s death. Most of the works executed by Pilon are funerary in nature. His *Tomb of Henry II and Catherine de' Medici* (1563–1570; St. Denis, Paris), the French monarchs, was executed under the direction of **Francesco Primaticcio**, a member of the Fontainebleau School. The seminude figures are shown as corpses, with the queen in a *Venus Pudica* pose, her hair sensually cascading over her shoulders. The king is presented with coarse features and greater details of anatomy than his consort. Pilon's *Lamentation* (c. 1580–1585; Paris, Louvre) was originally part of the decoration in the Chapel of René de Birague, chancellor of France, in the Church of Ste-Catherine du Val-des-Écoliers in Paris. The relief shows overstated curvilinear forms, complex drapery arrangements, and expressive poses and gestures, typical of Pilon's Mannerist style.

PINNACLE. In **altarpieces**, pinnacles are the ornamental tops that imitate the lacelike spires of Gothic structures. In sculpted altarpieces, such as **Michael Pacher**'s *Altarpiece of St. Wolfgang* (1471–1481; Sankt-Wolfgang, Parish Church), the pinnacles serve to extend the space of the main scene and place it within a Gothic church setting. In painted examples, the pinnacles can be filled with imagery, as in **Duccio**'s *Maestà Altarpiece* (1308–1311; Siena, Museo dell' Opera del Duomo), where scenes from the life of the **Virgin** are depicted, and **Piero della Francesca**'s *Misericordia Altarpiece* (beg. 1445; San Sepolcro, Museo Civico), where the Virgin **Annunciate**, the angel Gabriel, and saints are included.

PISANELLO, ANTONIO (bef. 1395–1455). The last of the Italian painters to work in the **International Style**, a mode he learned from his master, **Gentile da Fabriano**. Pisanello was born in Verona to a Pisan family. He was active in the courts of Milan, Ferrara, and Rimini, working primarily as a medallist. He achieved great fame during his lifetime, as attested by a number of poems written in his honor. His most famous work is the *St. George and the Princess* (c. 1437–1438), a **fresco** in the Pellegrini Chapel in the Church of Sant' Anastasia, Verona. Here St. George arrives to rescue the princess of Libya who has been offered as sacrifice to a dragon. The

scene is a courtly representation with elegant knights, horses, and even a castle in the background. Pisanello had a particular interest in the depiction of animals, denoted here by the different angles in which he presents the horses. His *Vision of St. Eustace* (c. 1440; London, National Gallery) also demonstrates his interest in this genre. The saint was converted to Christianity when, during a hunt, he saw the figure of the **crucified** Christ between the antlers of a stag. Pisanello's rendering shows the saint mounted on a horse experiencing the vision while surrounded by animals of prey and hunting dogs. Pisanello was also an accomplished portraitist. His *Portrait of Lionello d'Este* (1441; Bergamo, Accademia Carrara) and the *Portrait of a Princess from the d'Este House* (1436–1438; Paris, Louvre) show the sitters in profile in emulation of ancient Roman coinage to give a sense of permanence. The abundant patterning and emphasis on courtly elegance in these paintings are characteristic of Pisanello's art and the features that place him among the leading masters of the International Style.

PISANO, ANDREA (ANDREA DI PONTEDERA; c. 1290–1348).
Italian sculptor and architect from Pontedera on Pisan territory. Andrea, who is unrelated to **Nicola** and **Giovanni Pisano**, was the son of a notary named Ser Ugolino Nini. Nothing is known of his training or artistic activity before 1330 when he is documented working on the bronze doors for the **Baptistery of Florence**. In 1337, Andrea modified the upper part of the **Campanile** of the **Cathedral of Florence**, originally designed by **Giotto**, by adding niches to contain sculptures. He then executed four **prophets**, kings Solomon and **David**, and two **sibyls** for these niches. In the same year, he executed a series of rhomboid **reliefs** for the Campanile's base. These are arranged in two rows, the upper row depicting seven planets, seven **Virtues**, seven sacraments, and seven liberal arts. In the lower row are scenes from the Book of Genesis, the arts, the sciences, and the labors of man. They refer to the perfection of God's creation and human accomplishment. In 1340, Andrea continued the building of the Cathedral of Florence following the plans provided by **Arnolfo di Cambio**, who died in 1302, leaving the structure incomplete. Seven years later he was in Orvieto, working on the cathedral. He died in 1348, victim to the **Black Death**.

PISANO, GIOVANNI (c. 1248–after 1314). Italian sculptor and architect, son of **Nicola Pisano**. As noted in inscriptions that accompany his works, Giovanni was born in Pisa. He is mentioned in 1265 in the documentation relating to his father's commission for the **pulpit** of the **Cathedral of Siena** (1265–1268) on which he assisted. In 1278, he is again mentioned as his father's assistant in an inscription on the *Fontana Maggiore* in Perugia (fin. 1278), and he is also documented as an architect in Siena and at Massa Maritima. There is a gap in written records relating to Giovanni from 1270–1276, which some believe may signify that he took a trip to France since his works are closely tied to the French Gothic tradition. In 1285, he surrendered his Pisan citizenship to become a citizen of Siena where he worked until 1299. In the decade from 1285 to 1295, Giovanni provided the rich decoration of the lower part of the Siena Cathedral façade. In 1301 he executed the pulpit for Sant' Andrea in Pistoia, a work he signed and dated. In the following year he began the pulpit for the Cathedral of Pisa (fin. 1311), and in c. 1313 he created the *Monument to Margaret of Luxemburg* (Genoa, Palazzo Bianco) for the Church of San Francesco di Castelletto in Genoa. Though Giovanni worked with his father, the styles of these two masters are quite distinctive. While Nicola blended Gothic elements with the **classicism** found in Roman sarcophagi and other remains, his son depended mainly on the expressiveness of medieval forms.

PISANO, NICOLA (active 1258–1278). Italian sculptor, credited with introducing the Gothic vocabulary to Tuscany. Nicola is believed to have been born in Apulia, then ruled by Frederick II (d. 1250) who brought French masters, mainly architects, to his kingdom, and this is how the sculptor may have been exposed to the Gothic style. In 1258, Nicola is documented in Pisa. His best-known commission is the **pulpit** for the Pisan Baptistery (1255–1260), a work he signed and dated. For this building, he also provided exterior sculptures (c. 1278), including the figures of the arcade on the second level, the Gothic **tracery** above it, and the half-figures of Christ and the **Virgin Mary**, **John the Baptist**, and other saints at the points of the tracery. In 1265, Nicola was in Siena executing a pulpit for the cathedral, a commission completed in 1268. He was also involved in the execution of an elaborate fountain, the *Fontana Maggiore*, in Perugia (fin.

1278) along with his son, **Giovanni Pisano**. Nicola's work mingles the French Gothic style with ancient Roman elements, as exemplified by his pulpit in Pisa. Here, the overall form is Gothic (the trilobed columns and the lions that support them), yet the individual **reliefs** make extensive use of ancient prototypes.

PLAGUE. *See* BLACK DEATH.

PLATO (427–347 BCE). Greek philosopher whose writings exerted major influence in almost every field of the Renaissance, including literature, the arts, and the sciences. Plato was the student of Socrates. Upon his master's execution, which deeply affected him, he traveled to Egypt and Italy. He returned to Athens and established his own school of philosophy where he applied the Socratic method of teaching and where **Aristotle** became one of his pupils. Plato wrote approximately 30 treatises, most in dialogue form, including the *Republic*, *Symposium*, *Phaedrus*, *Timaeus*, and *Laws*. He emphasized the abstract and spiritual aspects of reality, contrasting with Aristotle's advocacy for the empirical observation of nature and its phenomena. Only a handful of works by Plato were known in the West during the medieval era. It was not until 1400 that most of his manuscripts were recovered when copies arrived in Italy from Constantinople. These were systematically translated into Latin in the early 15th century and made available to a wider audience. **Marsilio Ficino**, the humanist employed by **Cosimo de' Medici**, was the one to finally complete the translations of all of Plato's known works. Ficino also founded the Platonic Academy with Cosimo's backing and tried in his own writings to reconcile Platonism with Christianity. *See also* NEOPLATONISM.

PLEYDENWURFF, HANS (1420–1472). The most important painter in Nuremberg, Germany, in the third quarter of the 15th century. Originally from Bamberg, Pleydenwurff arrived in Nuremberg in c. 1451, where he remained until his death in 1472. His *Descent from the Cross* (1462; Nuremberg, Germanisches Nationalmuseum), originally part of the *Breslau Altarpiece*, is typical of his style and reveals his debt to the Early Netherlandish masters in the solidity of the figures, their deep pathos, and the angularity of their drapery folds.

More vertical in terms of the compositional arrangement than Early Netherlandish prototypes, the work includes a patterned gold brocade sky that flattens the background space. In a later version of the scene (c. 1470; Munich, Alte Pinakothek), originally one of the panels of the *Hof Altarpiece*, Pleydenwurff exchanged the gold brocade for a true blue sky. He also increased the solidity of the figures and gave them a greater sense of movement, contrasting the compact arrangement of the figures in the foreground with the ample landscape in the background. In his *Resurrection* (c. 1470; Munich, Alte Pinakothek) also part of the *Hof Altarpiece*, these contrasting elements of closed and opened spaces is also seen. His portrait *Count Georg von Loewenstein* (c. 1456; Nuremberg, Germanisches Nationalmuseum) is a naturalistic, nonidealized rendition of an aging male also inspired by Flemish precedents. Originally the work formed part of a diptych, with the *Man of Sorrows* on the accompanying panel. When together, the count, with book of devotions in hand, seemed to be meditating on the suffering of Christ. Along with **Stephan Lochner** and **Konrad Witz**, Pleydenwurff was among the first artists in Germany to experiment with the Flemish naturalism recently introduced by **Robert Campin**, **Jan van Eyck**, and **Roger van der Weyden**, thereby inaugurating a new phase in the art of the region.

PLUTO AND PROSERPINA (1621–1622; Rome, Galleria Borghese). Commissioned by Cardinal **Scipione Borghese** from **Gian Lorenzo Bernini**, the work depicts the god of the underworld abducting Proserpina, the daughter of **Jupiter** and Ceres, to make her his consort. At Pluto's feet is Cerberus, the three-headed dog that guards the entrance to Hades. Bernini here manipulated the marble as if it were soft clay. Pluto digs his fingers into Proserpina's thighs and her flesh responds to the pressure he applies, while his face wrinkles as she pushes her hand against it. The composition borrows from **Giovanni da Bologna**'s *serpentinate* (serpentine compositions). As in Bologna's *Rape of the Sabine Woman* (1581–1582; **Florence**, **Loggia** dei Lanzi), the work offers a different view on each side. Limbs push away from the central axis in a balanced and credible manner. By this time, Cardinal Scipione Borghese had fallen in disfavor as his uncle, **Paul V**, had died and been replaced by **Gregory XV**. To ingratiate himself with the new papal family, the Ludovisi,

Cardinal Scipione gave the new papal nephew, Cardinal **Ludovico Ludovisi**, the *Pluto and Proserpina* as a gift and ordered from Bernini the *Apollo and Daphne* (1622–1625; **Rome**, Galleria Borghese) as its replacement.

POLLAIUOLO, ANTONIO DEL (c. 1431–1498). Italian goldsmith, painter, sculptor, engraver, and draughtsman. Pollaiuolo was among the earliest masters to perform autopsies to gain full understanding of the anatomical constitution of the human form. He was particularly interested in depicting the human body in motion. His two versions of *Hercules and Antaeus*, one painted in c. 1460 (**Florence, Uffizi**) for the **Medici** and the other sculpted in the 1470s (Florence, Museo Nazionale del Bargello), clearly reflect his scientific approach as they show the strain of men engaged in physical struggle. His *Battle of the Ten Nudes*, an engraving from c. 1465 (New York, Metropolitan Museum), reads like a page in an anatomy book. This has led some to propose that the work was meant as a teaching tool used to demonstrate to students in Pollaiuolo's workshop the intricacies of rendering the body in movement. Pollaiuolo's *St. Sebastian* (fin. 1475; London, National Gallery), painted for the Oratory of San Sebastiano in the Church of Santisima Annunziata, Florence, shows six figures around the saint. Four shoot at him with arrows, while two others reload their crossbows, their muscles flexing and distending in response to their actions. Pollaiuolo preferred mythological scenes to religious representations. In fact, his Uffizi *Hercules and Antaeus* is among the earliest large-scale painted mythologies of the Renaissance. Another example is his *Apollo and Daphne* (London, National Gallery) of c. 1470–1480. His *Portrait of a Young Woman* (1460s; Milan, Museo Poldi Pezzoli) rejects the flat, caricature-like approach of previous masters in favor of a more realistic representation achieved by the inclusion of subtle details of anatomy. Pollaiuolo's paintings show that, for him, the human form was as worthy of study as light and space.

POLYPTYCH. *See* ALTARPIECE.

PONTORMO, JACOPO DA (JACOPO CARUCCI; 1494–1557). **Mannerist Florentine** painter who studied under **Leonardo da**

Vinci, Piero di Cosimo, and **Andrea del Sarto**. Pontormo's personal diary has survived and reveals that the man had a neurotic personality. At the end of his life he became a recluse and made his studio accessible only through a ladder that he would draw up after himself so no one could gain entry. The Mannerist style, which is full of illogical elements, was well suited for his temperament. In c. 1518, Pontormo received a commission to paint *Joseph in Egypt* (London, National Gallery) for the Florentine Pier Francesco Borgherini, **Michelangelo**'s friend, a work that falls in the early stages of his career. Borgherini wanted a series depicting the story of this biblical character for his nuptial chamber on occasion of his marriage to Margherita Acciaioli (1515) and he asked Michelangelo to recommend artists for its execution. Among those Michelangelo recommended were Pontormo and Andrea del Sarto. Pontormo's is a complex work with no specific central focus, with stairways that lead to nowhere, and crowded with figures and illogical proportions—all characteristic of the Mannerist style. It depicts various scenes at once, including the pharaoh's dream that Joseph interpreted, the discovery of the cup that leads to Joseph's reunion with his brothers who sold him into slavery, and his forgiveness of their deed.

In 1525–1528, Pontormo painted one of his most highly regarded works, the *Deposition* for the Capponi Chapel in the Church of Santa Felicità in Florence. This ambiguous representation of the removal of the body of Christ from the cross includes neither the cross nor a tomb. Inspired by Michelangelo's muscular figures, Pontormo's feature massive torsos, contorted, almost impossible poses, and sculptural draperies. The focus of the work is not on the dead body of Christ but on the hands that are stacked in the middle of the oval composition. The colors are applied in unusual combinations, with blue being the dominant hue. Lighting is harsh, facial expressions are strange, and some body parts do not seem to belong to any of the figures included. To this period also belongs his *Madonna and Child with Saints* (c. 1529; Paris, Louvre), painted for the Convent of **St. Anne** in Verzaia, just outside Florence, and his *Visitation* (1528–1529) for the Church of San Michele, Carmignano. Pontormo's restless images with at times perplexing components provided an inventive alternative to the harmonious, more forthright compositions of the High Renaissance style.

POUSSIN, NICOLAS (1594–1665). French artist who was mainly active in **Rome**. Little is known of Poussin's activities in France prior to his arrival in the papal city in 1624. He is then documented living with **Simon Vouet**, and in 1626 with **François Duquesnoy**. The earliest works Poussin executed in Italy were rendered in the Venetian mode he was able to study when he stopped in **Venice** on his way to Rome. His *Et in Arcadia Ego* (c. 1627; Chatsworth, Devonshire Collection), a work inspired by **Guercino**'s painting of the same title (c. 1618; Rome, Galleria Nazionale d'Arte Antica) provides an example of his Venetianized phase. Here, as in many of the works by Venetian masters, the brushwork is loose, the colors **Titian**-like, the landscape lush, and the figures fleshy. To this period also belongs the *Triumph of Flora* (c. 1627; Paris, Louvre) and the *Martyrdom of St. Erasmus* (1628–1629; Rome, Vatican Pinacoteca), this last commission meant for one of the altars in **St. Peter's** dedicated to the saint.

In the 1630s, Poussin changed his style to conform to the **classicist**-idealist mode of the **Carracci** and their followers, resulting from his contact with **Andrea Sacchi**, a member of the Carracci School. A work by Poussin that presents this change is the ***Rape of the Sabine Women*** (c. 1635; New York, Metropolitan Museum), a scene that seems as a choreographed ballet with figures in repetitive yet elegant poses. Poussin by now had become keenly interested in antiquity and had gained access to Cassiano dal Pozzo's **Museo Cartaceo**, which provided information on the architecture, sculpture, artifacts, and everyday objects of the ancients. The details in the *Rape of the Sabine Women*, down to the costumes and hairstyles, are based on these materials in Pozzo's collection.

In 1640, Poussin was invited by King **Louis XIII** of France to Paris, a trip that turned out to be somewhat of a catastrophe. He clashed with local artists, among them Vouet who by now had returned to France and become the king's official painter. Poussin was given commissions that were unsuitable for his temperament, including the decoration of the Great Gallery in the Louvre, which he left unfinished. In 1642, he returned to Rome feeling defeated, yet he maintained contacts with French patrons and stoicist philosophers, resulting in yet another change in his style. In the mid-1640s, he developed what he called the ***Grande Maniera***, a type of painting based on the classical Greek modes of music used to express different

moods. As a result, the movements and gestures of his figures became codified to denote piety, celebrations, or violence. His subjects also changed. He now favored stories with moral and heroic content, as his works the *Funeral of Phocion* (1648; Louvre, Paris) and the *Gathering of the Ashes of Phocion* (1648; Liverpool, Walker Art Gallery) exemplify. These scenes, taken from the writings of Plutarch, speak of a hero's fall and the triumph of truth and virtue.

To this period in Poussin's career also belong the *Madonna of the Steps* (1648; Washington, National Gallery) and the *Holy Family* (1651; Los Angeles, J. Paul Getty Museum). These works mimic the **reliefs** of the ancients and present clear, linear renditions. Unfortunately, they represent a decline in Poussin's art in that his figures are painted in unusually orange flesh tones with strange faces, the lines have become too stiff, and the color contrasts too jarring. In spite of this decline, Poussin's mature works of moral rectitude and vindication and his view that painting must appeal to reason and improve upon nature became the canon adopted by the **French Academy**. With this, Poussin determined the course of art in France during the second half of the 17th century and beyond.

PRATO CATHEDRAL, CHOIR FRESCO CYCLE (1452–1466). Commissioned by the Datini family from **Fra Filippo Lippi**, who settled in Prato, near **Florence**, these **frescoes** depict scenes from the life of Sts. **Stephen**, the cathedral's dedicatee, and **John the Baptist**, patron saint of Florence under whose rule Prato submitted, with the four **Evangelists** on the **vault**. Of the scenes depicting St. Stephen, the most complex from a compositional standpoint is his funeral. Here the saint's corpse is laid out on a **bier** surrounded by mourning figures with members of the clergy and the nobility of Prato at either side, some of which may portray actual individuals. The scene takes place in a complex church setting that features a **classical** vocabulary not unlike that introduced in architecture by **Filippo Brunelleschi** and developed further by **Leon Battista Alberti**. Rendered through the use of **one-point linear perspective**, the vanishing point in this work is on the altar upon which sits a simple cross that casts a shadow on the *aedicula* (small shrine) behind it. With this, Lippi paralleled the life of St. Stephen with that of Christ, and particularly his martyrdom for the sake of the faith.

Other scenes on the saint's life include his birth, his disputation with the elder Jews, and his martyrdom.

Scenes from the life of the Baptist are correlated thematically and compositionally to those of St. Stephen and include his birth and naming, his taking leave of his parents to live in the wilderness, and his preaching in the desert. Most noteworthy is the *Feast of Herod*, which shows Salome dancing, receiving the head of the Baptist as reward, and presenting the head to her mother, Herodias. In this scene, the vanishing point is on the Datini's coat of arms to call attention to the fact that they financed the commission. These frescoes must have presented a major challenge for the aging Lippi as their considerable distance from the ground demanded substantial figures and details. The officials of the cathedral in fact complained to the **Medici** that the artist was slow in completing the commission. The billowing draperies in these frescoes that vary from thick to diaphanous, the diverse poses of the figures, the impeccably rendered perspective of the interior spaces, and the elegant gestures that punctuate the dramatic moments in each episode are all part of Lippi's usual visual language.

PREDELLA. A *predella* is the base on which an **altarpiece** sits. It is usually decorated with sculpture **relief** or painting and the subject chosen normally refers to that of the main scenes of the altarpiece. So, for example, the *predella* in **Gentile da Fabriano**'s *Adoration of the Magi* (1423; **Florence**, **Uffizi**) complements the central scene with narratives from the infancy of Christ, namely the *Nativity*, *Flight into Egypt*, and *Presentation in the Temple*. **Giovanni Bellini**'s *Pesaro Altarpiece* (1470s; Pesaro, Museo Civico) includes **St. George** along the frame and his killing the dragon on the *predella*. A final example is **Fra Angelico**'s *Linaiuoli Altarpiece* (1433; Florence, Museo di San Marco), which shows **Sts. Peter** and Mark in the outer panels and *St. Peter Preaching* and the *Martyrdom of St. Mark* on the *predella*.

PRESENTATION IN THE TEMPLE. Jewish law requires that male children be circumcised eight days after birth, that mothers engage in a purification rite 40 days after the delivery, and that the firstborn be presented to the temple and consecrated to God. Scenes of Christ's

Presentation in the Temple sometimes conflate these events into one. In **Melchior Broederlam**'s *Presentation* in the **Dijon Altarpiece** (1394–1399; Dijon, Musée des Beaux-Arts), the **Virgin Mary** hands over the Christ Child to the prophet Simeon who welcomes him into the temple and recognizes him as the Messiah, while a female on the right holds a basket with the two doves required as offering for the purification. In **Stephan Lochner**'s *Presentation* (1447; Darmstadt, Hessisches Landesmuseum), the **Virgin** herself holds the doves while Simeon places the Christ Child on the altar to denote his future sacrifice. Other presentations to the temple include **Jan van Scorel**'s version (c. 1530–1535; Vienna, Kunsthistorisches Museum), where Simeon kisses the Christ Child as he lowers him onto the altar, and **Ambrogio Lorenzetti**'s (1342; **Florence, Uffizi**), where the prophetess Anna, who also recognized Christ's divinity, points to the child and holds the scroll that records her prophecy.

PRIMATICCIO, FRANCESCO (c. 1504–1570). Italian **Mannerist** painter, sculptor, and architect who studied under **Giulio Romano** in Mantua. Along with **Rosso Fiorentino**, Primaticcio headed the Fontainebleau School in France. He arrived at the French court in 1532, invited by **Francis I**, and remained there for the rest of his life save for a few short trips to Italy. Many of his works, particularly his buildings, were destroyed and are known only through prints and drawings. He is best remembered for his decorations in the Chambre de la Duchesse d'Étampes (c. 1541–1545) and his mantelpiece in the Chambre de la Reine (1533–1537), both at the Fontainebleau Palace. In the first, he created a series of sculpted caryatids, meant to enframe painted scenes, that do not follow **classical** forms. Rather, they are placed in profile or in three-quarter turns and support stylized cartouches. As Mannerist figures, they feature elongated proportions and little sense of musculature. The mantelpiece in the second room presents a play of circular and square forms that contrast with the elongations of the **relief** figures.

Primaticcio's *Ulysses and Penelope* (c. 1545; Toledo, Museum of Art) is an example of his painting abilities. Related to the decorative scheme of the Galerie d'Ulysse in the Fontainebleau Palace, now destroyed, the work presents an intimate moment between husband and wife influenced by the sculptural figures of **Michelangelo**. The dif-

fering scales between the main characters and the two who converse in the background, the elegant elongations, and vague details of anatomy translate the stylizations of Primaticcio's sculptures into painting. Along with Rosso, Primaticcio is credited with bringing the Mannerist mode to France. The combination of painting and relief sculpture he introduced at Fontainebleau and his graceful lengthened forms were to have an impact on French art for many decades.

***PRIMAVERA* (c. 1482; Florence, Uffizi).** A mythological painting created by **Sandro Botticelli** for the **Medici** family. The work was commissioned on the occasion of the wedding of Lorenzo di Pierfrancesco de' Medici, **Lorenzo "the Magnificent's"** cousin, to Semiramide d'Appiani. Appropriately, **Venus**, the goddess of love, stands in the center with **Cupid** hovering above her. To the right is Zephirus, the west wind, about to ravage the **nymph** Chloris who is rewarded for his transgression with marriage and her transformation into Flora, the goddess of flowers. To the left are the Graces, Venus' attendants, and **Mercury**, god of commerce, a reference to the Medici's **banking** activities. The orange grove in the background is a common feature in works commissioned by the Medici as the oranges recall their heraldic *palle* (balls).

The meaning of the painting has not been fully deciphered. Some scholars have interpreted it along the lines of **Neoplatonism**, a philosophy of great interest in the Medici court thanks to the presence of **Marsilio Ficino**, who revived Platonic thought and established the Platonic Academy in **Florence**. Others relate it to ancient and contemporary literature, and particularly the work of the poet Angelo Poliziano who also belonged to the Medici circle. A third school of thought considers the work in the context of marriage, viewing the image as admonition to the bride on the importance of chastity, submission to her husband's family, and procreation (Venus and Flora in the painting are pregnant).

In this work, Botticelli purposely rejected a construction of space in **perspective** and a rendition of accurate anatomies, favoring instead a stylized depiction of the human form. His figures gracefully prance in the flowered grove in a manner that is aesthetically pleasing but optically inaccurate. The liberties Botticelli took have resulted in a lyrical representation of the mythic scene.

PROPHETS. Prophets are figures from the Old Testament who conveyed the word of God, among them Abraham, Isaac, Jacob, Moses, Elijah, Ezekiel, and Habbakuk. Their prophecies usually admonished the Israelites and inspired their choice of a proper moral path. The message underscored the well-being of the Jewish nation and typically contained warnings against disobedience to God and promises of rewards for submission to his wishes. These biblical personages are not only key to Judaism but also to the Christian faith as they are the ones who foretold the coming of Christ. Isaiah, for instance, spoke of the **virgin** birth of the Messiah and Elijah spoke of his second coming.

The prophets are often represented in religious art, the most remarkable examples rendered by **Michelangelo** on the **Sistine ceiling** at the Vatican (1508–1512). They also appear in the *Psalter of Jean, Duke of Berry* (c. 1380–1385; Paris Bibliothèque Nationale) rendered by **André Beauneveu** and on the *predella* in **Pedro Berruguete**'s *Retablo de Santa Eulalia* (after 1483; Paredes de Nava, Church of Santa Eulalia). From 1415 to 1435, **Donatello** sculpted a series of prophets for the niches in the **Campanile** of the **Cathedral of Florence**, now housed in the Museo dell' Opera del Duomo.

PUCELLE, JEAN (c. 1300–1355). French manuscript illuminator who introduced Italianate elements into his works. His illuminations owe debt to the art of **Duccio**, especially in the treatment of space, and this he combined with the elegance of the French court. His is the use of varying tonal values to add volume to his draperies. Pucelle is among the first in France to view the elements of each page, including the illustration, text, and borders, as a whole rather than a set of distinctive components. His works therefore possess a harmony of design never before seen in French illuminations. His *Belleville Breviary* (1323–1326; Paris, Bibliothèque Nationale, Ms. Lat. 10483) includes these features. The page depicting **David** before Saul (fol. 24v), for example, presents the characters enclosed in a Duccio-like architectural setting that shows his attempt at **perspective**. The drolleries on the margins, composed of plants, birds, insects, and figures, enrich the aesthetic appeal of the page. In this same breviary, Pucelle illuminated the calendar pages with landscapes fit for each season. So, for example, the month of January features bare trees, heavy rain in

February, and so on, showing his interest in studying nature and its phenomena. His ***Book of Hours*** *of Jeanne d'Evreux* (1325–1328, New York, The Cloisters), queen of France, is executed in **grisaille** with only a few added touches of color in **tempera**. The manuscript includes scenes of the infancy and **Passion of Christ**, as well as episodes from the life of **St. Louis**. Along the margins are beggars, musicians, dancers, and other characters found in the streets of medieval France, as well as animals, attesting to Pucelle's keen observation of his surroundings and desire to replicate on the page these details of everyday life. *See also* ILLUMINATED MANUSCRIPT.

PULPIT. An elevated platform used by the clergy to address the congregation during religious ceremonies. In Italy in the 13th century, **Nicola Pisano** created a striking hexagonal pulpit for the Baptistery of Pisa (1255–1260). Supported by seven columns adorned at the base with animals and **grotesques** and at the capitals with the **Virtues** and **St. John the Baptist**, the pulpit features five **relief** sculptures with scenes from the infancy of Christ, his death, and judgment. In 1301, his son, **Giovanni Pisano**, also executed a pulpit, his for the Church of Sant' Andrea in Pistoia. This example follows Nicola's hexagonal form and support system. The scenes are also the same, except that Giovanni added the *Warning for the Holy Family to Flee* to Egypt, and the **Massacre of the Innocents**. While similarities of form and content exist between the works of father and son, stylistically they differ. Nicola's pulpit betrays his interest in **classical** antiquity. Templelike structures fill his backgrounds, his figures are crowded as they are in ancient Roman sarcophagi, and a nude male figure of the **Hercules** type stands in ***contrapposto***. Giovanni's reliefs, on the other hand, are more slender than his father's and less dependent on ancient prototypes. His carving goes deeper than Nicolas' and his figures show greater activity and emotional content.

– Q –

QUADRATURA. A term used to describe ceiling painting that uses fictitious architecture rendered in **perspective** to arrange coherently the image's figural and compositional elements. Examples are the

Farnese ceiling (c. 1598–1600) in the **Palazzo Farnese, Rome**, by **Annibale Carracci**, which includes fictive lintels adorned with shelled motifs and supported by herms in **grisaille**, and **Pietro da Cortona**'s *Glorification of the Reign of Urban VIII* (1633–1639) in the Palazzo **Barberini**, Rome, where a large painted architectural framework with a medallion at each corner divides the image into five separate scenes.

QUADRO RIPORTATO. A ceiling **fresco** made to look like framed easel paintings that have been attached to the **vault** with figures appearing to be viewed at normal eye level. The **Farnese ceiling** (c. 1597–1600) in the **Palazzo Farnese, Rome**, and **Guido Reni**'s *Aurora* (1613; Rome, Casino Rospigliosi) utilize this technique.

QUATREFOIL. A quatrefoil is an ornamental shape with four lobes, common to Gothic architectural or sculptural decoration. In the Renaissance, the quatrefoil design persisted in some regions until the 15th century. In **Venice**, the **Doge's Palace** (1340–1438) includes them as ornamentation in its upper arcade, while in **Florence** the quatrefoil appears on the **east doors** (1403–1424) of the **Baptistery**, used by **Lorenzo Ghiberti** as the background fields for his biblical scenes.

QUATTRO LIBRI DELL'ARCHITECTURA **(1570).** An architectural treatise written by **Andrea Palladio** that synthesizes the ideas on architecture expounded by **Leon Battista Alberti** and **Vitruvius**. The first book covers the rudiments of architecture and the **classical** orders. The second deals with domestic design and is based almost entirely on the villas and palaces Palladio built for the nobility in his hometown of Vincenza. The third book tackles public works, including roads and bridges, while the fourth is on ancient Roman architecture. Palladio's treatise, and especially book two, exerted tremendous influence in the development of architecture in Italy and elsewhere. **Inigo Jones,** who studied Palladio's designs, is credited with introducing Palladianism to England. His Banqueting House (1619–1622) in Whitehall Palace is based, in fact, on Palladio's design for the Palazzo Thiene in Vincenza, illustrated in the treatise.

QUERCIA, JACOPO DELLA (c. 1374–1438). The most important sculptor of the Sienese School. Jacopo's father was a goldsmith and woodcarver from the town of Quercia, near Siena. In 1401, Jacopo is documented as one of the participants in the competition for the **east doors** of the **Baptistery of Florence**. In 1414–1419, he was working on the Fonte Gaia, a fountain in the Piazza del Campo, Siena, that included **Virtues** and scenes from the story of Creation. The fountain was modified in the 19th century and Jacopo's contributions, now in the **Palazzo Pubblico**, Siena, are in deplorable condition. In c. 1417, Jacopo collaborated with **Donatello** and **Lorenzo Ghiberti** on the font for the Siena Baptistery, and, in 1425–1438, he was in **Bologna** working on panel **reliefs** for the main portal of San Petronio that depict scenes from the Book of Genesis. These had an impact on **Michelangelo** who based some of his scenes on the **Sistine ceiling** (1508–1512; Vatican) on Jacopo's reliefs. The muscular, **classicized** nudes in complex poses, the compositional arrangements, and the emotive content in Jacopo's works are the elements Michelangelo adopted for himself.

– R –

***RANUCCIO FARNESE* (1542; Washington, National Gallery).** Painted by **Titian**, this work depicts the grandson of Pope **Paul III** at the age of 12. A letter written in 1542 by the humanist Gian Francesco Leoni to Cardinal Alessandro **Farnese**, the sitter's brother, reports that the portrait was rendered as a gift to the boy's mother, Girolama Orsini, to commemorate his appointment as prior of San Giovanni dei Forlani, **Venice**, a property owned by the Order of the Knights of Malta. Ranuccio's elaborate costume, in fact, includes the insignia of the order emblazoned on his black cloak. The boy's innocent facial expression provides a stark contrast to the stiff silk attire, codpiece, and sword he is sporting. The favors bestowed upon Ranuccio continued after Titian painted the portrait. In 1545, he was made cardinal, deacon of S. Lucia in Silice in the following year, legate to Piceno and Ancona in 1546–1547, bishop of Farfa and San Salvatore Maggiore in 1547–1563, legate to Viterbo in 1551, and governor of Montefiascone in 1560. These represent

only a handful of the many benefices bestowed upon him. Ranuccio presents a classic example of the rampant nepotism that then permeated the papal court.

RAPE OF EUROPA. A mythological story told by **Ovid** in the *Metamorphoses*. Europa was the daughter of the Phoenician King Agenor and Telephassa. One day, as she played by the beach with her attendants, **Jupiter** appeared to her in the form of a white bull. At first, she was frightened but soon began to pet the animal, decorate it with flower garlands, and finally she sat on its back, at which point the bull took off with her to Crete. The union of Europa and Jupiter resulted in the birth of Minos, the Cretan king. The scene is often depicted in art, with **Titian** (1559; formerly Boston, Isabella Stewart Gardner Museum) and **Paolo Veronese** (1580; **Venice**, **Doge's Palace**) providing some of the most striking examples.

RAPE OF THE SABINE WOMEN. The story of the rape of the Sabine women stems from the writings of the ancient historian Livy. Having founded **Rome**, Romulus and his men were in need of women to populate the city and ensure its growth. They invited the Sabines to a festival in honor of **Neptune** and, on the signal given by Romulus, the Romans abducted the women and expelled the men. The Sabines declared war on the Romans but, during battle, their women stood between the two armies and persuaded them to lay down their weapons. **Nicolas Poussin** painted the *Rape of the Sabine Women* (1635; New York, Metropolitan Museum) as an orchestrated event filled with theatrical gestures. His work was influenced by **Pietro da Cortona**'s version (c. 1629; Rome, Capitoline Museum), which presents a more animated composition with lush brushwork. **Giovanni da Bologna** depicted only one woman being abducted by two males (1581–1582; **Florence**, **Loggia** dei Lanzi) and viewed the scene as an opportunity to render one of his complex serpentine compositions. Finally, **Peter Paul Rubens** rendered the scene (1635–1637; London, National Gallery) as a chaotic piling of desperate figures who form a sharp diagonal from upper left to lower right, in the center a woman pleading to Romulus for the Sabines' release.

RAPHAEL SANTI (RAPHAEL SANZIO; 1483–1520). One of the greatest figures of the High Renaissance and among the most influential, Raphael's works are known for their graceful and aesthetically pleasing qualities. Truthfully, although he is among the most admired, he certainly was not as innovative as **Leonardo da Vinci** or **Michelangelo**. Raphael was born in Urbino to Giovanni Santi, an average painter and poet who wrote a rhymed chronicle on the artists of the 15th century active in the court of the Duke of Urbino. Raphael was orphaned by age 11 and, as **Giorgio Vasari** informs, was taken in by **Pietro Perugino** who was already training him in his studio in Perugia. Raphael's early style is closely related to that of his master, so much so that his *Marriage of the Virgin* (1504; Milan, Brera) is completely based on Perugino's painting of the same subject.

Soon after creating this work, Raphael moved to **Florence**, where he remained until 1508. There he was exposed to the art of Michelangelo and Leonardo. His *Madonna of the Meadows* (1505; Vienna, Kunsthistorisches Museum) and *Madonna of the Goldfinch* (1507; Florence, **Uffizi**) are, in fact, simplified versions of Leonardo's **Virgin** and Child compositions. Both utilize Leonardo's pyramidal arrangements, monumentality of the figures, closely arranged folds of the drapery, and there is even a hint of **sfumato**, particularly around the eyes. The portraits *Angelo Doni* and *Maddalena Strozzi* (c. 1505; Florence, Pitti Gallery) and the *Entombment* (1507; **Rome**, Galleria **Borghese**) also belong to Raphael's Florentine period. *Maddalena Strozzi* loosely follows the composition of Leonardo's *Mona Lisa* (1503; Paris, Louvre) yet, unlike Leonardo who strove for anatomical and botanical accuracy, Raphael emphasized grace, elegance, and beauty.

By 1510–1511, Raphael was in Rome painting **frescoes** in the **Stanza della Segnatura** at the Vatican, a commission he received in 1509 from Pope **Julius II**. In 1511, he had the opportunity to view the **Sistine ceiling** (1508–1512) by Michelangelo while still in progress. Raphael was greatly influenced by what he saw, so much so that he included Michelangelo in the *School of Athens* in the Stanza della Segnatura as homage and began to paint in a more monumental mode, similar to that of the older master. In the following years, he continued work in the Vatican, painting the Stanza d'Eliodoro (1512–1514). To this period also belong his *Sistine Madonna* (1513; Dresden

Gemäldegalerie), thought to have been commissioned by Julius II to hang above his funerary **bier**, and the *Donna Velata* (c. 1513; Florence, Palazzo Pitti), which seems to portray the same woman who posed for the *Sistine Madonna* and who may be La Fornarina, Raphael's lover. In 1513, Raphael was also working for **Agostino Chigi**, a wealthy Sienese **banker** and close friend of the pope, in his **Villa Farnesina** painting mythological frescoes.

In 1514, Pope **Leo X** appointed Raphael his official architect and asked him to continue the work of **Donato Bramante** at **St. Peter's**. Raphael provided some drawings, but these were never implemented. Leo also gave him the commission to paint his portrait with Cardinals Giulio de' **Medici** and Luigi de' Rossi (c. 1517; Florence, Uffizi) and a series of cartoons for 10 tapestries to be woven in Flanders depicting scenes from the Acts of the **Apostles** (1515–1516) for hanging on the lower walls of the **Sistine Chapel**. These proved to be a major influence in the art of **Nicolas Poussin**, **Domenichino**, and later European masters such as Jacques-Louis David and Jean-Auguste-Dominique Ingres. Raphael's *Transfiguration* (1517; Rome, Pinacoteca Vaticana) he painted for Cardinal Giulio de' Medici, later Pope **Clement VII**. It was originally intended for the Cathedral of Narbonne in France, but Cardinal Giulio was so impressed when he saw the finished work that he decided to place it instead in the Church of San Pietro in Montorio, Rome. Raphael died suddenly in 1520 at the age of 37 and the *Transfiguration* was moved above his tomb in the Pantheon, Rome. His funeral mass was held at the Vatican, a major honor not normally accorded to artists.

REFECTORY. A dining hall in a monastery where meal-taking is permeated with the spirit of prayer and meditation. In the Renaissance, the religious nature of the refectory was often emphasized by the paintings that decorated the walls. These usually depicted scenes from the Bible or the lives of the saints that related to the act of meal-taking. Examples are the *Last Supper* by **Taddeo Gaddi** (c. 1340) at **Santa Croce**, **Andrea del Castagno**'s (1447) in the Monastery of Sant' Apollonia (both in **Florence**), and **Leonardo da Vinci**'s (1497–1498) at Santa Maria della Grazie in Milan. **Tintoretto** painted the *Marriage at Cana* in the refectory of the Monastery of San Giorgio Maggiore in 1563 and **Paolo Veronese** rendered the *Feast in the*

House of Levi (**Venice**, Galleria dell' Accademia) for the refectory of the **Dominican** Monastery of Santi Giovanni e Paolo in 1573, both in Venice. *See also* REFECTORY, SANT' APOLLONIA, FLORENCE; REFECTORY, SANTA CROCE, FLORENCE.

REFECTORY, SANT' APOLLONIA, FLORENCE. The **refectory** of the Monastery of Sant' Apollonia boasts **frescoes** by **Andrea del Castagno** executed in 1447. The largest scene is the *Last Supper*, and above it are the *Crucifixion*, *Entombment*, and *Resurrection*. Castagno's mastery at **one-point linear perspective** is evident in that the space in which the *Last Supper* unfolds is so convincing as to appear to pierce the refectory wall to reveal a second room. While little emotion is shown in the facial expressions of the figures in this scene, the marble panels behind them add drama as the veinings are busiest above the heads of Christ, Judas, **St. John**, and **St. Peter**. Judas is isolated from the rest by his placement on the opposite side of the table. He is also the only figure without a halo. While the rest of the **apostles** gesticulate in reaction to Christ's announcement that one of them will betray him and ponder on its significance, Judas keeps his hand movements to a minimum and seems unaffected. The work shows Castagno's focus on the representation of the human form. The figures are individualized and in a variety of poses, their heads and halos **foreshortened** to enhance realism. The draperies are as well defined as they are in **Donatello**'s sculptures, which were a major influence in Castagno's art. Above the *Last Supper*, the three scenes, now in poor condition, occupy one pictorial field, though interrupted by the room's two windows, with angels above converging toward the center. The *Crucifixion* is in the middle, with Christ's head foreshortened to bend toward the viewer below, the *Resurrection* is on the left, and the *Entombment* on the right. Christ's seminude body in these scenes afforded Castagno the opportunity to demonstrate his knowledge of human anatomy. Arm muscles bulge in response to the lifting of arms and they painfully stretch to emphasize Christ's suffering.

REFECTORY, SANTA CROCE, FLORENCE. The **refectory** of the Monastery of **Santa Croce** was **frescoed** by **Taddeo Gaddi** in c. 1340 with a complex genealogical theme of special interest to the

Franciscans who lived there. The central scene is composed of a Tree of Life with a **Crucifixion** as its trunk, an appropriate choice since *Santa Croce* translates to *Holy Cross*. At the foot of the cross are Sts. Anthony, **Dominic, Louis of Toulouse,** and **Francis,** all significant to the Franciscans, as well as grieving figures and a kneeling donor. The donor's dress of a tertiary Franciscan (a Franciscan lay order) and the Manfredi coast of arms included in the fresco suggest that she may be Mona Vaggia Manfredi who died in c. 1345 and was buried at Santa Croce. From the Crucifixion emanate a series of scrolls to form the branches that weave around medallions containing the bust portraits of the four **Evangelists** and 12 **prophets.** The Latin text on the scrolls admonishes the monks to meditate on the mystery of Christ's sacrifice. Below this scene is the *Last Supper*, also appropriate since the refectory is where the monks took their meals. The crucified Christ above ties in with this scene, which represents the institution of the Eucharist (Christ's body and blood) as a sacrament. This is the earliest example of a refectory fresco presenting a monumental rendition of the Last Supper. Earlier, these scenes were mainly confined to narrations of the life of Christ and his **Passion.** Four smaller scenes at either side of the Tree of Life are the *Stigmatization of St. Francis, St. Louis of Toulouse Feeding the Poor and the Sick at Santa Croce, A Priest at Easter Meal Receiving Word of St. Benedict's Hunger,* and *Christ in the House of Levi*. All but the *Stigmatization* also appropriately relate to meal-taking.

REFORMATION. The Reformation was a movement of dissent from the Catholic Church that took place in the 16th century and resulted in the birth of Protestantism. It was launched in 1517 when Martin Luther, dissatisfied with the excessive sale of indulgences by the pope to finance the building of **St. Peter's, Rome,** and abuses from the clergy, posted his Ninety-Five Theses on the main portals of Wittenberg Cathedral in Germany. These theses attacked the pope and explained Luther's own position on contrition and penance. Composed in Latin, they were translated into German and dispersed. The movement soon caught on in the major centers of Northern Europe with Philip Melanchthon, Martin Bucer, Ulrich Zwingli, and John Calvin emerging as leading figures. Some of the Catholic tenets the Protestants questioned were the role of the **Virgin Mary** in the story

of salvation, the validity of sainthood and martyrdom, and the doctrine of transubstantiation when the host becomes the actual body and blood of Christ. The Reformation brought major changes to art since Protestants do not decorate their churches with images or use them for private devotion. Therefore, patronage in Protestant countries centered mainly on portraiture and **genre** scenes. In Catholic regions, on the other hand, religious scenes that disputed Protestant views, such as the martyrdom of saints, for example, were commissioned in large quantities.

RELIEF SCULPTURE. A method of sculpture in which three-dimensional forms are made to project from a flat background. The materials normally used for this technique are stone, clay, or bronze. There are several categories of sculpture relief. The bas-relief technique entails keeping figures and objects attached to the background, allowing them to protrude only slightly. This is a method normally used for coins and medals. The artist must rely on the play of light on the surface to create the three-dimensional effects. An example is **Jacopo della Quercia**'s reliefs on the main portal of San Petronio in **Bologna** (1425–1438). In high-relief sculpture, the figures project more emphatically from the background; in some cases they are almost completely on the round. **Luca della Robbia**'s *Cantoria* (1431–1438; **Florence**, Museo dell' Opera del Duomo) utilizes this technique. *Relievo schiacciato*, a method devised by **Donatello**, is a flattened relief that seems as if drawn with the chisel rather than carved, as in his *Lamentation* (c. 1457), one of the bronze panels for the pulpit of San Lorenzo in Florence. Finally, hollow relief is an inversed technique whereby the sculptor carves into the stone or other material. This method is usually used for the carving of gems.

RELIEVO SCHIACCIATO. A flattened **relief** that allows for the rendition of convincing, infinite recession into space through optical illusion rather than actual projection. This technique was introduced by **Donatello** in the 15th century. Among the works he created in *relievo schiacciato* is his *St. George Slaying the Dragon*, the relief on the base of his statue of St. George (1415–1417) at **Orsanmichele**, **Florence**. In this work, the details of the foreground protrude somewhat from the background stone but, as the image moves away from

the viewer, the carving becomes flatter and flatter, until it seems as if drawn with the chisel. Both **Desiderio da Settignano** and **Michelangelo** used *relievo schiacciato* in their sculptures. Desiderio's *Virgin and Child* (c. 1460) in the Philadelphia Museum and Michelangelo's *Madonna of the Stairs* (1489–1492) in Casa Buonarroti, Florence, are rendered in this technique.

REMBRANDT VAN RIJN (1606–1669). Rembrandt is one of the central figures of Dutch **Baroque** art. Educated in Latin school and then at the University of Leiden, he was the son of a millworker. He left the university a few months after enrollment to pursue a career as painter. For three years he apprenticed with Jacob van Swanenburgh whose wife was from Naples and who had spent some time in Italy. Swanenburgh surely would have exposed Rembrandt to the Italian mode of painting. In 1624, Rembrandt moved to the studio of Pieter Lastman, who had visited Italy in 1605 and who was then the leading Dutch history painter. Rembrandt's early style is closely related to that of Lastman, as his *Stoning of St. Stephen* (1625; Lyons, Musée des Beaux-Arts) denotes. This is his earliest dated painting and includes the Italianate setting and figures he was taught to render by his masters. By the following year, his style became more intimate, with a lesser number of figures placed closer to the viewer, exemplified by his *Tobit, Anna, and the Kid* (1626; Amsterdam, Rijksmuseum), a scene from the **Apocrypha** painted in the manner of the **Utrecht Caravaggists** with crude figure types pushed to the foreground and wearing torn garments. The scene speaks of repentance as Tobit begs his wife for forgiveness for having accused her falsely of stealing the kid. While the lighting effects of the Utrecht Caravaggists are lacking in this work, they do appear in the *Money Changer* (1627; Berlin, Staatliche Museen) where the candlelight adds theatrical effects to dramatize the scene. The man depicted examines a coin, his eyeglasses denoting his nearsightedness for not recognizing his avarice. Rembrandt's *Judas Returning the Thirty Pieces of Silver* (1629; Yorkshire, Mulgrave Castle) represents the culmination of his Leiden period. The work was highly praised by **Constantijn Huygens** for its successful conveyance of deep emotions, calling Rembrandt the greatest of history painters. With this work, Rembrandt's mature style emerged, a style characterized by the use of earth tones speckled with

a golden glow that seems to come from within the individuals who populate his canvases.

In c. 1632, Rembrandt moved to Amsterdam where he acquired an international reputation and became very wealthy. In 1634, he married Saskia Uylenburgh who often appears in his paintings and whose cousin was Hendrik Uylenburgh, an art dealer who gave Rembrandt lodging and studio space when he first arrived in the city and who helped him obtain commissions. In Amsterdam, Rembrandt had the opportunity to study Flemish works, particularly those of **Peter Paul Rubens**. As a result, his scenes became more monumental and dramatic. His *Anatomy Lesson of Doctor Tulp* (1632; The Hague, Mauritshuis) shows this change in his art. Contemporary accounts state that Rembrandt by now was so busy that patrons had to beg him and offer exorbitant fees so that the artist would paint their portrait.

The *Descent from the Cross* (c. 1633; St. Petersburg, Hermitage Museum) is part of a series Rembrandt painted for the Stadholder Frederik Hendrik, prince of Orange, for whom Huygens worked as secretary. Inspired by Rubens' *Descent* at the Cathedral of Antwerp (1612–1614), which Rembrandt knew from an engraving, the work shows dramatic effects of light and dark and an unidealized, unclassicized, suffering Christ deeply mourned by the figures around him. The *Blinding of Samson* (1636; Frankfurt, Städelsches Kunstinstitut) Rembrandt painted for Huygens himself as a gift for having procured the stadholder's patronage. In the letter Rembrandt sent to Huygens informing him that he was shipping the painting, he gave specific instructions on how the work should be hung so that the maximum dramatic effect could be achieved.

In the 1640s, Rembrandt abandoned the overly dramatic historic representations, instead opting for more subdued compositions. This change is reflected not only in his history paintings but also his portraits. His *Self-Portrait Leaning on a Stone Sill* (1640; London, National Gallery) is one of the artist's many self-representations. In this rendition, he shows himself as a gentleman in expensive costume, fur collar, and jewel-studded hat. The diagonal arrangements of the 1630s have been replaced here by a series of parallel horizontals, resulting in a more stable, less movemented composition. In 1639, Rembrandt attended an auction where **Raphael**'s portrait *Baldassare Castiglione* (1516; Paris, Louvre) was put on the block. He made a quick sketch

of the work on a small piece of paper, now in the Albertina in Vienna, noting the price and the buyer. The sketch became the prototype for the compositional arrangement in his self-portrait.

In 1642, Rembrandt painted one of his best-known works, the **Night Watch** (Amsterdam, Rijksmuseum), one of the most innovative militia portraits ever rendered. Another major work belonging to these years is Rembrandt's **Aristotle Contemplating the Bust of Homer** (1653; New York, Metropolitan Museum), commissioned by the Sicilian nobleman Antonio Ruffo, who was also **Artemisia Gentileschi**'s patron. Aristotle wrote in his *Poetics* that Homer was the master of all poetry, which is why Rembrandt presented him admiring the poet's bust. Aristotle in the painting wears a gold chain with a medallion that features the profile portrait of Alexander the Great, his pupil. Supposedly, Alexander, who shared his master's admiration for Homer, slept with a copy of the *Iliad* edited by Aristotle under his pillow. Rembrandt's painting, then, brings together three major historical figures that shaped the world of literature, philosophy, and politics. The work is rendered with thick **impasto** applied with a palette knife, typical of Rembrandt's paint application method of the 1650s and 1660s.

The *Oath of the Batavians* (1662; Stockholm, Nationalmuseum) and *Return of the Prodigal Son* (c. 1669; St. Petersburg, Hermitage Museum) represent Rembrandt's late phase. The first presents an event from ancient history, as related by Tacitus in the *Historiae*. A tribe of Batavians from the Lower Rhine (now Holland), led by Claudius Civilis, rose against the Romans. In the painting, the figures are shown engaging in a barbarian swearing of allegiance. The work was commissioned as part of a series on the Batavians to decorate the newly built Amsterdam City Hall as reference to the fight for Dutch independence from Spain led by **William of Orange**. The second painting is a biblical story Rembrandt rendered not long before his death. It presents the prodigal son returning home to his father after squandering his inheritance.

While Rembrandt enjoyed a successful career, his personal life was plagued by misery. Of his four children with Saskia, only one, Titus, survived. When Saskia died, she gave her husband control of their child's inheritance, stipulating that, if Rembrandt remarried, the money and properties would be transferred to Titus. Rembrandt,

therefore, never remarried. He did take a common-law wife, Geertje Dircx, a widow who had cared for Titus as his wet-nurse. Geertje and Rembrandt had a bitter separation, went to court, and he was forced to pay her alimony. This separation may have had something to do with the presence of Hendrickje Stoffels who in 1647, at age 20, became part of their household. By 1649, Hendrickje was Rembrandt's mistress and, in 1656, Rembrandt, who spent lavishly on art and other luxuries, declared bankruptcy. Hendrickje died in 1663 and, in 1668, so did Titus, who was then only in his twenties. Rembrandt's death came in the following year.

RENI, GUIDO (1575–1642). One of the members of the Bolognese School, Guido Reni began his training as painter in the studio of the Flemish master Denys Calvaert in **Bologna**. After a fallout with Calvaert, Reni moved onto the **Carracci** School to complete his training. In 1601, he went to **Rome** to work as one of **Annibale Carracci's** assistants on the **Farnese ceiling** commission (c. 1597–1600; **Palazzo Farnese**). When he arrived, he was greatly influenced by the art of **Caravaggio** and began experimenting with the Caravaggesque style. His *David with the Head of Goliath* (1605–1606; Louvre, Paris) and *Massacre of the Innocents* (1611; Bologna, Pinacoteca Nazionale) belong to this phase in his career. After this last work, Reni moved toward greater **classicism**, as is exemplified by his *Aurora* (1613) in the Casino Rospigliosi, Rome. His colors in this work are more akin to those used by **Michelangelo, Raphael**, and Annibale, and the grace of the figures is also Raphaelesque. Having completed this work, Reni moved back to his native Bologna where he became the city's leading master, a position he held until his death in 1642.

In the 1620s, Reni adopted a silvery palette and began using silk instead of canvas. The reason for the change in material is that he witnessed the exhumation of a corpse in which only a piece of silk cloth emerged intact. After this, he became obsessed with using materials that would last beyond his lifespan. His portraits *Cardinal Roberto Ubaldini* (1625; Los Angeles, County Museum) and *Atalanta and Hippomenes* (1622–1625; Madrid, Prado) belong to Reni's silver phase. In his late career, Reni created works in the **unfinished style**, for instance, his *Flagellation* (1641; Bologna, Pinacoteca Nazionale) and *Holy Family with Sts. Elizabeth and John*

the Baptist (1641; private collection). It has been suggested that his paintings look unfinished because he was a heavy gambler and at this point in his life he was plagued with debt and painted as fast as he could to generate a higher income. Recently discovered documents show, however, that the paintings were still in his studio when he died, which would prove such suggestion wrong. Though the reasons for his change in style have been the cause of much debate, what is certain is that Reni was an exceptional artist who had a great impact on the younger generation, including **Simon Vouet**, **Eustache Le Seur**, and **Gian Lorenzo Bernini**.

REPOUSSOIR **FIGURE.** From the French *répousser*, which translates to *to push back*. A *repoussoir* figure is an illusionistic device used to increase the sense of depth in a painting. A figure is placed in the foreground, usually seen from behind or shadowed to define the viewer's position outside the pictorial space. **Giotto** in the *Lamentation*, one of the **frescoes** in the **Arena Chapel**, Padua (1305), used two seated figures with backs toward the viewer for this purpose. Similarly, **Caravaggio** included a *repoussoir* figure in the *Calling of St. Matthew* in the **Contarelli Chapel**, **Rome** (1599–1600, 1602).

RESURRECTION OF CHRIST. The moment when Christ resuscitates and emerges from his tomb, triumphant over death. The scene is often depicted in art, with Christ usually shown stepping out of his sarcophagus while holding a banner that symbolizes his triumph. On the tomb lean sleeping soldiers ordered by Pontius Pilate to guard the site. **Andrea del Castagno** included a Resurrection scene with these elements among his **refectory frescoes** in the Monastery of Sant' Apollonia, **Florence** (1447), as did **Hans Pleydenwurff** on one of the panels of the *Hof Altarpiece* (c. 1470; Munich, Alte Pinakothek) and **Dirk Bouts** in his panel in the Norton Simon Museum in Pasadena (c. 1455). **Piero della Francesca**'s *Resurrection* of c. 1458 (San Sepolcro, Museo Civico) painted for the San Sepolcro town hall also includes these elements and represents the coat-of-arms of San Sepolcro (*Holy Sepulcher*) said to have been founded by two pilgrims who brought relics from Christ's tomb to the town. **Mathias Grünewald's** *Isenheim Altarpiece* (fin. 1515; Colmar, Musée d'Uterlinden) does not include the banner, though the resur-

rected Christ is enclosed in a magnificent halo of red and yellow, a symbol of hope to those who suffered at the Hospital of the Order of St. Anthony in Isenheim, the work's original location.

RETABLE. *See* ALTARPIECE.

RIBALTA, FRANCISCO (1564–1628). Spanish painter from the Catalán region. Ribalta traveled to Madrid in 1581 to receive his training and perhaps to try to obtain a post as court painter. This was not to be since **Philip II** died in 1598. However, while in Madrid, Ribalta had the opportunity to study the works of **Titian** in the royal collection. He left Madrid and settled in Valencia where Archbishop Juan de Ribera, who was directing the **Counter-Reformation** in the region, had a splendid collection of paintings and a keen interest in art. Among the works in his collection figured some by **El Greco, Juan Pantoja de la Cruz, Juan Sánchez Cotán, Giovanni Baglione,** as well as a copy of **Caravaggio**'s *Crucifixion of St. Peter* in the **Cerasi Chapel, Rome** (1600). This last allowed Ribalta to become well acquainted with Caravaggism, which he eventually adopted as his own.

Archbishop Ribera gave Ribalta commissions, including the **altarpiece** for the College of Corpus Christi, which depicts the **Last Supper** (1606). He also created a series of paintings on the life of St. James for the church dedicated to the saint in Algemesí (1603–1606). These works were rendered utilizing the **Mannerist** style Ribalta learned during a trip to Rome. By c. 1620, however, he suddenly changed to Caravaggism, creating some of his most admired works, among them *St. Bernard Embracing Christ* (c. 1625; Madrid, Prado), the depiction of a vision experienced by the saint who founded the Cistercian Order and who was deeply devoted to Christ. The work presents tenebristic lighting with figures pushed close to the foreground and set against the undefined, dark background from which they emerge. Ribalta's Caravaggism, and particularly its deep emotionalism and theatrical lighting effects, proved to be a major force in the development of Spanish **Baroque** art, and particularly that of **Francisco de Zurbarán** and **Jusepe de Ribera.**

RIBERA, JUSEPE DE (LO SPAGNOLETTO; 1591–1652). Born in Jativa, near Valencia, Jusepe de Ribera was one of the most notable

painters of **Baroque** Spain. Nothing is known of his training, though some believe he may have studied with **Francisco Ribalta**. At the age of 16, he went to Naples, then part of the Spanish domain, a trip that coincided with **Caravaggio**'s stay in that region. As a result, Ribera adopted the Italian master's style. In 1611, Ribera is documented in Parma, working for Ranuccio **Farnese**, and in 1613 he was in **Rome** where he remained until 1616 and where he requested admittance into the **Accademia di San Luca**. His *Allegory of Taste* (1616; Hartford, Wadsworth Atheneum) belongs to this early period in his career. A Caravaggist composition, it shows a crude male eating eels. The still life in the foreground, the dark background, and the diagonal entry of light into the pictorial space are elements borrowed from Caravaggio.

In 1616, Ribera moved to Naples where he remained for the rest of his life. He began to sign his paintings *Jusepe Ribera Hispanus* to assert his nationality in a region where outside masters were normally not welcomed. A versatile artist, Ribera painted mythologies such as his *Drunken Silenus* (1626), religious scenes such as his *St. Jerome and the Angel of Judgment* (1626; both Naples, Museo Nazionale di Capodimonte), portraits such as his *Magdalena Ventura with Her Husband and Child* (1631; Toledo, Museo Fundación Duque de Lerma), and **genre** works such as his *Girl with a Tambourine* (1637; private collection) and *Clubfooted Boy* (1642; Paris, Louvre). By the mid-1620s, in response to the art of **Guido Reni**, Ribera loosened his brushwork and muted his colors. He also pushed his figures deeper into the picture plane. Ribera enjoyed a successful career, catering to both Italian and Spanish patrons, among them **Philip IV** of Spain. Though a Spaniard, stylistically Ribera's works should be categorized as Italian.

RICHELIEU, CARDINAL ARMAND JEAN DU PLESSIS (1585–1642). First minister of France, Cardinal Richelieu was educated in the Collège de Navarre, Paris, in the military arts and at the Collège de Calvi in theology. He received the bishophric of Luçon in Poitou in 1607, and the cardinalate in 1622. He came to the attention of **Marie de' Medici**, regent to **Louis XIII** of France, and was appointed secretary of state in 1616. In 1624, after his successful medi-

ation between Marie and her son, Richelieu was promoted to first minister. Though it was through Marie's intervention that he had obtained the post, his relations with her eventually became strained and she and the Duke of Orleans unsuccessfully conspired against him.

In his capacity as first minister, Richelieu was able to secure for France a position as the leading power of Europe. He restricted the power of the feudal nobility and severely punished those who tried to rebel against the monarchy. In 1627, he seized La Rochelle, a Huguenot stronghold and, by 1629, defeated the French Protestants, abolishing with the Peace of Alais their political rights and protections. To check Marie de' Medici's pro-**Hapsburg** policies, he strengthened the French army and navy and made the necessary alliances with Protestant states to prevent the further expansion of Hapsburg dominion. Cardinal Richelieu was well known for his art patronage. He was the protector of the Sorbonne University, had its buildings restored, and its chapel built by **Jacques Lemercier**. He was also the patron of **Simon Vouet** and Philippe de Champaigne.

ROAD TO CALVARY. After Christ endured the **Flagellation** and mocking, he was forced to carry his own cross up to Calvary where he was stripped of his clothes and **crucified**. The scene was depicted several times by **Hieronymus Bosch**, the version in the Musée des Beaux-Arts in Ghent (1490) being the most poignant as it shows Christ surrounded by the ugly humanity that caused his suffering. Similarly, **Simone Martini** chose a crowded representation (c. 1340–1344; Paris, Louvre), his dramatized by the flailing arms of **Mary Magdalen** and the **Virgin** who trail behind Christ. **El Greco**, on the other hand, painted the scene with the bleeding Christ alone, holding the cross, and looking up to heaven as if to denote that he has accepted his fate (c. 1590–1595; New York, Oscar B. Cintas Foundation).

ROBBIA, LUCA DELLA (c. 1399–1482). The best-known member of the **Florentine** della Robbia family of sculptors. Luca della Robbia's earliest documented work is the **Cantoria** for the **Cathedral of Florence** of 1431–1438, now housed in the Museo dell' Opera del Duomo. Della Robbia is known mainly for his glazed terracotta

reliefs, such as the ones filling the roundels in **Filippo Brunelleschi**'s **Pazzi Chapel** at **Santa Croce** in Florence he executed in c. 1443–1450 with images of saints. He is credited with the invention of the half-length **Virgin** and Child type glazed in white and set against a blue background that emphasizes the affection shared by the figures. An example is the *Madonna of the Apple* in the Museo Nazionale del Bargello, Florence, of 1455–1460 where the Christ Child smiles as his mother lovingly presses her head against his. The success of the Cantoria earned della Robbia further commissions from the committee of the cathedral works, among them two **lunette** terracotta reliefs titled the *Resurrection* (1442) and the *Ascension* of Christ (1446; both Florence, Museo dell' Opera del Duomo). These works he executed in the same white and blue glazes as his Virgin and Child reliefs. Other notable works by della Robbia include the *Tabernacle* in the Church of Santa Maria in Peretola (1443), the *Tomb of Bishop Benozzo Federighi* (1453; Santa Trinità, Florence), and the *Capuccini Tondo* (c. 1475; Florence, Museo Nazionale del Bargello).

ROBUSTI, MARIETTA (1560–1590). Marietta Robusti was the daughter of **Tintoretto**, who trained her as painter. As most female artists of the period, she specialized in portraiture, her skill in the field earning her an international reputation. Both Emperor Maximilian II and **Philip II** of Spain invited Marietta to their courts, but her father refused to let her go, instead marrying her off to Jacopo d'Augusta, the head of the **Venetian**'s silversmiths' **guild**. A precondition for the marriage was that Marietta was to remain in her father's household and continue working as his assistant for the rest of his life. Four years later, Marietta died in childbirth, at the age of 30.

Though Marietta attained great fame while living, the scholarship on her artistic activities is rather pitiable. The only work attributable to her with certainty is the *Portrait of an Old Man and a Boy* (c. 1585; Vienna, Kunsthistorisches Museum), attributed to her father until 1929 when her signature was discovered. There are also three paintings in the Madrid Prado currently assigned to her, one believed to be a self-portrait and the two others unidentified Venetian ladies. Also attributed to Marietta is the *Portrait of a Woman as Flora* in the Wiesbaden Museum.

ROELAS, JUAN DE (c. 1588–1625). Spanish painter who became the leading figure in Seville during the first two decades of the 17th century, only to be eclipsed by **Diego Velázquez, Francisco de Zurbarán**, and Esteban Murillo. Roelas first worked in Valladolid in c. 1600. Until 1606, he served as a priest in the town of Olivares, near Seville, which gave him the opportunity to forge relationships with Sevillian patrons. In 1617, he went to Madrid in the hopes of becoming royal court painter, an effort that resulted in failure. In 1621, he returned to Olivares, where he died four years later. Roelas is best known for the **altarpiece** he painted for the Church of St. Isidore in Seville (1613), a work that depicts the saint's death on the lower tier and the heavenly glory that awaits him above. Other works by Roelas include his *Adoration of the Name of Jesus* (1604–1605; Seville, University Chapel), *Vision of St. Bernard* (1611; Seville, Hospital de San Bernardo), and *Martyrdom of St. Andrew* (c. 1612; Seville, Museo de Bellas Artes). As his style is closely related to that of **Tintoretto**, he is often referred to as the *Spanish Tintoretto*.

***ROKEBY VENUS* (1648; London, National Gallery).** Known as the *Rokeby Venus* as it once formed part of the Morritt Collection at Rokeby Hall in Yorkshire, the work was created by **Diego Velázquez** for Gaspar Méndez de Haro, Marquis of Carpio and Heliche and nephew of Count-Duke Olivares, **Philip IV**'s minister. It was listed in his collection in 1651, hanging on the ceiling above a bed, which indicates that the work was meant as a private erotic image. It was probably painted by Velázquez in Italy, where he traveled from 1648 until 1650 to purchase antiquities for the king's collection. One of those works was a *Recumbent Hermaphrodite* from the Greek Hellenistic era whose pose recalls that of the *Rokeby Venus*, which no doubt served as the prototype. The painting is rare for Spain, as deep religious devotion impeded the rendering of erotic subjects. Venus' modesty here contrasts with the voluptuous reclining nudes by **Titian** and **Giorgione** who were surely on Velázquez's mind when he rendered the image. Unlike her unabashed Italian counterparts, Velázquez's Venus is turned away from the viewer and her reflection in the mirror is blurred to protect the identity of the woman who served as the model.

ROMANO, GIULIO (GIULIO PIPPI; c. 1499–1546). Italian **Mannerist** painter, architect, and engineer, the chief pupil of **Raphael** whom he assisted in the **frescoes** of the **Villa Farnesina** (1513–1518) and at the Vatican Palace. In c. 1524, Giulio went to Mantua to work for **Federigo Gonzaga** as his architect, painter, and engineer. He received the position at the recommendation of **Baldassare Castiglione** who was Federigo's agent. Giulio was charged with draining the marshes that threatened the health of the inhabitants of Mantua and with building a hydraulic system that prevented the flooding of the Rivers Po and Mincio. He also built the **Palazzo del Tè** (1527–1534), a suburban villa used by the Gonzaga for recreation purposes and also for Federigo's horse-breeding ventures. Giulio then frescoed the Sala dei Giganti (Room of the Giants) with his masterful rendition of the *Fall of the Giants* (1530–1532), painted at great speed so it would be finished in time for Emperor **Charles V**'s visit to Mantua. Giulio also contributed the frescoes in the Sala dei Cavalli (Room of the Horses) where Federigo's favorite horses were portrayed on the walls overseen by the Gods on Mount Olympus featured above them. In c. 1540, Giulio built his own house in Mantua, a **Bramantesque** structure that reflected his great success as architect and painter. His influence as architect was great, particularly outside of Italy. **Francesco Primaticcio**, who assisted Giulio in the Palazzo del Tè, took his master's Mannerist architectural vocabulary to France where it was adopted by the members of the Fontainebleau School. There the style spread to other parts of Europe. The palace of the Duke of Bavaria at Landshut, in fact, is built in Giulio's manner.

ROME. Ancient tradition has it that Rome was founded by the twins Romulus and Remus in the mid-eighth century BCE, a dating supported by archaeological evidence of early settlements found on the Palatine Hill. Romulus became Rome's first king, establishing a monarchic form of government that lasted until 509 BCE when the Senate abolished monarchic rule and established a republic. In 44 BCE, Julius Caesar, who had declared himself Rome's dictator, was murdered and in 27 BCE his great-nephew and adopted son, Octavian, became Rome's first emperor, taking on the name Caesar Augustus. The Roman Empire eventually grew to become one of the largest and most powerful of the ancient era, and in fact so huge that

in the third century CE Diocletian was forced to set up a tetradic ruling system to ensure its proper administration.

Constantine the Great, who ascended the imperial throne in 324, did away with Diocletian's tetradic form of government, declared himself sole ruler, and moved the capital from Rome to Constantinople (now Istanbul), splitting the empire into two. With the Edict of Milan (313) he granted Christians the freedom to worship openly and soon after he built Old **St. Peter's** to mark the saint's tomb, with this establishing Rome as the center of Christendom. In 321, he gave the Church the right to own and sell property, and donated to Pope Sylvester I the Lateran Palace in Rome. Soon landowners began granting their properties to the papacy, most in the vicinity of Rome, though some of the lands were as far south as Sicily. In 754–756, the Frankish King Pepin reaffirmed the Church's ownership of the Roman duchy and made further land donations to the papacy in the Umbrian, Emilia-Romagna, Marche, and Campania regions of Italy. In 781, and again in 787, Pepin's son, Charlemagne, reconfirmed the papacy's ownership of the territories his father had endowed to the papacy, and gave the Church added lands in Umbria, Emilia-Romagna, Marche, Campania, Tuscany, Lazio, and Calabria. The Papal States were extended further when in 1115 Countess Matilda of Tuscany bequeathed to the pope her domain in the Marche region. With these donations, the papacy became the largest landowner on the Italian peninsula, dominating most of the Tyrrhenian coast to the west, and a large portion of the Adriatic coast to the east.

For most of the medieval era, Rome was plagued with strife among the great feudal families, especially the Colonna and Orsini, and the power struggle between the papacy and the Holy Roman emperors. Though **Giotto**, **Pietro Cavallini**, and **Jacopo Torriti** had been active in the region, it was not until the papacy could be ensured a permanent seat in Rome that the city became a major player in the development of the Renaissance. **Martin V**, who returned the papacy to Rome in 1420 after the Great Schism, initiated the restoration of pilgrimage sites, such as the Church of St. John Lateran, to lure pilgrims to the area and encourage economic growth. He commissioned **Masolino**, **Gentile da Fabriano**, and **Antonio Pisanello** to provide works to embellish these sites. Other popes followed suit, but it was not until the reign of **Nicholas V** that Rome was systematically

improved under the direction of **Leon Battista Alberti**. By the 16th century, Rome had become a major center of art, thanks to the presence of **Michelangelo**, **Raphael**, and **Bramante** and, by the 17th century it was the capital of the art world, a position it held until the dawn of the 18th century, when France took the lead. *See also* SACK OF ROME.

ROSSELLINO, ANTONIO (1427–1479). Italian sculptor, the brother of **Bernardo Rossellino**. Antonio was from a family of artists from the town of Settignano and a close associate of **Desiderio da Settignano** from whom he adopted the **Sweet Style**. His most important commission is the *Tomb of the Cardinal of Portugal* (1460–1466) in the Church of San Miniato, **Florence**. Rossellino was also a masterful portraitist. His busts of the physician *Giovanni Chellini* (1456; London, Victoria and Albert Museum) and the historian *Matteo Palmieri* (1468; Florence, Museo Nazionale del Bargello) are among the finest of the period.

ROSSELLINO, BERNARDO (1409–1464). Italian sculptor and architect who came from a family of artists from Settignano. As sculptor, Bernardo's most important commission was the *Tomb of Leonardo Bruni* (c. 1445) in the Church of **Santa Croce**, **Florence**, a work that set the standard for Renaissance wall tombs. It consists of an **effigy** laid out on a **bier**, a sarcophagus below bearing a laudatory inscription, and a tondo of the **Virgin** and Child supported by angels on the **lunette** above. Stylistically, Rossellino's art is closely related to the **classicism** of **Lorenzo Ghiberti** and **Luca della Robbia**. As architect, Rossellino assisted **Leon Battista Alberti** while working on the Palazzo Rucellai (beg. c. 1453) in Florence. His greatest success was the rebuilding of the town of Pienza, south of Siena, in 1459–1462 for Pope Pius II, a commission that represents a major achievement in the history of urban planning. *See also* ROSSELLINO, ANTONIO.

RUBENS, PETER PAUL (1577–1640). Peter Paul Rubens was born in Seigen where his father was exiled. When Rubens was a year old, the exile was lifted and the family went to Cologne. Rubens' father died in 1589, and his mother, Maria Pijpelinckx, moved with her children to her native Antwerp. She ensured that Rubens receive a proper ed-

ucation by sending him to Latin school. She also placed him as a page boy in the service of the Countess of Ligne where he experienced court life for the first time. Rubens' training as painter began in the studio of Tobias Verhaecht, his mother's cousin, but soon he transferred to Adam van Noort's workshop, and finally to that of Otto van Veen who was interested in learning and familiar with the Italian mode of painting as he had trained with the **Mannerist** Federico Zuccaro in **Rome**. Not only did van Veen expose Rubens to Italian art but also to the art of **Hans Holbein the Younger** and Hendrik Goltzius. Rubens became an independent master in 1598.

In 1600, Rubens went to Italy, and there he entered into the service of the **Gonzaga** in Mantua. Vincenzo Gonzaga encouraged Rubens to visit other cities on the Italian peninsula, including Rome, where he became acquainted with the art of **Caravaggio**, which was to have an impact on his art. While in Rome, Rubens received the commission to paint the *Ecstasy of St. Helen*, *Mocking of Christ*, and *Elevation of the Cross* (1601), all for the Chapel of St. Helen in the Church of Santa Croce in Gerusalemme. Awkward in the treatment of the figures and their gestures, these are Rubens' first documented works. Rubens' style improved in great measure when in 1603 the Duke of Mantua sent him to Spain on a diplomatic mission, which gave him the opportunity to study the works of **Titian** in Philip III's collection. While there, Rubens painted the *Equestrian Portrait of the Duke of Lerma* (1603; Madrid, Prado), a work that clearly borrows from the **Venetian** master's portrait *Charles V on Horseback* (1548; Madrid, Prado) in style and composition.

By 1604, Rubens was back in Italy and in 1606 he went to Genoa to work for the Doria. Among the paintings he rendered for them is the *Portrait of Brigida Spinola Doria* (1606; Washington, National Gallery), a member of the Genoese ruling family dressed in a splendid silk gown rendered in the loose brushstrokes Rubens learned from Titian. Rubens' trip to Italy ended abruptly in 1608 when he received notice of his mother's illness. Back in Antwerp by 1609, Rubens was appointed official court painter to Albert and Isabella, the Archdukes of Flanders and, in the same year, he married Isabella Brant. He commemorated the union by painting the *Honeysuckle Bower* (1609–1610; Munich, Alte Pinakothek), a portrait of himself and his new bride in an intimate moment. Also in 1609, the fathers of

the Church of St. Walburga asked Rubens to paint an **altarpiece** depicting the *Elevation of the Cross* (1610–1611; Antwerp, Cathedral), a Caravaggist rendition with crude figure types that contrast with Christ's **classicized** anatomy, the setting a lush Titianesque landscape rendered in loose strokes. This commission was followed by the *Descent from the Cross* (1612–1614), painted for the **Guild** of Harquebusiers for their altar in Antwerp Cathedral, an emotive rendition of the event. To these years also belong his *Four Philosophers* (1612; Florence, Palazzo Pitti), the homage Rubens paid to his deceased brother and his teacher **Justus Lipsius**, and *Castor and Pollux Seizing the Daughters of Leucippus* (1618; Munich, Alte Pinakothek), a playful mythological rendition.

In 1622–1625, Rubens was working for **Marie de' Medici**, the widow of **Henry IV** of France and mother of **Louis XIII**, rendering the *Medici Cycle* for the Luxembourg Palace. The original commission called for over 40 paintings that related the lives and heroic deeds of Henry and Marie. Of these, only the scenes relating to Marie's story were executed and are now displayed in the Louvre in Paris. Isabella Brant died in 1626 and in 1629 Rubens was knighted by **Charles I** of England for the diplomatic missions and works he created while in his service, including *The Apotheosis of James I* (1629) on the ceiling of the Banqueting House in Whitehall Palace **Inigo Jones** had built (1619–1622). In 1630, Rubens married 16-year-old Helena Fourment, who would appear in a number of his paintings, including the *Woman in the Pelisse* (1638; Vienna, Kunsthistorisches Museum) and *Rubens, His Wife Helena Fourment, and Their Son Peter Paul* (c. 1639; New York, Metropolitan Museum). In the last decade of his life, Rubens withdrew from court life and spent most of his time in his estate, Steen Castle near Mechelen, painting mainly portraits and landscapes, among them the *Landscape with Steen Castle* (1636) in the London National Gallery. Rubens died in 1640 from gout.

RUSTICATION. The term refers to large blocks of stone that are roughly cut and applied to building façades to grant a bold surface texture. The use of rustication allows for statements of masculinity and power, as the **Palazzo Medici-Riccardi** in **Florence** (beg. 1436)

by **Michelozzo** denotes. The **Mannerists** used rustications to create anticlassical structures, such as **Giulio Romano**'s **Palazzo del Tè** in Mantua (1527–1534) and **Bartolomeo Ammannati**'s Palazzo Pitti courtyard in Florence (beg. 1560) where these rough surfaces appear in unexpected places, such as columns, windows, and arches.

– S –

SACCHI, ANDREA (c. 1599–1661). Andrea Sacchi was the pupil of **Francesco Albani** who encouraged him to study the **Farnese ceiling** (c. 1597–1600; **Rome, Palazzo Farnese**) and other works by **Annibale Carracci**, meaning that the artist received a **classicist** art education. In c. 1618, Sacchi went to **Bologna** with his master to examine the works of other members of the Bolognese School, returning to his native Rome in c. 1621. Sacchi's earliest patron was Cardinal Francesco Maria del Monte, who had also patronized **Caravaggio** early on in his career, followed by the **Barberini**. His works are few as he painted slowly and meticulously. This method resulted in idealized renderings, mainly in soft pastels, with elegant gestures, poses, and draperies. His *St. Gregory and the Miracle of the Corporal* (1625–1626; Vatican, Pinacoteca) is a commission he received from del Monte to be placed in the Chapter House of **St. Peter's**. It depicts a miracle where the cloth St. Gregory had used to wipe the chalice bled when he pierced it with a dagger. A man who had doubted its miraculous qualities is shown in the foreground sinking to his knees in response to the event. Sacchi's *Divine Wisdom* (1629–1633; Rome, Palazzo Barberini) he created for the Barberini. This large ceiling **fresco** utilizes a modified *di sotto in sù* technique and shows Divine Wisdom seated on her throne and surrounded by 11 of her **Virtues**—a scene based on the Wisdom of Solomon in the **Apocrypha**. Meant to denote the ability of Pope **Urban VIII**, a Barberini, to rule with great wisdom, the work also references the constellations and planets. In fact, in the fresco, Leo, the sun, and Jupiter are aligned, as they were on the day of the pope's election. The placement of the sun in the center of the composition denotes the Barberini's interest in current astronomical

debates. Then, the accepted notion was that the Earth occupied the center of the universe and Galileo Galilei at the time was expounding his heliocentric views, which Sacchi's fresco embraces.

In the **Accademia di San Luca**, Sacchi debated with **Pietro da Cortona** on the proper rendering of history paintings, advocating the **Aristotelian** approach to the genre of tragedy with a minimal number of actors and emphasis on grandeur and clarity. Sacchi's works reveal that he truly practiced what he preached. Along with **Alessandro Algardi**, **Nicolas Poussin**, and **François Duquesnoy**, he championed an art that provided only the essential components to tell the story and that refrained from excessive dramatization—an alternative to the compositional complexities and emotive appeal found in the works of Cortona and **Gian Lorenzo Bernini**. *See also* CORTONA/SACCHI CONTROVERSY.

SACK OF ROME (1527). The sack of Rome resulted from the rivalry between France and Spain over Northern Italy. In 1524, Pope **Clement VII** took sides on the issue by allying himself with **Francis I** of France and **Venice**. In 1525, however, Francis was captured in Pavia, leaving the pope with no choice but to seek the protection of **Charles V** of Spain. In 1526, in an effort to limit Charles' power, the pope again changed sides, joining the League of Cognac with France, Milan, **Florence**, and Venice. In retaliation, Charles' imperial troops invaded **Rome** in 1527, brutally ransacking it. Clement took refuge in the Castel Sant' Angelo, was eventually taken prisoner, and forced to pay 400,000 ducats for his release. He fled to Orvieto and later Viterbo, remaining in exile for the next two years. Clement eventually negotiated a truce with Charles and crowned him Holy Roman Emperor in **Bologna** in 1530.

Many scholars believe that the sack of Rome marked the end of the High Renaissance era and contributed to the advance of Protestantism because papal power was diminished by the event. In 1533, Henry VIII of England requested from Clement an annulment of his marriage to Catherine of Aragon, Charles V's aunt. The pope rejected the petition, leading Henry to establish the Church of England, for which he was excommunicated. Had the sack of Rome not taken place and the pope been forced to bow to Charles, Clement might

have simply acceded to the annulment and England would not have been lost to Protestantism.

SACRA CONVERSAZIONE. In English, *sacred conversation*. An image in a single pictorial field of the **Virgin** and Child surrounded by saints from different times in history who interact with each other through gestures and glances, or with the viewer. The *sacra conversazione* representations supplanted the earlier multipaneled **altarpieces** that featured a hierarchic arrangement of these sacred figures. Italian examples of this new type include **Domenico Veneziano**'s *St. Lucy Altarpiece* (c. 1445–1447; **Florence, Uffizi**), one of the earlier Renaissance *sacra conversazione* renditions, **Sandro Botticelli**'s *Bardi Altarpiece* (1484; Berlin, Staatliche Museen), and **Giovanni Bellini**'s *San Zaccaria Altarpiece* (1505) in the Church of San Zaccaria, **Venice**. Among the Northern examples are **Hans von Kulmbach**'s *Tucher Altarpiece* (1513; Nuremberg, Church of Sebald) and **Hans Memlinc**'s *St. John Altarpiece* (1474–1479), this last painted for the chapel of the Hospital of St. John in Bruges, now the Memlingmuseum.

SACRED AND PROFANE LOVE (1514; Rome, Galleria Borghese). The *Sacred and Profane Love* is an allegorical painting rendered by **Titian** that relates compositionally to the *Fête Champetre* (c. 1510; Louvre, Paris) by **Giorgione**, his teacher. Until recently, the work was interpreted solely as a **Neoplatonic** allegory of the superiority of sacred over profane love, with both women representing **Venus**—the one nude denoting pure celestial love and her clothed counterpart earthly sexuality. Scholarship on gender issues has revealed the implications offered by certain elements Titian included, which has led to the conclusion that the work was commissioned to celebrate a marriage. The coat of arms of Niccolò Aurelio, vice-chancellor of the **Venetian** Republic, on the sarcophagus by the two women identifies him as the groom, while the heraldry on the plate directly above it is that of his bride, Laura Bagarotto. Also, the clothed Venus wears the traditional Venetian white satin wedding gown with red sleeves and belt. Her loose hair and myrtles were part of the wedding attire, while the vessel she holds is a wedding casket used to collect monetary gifts. The rabbits that dot the distant landscape are symbols of fertility and

the hope for children, crucial to a society where the high child mortality rate sometimes precluded the continuation of the family.

SACRIFICE OF ISAAC. This is an episode from the Old Testament. To test Abraham's faith, God commanded him to sacrifice his son Isaac and, without hesitation, Abraham did as he was told. As he readied to plunge the knife into Isaac's throat, God sent an angel to stop him and a lamb was sacrificed in the boy's place. The story becomes a prefiguration to God's willingness to give up his own son so he may bring salvation to humankind. The *Sacrifice of Isaac* was the stipulated topic for the entries in the competition for the **east doors** of the **Baptistery of Florence** (1401). **Caravaggio** depicted the subject in 1601–1602 (Florence, **Uffizi**) and **Rembrandt** in 1635 (St. Petersburg, Hermitage Museum).

SAN FRANCESCO, ASSISI. The Church of San Francesco is dedicated to **St. Francis**, a resident of Assisi. Construction began sometime after the saint's death in 1226, its purpose to mark his burial site and to serve as the mother church of the **Franciscan Order** he established. The building consists of an upper and lower church, both with a **Latin cross plan** with aisleless **nave**, **transept**, and **apse**. The naves feature a four-partite **vault** system and the lower basilica also includes side chapels. As the structure was erected with papal support and needed to reflect the power and wealth of the papacy, it is quite ostentatious and therefore at odds with the Franciscans' vow of poverty.

The interiors in both churches are richly ornamented with **frescoes** executed by the most important masters of the 13th and 14th centuries who were either from **Rome** or somehow connected to the papacy. In the upper church, **Cimabue** was responsible for the apse and transept decorations (after 1279), the first featuring scenes from the life of the **Virgin** to whom St. Francis was especially devoted and the second the *Crucifixion*, *Apocalypse*, and lives of Sts. **Peter** and **Paul**. In c. 1287, Cimabue's pupil, **Giotto** (some question the attribution) painted 28 scenes from the life of St. Francis taken from St. Bonaventure's *Legenda Maior*, considered the official biography of the saint. Some of the vault frescoes in the upper church that depict scenes from the Book of Genesis have been attributed to **Jacopo Torriti** and dated to the 1290s. In c. 1328, in the lower church, **Simone**

Martini frescoed the **Montefiore Chapel** with scenes from the life of St. Martin. During the same decorative campaign, **Pietro Loren-zetti** contributed scenes from the **Passion** (1325–1330) in the lower church transept. These treasures mark the Church of San Francesco as one of the most important landmarks of the Proto-Renaissance era.

SAN IVO DELLA SAPIENZA, ROME (1642–1650). San Ivo is the church of the University of **Rome**, called the Sapienza. **Francesco Borromini** received the commission to create this structure in 1641 from Pope **Urban VIII** who requested that it be incorporated into the university courtyard. As a result, the building's façade is concave, its two stories composed of repetitive arched windows that harmonize with the courtyard arcades at either side. On the attic, a Latin inscription reads "House of Wisdom," suitable for a church in a university setting. A **dome** with a large drum sits atop, both composed of concave and convex forms that add movement to the façade. The spiral lantern capping the dome recalls the pope's tiara to assert that this was a papal commission, and also the flaming crown of Wisdom, reiterating visually the attic inscription. The interior is whitewashed and includes 18 colossal pilasters that support a continuous entablature and applied decorations added during the reign of Alexander VII when the church was completed. These include the heraldic mounds and stars of the Chigi, Alexander's family.

The structure's plan, echoed in the interior by the dome, is read by some as a stylized bee, the symbol of the **Barberini**, Urban VIII's family. Others see two superimposed triangles that form the six-pointed star of King Solomon, albeit with points replaced by the same play of concave and convex forms of the building's exterior. While the Barberini emblem would identify the patron of the structure, the Solomonic reference would reiterate symbolically the words inscribed on the façade as Solomon was known for his wisdom. Solomon was also the great builder of the Temple of Jerusalem, so the Solomonic references at San Ivo may have been included as well to hail Urban as the modern counterpart to this biblical figure who builds his own house of worship.

SAN MARCO MONASTERY, FLORENCE. Originally occupied by the Sylvestrine Order, in 1436 these monks were expelled and the

San Marco Monastery was turned over to the **Dominicans**. In the late 1430s, **Cosimo de' Medici**, who favored the order, provided funding for its renovation, giving the commission to **Michelozzo**. The most successful room in Michelozzo's design is the library, the first built in the Renaissance. Here the architect utilized a **Brunelleschian** vocabulary that includes a repetition of arches and columns to establish a rhythmic pattern and corbels, elements also found in Brunelleschi's **Ospedale degli Innocenti, Florence** (1419–1424). The flat roof in the central space, groin **vaults** for the aisles, and stuccoed walls trimmed in *pietra serena* are also Brunelleschian. Once completed, Cosimo donated over 400 Greek and Latin manuscripts to the library, making it into one of the most notable early public libraries of Italy. San Marco also boasts some of the most splendid **frescoes** of the Early Renaissance. **Fra Angelico**, who resided in the monastery, painted scenes in the cells and corridors between 1438 and 1445 to inspire meditation and prayer. Also financed by Cosimo, the subject of these works is believed to have been dictated by **St. Antonine Pierozzi**, the prior of San Marco. Among the most notable of these frescoes are the *Annunciation*, *Coronation*, *Transfiguration*, *Mocking of Christ*, *Resurrection and Women at the Tomb*, and *Noli me tangere*.

SAN ZENO ALTARPIECE, SAN ZENO, VERONA (1456–1459). Altarpiece painted by **Andrea Mantegna**, who looked to **Donatello**'s altar in the Church of San Antonio in nearby Padua for figural and compositional inspiration. The frame in the *San Zeno Altarpiece* takes on the form of a **classicized** façade with segmented (semicircular) **pediment** that ends in volutes (scroll-like ornaments), its elaborate columns attached to the painted piers of the altarpiece to enhance the sense of depth. In the center are the enthroned **Virgin** and Child surrounded by musical angels and flanked by saints in varying poses who line up diagonally one behind the other. The circular motif on the throne acts as the Virgin's halo. The figures occupy a classical setting where a continuous frieze of **reliefs** and piers are included. Above are garlands of fruits and flowers, as well as a rosary suspended directly above the Virgin. The *predella*, taken by Napoleon to France where it now forms part of the Louvre collection, consists of the *Agony in the Garden*, *Crucifixion*, and *Resurrection*. The most

outstanding of these is the *Crucifixion*, originally the central panel. Here, the crucified Christ is placed precisely where the lines on the ground converge and where two mounds in the landscape dip. The thieves' crosses are positioned diagonally to further the illusion of depth. The weeping mourners and the soldiers who gamble for Christ's vestments provide a poignant contrast of piety versus sinfulness. The work demonstrates Mantegna's interest in definition and clear organization. It also shows his rendering of sculptural forms and his fascination with ancient art.

SÁNCHEZ COELLO, ALONSO (c. 1531/1532–1588). Spanish painter who specialized in portraiture. Sánchez Coello was court painter to King **Philip II** and, in that capacity, he was instrumental in laying the foundations for **Hapsburg** portraiture in Spain. In his works, sitters are set against sparsely furnished interiors, their physiognomies rendered as clearly as the details of their elaborate courtly costumes. Sánchez Coello's interest in detailed representation came from his training with the Flemish master **Anthonis Mor**. His portrait of the *Infanta Isabella Clara Eugenia with Magdalena Ruiz* (c. 1585–1588; Madrid, Prado) depicts the king's daughter and her favorite dwarf. In her hand, she displays a cameo of her father to stress her royal lineage, while Magdalena, crouching at the infanta's side in a gesture of submission, holds two pet monkeys. Sánchez Coello also contributed some religious works to the Monastery of San Lorenzo in El **Escorial**, Philip II's pet project. These include *Sts. Stephen and Lawrence* (1580) and the *Martyrdom of Sts. Justus and Pastor* (1582–1583), both still in the monastery. Sánchez Coello's emphasis on detailing, also present in these works, provided a contrast to **Juan Fernández de Navarrete**'s Italianate paintings at the same site.

SÁNCHEZ COTÁN, JUAN (1561–1627). Spanish still-life painter from the region of Toledo who almost completely abandoned his career in 1603 when he entered the Carthusian Monastery of Granada as a lay brother. Sánchez Cotán's patrons included the aristocratic and learned citizens of Toledo. For this, scholars have read his works as studies in mathematical arrangements as well as recreations of ancient still lifes said to have been so masterfully rendered as to fool birds into pecking at the fruits depicted. Others have read his works

as warnings against gluttony or as spiritual compositions comparable to the literary works of **St. Theresa of Avila** and other Spanish mystics of the period. One of his most often discussed works is the *Still Life with Game Fowl, Fruit, and Vegetables* (1602; Madrid, Prado), which, aside from its iconographic significance, presents the staple ingredients of Spanish cuisine, including cardoons, assorted roots, wild fowl, and lemons.

SANCTA SANCTORUM. Located in the Lateran Palace in **Rome**, the *Sancta Sanctorum* is a chapel dedicated to **St. Lawrence** and used by the early popes for personal devotion. The chapel was meant to house a number of religious relics, the most important of which is the true portrait of Christ (the *Acheropita*) painted by **St. Luke** the **Evangelist**. The chapel is accessed through a staircase that originally led to Pilate's house and that Christ climbed to be judged. Called the *Scala Sancta*, the staircase was brought to Rome from Jerusalem by **St. Helena**, Constantine the Great's mother. Pilgrims today still climb the stairs on their knees while engaging in prayer.

In 1278 a major earthquake destroyed the original chapel, and Nicholas III had it rebuilt and decorated. The new structure has a square plan capped by a cross-ribbed **vault**. Porphyry columns separate the **apse** from the **nave** and the floor features an elaborate **Cosmatesque** mosaic. The lower portions of the walls are covered in marble, while the upper parts feature **frescoes** by unknown artists. The scenes depicted illustrate the lives of the saints whose relics were kept in the chapel, including St. Lawrence. In the 16th century, during the reign of Sixtus V (r. 1585–1590), further decorations were added, mainly to the apse, as well as an inscription that reads "No holier place on earth exists," a reference to the holy relics originally kept in the chapel, some of which have since been moved to **St. Peter's**.

SANGALLO, GIULIANO DA (1443–1516). Giuliano da Sangallo was the founding member of a dynasty of **Florentine** architects. Like **Filippo Brunelleschi** and **Leon Battista Alberti** who influenced him, he was deeply interested in ancient architecture. The notes he took on the ancient monuments he studied during an early stay in **Rome** (c. 1465–c. 1472), the *Codex Barberiano*, are now housed in

the Vatican and record some Roman buildings that no longer stand. Upon his return to Florence and armed with the knowledge he acquired in the papal city, Sangallo worked on the courtyard of the Palazzo Scala (1472–1480), a commission he received from the statesman and humanist Bartolomeo Scala. Made to look like an ancient peristyle, the courtyard features arches flanked by pilasters on the lower story and above these a series of **reliefs**, also executed by Sangallo, based on a poem, the *Cento Apologi*, written by his patron that deals with moralizing mythological themes. After this, Sangallo became the architect favored by **Lorenzo "the Magnificent" de' Medici**. For him he built the Villa Medici at Poggio a Caiano in the early 1480s, the earliest attempt by a Renaissance architect to recreate an ancient suburban villa based on the descriptions of **Vitruvius** and Pliny the Younger. It is also the first domestic structure with a completely symmetrical arrangement of rooms around a large central hall. In this, it foreshadows the villas of **Palladio**.

Sangallo's Church of Santa Maria delle Carceri in Prato, built in 1484–1492 and also commissioned by Lorenzo de' Medici, was meant as repository for an image of the **Virgin** that effected miracles. This structure, shaped like a **Greek cross**, depends on the mathematical system of proportions introduced by Brunelleschi earlier in the century. The **dome** and interior are also Brunelleschian, this last relying heavily on Brunelleschi's **Pazzi Chapel** at **Santa Croce**, Florence (1433–1461). In the exterior, Sangallo applied the **Colosseum principle** introduced by Alberti in his design for the Palazzo Rucellai in Florence. These structures for Lorenzo were followed by the Palazzi Gondi (beg. 1490) and Strozzi (1489–1490), this last completed by Cronaca and Benedetto da Maiano.

After the expulsion of the Medici from Florence in 1494, Sangallo returned to Rome. There he worked for Cardinal Giuliano **della Rovere**, later Pope **Julius II**. When **Donato Bramante** died, Sangallo was called by **Leo X**, a Medici, to work alongside **Raphael** on New **St. Peter's**, but was soon dismissed as the commission proved to difficult for him to handle. He returned to Florence where he submitted designs for the façade of San Lorenzo (1515–1516), by then considered antiquated. Disheartened, Sangallo died in 1516. *See also* SANGALLO THE ELDER, ANTONIO DA; SANGALLO THE YOUNGER, ANTONIO DA.

**SANGALLO THE ELDER, ANTONIO DA (1455–1534). Floren-
tine** master from a family of prominent architects that included his
older brother **Giuliano da Sangallo** and his nephew **Antonio da
Sangallo the Younger.** His most important commission is the
Church of the Madonna di San Biagio in Montepulciano (1518–
1534), a structure inspired by Giuliano's Santa Maria delle Carceri at
Prato (1484–1492), which Antonio finished after his brother's death.
As in Giuliano's church, the Madonna di San Biagio features a **Greek
cross plan,** though here, instead of four equal arms, Antonio only
used three, the fourth forming the main **apse.** In the exterior, there are
only three equal façades instead of four, and Antonio added two tow-
ers by the main entrance, the second with only the first story com-
pleted. Like Giuliano, Antonio applied the **Colosseum principle** to
the exterior. He also used alternating niches and **pediments** and small
obelisks at the corners of the third story. The building is capped by a
dome on a high drum and lantern reminiscent of **Donato Bramante**'s
dome in the Tempietto (c. 1502–1512; **Rome**, San Pietro in Monto-
rio). In the interior, the proportions are stocky, the walls are white-
washed and trimmed with travertine, and engaged columns support a
Doric frieze. Antonio's ability to synthesize the elements he learned
from his brother Giuliano and Bramante resulted in a new **classical**
Tuscan vocabulary.

SANGALLO THE YOUNGER, ANTONIO DA (1485–1546). Italian
architect, the nephew of **Giuliano da Sangallo** and **Antonio da San-
gallo the Elder.** In c. 1503, Antonio went to **Rome** where he first
worked with **Donato Bramante** at **St. Peter's,** acting as his assistant
and draughtsman. In c. 1539, he was put in charge of the basilica's
construction. This proved to be a major debacle as the wooden model
he produced was not well received by his contemporaries. One of his
harshest critics was none other than **Michelangelo,** who in 1564
completed the building. Antonio's most notable work is the **Palazzo
Farnese** in Rome (c. 1513–1546), commissioned by Cardinal
Alessandro **Farnese** to serve as his principal residence. In 1534, the
cardinal ascended the papal throne as **Paul III** and asked Antonio to
increase the size of the original design to reflect his new position of
power. Much to Antonio's mortification, the pope also announced a

competition for the palace's cornice. Michelangelo won and, after Antonio died, he completed this building as well.

SANSOVINO, JACOPO (JACOPO TATTI; 1486–1570). Florentine architect and sculptor who trained with Andrea Sansovino from whom he adopted his surname. He traveled to **Rome** in 1505 or 1506 where he entered **Donato Bramante**'s circle. For the next two decades he split his time between Rome and Florence, leaving the papal city permanently in 1527 when imperial forces invaded. Sansovino established himself in **Venice**, where he spent the rest of his life. In 1529, he was appointed principal architect of the Venetian Republic, an office he held for 40 years. In 1537 he began his greatest masterpiece, the **Library of St. Mark**, built directly across from the **Doge's Palace**. The purpose of the structure was to house the famous book collection of the humanist **Cardinal Basilius Bessarion** who bequeathed it to the Venetian Republic in 1468. In 1545, a major frost caused part of the building's ceiling to collapse, resulting in Sansovino's imprisonment. His friends **Titian** and **Pietro Aretino** spoke out in his favor and he soon was released and able to resume his position as official architect. Sansovino did not see the building completed; his pupil, Vincenzo Scamozzi, finished the structure after his death.

The library adjoins the Campanile of the Basilica of St. Mark. At the Campanile's foot, Sansovino built a small **loggia**, called the Loggetta (beg. 1538), meant as a meeting hall for Venetian patricians during the Councils of State. Its design, based on an ancient **triumphal arch**, harmonizes with the design of his library. The other major commission Sansovino received from the Venetian Republic was the Zecca or mint (beg. 1536), adjoining the library. With this structure, Sansovino introduced to Venice the **Mannerist** custom of **rusticating** the columns of the façade, already used by **Giulio Romano** in the **Palazzo del Tè** (1527–1534) in Mantua. The *Palazzo Corner de la Cà Grande* (beg. c. 1545) is the only major commission Sansovino received from a private family. The structure, with its Mannerist elements also inspired by Giulio Romano, established a new Venetian palace type that was to be emulated by future architects in the 16th and 17th centuries. *See also* SACK OF ROME.

SANT' ANDREA, MANTUA (beg. 1470). The church commissioned from **Leon Battista Alberti** by Ludovico **Gonzaga**, Duke of Mantua, to house the relic of the holy blood of Christ brought to Mantua by St. Longinus after the **Crucifixion**. Alberti believed that the traditional Gothic church design with **nave** and aisles was impractical because the piers of the nave arcade blocked the full view of the main altar. Therefore, at Sant' Andrea he provided a longitudinal, aisleless structure. Alberti added a series of oculi (round openings) to provide focus to the main altar through light, and a **coffered** barrel **vault** to lead the visitor's eyes in that direction. Instead of a nave arcade to support the vault, Alberti added massive piers that alternate with arched entrances to the side chapels. The design was inspired by the Roman baths of Diocletian and the Basilica of Constantine Alberti studied in **Rome**. In the exterior, the architect used a **triumphal arch** motif, symbol of the triumph of Christianity over paganism, yet instead of capping the façade with a rectilinear attic, as was done in ancient Roman examples, he used a **pediment**. He also applied the colossal order, his own invention inspired by the massive scale of Roman prototypes. Alberti's inventive design became widely used in the 16th and 17th centuries, particularly in the building of **Jesuit** churches, among them **Il Gesù** (1568–1584) in Rome.

SANTA CROCE, FLORENCE (beg. 1294; consecrated 1442). Santa Croce is the **Franciscan** Church of **Florence**, its design commonly attributed to **Arnolfo di Cambio**. During the planning stages, the Franciscans were divided on whether to build a modest design that accorded with their vow of poverty or to emulate the **Dominicans** with whom they competed and who at the time were involved in erecting the impressive Church of **Santa Maria Novella** (1279–early 1300s), also in Florence. In the end, they opted for an opulent structure, made possible through donations from local merchant families. Like Santa Maria Novella, Santa Croce has a **Latin cross plan** with **nave** bays that are twice as wide as they are long. The **apse** is polygonal with a greater number of chapels flanking it than those in the rectangular apse at Santa Maria Novella. As in the Dominican church, Santa Croce has an elevation consisting of a nave arcade and **clerestory**, though the windows here are larger for more effective illumination. Instead of the four-partite **vault** system of Santa Maria Novella, Santa Croce is tim-

ber-roofed. Also different is the use of a **triumphal arch** pierced by two pointed windows to separate the apse from the rest of the church and a catwalk that sets apart the nave arcade from the clerestory. *See also* BARDI CHAPEL, SANTA CROCE, FLORENCE; BARDI DI VERNIO CHAPEL, SANTA CROCE, FLORENCE; BARONCELLI CHAPEL, SANTA CROCE, FLORENCE; PAZZI CHAPEL, SANTA CROCE, FLORENCE; PERUZZI CHAPEL, SANTA CROCE, FLORENCE; REFECTORY, SANTA CROCE, FLORENCE.

SANTA MARIA NOVELLA, FLORENCE (1279–early 1300s; façade c. 1456–1470). Built to function as the mother church of the **Dominican Order** in **Florence** and partially financed by the Florentine State, Santa Maria Novella features a traditional **Latin cross plan** with square **apse** flanked by two square chapels at either side. The central bays are also squared to allow for large, open spaces that can accommodate sizable crowds during the mass and on feast days. The aisle bays are half the size of the central bays and contain a number of small chapels allocated to wealthy Florentines for funerary purposes and private devotion. The building's elevation consists of a **nave** arcade and **clerestory** of equal height, this last featuring oculi (round openings) instead of the customary squared windows. The repetition of geometric forms and mathematical relations lend to the structure its symmetry and harmonious proportions, while the fourpartite **vault** allows for effective acoustics so the mass may be heard from all parts of the church. The façade, financed by Giovanni Rucellai, a wealthy Florentine merchant, is by **Leon Battista Alberti** and became the prototype for **Baroque** church façades of the late 16th and 17th centuries. It was conceived as a series of square modules of equal size, with two forming the lower story and one centered above them. A volute (ornamental scroll) at either side of the upper square visually unifies the two levels. In conceiving his design, Alberti utilized the Roman principles of order, balance, and symmetry reintroduced in the 15th century by **Filippo Brunelleschi**, thereby updating the modular approach to building of the unknown Late Gothic architect who designed the rest of the structure. *See also CHIOSTRO VERDE*, SANTA MARIA NOVELLA, FLORENCE; GUIDALOTTI CHAPEL, SANTA MARIA NOVELLA, FLORENCE; STROZZI CHAPEL, SANTA MARIA NOVELLA, FLORENCE.

SANTI LUCA E MARTINA, ROME (1635–1664). In 1588, the **Accademia di San Luca** purchased the chapel of Santa Martina, a small seventh-century structure that stood by the Roman Forum. In 1634, **Pietro da Cortona** became the academy's director and obtained permission to build his own funerary chapel in the old structure. During construction, the saint's body was unearthed so, to celebrate the event, Cardinal Francesco **Barberini**, nephew of Pope **Urban VIII** and the academy's protector, commissioned Cortona to design a whole new church. Since the building now belonged to the academy, the new church was dedicated to both Sts. **Luke** (in Italian, *Luca*) and Martina. Cortona opted for a **Greek cross plan** with longer and narrower arms than customary and placed the façade to overlook the ancient forum, fitting for the theme of the triumph of Christianity over paganism common to the Renaissance and **Baroque** eras. His is the first church façade ever created to utilize curvilinear planes, an element that was to be repeated many times throughout the 17th and 18th centuries. The pairing of colossal columns and jutting steps that emphasize the main entrance and invite the viewer into the interior are common to churches built during the **Counter-Reformation** era. The structure's crowning glory is the **dome**, a ribbed construction over a tall drum pierced by large windows with rhythmic undulations, characteristic of Cortona's style. The interior is a silvery monochrome, with doubled columns supporting the entablature. Textures increase as the building rises. The windows feature garlands, scrolls, shells, and female heads, and the **vaulting** and dome are **coffered** and trimmed with the Barberini bees and laurel, lilies of chastity, and palms of martyrdom. Aside from asserting Barberini patronage, this decorative crescendo glorifies the sacrifice of St. Martina who suffered torture and martyrdom at the hand of Alexander Serverus for refusing to bow to pagan idols.

SANTI, RAPHAEL. *See* RAPHAEL SANTI.

SANTO SPIRITO, FLORENCE (beg. 1436). Built by **Filippo Brunelleschi**, Santo Spirito is modeled after the Early Christian basilicas of **Rome**. Gone are the Gothic elements of the churches built in **Florence** before Brunelleschi's time, such as **Santa Croce** (beg. 1294) and **Santa Maria Novella** (1279–early 1300s), including the pointed arches and four-partite **vaults**. Instead, the church pres-

ents a simple three-aisled system and a flat roof. In the place of the Gothic compound piers (piers with columns attached to them), Brunelleschi's **nave** arcade is supported by Corinthian columns. To increase the height of the structure, he added impost blocks (flat slabs that sit above the capital of a column) to the arcade, a Byzantine feature also used on Italian soil in places such as Ravenna, once part of the Byzantine Empire. Brunelleschi covered the interior walls with white stucco trimmed with *pietra serena*, characteristic of his architecture and used by subsequent Florentine masters until the 19th century. Here, Brunelleschi utilized a Pythagorean approach to architecture. Consequently, the width of the nave is the same as the height of its arcade, and the aisle bays are half the height and width of the nave bays. By applying this system, Brunelleschi was able to create a harmonious, rational design that follows the ancient Roman principles of construction he learned when he measured the antique monuments of Rome during a visit at the onset of his career.

SARAZIN, JACQUES (c. 1588–1660). French sculptor who studied under Nicolas Guillain, **Simon Guillain**'s father. From c. 1610 to c. 1627, Sarazin was in **Rome** completing his training and there he worked for the architect **Carlo Maderno**. He also came into contact with **Domenichino**, **Francesco Mochi**, Pietro Bernini, and **François Duquesnoy**. From these masters he adopted a **classical** visual language that was to permeate his works for the rest of his life. Back in France, Sarazin worked on the sculptural program in the Pavillon de l'Horloge at the Louvre Palace in Paris (1641) and directed the decorations of the Château des Maisons, built by **François Mansart** in 1642–1646 for René de Longueil. His caryatids in the Louvre pavilion represent the earliest instance of classical-idealized sculpture in France.

One of Sarazin's most important commissions is the *Tomb of Henri de Bourbon* (1648–1663), prince of Condé, in the Church of **St. Paul-St. Louis** in Paris. The execution of the work was interrupted by the Fronde (civil war; 1648–1653) and completed only after the sculptor's death. Unfortunately, it was moved to Chantilly in the 19th century where it is now housed in the local Musée Condé and rearranged so it no longer presents Sarazin's original intentions. His *Prudence*, part of the monument, features figures reliant on ancient prototypes with restrained movement of figures and drapery folds.

In 1630–1660, Sarazin also worked on the pendant figures of the penitent Sts. **Peter** and **Mary Magdalen**. Commissioned by Magistrate Pierre Séguier for his chapel in the Church of Saint-Joseph-des-Carmes, the two figures are the namesaints of Séguier and his wife, Madeleine Fabri. Peter is shown with hands clasped in a zigzagging pose and troubled expression, at his feet the rooster who crowed after he denied Christ. Mary Magdalen is an elegant, idealized figure with her ointment jar in one hand and a towel in the other used to wipe her tears. Sarazin's works established the standard for French **Baroque** sculpture for the rest of the century, and particularly at Versailles.

SARTO, ANDREA DEL (1486–1530). Florentine painter who trained in the studio of Piero di Cosimo, an artist known mainly for his mythic landscapes inhabited by strange creatures. Andrea del Sarto did not adopt his master's peculiar subjects. Instead, he was deeply influenced by the art of **Leonardo, Raphael**, and Fra Bartolomeo. As a result, his figures are elegant and monumental, his compositions rational and balanced, and his colors harmonious. By the second decade of the 16th century, with the absence of **Michelangelo** and Raphael from Florence and Leonardo now deceased, del Sarto became the city's leading painter. His *Annunciation* (1512; Florence, Palazzo Pitti) is an early work created for the Monastery of San Gallo in Florence. It is unusual in that the archangel Gabriel is placed on the right, instead of the more common left. Also, the **Virgin** is standing, not sitting, and the scene takes place in front of a temple and not the customary domestic setting. The softness of contours and hazy quality in this work, particularly around the figures' eyes, are the result of del Sarto's implementation of Leonardo's **sfumato** technique.

Del Sarto's *Madonna of the Harpies* (1517; Florence, **Uffizi**) is his best-known work and belongs to his mature style. Here, **St. John the Baptist**, who holds a book, relies on one of the figures in Raphael's *School of Athens* in the **Stanza della Segnatura** (1510–1511) at the Vatican, though the sculptural approach to draperies and figures is Michelangelesque. This work is as unconventional as his earlier *Annunciation*. The Virgin is not enthroned but stands above a pedestal decorated with harpies, female winged monsters from mythology who carry away the souls of the dead. Del Sarto's *Lamentation* (1524; Florence, Palazzo Pitti) he painted for the Church of San Pietro in Luco, where he and his family spent some time to save themselves

from the **plague** that struck Florence in 1523. The work is an illustration of the doctrine of transubstantiation when the blessed host becomes the actual body and blood of Christ as signaled by the chalice, paten, and host stacked in front of Christ's dead body. Here, Andrea opted for an unconventional X-shaped composition, instead of the preferred pyramidal arrangements of his contemporaries. Among Andrea's late works is the *Assumption of the Virgin* (1526–1529; Florence, Palazzo Pitti), painted for the Church of San Antonio dei Servi in Cortona and financed by Margherita Passerini whose namesaint, Margaret of Cortona, is included in the painting. Del Sarto trained a number of important masters in his workshop, among them **Jacopo da Pontormo**, **Rosso Fiorentino**, and **Giorgio Vasari**.

SASSETTA (STEFANO DI GIOVANNI; active c. 1423–1450). Considered the greatest painter of the early 15th century in Siena, Sassetta's most notable work is the *Sansepolcro Altarpiece* of 1437–1444, painted for the high altar of the Church of San Francesco in Borgo Sansepolcro. This double-sided altarpiece was dismantled and the panels scattered in various museums, leaving scholars with the problem of reconstructing the intended order of the scenes. A *Virgin and Child* flanked by four saints occupied the front, *St. Francis in Ecstasy* (now Settignano, Villa i Tatti) the verso, while the rest of the panels depicted scenes from the saint's life. The *St. Francis in Ecstasy* divulges Sassetta's awareness of the latest **Florentine** developments for his saint displays the same substance and verism as **Masaccio**'s figures. As a Sienese master, Sassetta combined these Florentine elements with a profusion of gilding and brilliant palette, both frequently seen in Sienese art.

SASSETTI CHAPEL, SANTA TRINITÀ, FLORENCE (1483–1486). This chapel was **frescoed** by **Domenico del Ghirlandaio** for Francesco Sassetti, a wealthy **Florentine banker** and associate of the **Medici**, with the major episodes of the life of his namesaint, **Francis**. The frescoes include the saint's renunciation of worldly goods, the vision that led to his receiving the stigmata (the wounds of the crucified Christ), the test of fire before the sultan to demonstrate his faith, the confirmation of the rules of the **Franciscan Order** he founded, his funeral, and the resuscitation he effected posthumously of a boy who fell from a window. This last scene, called the *Miracle*

of the Child of the French Notary, occupies the center tier of the altar wall. The boy is shown on his **bier** surrounded by mourners, including members of the Sassetti family. Saint Francis appears in the heavens and blesses the child, who sits up and clasps his hands in prayer as if thanking him for the miracle. The scene takes place in front of the Church of Santa Trinità, where the frescoes are housed, instead of **Rome** where the event is said to have taken place. It is believed that the inclusion of this scene of death and rebirth and its predominant placement had to do with the death of Francesco Sassetti's oldest son, Teodoro, in 1479, and the birth of his new child a few months later. Ghirlandaio himself stands on the extreme left among the Sassetti and looks directly at the viewer, a common way for artists of the era to assert their authorship of their works.

In the *Confirmation of the Rules of the Franciscan Order*, Ghirlandaio included **Lorenzo "the Magnificent"** and other members of the Medici family as witnesses to St. Francis' presentation of the rules to Pope Honorius III. Ghirlandaio again situated the scene in Florence by including an architectural background reminiscent of the Piazza della Signoria in front of the **Palazzo Vecchio**. In the *Funeral of St. Francis*, the **classical** setting reflects the latest developments in Florentine architecture, the **vanishing point** placed at the **crucifix** that sits above the altar to indicate the saint's profound devotion for and emulation of Christ.

The Sassetti chapel's **altarpiece** depicts the Annunciation and Adoration of the Shepherds, with the donors, Francesco and his wife, Nera Corsi, frescoed on the wall at either side. This altarpiece was influenced by **Hugo van der Goes'** *Portinari Altarpiece* (c. 1474–1476; Florence, **Uffizi**), then in the Portinari Chapel in the Church of San Egidio, Florence. Ghirlandaio's emphasis on details, poses of the shepherds, their crudity and emotionalism, and the profusion of objects and flowers in the foreground are all elements taken from van der Goes' painting. *See also* ANNUNCIATION TO THE SHEPHERDS.

SATYR. A mythical half-beast, half-man who frolics in the woods. As a lustful creature who pursues **nymphs** and enjoys drinking, the satyr represents the bestial aspects of human nature. Satyrs had been part of the repertoire of mythic creatures in art since antiquity. In the Renaissance, these creatures were once again depicted, often in the

company of **Bacchus**, god of wine, as **Annibale Carracci**'s *Triumph of Bacchus* on the **Farnese ceiling** (c. 1597–1600; **Rome, Palazzo Farnese**) exemplifies. In the North, though satyrs were also rendered frolicking and imbibing, more often than not they were placed within the family context, with equally half-beast, half-human wife and offspring, as demonstrated by **Albrecht Altdorfer**'s *Satyr Family* (1507; Berlin, Staatliche Museen) and **Jacob Jordaens'** *Satyr and Peasants* (c. 1620; Munich, Alte Pinakothek). **Artemisia Gentileschi** offered a unique depiction of the creature in her *Corsica and the Satyr* (1640s; private collection). Tired of being pursued, the astute nymph donned a hairpiece that came off as the satyr tried to grab it, allowing her to get away.

SAVONAROLA, GIROLAMO (1452–1498). Ascetic friar from Ferrara who entered the **Dominican Order** in 1475 in **Bologna** after hearing a powerful sermon. In 1490, at the request of **Lorenzo "the Magnificent" de' Medici**, Savonarola transferred to the **San Marco Monastery** in **Florence** where he was appointed prior in the following year. No sooner had he received this post than he began criticizing the Medici's materialism and misuse of power, accusing them of promoting paganism. Lorenzo died in 1492 and his son Piero, who lacked his father's political savvy, took over the leadership of Florence. When Charles VIII of France threatened invasion, Piero ceded to him the city of Pisa, causing great anger among the Florentines and his subsequent exile. In the Medici's absence, Savonarola became the regulator of morality. He persuaded the Florentines to bring to San Marco articles of luxury and texts deemed to be pagan and immoral for public burning. This, unfortunately, resulted in the destruction of a number of important works of art and other precious items. Additionally, Savonarola established a group of brothers who went door to door to remove luxury and gambling objects and to persuade Florentines to renounce the frivolous life. Savonarola's downfall began when he attacked Pope **Alexander VI** from the **pulpit**. The pope ordered him to stop preaching and yet the monk continued to do so even after his excommunication in 1497. By now, the Florentines had tired of Savonarola's fanaticism and, in 1498, he and his followers were tried for heresy, tortured, and hung in front of the **Palazzo Vecchio.**

SAX, ANDRÉS MARZAL DE (active 1393–1410). Marzal de Sax may have been a native of Saxony, but was active in Valencia, Spain, from 1393 until his death in 1410 where he became one of the local exponents of the **International Style**. He is believed to have studied with Pedro Nicolau as the earliest work he rendered, an **altarpiece** for the **Confraternity** of St. James, was a collaboration with this artist. He was to work together with other Valencian painters, among them Gonzalo Pérez in 1404 and Gerardo Gener in 1405. In 1410, Marzal de Sax received free lodging from the city of Valencia for his artistic merits and generosity in imparting his knowledge of art to fellow local masters. In the documents relating to this grant he is qualified as ill and impoverished.

Marzal de Sax's most outstanding work is the *Retable of St. George* (c. 1400–1410; London, Victoria and Albert Museum), a complex altarpiece that consists of three major scenes in the center presenting St. George fighting the dragon, the Battle of El Puig de Santa Maria (1238) when James I of Aragon conquered Valencia, and a nursing **Virgin** and Child surmounted by an adult enthroned Christ. At either side are 16 narrative panels of the life of St. George and on the *predella* are scenes from the **Passion**. Marzal de Sax's art is characterized by the use of elongated crude types crowded into the pictorial space and engaged in overstated gestures, as well as heavy gilding, all part of the language of the International Style.

SCHEDONI, BARTOLOMEO (1578–1615). Caravaggist painter from Modena, Italy, whose career was cut short when he committed suicide at the age of 37 after a night of heavy gambling losses. Schedoni was the son of a maskmaker who worked for the d'**Este** dukes in Modena and for the **Farnese** in Parma. Having recognized Schedoni's talent, Duke Ranuccio I Farnese sent the 17-year-old to **Rome** to train as painter. There Schedoni entered the studio of the **Mannerist** Federico Zuccaro, but an illness forced him to return to Parma where he spent the rest of his life. Schedoni was described by his contemporaries as an ill-tempered individual who engaged in violence more than once; in 1600 his hostile behavior caused his temporary banishment from Parma. Among his most notable works is the *Entombment* (c. 1613; Parma, Galleria Nazionale), painted for the Capuchin convent at Fontevivo in the Parmese countryside, founded by

Ranuccio in 1605. The work relates to **Caravaggio**'s *Entombment* (1603–1604; Vatican, Pinacoteca) in the use of sculptural forms, crude figure types, dark background, emphasis on diagonals, and dramatic **chiaroscuro**. **Mary Magdalen**'s gesture with arms raised denotes that Schedoni's was a deliberate reinterpretation of Caravaggio's version. Other important works by Schedoni include his *Charity* (1611) at the Museo Nazionale di Capodimonte in Naples and *The Two Maries at the Tomb* (1613) in the Galleria Nazionale in Parma.

SCHÖN, ERHARD (c. 1491–1542). German woodcut designer from Nuremberg who was influenced by **Albrecht Dürer** in whose house he lived for a while. Over 1,000 woodcut illustrations by Schön have survived, including those in Johann Koberger's *Hortulus Animae* of 1517–1519, a popular compilation of prayers. In the mid-1520s, Schön embraced Lutheranism and devoted his time to creating engravings that furthered the Lutheran anti-Catholic agenda. Schön is best remembered for his *Four Rulers* (c. 1534), an anamorphic woodcut that includes the portraits of the **Hapsburg Charles V** who condemned Martin Luther at the Diet of Worms in 1521, his brother and heir Ferdinand I, Pope **Paul III** who would later convoke the **Council of Trent** to curtail the spread of Protestantism, and **Francis I** of France who persecuted the Protestants of France. When viewed head-on, the work is a blur of zigzagging lines. The figures do not reveal themselves until viewed from the left and at a low angle. The work is the ultimate expression of the interest in optics that had awakened in the 15th century among Northern masters.

SCHONGAUER, MARTIN (c. 1435–1491). German painter and engraver. The son of a goldsmith, Schongauer moved with his family from Augsburg to Colmar in c. 1440, becoming a citizen there in 1445. Twenty years later, he is recorded at the University of Leipzig, though the document does not specify whether he was there as a student receiving an education or as an artist fulfilling a commission. The only painting that can be attributed to him with certainty is the *Virgin of the Rose Bower* (1473; Colmar, Church of St. Martin), the style of its rendition akin to that of **Dirk Bouts** and **Rogier van der Weyden**. Although his mastery is evident in this work, the medium in which he truly excelled was printmaking. Of his engravings, 115 have survived

and they too depend on the Netherlandish idiom. The most often discussed print by his hand is the *Temptation of St. Anthony* (c. 1470–1475), a circular composition with the saint floating in midair while taunted by demonic creatures. The subtle gradations from dark to light, the able draughtsmanship, and the image's emotive power mark Schongauer as one of the most remarkable printmakers in history. His superb talent was to have a great impact on the field of printmaking and to influence **Albrecht Dürer** who wanted to study with the master, only to hear of his death upon arrival in Colmar.

SCOREL, JAN VAN (1495–1562). Dutch Romanist painter from Schoorl, a village near Alkmaar; the bastard son of a priest, his birth legitimized by Emperor **Charles V** in 1541. While attending Latin school in Alkmaar, Jan van Egmond, who later became the city's burgomaster, recognized van Scorel's talent and sent him to study with Cornelis Buys, Jacob Cornelisz van Oostsanen's brother. Some scholars believe that van Scorel also studied with van Oostsanen himself in 1512 and that he may have gone to Utrecht in c. 1517–1518 where he would have met fellow Romanist **Jan Gossart**. In c. 1518–1519, he also went to **Venice** and, in 1520, he left for the Holy Land with a group of pilgrims. Two years later, he was in **Rome** where the Dutch Pope Hadrian VI put him in charge of the antiquities housed in the Belvedere, a position he lost when the pope died in 1523. Five years later, van Scorel settled in Utrecht where by 1551 he owned three houses and acted as canon of the local parish church. He died in Utrecht in 1562.

Some of van Scorel's works show the influence of Venetian art, as seen in his *Death of Cleopatra* (c. 1522; Amsterdam, Rijksmuseum), a **Giorgionesque** reclining nude in a landscape, and *Mary Magdalen* (c. 1529; Amsterdam, Rijksmuseum), a three-quarter sculptural figure set outdoors that recalls some of the compositions of Palma Vecchio and **Lorenzo Lotto**, both active in Venice. Van Scorel's *Baptism of Christ* (c. 1528; Haarlem, Frans Halsmuseum) is a landscape populated by seminude figures inspired by **Michelangelo**, and his *Presentation in the Temple* (c. 1530–1535; Vienna, Kunsthistorisches Museum) unfolds within a **Bramantesque** architectural setting that recalls **Raphael**'s *School of Athens* in the **Stanza della Segnatura** at the Vatican (1510–1511). Van Scorel's eclecticism no doubt resulted

from his enthusiasm for the many lessons the Italians had to offer. He was responsible for the artistic training of **Anthonis Mor** and **Maerten van Heemskerck**, who owe their interest in the Italian idiom to their master.

SCUOLA DI SAN ROCCO, VENICE. One of the six major **confraternities** of **Venice**, founded in 1478 and dedicated to St. Rock (in Italian, *Rocco*) who spent most of his life tending to those stricken by the **plague**. The Scuola's meeting hall contains approximately 50 paintings by **Tintoretto** executed between 1564 and 1587 and most dealing with scenes from the life and **Passion** of Christ. These provide unusual renditions of traditional religious scenes that are filled with action, enhanced by the brisk application of paint and sharp diagonal arrangements.

In the *Last Supper*, Tintoretto placed the table in a diagonal that recedes rapidly into space, instead of in the usual frontal position. Christ is shown in the background administering the Eucharist to **St. Peter**, while servants in an adjoining room prepare the meal and a dog in the foreground adds to the commotion. Instead of a solemn scene, the work presents a noisy, mundane depiction that focuses on Christ's humanity more than his divinity. The *Crucifixion*, a work of huge proportions, shows a panoramic view of Golgotha filled with figures. Again, Tintoretto provided a noisy scene with soldiers pulling up the crosses of the thieves who were crucified alongside Christ, mourners at the Savior's feet, men betting on a game of dice, and other incidentals. The dynamism of the scene is augmented by the series of diagonals Tintoretto included, as well as the heavy **foreshortening** of figures and crosses. Other works include the *Adoration of the Shepherds*, *Baptism of Christ*, *Christ before Pilate*, *Road to Calvary*, *Ascension*, *Brazen Serpent*, and *Moses Drawing Water from the Rock*. This commission represents one of the most extensive ever granted to a single artist of the Renaissance, and stands among the greatest masterpieces of the era.

SEBASTIAN, SAINT. A Roman soldier during the reign of Diocletian who converted to Christianity and miraculously cured several individuals, including the deaf-mute Zoé and the prefect Chromatius who suffered from gout. He was shot with arrows and left for dead

for professing his faith, his martyrdom depicted by **Antonello da Messina** in 1476–1477 (Dresden, Gemäldegalerie). St. Irene nursed him back to health, which is the scene **George de La Tour** presented in 1650 (Paris, Louvre), but, when Sebastian denounced the emperor for the cruelty he directed at Christians, he was beaten to death and his body thrown into the Cloaca Maxima, the main sewer line in **Rome**. His beating is the subject of **Albrecht Altdorfer**'s painting for the Monastery of Sankt-Florian (1515), and the disposal of his body was rendered by **Ludovico Carracci** in c. 1613 (*St. Sebastian Thrown into the Cloaca Maxima*; Los Angeles, J. Paul Getty Museum). St. Sebastian is the patron saint of archers and soldiers. Because of the cures he effected, and the fact that St. Irene nursed him back to health, he is usually invoked during illness and the **plague**.

SERAPION, SAINT (1628; Hartford, Wadsworth Atheneum). Painted by **Francisco de Zurbarán** for the Monastery of the Merced Calzada in Seville, Spain, the work shows a saint of the Mercedarian Order to which the monastery belonged. The Mercedarians took a vow of poverty and exchanged themselves for Christian hostages. Their history therefore includes a large number of members who were martyred, including St. Serapion. Peter Serapion was a British member of the order who lived in the 12th century and who fought against the Moors in Spain. Travels through Europe to liberate Christian captives led to his arrest in Scotland by pirates. They bound his hands and feet, beat him, and then dismembered and disemboweled him. They also partially severed his neck, leaving his head to dangle. This is how Zurbarán depicted him. In the painting, St. Serapion's hands are tied, his head tilted to the side, his forehead marked by a welt. Though the details of the saint's death are brutal, Zurbarán chose to depict a pristine white robe without any trace of blood or other evidence of violence. Pinned to Serapion's robe is the badge of the Mercedarian Order, and his pose is that of a **crucified** Christ— elements that denote the selfless sacrificial act of the Mercedarians. Zurbarán also included the words *Beatus Serapius* written on a crumpled paper nailed on the right post onto which the saint is tied. St. Serapion was canonized in 1728 for choosing a heroic death for the sake of the faith.

SERLIO, SEBASTIANO (1475–c. 1553). Architect from **Bologna** who trained with **Donato Bramante** in **Rome**. After the 1527 **sack of Rome**, Serlio moved to **Venice** where he lived until 1541, when he was invited by **Francis I** of France to his court to act as advisor in the construction of the Palace of Fontainebleau. Most of Serlio's buildings were destroyed. In France, only his Château d'Ancy-le-Franc (1544–1550) remains, which Serlio built for Antoine III of Clermont, one of the king's courtiers. This structure is built around a central courtyard, with a three-story elevation, pitched roof, and a square tower marking each corner. Though essentially French in form, the application of the Doric order on the façade and the emphasis on symmetry and simplicity are the hallmarks of Italian construction.

Serlio's greatest contribution to architecture was in writing. He published a series of treatises on its various aspects. The first, published in 1537, was Book IV and dealt with the architectural orders, followed by Book III (1540) on ancient monuments, Books I and II (1545) on geometry and **perspective**, Book V (1547) on churches, the *Libro Extraordinario* (1551) on gateways, and Book VII (published posthumously in 1575) on accidents architects may suffer. Two versions of Book VI, on domestic architecture, and his *Castramentation of the Romans*, on Roman encampments, were known until recently only in manuscript form. Book III is of particular value as it was the first publication ever to include woodcuts of ancient Roman buildings, making them available to architects and humanists all over Italy and other parts of Europe. Having been translated into French, Flemish, and German, Serlio's books in general were responsible for disseminating abroad the Italian architectural vocabulary and design principles. Also, the profusion of woodcut illustrations in these books and the short explanatory texts facing them inaugurated a new phase in the architectural treatise genre. Serlio's method in fact inspired **Andrea Palladio** to approach his ***Quattro Libri*** in the same manner.

***SEVEN ACTS OF MERCY*, CHURCH OF THE MADONNA DELLA MISERICORDIA, NAPLES (1606).** Painted by **Caravaggio** who used as his source a passage from the Gospel of **St. Matthew** where the seven acts of mercy (in Italian, *misericordia*) are listed. These are the feeding of the hungry, providing drink to the thirsty,

sheltering the homeless, clothing the naked, tending to the sick, bury-
ing the dead, and visiting those in prison. In the painting these acts
are depicted as Samson drinking from the jawbone of an ass, a man
welcoming a pilgrim in need of shelter, St. Martin giving half his
cloak to a naked ill man, a corpse being carried away for burial, and
Pero visiting her father Cimon in prison and sustaining him with her
breastmilk. The **Virgin** and Child and two adolescent angels hover
above in a complex intertwined arrangement and convey their ap-
proval of the scene below. The painting's intended message is that
salvation is attainable through good deeds, as advocated by the
Church of the **Counter-Reformation**. An oppressive atmosphere
permeates the work, mainly due to the fact that the space above the
figures is dark and takes up more than half of the pictorial surface.
This is characteristic of Caravaggio's post-Roman phase and reflec-
tive of the turbulence in his life from constantly running from the law.

SEVEN DEADLY SINS. *See* VIRTUES AND VICES.

SFORZA FAMILY. *Sforza* (*strength*) was the nickname of the **condot-
tiere** Muzio Attendolo and soon was adopted as the family's surname.
Muzio's son Francesco Sforza married Bianca **Visconti** from the rul-
ing family of Milan, thus inheriting his father-in-law's dominion.
Francesco was succeeded as Duke of Milan by his despot son, Gian-
galeazzo Maria, who was assassinated in the Church of San Stefano in
1476 by republican conspirators. Giangaleazzo's son and namesake,
still a child, was deposed in 1494 by his uncle **Ludovico "il Moro"
Sforza**. Ludovico encouraged Charles VIII of France to invade
Naples, but he soon realized that this could end in French invasion in
Milan. To prevent such a fate, he obtained the protection of Holy Ro-
man Emperor **Maximilian I**, but to no avail as Louis XII of France,
who was related by blood to the Visconti, invaded in 1500 and im-
prisoned Ludovico. In 1512, the Holy League, an alliance formed by
Maximilian, Pope **Julius II**, Ferdinand II of Aragon, and others to ex-
pel the French from Italy, stormed Milan and reinstated the Sforza,
who ruled, with few interruptions, until 1535 when the family died
out. The Sforza were the patrons of **Antonello da Messina, Antonio
Filarete, Leonardo da Vinci**, and **Donato Bramante**.

SFORZA, LUDOVICO "IL MORO" (1451–1508). Ludovico "Il Moro" **Sforza** assumed the title of Duke of Milan in 1494, a position he seized from his young nephew Giangaleazzo Sforza who had not yet attained his majority. A year earlier, he had allied himself with **Venice** and the papacy against Naples and **Florence** and had encouraged the French King Charles VIII to invade the Neapolitan territory. When it became clear that his own position was being threatened by the French, Ludovico allied himself with Emperor **Maximilian I**, giving him his niece, Bianca Maria Sforza, in marriage. Louis XII, who had claims over the Duchy of Milan as he was related by blood to the **Visconti**, the previous Milanese rulers, invaded in 1500 and had Ludovico imprisoned in the Castle of Loches, where he died.

Political blunders aside, Ludovico was enthusiastic about learning and the arts. He penned the lives of illustrious men and was the patron of **Leonardo da Vinci** who, while in his service, painted the *Last Supper* (1497–1498) for the **Dominicans** living in the Monastery of Santa Maria delle Grazie, favored by Ludovico. He also painted the portrait of Ludovico's mistress, Cecilia Galleriani, called the *Portrait of a Woman with an Ermine* (c. 1485; Cracow, Czartoryski Museum). The architect **Donato Bramante** also worked for Ludovico in Milan on the Church of Santa Maria delle Grazie (beg. 1493), where he contributed the **transept**, crossing (where the **nave** and transept cross), and **apse**, and the Church of Santa Maria presso San Satiro (beg. 1478) where the **perspective relief** in the apse brilliantly solves the problem of little space to produce an imposing design.

SFUMATO. The Italian word for *smoky*, it refers to a shading technique developed by **Leonardo da Vinci** to soften the contours in his paintings and add an ethereal effect. The technique entails gradually darkening colors and layering them onto the pictorial surface in such a way as to blur the lines from light to medium to dark until they become imperceptible. Leonardo's *Mona Lisa* (1503; Paris, Louvre) and *Madonna of the Rocks* (1483–1486; Paris, Louvre) embody this technique. In both paintings, the forms seem to be emerging from the dark, a feature that imbues the scenes with an aura of mystery. A number of Renaissance masters adopted sfumato as part of their own

visual vocabulary, among them **Domenico Beccafumi**, **Correggio**, **Giorgione**, and **Parmigianino**.

SIBYLS. Sibyls were women from the ancient era who could foretell the future. They were named for their region of origin. So, for example, the Delphic Sibyl was from Delphi, the Libyan Sibyl from Libya, and so on. The Romans identified 10 sibyls in their writings, each associated with an oracular shrine where they obtained the information that allowed them to declare their prophecies, like the Persian Sibyl who foretold Alexander the Great's successes in battle while presiding over the Oracle of **Apollo** in Babylon.

The Early Christian leaders interpreted the prophecies of the sibyls as announcements of the coming of Christ. As a result, sibyls were commonly depicted in religious art. The best-known representations of these women are in **Michelangelo's Sistine ceiling** at the Vatican (1508–1512). **Jan van Eyck** included sibyls and **prophets**, their male counterparts, on the **lunettes** of the *Ghent Altarpiece* (c. 1425–1432; Ghent, Cathedral of St-Bavon) above the *Annunciation*. **Andrea del Castagno** added the Cumean Sibyl to the group of illustrious men and women he painted in the **loggia** of the Villa Carducci at Legnaia (1448; now in **Florence, Uffizi**), **Raphael** rendered five sibyls above an arch in the **Chigi** Chapel at Santa Maria della Pace, **Rome** (1512–1513), and **Domenichino** painted an unidentified sibyl (1616–1617; Rome, Galleria **Borghese**) as a single figure surrounded by musical instruments, as supposedly these women imparted their prophecies through song.

SIENA, CATHEDRAL OF. To commemorate their victory against **Florence** in the Monteaperti Battle of 1260, the Sienese decided to dedicate their city to the **Virgin** and build a cathedral in her honor. The plan selected for the building was a traditional **Latin cross** with square **apse** and hexagonal crossing (where the **nave** and **transept** meet), its elevation comprised of a nave arcade supported by compound piers (piers with columns attached to them) and a **clerestory**. The black and white stripes of marble in both the cathedral's interior and exterior were specifically chosen to reference the founding of Siena by Senius and Aschius, sons of Remus, who, according to legend, were protected on their journey there by a white cloud at day-

time and a black cloud at night. Called the *balzana*, this black and white motif is part of the city's heraldic device, confirming that in Renaissance Siena faith and politics were intertwined.

The façade, built and decorated with statuary by **Giovanni Pisano** in 1285–1295, features a triple entrance crowned by gabled arches to symbolize the **Holy Trinity** (in its present form, only the lower portion of the façade is by Giovanni). Above is a gallery, rose window, and three gables, decorated with **mosaics** of the *Nativity*, *Coronation of the Virgin*, and her presentation to the temple. The façade sculptures include representations of the ancient philosophers **Plato** and **Aristotle**, the **prophet** Habakkuk, a **sibyl**, kings **David** and Solomon, and Moses. Most have been heavily restored and are now housed in the Museo dell' Opera del Duomo in Siena, making it difficult to reconstruct their original location and placement order.

In 1265–1268, Giovanni's father, **Nicola Pisano**, contributed his **pulpit** for the cathedral's interior. Then, in the 14th century, a number of **altarpieces** were commissioned for its decoration. In 1308–1311, **Duccio** painted the main altarpiece, the *Maestà* (Siena, Museo dell' Opera del Duomo). Then in the decades of the 1330s and 1340s, **Simone Martini** contributed his *Annunciation* (1333; Florence, **Uffizi**), **Pietro Lorenzetti** his *Birth of the Virgin* (1342; Siena, Museo dell' Opera del Duomo), and his brother **Ambrogio Lorenzetti** the *Presentation in the Temple* (1342; Florence, Uffizi). The Cathedral of Siena stands as one of the great monuments of the Italian Late Gothic era and reflects the civic pride of the Sienese and their devotion to the Virgin.

SIENA, GUIDO DA (active second half of the 13th century). Guido da Siena is considered the founder of the Sienese School. He painted in the *Maniera Greca* mode, as exemplified by his key work, the *Enthroned Madonna and Child* (c. 1280; Siena, **Palazzo Pubblico**). This **altarpiece**, commissioned by the **Dominican Order** for their Church of San Domenico, Siena, has been the subject of major debate. Its inscription states that Guido painted the work during the "happy days of 1221." Though seemingly authentic and used by the Sienese to assert their artistic priority over **Florence**, we are hard-pressed to justify the early dating of this masterpiece vis-à-vis the crudity of Sienese works in general during the early decades of the

13th century. It has been suggested that the 1221 date does not refer to the time of the altarpiece's execution, but rather to the year of the death of **St. Dominic**, to whom the Church of San Domenico is dedicated, and other events of importance to the Dominicans that took place in that year, including their establishment in Siena when they where ceded the hospice of Santa Maria Maddalena and the saint's visit to the city prior to his death in August.

The *Enthroned Madonna and Child* is the only work known with certainty to have been created by Guido. Several other works have been attributed to him based on stylistic analysis, including a gable-shaped *Crucifixion* panel at the Yale University Art Gallery, New Haven (c. 1260), a gabled *Coronation of the Virgin* at the Courtauld Institute, London (mid to late 13th century), and two panels in the Louvre Museum, Paris, depicting the Nativity and **Presentation** (1270s–1280s).

SILENUS. Depending on the ancient source consulted, Silenus is either the son of Pan or **Mercury**. Custodian, educator, and follower of **Bacchus**, he is normally represented in art as a jolly heavy-set figure who rides on a donkey, wears a crown of flowers or grape leaves, and is perpetually inebriated. **Jusepe de Ribera** presented the *Drunken Silenus* (1626; Naples, Museo Nazionale di Capodimonte) as a comical reclining nude holding up a glass of wine for one of his **satyr** companions to drink—a spoof on the sensuous female nudes from the **Venetian** School. Silenus is also featured in **Annibale Carracci's** *Triumph of Bacchus*, the central scene on the **Farnese ceiling** (c. 1597–1600; **Palazzo Farnese, Rome**), riding his donkey in the bacchic procession. In the *Glorification of the Reign of Pope Urban VIII* (1633–1639; Palazzo **Barberini**, Rome), he is included among the satyrs to denote the pope's rejection of lust and intemperance.

SINOPIA. An underdrawing for a **fresco** that is rendered in red earth mixed with water. Examples of sinopie that have been revealed during restorations are those now housed in the Papal Palace in **Avignon** for frescoes commissioned from **Simone Martini** by Cardinal Jacopo Stefaneschi in the 1340s in the Church of Notre-Dame-des-Doms. They represent a *Blessing Christ* and a *Madonna of Humility*. The sinopie for the *Triumph of Death* (1330s) in the Campo Santo,

Pisa, were also revealed during restorations after the fresco was badly damaged during World War II. Attributed to **Francesco Traini**, the sinopie were rendered more spontaneously than the final fresco, giving these underdrawings a robust, energetic flavor. A final example is the sinopia for **Andrea del Castagno**'s *Resurrection* (1447), which has also been detached from the wall and is now exhibited alongside the corresponding fresco in the **refectory** of the Monastery of Sant' Apollonia, **Florence**.

SINT JANS, GEERTGEN TOT (1460/1465–1490). According to **Karel van Mander**, the Dutch painter Geertgen tot Sint Jans was born in Leiden and studied with Albert van Ouwater. He worked in Haarlem for various monastic orders, including the Knights of the Order of St. John, with whom he lived and for whom he painted an **altarpiece**. The side panels of this work have survived and are housed in the Kunsthistorisches Museum in Vienna (c. 1484). The works include the *Lamentation* and the *Burning of the Bones of St. John the Baptist*, possibly painted to commemorate the knights' acquisition of parts of the saint's hand and arm from Sultan Bayazid in 1484. The *Lamentation* in particular shows the influence of **Hugo van der Goes**, which has prompted some to suggest that Geertgen may have trained in Bruges in c. 1475. Geertgen's *Nativity* (c. 1480–1485; London, National Gallery) denotes his interest in depicting supernatural light effects. In this work, the Christ Child becomes the light source that illuminates the rest of the figures, enhancing the sense of piety and humility that fills the work. The figures are delicate and elongated, their demeanor reserved. These types, humbled by the presence of the Savior, reappear in the several versions Geertgen painted of the *Adoration of the Magi*, among them the panel of c. 1490–1495 in the Cleveland Museum of Art, also influenced by van der Goes. According to van Mander, Geertgen died at the age of 28.

SISTINE CEILING, SISTINE CHAPEL, ROME (1508–1512). During the late 15th century decorative campaign of the **Sistine Chapel**, initiated by **Sixtus IV**, the ceiling was painted blue and dotted with stars to symbolize the heavens. In 1504, a large crack appeared on the ceiling and its repair left a dreadful mark. This gave Pope **Julius II**, Sixtus' nephew, the impetus to have it redecorated with a pictorial

program that would complement the earlier wall **frescoes** and thus provide a visual continuum of the two **della Rovere** papal reigns. Julius gave the commission to **Michelangelo**. At first, he asked the artist to render no more than the 12 **apostles** surrounded by ornamental motifs, but the scheme was soon modified when Michelangelo objected to the program's simplicity. We are told that the pope gave Michelangelo complete freedom to do as he wished, though he may have used a theological consultant for the task—perhaps the **Franciscan** Cardinal Vigerio della Rovere, the pope's cousin.

In the final design, Michelangelo chose multiple scenes organized in three coherent bands, the outer ones occupied by the **sibyls** and **prophets** who foretold the coming of Christ. Above each sit two *ignudi* (nude men), between them a fictive bronze medallion and in their hands oak leaves and acorns, references to the della Rovere family (*rovere* is *oak* in English). The **lunettes** above the chapel's windows and the spandrels between the seers are occupied by Christ's ancestors, while the corner spandrels feature scenes that prefigure Christ's sacrifice, specifically *David Slaying Goliath*, *Judith and Holofernes*, *The Brazen Serpent*, and *The Death of Haman*. In the central band are nine scenes from the Book of Genesis. Of these, three show God the Father creating the world, three portray scenes from the story of Adam and Eve, and three more are from the story of Noah. In rendering the ceiling, Michelangelo is known to have used about a dozen assistants, but mainly for the preparation stages. After that, he painted the frescoes almost entirely on his own, a gargantuan task considering that he included about 380 figures on a pictorial field that measures approximately 13,000 square feet.

The first scenes Michelangelo executed in the central band show some hesitation. The *Deluge* lacks unity, its figures scattered across the pictorial surface. Then, Michelangelo realized the importance of clarity and simplicity as these biblical episodes would be viewed from great distance. Therefore, in subsequent scenes he reduced the number of figures, monumentalized them, and brought them closer to the foreground. He also included only enough of the background details to convey effectively the story while creating little distraction from the main theme. The *Creation of Adam* shows these adjustments. It places all focus on the story's most important moment: God's index finger about to touch that of Adam to transmit the spark

of life. Overall, Michelangelo's figures are robust and sculptural, constructed of bold areas of color that imitate the surface of marble, bronze, and other sculpture materials. His keen observation of the human form in movement is reflected in his work. As figures pivot their skin creases, a foot tucked behind the opposite leg pushes the calf muscle forward, and no pose is ever repeated. Michelangelo has been criticized heavily in current scholarship for rendering masculine women. In this case, however, the choice would seem appropriate as the women depicted on the ceiling bear tremendous responsibility and therefore their exceedingly muscular makeup is justified. Eve, for instance, is the mother of humankind and the sibyls are the women who informed the world of the coming of Christ.

Many interpretations have been offered on the ceiling's program. For some, Michelangelo's work speaks of the history of humankind from a time before religion, to paganism, and finally the Christian era. In this reading, the move from blindness to enlightenment corresponds to the **Neoplatonic** tenet of the soul's trajectory from the mundane to the spiritual through contemplation in order to achieve union with God. Others have related the ceiling to **Dominican, Franciscan**, and **Augustinian** theology. **Pentecostal** and **apocalyptic** interpretations have also been offered.

In 1511, **Raphael** had the opportunity to view the Sistine ceiling when the scaffolding was temporarily removed. The impact of what he saw was so tremendous that he returned to his **Stanza della Segnatura** frescoes (1510–1511) and added Michelangelo to the *School of Athens*. He depicted the man dressed in the smock and soft boots of a stonecutter at the very front, isolated from all others so he could be spotted immediately. His brooding demeanor is that of *Melancholia*, the temperament of genius. By placing Michelangelo among the greatest minds of the ancient era, and depicting him as the personification of genius, Raphael paid homage to a man who had just achieved the inconceivable. Perhaps Michelangelo's stonecutter's attire expresses Raphael's frustration, consciously or otherwise, over the fact that a man who professed to be primarily a sculptor had just surpassed him in his own field.

SISTINE CHAPEL, ROME (fin. 1483). The Sistine Chapel was built for Pope **Sixtus IV** to replace the 13th-century Great Chapel of

Nicholas III. The proportions of the new structure followed the biblical description in I Kings of the Holy of Holies in Solomon's temple in Jerusalem where the Ark of the Covenant was housed. With this, Sixtus could compare himself to Solomon, hailed for his building activities and wisdom. The chapel's interior was decorated in 1481–1482 with **frescoes** by some of the leading central Italian masters of the period, namely **Sandro Botticelli**, **Domenico del Ghirlandaio**, Luca Signorelli, Cosimo Rosselli, and **Pietro Perugino**, this last believed to have overseen the commission. These men painted on the walls narratives from the lives of Moses and Christ, paired thematically to denote that the law of the Jews has been supplanted by that of Christians. Although the frescoes on the walls turned out to be somewhat of a fiasco as severe stylistic and compositional discrepancies exist between the scenes, some of the contributions stand out as masterpieces, among them Botticelli's *Punishment of Korah, Dathan, and Abiram*, Ghirlandaio's *Calling of Sts. Peter and Andrew*, and Perugino's *Christ Giving the Keys of the Kingdom of Heaven to St. Peter*. In this decorative campaign, the **vault** was covered in blue and dotted with stars to resemble the heavens, the understated design replaced in 1508–1512 by **Michelangelo**'s magnificent **Sistine ceiling**. Later, Michelangelo also replaced Perugino's *Assumption* on the altar wall, with his *Last Judgment* (1536–1541). The chapel's overall decoration serves as imposing backdrop for liturgical celebrations and the election of the new pope, which, to this day, takes place in this building. This is why the frescoes on the wall speak of papal primacy and authority while those on the ceiling relate the recognition by mankind of Christianity as the true faith.

SIXTUS IV (FRANCESCO DELLA ROVERE; r. 1471–1484). Sixtus IV was a **Franciscan** who served as the general of the order in 1464. In 1467, he received the cardinalate at the recommendation of the Greek Cardinal **Basilius Bessarion** who admired him for the theological treatises he wrote on divisive questions among Franciscans and **Dominicans**. When Pope Paul II died suddenly in 1471, Sixtus emerged as the favorite candidate during the conclave, his election ensured by his nephew Pietro Riario's promises of preferred treatment to the attending cardinals. Sixtus' reign was punctuated by mod-

est successes in crusades against the Turks, strained relations with Louis XI who required that papal decrees receive royal approval prior to their publication in France, negotiations with Russia for the unification of its church with that of **Rome**, and their support in the fight against the Turks. Sixtus also set up the Spanish Inquisition in 1478 and confirmed Tomás de Torquemada as grand inquisitor.

On the domestic front, Sixtus gave added privileges to the mendicant orders and he approved the Feast of the **Immaculate Conception**. He showered his family with favors, including his two nephews, Pietro Riario and Giuliano **della Rovere**, both of whom he appointed to the cardinalate soon after his election to the throne. In 1478, Sixtus was involved in the **Pazzi Conspiracy** against the **Medici**, which resulted in war against **Florence** (1478–1480). In 1482, he also involved himself in the war between **Venice** and Ferrara and, in the following year, he turned on Venice by imposing an interdict (suspension of public worship and withdrawal of the Church's sacraments) on the city.

Sixtus also committed himself to the aggrandizement of the papacy. To this effect, he called leading masters to Rome to work on the **Sistine Chapel** decorations, among them **Pietro Perugino**, **Domenico del Ghirlandaio**, and **Sandro Botticelli**. He was also the patron of **Melozzo da Forli**, whose experiments in **perspective** changed the history of ceiling painting, and **Antonio del Pollaiuolo**, who rendered his tomb in **St. Peter's**. Sixtus' restoration campaign, which included the widening and repaving of roads, the refurbishing of the Ospedale di Santo Spirito, and the building of Santa Maria della Pace, his family's final resting place, has earned him the recognition of having transformed Rome from a medieval to a Renaissance city.

SLEEPING VENUS (c. 1510; Dresden, Gemäldegalerie). The *Sleeping Venus* was painted by **Giorgione**, and perhaps completed by his pupil **Titian**. Unfortunately, heavy repainting in the 19th century has altered the work. X-rays have revealed that originally a **Cupid** knelt at Venus' feet, which would have provided balance to the composition. Also, some of the softness of the contours and facial details have been lost. In spite of these problems, the work still remains as a groundbreaking example of Renaissance art. It presents the goddess

of love sleeping in the landscape, her body echoing the shape of the natural forms around her. The figure's voluptuousness, her unabashed pose, and the lushness of the landscape in which she exists are common to Giorgione's art—a mode of representation of mythical scenes that would have an impact on the **Venetian** masters of the 16th century. This work presents the first female recumbent nude, a theme that was to become one of the most popular in the history of art.

SLUTER, CLAUS (c. 1350–1406). Claus Sluter from Haarlem is listed in the records of the stonemasons' **guild** in Brussels in 1379. In 1385, he entered in the service of **Philip the Bold** of Burgundy, who established the Chartreuse de Champmol, the Carthusian monastery in Dijon as his and his family's final resting place. Philip put Sluter in charge of the monastery's sculptural decorations in 1389 when his court mason, Jean de Marville, died. Sluter's *Well of Moses* (1395–1406; Dijon, Musée Archéologique), rendered for the Chartreuse, is among the most impressive of his surviving works. This piece was originally surmounted by a Calvary scene and polychromed and gilded by **Jean Malouel**, the duke's court painter. In its present state, the work features six life-size **prophets** holding scrolls, with Moses at the front. Though dependent on French Gothic precedents, Sluter's figures possess a monumentality and forcefulness not present in the more delicate, elegant figures of the Gothic style. For this reason, he is considered the father of Northern Renaissance sculpture and a pioneer of Northern realism. *See also* ROAD TO CALVARY.

ST. LUCY ALTARPIECE **(c. 1445–1447; Florence, Uffizi).** Painted by **Domenico Veneziano** for the Church of Santa Lucia de' Magnoli, **Florence**, this work presents major advancements in Renaissance religious art. It is one of the earliest depictions of the *sacra conversazione* type; here, the **Virgin** and Child interact with Saints **Lucy**, Zenobius, **Francis**, and **John the Baptist** in a silent conversation carried out through gestures and glances. The characters share one pictorial space, a format that would eventually render the **triptych** obsolete. Veneziano's colorism and skillful use of **perspective** are evident in this work. Gone is the gilded background of earlier Madonna and Child representations. Instead, the figures occupy an

impeccably rendered **loggia**. Light enters the space diagonally to add to the vibrancy of the colors and to bathe the figures and architectural surfaces. Veneziano's dependence on **Masaccio** is palpable in the gesture of the Baptist, which repeats the gesture of the Virgin in Masaccio's *Holy Trinity* (1427; Florence, **Santa Maria Novella**) that serves to bring the crucified Christ to the viewer's attention.

ST. PETER'S BASILICA, ROME. The Mother Church of the Catholic faith, built over **St. Peter**'s burial site. The history of St. Peter's basilica is quite complex. The first building to occupy the site was an Early Christian basilica with a **Latin cross plan** built during the reign of Emperor Constantine the Great. By the 15th century, the old structure had decayed considerably. Pope **Nicholas V** intended the reconstruction of its **apse**, for which new foundations were laid, but he died in 1455 and the project was abandoned. In 1503, Pope **Julius II** was elected to the throne and in 1506 he asked **Donato Bramante** to design a new basilica. Bramante's plan suggests that he intended to build a **Greek cross** structure with each arm flanked by smaller Greek crosses and towers at the corners. Since he only rendered half the cross, some believe that the plan only shows the basilica's **choir** to which a long **nave** and aisles were to be attached. A medal by Cristoforo Caradosso, one of Bramante's assistants, shows that the architect wanted to surmount each of the crosses with a **dome**, the largest surrounded by a colonnade. The façade was to employ a **classical** vocabulary with a **pedimented** entrance.

Bramante died in 1514 and was succeeded by **Raphael** and, in 1520, Baldassare Peruzzi also became involved in the project. Both masters provided a number of drawings intended to correct the shortcomings of Bramante's design, including the inadequate size of the central piers that were to support the main dome. In 1527, the **sack of Rome** halted building activity. Then **Antonio da Sangallo the Younger** became involved, writing a memorandum that criticized Raphael's design. Building moved slowly, until 1546 when Sangallo died and **Michelangelo** volunteered to complete the building without pay. Michelangelo reverted to Bramante's original plan. He thickened the outer walls and central piers and simplified Bramante's distribution of space, creating a more unified and coherent design. He then added a double-columned portico to the entrance to give it greater

definition. He used the colossal order, an **Albertian** feature, throughout, granting the structure a virile, robust appearance, not unlike the muscular figures in his paintings and sculptures. An imposing dome on a drum, completed after Michelangelo's death in 1564 by his pupil Giacomo della Porta, caps the structure.

In 1605, Pope **Paul V** called for a competition for the conversion of St. Peter's from a central to a longitudinal church and the building of a new façade. The motivation for this was the declaration by the **Council of Trent** that the Latin cross plan was better suited for the rituals of the mass. Also, the pope wanted the basilica to cover the same ground as the old Early Christian structure that had stood earlier on the site. **Carlo Maderno** won the competition and, between 1606 and 1612, he carried out the building's restructuring. He added a three-bay nave, continuing some of Michelangelo's features to ensure a harmonious design. His façade follows the principles established by Giacomo da Vignola and Giacomo della Porta in the Church of **Il Gesù**, **Rome** (1568–1584), mainly the rapid progression from the outer bays to the main portal.

Once completed, the pope decided to add towers at either end of the façade. This proved to be a disaster. Two outer bays were added to support the towers, but soon it was discovered that an underground spring would prevent a structurally sound construction. The project was abandoned, but the outer bays were left in place. These, unfortunately, ruined Maderno's well-planned proportions, a situation for which he has been severely and unjustly criticized. In the 1630s, **Gian Lorenzo Bernini** proposed the completion of the towers. With **Urban VIII**'s approval, he erected the south tower, but again the underground spring caused problems and the new structure began to crack. Bernini was able to redeem himself after this major blow to his career when in 1656–1667 he built for Innocent X the piazza in front of the basilica, a space now used to hold the crowds who come to hear the pontiff speak from the papal balcony, its colonnades the symbol of the all-embracing arms of the Catholic Church.

ST. SEBASTIAN THROWN INTO THE CLOACA MAXIMA (c. 1613; Los Angeles, J. Paul Getty Museum).
Cardinal Maffeo **Barberini**, later Pope **Urban VIII**, commissioned this work from **Ludovico Carracci** while serving as papal legate in **Bologna** for his

chapel in the Church of Sant' Andrea della Valle, **Rome**. The work is unusual in that it depicts the disposal of **St. Sebastian**'s body instead of the customary martyrdom by arrows or the tending to his wounds by St. Irene. When the arrows did not kill him, Emperor Diocletian ordered that the saint be beaten to death and his body thrown into the Cloaca Maxima, the main Roman sewer line. The saint appeared to his companion Lucina in a dream and told her where to find his body for proper burial in the catacombs. Lucina did as instructed, and eventually a church was built in the saint's honor to mark the site where his body was recovered. In the 16th century, that church was razed to make way for Sant' Andrea. The site of the high altar in the earlier church coincided with the location of Cardinal Barberini's chapel, hence the subject choice for Ludovico's painting. Once the work was delivered to the cardinal, he placed it in his home as, in his view, it did not inspire devotion sufficiently.

STANZA DELLA SEGNATURA, VATICAN (1510–1511). In 1509, Pope **Julius II** commissioned **Raphael** to **fresco** the Stanza della Segnatura in the Vatican, a meeting room for the papal tribunal of the Segnatura (seal), normally presided over by the pope. The frescoes represent the fields of theology, philosophy, law, and the poetic arts, reflecting the room's function as well as the humanistic interest of its occupants. The *Disputà* represents theology. It depicts the disputation over the doctrine of transubstantiation, the moment when the host, after having been blessed by the priest during the mass, becomes the actual body and blood of Christ. In the fresco, a church council presided over by the **Holy Trinity** and witnessed by saints, patriarchs, and **prophets** has gathered to discuss the doctrine's validity. The host, object of the debate, is displayed in a monstrance above the altar.

The *School of Athens* on the opposite wall represents philosophy. Here, **Plato** and **Aristotle** stand in the center of a space that recalls **Donato Bramante**'s design for New **St. Peter's**. Plato holds the *Timaeus*, one of his texts, and points upward to denote that his interests are in the world of ideas. Aristotle holds his *Nichomachean Ethics* and points down, as his concerns were directed at nature and its phenomena. In the niches behind them are **Apollo**, god of poetry and eloquence, and **Minerva**, goddess of wisdom, to provide inspiration to the men depicted. Nearby, Socrates speaks to the Athenean

youths he is said to have corrupted, Pythagoras demonstrates his system of proportions, Ptolemy holds a celestial globe, Euclid solves a problem of geometry, and Diogenes, the father of Cynicism, ponders. In the foreground is Heraclitus, a portrait of **Michelangelo** dressed in the smock and boots of a stonecutter and posed as *Melancholia*, the personality trait of a genius. Raphael included him in the fresco after viewing the **Sistine ceiling** (1508–1512; Vatican) to pay homage to the man's brilliance.

The law and poetic arts are represented in the **lunettes** at either side of the windows. The first shows *Emperor Justinian Presenting the Roman Civil Law to Trebonianus* and *Gregory XI Approving the Canon Law Decretals*, this last a portrait of Julius and members of his court. The second is a representation of Parnassus where Apollo and the **Muses** convene. Here, **Dante**, **Petrarch**, **Giovanni Boccaccio**, and Ludovico Ariosto exchange ideas with Homer, **Virgil**, and Sappho, their ancient counterparts. The fresco cycle also includes a depiction of the Cardinal **Virtues** in a lunette. Fortitude holds an oak tree, heraldic symbol of the **della Rovere** family to which Julius belonged. The Stanza della Segnatura's decorative program speaks eloquently of the general feeling that permeated the Renaissance as it depicts the greatest minds from antiquity who inspired the intellectual reawakening of the era.

STEPHEN, SAINT (?–c. 35 CE). St. Stephen was a learned member of the Jewish community of Jerusalem where, after his conversion to Christianity, he was ordained as deacon. His preaching successes ignited the jealousy of the Jewish elders who, unable to compete with him in religious debate, charged him with blasphemy. During his trial, St. Stephen denounced his accusers for failing to recognize the Holy Spirit. Those assembled dragged him through the city's outskirts and stoned him to death. With this, St. Stephen became the first Christian to be martyred. The details of his life are rendered in the **Chapel of Nicholas V** (1448) at the Vatican by **Fra Angelico** and the choir in **Prato Cathedral** (1452–1466) by **Fra Filippo Lippi**.

STROZZI CHAPEL, SANTA MARIA NOVELLA, FLORENCE (1355–1357). The wealthy **banker** Tomasso Strozzi commissioned

Andrea Orcagna and his brother Nardo del Cione to provide the decorations for his family chapel at **Santa Maria Novella**, the principal **Dominican** church of **Florence**. As the Strozzi Chapel is dedicated to **St. Thomas Aquinas**, a leading Dominican and Tomasso's namesaint, he figures prominently in the decorations. He is represented twice in the chapel's **altarpiece** (the *Strozzi Altarpiece*) painted by Orcagna and once in the large stained glass window above the altar. The altarpiece shows the Christ of the **Last Judgment** enclosed in a *mandorla* of seraphim and angels. He presents to the kneeling St. Thomas at his right a book opened in one of the passages from Revelations that speaks of final judgment. He also gives to **St. Peter** at his left the keys to the kingdom of heaven. Thomas is presented to Christ by the **Virgin Mary**, who is dressed in a Dominican habit, and Peter by **St. John the Baptist**, patron saint of Florence. Also present are St. Michael, who weighs the souls, **Catherine of Alexandria**, of particular significance to the Dominicans, **Lawrence**, and **Paul**. On the *predella* are *St. Thomas in Ecstasy during the Mass*, *Christ Walking on Water to Save Peter from Drowning*, and *The Saving of the Soul of Henry II* who, according to the **Golden Legend**, donated a gold chalice to the Cathedral of Bamberg, which gained him entry into heaven. These three scenes then speak of spiritual recognition, salvation through Christ, and reward in the afterlife.

On the chapel's altar wall, **frescoed** by Nardo, Christ again appears as judge, below him the Virgin, St. John the Baptist, the **apostles**, the blessed, and the damned. On the right wall is *Hell*, a chaotic scene based on **Dante**'s description in the *Inferno* with the **Seven Deadly Sins**, each carefully labeled to ensure their proper identification by viewers. On the chapel's left wall is a depiction of Paradise where the blessed line up in orderly fashion at either side of Christ and the Virgin, who welcome them to heaven while two musical angels add a celebratory tone. One question that arises is why the iconic imagery and the emphasis on death and last judgment at a time when **Giotto** had already introduced a naturalistic method of representation and rejected morbid medieval subjects in favor of humanized renditions of religious episodes. It has been suggested that the regressive attitudes demonstrated by Orcagna and Nardo del Cione in this commission reflect a fearful Florentine society, traumatized by the devastation caused by the **Black Death** of 1348.

STUDIOLO **OF FRANCESCO I DE' MEDICI, PALAZZO VEC-CHIO, FLORENCE (1568–1575).** The *studiolo* of Duke Francesco I de' **Medici** is located on the second story of the **Palazzo Vecchio** and was used for geological and alchemist studies, two of the duke's main interests. The doors of the cupboards that once contained his scientific books and instruments were painted by **Giorgio Vasari** and his pupils with scenes that link to the room's function. The program was devised by the learned Vicenzo Borghini, a Benedictine prelate, prior of the **Ospedale degli Innocenti** and first lieutenant to the artists' academy in **Florence**, who had close ties to the Medici and Vasari.

In all, 34 paintings were commissioned for the project with an overall theme of the relationship between art and nature. The ceiling, by Francesco Morandi and Jacopo Zucchi, establishes the tone for the rest of the decorations. It represents an allegory of nature that references the Pythagorean tetrad of the four elements (earth, wind, fire, and water), as well as the seasons and humors of man (sanguine, choleric, melancholic, and phlegmatic). The elements are then also referenced on the wall cabinets. So, for example, for water Vasari rendered his *Perseus and Andromeda*, which relates how sea coral was formed, and Alessandro Allori painted the *Pearl Fishers*, which depicts nude figures diving for pearls and frolicking by the seashore. Mirabello Cavalori's *Wool Factory*, which shows men engaged in the carding, boiling, and wringing of wool, would refer to the element of fire as the men in the foreground ensure that the blaze under the cauldron remains lit. Also related to fire is Giovanni Maria Butteri's *Discovery of Glass*, as the material is heated during its manufacturing.

The decorative program originally included eight statuettes contained in niches executed by **Bartolomeo Ammannati**, **Giovanni da Bologna**, Vincenzo di Raffaello de' Rossi, and others. These presented related mythological figures—for instance, Rossi's Vulcan, the god of fire. The *studiolo* was dismantled by Francesco I in 1586 and only reassembled in the early 20th century, which has led to questions on the original scheme and order of the works. The commission represents one of the most significant examples of late Florentine **Mannerism** and points to the Medici's contributions to the arts and learning.

SUPPER AT EMMAUS. An episode from the story of Christ that takes place after the **Resurrection**. Christ appears to two of his **apostles** at

Palestine who do not recognize him. They tell him of their grief over the death of the Savior and the disappearance of his body from his tomb. The three men go to Emmaus and when Christ breaks the bread during supper, the disciples finally realize who he is. **Caravaggio** painted two versions of this theme, in 1600 (London, National Gallery) and again in 1606 (Milan, Pinacoteca di Brera), the earlier being the more dramatic rendition. This version was Abraham Blomaert's prototype for his *Supper at Emmaus* of 1622 (Brussels, Musées Royaux des Beaux-Arts), a work with the same theatrical lighting effects and dramatic gestures as Caravaggio's. **Rembrandt** painted several versions, including the one in 1648 at the Louvre in Paris. **Jacob Jordaens**' painting of the subject of c. 1650 is in the National Gallery of Ireland in Dublin.

SUSANNA AND THE ELDERS. The story of Susanna and the elders stems from the **Apocrypha**. Susanna was the wife of a wealthy Jew from Babylon. One day, as she was taking a bath in her garden, two elderly men who lusted after her surprised her and forced her to submit to their sexual advances. As she rejected them, they accused her of having committed adultery for which the penalty was death. At the trial, Daniel separated the elders and exposed the contradictions of their testimony, clearing Susanna's reputation. The story had been a favored subject in art since the Early Christian era when it appeared in Roman catacombs, with Daniel's restoration of Susanna's reputation as the scene usually depicted. In the Renaissance, artists transformed the religious theme of vindication into an erotic, voyeuristic scene. In these works, Susanna is shown bathing in the nude and the two elders hide behind bushes to watch her. Examples of this type are **Tintoretto**'s version of c. 1555–1556 (Vienna, Kunsthistorisches Museum), **Ludovico Carracci**'s of 1616 (London, National Gallery), and **Anthony van Dyck**'s of 1621–1622 (Munich, Altepinakothek). **Artemisia Gentileschi**'s version of c. 1610 (Pommersfelden, Graf von Schoenborn Collection) still shows the nude female, but now harassed by the men. **Albrecht Altdorfer** (1526; Munich, Alte Pinakothek) saw the theme as an opportunity to demonstrate his skills in rendering the landscape. His fully clothed Susanna is being watched by the elders as her feet are washed—the scene a mere incidental event unfolding in the vast idyllic setting. The transgression does not go unpunished as on the right the men are stoned to death.

SWEET STYLE. A style in sculpture and painting that came to domi-
nate the art of the mid-14th century in Tuscany. It is characterized by
the use of refined, elegant figures that exhibit a certain sweetness.
The greatest exponent of this style was **Desiderio da Settignano** who
often depicted the tenderness shared by the **Virgin** and her son, or
smiling figures. An example is his *Virgin and Child* (c. 1460) in the
Philadelphia Museum, a **relief** that captures a playful, intimate mo-
ment between the characters depicted. **Antonio Rossellino**, who like
Desiderio was a native of Settignano, adopted the Sweet Style, as ex-
emplified by his smiling Madonna and Child and gentle angels who
gaze at the Cardinal of Portugal in his tomb (1460–1466) at San
Miniato, **Florence**. **Alesso Baldovinetti** translated the Sweet Style
from sculpture into painting. His *Virgin and Child* (c. 1460) in the
Louvre, Paris, presents a smiling Madonna with the customary deli-
cate features of this mode. *See also TOMB OF THE CARDINAL OF
PORTUGAL*, SAN MINIATO, FLORENCE.

– T –

TASSO, TORQUATO (1544–1595). Italian poet, writer, and theorist,
active in Ferrara. Tasso was born in Sorrento and educated in law and
philosophy at the universities of Padua and **Bologna**. Soon thereafter,
he entered in the service of Cardinal Luigi d'**Este** and later Luigi's
brother Duke Alfonso II. While in their service, Tasso wrote the *Am-
inta* (published in 1573), one of the greatest examples of Renaissance
pastoral drama, and the *Gerusalemme liberata* (published in 1581),
an epic romance that celebrates the d'Este family's ancestry. Tasso
suffered from mental illness, which caused his imprisonment in 1577
after a violent outburst in front of Lucrezia d'Este and a stay in the
Hospital of Santa Anna from 1579 to 1586. Upon his release, he
moved to Mantua where he enjoyed the protection of Duke Vincenzo
Gonzaga. He spent the last years of his life moving from city to city.
He died in **Rome** in the Monastery of San Onofrio.

TEMPERA. A painting medium composed of pigments that are mixed
with egg, glue, or casein. Until the introduction of **oils** in the 15th
century, tempera was the medium used for panel painting, normally

applied over a smooth coat of white gesso. The advantage of tempera is that it is fast drying and produces brilliant colors and clear, sharp outlines. The disadvantage is that it is an opaque medium that does not lend itself to transparent effects. Once oils were introduced, many 15th- and 16th-century masters used oil overlays over a tempera underpainting to achieve both the luminosity of oil paints and the precision of tempera.

TEMPIO MALATESTIANO, **RIMINI (SAN FRANCESCO; beg. 1450).** Meant as a pagan shrine, this temple was one of the pieces of evidence used by Pope Pius II in 1462 against **Sigismondo Malatesta** to prove his impiety. A church dedicated to **St. Francis** already existed on the site where the *Tempio Malatestiano* now stands, then used by the Malatesta as their mausoleum. Sigismondo charged the Veronese architect Matteo de' Pasti to renovate the existing structure by adding two chapels to function as his own memorial and that of his mistress Isotta degli Atti. In the process, Pasti destroyed **frescoes** painted in the 14th century by **Giotto**. In 1450, a jubilee year, Sigismondo went to **Rome** to participate in the celebrations and there he met **Leon Battista Alberti** who criticized Pasti's work, so Sigismondo invited him to submit his own plans. The new designs were accepted and Pasti carried out the rest of the commission under Alberti's direction through correspondence from Rome.

Sigismondo wanted his body and that of Isotta to have their final resting place in sarcophagi inserted into niches in the building's façade alongside that of famous men, including the Greek humanist Gemistus Pletho whose body Sigismondo recovered when he led the **Venetian** army against the Turks in Morea (1465). For this, Alberti used a series of arched niches that provide a rhythmic repetition, calling to mind the aqueducts of the ancient Romans. The greatest challenge Alberti faced in this project was how to apply a **classicized** façade onto a medieval structure where the height of the nave is greater than the aisles. He found the solution in the **triumphal arches** of the ancients. He looked to the arches of Constantine in Rome and Augustus in Rimini for inspiration. The ancient motif is suitable to a funerary structure as it can be related to the concept of triumph over death—in this case not in the religious sense, however, but as a result of the deceased's deeds. The arches of Alberti's façade are surmounted

by a large **pediment** broken by another partially built arch that is flanked by pilasters at either side—an Albertian invention.

The project was halted in 1461 when Sigismondo had his fallout with the pope that resulted in his public excommunication and casting to hell in front of **St. Peter's** in the following year. We know from Alberti's written instructions to Pasti and a medal struck when the cornerstone was laid that Alberti intended to include a large **dome** over the **choir**. Alberti, a great admirer of **Filippo Brunelleschi**, utilized the same principles of design his predecessor had introduced to the field of architecture. His classically inspired structure, emphasis on the rhythmic repetition of forms, and sober approach are all Brunelleschian elements.

TERBRUGGHEN, HENDRICK (1588–1629). Terbrugghen was born in Deventer, Holland, and taken to Utrecht as an infant. He went to Italy in c. 1603, and spent a decade in **Rome** and visiting Milan and other major cities. He returned to Utrecht in 1614 where he became one of the leading figures among the **Utrecht Caravaggists**. His *Calling of St. Matthew* (1621; Utrecht, Centraal Museum) borrows heavily from **Caravaggio**'s painting of the same subject in the **Contarelli Chapel**, Rome (1599–1600, 1602). The diagonal formed by the light entering the room, the theatrical costumes, eyeglasses worn by the elderly man, and crude types, all stem from Caravaggio's work. His *Bagpipe Player* (1624; Cologne, Wallraf-Richartz Museum) was inspired by Caravaggio's young, sensuous boys, while the cascading of figures in his St. *Sebastian Attended by St. Irene* (1625; Oberlin, Allen Memorial Art Museum) borrows compositionally from the Italian master's ***Entombment*** (1603–1604; Vatican, Pinacoteca).

TESSERAE. Small pieces of stone or glass cut into squares and used to create **mosaics**. Tesserae of different colors are glued to the wall, ceiling, or floor to form an image or decorative pattern and the spaces between them are then grouted to produce an even surface. This method was devised in the ancient era to decorate interior domestic and public spaces with mythological or political scenes. With the adoption of Christianity as the official faith of the Roman Empire, the subjects of the mosaics changed from mythological to religious. Bril-

liantly colored tesserae were applied to the wall surfaces of churches to create images that awed the faithful and instructed them on Christian doctrine. The glitter produced by the tesserae, especially those cut from colored glass, provided a splendorous backdrop for the mass. These types of mosaics continued to be produced well into the Proto-Renaissance era. Examples include **Jacopo Torriti**'s **apse** mosaics in the Basilica of St. John Lateran (c. 1291) and at Santa Maria Maggiore (c. 1294), **Rome**, **Coppo di Marcovaldo**'s mosaics covering the **vault** of the **Baptistery of Florence** (second half of the 13th century), and **Giotto**'s *Navicella*, the scene when Christ walks on water to save **St. Peter** from drowning, once placed in the courtyard façade of Old **St. Peter's** (c. 1307, destroyed) *See also* COSMATESQUE STYLE.

THE TEMPEST (c. 1500–1505; Venice, Galleria dell' Accademia). Painted by **Giorgione**, the subject of *The Tempest* is not completely understood. The **Venetian** collector and connoisseur Marcantonio Michiel recorded in 1530 in his journal that he saw the painting in the house of fellow collector Gabriel Vendramin, noting that it represents a gypsy and soldier in a landscape. The woman, whoever she may be, is nude and sits on a white sheet while nursing her baby. In the background, a thunderbolt appears among the thick, dark clouds where a storm is brewing. Her anxiety over the weather conditions is read clearly in her facial expression. Regardless of the subject, the work is a masterful representation of figures in a landscape with an atmosphere so thick that the viewer can almost feel the dampness in the air. Giorgione granted the scene an ethereal quality, typical of his mature style, by applying to it a lush, soft brushwork. The profusion of earth tones and greens dotted with deep reds stem from the palette of **Leonardo da Vinci** who visited Venice in 1500 where Giorgione was active. *The Tempest* is the earliest known work to portray a sensuous, voluptuous female nude in the landscape, a subject that will be repeated many times by the members of the 16th-century Venetian School.

THERESA OF AVILA, SAINT (1515–1582). Saint Theresa, a native of Avila in the Castilian region of Spain, decided to pursue the religious life at a young age. In 1536, she entered the Carmelite convent

of Avila where she began to experience visions that at first caused her great concern, but soon a spiritual adviser helped her recognize that these were mystical occurrences. In the 1560s she began a reformation campaign of the Carmelite Order by establishing new convents all over Spain. She met bitter opposition until, in 1580, Gregory XIII persuaded King **Philip II** of Spain to give recognition to her new Order of the Discalced Carmelites. While engaged in these efforts, St. Theresa wrote her *Autobiography* (1565), *The Way of Perfection* (1573), and *Interior Castle* (1577), all meant as instructional manuals and considered today to be among the most notable examples of mystic literature. Her writings inspired **Gian Lorenzo Bernini** to render her experiencing one of her mystical moments in the **Cornaro Chapel** in the Church of Santa Maria della Vittoria, **Rome** (1645–1652). In 1622, **Gregory XV** canonized St. Theresa and, in 1970, she was declared a Doctor of the Church, the first woman to receive such an honor.

THOMAS AQUINAS, SAINT (c. 1225–1274). Saint Thomas Aquinas is considered one of the greatest representatives of Scholasticism. He was born near Aquino, Italy, to a noble family related to the royal house of France and he entered the Benedictine Monastery of Monte Cassino at the age of five. In 1239, he attended the University of Naples and five years later joined the **Dominicans** in that city. His family was so opposed to his decision that they kidnapped and imprisoned him for 15 months in an attempt to persuade him to renounce his religious calling. Their efforts were futile as, once released, the saint rejoined the Dominicans and taught for them in Naples, Orvieto, **Rome**, and other major Italian cities. Pope Gregory X invited St. Thomas to discuss the reunion of the Greek and Latin churches at the General Council of Lyons, but he died on his way there. He was canonized in 1323 by Pope John XXII, and declared one of the Doctors of the Church in 1567. His writings, which include the *Summa Theologica*, *Quaestiones Disputatae*, and *Summa contra Gentiles*, became the basis for modern Catholic theology.

In art, St. Thomas is portrayed often. In the *Triumph of St. Thomas* of c. 1340, painted for the Church of Santa Caterina in Pisa and attributed to **Francesco Traini** or **Lippo Memmi**, he receives wisdom from Christ, the **Evangelists**, and the philosophers of the ancient

world, including **Plato** and **Aristotle**. The most important episodes of his life are the subject of the decorations by **Filippino Lippi** in the Carafa Chapel at Santa Maria sopra Minerva, Rome (beg. 1489). He also figures prominently in the **Strozzi Chapel** at **Santa Maria Novella** (1355–1357), the Dominican church of **Florence**, as one of the most notable representatives of the order.

TINTORETTO (JACOPO ROBUSTI; 1518–1594). Leading master of the **Venetian** School, along with **Titian** and **Paolo Veronese**. *Tintoretto* is a nickname that resulted from his father's profession as a fabric dyer (in Italian, *tintore*). Carlo Ridolfi, who wrote Tintoretto's biography in 1642, informs that the artist was apprenticed to Titian who influenced him and with whom he had a turbulent relationship that led to his eventual expulsion from the master's studio. His works are known for their dynamism and spontaneity that at times lead to the raw canvas peeking through his pictorial surfaces. Tintoretto, in fact, is said to have worked with very large brushes that allowed him to apply the colors swiftly. Also characteristic of his style is the mixing of deep reds with black for application in the shaded areas, which add a visual richness to his scenes.

The work that established Tintoretto's reputation is the commission he received from the Scuola di San Marco, one of the six large **confraternities** in Venice. This was his *St. Mark Freeing a Christian Slave* (1548; Venice, Galleria dell' Accademia) for the Scuola's meeting hall, where a slave is punished for having visited the saint's relics in Alexandria without his master's consent. He and the **foreshortened** St. Mark who comes to his rescue form two parallel diagonals that rapidly recede into space, one of Tintoretto's favored compositional arrangements. The astonished figures who witness the miracle twist and turn in dynamic poses as do the draperies in response to their movements. When the painting was unveiled, Titian's pupils criticized it to the point that the discouraged Tintoretto removed the work. It was not until 1562 that he returned it to the Scuola and then received two further commissions that continued the story of St. Mark, patron saint of the confraternity and also of Venice.

The first of these works, the *Transport of the Body of St. Mark* (1562–1566; Venice, Galleria dell' Accademia), relates how the saint's body was rescued from his tormentors, who wished to burn it.

A major storm broke out that impeded them from carrying out the desecration, which allowed Christians to recover the body for proper burial. Among the rescuers is Tommaso Rangone from the Scuola, who arranged for the commission, and Tintoretto himself. To enhance drama, a stormy sky lurks above the scene and water runs down the stairs of a nearby building. The *Discovery of the Body of St. Mark* (1562–1566; Milan, Brera) takes place centuries later when Venetians travel to Alexandria to recover the saint's body from the Saracens. As they remove corpses from their sarcophagi, Mark appears to them to prevent further desecrations, his raised hand on the vanishing point of **perspective**. Rangone is again included, here kneeling at the saint's feet. In these works, the rapid recession and heavy foreshortenings are even more pronounced, the brushwork has become much looser, and the drama has intensified.

The success of these paintings led in 1564 to a commission from the members of the **Scuola di San Rocco**—a *Crucifixion* for the Sala dell' Albergo in their meeting hall. This scene was a tremendous undertaking as it measures 40 feet in width and offers a panoramic view of Golgotha populated by a large number of figures. Soldiers pull up the crosses of the thieves who were crucified alongside Christ, others engage in a game of dice to see who will win the Savior's garments, and the **Virgin** faints in the foreground. The scene is noisy and filled with action and emphasizes the human aspect of Christ and his followers, not their divinity. Tintoretto eventually was asked to render close to 50 scenes from the Old and New Testament in the Scuola's Sala Grande and the ground floor. These include the *Adoration of the Shepherds*, the ***Last Supper***, *Christ before Pilate*, and ***Road to Calvary***, works that offer innovative interpretations of traditional scenes. Like the *Crucifixion*, these paintings are filled with pronounced diagonals and extreme foreshortenings, resulting in vigorous compositions that stress the mundane aspects of the lives of the religious protagonists.

By the early 1590s, Tintoretto began to mix the mundane with the otherworldly, as his *Last Supper* at San Giorgio Maggiore (1592–1594) demonstrates. Here, translucent angels witness the event from above, servants clear the dishes, a cat attempts to steal a morsel, and a dog chews on a bone. To this period also belongs Tintoretto's *Paradise* (1588–1592) in the Great Council Hall at the

Doge's Palace, Venice. A large **fresco** in this room by the Paduan painter Guariento da Arpo, rendered in the early 14th century and depicting the **Coronation of the Virgin**, was destroyed in 1577 by fire. Tintoretto was asked to replace it with a large complex scene that included some of the same elements as Guariento's earlier work, specifically a Christ and Virgin in the center of the composition and the Virgin Annunciate on the upper left to reference the founding of Venice on 25 March, the Feast of the **Annunciation**. Surrounding the main figures are the **Evangelists**, saints, **prophets**, and angels, with St. Michael holding the scales used to judge the souls on the upper right. The Great Council Hall was the meeting room where the patricians who ruled the city made their political decisions, so the work reminded these men to judge wisely and to look to Christ and the Virgin for divine inspiration.

Tintoretto was as accomplished a painter of mythologies and allegories as of religious works. His *Susanna and the Elders* (c. 1555–1556; Vienna, Kunsthistorisches Museum), the *Origin of the Milky Way* (c. 1570; London, National Gallery), and *Ariadne, Bacchus, and Venus* (1576; Venice, Doge's Palace) demonstrate that he was as adept at rendering erotic female nudes as Titian. Tintoretto proved to be a major force in the development of **Baroque** art. His sharp oblique arrangements, heavy foreshortenings, and noisy, active scenes became common elements of the Baroque repertoire. *See also LAST SUPPER*, SAN GIORGIO MAGGIORE, VENICE.

TITIAN (TIZIANO VECELLIO; c. 1488–1576). Titian was born in Pieve di Cadore on **Venetian** territory. He first trained with **Giovanni Bellini** and later **Giorgione**, whose *Sleeping Venus* (c. 1510; Dresden, Gemäldegalerie) and *Fête Champetre* (c. 1510; Louvre, Paris) are believed by some to have been collaborations with Titian. By c. 1510, Titian became an independent master, catering to some of the most important patrons of the period, including Emperor **Charles V**, who knighted the artist, and Charles' son, King **Philip II** of Spain.

Titian's *Noli me tangere* (c. 1510; London, National Gallery) is one of his earliest works and shows the influence of Giorgione, particularly in the lush application of paint, the emphasis on earth tones, olive greens, and deep reds, the sensuous seminude body of Christ, and the pastoral landscape. Titian's *Man with Blue Sleeve* (c. 1511–1515;

London, National Gallery), believed by some to be a self-portrait and by others to represent the poet Ludovico Ariosto, also belongs to his formative years, and yet represents a major innovation in the field of portraiture in that it shows the man in an animated pose with body in profile, head turned, eyes gazing intently at the viewer, and a **foreshortened** arm resting on a parapet with elbow jutting into the viewer's space—elements that until then did not figure in the history of portraiture, at least not collectively. Also innovative is the placement of the figure against a dark, undefined background to relegate all focus on his persona.

Portraiture became one of Titian's strongest suits. His *Young Englishman* (c. 1540–1545; Paris, Louvre) and *Ranuccio Farnese* (1542; Washington, National Gallery) depict two aristocrats, the one unidentified and the other a member of the family of Pope **Paul III**. Titian also depicted the pope himself in 1543 (Toledo, Cathedral Museum). In these works, the master captured not only the appearance of his sitters but also their character. The Englishman is aloof, his gloves, gold chain, and ring stressing his elevated status; young Ranuccio is a shy, innocent 12-year-old boy; and the pope is a stern, authoritarian figure, his papal ring prominently displayed to assert his position of power. In 1548, Titian spent nine months in Germany working for Charles V. His *Charles V on Horseback* (1548; Prado, Madrid) follows the precedent of ancient equestrian imperial portraits that equate the ability to ride with that of commanding an army. With this work, Titian established the official portrait type for members of the Spanish court, a format that both **Peter Paul Rubens** and **Diego Velázquez** would later adopt.

Titian's religious works are just as innovative as his portraits. His *Assumption of the Virgin* (1516–1518; Venice, Santa Maria dei Frari) was his first public commission and depicts a scene that up to that point had been represented in a rather formulaic manner. Titian injected life into it by conveying the excitement of the **apostles** as they witness the **Virgin Mary**'s ascent to heaven. Some point up, others hold their hands in prayer, and others still comment to each other on the event. The scene is imbued with a celebratory tone, appropriate as it preambles Mary's **coronation** as queen of heaven. Titian's *Madonna of the Pesaro Family* (1519–1526; Venice, Santa Maria dei Frari) follows the format established by Giovanni Bellini

of placing the Madonna and Child on an elevated throne flanked by columns and set against a landscape. However, the artist here introduced a new twist. Mary's throne is now at an angle to form a sharp diagonal, granting a sense of dynamism to the work, and the Christ Child is a playful toddler who lifts his mother's veil over his head to play peek-a-boo. Titian's *Mary Magdalene* (c. 1535; **Florence**, Palazzo Pitti) is a far cry from **Donatello**'s emaciated figure (1430s–1450s; Florence, Museo dell' Opera del Duomo). Instead, she is a sensuous nude with long, flowing hair that does little to cover her nudity. His *Pietà* of c. 1576 (Venice, Galleria dell' Accademia; completed by Palma Giovanne) he painted for his own tomb in the Church of Santa Maria Gloriosa dei Frari. While it follows the format established by **Michelangelo** in his Roman *Pietà* (1488/1499–1500) with the body of Christ sprawled on his mother's lap, here again Titian composed a more energetic scene. The distressed **St. Jerome**, a self-portrait, crawls toward Christ to touch his lifeless hand, and Mary Magdalen runs with her right arm elevated as if to announce to the world that the Savior has died.

Titian was also a masterful painter of mythological and allegorical scenes. His *Sacred and Profane Love* (1514; **Rome**, Galleria Borghese) relates to Giorgione's *Fête Champetre* in which the sensuous female nude is placed within a pastoral landscape. The three mythologies he created for Alfonso I d'**Este**, Duke of Ferrara, to be placed in his *Camerino d'Alabastro* depict erotic bacchanals (scenes related to **Bacchus**) set in luscious landscapes. The scenes are based on the *ekphrases* written by Philostratus, the ancient writer of the third century, of paintings he saw in a villa in Naples. Titian's most famous work of this genre is the *Venus of Urbino* (1538; Florence, **Uffizi**), a painting based on Giorgione's *Sleeping Venus*. His *Danaë* (1554; Vienna, Kunsthistorisches Museum), painted for Philip II, also belongs to the reclining nude type established by Giorgione, yet the pose of the figure with bent knees depends also on Michelangelo's *Leda and the Swan* (destroyed), a work that exerted tremendous influence in the Renaissance.

Titian was already recognized as a genius in his own time. The impact of his style and innovations continued beyond his lifetime. The **Carracci Reform** owes much to his artistic example. Rubens and Velázquez together studied the many works by Titian in the Spanish

royal collection and adopted his animated brushwork, luscious colors, golden light, and dynamic arrangement of figures. **Pietro da Cortona** and **Nicolas Poussin** were among the artists in Rome to establish the Neo-Venetian style, which was based on the art of Titian. Of the masters of the 16th century, Titian stands out as among the most influential and inventive. *See also* PIETÀ, ST. PETER'S, ROME.

TOLENTINO, NICCOLÒ DA (c. 1350–1435). Lombard **condottiere** in the service of Pandolofo **Malatesta**, Lord of Fano and Cesena, who rewarded Niccolò for his services by appointing him Count of Stacciola, a title Pope Eugenius IV confirmed in 1431. Niccolò also served the **Visconti** of Milan and Queen Joanna of Naples, and he commanded the pontifical army for which he received the Lordship of Borgo Sansepolcro. In 1432, he led the **Florentines** to victory in the **Battle of San Romano** against the Sienese, as depicted in one of **Paolo Uccello**'s *Battle of San Romano* panels (1430s; London, National Gallery). In 1434, Niccolò was captured by the Visconti, who threw him into a ravine. He died of his wounds in Borgo Valdi di Taro in the following year. The Florentine Republic honored Niccolò posthumously with a state funeral and a monument in the **Cathedral of Florence**. Executed by **Andrea del Castagno** in 1456, the monument was carried out as a **fresco** that simulates marble statuary. Here Niccolò sits on his horse, the picture of the able army commander. At his sides are his coat-of-arms and the *marzocco*, the heraldic lion of Florence. The monument complements Uccello's *Sir **John Hawkwood*** (1436) also in the cathedral. Together, they served to denote that Florence showered those willing to serve the Republic with the highest honors.

***TOMB OF POPE JULIUS II*, SAN PIETRO IN VINCOLI, ROME (beg. 1505).** In 1505, Pope **Julius II** summoned **Michelangelo** to **Rome** to work on his tomb. It is not clear where Julius intended it to be placed; some art historians have suggested the crossing (where the **nave** and **transept** cross) of New **St. Peter's**. Not only is the intended location unknown, but the details of the commission in general are sketchy. Michelangelo's original design called for a large freestanding monument with three levels and some 40 life-sized figures. The lower level was to include niches filled with statues of Vic-

tories flanked by bound and struggling male captives who, according to **Giorgio Vasari**, were to represent the provinces conquered by the pope. Others have suggested that they were to symbolize the liberal arts bound and dying after losing their greatest patron. On the second level, Moses, **St. Paul**, and allegorical representations of the **Neoplatonic** active and contemplative lives were to be included. The third level, Vasari informs, was to feature bronze **reliefs**, putti, and the pope's sarcophagus supported by allegorical figures of heaven and earth, the one smiling at the thought of Julius' attainment of salvation and the other crying over his loss. The actual body of the pope would be kept in a crypt below the monument.

In 1506, for unknown reasons, the pope halted the project and Michelangelo returned to **Florence** to continue work on the *Battle of Cascina* in the **Palazzo Vecchio** (1504–1506). Julius died in 1513 and his heirs asked Michelangelo to change the freestanding monument to the more traditional wall tomb format. The lower level would still feature niches, Victories, and captives, but now with significantly fewer figures. The pope's body would be placed in a sarcophagus on the second level, not a crypt, and his **effigy** would either be raised from or lowered into it by angels. Moses, Paul, and the active and contemplative lives were to surround the sarcophagus while a **Virgin**, Child, and standing saints would surmount it. Michelangelo worked on this new scheme for three years, completing the figure of Moses, the *Dying Slave*, and the *Bound Slave*; these last two are now in the Louvre in Paris. In 1527–1528, he also carved one of the Victories (Florence, Palazzo Vecchio) and began work on four more captives (Florence, Accademia).

By 1532, the work was still unfinished and Julius' heirs took Michelangelo to court where the details of a third design were fleshed out. The wall tomb format was retained, but now with only four captives and one Victory, a **bier** with reclining effigy flanked by Moses and another seated figure in the center of the second tier, and a standing Virgin and Child contained in an arch surmounting the structure. As the tomb stands today (1545) at San Pietro in Vincoli, Rome, Julius' titular church, Moses is in the center of the lower tier, flanked by Leah and Rachel who respectively personify the active and contemplative lives. The reclining effigy with two seated figures occupies the middle tier, and a standing Virgin and Child are above them.

The four captives begun in 1527–1528 were neither completed nor included in the final design. These provide insight into Michelangelo's creative process as they seem to be struggling to free themselves from the stone. Though the tomb as built is quite disappointing, especially when evaluated vis-à-vis Michelangelo's original scheme, Moses stands out as one of the most powerful figures the artist created. His commanding presence and intense gaze befit the portrayal of the man who led the Israelites out of slavery.

TOMB OF THE CARDINAL OF PORTUGAL, **SAN MINIATO, FLORENCE (1460–1466)**. Created by **Antonio Rossellino** as the final resting place for Cardinal Prince James, cousin to the king of Portugal, who died in **Florence** of tuberculosis at the age of 25. In his honor, a chapel was built in the Church of San Miniato where the tomb acts as the centerpiece. Antonio here followed the prescription for wall tombs established by his brother **Bernardo** when rendering the *Tomb of Leonardo Bruni* (c. 1445) in the Church of **Santa Croce**, Florence. An **effigy** of the cardinal lies on a **bier** above the sarcophagus. Surmounting the tomb are the *Virgin and Child* who smile tenderly at the cardinal as they ready to receive him in heaven. Antonio's design is more dynamic than his brother's. Gone are the restrictive architectural details of the Bruni tomb, which allows the free movement of the soaring angels above the cardinal. Two more angels stand at either side of the sarcophagus and gaze at him with kindness, as if to suggest that the man's suffering has ended and he will now reap his just rewards in heaven. The chapel's décor includes a ceiling in glazed terracotta by **Luca della Robbia** and an **altarpiece** by the **Pollaiuolo** brothers. The works of these masters, created in brilliant colors, provide a stark visual contrast to the light marble surfaces of Antonio's tomb. *See also* SWEET STYLE.

TORRITI, JACOPO (active c. 1270–1300). Italian painter and **mosaicist** active in **Rome**. Torriti obtained important commissions from Pope **Nicholas IV**, including the mosaics for the **apses** of St. John Lateran (c. 1291) and Santa Maria Maggiore (c. 1294), Rome. His work in the Lateran is barely recognizable as it was later almost completely reworked. At Santa Maria Maggiore he rendered the *Coronation of the Virgin*. This mosaic combines Byzantine, Gothic, and an-

cient elements, which sets it apart from other works created during this period. Christ and the **Virgin** are shown enthroned, surrounded by a heavenly sphere. The gold striations of the draperies and profusion of gilding throughout belong to the Byzantine (***Maniera Greca***) tradition, the subject itself stems from French Gothic sculpture prototypes, and the acanthus motifs around the figures are **classical**. Also classical are the fifth-century fragments showing a river god and a Roman sail ship that Torriti inserted into the mosaic. Torriti is also credited with the **frescoes** of the Creation on the **vault** of the Upper Church of **San Francesco** in Assisi (1290s), the attribution based on their stylistic similarities to the artist's Roman works.

TRACERY. Gothic ornamental stonework carved to form geometric patterns, most commonly trefoils and **quatrefoils**. In the earliest examples of Gothic architecture, tracery was confined mainly to the upper parts of pointed windows. In later Gothic structures, tracery can also be found in other parts of the building, including buttresses, gables, spires, interior walls, and **choir** screens.

TRAINI, FRANCESCO (active 1321–1363). Italian painter from Pisa. To him are attributed the **frescoes** (1330s) in the Campo Santo adjacent to the Cathedral of Pisa depicting the **Triumph of Death**, an attribution questioned by some art historians who give the work instead to Buonamico Buffalmacco. Also attributed to Traini is the *Triumph of St. Thomas Aquinas* of c. 1340 painted for the Church of Santa Caterina in Pisa (some believe the work to have been painted by **Lippo Memmi**) where the saint is shown receiving wisdom from Christ, the **Evangelists**, and the philosophers of the ancient world, including **Plato** and **Aristotle**. Traini's only signed work is the *St. Dominic Polyptych* in the Museo Nazionale, Pisa, dated to 1344–1345, a painting that shows St. Dominic with book and lily in hand, surrounded by scenes from his life.

TRANSEPT. The transverse arms of a cruciform church, usually facing north and south. Since the transept precedes the **apse**, the most sacred part of the church, it becomes a space where religious decorations that inspire devotion can be included. Examples are **Cimabue's frescoes** (after 1279) from the **Passion, Apocalypse,**

and lives of Sts. **Peter** and **Paul** in the transept of the Upper Church of **San Francesco**, Assisi, and **Pietro Lorenzetti**'s (1325–1330) Passion scenes in San Francesco's Lower Church. At times, transepts also contain chapels with holy relics or tombs, among the most notable Renaissance examples being **Filippo Brunelleschi**'s **Old Sacristy** (1421–1428) and **Michelangelo**'s **New Sacristy** (1519–1534), both radiating from the transept in the Church of San Lorenzo, **Florence**, which function as the funerary chapels of members of the **Medici** family.

TRANSFIGURATION. Christ took his disciples **Peter**, James, and **John** up to Mount Tabor to pray. When they arrived, Christ's face began to shine like the sun and his clothes became as white as snow. The brightness that emanated from him was meant to reveal his divinity to his followers. Moses and Elijah appeared at his side, the one to denote the Old Law of the Jews and the other to represent the **prophets** who foretold the coming of Christ. At the same time, the voice of God was heard to proclaim Christ as his son. With this, the **Passion** was foretold. The scene was depicted by **Fra Angelico** in 1438–1445 in one of the monk's cells in the **San Marco Monastery**, **Florence**. The most famous *Transfiguration* is **Raphael**'s version in the Vatican Pinacoteca (1517), moved above his tomb in the Pantheon in 1520, the year when **Gerard David** painted his version, now in the Church of Our Lady, Bruges.

TRIPTYCH. An **altarpiece** composed of three panels that are hinged together so the outer wings can close over the larger central panel. The first triptychs of the Renaissance appeared in Tuscany in the 13th century. These were used for personal devotion in the home and were portable so they could be moved as needed, for example, into a sick or birthing room. Since they needed to be portable, these triptychs were of small dimensions, they stood on a base, and had a latch so they could be securely closed to prevent any damage while being moved. The image featured in these early altarpieces was normally an enthroned **Virgin** and Child surrounded by saints and angels in the central panel. Oftentimes, a Nativity and **Crucifixion** occupied the lateral panels to reference the incarnation of Christ and his sacrifice for the good of humanity. An early example is the *Bigallo Triptych*

(1312–1348; **Florence**, Museo del Bigallo) by **Bernardo Daddi**. Eventually, the scale of triptychs increased and the subjects became more varied, as in, for example, **Roger van der Weyden**'s *Calvary Triptych* (c. 1438–1440; Vienna, Kunsthistorisches Museum) and **Hans Memlinc**'s *Last Judgment Triptych* (1473; Danzig, Muzeum Pomorskie). **Hieronymus Bosch** used the format to render strange depictions of human folly, among them *The Hay Wain Triptych* (c. 1490–1495; El **Escorial**, Monasterio de San Lorenzo) and the *Garden of Earthly Delights* (c. 1505–1510, Madrid, Prado).

TRISTÁN, LUIS (1580–1624). Spanish painter trained by **El Greco** in Toledo. Tristán is documented in El Greco's studio in 1603, and he is known to have been in Italy from 1606 to 1613 where he catered to some of the same clients as his master. Though his style is clearly indebted to El Greco's elongated forms and **Tintoretto**-like palette, Tristán injected a greater sense of naturalism into his images. His works include the main retable for the Church of Yepes (1616), the **altarpiece** he created for the Jeronymite Convent in Toledo (1620), now dispersed in various museums around the world, and the *Adoration of the Shepherds*, part of the retable of Santa Clara (1623; Toledo; Museo de Santa Cruz).

***TRIUMPH OF DEATH*, CAMPO SANTO PISA (1330s).** A **fresco** of huge proportions attributed to **Francesco Traini**, though some have suggested that the work is by Buonamico Buffalmacco, a **Florentine** master active in 1315–1336. The panoramic view offered by the scene is closely tied to **Pietro Lorenzetti**'s *Allegory of Good and Bad Government* (1338–1339; Siena, **Palazzo Pubblico**), yet the atmosphere here is of death and desolation appropriate to the fresco's setting—the Campo Santo, an enclosed cemetery attached to the Cathedral of Pisa considered sacred because, according to legend, it contains dirt brought from the Holy Land. In the fresco, aristocratic youths on horseback come across three decomposing corpses. The women turn away in horror, while one of the men holds his nose in a traditional gesture of decay. To the left, an old hermit unrolls a scroll that proclaims the foolishness of those who engage in pleasure and of the inevitability of death. To the right, men and women in an orange grove occupy themselves with music to sooth their anxieties over the

temporality of life, while next to them angels and demons struggle for souls over a pile of corpses. The fresco was badly damaged during World War II and had to be detached from the wall, revealing the **sinopie** underneath. These show an energy of rendering and spontaneity lacking in the final scene.

***TRIUMPH OF MORDECAI*, SAN SEBASTIANO, VENICE (1556).** Rendered by **Paolo Veronese**, this ceiling painting was part of a series of works for the Church of San Sebastiano in **Venice** that included an **altarpiece** and organ shutters. The scene is from the Book of Esther and recounts the event celebrated during the Jewish feast of Purim. Mordecai was Esther's adoptive father and uncle and he refused to bow to Haman, King Ahasuerus' officer. Haman wanted revenge, so he plotted the assassination of Mordecai and destruction of his people, the Jews. Esther invited her consort Ahasuerus and Haman to a banquet and there revealed the plot. Haman was executed in the gallows he had prepared for Mordecai, and Mordecai was appointed the king's new officer and showered with honors. The scene Veronese depicted shows the procession that took place to celebrate Mordecai's triumph. Veronese took the viewer's point of view into consideration by rendering the scene using a *di sotto in sù* technique. As a result, we see the undersides of the horses and figures. The remarkable illusionism in this work became a source of inspiration for the ceiling paintings of the **Baroque** era.

***TRIUMPH OF VENICE*, HALL OF THE GREAT COUNCIL, DOGE'S PALACE, VENICE (c. 1585).** This work, created by **Paolo Veronese** for the ceiling of the Hall of the Great Council in the **Doge's Palace**, is sometimes also called *The Apotheosis of Venice* because it shows an allegorical representation of the city being taken up to heaven. The scene is rendered through the use of the *di sotto in sù* technique and consists of three parts. In the topmost portion is the enthroned Venice modeled after the **Virgin Mary**, with scepter in hand and surrounded by **Virtues**, rising in all her glory. She is flanked by the towers of the Venetian Arsenal, a symbol of the city's military power, and above her hovers a winged Victory who crowns her. In the central portion of the painting, the Venetian citizenry witness the momentous occasion. Below the balcony on which the fig-

ures stand is the Venetian army. In the center of this lower level, the lion of St. Mark, patron saint of Venice, is clearly discerned. The scene, then, commingles allegorical, political, and religious elements to denote clearly the glory and might of Venice, and its enjoyment of divine protection.

TRIUMPHAL ARCH. In the Roman era, triumphal arches were monuments used to commemorate the great deeds of emperors and military leaders. They usually consisted of a single arch supported by a heavy pier at either side, the whole structure then capped by a quadrangular attic onto which a commemorative inscription was added to explain the reasons for its construction. After a successful military campaign, the person honored would enter **Rome** triumphantly by passing through the arch in grand procession. In the Early Christian era, the triumphal arch motif was used to separate the **apse** of a church from the **nave** as symbolic reference to the triumph of Christianity over paganism. In the Proto-Renaissance, the triumphal arch became a surface where religious scenes that instructed the faithful could be rendered, as **Giotto**'s **fresco** of the *Annunciation* on the triumphal arch of the **Arena Chapel** in Padua (1305) denotes. In the Early Renaissance, architects began utilizing the triumphal arch motif for the façades of religious buildings. **Filippo Brunelleschi** was the first to do so in the *Pazzi Chapel* in **Santa Croce**, **Florence** (1433–1461). **Leon Battista Alberti** followed suit with the *Tempio Malatestiano* in Rimini (beg. 1450) and at **Sant' Andrea**, Mantua (beg. 1470).

– U –

UCCELLO, PAOLO (PAOLO DI DONO; 1397–1475). Uccello was the apprentice of **Lorenzo Ghiberti**, whom he assisted in the execution of the **east doors** for the **Baptistery of Florence** (1403–1424). Though he lived a long life, his works are few. He is known to have been active in **Venice** from 1425 to 1431 where he rendered **mosaics** on the Basilica of San Marco façade, now lost. The **frescoes** in the Chapel of the **Assumption** in the Cathedral of Prato (c. 1435) are attributed to him and depict scenes from the lives of **St. Stephen** and

the **Virgin**, as well as **Virtues**. These scenes show a precision of rendering with stiff, repetitive drapery folds, dramatic gestures, and varied facial expressions. His fresco in the **Cathedral of Florence** depicting Sir **John Hawkwood** on horseback (1436) is a scene that inspired **Andrea del Castagno's** *Niccolò da Tolentino* (1456), also in the cathedral, and **Donatello's** *Equestrian Monument of Gattamelata* (c. 1445–1453) in the Piazza del Santo, Padua. The fresco is made to look like a bronze monument, a substitute to the marble memorial **Florence** was preparing in Hawkwood's honor just as England claimed his body. As **Giorgio Vasari** informs, Uccello was completely taken with the latest developments in **perspective**, which he applied to his frescoes in the *Chiostro Verde* at **Santa Maria Novella** (c. 1450) and the panels depicting the *Battle of San Romano* (c. 1430s; London, National Gallery, Paris, Louvre, and Florence, **Uffizi**). Unfortunately, in the battle scenes, he took the techniques to an extreme, resulting in ornamental rather than dramatic renderings of bloodshed and death. The portrait *A Young Lady of Fashion* (early 1460s; Boston, Isabella Stewart Gardner Museum) is also attributed to Uccello. It shows a profile view that emphasizes wealth through costume and jewels, the customary portrayal at the time of a noblewoman.

UFFIZI, FLORENCE (1560–c. 1580). The Uffizi (*offices*) is a structure commissioned by Cosimo I de' **Medici** to bring together under one roof the governmental offices that were scattered throughout **Florence**. This move caused major protests from government administrators as well as owners whose homes and shops were demolished to make way for the project. Cosimo gave the commission to **Giorgio Vasari** who died in 1574, and the building was completed by Vasari's pupil Bernardo Buontalenti to whom the design of the Porta delle Suppliche, one of the Uffizi's side entrances, is usually given. The structure is composed of two blocks connected by a **loggia** based on the **triumphal arch** motif and facing the Arno River. In the lower stories of the two blocks are also loggias, here barrel **vaulted**, that provide shelter from the elements and served at one time as a waiting area for those who came to conduct business with the Uffizi administrators. Here, columns alternate with pilasters and sculptures in rhythmic triadic successions, patterns repeated in the upper stories where the window **pediments** and supporting brackets are also

arranged in triadic repetitions. This play of forms and rhythms are what qualify the building as **Mannerist**. Once the building was completed, some of its rooms were set aside for the housing of the Medici's art treasures. In 1737, Anna Maria Ludovica de' Medici bequeathed the family collection to the city of Florence, thereby establishing the building as one of the finest museums in the world. Here, 45 rooms display works from the 13th to the 18th centuries, most representative of the Italian Renaissance of Tuscany, though ancient Roman, medieval, and Northern art are also well represented.

UNFINISHED STYLE. A term used to refer to the style utilized by **Guido Reni** in the last years of his career. These works are sketchy, with facial and other anatomical details kept to a bare minimum, a rather monochromatic palette, and brushstrokes that were applied rapidly. Until recently art historians believed that the reason these works seem unfinished is because Reni painted them as quickly as he could to generate money to cover the large debts he had incurred from gambling. This explanation was proved wrong when documents revealed that these paintings were still in Reni's studio after his death and bequeathed to friends and patrons. This means that Reni only blocked the main elements of his compositions and never had the opportunity to refine them by adding further layers of color. Examples of this phase in Reni's oeuvre are the *Flagellation* (1641; **Bologna**, Pinacoteca Nazionale), *Holy Family with Sts. Elizabeth and John the Baptist* (1641; private collection), and *Anima Beata* (c. 1640–1642; **Rome**, Capitoline Museum).

URBAN VIII (MAFFEO BARBERINI; r. 1623–1644). Born in **Florence** in 1568 to a well-to-do family of merchants, Maffeo Barberini received a **Jesuit** education, his ecclesiastic career promoted by his uncle, an apostolic protonotary. He graduated with a degree in law from the University of Pisa in 1589. Pope **Paul V** gave Maffeo the cardinalate in 1606 after serving as legate in France and, in 1623, he ascended the papal throne as Urban VIII. Among the most nepotistic of popes, he immediately granted favors to his family members. He elevated his brother Antonio and nephews Francesco and Antonio to the cardinalate, and his nephew Taddeo he appointed prefect of **Rome** and prince of Palestrina. Later, he also appointed

Francesco vice-chancellor and the younger Antonio commander of the papal army. In 1626, Urban added the Duchy of Urbino to the Papal States by forcing the aging Duke Francesco Maria **della Rovere** to cede the territory to the papacy. In 1641, he seized the territory of Castro when Duke Odoardo **Farnese** defaulted on his interest payments. Castro was returned to the Farnese in 1644 after a peace agreement was reached between them and Urban. Urban did much to embellish the city of Rome. Already as cardinal he had patronized artists such as Pietro Bernini, **Francesco Mochi**, and **Ludovico Carracci**. As pope, he appointed **Gian Lorenzo Bernini** as his official artist and promoted the painters **Nicolas Poussin**, **Pietro da Cortona**, and **Andrea Sacchi**. *See also* BARBERINI FAMILY.

UTRECHT CARAVAGGISTS. A group of Dutch artists who were active in the city of Utrecht in the early decades of the 17th century. Most went to **Rome** where they were exposed to the style of **Caravaggio**, and then brought this visual vocabulary back to Utrecht, making it available to other Dutch masters. The most notable figures among the Utrecht Caravaggists are **Dirck van Baburen**, **Hendrick Terbrugghen**, and **Gerrit van Honthorst**. All three painted mainly religious scenes while in Italy, and changed to **genre** upon returning to the North as the demand for religious images in the Dutch market diminished after the region embraced Protestantism.

– V –

VAGA, PERINO DEL (c. 1500–1547). Perino del Vaga was among those responsible for establishing the **Mannerist** style in **Rome** where he worked for a while as one of **Raphael**'s assistants. He was originally from **Florence**, where he studied with Andrea de' Ceri and later Ridolfo, the son of **Domenico del Ghirlandaio**. Perino's style owes debt to **Michelangelo** from whose works he drew while both in Florence and Rome. His most notable work is the *Fall of the Giants* (beg. 1529) in the Sala dei Giganti (Room of the Giants) of the Palazzo del Principe, Genoa, commissioned by **Andrea Doria** who in 1528 established himself as the dictator of the Genoese Republic. Since Doria's palace was damaged by fire in 1527, Perino was also

charged with the architectural renovations. There, a number of artists worked as his assistants, including Giovanni Antonio de Sacchis, called il Pordenone, and **Domenico Beccafumi**.

VALLA, LORENZO (1405–1457). Renaissance humanist and philosopher who in 1440 wrote *The Donation of Constantine*, declaring an eighth-century document used by the papacy to support its claims to temporal power to be a forgery. Lorenzo was a student of **Florentine** Chancellor Leonardo Bruni. In 1430, he accepted a lecturing position at the University of Pavia after his attempts to obtain employment in the papal court had failed. At Pavia he wrote his *De voluptate* (1431), composed as a discussion between Florentine humanists that criticizes Ciceronian Stoic ethics. An open letter he wrote in 1433 attacking a jurist and ridiculing Pavian jurisprudence forced him to leave the city. First he went to Milan and later Genoa, finally settling in Naples where he became secretary to King Alfonso I of Aragon. Aside from writing *The Donation of Constantine* while in his service, he also published the *Dialecticae disputationes* attacking **Aristotelianism**. His skepticism toward the papacy and Christian philosophy led to charges of heresy. In 1448, in spite of the allegations, he was invited by Pope **Nicholas V** to **Rome** to translate Greek texts. He died in Rome in 1457.

VANISHING POINT. *See* ONE-POINT LINEAR PERSPECTIVE.

VANITAS. In English, *vanity*. *Vanitas* is a theme in art that reminds viewers of the transience of life and admonishes them on the importance of living righteously to ensure salvation. The term is taken from a verse in Ecclesiastes (12: 8) that reads, "Vanity of vanities, saith the preacher, all is vanity." The Dutch, inspired by **Caravaggio**'s depictions of fruits in different stages of ripeness, were the first to use the *vanitas* theme in **genre** paintings. Wilting flowers, decomposing fruits, half-eaten foods, skulls, hourglasses, extinguished pipes, and bubbles, all form part of the visual vocabulary of vanitas paintings. *See also* MEMENTO MORI.

VASARI, GIORGIO (1511–1574). Tuscan painter, architect, and writer, best known for his *Lives of the Most Excellent Painters, Sculptors, and*

Architects, the earliest compendium of biographies of artists. Born in Arezzo, the 16-year-old Vasari was sent by Cardinal Silvio Passerini, who had close ties with the **Medici**, to **Florence** to apprentice with **Andrea del Sarto** alongside **Rosso Fiorentino** and **Jacopo da Pontormo**. The cardinal also sponsored the artist's humanist education alongside the young Ippolito and Alessandro de' Medici, who were under his guardianship. Vasari's relationship with the Medici was to sustain his artistic career for the rest of his life.

Vasari's output as painter is vast as he steadily received commissions from this family as well as the papal court in **Rome**. In the 1540s he was occupied with the **frescoes** in the papal Palazzo della Cancelleria for Pope **Paul III**. For the *studiolo* of **Francesco I de' Medici** in the **Palazzo Vecchio**, Florence, Vasari contributed his *Perseus and Andromeda* (1570–1572) to represent the element of water and relate the story of the formation of coral. Other works by him include the *Allegory of the Immaculate Conception* (1541) and the *Prophet Elijah* (c. 1555), both in the **Uffizi**, Florence. Vasari's greatest accomplishment as architect was the Uffizi (*offices*) (beg. 1560), a structure commissioned by Cosimo I de' Medici to consolidate the governmental offices under one roof. Vasari also built for him a **grotto** (1556–1560) in the Boboli Gardens located between the Uffizi and the Palazzo Pitti where the Medici resided.

Though Vasari had a distinguished career as artist, he is most often invoked for the wealth of information he provided in his *Lives*, first published in 1550. The work is a product of the Renaissance mindset that individual achievement should be recorded so it may inspire others to excel. The *Lives* is a chronological account of the progress of art divided into three stages. In the first stage, the leading figure is **Giotto** who, in Vasari's view, was responsible for the rebirth of art after the decline it had suffered when the Roman era ended. Giotto and his followers examined nature carefully, tried to imitate its colors and forms on the pictorial surface, and to portray their figures expressively. The second stage is the era of **Masaccio** who applied science to art, introducing anatomical realism and **one-point linear** and **atmospheric perspective**. The third and final stage, the era of **Leonardo da Vinci**, **Raphael**, and **Michelangelo**, resulted in the complete triumph over nature. Of these three key figures, Vasari believed that it was Michelangelo, whom he knew personally, who had

achieved the heights of perfection. Vasari's text continues to be employed as a major source of information on the artists of the Renaissance and its three-partite division of the period still serves as the basis for the modern assessment of Renaissance art.

VAULT. An arched ceiling built of brick, stone, or concrete. Of these materials, concrete is the most effective as it allows for greater expanses since it forms one solid, rigid, surface requiring a lesser number of internal supports. The solid surfaces can then be decorated with **coffers**, **mosaics**, or **frescoes**. There are many types of vaults. A barrel vault is a tunnel-like, semicylindrical ceiling, while a groin or cross vault is composed of two intersecting barrel vaults at right angles. The advantage of this system is that it allows for the inclusion of windows on the sides to bring lighting into the interior of the structure it covers. Groin vaults also require less construction materials and labor. Sometimes the groin vaults are ribbed. The ribs serve various purposes: to reduce the number of wooden supports needed during construction, to lighten the thickness of the groin vaults and therefore allowing for larger windows, and to visually separate them into segments, their repetition granting a rhythmic quality to the building. Pointed ribs, common in Gothic architecture, provide greater stability than the rounded ribs of Romanesque construction. A **dome** is another type of vaulting, a semicircular structure that sits on a drum or is carried by **pendentives**. Domes are often placed above the crossing (where the **nave** and **transept** cross) of churches. Their lantern and piercings on the drum allow for light to radiate over the altar, giving it a mystical quality.

VELÁZQUEZ, DIEGO (1599–1660). The most important **Baroque** master in Spain. Velázquez was born in Seville to a family from the lesser nobility. He studied under **Francisco Pacheco**, marrying his daughter in 1618. Pacheco was not a talented painter, but he was interested in theory and surrounded himself with scholars and poets with whom Velázquez gained contacts. In his Sevillian period, Velázquez painted mainly *bodegónes*, among these the *Old Woman Cooking Eggs* (1618; Edinburgh, National Gallery of Scotland) and the *Water Carrier of Seville* (1619; London, Wellington Museum). In 1622, he went to Madrid in the hopes of becoming King **Philip IV**'s

court painter. At first, he was not successful, yet in the following year he tried again and was in fact appointed to the king's court. From this point on he devoted himself primarily to portraiture, also creating some mythologies and religious paintings.

At the Madrid royal palace, Velázquez had the opportunity to study the works in the king's collection, including the many paintings by **Titian**. In response, Velázquez loosened his brushwork and began incorporating the landscape into some of his works, as exemplified by *Los Borrachos* (1628; Madrid, Prado), a **bacchic** scene with a reclining **satyr** taken directly from Titian. When Velázquez was painting this work, **Peter Paul Rubens** arrived in Madrid, sent there on diplomatic mission by Archduchess Isabella of Flanders, the Spanish king's aunt. Velázquez and Rubens immediately struck up a friendship and together they studied carefully the art of the **Venetians** in the king's collection.

In 1629, Velázquez traveled to Italy, spending most of his stay in **Rome**, but also stopping in Genoa, Venice, and Milan. After this trip, he acquired greater confidence and his artistic abilities improved in great measure. In 1635, he painted his famed *Surrender at Breda* (Madrid, Prado) for the Hall of Realms in the Palace of El Buen Retiro. He in fact also directed the decoration of this room, granting commissions to other masters and contributing five portraits of the royal family. His *Mars* (c. 1639–1641; Madrid, Prado) he painted for the decoration of the Torre de la Parada, the royal hunting lodge, and, in 1648, he rendered the *Rokeby Venus* (London, National Gallery) for the Marquis of Carpio and Heliche.

Velázquez' most striking and original works are the *Fable of Arachne*, a mythology witnessed by two Spanish ladies, and *Las Meninas* (both 1656; Madrid, Prado), a group portrait of members of the royal court, including Velázquez himself. The first presents women in the foreground spinning and carding wool in preparation for weaving. In the background the fable of Arachne unfolds where she challenges the goddess **Minerva** to a weaving contest (which she ultimately loses and is transformed into a spider doomed to spin webs for the rest of her existence). In the background is Titian's *Rape of Europa*, made to look like a tapestry as the **Ovidian** fable specifies that this was the subject of the tapestries the two women wove. The second work shows Velázquez himself engaged in the act of painting

in front of a large canvas, perhaps a portrait of the Infanta Margarita, Philip IV's daughter, who appears in the foreground with her maids of honor, dwarfs, chambermaids, and other attendants. The reflection in the background mirror is that of the king and his consort, which raises questions as to whether the artist is in fact painting the portrait of Margarita or the royal couple. Have the royal couple just entered the room and interrupted the scene? And why is the viewer placed where the king and queen stand outside the picture? Velázquez's studio has been identified as the place where the scene unfolds, which would denote that his work wishes to ennoble the act of painting and the artist's own social standing, as the implication is that royalty comes to him and not the other way around. Velázquez did in fact exert great effort in asserting his nobility and it was recognized soon after he painted *Las Meninas*. In the work, he wears the cross of Santiago, an order to which only nobles could belong. Legend has it that the king himself added the cross to the painting when the honor of entering the order was granted to Velázquez.

VENEZIANO, DOMENICO (DOMENICO DI BARTOLOMEO DA VENEZIA; c. 1410–1461). Venetian painter who settled in **Florence** in 1439 after requesting from Piero de' **Medici** help in obtaining a commission from Piero's father, **Cosimo**. In that year, Domenico Veneziano is documented working on the **frescoes** from the life of the **Virgin** in the Church of Sant' Egidio, Florence, unfortunately destroyed, which suggests that his plea to the Medici was successful. According to **Giorgio Vasari**, Veneziano was murdered by **Andrea del Castagno** who, jealous of the artist's **oil painting** abilities, struck him with an iron bar. In the 19th century it was discovered, however, that Castagno died in 1457, four years earlier than Veneziano. Vasari was writing at a time when debates on the merits of colorism versus draughtsmanship were taking place. It is possible that he was metaphorically arguing for the superiority of draughtsmanship, usually associated with the Florentine School of which Castagno formed part, over colorism, characteristic of the Venetian School represented by Veneziano.

Very few works by Veneziano have survived. A *Virgin and Child* and two heads of saints (both c. 1440–1445) in the National Gallery, London, are the extant fragments of a street tabernacle he painted at

the Canto de' Carnesecchi, in Florence. The *Adoration of the Magi* (1440–1443) in the Staatliche Museen, Berlin, is a courtly rendition dependent on the **International Style**. Veneziano's best-known painting is the *St. Lucy Altarpiece* of c. 1445–1447 in the **Uffizi**, Florence, one of the earliest *sacra conversazione* types. His vivid colorism and interest in **perspective** are clearly demonstrated by this painting. Veneziano's last known work is the fresco of *Sts. John the Baptist and Francis* (c. 1455–1460; Florence, Museo dell' Opera di Santa Croce), painted for the Cavalcanti Chapel at **Santa Croce**, Florence, and removed from the wall in the mid-1560s during renovations.

VENEZIANO, PAOLO (active c. 1333–1360). The first **Venetian** painter to be known by name. Although **Giotto** had already introduced a new mode of painting that rejected the *Maniera Greca* and depended on the empirical observation of nature, Paolo Veneziano nevertheless continued to paint in the Greek mode. The reason for this is that the style was well suited to Venetian taste as Venice had close ties to Byzantium from where the *Maniera Greca* originated. One of Paolo's most important commissions is the *Coronation of the Virgin* painted in 1324 (Washington, National Gallery), a work featuring heavy gilding, emphasis on lines, gold striations to denote the folds of drapery, and brilliant colors typical of the *Maniera Greca* mode. His other noteworthy commission is the series of wooden panels he painted in 1345 for **Doge** Andrea Dandolo as the cover to the *Pala D'Oro*, a major bejeweled **altarpiece** from the 10th century housed in the Basilica of San Marco.

VENICE. During the Roman era, Venice was a military outpost inhabited mainly by fishermen. It was also the place where salt and clay for brick production could be extracted. The barbarian invasions caused the inhabitants of nearby cities to seek refuge in Venice as its marshy islets along the Adriatic sea provided natural protection. In the fifth century, Venice was ruled by the Byzantine Emperor Theodoric, king of the Ostrogoths, who carried out a major building campaign in nearby Ravenna that was to influence the art and architecture of the region for several centuries. At the end of the seventh century, the various settlements of Venice pulled together and, in 697, they elected **Doge** Paoluccio Anafesto as their leader. By the ninth century,

trade with Byzantium, the Levant, and the Holy Roman Empire established Venice's economic preeminence. The need to find secure access to the markets north of the Alps led to the acquisition of Treviso, Belluno, and Feltre in the 14th century. At the turn of the 15th century, the Venetians took Padua, Vincenza, Verona, Friuli, Brescia, and Bergamo and, by 1500, their territory was extended farther to include Cremona. In 1508, the **League of Cambrai** was formed between Pope **Julius II**, King Louis XII of France, and Holy Roman Emperor **Maximilian I** to curtail Venice's territorial expansion. The league collapsed in 1510 due to disagreements between Louis and the pope, who now allied himself with Venice. Together they drove the French out of Italy in 1512, but disagreements caused Venice to change sides. In 1515, the French, now led by **Francis I**, regained their territories in Italy and, in 1517 the lands taken from the Venetian Republic were returned.

Palpable in the art of Venice is the Eastern influence that came with trade and Byzantine rule early in its history. The **Doge's Palace** (1340–1438) blends French Gothic arcades and **traceries** with Eastern flamelike spires, and the Basilica of San Marco (beg. 1063) relies completely on the Byzantine style, especially for its **Greek cross plan**, the shape of its **domes**, its monumental scale, and **mosaic** decorations. A school of painting did not develop in Venice until the 14th century when **Paolo Veneziano** began rendering scenes in the *Maniera Greca*, brought to Italy from Byzantium in the 13th century. This style remained the preferred mode of painting in the region until the early 15th century when the **Bellini** and **Andrea Mantegna**, influenced by foreign masters such as **Donatello**, **Andrea del Castagno**, and **Antonello da Messina**, finally embraced a more naturalistic mode of representation. The 16th century saw the art of **Tintoretto**, **Paolo Veronese**, and **Titian** whose colorism and experiments in **perspective** laid the ground for the developments of the **Baroque** era.

VENUS. The goddess of love, Venus was born from the foam caused by the severed testicles of Uranus that Saturn threw into the sea. She was brought to the shores of Cythera, her sacred island, on a seashell, which is how **Sandro Botticelli** depicted her in the *Birth of Venus* (c. 1485; Florence, **Uffizi**). Frustrated by her rejection, **Jupiter** married her off

to the deformed Vulcan, but, in spite of this union, Venus had many illicit affairs. **Annibale Carracci** depicted her at her toilet assisted by the Graces (*Venus Adorned by the Graces*; 1594–1595; Washington, National Gallery), the event after her indiscretion with **Mars**. **Titian** painted her trying to stop Adonis, whom she loved, from hunting the boar that would cause his death (*Venus and Adonis*; 1553–1554; Madrid, Prado), and Annibale rendered her in the **Farnese ceiling** (c. 1597–1600; **Rome, Palazzo Farnese**) in bed with Anchises, with whom she bore Aeneas, the hero of **Virgil**'s *Aeneid*. Paris gave Venus the Golden Apple of Hesperides as reward for her beauty, the scene depicted by **Lucas Cranach the Elder** in 1530 (*The Judgment of Paris*; Karlsruhe, Staatliche Kunsthalle), and **Peter Paul Rubens** in 1602 (London, National Gallery). The reclining Venus became a major subject in art, as established by **Giorgione** in his *Sleeping Venus* (c. 1510; Dresden, Gemäldegalerie). She was sometimes paired with her son **Cupid** by artists such as Cranach (*Venus and Cupid*; 1520; Bucharest, Muzeul National), **Agnolo Bronzino** (**Allegory of Venus and Cupid**; 1540s; London, National Gallery), and **Lorenzo Lotto** (*Venus and Cupid*; c. 1525; New York, Metropolitan Museum). *See also VENUS PUDICA.*

VENUS ADORNED BY THE GRACES (1594–1595; Washington, National Gallery). Painted by **Annibale Carracci**, this work betrays his interest in **Venetian** art as **Venus** is the nude reclining type favored by Venetian masters such as **Giorgione** and **Titian**. She is as voluptuous as her Venetian counterparts, around her the usual props, including the curtain behind her, the luscious landscape, and the pudgy putti. The scene derives from Homer's *Odyssey* when **Mars** and Venus are caught by Vulcan, her consort, in an act of infidelity. Venus retires to Cythera, her sacred island, where she is bathed and adorned by the Graces while she awaits Vulcan's return from collecting the adulterer's fee from Mars, the scene shown in the background. The painting is thought to have been commissioned on the occasion of a wedding celebration as denoted by certain elements within the work. Venus is the goddess of love, Mars and Vulcan are symbols of passion and generative heat, and **Bacchus**, shown as a statue on a fountain in the background, is a symbol of fertility. The

details of the commission are unknown, though by 1638, the painting was in the possession of the **Bolognese** Count Alessandro Tanari.

VENUS PUDICA. In English, *modest Venus*. The term describes a **classical** sculpture type where Venus is surprised at her bath and covers her nudity with her arms. Examples of this kind were known in the Renaissance, including a Roman copy in the **Medici** collection, now in the **Uffizi, Florence. Masaccio** borrowed the model to depict his Eve in the *Expulsion from Paradise* in the **Brancacci Chapel** (c. 1425) at Santa Maria del Carmine, Florence, who feels ashamed of her nudity. **Sandro Botticelli** used it in his *Birth of Venus* (c. 1485; Florence, Uffizi) appropriately as it depicts the moment when the goddess, having emerged from the waters, arrives in Cythera, her sacred island, where one of the Hours (or perhaps Flora or Pomona) awaits to cover her nudity with a flowered mantle. In his *Venus and Anchises* on the **Farnese ceiling** (c. 1597–1600; **Rome, Palazzo Farnese**), **Annibale Carracci** used the pose to denote Venus' hesitation on whether to give in to the sexual advances of a mere mortal.

VERONESE, PAOLO (PAOLO CALIARI; 1528–1588). Master from the Venetian School who competed for commissions with **Tintoretto** and **Titian**. Veronese was from the city of Verona, hence his surname, where he was trained by a local painter named Antonio Badile. In 1553, at 25, he moved to **Venice** where he became one of the city's leading and most innovative masters. Veronese particularly excelled at rendering illusionistic ceilings, as the *Triumph of Mordecai* (1556) at San Sebastiano and the *Triumph of Venice* in the Hall of the Great Council at the **Doge's Palace** (c. 1585) demonstrate.

In 1560, the artist traveled to **Rome** and upon his return he received the commission to paint a series of allegorical and contemporary scenes in the Villa Barbaro at Maser for Marcantonio and **Daniele Barbaro**. These works show that Veronese closely studied **Raphael**'s **frescoes** in the **Villa Farnesina**, Rome (1513–1518), as some of the figures are borrowed from that source. In 1563, Veronese worked on the *Marriage at Cana* in the **refectory** of the Benedictine Monastery of San Giorgio Maggiore, Venice, a scene that depicts

Christ's first miracle as a contemporary Venetian banquet. The figures are dressed in sumptuous costumes and engaged in eating and conversation. In the foreground, the three musicians who entertain the crowd are portraits of the artists Jacopo Bassano, Titian, and Veronese himself. With this, Veronese compared the art of painting to music to argue for the placement of his craft, which until then was considered a manual labor, among the liberal arts. Veronese's *Mars and Venus United by Love* (c. 1570; New York, Metropolitan Museum), *Allegory of Love* (1570; London, National Gallery), and *Rape of Europa* (1580; Venice, Doge's Palace) exemplify his ability to render sensuous and luxurious mythological and allegorical scenes.

In 1573 Veronese painted the *Feast in the House of Levi* (Venice, Galleria dell' Accademia) for the refectory of the **Dominican** Monastery of Santi Giovanni e Paolo in Venice, for which he was summoned to the tribunal of the Inquisition. Its judges deemed the presence of buffoons, dwarfs, inebriated figures, and animals in the painting to be inappropriate for the depiction of the Lord's **Last Supper**, the work's original subject. Veronese was able to avoid the charges of heresy levied against him simply by changing the painting's title.

Veronese's *di sotto in sù* experiments had much to do with the development of illusionistic ceilings in Italy, as it paved the way for the grand **Baroque** ceiling frescoes of **Giovanni Lanfranco**, **Pietro da Cortona**, and later Giovanni Battista Gauli and Andrea Pozzo. His mythologies, with their exceptional colorism, shimmering fabric effects, and lush brushwork, were also a major force, inspiring artists such as **Peter Paul Rubens** and **Anthony van Dyck**.

VERROCCHIO, ANDREA DEL (1425–1488). Italian sculptor and painter who worked primarily for the **Medici** and who trained **Leonardo da Vinci** in his workshop. Among his paintings are the *Baptism of Christ* (1472–1475) in the **Uffizi**, commissioned for the monastery Church of San Salvi, **Florence**, the *Virgin and Child with Sts. John the Baptist and Donatus* (1475–1483) at the Cathedral of Pistoia, and *Tobias and the Angel* (1470–1480) in the London National Gallery. These works demonstrate Verrocchio's keen interest in rendering the details of the human anatomy. Along with **Antonio del Pollaiuolo**, he in fact was among the first artists to utilize a scientific

approach to the study of the human form, engaging in dissections to gain understanding of the body's underlying structure.

Verrocchio's greatest achievements are in sculpture. His *Doubting of Thomas* (c. 1465–1483) at **Orsanmichele**, Florence, commissioned by the Guild of Merchants, is a scene of intense drama achieved by the movement of Thomas' hand toward Christ's side wound, Christ's blessing hand over the saint's head, and the complicated curvilinear folds of the draperies. The *David* (early 1470s; Florence, Museo Nazionale del Bargello) he created for **Lorenzo "the Magnificent" de' Medici** as a commentary on **Donatello**'s bronze *David*, also in the Medici collection. Unlike Donatello's version, Verrocchio's is clothed, less sensuous, with a sword that accords with the figure's scale, a head of Goliath visible from the front, a less exaggerated sway of the body, and well-defined musculature. Verrocchio's final work is his *Colleoni Monument* (1481–1496) in the Campo dei Santi Giovanni e Paolo, **Venice**. Loosely based on Donatello's *Equestrian Monument of Gattamelata* (c. 1445–1453; Padua, Piazza del Santo), it portrays the Venetian army commander as a fearless individual aggressively straddling his horse. Verrocchio's interest in physiognomy, evidenced by Colleoni's leonine facial features, exerted tremendous influence on his pupil, Leonardo.

VICES. *See* VIRTUES AND VICES.

VILLA FARNESINA, ROME. Baldassare Peruzzi built the Villa Farnesina for the papal banker **Agostino Chigi** in 1508–1511—the first suburban villa built in **Rome** in the 16th century. It replicated the country houses of the Roman patriciate described in ancient literature, its proportional relations of width, length, and height and tripartite plan taken directly from **Vitruvius**' treatise on architecture. Peruzzi provided a U-shaped two-storied structure with two open **logge** (now glazed over) on the ground floor. The *Loggia di Psiche*, between the two protruding wings, was originally the villa's main entry. In front of it was a podium, now sunken, used as a stage for theatrical productions. Its exterior frieze is sculpted *all' antica* with putti clasping festoons and ribbons, heralding the lighthearted nature of the villa's interior ornamentations. In the *Loggia de Psiche* (1517–1518),

Raphael and assistants **frescoed** on the ceiling the *Council of the Gods* and the *Wedding Banquet of Cupid and Psyche*, both made to look like tapestries hung to protect visitors from the sun. The second loggia, the *Sala di Galatea*, overlooks the Tiber River and features Raphael's famed *Galatea* fresco (1513) on one of the walls and a ceiling by Peruzzi (c. 1511) that depicts the owner's astrological chart. Sebastiano del Piombo rendered the **lunette** frescoes with mythologies, including the *Fall of Icarus* and *Fall of Phaeton*.

In c. 1517, Giovanni Antonio Bazzi, called il Sodoma, was charged with the decoration of the villa's bedroom, the *Stanza delle Nozze*. He painted scenes from the life of the ancient hero Alexander the Great, including his marriage to Roxana, his meeting with Darius' widow, and his taming of Bucephalus, his horse. Next to the *Sala delle Nozze* is the *Sala delle Prospettive* (1515–1517) by Peruzzi, a masterpiece of illusionism as the frescoes have transformed the room into a feigned loggia with painted views of the Roman countryside. Agostino Chigi died in 1520 and, at the end of the century, the **Farnese** purchased the villa, hence the name *Farnesina*. Today it functions as the Accademia dei Lincei, an academy of the sciences, and the Gabinetto dei Disegni e delle Stampe, the Roman department of drawings and prints.

VINCI, LEONARDO DA. *See* LEONARDO DA VINCI.

VIRGIL (PUBLIUS VERGILIUS MARO; 70–19 BCE). Considered the most important poet of the ancient Roman era, Virgil was born in a small village near Mantua to a well-to-do family of landowners. He was educated in Cremona, Milan, and **Rome**, where he studied medicine, mathematics, law, and rhetoric. Civil disturbances in 49 BCE forced Virgil to flee from Rome to Naples, and there he studied with the Epicurean philosopher Siro and began his career as poet. He composed his *Eclogues* in 39 BCE and the *Georgics* 10 years later, both on the rustic life. With Emperor Augustus' backing, he wrote his greatest masterpiece, the ***Aeneid***, an epic poem intended to build upon Homer's *Iliad* and *Odyssey* that combined history and mythology, which proved to be a major source for artists. Virgil died while journeying to Greece when he caught a fever that proved fatal.

VIRGIN MARY. The mother of God whom Catholic doctrine declares she conceived without sin. Mary is the most highly regarded of all saints. She was the daughter of **Joachim** and **Anne** who conceived her in old age, and was betrothed to **Joseph** when the angel Gabriel announced to her that she would conceive the Christ Child through the Holy Spirit. The **Annunciation** is one of the most popular subjects in religious art, with versions by **Simone Martini** (1333; **Uffizi, Florence**), **Rogier van der Weyden** (c. 1435; Paris, Louvre), and **Tintoretto** (1583–1587; **Venice, Scuola di San Rocco**) serving as examples. Mary visited her cousin Elizabeth to tell her the good news and found out that Elizabeth too was with child; her son, also conceived in old age, was **St. John the Baptist.** **Federico Barocci** depicted this scene (1586) for the **Visitation** Chapel at the Chiesa Nuova, **Rome.** Once Christ was born, Joseph took the Holy Family to Egypt to escape persecution from Herod who was afraid that the child would take his throne. The **Flight into Egypt** is the topic of **Annibale Carracci**'s landscape in the Galleria Doria-Pamphili (1603) and one of the scenes in **Melchior Broederlam's** **altarpiece** for the Carthusian Monastery of Dijon (1394–1399).

Mary was present at the **marriage at Cana** where Christ performed his first miracle, a scene depicted by **Paolo Veronese** in 1563 in the **refectory** of San Giorgio Maggiore, Venice. At the **Crucifixion**, Christ placed Mary in **St. John**'s care. She was present when the **apostles** began to speak in tongues, the topic of **El Greco**'s *Pentecost* (c. 1608–1610; Madrid, Prado). In turn, the apostles were present when she fell into her **Dormition**, as depicted by **Hugo van der Goes** in c. 1481 (Bruges, Groeningemuseum). Her ascent into heaven finally became Catholic dogma in 1950, but had been a major subject in Renaissance and **Baroque** art, with **Titian**'s *Assumption* (1516–1518; Venice, Santa Maria dei Frari) providing one of the most superb examples.

The concept of the Virgin's **Immaculate Conception** was declared dogma in 1854, though it had already gained tremendous popularity in the Renaissance and Baroque eras, particularly in Spain where the subject was often depicted. **Diego Velázquez'** rendition of 1619 (London, National Gallery) provides one of many examples. The most popular depiction of Mary is as an iconic figure carrying the Christ Child, in the *Virgin and Child* by Simone Martini (c. 1325;

Boston, Isabella Stewart Gardner Museum) and **Giovanni Bellini**'s *Madonna and Child* (late 1480s; New York, Metropolitan Museum) providing two examples. *See also* MARRIAGE OF THE VIRGIN.

VIRTUES AND VICES. Virtues and vices are essential concepts of moral philosophy as they represent the strengths and weaknesses of humanity. Among the main themes in the writings of **Plato**, **Aristotle**, and other ancient philosophers is the attainment of a virtuous existence through the rejection of pleasure. The fathers of Christianity also wrote extensively on virtues and vices, though these were not standardized until about the 10th or 11th centuries. The virtues are divided into two groups. The first, the Cardinal Virtues, derive from Plato's *Republic* and consist of temperance, prudence, justice, and fortitude. The second, the Theological Virtues, are faith, hope, and charity. These are listed in the Bible, in I Corinthians 13:13. The vices, or Seven Deadly Sins, are pride, envy, wrath, sloth, avarice, gluttony, and lust. Virtues and vices often appear in art. **Giotto** included their personifications in the lower tier of the **Arena Chapel frescoes** in Padua (1305). In **Andrea Mantegna**'s *Expulsion of the Vices from the Garden of Virtue* (1497; Paris, Louvre), **Minerva** rids the garden of evil. The Virtues are included in the lower panels of **Andrea Pisano**'s bronze doors for the **Baptistery of Florence** (1330–1334) and in **Jacopo della Quercia**'s *Fonte Gaia* in Perugia (1414–1419). The Vices appear in **Hieronymus Bosch**'s *Hay Wain Triptych* (c. 1490–1495; El **Escorial**, Monasterio de San Lorenzo) and they are the main subject of his *Seven Deadly Sins* tabletop (c. 1475) at the Madrid Prado Museum.

VISCONTI FAMILY. The Visconti became the predominant family of Milan when in 1277 Ottone Visconti, the local archbishop, wrested control of the city from Napo de la Torre. In 1297, Ottone arranged for the appointment of his great-nephew Matteo as Capitano del Popolo (Captain of the People) and in 1311 Holy Roman Emperor Henry VII also made Matteo his imperial vicar. With this, Matteo was able to establish his lordship over the Lombard territory. He married off his son Galeazzo to Beatrice d'**Este**, a union that granted the Visconti a title of nobility. In the mid-14th century, the Visconti also

married into the French and English monarchic houses, confirming their position of power. In 1395, they obtained the title of dukes from Holy Roman Emperor Wenceslaus and in this capacity they ruled Milan until 1447, when Filippo Maria Visconti died without a male heir. Francesco **Sforza**, husband to Filippo Maria's daughter Bianca, inherited his father-in-law's dominion and, with this, the Sforza ruled Milan, with some interruptions, until 1535 when the family died out. *See also* VISCONTI, GIANGALEAZZO.

VISCONTI, GIANGALEAZZO (1351–1402). Duke of Milan from 1395 until his death in 1402. The **Visconti** dominion had been split between Giangaleazzo's father, Galeazzo II, and uncle Bernabò. When his father died, Giangaleazzo imprisoned his uncle and seized his territories on the Lombard region, consolidating once again the Visconti lands. In 1360, Giangaleazzo married Isabelle of Valois, daughter of King John II of France, whose dowry included land in the Champagne region, thus establishing monarchic ties to secure his position of power. Then in 1395, Holy Roman Emperor Wenceslaus granted him the title of duke. Giangaleazzo's rule was dominated by his campaign to expand his dominion. He waged war against **Florence** and managed to have the city completely surrounded when, in 1402, he suddenly died from the **plague**. Giangaleazzo was a generous patron. He initiated construction of the Certosa di Pavia, a splendid Carthusian monastery and church complex. He also supported the University of Pavia and the production of manuscript illumination in the Lombard region. *See also* ILLUMINATED MANUSCRIPT.

VISITATION. After being told by the Archangel Gabriel that she would give birth to the Christ Child (the **Annunciation**), the **Virgin Mary** went to visit her cousin, St. Elizabeth, to share with her the good news. Elizabeth told her that she too was with child, a miracle as she was beyond her child-bearing years. That child was **St. John the Baptist** who would later meet up with Christ in the desert and baptize him. **Roger van der Weyden** (c. 1435; Leipzig, Museum der Bildenden Künste) depicted the Virgin and Elizabeth meeting at a path that leads to a Gothic church, both tenderly placing their hands on each other's pregnant belly. **Jacopo da Pontormo** depicted this

subject for the Church of San Michele, Carmignano in 1528–1529, an unusual **Mannerist** painting with elongated figures and a lozenge-like composition. **Barocci** created his version in 1586 for the Visitation Chapel at the Chiesa Nuova, **Rome**, a work so well received that for three days after its installation the people of Rome stood in long lines to view it.

VITRUVIUS (MARCUS VITRUVIUS POLLIO; c. 80–25 BCE). Roman engineer and writer who served Emperor Caesar Augustus. Vitruvius was the author of the only architectural treatise from antiquity to have survived, *De architectura*. Although this text was known throughout the Middle Ages, it was not until **Poggio Bracciolini** found an original ancient version that interest in the principles of ancient architecture as expounded by Vitruvius increased in great measure. In 1486, the first printed volume of Vitruvius' treatise was published and, in 1511, an illustrated edition was also made available. **Daniele Barbaro** translated the text from Latin to Italian in 1556, with this volume accompanied by illustrations carried out by **Andrea Palladio**.

Vitruvius believed that architecture must reflect utility, strength, and beauty, this last achieved through symmetry and the relationship of its parts to the whole. The proportions of a building should conform to those of the human form and its design should relate to its function and type. Vitruvius provided the three classifications of the orders (Doric, Ionic, Corinthian) normally found in ancient structures, explaining their derivation, use, proportions, and symbolism. He also provided information on ancient city planning, building materials, hydraulics, and military machinery. Vitruvius' text had a great impact on the development of Renaissance architecture and architectural theory. It inspired **Leon Battista Alberti** to write his own treatise, *De re aedificatoria*. Palladio's *Quattro Libri* synthesizes the materials expounded by Alberti and Vitruvius, and his Teatro Olimpico in Vincenza reconstructs a Roman theater described in the *De architectura*. **Giuliano da Sangallo**'s Villa **Medici** at Poggio a Caiano is based on a description of a suburban villa by Vitruvius, and the **Villa Farnesina** in Rome by Baldassare Peruzzi has the proportional relations of width, length, and height and three-partite plan also provided by the ancient writer.

VORAGINE, JACOBUS DA (c. 1230–c. 1298). Dominican priest and hagiologist who served as archbishop of Genoa from 1292 until his death in c. 1298. Voragine is best known as the author of the *Golden Legend*, a collection of stories of the saints that became a major source for artists. He also authored the *Chronicon Genovese*, a chronicle of Genoa that provides important historical information, and a series of theological writings, including the *Sermones de sanctis, de tempore, quadragesimales, de Beata Maria Virgine*, a collection of 307 sermons.

VOUET, SIMON (1590–1649). French artist born in Paris to a bourgeois family, his father a painter employed in the French court. In 1604, at 14, Vouet was called to England to render the portrait of a French lady and, in 1611, he accompanied the French Ambassador to Constantinople where he remained for a year painting portraits of Sultan Achmet I. These works are unfortunately lost. From Constantinople, he went to **Venice** in 1613, and in the following year to **Rome** where he supported himself financially through a pension from the French crown. Visits to Naples, Genoa, Modena, and **Bologna** gave him the opportunity to study the art in major Italian collections. In 1624, Vouet was elected president of the **Accademia di San Luca**, attesting to his success. The fact that many of his early paintings are lost has hindered the tracing of his artistic development and reconstruction of a reasonable chronology.

Upon arrival in Rome, Vouet began experimenting with the **Caravaggist** mode of painting, with *St. Jerome and the Angel of Judgment* (c. 1625; Washington, National Gallery) and the *Birth of the Virgin* (c. 1620; Rome, San Francesco a Ripa) providing examples of this phase in his career. By the mid-1620s, the popularity of Caravaggism had waned and patrons demanded works in the more **classicizing** style of the **Carracci**. Vouet responded by eliminating the theatrical lighting and crude figure types of his Caravaggist phase and by replacing them with more elegant renditions. His *Time Vanquished by Hope, Love, and Beauty* (1627; Madrid, Prado) shows this change and in particular the influence of **Guido Reni**.

Vouet was summoned back to France in 1627 and appointed Peintre du Roi (The King's Painter). At the Louvre, he established a school of painting where he trained the next generation of French

masters, including **Eustache Le Seur**, Charles Lebrun, and Pierre Mignard. His studio became the locus of dissemination of the official artistic ideology of the French monarchs—**Louis XIII**, his wife Anne of Austria, and mother **Marie de' Medici**. Many of the large decorative programs Vouet carried out in Paris were destroyed. Of his surviving works, the *Allegory of Wealth* (c. 1630–1635; Paris, Louvre), believed to have been painted for Louis XIII's principal residence, St. Germain-en-Laye, and the *Presentation* (1641; Paris, Louvre), painted for the high altar of the Novitiate Church of the **Jesuits** in Paris and commissioned by Cardinal **Armand Richelieu**, are among the most notable examples. Vouet is credited with bringing the classicizing Italian style of painting to France and therefore changing the course of art in the region.

– W –

WATER CARRIER OF SEVILLE (1619; London, Wellington Museum). **Diego Velázquez** painted the *Water Carrier of Seville* four years before entering in the service of King **Philip IV** of Spain. It belongs to his Sevillian period when *bodegónes* were his favored subjects, usually painted in the **Caravaggist** style. The work shows a humble street peddler of advanced age in torn clothes offering a glass of water to a customer. He is depicted with the same dignity as a priest holding the challis during the mass. The fact that there are three males in the picture at three different stages of life—one in profile, another in a three-quarter turn, and the last in a frontal pose— suggests the theme of the three ages of man—childhood, adulthood, and old age—common to the **Baroque** era. The painting demonstrates Velázquez's ability at rendering different textures, including the terracotta jugs, the beads of sweat on them, the transparency of the glass and water, and the fig at the bottom of the glass then thought to possess purifying properties.

WEYDEN, ROGIER VAN DER (1399/1400–1464). One of the leading Early Netherlandish painters, van der Weyden was born in Tournai. His apprenticeship with **Robert Campin** is known to have begun in 1427 and his entry into the painter's **guild** to have taken place

in 1432. He is recorded in Brussels in 1435 where he was appointed city painter in the following year and where he remained for the rest of his life, save for a trip to **Rome** in the jubilee year of 1450. None of his paintings are signed or dated and many are lost. Therefore, attributions and chronology relating to his oeuvre rely mainly on visual evidence. Though van der Weyden's art depends on the developments introduced by Campin, what sets him apart from his contemporaries is the emotive content of his works.

The *Virgin and Child in a Niche* (c. 1432–1433; Vienna, Kunsthistorisches Museum) is believed to fall in the early years of the artist's career. It shows the crowned Mary suckling the Christ Child, both standing in a shallow niche to imitate Gothic sculpture. The Virgin type, with a broad face, van der Weyden borrowed from Campin. The tender tilt of Mary's head and her smile as she nurtures her infant son is, however, very much his own. Van der Weyden's *Visitation* (c. 1435; Leipzig, Museum der Bildenden Künste) also belongs to his early years. Here, the Virgin and St. Elizabeth meet at the crossing of two paths, the two women affectionately touching each other's pregnant belly to feel the children they carry inside. One of van der Weyden's most striking works is the *Deposition* (c. 1438; Madrid, Prado), commissioned by the Archers' Guild of Louvain for Notre Dame Hors-les-Murs. This too takes place in a shallow Gothic niche to give the impression of sculpture that has come alive. The brilliant colors utilized by the artist and rhythmic linear contours add to the work's aesthetic appeal. The scene is deeply emotional. Mary, who has fainted, echoes her son's limp body to denote that his pain is hers. The other figures cry, their eyes and noses red and swollen. To this period also belongs the *Calvary Triptych* (c. 1438–1440; Vienna, Kunsthistorisches Museum), an **altarpiece** with the **Crucifixion** in the center and **Mary Magdalen** and Veronica on the wings. The Virgin embraces the cross and her facial expression, like that of **John**, is that of deep sorrow. The intense emotionalism of van der Weyden's work continued into the 1440s and 1450s, with the *Seven Sacraments Altarpiece* (c. 1448; Antwerp, Musée des Beaux-Arts) painted for Jean Chevrot, bishop of Tournai; the *Entombment* (c. 1450; Florence, **Uffizi**) painted in Italy possibly for the **Medici**; and the *Crucifixion with the Virgin and St. John* (c. 1455–1459; Philadelphia Musem) providing particular examples.

Van der Weyden was also an accomplished portraitist. His *Portrait of a Lady* (c. 1455; Washington, National Gallery) presents the sitter in bust length, with hands clasped together and resting on the frame. The crisp rendering of the costume, coif, and veil identify the woman as an aristocrat, while her lowered eyes grant her a sense of introspection. The *Portrait of Francesco d'Este* (c. 1455–1460; New York, Metropolitan Museum), the illegitimate son of Lionello d'Este who was sent to Brussels in 1444 for his education, is the male version of the aristocratic portrait type. The fact that many copies were made of van der Weyden's works attests to his immense popularity. He was a major influence on Northern artists up to the end of the 15th century. Regrettably, by the 19th century he fell into complete oblivion and it was not until recently that methodic study of documentation pertaining to the artist returned him to his rightful placement in the history of art.

WILLIAM "THE SILENT" OF ORANGE (1533–1584). William "the Silent" of Orange was born in Dillenburg near Wiesbaden, Germany, to the Protestant Count William of Nassau and Juliana of Stolberg. In 1544, William became the prince of Orange when his cousin René de Châlon, who held the position, died without leaving any heirs. Holy Roman Emperor **Charles V**, who acted as William's regent until he came of age, insisted that the boy receive a Catholic education at the court in Brussels. In 1559, **Philip II** of Spain, Charles' son, appointed William stadtholder (governor) of Holland, Utrecht, and Zeeland. The king's persecution of Protestants in the region and his curtailment of freedom prompted William to lead the revolt against the Spanish crown that resulted in the declaration of emancipation by the United Dutch provinces in 1579. In 1581, Philip denounced William as a traitor and offered a reward on his head, at the same time as Brabant, Flanders, Utrecht, Gelderland, Holland, and Zeeland declared Philip's deposition from sovereignty over them. A Catholic fanatic assassinated William in Delft in 1584.

WITZ, KONRAD (c. 1410–c. 1446). German painter from Rottweil in Württemberg who entered the Painter's **Guild** in Basel in 1434 and became a citizen of the region in the following year. The fact that he purchased a house there in 1443 suggests that he had a busy work-

shop. Nothing is known of his training. His earliest known work is the *Heilspiegel Altarpiece* (c. 1435), its panels now dispersed in various museums and its main scene missing. Of these, *Esther and Ahasuerus*, in the Kunstmuseum in Basel, demonstrates Witz's use of deep contrasts of color and angular draperies typical of the Early Netherlandish style. His *Sts. Catherine and Mary Magdalen* (c. 1440–1443; Strasbourg, Musée de l'Oeuvre Notre-Dame) shows a major departure from the earlier, more naïve portrayal. Here the sense of depth is successfully rendered through a repetition of four-partite **vaults** that diminish in size as they move into the distance. The same feature is seen in his *Madonna and Child with Saints in a Church Interior* (c. 1443) in the Museo di Capodimonte, Naples. Witz's best known work is the *Miraculous Draft of Fishes* (1444; Geneva, Musée d'Art et d'Histoire), part of the *St. Peter* Altarpiece commissioned by Bishop François de Mies for the chapel of Notre-Dame des Maccabées in the Cathedral of St.-Pierre in Geneva that belonged to his uncle, Cardinal de Brogny. The scene shows Witz's close study of reflections on the water and distortions of figures and objects seen beneath its surface. The date of the artist's death is unknown. In 1466, his wife is referred to in a document as a widow.

– Z –

ZURBARÁN, FRANCISCO DE (1598–1664). Francisco de Zurbarán was born in Extremadura, a small town near Seville, Spain. In 1625, he married into a family of landowners and merchants, which provided him with the necessary funds to establish a workshop where he catered mainly to religious communities as well as the Spanish colonies in the Americas. In 1629, he settled in Seville, where he became the city's leading artist. His earliest documented work is the *Crucified Christ* (1627; Chicago, Art Institute) he painted for the Monastery of San Pablo el Real in Seville, a work inspired by the polychromed wood sculptures carried during Spanish religious processions. His *St. Serapion* (1628; Hartford, Wadsworth Atheneum), rendered for the Monastery of the Merced Calzada in Seville, shows Zurbarán's mastery in portraying white, crisp fabrics. Zurbarán specialized in depictions of single saints either meditating

or simply standing in heroic fashion accompanied by their attributes. Examples of this are his *St. Francis Meditating* (1638; London, National Gallery) and *St. Margaret of Antioch* (1634; London, National Gallery). Among his narratives is *Christ and the Virgin in the House at Nazareth* (1640; Cleveland Museum of Art), an unusual subject. In the 1640s, Zurbarán changed his style to a softer, more spontaneous manner so he could compete with Murillo who was quickly becoming the most popular artist in Seville. His *Immaculate Conception* (1660s; Dublin, National Gallery of Ireland) represents this change in his style. The shift proved to be disastrous to his career. His popularity declined and his finances collapsed. He died penniless in Madrid in 1664.

Bibliography

CONTENTS

I. INTRODUCTION

The scholarly literature on Renaissance art is vast, mainly due to the fact that the most important masters of the era were influential characters whose innovations proved to be a major force in the development of later movements and that, in fact, continue to affect the production of art to this day. In compiling the bibliography, the list has therefore been limited to the key texts on the artists covered in the dictionary and introduction, and their most salient works, as well as themes crucial to the understanding of Renaissance art. The most current sources have been chosen, and older works have only been added when still considered standard for in-depth research.

The first section provides the survey books on the art created in the major artistic centers of Europe. Not only do these books present primordial models for scholarship, but they also include comprehensive bibliographies. Many are part of a series first published by Penguin Books under the editorship of Nikolaus Pevsner titled *The Pelican History of Art,* now taken over by Yale University Press, which continues to update these volumes for use as teaching tools. Others are from the *Sources and Documents Series* first published by Prentice Hall and edited by H. W. Janson and now taken over by Northwestern University Press. The books in this second series offer English translations of letters written by both Renaissance artists and patrons, early biographies, excerpts from art treatises, and other such invaluable documents that provide insight on the attitudes toward art during the period in question. The materials in this second series are in most cases abridged and, therefore, readers will benefit from consulting the primary sources listed under the next section in the bibliography, titled "Treatises, Artists' Biographies, Emblem Books, and Other Renaissance Texts Related to Art." That section also includes texts often used by artists and patrons as sources for subjects (for example, Tasso's *Gerusalemme Liberata*), iconography manuals (such as Ripa's *Iconologia*), and philosophical treatises (such as Ficino's *Platonic Theology*) that had an impact on the art of the period.

Renaissance artists were cognizant of the revolutionary nature of their developments and felt the need to record them in writing for dissemination. Their rationalization of art and theoretical formulations led to major changes in their societal ranking. Early on considered mere manual laborers, artists eventually came to be seen as gifted geniuses blessed with the God-like ability to create. Consequently, art was raised from the realm of craft to that of liberal art and academies were founded to offer not only training but also an environment for learned discussion and theoretical thinking. Among these were the Accademia del Disegno in Florence, the Accademia di San Luca in Rome, the Accademia dei Desiderosi (later the Accademia degli Incamminati) in Bologna, and the French Academy in Paris. Sources on the training of artists and their rise in status are listed under the heading "Academies, Art Training, and Artistic Identity."

The concept of an academy that provides an intellectually stimulating environment is familiar to the modern world. In the Renaissance, however, this was a novel idea for artists who had been trained since childhood in busy workshops alongside a master whose main concern was to produce art in as efficient and as timely a manner as possible. Also different from our modern views is that artistic freedom did not exist in the Renaissance and the large majority of the works then produced were made to order. They were commissioned under rigorous standards, the negotiations usually involving the signing of a legal contract. Only recently have scholars begun a systematic exploration of the processes involved in the fulfillment of commissions. A number of important

anthologies and independent studies have been published that have revealed the rationale for commissioning and collecting art. The impulses that led to patronage and collecting varied. Some patrons engaged in the activity out of a sense of duty, as support of the arts was expected from individuals in the high echelons of society. Others used art as political propaganda, to memorialize a departed family member, or to celebrate a marriage, or purchased it simply for the appreciation of its aesthetic and intellectual value. Art sometimes also served as vehicle for the expiation of sins, for the attainment of salvation, or the commemoration of a miraculous event. The sources listed under the heading "Art Patronage and Collecting" unravel the intricacies of the relationships between artists and clients and of art as commodity.

Then follow a series of sections by region, starting with Italy, then Flanders and the Netherlands, Germany and Austria, France, England, and finally Spain and Portugal. In these sections, the books listed deal with individual artists and particular works of art and architecture. Since the scholarly literature on Italy is particularly abundant, this section has been subdivided chronologically, beginning with the Proto-Renaissance era and continuing to the Early Renaissance, High Renaissance and Mannerism, and Baroque.

Here, mention must also be made of some useful Internet sources. The Web Gallery of Art, www.wga.hu; Olga's Gallery, www.abcgallery.com; and Artchive, http://artchive.com/ftp_site.htm provide general biographical information on artists and are valuable for their collection of images. The Catholic Encyclopedia is available online, www.newadvent.org/cathen/index.html, and is useful mainly as a historical source, particularly on the papacy and popes, cardinals, and bishops who were among the greatest supporters of art. The *Best of History Websites* includes a comprehensive list of sites related to art history, www.besthistorysites.net/ArtHistory.shtml. Of these, *The Mother of All Art and Art History* site, www.art-design.umich.edu/mother, stands out as it includes links to research sources, image collections and online art, and art history journals and newsletters. Finally, most museums today maintain websites that include information on the works in their collections and the artists who created them. Lists of museums and links to their websites are available at *The Mother of All Art and Art History* site.

II. GENERAL STUDIES

Adams, Laurie Schneider. *Italian Renaissance Art*. Boulder, Colo.: Westview Press, 2001.

Ames-Lewis, Francis. *The Intellectual Life of the Early Renaissance Artist*. New Haven, Conn.: Yale University Press, 2000.

Baneke, Joost, ed. *Dutch Art and Character: Psychoanalytic Perspectives on Bosch, Bruegel, Rembrandt, van Gogh, Mondrian, Willink, Queen Wilhelmina*. Amsterdam: Swets & Zeitlinger, 1993.

Benedict, Nicholson. *Caravaggism in Europe*. Turin: U. Allemandi, 1989.

Blunt, Anthony. *Art and Architecture in France 1500–1700*. New Haven, Conn.: Yale University Press, 1999.

Boucher, Bruce. *Italian Baroque Sculpture*. London: Thames & Hudson, 1998.

Brown, Jonathan. *Painting in Spain 1500–1700*. New Haven, Conn.: Yale University Press, 1998.

Brown, Patricia Fortini. *Art and Life in Renaissance Venice*. Upper Saddle River, N.J.: Prentice Hall & Harry N. Abrams, 1997.

Campbell, Gordon. *Renaissance Art and Architecture*. Oxford: Oxford University Press, 2004.

Chadwick, Whitney. *Women, Art, and Society*. London: Thames & Hudson, 1990.

Cheney, Liana de Girolami, Alicia Craig Faxon, and Kathleen Lucey Russo. *Self-Portraits by Women Painters*. Aldershot, U.K.: Ashgate, 2000.

Cole, Alison. *Virtue and Magnificence: Art of the Italian Renaissance Courts*. New York: Harry N. Abrams, 1995.

Cole, Bruce. *Italian Art, 1250–1550: The Relation of Renaissance Art to Life and Society*. New York: Harper & Row, 1987.

———. *The Renaissance Artist at Work: From Pisano to Titian*. New York: Harper & Row, 1983.

Cuttler, Charles D. *Northern Painting from Pucelle to Bruegel/Fourteenth, Fifteenth, and Sixteenth Centuries*. New York: Holt, Rinehart & Winston, 1968.

Delaney, John J. *Dictionary of Saints*. New York: Image Books, Doubleday, 1983.

Enggass, Robert, and Jonathan Brown. *Italy and Spain, 1600–1750: Sources and Documents*. Evanston, Ill.: Northwestern University Press, 1992.

Freedberg, Sydney Joseph. *Painting in Italy 1500–1600*. New Haven, Conn.: Yale University Press, 1993.

Gilbert, Creighton E. *Italian Art, 1400–1500: Sources and Documents*. Evanston, Ill.: Northwestern University Press, 1992.

Hale, J. R., ed. *Encyclopaedia of the Italian Renaissance*. London: Thames & Hudson, 1981.

Hartt, Frederick. *History of Italian Renaissance Art: Painting, Sculpture, Architecture*. New York: Harry N. Abrams, 2003.

Haskell, Francis. *Patrons and Painters: Art and Society in Baroque Italy*. New Haven, Conn.: Yale University Press, 1980.

Heydenreich, Ludwig Heinrich. *Architecture in Italy 1400–1500*. New Haven, Conn.: Yale University Press, 1996.

Hollingsworth, Mary. *Patronage in Renaissance Italy: From 1400 to the Early Sixteenth Century*. Baltimore, Md.: Johns Hopkins University Press, 1994.

Howarth, David. *Images of Rule: Art and Politics in the English Renaissance, 1485–1649*. Berkeley: University of California Press, 1997.

Impelluso, Lucia. *Gods and Heroes in Art*. Translated by Thomas Michael Hartmann. Los Angeles: J. Paul Getty Museum, 2002.

Jenkens, A. Lawrence, ed. *Renaissance Siena: Art in Context*. Kirksville, Mo.: Truman State University Press, 2005.

Kahr, Madlyn Millner. *Dutch Painting in the Seventeenth Century*. New York: Harper & Row, 1978.

Kelly, J. N. D. *The Oxford Dictionary of Popes*. Oxford: Oxford University Press, 1986.

Klein, Robert, and Henri Zerner. *Italian Art, 1500–1600: Sources and Documents*. Evanston, Ill.: Northwestern University Press, 1994.

Kliemann, Julian-Matthias. *Italian Frescoes: High Renaissance and Mannerism, 1510–1600*. New York: Abbeville Press, 2004.

Lawrence, Cynthia, ed. *Women and Art in Early Modern Europe: Patrons, Collectors, and Connoisseurs*. University Park: Pennsylvania State University Press, 1997.

Levy, Allison M. *Re-membering Masculinity in Early Modern Florence: Widowed Bodies, Mourning and Portraiture*. Aldershot, U.K.: Ashgate, 2003.

Lotz, Wolfgang. *Architecture in Italy 1500–1600*. New Haven, Conn.: Yale University Press, 1995.

Magnuson, Torgil. *Rome in the Age of Bernini*. 2 vols. Stockholm: Almqvist & Wiksell, 1982.

Mateer, David, ed. *The Renaissance in Europe: A Cultural Enquiry, Courts, Patrons and Poets*. New Haven, Conn.: Yale University Press, 2000.

Mérot, Alain. *French Painting in the Seventeenth Century*. New Haven, Conn.: Yale University Press, 1995.

Metropolitan Museum of Art. *The Age of Caravaggio*. New York: Metropolitan Museum of Art, 1985.

Montagu, Jennifer. *Roman Baroque Sculpture: The Industry of Art*. New Haven, Conn.: Yale University Press, 1989.

National Gallery of Art. *The Age of Correggio and the Carracci: Emilian Painting of the Sixteenth and Seventeenth Centuries*. Washington, D.C.: National Gallery of Art, 1986.

Pächt, Otto. *Early Netherlandish Painting: From Rogier van der Weyden to Gerard David*. Edited by Monika Rosenauer. Translated by David Britt. London: Harvey Miller, 1997.

Panofsky, Erwin. *Early Netherlandish Painting: Its Origins and Character*. New York: Harper & Row, 1971.

Partridge, Loren W. *The Art of the Renaissance in Rome 1400–1600*. Upper Saddle River, N.J.: Prentice Hall, 2005.

Pearson, Andrea. *Envisioning Gender in Burgundian Devotional Art, 1350–1530: Experience, Authority, Resistance*. Aldershot, U.K.: Ashgate, 2005.

Pope-Hennessy, John. *Italian Renaissance Sculpture: An Introduction to Italian Sculpture.* 3 vols. New York: Vintage Books, 1985.

Slive, Seymour. *Dutch Painting 1600–1800.* New Haven, Conn.: Yale University Press, 1995.

Smyth, Craig Hugh. *Mannerism and Maniera.* Vienna: IRSA, 1992.

Stechow, Wolfgang. *Northern Renaissance Art 1400–1600: Sources and Documents.* Evanston, Ill.: Northwestern University Press, 1989.

Tinagli, Paola. *Women in Italian Renaissance Art: Gender, Representation and Identity.* Manchester: Manchester University Press, 1997.

Tomlinson, Janis. *From El Greco to Goya: Painting in Spain, 1561–1828.* New York: Harry N. Abrams, 1997.

Turner, Richard A. *Renaissance Florence: The Invention of a New Art.* Upper Saddle River, N.J.: Prentice Hall & Harry N. Abrams, 1997.

Varriano, John. *Italian Baroque and Rococo Architecture.* New York: Oxford University Press, 1986.

Vlieghe, Hans. *Flemish Art and Architecture 1585–1700.* New Haven, Conn.: Yale University Press, 1998.

Voss, Hermann. *Painting in the Late Renaissance in Rome and Florence.* Revised and translated by Susanne Pelzel. San Francisco: Alan Wofsy Fine Arts, 1997.

Waterhouse, Ellis Kirkham. *Painting in Britain: 1530 to 1790.* 5th ed. New Haven, Conn.: Yale University Press, 1994.

Welch, Evelyn. *Art in Renaissance Italy 1350–1500.* Oxford: Oxford University Press, 2000.

Westermann, Mariët. *A Worldly Art: The Dutch Republic 1585–1718.* Upper Saddle River, N.J.: Prentice Hall & Harry N. Abrams, 1996.

Wittkower, Rudolf. *Art and Architecture in Italy 1600–1750.* Harmondsworth, U.K.: Penguin Books, 1980.

Wolf, Robert Erich. *Renaissance and Mannerist Art.* New York: Abrams, 1968.

Zerner, Henri. *Renaissance Art in France: The Invention of Classicism.* Paris: Flammarion, 2003.

III. TREATISES, ARTISTS' BIOGRAPHIES, EMBLEM BOOKS, AND OTHER RENAISSANCE TEXTS RELATED TO ART

Alberti, Leon Battista. *L'architettura (De re aedificatoria).* Edited by Giovanni Orlandi. Milan: Edizione Il Polifilo, 1966.

———. *On Painting.* Translated by Cecil Grayson. London: Penguin Books, 1991.

———. *On the Art of Building in Ten Books.* Translated by Joseph Rykwert, Neil Leach, and Robert Tavernor. Cambridge, Mass.: MIT Press, 1988.

Alciati, Andrea. *Emblemata: Lyons, 1550.* Translated and edited by Betty I. Knott. Aldershot, U.K.: Scolar Press, 1996.

Ariosto, Lodovico. *Orlando Furioso.* Edited by Gioacchino Paparelli. Milan: Biblioteca universale Rizzoli, 2000.

Baglione, Giovanni. *Le vite de' pittori, scultori et architetti: dal pontificato di Gregorio XIII del 1572 in fino a' tempi di Papa Urbano Ottavo nel 1642.* Edited by Jacob Hess and Herwarth Röttgen. Vatican: Biblioteca Apostolica Vaticana, 1995.

Baldinucci, Filippo. *Life of Bernini.* Translated by Catherine Enggass. University Park: Pennsylvania State University Press, 1966.

———. *Notizie dei professori del disegno da Cimabue in qua.* Florence: S.P.E.S., 1974–1975.

Bellori, Giovanni Pietro. *The Lives of Annibale and Agostino Carracci.* Translated by Catherine Enggass. University Park: Pennsylvania State University Press, 1968.

———. *The Lives of the Modern Painters, Sculptors and Architects.* Edited by Alice Sedgwick Wohl and Hellmut Wohl. New York: Cambridge University Press, 2005.

———. *Vite di Guido Reni, Andrea Sacchi, e Carlo Maratti.* Rome: Biblioteca d'arte editrice, 1942.

Bernini, Domenico. *Vita del cavalier Gio. Lorenzo Bernino.* Rome: Rocco Bernabò, 1713.

Boccaccio, Giovanni. *Decameron.* Edited by Vittore Branca. Florence: Le lettere & D. de Selliers, 1999.

———. *Famous Women.* Translated by Virginia Brown. Cambridge, Mass.: Harvard University Press, 2001.

Borsi, Franco. *Leon Battista Alberti: The Complete Works.* London: Faber & Faber, 1989.

Cairns, Christopher. *Pietro Aretino and the Republic of Venice: Researches on Aretino and His Circle in Venice, 1527–1556.* Florence: L. S. Olschki, 1985.

Carduccho, Vicente. *Diálogos de la pintura: Su defensa, origen, esencia, definición, modos y diferencias.* Edited by Francisco Calvo Serraller. Madrid: Turner, D. L., 1979.

Cellini, Benvenuto. *The Life of Benvenuto Cellini Written by Himself.* Translated by John Addington Symonds. 2nd ed. London: Phaidon Press, 1995.

Cennini, Cennino. *Il libro dell' arte.* Edited by Franco Brunello. Vincenza: N. Pozza, 1998.

Chantelou, Paul Fréart. *Diary of the Cavaliere Bernini's Visit to France.* Edited by Anthony Blunt. Translated by Margery Corbett. Princeton, N.J.: Princeton University Press, 1985.

Colonna, Francesco. *Hypnerotomachia Poliphili.* Edited by Marco Ariani and Mino Gabrielle. Milan: Adelphi Edizioni, 1998.

Condivi, Ascanio. *The Life of Michel-Angelo.* Edited by Hellmut Wohl. Translated by Alice Sedgwick Wohl. 2nd ed. University Park: Pennsylvania State University Press, 1999.

De Mambro Santos, Ricardo. *Arcadie del Vero: arte e teoria nella Roma del Seicento.* Rome: Apeiron, 2001.

Dürer, Albrecht. *Diary of His Journey to the Netherlands, 1520–1521, Accompanied by the Silverpoint Sketchbook, and Paintings and Drawings Made during His Journey.* Translated by Philip Troutman. Greenwich, Conn.: New York Graphic Society, 1971.

———. *The Painter's Manual: A Manual of Measurement of Lines, Areas, and Solids by Means of Compass and Ruler Assembled by Albrecht Dürer for the Use of All Lovers of Art with Appropriate Illustrations Arranged to Be Printed in the Year MDXXV.* Translated by Walter L. Strauss. New York: Abaris Books, 1977.

Ficino, Marsilio. *Platonic Theology.* Edited by James Hankins and William Bowen. Translated by Michael J. B. Allen and John Warden. Cambridge, Mass.: Harvard University Press, 2001.

Filarete, Antonio. *Trattato di architettura.* Edited by Anna Maria Finoli and Liliana Grassi. Milan: Il Polifilo, 1972.

Finotti, Fabio. *Retorica della diffrazione: Bembo, Aretino, Giulio Romano e Tasso, letteratura e scena cortigiana.* Florence: L. S. Olschki, 2004.

Freedman, Luba. *Titian's Portraits through Aretino's Lens.* University Park: Pennsylvania State University Press, 1995.

Ghiberti, Lorenzo. *I Commentarii: Biblioteca nazionale centrale di Firenze, II, I, 333.* Edited by Lorenzo Bartoli. Florence: Giunti, 1998.

Ivins, William Mills. *On the Rationalization of Sight: With an Examination of Three Renaissance Texts on Perspective.* New York: Da Capo Press, 1973.

Jarzombek, Mark. *On Leon Battista Alberti: His Literary and Aesthetic Theories.* Cambridge, Mass.: MIT Press, 1989.

Kanerva, Liisa. *Defining the Architect in Fifteenth-Century Italy: Exemplary Architects in L. B. Alberti's De re aedificatoria.* Helsinki: Suomamalainen Tiedeakatemia, 1998.

Leonardo da Vinci. *Tratatto della Pittura.* Edited by Ettore Camesasca. Milan: Neri Pozza, 2000.

Malvasia, Cesare. *Felsina Pittrice: Vite dei pittori bolognesi.* Bologna: Alfa, 1971.

———. *Malvasia's Life of the Carracci: Commentary and Translation.* Translated by Anne Summerscale. University Park: Pennsylvania State University Press, 2000.

Mancini, Giulio. *Considerazioni sulla pittura.* Rome: Accademia nazionale dei Lincei, 1956.

Mancini, Giulio, Giovanni Baglione, and Giovan Pietro Bellori. *Lives of Caravaggio*. Edited by Helen Langdon. London: Pallas Athene, 2005.

Mander, Karel van. *The Lives of the Illustrious Netherlandish and German Painters, from the First Edition of the Schilder-Boeck (1603–1604): Preceded by the Lineage, Circumstances and Place of Birth, Life and Works of Karel Van Mander, Painter and Poet and Likewise His Death and Burial, from the Second Edition of the Schilder-Boeck (1616–1618)*. Edited and translated by Hessel Miedema. Doornspijk, Netherlands: Davaco, 1994.

Massey, Lyle, ed. *The Treatise on Perspective: Published and Unpublished*. Washington, D.C.: National Gallery & Yale University Press, 2003.

O'Neil, Maryvelma Smith. *Giovanni Baglione: Artistic Reputation in Baroque Rome*. Cambridge: Cambridge University Press, 2002.

Pacheco, Francisco. *Arte de la pintura*. Madrid: Instituto de Valencia de Don Juan, 1956.

Paleotti, Gabriele. *Discorso intorno alle imagini sacre et profane: Bologna, 1582*. Edited by Paolo Prodid. Bologna: Arnaldo Forni, 1990.

Palladio, Andrea. *The Four Books of Architecture*. London: Isaac Ware, n.d.

Palomino de Castro y Velasco, Antonio. *Lives of the Eminent Spanish Painters and Sculptors*. Translated by Nina Ayala Mallory. Cambridge: Cambridge University Press, 1987.

———. *El museo pictorico, y escala óptica. Teórica de la pintura, en que se describe su origen, esencia, especies y qualidades, con todos los demas accidentes que la enriquecen é ilustran. Y se prueban con demonstraciones matematicas y filosoficas sus mas radicales fundamentos*. 3 vols. Madrid: Imprenta de Sancha, 1795–1797.

Piero della Francesca. *De prospectiva pingendi*. Parma: Di Montanari, 2000.

Ridolfi, Carlo. *The Life of Tintoretto, and of His Children Domenico and Marietta*. Translated by Catherine Enggass and Robert Enggass. University Park: Pennsylvania State University Press, 1984.

———. *The Life of Titian*. Translated by Julia Conaway Bondanella and Peter Bondanella. University Park: Pennsylvania State University Press, 1996.

Ripa, Cesare. *Iconologia*. Edited by Piero Buscaroli. Milan: Neri Pozza, 2000.

Serlio, Sebastiano. *I sette libri dell'architettura: Venezia, 1584*. Bologna: A. Forni, 1978.

Tasso, Torquato. *Jerusalem Delivered [Gerusalemme Liberata]*. Edited and translated by Anthony M. Esolen. Baltimore, Md.: Johns Hopkins University Press, 2000.

Vasari, Giorgio. *The Lives of the Artists*. Translated by Julia Conaway Bondanella and Peter Bondanella. Oxford: Oxford University Press, 1991.

Vignola, Giacomo da. *Regole della prospettiva prattica*. Edited by Ciro Luigi Anzivino. Bologna: A. Forni, 1985.

Voragine, Jacobus de. *The Golden Legend: Readings on the Saints*. Translated by William Granger Ryan. Princeton, N.J.: Princeton University Press, 1993.

Waddington, Raymond B. *Aretino's Satyr: Sexuality, Satire and Self-Projection in Sixteenth-Century Literature and Art*. Toronto: University of Toronto Press, 2004.

IV. ACADEMIES, ART TRAINING, AND ARTISTIC IDENTITY

Ames-Lewis, Francis. *The Intellectual Life of the Early Renaissance Artist*. New Haven, Conn.: Yale University Press, 2000.

Barzman, Karen-edis. *The Florentine Academy and the Early Modern State: The Discipline of Disegno*. Cambridge: Cambridge University Press, 2000.

Boschloo, Anton W. A., et al. *Academies of Art between Renaissance and Romanticism*. s-Gravenhage, Netherlands: SDU, 1989.

Cole, Bruce. *The Renaissance Artist at Work: From Pisano to Titian*. New York: Harper & Row, 1983.

Field, Arthur. *The Origins of the Platonic Academy of Florence*. Princeton, N.J.: Princeton University Press, 1988.

Gallucci, Margaret A. *Benvenuto Cellini, Sexuality, Masculinity, and Artistic Identity in Renaissance Italy*. New York: Houndmills & Palgrave Macmillan, 2003.

Goldstein, Carl. *Teaching Art: Academies and Schools from Vasari to Albers*. Cambridge: Cambridge University Press, 1996.

Ladis, Andrew, and Carolyn Wood, eds. *The Craft of Art. Originality and Industry in the Italian Renaissance and Baroque Workshop*. Athens: University of Georgia Press, 1995.

Martindale, Andrew. *The Rise of the Artist in the Middle Ages and the Early Renaissance*. New York: McGraw-Hill, 1972.

Negro, Emilio, and Massimo Pirondini, eds. *La scuola dei Carracci: dall'Accademia alla bottega di Ludovico*. Modena: Artioli, 1994.

Pevsner, Nikolaus. *Academies of Art, Past and Present*. New York: Da Capo Press, 1973.

Rogers, Mary, ed. *Fashioning Identities in Renaissance Art*. Aldershot, U.K.: Ashgate, 2000.

Scheller, Robert W. *Exemplum: Model-Book Drawings and the Practice of Artistic Transmission in the Middle Ages (ca. 900–1470)*. Amsterdam: Amsterdam University Press, 1995.

Thomas, Anabel. *The Painter's Practice in Renaissance Tuscany*. Cambridge: Cambridge University Press, 1995.

Wackernagel, Martin. *The World of the Florentine Renaissance Artist: Projects and Patrons, Workshop and Art Market.* Translated by Alison Luchs. Princeton, N.J.: Princeton University Press, 1981.

Waźbiński, Zygmunt. *L'Accademia medicea del disegno a Firenze nel Cinquecento: idea e istituzione.* 2 vols. Florence: L. S. Olschki, 1987.

Woods-Marsden, Joanna. *Renaissance Self-Portraiture: The Visual Construction of Identity and the Social Status of the Artist.* New Haven, Conn.: Yale University Press, 1998.

V. ART PATRONAGE AND COLLECTING

Autrand, Françoise. *Jean de Berry: l'art et le pouvoir.* Paris: Fayard, 2000.

Bentini, Jadranka. *Gli Este a Ferrara: una corte nel Rinascimento.* Cinisello Balsamo, Milan: Silvana, 2004.

Boccardo, Piero, ed. *L'età di Rubens: dimore, committenti e collezionisti genovesi.* Milan: Skira, 2004.

Borean, Linda, and Stefania Mason, eds. *Figure di collezionisti a Venezia tra Cinque e Seicento.* Udine: Forum, 2002.

Brown, Jonathan. *A Palace for a King: The Buen Retiro and the Court of Philip IV.* New Haven, Conn.: Yale University Press, 1980.

Burke, Jill. *Changing Patrons: Social Identity and the Visual Arts in Renaissance Florence.* University Park: Pennsylvania State University Press, 2004.

Callmann, Ellen. *Beyond Nobility: Art for the Private Citizen in the Early Renaissance. Allentown Art Museum, September 28, 1980, through January 4, 1981.* Allentown, Pa.: The Museum, 1980.

Cappelletti, Francesca, ed. *Decorazione e collezionismo a Roma nel Seicento: vicende di artisti, committenti, mercanti.* Rome: Gangemi, 2003.

Cassa di Risparmio delle Provincie Lombarde. *Arte lombarda dai Visconti agli Sforza.* Milan: Cassa di Risparmio delle Provincie Lombarde, 1959.

Chambers, David Sanderson. *Patrons and Artists in the Italian Renaissance.* London: Macmillan, 1970.

Checa Cremades, Fernando. *Carlos V y la Imagen del Héroe en el Renacimiento.* Madrid: Taurus, 1987.

Chong, Alan, Donatella Pegazzano, and Dimitrios Zikos. *Raphael, Cellini, and a Renaissance Banker: The Patronage of Bindo Altoviti.* Translated by Mario Pereira et al. Boston, Mass.: Isabella Stewart Gardner Museum, 2003.

Cox-Rearick, Janet. *The Collection of Francis I: Royal Treasures.* Antwerp: Fonds Mercator, Harry N. Abrams, 1996.

———. *Dynasty and Destiny in Medici Art: Pontormo, Leo X, and the Two Cosimos.* Princeton, N.J.: Princeton University Press, 1984.

Danesi Squarzina, Silvia, ed. *Caravaggio e i Giustiniani: toccar con mano una collezione del Seicento.* Milan: Electa, 2001.

De Marchi, Andrea. *Scrive sui quadri: Ferrara e Roma, Agucchi e alcuni ritratti rinascimentali.* Florence: Centro Di, 2004.

Debenedetti, Elisa, ed. *Artisti e mecenati: dipinti, disegni, sculture e carteggi nella Roma curiale.* Rome: Bonsignori, 1996.

Fliegel, Stephen N., and Sophie Jugie in collaboration with Virginie Barthélémy. *Art from the Court of Burgundy: The Patronage of Philip the Bold and John the Fearless 1364–1419: Musée des Beaux-Arts de Dijon, May 28–September 15, 2004, the Cleveland Museum of Art, October 24, 2004–January 9, 2005.* Dijon: Musée des Beaux-Arts, Cleveland Museum of Art, & Réunion des Musées Nationaux, 2004.

Fulton, Christophers. *An Earthly Paradise: The Medici, Their Collection, and the Foundations of Modern Art.* Florence: L. S. Olschki, 2006.

Fusconi, Giulia, ed. *I Giustiniani e l'antico: Palazzo Fontana di Trevi, Roma, 26 ottobre 2001–27 gennaio 2002.* Rome: "l'Erma" di Bretschneider, 2001.

Gallo, Marco. *I cardinali di Santa Romana Chiesa: collezionisti e mecenati.* Rome: Associazione culturale Shakespeare and Company 2, 2001–2002.

Gee, Loveday Lewes. *Women, Art and Patronage from Henry III to Edward III, 1216–1377.* Woodbridge, U.K.: Boydell Press, 2002.

Gilman, Ernest B. *Recollecting the Arundel Circle: Discovering the Past, Recovering the Future.* New York: Peter Lang, 2002.

Goffen, Rona. *Piety and Patronage in Renaissance Venice: Bellini, Titian, and the Franciscans.* New Haven, Conn.: Yale University Press, 1986.

Goldberg, Edward L. *After Vasari: History, Art, and Patronage in Late Medici Florence.* Princeton, N.J.: Princeton University Press, 1988.

———. *Patterns in Late Medici Art Patronage.* Princeton, N.J.: Princeton University Press, 1983.

Goldfarb, Hilliard Todd, ed. *Richelieu: Art and Power.* Montreal: Montreal Museum of Fine Arts, Wallraf-Richartz-Museum-Fondation Corboud, Snoeck-Ducaju & Zoon, 2002.

Harness, Kelley Ann. *Echoes of Women's Voices: Music, Art, and Female Patronage in Early Modern Florence.* Chicago: Chicago University Press, 2006.

Haskell, Francis. *Patrons and Painters: Art and Society in Baroque Italy.* New Haven, Conn.: Yale University Press, 1980.

Hollingsworth, Mary. *Patronage in Renaissance Italy: From 1400 to the Early Sixteenth Century.* Baltimore, Md.: Johns Hopkins University Press, 1994.

Howarth, David. *Lord Arundel and His Circle.* New Haven, Conn.: Yale University Press, 1985.

Jones, Pamela M. *Federico Borromeo and the Ambrosiana: Art Patronage and Reform in Seventeenth-Century Milan.* Cambridge: Cambridge University Press, 1993.

Kalveram, Katrin. *Die Antikensammlung des Kardinals Scipione Borghese.* Worms am Rhein, Germany: Wernersche Verlagsgesellschaft, 1995.

Kempers, Bram. *Painting, Power, and Patronage: The Rise of the Professional Artist in the Italian Renaissance.* Translated by Beverley Jackson. London: A. Lane, Penguin Press, 1992.

Kent, D. V. *Cosimo de' Medici and the Florentine Renaissance: The Patron's Oeuvre.* New Haven, Conn.: Yale University Press, 2000.

Kent, F. W., and Patricia Simons, eds. *Patronage, Art, and Society in Renaissance Italy.* New York: Oxford University Press, 1987.

King, Catherine. *Renaissance Women Patrons: Wives and Widows in Italy c. 1300–c. 1550.* Manchester, U.K.: Manchester University Press, 1998.

Leone De Castris, Pierluigi. *Arte di corte nella Napoli angioina.* Florence: Cantini, 1986.

Lord, Carla. *Royal French Patronage and Art in the Fourteenth Century: An Annotated Bibliography.* Boston, Mass.: G. K. Hall, 1985.

Lytle, Guy Fitch, and Stephen Orgel, eds. *Patronage in the Renaissance.* Princeton, N.J.: Princeton University Press, 1981.

Marchand, Eckart, and Alison Wright, eds. *With and without the Medici: Studies in Tuscan Art and Patronage 1434–1530.* Aldershot, U.K.: Ashgate, 1998.

Marrow, Deborah. *The Art Patronage of Marie de' Medici.* Ann Arbor, Mich.: UMI Research Press, 1982.

McIver, Katherine A. *Women, Art, and Architecture in Northern Italy, 1520–1580: Negotiating Power.* Aldershot, U.K.: Ashgate, 2006.

Muir, Bernard J. *Reading Texts and Images: Essays on Medieval and Renaissance Art and Patronage in Honour of Margaret M. Manion.* Exeter, U.K.: University of Exeter Press, 2002.

Mulcahy, Rosemarie. *Philip II of Spain: Patron of the Arts.* Dublin, Ireland: Four Courts, 2004.

Museo de Santa Cruz, Toledo. *Reyes y mecenas: los Reyes Católicos, Maximiliano I y los inicios de la casa de Austria en España.* Milan: Electa, 1992.

Myers, Bernard S., and Trewin Copplestone, eds. *Art Treasures in France: Monuments, Masterpieces, Commissions, and Collections.* New York: McGraw-Hill, 1969.

———. eds. *Art Treasures in Germany: Monuments, Masterpieces, Commissions, and Collections.* New York: McGraw-Hill, 1970.

———. eds. *Art Treasures in Spain: Monuments, Masterpieces, Commissions, and Collections.* New York: McGraw-Hill, 1969.

Norman, Diana. *Siena and the Virgin: Art and Politics in a Late Medieval City-State.* New Haven, Conn.: Yale University Press, 1999.

North, Michael, and David Ormrod. *Art Markets in Europe 1400–1800.* Aldershot, U.K.: Ashgate, 1998.

Orso, Steven N. *Art and Death at the Spanish Habsburg Court: The Royal Exequies for Philip IV.* Columbia: University of Missouri Press, 1989.

Periti, Giancarla. *Drawing Relationships in Northern Italian Renaissance Art: Patronage and Theories of Invention.* Aldershot, U.K.: Ashgate, 2004.

Ploeg, Peter van der. *Princely Patrons: The Collection of Frederick Henry of Orange and Amalia of Solms in the Hague.* The Hague: Mauritshuis, Waanders, 1997.

Poggetto, Paolo Dal. *I Della Rovere: Piero della Francesca, Raffaello, Tiziano.* Milan: Electa, 2004.

Rebecchini, Guido. *Private Collectors in Mantua 1500–1630.* Rome: Edizione di storia e letteratura, 2002.

Reiss, Sheryl E., and David G. Wilkins, eds. *Beyond Isabella: Secular Women Patrons of Art in Renaissance Italy.* Kirksville, Mo.: Truman State University Press, 2001.

Réunion des Musées Nationaux. *Paris, 1400: les arts sous Charles VI.* Paris: Fayard, Réunion des Musées Nationaux, 2004.

Robertson, Clare. *Il Gran Cardinale: Alessandro Farnese, Patron of the Arts.* New Haven, Conn.: Yale University Press, 1992.

Schianchi, Lucia Fornari. *I Farnese: arte e collezionismo, studi.* Milan: Electa, 1995.

Southorn, Janet. *Power and Display in The Seventeenth Century: The Arts and Their Patrons in Modena and Ferrara.* Cambridge: Cambridge University Press, 1988.

Trevor-Roper, H. R. *Princes and Artists: Patronage and Ideology at Four Habsburg Courts, 1517–1633.* New York: Harper & Row, 1976.

Vergara, Alexander. *Rubens and His Spanish Patrons.* Cambridge: Cambridge University Press, 1999.

Via, Claudia Cieri, ed. *Immagini degli dei: mitologia e collezionismo tra '500 e '600.* [no city]: Leonardo Arte, 1996.

Vlieghe, Hans, and Katlijne van der Stighelen, eds. *Sponsors of the Past: Flemish Art and Patronage 1550–1700, Proceedings of the Symposium Organized at the Katholieke Universiteit Leuven, December, 14–15, 2001, Faculteit Letteren, Departement Archeologie, Kunstwetenschap en Musicologie.* Turnhout, Belgium: Brepols, 2005.

Von Barghahn, Barbara. *Age of Gold, Age of Iron: Renaissance Spain and Symbols of Monarchy, The Imperial Legacy of Charles V and Philip II, Royal Castles, Palace-Monasteries, Princely Houses.* Lanham, Md.: University Press of America, 1985.

Wackernagel, Martin. *The World of the Florentine Renaissance Market: Projects and Patrons, Workshop and Art Market.* Translated by Alison Luchs. Princeton, N.J.: Princeton University Press, 1981.

Wilson, Jean C. *Painting in Bruges at the Close of the Middle Ages: Studies in Society and Visual Culture.* University Park: Pennsylvania State University Press, 1998.

Wisch, Barbara, and Diane Cole Ahl, eds. *Confraternities and the Visual Arts in Renaissance Italy: Ritual, Spectacle, Image.* Cambridge: Cambridge University Press, 2000.

Woods-Marsden, Joanna. *The Gonzaga of Mantua and Pisanello's Arthurian Frescoes.* Princeton, N.J.: Princeton University Press, 1988.

Zeitz, Lisa. *Tizian, teurer Freund: Tizian und Federico Gonzaga, Kunstpatronage in Mantua im 16. Jahrhundert.* Petersberg, Germany: M. Imhof, 2000.

Zirpolo, Lilian H. *Ave Papa/Ave Papabile: The Sacchetti Family, Their Art Patronage, and Political Aspirations.* Toronto: Centre for Reformation and Renaissance Studies, 2005.

VI. ITALY

A. Proto-Renaissance

Acidini Luchinat, Cristina, and Enrica Neri Lusanna, eds. *Maso di Banco: La Cappella di San Silvestro.* Milan: Electa, 1998.

Ascheri, Mario. *Ambrogio Lorenzetti: la vita del Trecento in Siena e nel contado senese nelle committenze istoriate, pubbliche e private, guida al Buon governo.* Edited by Alberto Colli. Siena: Nuova Immagine, 2004.

Baggio, Luca, Gianluigi Colalucci, and Daniela Bartoletti, eds. *Altichiero da Zevio nell' Oratorio di San Giorgio: il restauro degli affreschi.* Padua: Centro studi Antoniani, 1999.

Bagnoli, Alessandro, ed. *Duccio: alle origini della pittura senese.* Cinisello Balsamo, Milan: Silvana, 2003.

———. ed. *Duccio: Siena fra tradizione bizantina e mondo gotico.* Cinisello Balsamo, Milan: Silvana, 2003.

———. *La Maestà di Simone Martini.* Cinisello Balsamo, Milan: Silvana, 1999.

Bartoli, Maria Teresa, and Stefano Bertocci, eds. *Città e architettura: le matrici di Arnolfo.* Florence: Edifir, 2003.

Basile, Giuseppe, ed. *Giotto: The Arena Chapel Frescoes.* London: Thames & Hudson, 1993.

———. *Giotto: The Frescoes of the Scrovegni Chapel in Padua.* Translated by Rhoda Billingsley. Milan: Skira, 2002.

Beck, Nora. *Giotto's Harmony: Music and Art in Padua at the Crossroads of the Renaissance.* Florence: European Press Academic Pub., 2005.

Bellosi, Luciano. *Cimabue.* Translated by Alexandra Bonfante-Warren, Frank Dabell, and Jay Hyams. New York: Abbeville Press, 1998.

———. *Duccio, la Maestà.* Milan: Electa, 1998.

———. *Pietro Lorenzetti a Assise.* Assisi: DACA, 1982.

Bellosi, Luciano, and Alessandro Angelini. *Sassetta e i pittori toscani tra XIII e XV secolo.* Florence: Studio per edizioni scelte, 1986.

Bertani, Licia, and Muriel Vervat, eds. *La Madonna di Bernardo Daddi negli "horti" di San Michele.* Livorno: Sillabe, 2000.

Bonsanti, Giorgio. *The Basilica of St. Francis of Assisi: Glory and Destruction.* Translated by Stephen Sartarelli. New York: H. N. Abrams, 1998.

Cairola, Aldo. *Simone Martini and Ambrogio Lorenzetti in the Town Hall of Siena.* Florence: I.F.I., 1979.

Calabrese, Omar. *Duccio e Simone Martini: la Maestà come manifesto politico.* Cinisello Balsamo, Milan: Silvana Editoriale, 2002.

Carli, Enzo. *Duccio.* Milan: Electa, 1999.

———. *Duccio a Siena.* Novara: Istituto geografico De Agostini, 1983.

———. *Il Duomo di Siena.* Genoa: Sagep, 1979.

———. *Giovanni Pisano.* Pisa: Pacini, 1977.

———. *Giovanni Pisano: il pulpito di Pistoia.* Milan: G. Mondadori, 1986.

———, ed. *Simone Martini: La Maestà.* Milan: Electa, 1996.

Cecchi, Alessandro, ed. *Simone Martini e l'Annunciazione del Uffizi.* Cinisello Balsamo, Milan: Silvana, 2001.

Chiellini, Monica. *Cimabue.* Florence: Scala Books, 1988.

Ciatti, Marco, ed. *La Croce di Bernardo Daddi del Museo Poldi Pezzoli: ricerche e conservazione.* Florence: Edizione Firenze, 2005.

Ciatti, Marco, and Maria Pia Mannini, eds. *Giovanni da Milano: il Polittico di Prato.* Prato: C. Martini, 2001.

Cole, Bruce. *Giotto: The Scrovegni Chapel, Padua.* New York: George Braziller, 1993.

Di Cagno, Gabriella. *The Cathedral, the Baptistery, and the Campanile.* Translated by Eve Leckey. Florence: La Mandragora, 1994.

Eisenberg, Marvin. *Lorenzo Monaco.* Princeton, N.J.: Princeton University Press, 1989.

Filieri, Maria Teresa, et al. *Un capolavoro del Duecento: il crocifisso di Berlinghiero Berlinghieri nella Chiesa di Santa Maria Assunta a Tereglio.* Garfagnana: Lions Club Garfagnana, 1998.

Flores d'Arcais, Francesca. *Altichiero e Avanzo: la Cappella di San Giacomo.* Milan: Electa, 2001.

Flores d'Arcais, Francesca, and Giovanni Gentili, eds. *Il Trecento adriatico: Paolo Veneziano e la pittura tra Oriente e Occidente.* Cinisello Balsamo, Milan: Silvana, 2002.

Frugoni, Chiara. *Pietro and Ambroggio Lorenzetti.* Florence: Scala, 1988.

———, ed. *Pietro e Ambrogio Lorenzetti*. Florence: Le Lettere, 2002.

Gardner, Julian. *Sancta Sanctorum*. Milan: Electa, 1995.

———. *The Tomb and the Tiara: Curial Tomb Sculpture in Rome and Avignon in the Later Middle Ages*. Oxford: Clarendon Press, 1992.

Garzelli, Annarosa. *Il fonte del Battistero di Pisa: cavalli, arieti e grifi alle soglie di Nicola Pisano*. Ospedaletto: Pacini, 2002.

Goffen, Rona. *Spirituality in Conflict: Saint Francis and Giotto's Bardi Chapel*. University Park: Pennsylvania State University Press, 1988.

Guidoni, Enrico, ed. *Arnolfo di Cambio urbanista*. Rome: Bonsignori Editore, 2003.

Guillaud, Jacqueline. *Giotto: Architect of Color and Form*. New York: C. N. Potter, 1987.

Gurrieri, Francesco. *La Cattedrale di Santa Maria del Fiore a Firenze*. Florence: Cassa di risparmio di Firenze, 1994.

Hetherington, Paul. *Pietro Cavallini: A Study in the Art of Late Medieval Rome*. London: Sagittarius Press, 1979.

Kreytenberg, Gert. *Andrea Pisano und die toskanische Skulptur des 14. Jahrhunderts*. Munich, Germany: Bruckmann, 1984.

———. *Orcagna's Tabernacle in Orsanmichele, Florence*. New York: Harry N. Abrams, 1994.

Ladis, Andrew, ed. *The Arena Chapel and the Genius of Giotto: Padua*. New York: Garland, 1998.

———, ed. *Franciscanism, the Papacy, and Art in the Age of Giotto*. New York: Garland, 1998.

———, ed. *Giotto, Master Painter and Architect: Florence*. New York: Garland, 1998.

———. *Taddeo Gaddi: Critical Reappraisal and Catalogue Raisonné*. Columbia: University of Missouri Press, 1982.

Leone de Castris, Pierluigi. *Simone Martini*. Milan: F. Motta, 2003.

Lusanna, Enrica Neri. *Arnolfo: alle origini del rinascimento fiorentino*. Florence: Polistampa, 2005.

Luzi, Mario. *Earthly and Heavenly Journey of Simone Martini*. Translated by Luigi Bonaffini. Copenhagen, DK: Green Integer, 2003.

Marabottini, Alessandro. *Giovanni da Milano*. Florence: G. C. Sansoni, 1950.

Martindale, Andrew. *Simone Martini*. New York: New York University Press, 1988.

Meiss, Millard. *Francesco Traini*. Edited by Hayden B. J. Maginnis. Washington, D.C.: Decatur House Press, 1983.

Moretti, Italo, Cinzia Nenci, and Giuliano Pinto. *La Toscana di Arnolfo: storia, arte, architettura, urbanistica, paesaggi*. Florence: L. S. Olschki, 2003.

Moskowitz, Anita Fiderer. *Nicola Pisano's Arca di San Domenico and Its Legacy*. University Park: Pennsylvania State University Press, 1994.

————. *The Sculpture of Andrea and Nino Pisano*. Cambridge: Cambridge University Press, 1986.

Muraro, Michelangelo. *Paolo da Venezia*. University Park: Pennsylvania State University Press, 1970.

Parronchi, Alessandro. *Cavallini: Discepolo di Giotto*. Florence: Edizioni Polistampa, 1994.

Pedrocco, Filippo. *Paolo Veneziano*. Milan: A. Maioli & Società Veneta Editrice, 2003.

Pierini, Marco. *Simone Martini*. Cinisello Balsamo, Milan: Silvana, 2000.

Poeschke, Joachim. *Italian Frescoes, the Age of Giotto, 1280–1400*. New York: Abbeville Press, 2005.

Raspi Serra, Joselita. *I Pisano e il gotico*. Milan: Fabbri, 1969.

Richards, John. *Altichiero: An Artist and His Patrons in the Italian Trecento*. Cambridge: Cambridge University Press, 2000.

Sgarbi, Vittorio, ed. *Giotto e il suo tempo*. Milan: F. Motta, 2000.

Skinner, Quentin. *Ambrogio Lorenzetti: The Artist as Political Philosopher*. London: British Academy, 1988.

Spannocchi, Sabina. *Giovanni Pisano*. Rome: Gruppo Editoriale l'Espresso, 2005.

Spiazzi, Anna Maria. *Giotto: La Cappella degli Scrovegni a Padova*. Milan: Skira, 2002.

Starn, Randolph. *Ambrogio Lorenzetti: The Palazzo Pubblico, Siena*. New York: George Braziller, 1994.

Stubblebine, James. *Duccio di Buoninsegna and His School*. 2 vols. Princeton, N.J.: Princeton University Press, 1979.

————, ed. *Giotto: The Arena Chapel Frescoes*. New York: Norton, 1995.

————. *Guido da Siena*. Princeton, N.J.: Princeton University Press, 1964.

Tartuferi, Angelo. *Bernardo Daddi: l'Incoronazione di Santa Maria Novella*. Livorno: Sillabe, 2000.

Tiberia, Vitaliano. *I mosaici del XII secolo e di Pietro Cavallini in Santa Maria in Trastevere: restauri e nuove ipotesi*. Todi, Italy: Ediart, 1996.

Tomei, Alessandro. *Iacobus Torriti pictor: una vicenda figurativa del tardo Duecento romano*. Rome: Argos, 1990.

————. *Pietro Cavallini*. Cinisello Balsamo, Milan: Silvana, 2000.

————, ed. *Roma, Napoli, Avignone: arte di curia, arte di corte 1300–1377*. Turin: Seat, 1996.

Trachtenberg, Marvin. *The Campanile of Florence Cathedral: "Giotto's Tower."* New York: New York University Press, 1971.

Volpe, Carlo. *Pietro Lorenzetti*. Milan: Electa, 1989.

White, John Reeves. *Duccio: Tuscan Art and the Medieval Workshop*. New York: Thames & Hudson, 1979.

Zanardi, Bruno. *Giotto e Pietro Cavallini: La questione di Assisi e il cantiere medievale di pittura a fresco.* Milan: Skira, 2002.

B. Early Renaissance

Acidini Luchinat, Cristina. *Il Battistero e il Duomo di Firenze.* Milan: Electa, 1994.

———. *Benozzo Gozzoli.* Antella, Florence: Scala, 1994.

Acidini Luchinat, Cristina, and Riccardo Dalla Negra. *La cupola di Santa Maria del Fiore: architettura, pittura, restauro.* Rome: Istituto poligrafico e Zecca dello Stato and Libreria dello Stato, 1996.

Acidini Luchinat, Cristina, and Gabrielle Morolli, eds. *L'uomo del Rinascimento: Leon Battista Alberti e le arti a Firenze; tra ragione e bellezza.* Florence: Maschietto, 2006.

Ahl, Diane Cole. *Benozzo Gozzoli.* New Haven, Conn.: Yale University Press, 1996.

Arasse, Daniel, Pierluigi De Vecchi, and Jonathan Katz Nelson, eds. *Botticelli e Filippino: l'inquietudine e la grazia nella pittura fiorentina del Quattrocento.* Milan: Skira, 2004.

Arasse, Daniel, Pierluigi De Vecchi, and Patrizia Nitti, eds. *Botticelli: From Lorenzo de Magnificent to Savonarola.* Milan: Skira, 2003.

Arbace, Luciana. *Antonello da Messina: catalogo completo dei dipinti.* Florence: Cantini, 1993.

Avery, Charles. *Donatello: Catalogo Completo delle Opere.* Florence: Cantini, 1991.

———. *Donatello: An Introduction.* New York: Icon Editions, 1994.

Baldini, Umberto. *Botticelli.* Florence: Edizioni d'arte il Fiorino, 1988.

———. *Masaccio.* Milan: Electa, 2001.

———, ed. *Primavera: The Restoration of Botticelli's Masterpiece.* Translated by Mary Fitton. New York: H. N. Abrams, 1986.

Baldini, Umberto, and Ornella Casazza. *The Brancacci Chapel.* New York: Abrams, 1992.

Baldinotti, Andrea, Alessandro Cecchi, and Vincenzo Farinella. *Masaccio e Masolino: il gioco delle parti.* Milan: 5 Continents Editions, 2002.

Banker, James. *The Culture of San Sepolcro during the Youth of Piero della Francesca.* Ann Arbor: University of Michigan Press, 2003.

Barbera, Gioacchino, ed. *Antonello da Messina: San Girolamo nello Studio.* Naples: Electa Napoli, 2006.

Becherer, Joseph Antenucci. *Pietro Perugino: Master of the Italian Renaissance.* New York: Rizzoli International & Grand Rapids Art Museum, 1997.

Bellosi, Luciano, and Alessandro Angelini. *Sassetta e i pittori toscani tra XIII e XV secolo.* Florence: Studio per edizioni scelte, 1986.

Bellosi, Luciano, and Aldo Galli. *Un nuovo dipinto dell'Angelico.* Turin: Umberto Allemandi, 1998.

Berti, Luciano. *Filippino Lippi.* Florence: Edizioni d'Arte il Fiorino, 1991.

Biscottini, Paolo, ed. *Antonello da Messina: Ecce homo.* Cinisello Balsamo, Milan: Silvana, 2002.

Bonsanti, Giorgio. *Beato Angelico: Catalogo completo.* Florence: Octavo, 1998.

Borsi, Franco. *Paolo Uccello.* Translated by Elfreda Powell. New York: H. N. Abrams, 1994.

Borsi, Stefano. *Giuliano da Sangallo: i disegni di architettura e dell'antico.* Rome: Officina Edizioni, 1985.

———. *Leon Battista Alberti a Roma.* Florence: Fondazione Spadolini Nuova Antologia, 2003.

———. *Leon Battista Alberti e l'antichità romana.* Florence: Fondazione Spadolini Nuova Antologia, 2004.

Borsook, Eve, and Johannes Offerhaus. *Francesco Sassetti and Ghirlandaio at Santa Trinità, Florence: History and Legend in a Renaissance Chapel.* Doornspijk, Netherlands: Davaco, 1981.

Brandi, Cesare. *Dal gotico al rinascimento: Filippo Brunelleschi, lezzioni.* Rome: Arachne, 2004.

Bule, Steven, Alan Phipps Darr, and Fiorella Superbi Gioffredi, eds. *Verrocchio and Late Quattrocento Italian Sculpture.* Florence: Le Lettere, 1992.

Buranelli, Francesco, ed. *Il Beato Angelico e la Cappella Niccolina: storia e restauro.* Vatican: Musei Vaticani and De Agostini, 2001.

Butterfield, Andrew. *The Sculptures of Andrea del Verrocchio.* New Haven, Conn.: Yale University Press, 1997.

Cadogan, Jeanne K. *Domenico Ghirlandaio: Artist and Artisan.* New Haven, Conn.: Yale University Press, 2000.

Caglioti, Francesco. *Donatello e i Medici: storia del David e della Giuditta.* Florence: L. S. Olschki, 2000.

Calvesi, Maurizio. *La Cappella Sistina e la sua decorazione da Perugino a Michelangelo.* Rome: Lithos, 1997.

———. *Piero della Francesca.* New York: Rizzoli, 1998.

Calzona, Arturo. *Il San Sebastiano di Leon Battista Alberti: Studi.* Florence: L. S. Olschki, 1994.

Camerota, Filippo, ed. *Nel segno di Masaccio: l'invenzione della prospettiva.* Florence: Giunti and Firenze Musei, 2001.

Campbell, Caroline, and Allan Chong. *Bellini and the East.* London: National Gallery, Isabella Stewart Gardner Museum, & Yale University Press, 2005.

Caneva, Caterina. *Botticelli: catalogo completo dei dipinti.* Florence: Cantini, 1990.

Canuti, Fiorenzo. *Il Perugino*. Foligno: Editoriale Umbra, 1983.

Caplow, Harriet McNeal. *Michelozzo*. New York: Garland, 1977.

Capolei, Francesco. *Brunelleschi anticlassico*. Turin: Testo & immagine, 1999.

Capretti, Elena. *Brunelleschi*. Florence: Giunti, 2003.

Cardini, Franco. *I Re Magi di Benozzo a Palazzo Medici*. Florence: Arnaud, 1991.

Carniani, Mario. *Santa Maria del Carmine e la Cappella Brancacci*. Florence: Edizioni Becocci, 1990.

Carpiceci, Alberto Carlo. *La fabbrica di San Pietro: venti secoli di storia e progetti*. Vatican: Libreria editrice vaticana and Bonechi, 1983.

Carr, Dawson W. *Andrea Mantegna: The Adoration of the Magi*. Los Angeles: J. Paul Getty Museum, 1997.

Casazza, Ornella. *Masaccio and the Brancacci Chapel*. Florence: Scala, 1990.

Cassarino, Enrica. *La Cappella Sassetti nella Chiesa di Santa Trinità*. Lucca: M. Pacini Fazzi, 1996.

Cavazzini, Laura. *Donatello*. Rome: Gruppo Editoriale l'Espresso, 2005.

Cecchi, Alessandro. *Botticelli*. Milan: Motta, 2005.

Centi, Tito S. *Il beato Angelico: Fra Giovanni da Fiesole, biografia critica*. Bologna: Edizioni studio domenicano, 2003.

Christiansen, Keith. *Andrea Mantegna: Padua and Mantua*. New York: G. Braziller, 1994.

———. *Gentile da Fabriano*. Ithaca, N.Y.: Cornell University Press, 1982.

Clark, Nicholas. *Melozzo da Forlì: Pictor Papalis*. London: Sotheby's, 1990.

Cordaro, Michele, ed. *Mantegna: La Camera degli Sposi*. Milan: Electa and Olivetti, 1992.

Damiani, Giovanna. *San Marco, Florence: The Museum and Its Art*. London: Philip Wilson, 1997.

De Nicolò Salmazo, Antonia. *Mantegna: La Camera Picta*. Milan: Electa, 1996.

Dempsey, Charles. *The Portrayal of Love: Botticelli's Primavera and Humanist Culture at the Time of Lorenzo the Magnificent*. Princeton, N.J.: Princeton University Press, 1992.

Di Pasquale, Salvatore. *Brunelleschi: la costruzione della cupola di Santa Maria del Fiore*. Venice: Marsilio, 2002.

Dianich, Severino. *La Trinità di Masaccio: arte e teologia*. Bologna: EDB, 2004.

Didi-Huberman, Georges. *Fra Angelico: Dissemblance and Figuration*. Translated by Jane Marie Todd. Chicago: Chicago University Press, 1995.

Domestici, Fiamma. *Della Robbia: A Family of Artists*. Florence: Scala & Riverside, 1992.

Ettlinger, Leopold D. *Antonio and Piero Pollaiuolo: Complete Edition with a Critical Catalogue*. Oxford: Phaidon & Dutton, 1978.

Fanelli, Giovanni. *Brunelleschi's Cupola: Past and Present of an Architectural Masterpiece.* Florence: Mandragora, 2004.

Ferrari, Curzia. *Donne e madonne: la sacre maternità di Giovanni Bellini.* Milan: Ancora, 2000.

Field, Judith Veronica. *Piero della Francesca: A Mathematician's Art.* New Haven, Conn.: Yale University Press, 2005.

Finelli, Luciana. *L'umanesimo giovane: Bernardo Rossellino a Roma e a Pienza.* Rome: Veutro, 1984.

Finn, David. *The Florence Baptistery Doors.* New York: Viking Press, 1980.

Finocchi Ghersi, Lorenzo. *Il rinascimento veneziano di Giovanni Bellini.* Venice: Marsilio, 2004.

Foschi, Marina, and Luciana Prati, eds. *Melozzo da Forlì: la sua città e il suo tempo.* Milan: Leonardo arte, 1994.

Fremantle, Richard. *Masaccio: Catalogo completo.* Florence: Octavo, 1998.

Garibaldi, Vittoria. *Perugino.* Florence: Scala, 1997.

———. *Perugino: catalogo completo.* Florence: Octavo, 1999.

Garibaldi, Vittoria, and Francesco Federico Mancini, eds. *Perugino: il divin pittore.* Cinisello Balsamo, Milan: Silvana, 2004.

Gavitt, Philip. *Charity and Children in Renaissance Florence: The Ospedale degli Innocenti, 1410–1536.* Ann Arbor: University of Michigan Press, 1990.

Gilbert, Creighton. *How Fra Angelico and Signorelli Saw the End of the World.* University Park: Pennsylvania State University Press, 2003.

Ginzburg, Carlo. *The Enigma of Piero: Piero della Francesca.* Translated by Martin Ryle and Kate Soper. London: Verso, 2000.

Goffen, Rona. *Giovanni Bellini.* New Haven, Conn.: Yale University Press, 1989.

———, ed. *Masaccio's Trinity.* Cambridge: Cambridge University Press, 1998.

Goffen, Rona, and Giovanna Nepi Scirè, eds. *Il colore ritrovato: Bellini a Venezia.* Milan: Electa, 2000.

Gore, John St. *Sassetta, c. 1400–1450.* London: Knowledge Publications, 1966.

Grafton, Anthony. *Leon Battista Alberti: Master Builder of the Italian Renaissance.* New York: Hill & Wang, 2000.

Greenstein, Jack Matthew. *Mantegna and Painting as Historical Narrative.* Chicago: Chicago University Press, 1992.

Gurrieri, Francesco. *La Cattedrale di Santa Maria del Fiore a Firenze.* Florence: Cassa di risparmio di Firenze, 1994.

Holmes, Megan. *Fra Filippo Lippi: The Carmelite Painter.* New Haven, Conn.: Yale University Press, 1999.

Horne, Herbert Percy. *Alessandro Filipepi, Commonly Called Sandro Botticelli, Painter of Florence.* Florence: Studio per edizioni scelte, 1986.

Horster, Marita. *Andrea del Castagno: Complete Edition with a Critical Catalogue.* Ithaca, N.Y.: Cornell University Press, 1980.

Ippolito, Lamberto. *La cupola di Santa Maria del Fiore*. Rome: La Nuova Italia scientifica, 1997.

James, Sara Nair. *Signorelli and Fra Angelico at Orvieto: Liturgy, Poetry, and a Vision of the End of Time*. Aldershot, U.K.: Ashgate, 2003.

Joannides, Paul. *Masaccio and Masolino: A Complete Catalogue*. London: Phaidon, 1993.

Kanter, Laurence B., Hilliard T. Goldfarb, and James Hankins. *Botticelli's Witness: Changing Style in a Changing Florence*. Boston, Mass.: Isabella Stewart Gardner Museum, 1997.

Kanter, Laurence B., and Pia Palladino. *Fra Angelico*. New York: Metropolitan Museum of Art & Yale University Press, 2005.

Kecks, Ronald G. *Domenico Ghirlandaio und die Malerei der Florentiner Renaissance*. Munich: Deutscher Kunstverlag, 2000.

———. *Ghirlandaio: Il catalogo completo*. Translated by Nora Zilli. Florence: Octavo, 1995.

King, Ross. *Brunelleschi's Dome: How a Renaissance Genius Reinvented Architecture*. New York: Penguin Books, 2001.

Klotz, Heinrich. *Filippo Brunelleschi: The Early Works and the Medieval Tradition*. New York: Rizzoli & Academy, 1990.

Kramer, Thomas. *Die grosse Kuppel von Florenz: ein Führer zu dem architektonischen Meisterwerk des Filippo Brunelleschi*. Stuttgart, Germany: Verlag Freies Geistesleben & Urachhaus, 2001.

Krautheimer, Richard, and Trude Krautheimer Hess. *Lorenzo Ghiberti*. Princeton, N.J.: Princeton University Press, 1982.

Kreytenberg, Gert. *The Brancacci Chapel, Florence*. New York: George Braziller, 1993.

Lavin, Marilyn Aronberg. *Piero della Francesca*. London: Phaidon Press, 2002.

———, ed. *Piero della Francesca and His Legacy*. Washington, D.C.: National Gallery of Art, 1995.

Levi D'Ancona, Mirella. *Botticelli's Primavera: A Botanical Interpretation, Including Astrology, Alchemy, and the Medici*. Florence: L. S. Olschki, 1983.

———. *Due quadri del Botticelli eseguiti per nascite in Casa Medici: nuova interpretazione della Primavera e della Nascita di Venere*. Florence: Olschki, 1992.

Levi D'Ancona, Mirella, Maria Adele Signorini, and Alberto Chiti-Batelli. *Piante e animali intorno alla Porta del Paradiso*. Lucca: Pancini Fazzi, 2000.

Lightbown, R. W. *Donatello and Michelozzo: An Artistic Partnership and Its Patrons in the Early Renaissance*. London: H. Miller, 1980.

———. *Mantegna: With a Complete Catalogue of Paintings, Drawings, and Prints*. Berkeley: University of California Press, 1986.

———. *Sandro Botticelli: Life and Work*. New York: Abbeville Press, 1989.

Löhneysen, Wolfgang von, ed. *Der Humanismus der Architektur in Florenz: Filippo Brunelleschi und Michelozzo di Bartolomeo.* Hildesheim: Weidmann, 1999.

Longhi, Roberto. *Piero della Francesca.* Riverdale-on-Hudson, N.Y.: Stanley Moss-Sheep Meadow Press, 2002.

Maetzke, Ana Maria, and Carlo Bertelli, eds. *Piero della Francesca: The Legend of the True Cross in the Church of San Francesco in Arezzo.* Milan: Skira, 2001.

Malaguzzi, Silvia. *Botticelli: The Artist and His Works.* Translated by Catherine Frost. Florence: Giunti, 2006.

Mallory, Michael. *The Sienese Painter Paolo di Giovanni Fei.* New York: Garland, 1976.

Manca, Joseph. *Andrea Mantegna and the Italian Renaissance.* London: Parkstone, 2006.

Mannini, Maria Pia, ed. *Filippino Lippi: un bellissimo ingegno, origini ed eredità nel territorio di Prato.* Florence: Giunti, 2004.

Mannini, Maria Pia, and Marco Fagioli. *Filippo Lippi: Catalogo completo.* Florence: Octavo, 1997.

Marcelli, Fabio. *Gentile da Fabriano.* Cinisello Balsamo, Milan: Silvana, 2005.

Martineau, Jane, ed. *Andrea Mantegna.* New York: Metropolitan Museum of Art & Royal Academy of the Arts, 1992.

Meiss, Millard. *Giovanni Bellini's St. Francis in the Frick Collection.* Princeton, N.J.: Princeton University Press, 1964.

Micheletti, Emma. *Domenico Ghirlandaio.* Translated by Anthony Brierley. Florence: Scala & Riverside, 1990.

Mitrovic, Branko. *Serene Greed of the Eye: Leon Battista Alberti and the Philosophical Foundations of Renaissance Architectural Theory.* Munich: Deutscher Kunstverlag, 2005.

Morolli, Gabriele. *Leon Battista Alberti, Firenze e la Toscana: itinerari territoriali e percorsi mentali.* Florence: Maschietto, 2006.

———, ed. *Michelozzo: scultore e architetto.* Florence: Centro Di, 1998.

Muscolino, Cetty. *Il Tempio Malatestiano di Rimini.* Ravenna: Longo, 2000.

Negri, Francesco. *Desiderio da Settignano, 1428–1464.* Milan: Fratelli Fabbri, 1966.

Olivari, Mariolina. *Giovanni Bellini.* Florence: Scala, 1990.

Pächt, Otto. *Venetian Painting in the 15th Century: Jacopo, Gentile and Giovanni Bellini and Andrea Mantegna.* Edited by Margareta Vyoral-Tschapka and Michael Pächt. Translated by Fiona Elliott. London: Harvey Miller, 2003.

Padoa Rizzo, Anna. *Benozzo Gozzoli: un pittore insigne, pratico di grandissima invenzione.* Cinisello Balsamo, Milan: Silvana, 2003.

Pagano Denise Maria, ed. *Benozzo Gozzoli in Toscana.* Florence: Octavo, 1997.

Palumbo, Umberto. *Perugino e Perugia*. Perugia: Edizioni Guerra, 1985.

Paolieri, Annarita. *Paolo Uccello, Domenico Veneziano, Andrea del Castagno*. Translated by Lisa Pelletti. Florence: Scala, 1991.

Paolucci, Antonio. *The Origins of Renaissance Art: The Baptistry Doors, Florence*. Translated by Françoise Pouncey Chiarini. New York: George Braziller, 1996.

Parronchi, Alessandro. *Donatello: saggi e studi, 1962–1997*. Vincenza: Neri Pozza, 1998.

Pasini, Pier Giorgio. *Il Tempio Malatestiano: splendore cortese e classicismo umanistico*. Milan: Skira, 2000.

Petrucci, Francesca. *Luca della Robbia*. Rome: Gruppo Editoriale l'Espresso, 2005.

———. *La scultura di Donatello: tecniche e linguaggio*. Florence: Le lettere, 2003.

Poeschke, Joachim. *Donatello and His World: Sculpture of the Italian Renaissance*. New York: H. N. Abrams, 1993.

Poletti, Federico. *Antonio e Piero Pollaiuolo*. Cinisello Balsamo, Milan: Silvana, 2001.

Pons, Nicoletta. *I Pollaiuolo*. Florence: Octavo, 1994.

Pope-Hennessy, John. *Angelico*. Florence: Scala Books, 1981.

———. *Donatello, Sculptor*. New York: Abbeville Press, 1993.

———. *Luca della Robbia*. Ithaca, N.Y.: Cornell University Press, 1980.

Roberts, Perri Lee. *Masolino da Panicale*. Oxford: Clarendon Press & Oxford University Press, 1993.

Robertson, Giles. *Giovanni Bellini*. Oxford: Clarendon Press, 1968.

Roccasecca, Pietro. *Paolo Uccello: le battaglie*. Milan: Electa, 1997.

Rosenauer, Artur. *Donatello*. Milan: Electa, 1993.

Rowlands, Eliot Wooldridge. *Masaccio: St. Andrew and the Pisa Altarpiece*. Los Angeles: Getty Publications & Windsor, 2003.

Saalman, Howard. *Filippo Brunelleschi: The Buildings*. University Park: Pennsylvania State University Press, 1993.

Sale, J. Russell. *Filippino Lippi's Strozzi Chapel in Santa Maria Novella*. New York: Garland, 1979.

Savettieri, Chiara. *Antonello da Messina*. Palermo: Flaccovio, 1998.

Schefer, Jean Louis. *The Deluge, the Plague: Paolo Uccello*. Translated by Tom Conley. Ann Arbor: University of Michigan Press, 1995.

Schulz, Anne Markham. *The Sculpture of Bernardo Rossellino and His Workshop*. Princeton, N.J.: Princeton University Press, 1977.

Scudieri, Magnolia. *The Frescoes by Angelico at San Marco*. Translated by Joan M. Reifsneyder. Florence: Giunti & Mvsei, 2004.

Scudieri, Magnolia, and Giovanna Rasario, eds. *Biblioteca di Michelozzo a San Marco: tra recupero e scoperta*. Florence: Giunti, 2000.

Seymour, Charles. *Jacopo della Quercia, Sculptor*. New Haven, Conn.: Yale University Press, 1973.

———. *The Sculpture of Verrocchio*. Greenwich, Conn.: New York Graphic Society, 1971.

Shulman, Ken. *Anatomy of a Restoration: The Brancacci Chapel*. New York: Walker, 1991.

Signorini, Rodolfo. *La più bella camera del mondo: la camera dipinta di Andrea Mantegna detta "degli Sposi."* Mantua: Editrice MP, 1992.

Sloman, Susan. *Botticelli*. London: Chauser, 2004.

Spencer, John R. *Andrea del Castagno and His Patrons*. Durham, N.C.: Duke University Press, 1991.

Spike, John T. *Fra Angelico*. New York: Abbeville Press, 1997.

———. *Masaccio*. New York: Abbeville Press, 1995.

Strehlke, Carl Brandon. *Angelico*. Translated by Anna Maria Agosti. Milan: Jaca Book, 1998.

———. *The Panel Paintings of Masolino and Masaccio: The Role of Technique*. Milan: 5 Continents Editions, 2002.

Syson, Luke, and Dillian Gordon. *Pisanello: Painter to the Renaissance Court*. London: National Gallery, 2001.

Taddei, Ilaria. *Botticelli*. Translated by Antony Cafazzo. Livorno: Sillabe, 2001.

Tavernor, Robert. *On Alberti and the Art of Building*. New Haven, Conn.: Yale University Press, 1998.

Tempestini, Anchise. *Bellini e belliniani in Romagna*. Rimini: Fondazione Cassa di Risparmio di Rimini, 1998.

———. *Giovanni Bellini*. Milan: Electa, 2000.

Turchini, Angelo. *Il Tempio malatestiano, Sigismondo Pandolfo Malatesta e Leon Battista Alberti*. Cesena: Società editrice "Il Ponte vecchio," 2000.

Venchi, Innocenzo, and Alessandro Branccchetti. *Fra Angelico and the Chapel of Nicholas V*. Vatican: Edizioni Musei Vaticani, 1999.

Westfall, Carroll William. *In This Most Perfect Paradise: Alberti, Nicolas V, and the Invention of Conscious Urban Planning in Rome, 1447–1455*. University Park: Pennsylvania State University Press, 1974.

Wind, Edgar. *Bellini's Feast of the Gods, A Study in Venetian Humanism*. Cambridge, Mass.: Harvard University Press, 1948.

Windt, Franziska. *Andrea del Verrocchio und Leonardo da Vinci: Zusammenarbeit in Skulptur und Malerei*. Münster, Germany: Rhema, 2003.

Wohl, Hellmut. *The Paintings of Domenico Veneziano, ca. 1410–1461: A Study in Florentine Art of the Early Renaissance*. New York: New York University Press, 1980.

Woods-Marsden, Joanna. *The Gonzaga of Mantua and Pisanello's Arthurian Frescoes*. Princeton, N.J.: Princeton University Press, 1988.

Wright, Alison. *The Pollaiuolo Brothers: The Arts of Florence and Rome*. New Haven, Conn.: Yale University Press, 2005.

Zöllner, Frank. *Botticelli: Images of Love and Spring*. Translated by Fiona Elliott. Munich: Prestel, 1998.

——. *Sandro Botticelli*. Translated by Ishbel Flett. Munich: Prestel, 2005.

C. High Renaissance and Mannerism

Acidini Luchinat, Cristina. *The Medici, Michelangelo, and the Art of Late Renaissance Florence*. Detroit, Mich.: Yale University Press & Detroit Institute of Fine Arts, 2002.

——. *Michelangelo scultore*. Milan: F. Motta, 2005.

Anderson, Jaynie. *Giorgione: The Painter of "Poetic Brevity": Including Catalogue Raisonné*. Paris: Flammarion, 1997.

Arasse, Daniel. *Leonardo da Vinci: The Rhythm of the World*. New York: Konecky & Konecky, 1998.

Argan, Giulio Carlo. *Michelangelo architetto*. 5th ed. Milan: Electa, 2000.

Atalay, Bülent. *Math and the Mona Lisa: The Art and Science of Leonardo da Vinci*. New York: Smithsonian Books & Collins, 2006.

Augusti Ruggeri, Adriana, and Simona Savini Branca. *Chiesa di San Sebastiano: arte e devozione*. Venice: Marsilio, 1994.

Balas, Edith. *Michelangelo's Double Self-Portraits*. Pittsburgh, Pa.: Carnegie Mellon University Press, 2002.

——. *Michelangelo's Medici Chapel: A New Interpretation*. Philadelphia, Pa.: American Philosophical Society, 1995.

Baldini, Umberto. *Giorgio Vasari: pittore*. Florence: Edizioni d'arte il Fiorino, 1994.

Barnes, Bernardine Ann. *Michelangelo's Last Judgment: The Renaissance Response*. Berkeley: University of California Press, 1997.

Barocchi, Paola. *Il Rosso Fiorentino*. London: Verba Volant, 2003.

Barolsky, Paul. *The Faun in the Garden: Michelangelo and the Poetic Origins of Italian Renaissance Art*. University Park: Pennsylvania State University Press, 1994.

——. *Michelangelo and the Finger of God*. Athens: Georgia Museum of Art, 2003.

——. *Michelangelo's Nose: A Myth and Its Maker*. University Park: Pennsylvania State University Press, 1990.

Battilotti, Donata. *The Villas of Palladio*. Milan: Electa, 1990.

Beck, James H. *Jacopo della Quercia e il portale di San Petronio a Bologna: Ricerche storiche, documentarie e iconografiche*. Bologna: Alfa, 1970.

——. *Jacopo della Quercia*. 2 vols. New York: Columbia University Press, 1991.

————. *Raphael: The Stanza della Segnatura*. New York: George Braziller, 1993.

————. *Three Worlds of Michelangelo*. New York: W. W. Norton, 1999.

Beck, James H., Antonio Paolucci, and Bruni Santi. *Michelangelo: The Medici Chapel*. New York: Thames & Hudson, 1994.

Belluzi, Amadeo. *Palazzo Tè a Mantova*. Modena: F. C. Panini, 1998.

Berger Andreadakis, Katya, and John Berger. *Titian: Nymph and Shepherd*. Munich: Prestel, 1996.

Bertani, Licia. *San Lorenzo: The Medici Chapels and the Laurentian Library*. Florence: Scala, 1998.

Berti, Luciano. *Pontormo e il suo tempo*. Florence: Banca toscana, 1993.

Borsi, Franco. *Bramante*. Milan: Electa, 1989.

Borsi, Stefano. *Bramante e Urbino: il problema della formazione*. Rome: Officina, 1997.

Boucher, Bruce. *Andrea Palladio: The Architect of His Time*. New York: Abbeville Press, 1998.

Brocke, Maurice. *Bronzino*. Paris: Flammarion, 2002.

Brown, David, and Jane Van Nimmen. *Raphael and the Beautiful Banker: The Story of the Bindo Altoviti Portrait*. New Haven, Conn.: Yale University Press, 2005.

Brown, David Alan. *Leonardo da Vinci: Origins of a Genius*. New Haven, Conn.: Yale University Press, 1998.

————. *The Young Correggio and His Leonardesque Sources*. New York: Garland, 1981.

Brown, David Alan, Peter Humfrey, and Mauro Lucco. *Lorenzo Lotto: Rediscovered Master of the Renaissance*. Washington, D.C.: National Gallery of Art, 1997.

Brown, Patricia Fortini. *Venetian Narrative Painting in the Age of Carpaccio*. New Haven, Conn.: Yale University Press, 1988.

Calabrese, Omar, ed. *Venere svelata: la Venere di Urbino di Tiziano*. Cinisello Balsamo, Milan: Silvana, 2003.

Calvesi, Maurizio. *La Cappella Sistina e la sua decorazione da Perugino a Michelangelo*. Rome: Lithos, 1997.

Carpiceci, Alberto Carlo. *La fabbrica di San Pietro: venti secoli di storia e progetti*. Vatican: Libreria editrice vaticana and Bonechi, 1983.

Cenci, Letizia. *L'ultima cena: Leonardo in Santa Maria delle Grazie*. Roma: Libreria dello Stato, Istituto poligrafico e Zecca dello Stato, 2003.

Chapman, Hugo, Tom Henry, and Carol Plazzotta. *Raphael: From Urbino to Rome*. London: National Gallery & Yale University Press, 2004.

Chiades, Antonio. *Vita di Tiziano*. Isola, Bologna: La Mandragora, 2000.

Chong, Alan, Donatella Pegazzano, and Dimitrios Zikos, eds. *Raphael, Cellini, and a Renaissance Banker: The Patronage of Bindo Altoviti*. Translated by Mario Pereira et al. Boston, Mass.: Isabella Stewart Gardner Museum, 2003.

Ciammitti, Luisa, Steven F. Ostrow, and Salvatore Settis, eds. *Dosso's Fate: Painting and Court Culture in Renaissance Italy*. Los Angeles: Getty Research Institute for the History of Art and the Humanities, 1998.

Clayton, Martin. *Leonardo da Vinci: The Divine and the Grotesque*. London: Royal Collection, 2002.

Cocke, Richard. *Paolo Veronese: Piety and Display in the Age of Religious Reform*. Aldershot, U.K.: Ashgate, 2001.

———. *Raphael: Raffaello Sanzio*. London: Chaucer, 2004.

———. *Veronese*. London: Chaucer, 2005.

Cole, Bruce. *Titian and Venetian Painting, 1450–1590*. Boulder, Colo.: Icon Editions, 1999.

Cole, Michael Wayne. *Cellini and the Principles of Sculpture*. Cambridge: Cambridge University Press, 2002.

Collins, Bradley I. *Leonardo, Psychoanalysis and Art History: A Critical Study of Psychobiographical Approaches to Leonardo da Vinci*. Evanston, Ill.: Northwestern University Press, 1997.

Conforti, Claudia. *Vasari architetto*. Milan: Electa, 1993.

Conti, Alessandro. *Pontormo*. Milan: Jaca Book, 1995.

Cooper, Tracy Elizabeth. *Palladio's Venice: Architecture and Society in a Renaissance Republic*. New Haven, Conn.: Yale University Press, 2005.

Costamagna, Philippe. *Pontormo*. Translated by Alberto Curotto. Milan: Electa, 1994.

Cox-Rearick, Janet. *Bronzino's Chapel of Eleonora in the Palazzo Vecchio*. Berkeley: University of California Press, 1993.

Cozzi, Mauro. *Antonio da Sangallo il Vecchio e l'architettura del Cinquecento in Valdichiana*. Genoa: Sagep, 1992.

Crispino, Enrica. *Leonardo*. Florence: Giunti, 2002.

Cropper, Elizabeth. *Pontormo: Portrait of a Halberdier*. Los Angeles: Getty Museum, 1997.

D'Elia, Una Roman. *The Poetics of Titian's Religious Paintings*. Cambridge: Cambridge University Press, 2005.

Denker Nesselrath, Christiane. *Bramante's Spiral Staircase*. Translated by Peter Spring. Vatican: Edizioni Musei Vaticani, 1997.

Di Giampaolo, Mario. *Parmigianino: catalogo completo dei dipinti*. Florence: Cantini, 1991.

Di Teodoro, Francesco Paolo. *Donato Bramante: ricerche, proposte, riletture*. Urbino: Accademia Raffaello, 2001.

Ekserdjian, David. *Correggio*. New Haven, Conn.: Yale University Press, 1997.

———. *Parmigianino*. New Haven, Conn.: Yale University Press, 2006.

Emiliani, Andrea, and Michela Scolaro. *Raffaello: La Stanza della Segnatura*. Milan: Electa, 2002.

Fabianski, Marcin. *Correggio: Le mitologie d'amore*. Cinisello Balsamo, Milan: Silvana, 2000.

Falciani, Carlo. *Il Pontormo e il Rosso: Guida delle Opere*. Florence: Giunta regionale Toscana and Marsilio, 1994.

———. *Il Rosso Fiorentino*. Florence: L. S. Olschki, 1996.

Farinella, Vincenzo. *Raphael*. Milan: 5 Continents Editions, 2004.

Ferino Pagden, Sylvia. *Sofonisba Anguissola: A Renaissance Woman*. Washington, D.C.: National Museum of Women in the Arts, 1995.

Franklin, David. *The Art of Parmigianino*. New Haven, Conn.: Yale University Press & National Gallery of Canada, 2003.

———. *Rosso in Italy: The Italian Career of Rosso Fiorentino*. New Haven, Conn.: Yale University Press, 1994.

Franzina, Antonio. *Palladio: le ville*. Milan: Touring club italiano, 2002.

Frazzi, Michele. *Correggio: La camera alchemica*. Cinisello Balsamo, Milan: Silvana, 2004.

Freedberg, S. J. *Andrea del Sarto*. Cambridge, Mass.: Belknap Press of Harvard University Press, 1963.

———. *Parmigianino: His Works in Painting*. Westport, Conn.: Greenwood Press, 1971.

Freedman, Luba. *Titian's Portraits through Aretino's Lens*. University Park: Pennsylvania State University Press, 1995.

Frommel, Christoph L., ed. *La villa Farnesina a Roma [The Villa Farnesina in Rome]*. Modena: F. C. Panini, 2003.

Frommel, Christoph L., and Nicholas Adams, eds. *The Architectural Drawings of Antonio da Sangallo the Younger and His Circle*. New York: Architectural History Foundation & MIT Press, 1994.

Frommel, Christoph L., Luisa Giordano, and Richard Schofield, eds. *Bramante milanese e l'architettura del Rinascimento Lombardo*. Venice: Marsilio, 2002.

Frommel, Sabine, ed. *Francesco Primaticcio architetto*. Milan: Electa, 2005.

———. *Sebastiano Serlio, Architect*. Translated by Peter Spring. Milan: Electaarchitecture and Phaidon, 2003.

Gallucci, Margaret A. *Benvenuto Cellini: Sexuality, Masculinity, and Artistic Identity in Renaissance Italy*. New York: Palgrave Macmillan, 2003.

Gallucci, Margaret A., and Paolo L. Rossi, eds. *Benvenuto Cellini: Sculptor, Goldsmith, Writer*. Cambridge: Cambridge University Press, 2004.

Gerlini, Elsa. *Villa Farnesina alla Lungara: Roma*. Rome: Istituto Poligrafico e Zecca dello Stato, 1999.

Ghisetti Giavarina, Adriano. *Palladio: Architetto a Vincenza*. Pescara: Carsa, 2000.

Giacobello Bernard, Giovanna, and Enrica Pagella, eds. *Van Eyck, Antonello, Leonardo: tre capolavori del Rinascimento*. Turin: U. Allemandi, 2003.

Gilbert, Creighton. *Michelangelo: On and off the Sistine Ceiling.* New York: George Braziller, 1994.

Goffen, Rona. *Renaissance Rivals: Michelangelo, Leonardo, Raphael, Titian.* New Haven, Conn.: Yale University Press, 2002.

———, ed. *Titian's Venus of Urbino.* Cambridge: Cambridge University Press, 1997.

———. *Titian's Women.* New Haven, Conn.: Yale University Press, 1997.

Goldscheider, Ludwig. *Michelangelo: Paintings, Sculpture, Architecture.* London: Phaidon Press, 1996.

Gosselin, Jean Matthieu. *Michelangelo.* London: Parkstone, 2005.

Gould, Cecil Hilton Monk. *The Paintings of Correggio.* Ithaca, N.Y.: Cornell University Press, 1976.

———. *Parmigianino.* New York: Abbeville Press, 1994.

Guidoni, Enrico. *Giorgione: opere e significati.* Rome: Editalia, 1999.

Hall, James. *Michelangelo and the Reinvention of the Human Body.* New York: Farrar, Straus, & Giroux, 2005.

Hall, Marcia, ed. *Michelangelo's Last Judgment.* Cambridge: Cambridge University Press, 2005.

Hersey, George L. *High Renaissance Art in St. Peter's and the Vatican: An Interpretive Guide.* Chicago: University of Chicago Press, 1993.

Holberton, Paul. *Palladio's Villas: Life in the Renaissance Countryside.* London: Murray, 1990.

Holderbaum, James. *The Sculptor Giovanni Bologna.* New York: Garland, 1983.

Howard, Deborah. *Jacopo Sansovino: Architecture and Patronage in Renaissance Venice.* New Haven, Conn.: Yale University Press, 1975.

Hughes, Anthony. *Michelangelo.* London: Phaidon Press, 1997.

Humfrey, Peter. *Carpaccio.* London: Chaucer, 2005.

———. *Lorenzo Lotto.* New Haven, Conn.: Yale University Press, 1997.

Humfrey, Peter, and Mauro Lucco. *Dosso Dossi: Court Painter in Renaissance Ferrara.* New York: Metropolitan Museum of Art, 1998.

Jaffé, David, ed. *Titian.* London: National Gallery & Yale University Press, 2003.

Joannides, Paul. *Michelangelo.* Milan: 5 Continents & Louvre Museum, 2003.

———. *Titian to 1518: The Assumption of Genius.* New Haven, Conn.: Yale University Press, 2001.

Joost-Gaugier, Christiane L. *Raphael's Stanza della Segnatura: Meaning and Invention.* Cambridge: Cambridge University Press, 2002.

Kemp, Martin. *Leonardo.* New York: Oxford University Press, 2004.

———. *Leonardo da Vinci: The Marvelous Works of Nature and Man.* Oxford: Oxford University Press, 2006.

Kessler, Hans-Ulrich. *Pietro Bernini (1562–1629).* Munich: Hirmer, 2005.

Kiene, Michael. *Bartolomeo Ammannati.* Milan: Electa, 1995.

Kinney, Peter. *The Early Sculpture of Bartolomeo Ammannati*. New York: Garland, 1976.

Langdon, Gabrielle. *Medici Women: Portraits of Power, Love, and Betrayal from the Court of Duke Cosimo I*. Toronto: Toronto University Press, 2006.

Liebert, Robert S. *Michelangelo: A Psychoanalytic Study of His Life and Images*. New Haven, Conn.: Yale University Press, 1983.

Lucco, Mauro. *Giorgione*. Milan: Electa, 1995.

Marani, Pietro C. *Leonardo da Vinci: The Complete Paintings*. New York: Abrams, 2000.

Marchetti Letta, Elisabetta. *Pontormo, Rosso Fiorentino*. Florence: Scala, 1994.

Marrucci, Rosa Auletta, ed. *Bramante in Lombardia: restauri 1974–2000*. Milan: Skira, 2001.

Mason Rinaldi, Stefania. *Carpaccio: The Major Pictorial Cycles*. Translated by Andrew Ellis. Milan: Skira, 2000.

McCorquodale, Charles. *Bronzino*. London: Chaucer Press, 2005.

McMullen, Roy. *Mona Lisa: The Picture and the Myth*. Boston, Mass.: Houghton Mifflin, 1975.

Meilman, Patricia. *Titian and the Altarpiece in Renaissance Venice*. Cambridge: Cambridge University Press, 2000.

Monducci, Elio. *Il Correggio: La vita e le opere nelle fonti documentarie*. Cinisello Balsamo, Milan: Silvana, 2004.

Morselli, Piero, and Gino Corti. *La Chiesa di Santa Maria delle Carceri in Prato: contributo di Lorenzo de' Medici e Giuliano da Sangallo alla progettazione*. Prato: Società pratese di storia patria & EDAM, 1982.

Musée du Louvre. *Primatice: maître de Fontainebleau, Paris, Musée du Louvre, 22 septembre 2004–3 janvier 2005*. Paris: Réunion des Musées Nationaux, 2004.

Nagel, Alexander. *Michelangelo and the Reform of Art*. Cambridge: Cambridge University Press, 2000.

Natali, Antonio. *Andrea del Sarto: maestro della maniera moderna*. Milan: Leonardo arte, 1998.

Nepi Scirè, Giovanna. *Carpaccio: Pittore di storie*. Venice: Marsilio, 2004.

———, ed. *Carpaccio: Storie di Sant' Orsola*. Milan: Electa, 2000.

Nicholl, Charles. *Leonardo da Vinci: Flights of the Mind*. New York: Viking Penguin, 2004.

Nichols, Tom. *Tintoretto: Tradition and Identity*. London: Reaktion Books, 1999.

Nuland, Sherwin B. *Leonardo da Vinci*. New York: Viking, 2000.

Oremland, Jerome D. *Michelangelo's Sistine Ceiling: A Psychoanalytic Study of Creativity*. Madison, Conn.: International Universities Press, 1989.

Pallanti, Giuseppe. *Mona Lisa Revealed: The True Identity of Leonardo's Model*. Milan: Skira, 2006.

Pallucchini, Rodolfo, and Paola Rossi. *Tintoretto*. 3 vols. Milan: Electa, 1990.

Parker, Deborah. *Bronzino: Renaissance Painter as Poet*. Cambridge: Cambridge University Press, 2000.

Parma, Elena. *Perin del Vaga: l'anello mancante, studi sul manierismo*. Genoa: Sagep, 1986.

———, ed. *Perino del Vaga: prima, durante, dopo: atti delle giornate internazionali di studio, Genova, 26–27 maggio 2001, Palazzo Doria "del Principe."* Genoa: De Ferrari, 2004.

———. *Perino del Vaga: tra Raffaello e Michelangelo*. Milan: Electa, 2001.

Partridge, Loren. *Michelangelo: The Sistine Chapel Ceiling, Rome*. New York: Braziller, 1996.

Patetta, Luciano, ed. *Bramante e la sua cerchia: a Milano e in Lombardia 1480–1500*. Milan: Skira, 2001.

Pedrocco, Filippo. *Veronese*. Florence: Scala, 1998.

Pegazzano, Donatella. *Benvenuto Cellini*. Rome: Gruppo Editoriale l'Espresso, 2005.

Penck, Stefanie. *Michelangelo*. Munich: Prestel, 2005.

Perlingieri, Ilyia Sandra. *Sofonisba Anguissola: The First Great Woman Artist of the Renaissance*. New York: Rizzoli, 1992.

Perocco, Guido. *The Scuola di San Rocco*. Venice: Ardo Art Edition, 1979.

Pignatti, Terisio. *Giorgione*. New York: Rizzoli, 1999.

———. *Paolo Veronese*. Venice: Canal & Stamperia editrice, 2000.

Pilliod, Elizabeth. *Pontormo, Bronzino, Allori: A Genealogy of Florentine Art*. New Haven, Conn.: Yale University Press, 2001.

Pinacoteca Nazionale di Siena. *Domenico Beccafumi e il suo tempo*. Milan: Electa, 1990.

Pinessi, Orietta. *Sofonisba Anguissola: Un "pittore" alla corte di Filippo II*. Milan: Selene, 1998.

Pirovano, Carlo. *Lotto*. Milan: Electa, 2002.

Poeschke, Joachim. *Michelangelo and His World: Sculpture of the Italian Renaissance*. New York: Harry N. Abrams, 1996.

Pope-Hennessy, John. *Tiziano*. Milan: Electa, 2004.

Prada, Juan Manuel de. *The Tempest*. Translated by Paul Antill. Woodstock, N.Y.: Overlook Press, 2003.

Puppi, Lionello. *Andrea Palladio: The Complete Works*. London: Faber & Electa, 1989.

———. *Per Tiziano*. Milan: Skira, 2004.

Puttfarken, Thomas. *Titian and Tragic Painting: Aristotle's Poetics and the Rise of the Modern Artist*. New Haven, Conn.: Yale University Press, 2005.

Riccòmini, Eugenio. *Correggio*. Milan: Electa, 2005.

Romanelli, Giandomenico. *Tintoretto: La Scuola grande di San Rocco*. Milan: Electa, 1994.

Rosand, David. *Painting in Sixteenth-Century Venice: Titian, Veronese, Tintoretto.* Rev. ed. Cambridge: Cambridge University Press, 1997.

Rubin, Patricia Lee. *Giorgio Vasari: Art and History.* New Haven, Conn.: Yale University Press, 1995.

Rybczynski, Witold. *The Perfect House: A Journey with the Renaissance Master Andrea Palladio.* New York: Scribner, 2002.

Sassoon, Donald. *Becoming Mona Lisa: The Making of a Global Icon.* New York: Harcourt, 2001.

———. *Leonardo and the Mona Lisa Story: The History of a Painting Told in Pictures.* New York: Overlook Duckworth/Madison Press, 2006.

Satkowski, Leon George. *Giorgio Vasari: Architect and Courtier.* Princeton, N.J.: Princeton University Press, 1993.

———. *Studies on Vasari's Architecture.* New York: Garland, 1979.

Satzinger, Georg. *Antonio da Sangallo der Ältere und die Madonna di San Biagio bei Montepulciano.* Tübingen, Germany: E. Wasmuth, 1991.

Scigliano, Eric. *Michelangelo's Mountain: The Quest for Perfection in the Marble Quarries of Carrara.* New York: Free Press, 2005.

Serres, Michel. *Carpaccio studi.* Edited and translated by Anna-Maria Sauzeau Boetti. Florence: Hopefulmonster, 1990.

Settis, Salvatore. *Giorgione's Tempest: Interpreting the Hidden Subject.* Translated by Ellen Bianchini. Chicago: University of Chicago Press, 1990.

Sgarbi, Vittorio. *Carpaccio.* Milan: Fabbri, 1994.

———. *Parmigianino.* Milan: Rizzoli & Skira, 2003.

Shearman, John K. G. *Raphael in Early Modern Sources (1483–1602).* New Haven, Conn.: Yale University Press, 2003.

Signorini, Rodolfo. *Il Palazzo del Tè e la Camera di Psiche: miti e altre fantasie e storie antiche nella villa di Federico II Gonzaga ideata da Giulio Romano a Mantova.* Mantua: Sometti, 2001.

Smyth, Carolyn. *Correggio's Frescoes in Parma Cathedral.* Princeton, N.J.: Princeton University Press, 1997.

Spadaro, Giorgio I. *The Esoteric Meaning in Raphael's Paintings: The Philosophy of Composition in the Disputà, the School of Athens, the Transfiguration.* Great Barrington, Mass.: Lindisfarne Books, 2006.

Spagnesi, Gianfranco, ed. *Antonio da Sangallo il Giovane: la vita e l'opera, atti del XXII Congresso di storia dell'architettura, Roma, 19–21 febbraio 1986.* Rome: Centro di Studi per la storia dell'architettura, 1986.

Spike, John T. *La favola di Apollo e Marsia di Agnolo Bronzino.* Florence: Polistampa, 2000.

Steinberg, Leo. *Leonardo's Incessant Last Supper.* New York: Zone Books, 2001.

Strehlke, Carl Brandon. *Pontormo, Bronzino, and the Medici: The Transformation of the Renaissance Portrait in Florence.* Philadelphia: Philadelphia Museum of Art and the Pennsylvania State University Press, 2004.

Tafuri, Manfredo. *Jacopo Sansovino e l'architettura del '500 a Venezia*. Padua: Marsilio, 1972.

———, ed. *Giulio Romano*. Translated by Fabio Berry. Cambridge: Cambridge University Press, 1998.

Tavernor, Robert. *Palladio and Palladianism*. New York: Thames & Hudson, 1991.

Tazartes, Maurizia. *Bronzino*. Milan: Rizzoli & Skira, 2003.

Tessari, Cristiano, ed. *San Pietro che non c'è: da Bramante a Sangallo il giovane*. Milan: Electa, 1996.

Thies, Harmen. *Michelangelo: Das Kapitol*. Munich: Bruckmann, 1982.

Torriti, Piero. *Beccafumi*. Milan: Electa, 1998.

Valcanover, Francesco. *Carpaccio*. Florence: Scala, 1989.

Valcanover, Francesco, and Terisio Pignatti. *Tintoretto*. Translated by Robert Erich Wolf. New York: H. N. Abrams, 1985.

Varoli-Piazza, Rosalia, ed. *Raffaello: la loggia di Amore e Psiche alla Farnesina*. Cinisello Balsamo, Milan: Silvana & Istituto centrale per il restauro, 2002.

Vinti, Francesca. *Giulio Romano pittore e l'antico*. Florence: La Nuova Italia, 1995.

Wallace, William E. *Michelangelo at San Lorenzo: The Genius as Entrepreneur*. Cambridge: Cambridge University Press, 1994.

———. *Michelangelo: The Complete Sculpture, Painting, Architecture*. New York: Hugh Lauter Levin, 1998.

Weissmüller, Alberto. *Palladio in Venice*. Ponzano, Treviso: Vianello, 2005.

Wind, Edgar. *The Religious Symbolism of Michelangelo: The Sistine Ceiling*. Edited by Elizabeth Sears. Oxford: Oxford University Press, 2000.

Wolf, Norbert. *I, Titian*. Munich: Prestel, 2006.

Wolff Metternich, Franz Graf. *Bramante und St. Peter*. Munich: Fink, 1975.

Zanchi, Mauro. *L'opera ermetica di Lorenzo Lotto*. Clusone: Ferrari, 1999.

Zenkert, Astrid. *Tintoretto in der Scuola di San Rocco: Ensemble und Wirkung*. Tübingen, Germany: E. Wasmuth, 2003.

Zöllner, Frank. *Leonardo da Vinci, 1452–1519: The Complete Paintings and Drawings*. Cologne: Taschen, 2003.

Zorzi, Alvise. *Il colore e la gloria: genio, fortuna e passioni di Tiziano Vecellio*. Milan: Mondadori, 2003.

Zuffi, Stefano. *Lotto*. Milan: Electa, 1993.

———. *Tintoretto*. Milan: Electa, 1993.

D. Baroque

Avery, Charles. *Bernini: Genius of the Baroque*. Boston, Mass.: Bulfinch, 1997.

Bellini, Federico. *Le cupole di Borromini: la "scientia" costruttiva in età barocca*. Milan: Electa, 2004.

Benocci, Carla. *Algardi a Roma: Il Casino del Bel Respiro a Villa Doria Pamphilj.* Rome: Edizioni de Luca, 1999.

Bernardini, Maria Grazia. *Caravaggio, Carracci, Maderno: la Cappella Cerasi in Santa Maria del Popolo a Roma.* Cinisello Balsamo, Milan: Silvana, 2001.

Bernini, Giovanni Pietro. *Giovanni Lanfranco (1582–1647).* 2nd ed. Calestano, Parma: Centro studi della Val Baganza and Associazione "Comunità di Terenzo," 1985.

Bissell, R. Ward. *Artemisia Gentileschi and the Authority of Art: Critical Reading and Catalogue Raisonné.* University Park: Pennsylvania State University Press, 1999.

———. *Orazio Gentileschi and the Poetic Tradition in Caravaggesque Painting.* University Park: Pennsylvania State University Press, 1981.

Blunt, Anthony. *Borromini.* Cambridge, Mass.: Harvard University Press, 1979.

Borsi, Franco. *Bernini.* Translated by Robert Erich Wolf. New York: Rizzoli, 1984.

Bösel, Richard, and Christoph L. Frommel., eds. *Borromini e l'universo barocco.* 2 vols. Documenti di Architettura, 127. Milan: Electa, 1999–2000.

Brejon de Lavergnée, Arnauld. *Dopo Caravaggio: Bartolomeo Manfredi e la manfrediana methodus.* Milan: Mondadori, 1987.

Briganti, Giuliano. *Pietro da Cortona o della pittura barocca.* 2nd ed. Florence: Sansoni, 1982.

Brogi, Alessandro. *Ludovico Carracci (1555–1619).* 2 vols. Bologna: Tipoarte, 2001.

Campbell, Malcolm. *Pietro da Cortona at the Pitti Palace: A Study of the Planetary Rooms and Related Projects.* Princeton, N.J.: Princeton University Press, 1977.

Careri, Giovanni. *Bernini: Flights of Love, the Art of Devotion.* Chicago: University of Chicago Press, 1995.

Carpiceci, Alberto Carlo. *La fabbrica di San Pietro: venti secoli di storia e progetti.* Vatican: Libreria editrice vaticana and Bonechi, 1983.

Cassani, Silvia. *Domenichino: Storia di un restauro.* Naples: Electa Napoli, 1987.

Cerutti Fusco, Annarosa. *Pietro da Cortona architetto.* Rome: Gangemi, 2002.

Christiansen, Keith, and Judith W. Mann, eds. *Orazio and Artemisia Gentileschi.* New York: Metropolitan Museum of Art & Yale Univeristy Press, 2001.

Colantuono, Anthony. *Guido Reni's Abduction of Helen: The Politics and Rhetoric of Painting in Seventeenth-Century Europe.* Cambridge: Cambridge University Press, 1997.

Connors, Joseph. *Borromini and the Roman Oratory: Style and Society.* Cambridge, Mass.: MIT Press, 1980.

Cropper, Elizabeth. *The Domenichino Affair: Novelty, Imitation, and Theft in Seventeenth-Century Rome*. New Haven, Conn.: Yale University Press, 2005.

Dallasta, Federica. *Bartolomeo Schedoni a Parma (1607–1615): pittura e controriforma alla corte di Ranuccio I Farnese*. Colorno, Parma: TLC Editrice, 2002.

Dallasta, Federica, and Cristina Cecchinelli. *Bartolomeo Schedoni: pittore emiliano, Modena 1578 Parma 1615*. Parma: Fondazione Monte di Parma, 1999.

D'Avossa, Antonio. *Andrea Sacchi*. Rome: Kappa, 1985.

Dempsey, Charles. *Annibale Carracci and the Beginnings of the Baroque Style*. Glückstadt: Augustin, 1977.

———. *Annibale Carracci: The Farnese Gallery, Rome*. New York: George Braziller, 1995.

Ebert-Schifferer, Sybille, Andrea Emiliani, and Erich Schleier, eds. *Guido Reni e l'Europa: fama e fortuna*. Bologna: Nuova Alfa Editoriale & Schirn Kunsthalle, 1988.

Emiliani, Andrea. *Federico Barocci: Urbino, 1535–1612*. Bologna: Nuova Alfa, 1985.

———, ed. *Ludovico Carracci*. Milan: Electa, Abbeville, & Kimbell Art Museum, 1994.

———, ed. *Mostra di Federico Barocci: Bologna, Museo civico, 14 settembre–16 novembre 1975*. Bologna: Alfa, 1975.

Fagiolo, Marcello, and Paolo Portoghesi, eds. *Roma barocca: Bernini, Borromini, Pietro da Cortona*. Milan: Electa, 2006.

Fagiolo dell' Arco, Maurizio. *Pietro da Cortona e i "cortoneschi": bilancio di un centenario e qualche novità*. Rome: Bulzoni Editore, 1998.

Frommel, Christoph Luitpold, and Sebastian Schütze, eds. *Pietro da Cortona: atti del convengno internazionale Roma-Firenze, 12–15 novembre 1997*. Milan: Electa, 1998.

Frommel, Christoph Luitpold, and Elisabeth Sladek, eds. *Francesco Borromini: atti del convegno internazionale, Roma, 13–15 gennaio 2000*. Milan: Electa, 2000.

Gallavotti Cavallero, Daniela. *Bernini e la pittura*. Rome: Gangemi, 2003.

Gammino, Nicoló Mario, ed. *S. Carlino alle Quattro Fontane: il restauro della facciata, note di cantiere*. Rome: C.T.R. Consorzio Tecnici del Restauro, 1993.

Garrard, Mary D. *Artemisia Gentileschi: The Image of the Female Hero in Italian Baroque Art*. Princeton, N.J.: Princeton University Press, 1989.

———. *Artemisia Gentileschi around 1622: The Shaping and Reshaping of an Artistic Identity*. Berkeley: University of California Press, 2001.

Gash, John. *Caravaggio*. London: Chaucer, 2003.

Ginzburg Carignani, Silvia. *Annibale Carracci a Roma: gli affreschi di Palazzo Farnese*. Rome: Donzelli, 2000.

Harris, Ann Sutherland. *Andrea Sacchi: Complete Edition of the Paintings with a Critical Catalogue*. Oxford: Phaidon, 1977.

Hendrix, John. *The Relation between Architectural Forms and Philosophical Structures in the Work of Francesco Borromini in Seventeenth-Century Rome*. Lewiston, N.Y.: Mellen Press, 2002.

Herrmann Fiore, Kristina. *Apollo e Dafne del Bernini nella Galleria Borghese*. Cinisello Balsamo, Milan: Silvana, 1997.

Hibbard, Howard. *Carlo Maderno*. Edited by Aurora Scotti Tossini. Translated by Giuseppe Bonaccorso and Nicoletta Marconi. Milan: Electa, 2001.

———. *Carlo Maderno and Roman Architecture, 1580–1630*. University Park: Pennsylvania State University Press, 1971.

Khan-Rossi, Manuela, and Marco Franciolli, eds. *Il giovane Borromini: dagli esordi a San Carlo alle Quattro Fontane*. Milan: Skira, 1999.

Kirwin, William Chandler. *Powers Matchless: The Pontificate of Urban VIII, the Baldachin, and Gian Lorenzo Bernini*. New York: Peter Lang, 1997.

Lagerlöf, Margaretha Rossholm. *Ideal Landscape: Annibale Carracci, Nicolas Poussin and Claude Lorrain*. New Haven, Conn.: Yale University Press, 1990.

Langdon, Ellen. *Caravaggio: A Life*. New York: Farrar, Straus & Giroux, 1999.

Lavin, Irving. *Bernini and the Unity of Visual Arts*. New York: Oxford University Press, 1980.

———. *Essays on Style and Meaning in the Art of Gianlorenzo Bernini*. London: Pindar, 2003.

Lo Bianco, Anna. *Cecilia: la storia, l'immagine, il mito: la scultura di Stefano Maderno e il suo restauro*. Rome: Campisano, 2001.

———, ed. *Pietro da Cortona, 1597–1669*. Milan: Electa, 1997.

Loire, Stéphane. *L'Albane, 1578–1660*. Paris: Réunion des musées nationaux, 2000.

Loisel, Catherine. *Ludovico Carracci*. Milan: 5 Continents & Musée du Louvre, 2004.

Magnuson, Torgil. *Rome in the Age of Bernini*. 2 vols. Stockholm, Sweden: Almqvist & Wiksell International, 1982.

Mahon, Denis. *Guercino: Master Painter of the Baroque*. Washington, D.C.: Washington National Gallery, 1992.

Mahon, Denis, Massimo Pulini, and Vittorio Sgarbi, eds. *Guercino: poesia e sentimento nella pittura del '600*. Milan: De Agostini, 2003.

Mann, Judith W., ed. *Artemisia Gentileschi: Taking Stock*. Turnhout, Belgium: Brepols, 2005.

Marder, Tod A. *Bernini and the Art of Architecture*. New York: Abbeville Press, 1998.

———. *Bernini's Scala Regia at the Vatican Palace*. Cambridge: Cambridge University Press, 1997.

Martin, John Rupert. *The Farnese Gallery*. Princeton, N.J.: Princeton University Press, 1965.

Masini, Patrizia, ed. *Pietro da Cortona: il meccanismo della forma, ricerche sulla tecnica pittorica*. Milan: Electa, 1997.

McPhee, Sarah. *Bernini and the Bell Towers: Architecture and Power at the Vatican*. New Haven, Conn.: Yale University Press, 2002.

Merz, Jörg Martin. *Pietro da Cortona: der Aufstieg zum führenden Maler im barocken Rom*. Tübingen, Germany: Wasmuth, 1991.

Moffitt, John F. *Caravaggio in Context: Learned Naturalism and Renaissance Humanism*. Jefferson, N.C.: McFarland, 2004.

Montagu, Jennifer. *Alessandro Algardi*. New Haven, Conn.: Yale University Press, 1985.

———, ed. *Algardi: L'altra faccia del barocco, Roma, Palazzo delle esposizioni, 21 gennaio–30 aprile 1999*. Rome: Edizioni De Luca, 1999.

Montanari, Tomaso. *Gian Lorenzo Bernini*. Rome: Gruppo Editoriale l'Espresso, 2005.

Montijano García, Juan María, ed. *San Carlo alle Quattro Fontane di Francesco Borromini: nella "Relatione della Fabrica" di fra Juan de San Buenaventura*. Milan: Il polifilo, 1999.

Morrissey, Jake. *The Genius in the Design: Bernini, Borromini, and the Rivalry That Transformed Rome*. New York: William Morrow, 2005.

Museo Civico di Bologna. *I bronzi di Piacenza: rilievi e figure di Francesco Mochi dai monumenti equestri farnesiani, [mostra] Bologna, Museo civico archeologico, 21 marzo–18 maggio 1986*. Bologna: Grafis edizioni, 1986.

Nava Cellini, Antonia. *Stefano Maderno*. Milan: Fratelli Fabbri, 1966.

Negro, Emilio. *Bartolomeo Schedoni: 1578–1615*. Modena: Artioli, 2000.

Negro, Emilio, and Massimo Pirondini, eds. *La scuola dei Carracci: dall'Accademia alla bottega di Ludovico*. Modena: Artioli, 1994.

Negro, Emilio, and Massimo Pirondini, eds. *La scuola dei Carracci: I seguaci di Annibale e Agostino*. Modena: Artioli, 1995.

Noehles, Karl. *La Chiesa dei SS. Luca e Martina nell'opera di Pietro da Cortona*. Rome: U. Bozzi, 1970.

Olsen, Harald. *Federico Barocci*. 2nd ed. Copenhagen: Munksgaard, 1962.

O'Neil, Maryvelma Smith. *Giovanni Baglione: Artistic Reputation in Baroque Rome*. Cambridge: Cambridge University Press, 2002.

Pagano, Denise Maria, ed. *In paradiso: gli affreschi del Lanfranco nella Capella del tesoro di San Gennaro*. Naples: Electa, 1996.

Pantaleoni, Gaetano. *Il barocco del Mochi nei cavalli Farnesiani*. Piacenza, Italy: T.E.P., 1981.

Papi, Gianni. *Manfredi: La cattura di Cristo*. Milan: Marco Voena, 2004.

Pepper, D. Stephen. *Guido Reni: A Complete Catalogue of His Works with an Introductory Text.* New York: New York University Press, 1984.

Petersson, Robert T. *Bernini and the Excesses of Art.* Florence: M & M, Maschietto & Ditore, 2002.

Pollak, Oskar. *Die Kunsttätigkeit unter Urban VIII.: die Peterskirche in Rom.* Hildesheim, Germany: G. Olms, 1981.

Portoghesi, Paolo. *Francesco Borromini.* Milan: Electa, 1990.

———. *Storia di San Carlino alle Quattro Fontane.* Rome: Newton & Compton, 2001.

Posner, Donald. *Annibale Carracci: A Study in the Reform of Italian Painting around 1590.* London: Phaidon, 1971.

Pratesi, Ludovico. *Roman Fountains by Bernini, the Baroque Master.* Rome: Ingegneria per la cultura, 1999.

Prose, Francine. *Caravaggio: Painter of Miracles.* New York: Atlas Books/Harper Collins, 2005.

Puglisi, Catherine. *Caravaggio.* London: Phaidon, 1998.

———. *Francesco Albani.* New Haven, Conn.: Yale University Press, 1999.

Raspe, Martin. *Die Architektursystem Borrominis.* Munich: Deutscher Kunstverlag, 1994.

Rice, Louise. *The Altars and Altarpieces of St. Peter's: Outfitting the Basilica, 1621–1666.* New York: Cambridge University Press, 1997.

Salerno, Luigi. *I dipinti del Guercino.* Rome: Ugo Bozzi, 1988.

Schleier, Erich, ed. *Giovanni Lanfranco: un pittore barocco tra Parma, Roma e Napoli.* Milan: Electa, 2001.

Scott, John Beldon. *Images of Nepotism: The Painted Ceilings of Palazzo Barberini.* Princeton, N.J.: Princeton University Press, 1991.

Sinisgalli, Rocco. *A History of the Perspective Scene from the Renaissance to the Baroque: Borromini in Four Dimensions.* Florence: Cadmo, 2000.

Spear, Richard E. *The Divine Guido: Religion, Sex, Money, and Art in the World of Guido Reni.* New Haven, Conn.: Yale University Press, 1997.

———. *Domenichino.* New Haven, Conn.: Yale University Press, 1982.

Spike, John T. *Caravaggio.* New York: Abbeville Press, 2001.

Steinberg, Leo. *Borromini's San Carlo alle Quattro Fontane: A Study in Multiple Form and Architectural Symbolism.* New York: Garland, 1977.

Strinati, Claudio, and Rossella Vodret, eds. *Guercino and Emilian Classicist Painting: From the Collections of the Galleria Nazionale d'Arte Antica in Palazzo Barberini, Rome.* Naples: Electa Napoli, 1999.

Tiberia, Vitaliano. *Gian Lorenzo Bernini, Pietro da Cortona, Agostino Ciampelli in Santa Bibiana a Roma: i restauri.* Todi, Italy: Ediart, 2000.

Varriano, John. *Caravaggio: The Art of Realism.* University Park: Pennsylvania State University Press, 2006.

Warwick, Genevieve, ed. *Caravaggio: Realism, Rebellion, Reception.* Newark: University of Delaware Press, 2006.

Weston-Lewis, Aidan. *Effigies & Ecstasies: Roman Baroque Sculpture and Design in the Age of Bernini.* Edinburgh: National Gallery of Scotland, 1998.

Wimböck, Gabriele. *Guido Reni (1575–1642): Funktion und Wirkung des religiösen Bildes.* Regensburg, Germany: Schnell & Steiner, 2002.

Wittkower, Rudolf. *Bernini: The Sculptor of the Roman Baroque.* 4th ed. London: Phaidon Press, 1997.

Zitzlsperger, Philipp. *Gianlorenzo Bernini, die Papst- und Herrscherporträts: zum Vermächtnis von Bildnis und Macht.* Munich: Hirmer, 2002.

VII. FLANDERS AND THE NETHERLANDS

Ainsworth, Maryan W. *Gerard David: Purity of Vision in an Age of Transition.* New York: Metropolitan Museum of Art, 1998.

———. *Petrus Christus: Renaissance Master of Bruges.* New York: Metropolitan Museum of Art, 1994.

———, ed. *Petrus Christus in Renaissance Bruges: An Interdisciplinary Approach.* New York: Metropolitan Museum of Art and Brepols, 1995.

Alpers, Svetlana. *The Making of Rubens.* New Haven, Conn.: Yale University Press, 1995.

Bangs, Jeremy Dupertuis. *Cornelis Engebrechtsz's Leiden: Studies in Cultural History.* Assen, Netherlands: Van Gorcum, 1979.

Bard, H. P. *Frans Hals.* Translated by George Stuyck. New York: H. N. Abrams, 1981.

Barnes, Susan J. *Van Dyck: A Complete Catalogue of the Paintings.* New Haven, Conn.: Yale University Press, 2004.

Bax, Dirk. *Hieronymus Bosch and Lucas Cranach, Two Last Judgement Triptychs: Description and Exposition.* Translated by M. A. Bax-Botha. Amsterdam: North-Holland, 1983.

Beagle, Peter. *The Garden of Earthly Delights.* New York: Viking Press, 1982.

Belting, Hans. *Hieronymus Bosch: Garden of Earthly Delights.* Munich: Prestel, 2002.

Blake, Robin. *Anthony van Dyck: A Life, 1599–1641.* Chicago: Ivan R. Dee, 2000.

Bodenhausen, Eberhard Frieherr von. *Gerard David und seine Schule.* New York: Collectors Editions, 1970.

Borchert, Till. *Le siècle de Van Eyck: le monde méditerranéen et les primitifs flamands, 1430–1530.* Gand, Belgium: Ludion, 2002.

Boudon-Machuel, *François Du Quesnoy, 1597–1643.* Paris: Arthena, 2005.

Brown, Christopher. *Rubens' Landscapes*. London: National Gallery, 1996.

———. *Van Dyck: 1599–1641*. London: Royal Academy, 1999.

Campbell, Lorne. *Van der Weyden*. London: Chaucer, 2004.

Cellini, Antonia Nava. *Francesco Duquesnoy*. Milan: Fratelli Fabbri, 1966.

Crenshaw, Paul. *Rembrandt's Bankruptcy: The Artist, His Patrons, and the Art Market in Seventeenth-Century Netherlands*. New York: Cambridge University Press, 2006.

Davies, Martin. *Rogier van der Weyden: An Essay, with a Critical Catalogue of Paintings Assigned to Him and to Robert Campin*. New York: Phaidon, 1972.

Dhanens, Elisabeth. *Van Eyck: The Ghent Altarpiece*. New York: Viking Press, 1973.

Dixon, Laurinda S. *Alchemical Imagery in Bosch's Garden of Delights*. Ann Arbor, Mich.: UMI Research Press, 1981.

Donovan, Fiona. *Rubens and England*. New Haven: Yale University Press, 2004.

Durham, John I. *The Biblical Rembrandt: Human Painter in a Landscape of Faith*. Macon, Ga.: Mercer University Press, 2004.

Elsig, Frédéric. *Jheronimus Bosch: la question de la chronologie*. Geneva, Switzerland: Librairie Droz, 2004.

Faggin, Giorgio T., and Edith de Bonnafos. *Hugo van der Goes*. Paris: Hachette, 1968.

Falkenburg, Reindert Leonard. *Joachim Patinir: Landscape as an Image of the Pilgrimage of Life*. Amsterdam, Netherlands: J. Benjamins, 1988.

Faries, Mollie, and Liesbeth M. Helmus. *The Madonnas of Jan van Scorel, 1495–1562: Serial Production of a Cherished Motif*. Translated by David Alexander, Jennifer M. Kilian, and Cornelia H. Kist. Utrecht, Netherlands: Centraal Museum, 2000.

Filippi, Elena. *Maarten van Heemskerck: inventio urbis*. Milan: Berenice, 1990.

Foister, Susan, Sue Jones, and Delphine Cool. *Investigating Jan van Eyck*. Turnhout, Belgium: Brepols, 2000.

Foister, Susan, and Susie Nash, eds. *Robert Campin: New Directions in Scholarship*. Turnhout, Belgium: Brepols, 1996.

Fraenger, Wilhelm. *Hieronymus Bosch*. Translated by Helen Sebba. Basel, Switzerland: G&B Arts International, 1994.

Frinta, Mojmir S. *The Genius of Robert Campin*. The Hague: Mouton, 1966.

Gibson, Michael. *The Mill and the Cross: Pieter Bruegel's Way to Calvary*. Lausanne, Switzerland: Editions Acatos, 2000.

Gibson, Walter S. *The Art of Laughter in the Age of Bosch and Bruegel*. Groningen, Netherlands: Gerson Lectures Foundation, 2003.

———. *The Paintings of Cornelis Engebrechtsz*. New York: Garland, 1977.

———. *Pieter Bruegel and the Art of Laughter*. Berkeley: University of California Press, 2006.

Goodman, Elise. *Rubens: The Garden of Love as "Conversatie à la Mode."* Amsterdam, Netherlands: Benjamins, 1992.

Greenaway, Peter. *Nightwatching*. Paris: Dis Voir, 2006.

Grimm, Claus. *Frans Hals: The Complete Work*. Translated by Jürgen Riehle. New York: H. N. Abrams, 1990.

Grosshans, Rainald. *Maerten van Heemskerck: die Gemälde*. Berlin: Boettcher, 1980.

Hall, Edwin. *The Arnolfini Betrothal: Medieval Marriage and the Enigma of Van Eyck's Double Portrait*. Berkeley: University of California Press, 1994.

Hand, John Oliver. *Joos van Cleve: The Complete Paintings*. New Haven, Conn.: Yale University Press, 2004.

Harbison, Craig. *Jan Van Eyck: The Play of Realism*. London: Reaktion Books, 1991.

Harting Ursula, ed. *Gärten und Höfe der Rubenszeit: im Spiegel der Malerfamilie Brueghel und der Künstler um Peter Paul Rubens*. Munich: Hirmer, 2000.

Haverkamp Begemann, Egbert. *Rembrandt: The Nightwatch*. Princeton, N.J.: Princeton University Press, 1982.

Healy, Fiona. *Rubens and the Judgment of Paris: A Question of Choice*. Turnhout, Belgium: Brepols, 1997.

Hofmann, Gert. *The Parable of the Blind*. New York: Fromm International, 1986.

Hull, Vida Joyce. *Hans Memlinc's Paintings for the Hospital of St. John in Bruges*. New York: Garland, 1981.

Hulst, Roger Adolf d.' *Jacob Jordaens*. Translated by P. S. Falla. Ithaca, N.Y.: Cornell University Press, 1982.

Jaffé, David, and Elizabeth McGrath. *Rubens: A Master in the Making*. London: National Gallery & Yale University Press, 2005.

Judson, J. Richard, and Rudolf E. O. Ekartt. *Gerrit van Honthorst, 1592–1656*. Doornspijk, Netherlands: Davaco, 1999.

Kavaler, Ethan Matt. *Pieter Bruegel: Parables of Order and Enterprise*. Cambridge: Cambridge University Press, 1999.

Keith P. F. *Pieter Aertsen, Joachim Beuckelaer, and the Rise of Secular Painting in the Context of the Reformation*. New York: Garland, 1977.

Kemperdick, Stephan. *Der Meister von Flémalle: die Werkstatt Robert Campins und Rogier van der Weyden*. Turnhout, Belgium: Brepols, 1997.

Koch, Robert A. *Joachim Patinir*. Princeton, N.J.: Princeton University Press, 1968.

Koldewij, Jos, Paul Vandenbroeck, and Bernard Vermet, eds. *Hieronymous Bosch: The Complete Paintings and Drawings*. Translated by Ted Alkins. Ghent, Belgium: Ludion, 2001.

Koldewij, Jos, Bernard Vermet, and Barbera van Kooij, eds. . *Hieronymus Bosch: New Insights into His Life and Work*. Ghent, Belgium: Ludion, 2001.

Lammertse, Friso and Alejandro Vergara. *Peter Paul Rubens: The Life of Achilles*. Rotterdam: Museum Boijmans Van Beuningen & Museo Nacional del Prado, 2003.

Lawson, Susan. *Rubens*. London: Chaucer Press, 2006.

Marlier, Georges. *La Renaissance Flamande: Pierre Coeck d'Alost*. Brussels: R. Fink, 1966.

Martin, Gregory. *The Ceiling Decoration of the Banqueting Hall*. Edited by Arnout Balis. 2 vols. London: Harvey Miller, 2005.

McFarlane, K. B. *Hans Memlinc*. Edited by Edgar Wind and G. L. Harriss. Oxford: Clarendon Press, 1971.

Meadow, Mark A. *Pieter Bruegel the Elder's Netherlandish Proverbs and the Practice of Rhetoric*. Zwolle: Waanders, 2002.

Michelucci, Mauro. *François Duquesnoy: la fama e il sospetto*. Livorno: Editrice l'informazione, 2002.

Mieder, Wolfgang, ed. *The Netherlandish Proverbs: An International Symposium on Pieter Brueg(h)ls*. Burlington: University of Vermont, 2004.

Musée Communal. *Rogier van der Weyden [Rogier de le Pasture]: Official Painter to the City of Brussels, Portrait Painter of the Burgundian Court*. Brussels, Belgium: Crédit communal de Belgique, 1979.

Nadler, Steven M. *Rembrandt's Jews*. Chicago: University of Chicago Press, 2003.

Nicolson, Benedict. *Hendrick Terbrugghen*. London: L. Humphries, 1958.

Pächt, Otto. *Van Eyck and the Founders of Early Netherlandish Painting*. Edited by Maria Schmidt-Dengler. Translated by David Brittm. London: H. Miller, 1994.

Paleis der Academiën. *Rogier van der Weyden en zijn tijd: internationaal colloquium, 11–12 juni 1964 [Roger van der Weyden et son époque: colloque international, 11–12 juin 1964]*. Brussels, Belgium: Paleis der Academiën, 1974.

Panhans-Bühler, Ursula. *Eklektizismus und Originalität im Werk des Petrus Christus*. Vienna: Holzhausen, 1978.

Papi, Gianni. *Gherardo delle Notti: Gerrit Honthorst in Italia*. Soncino, Cremona: Edizioni dei Soncino, 1999.

Philip, Lotte Brand. *The Ghent Altarpiece and the Art of Jan van Eyck*. Princeton, N.J.: Princeton University, 1971.

Purtle, Carol J. *The Marian Paintings of Jan van Eyck*. Princeton, N.J.: Princeton University Press, 1982.

Puyvelde, Leo van. *L'Agneau mystique d'Hubert et Jean van Eyck*. Brussels, Belgium: Meddens, 1964.

Rembert, Virginia. *Bosch: Hieronymus Bosch and the Lisbon Temptation: A View from the 3rd Millennium*. New York: Parkstone Press, 2004.

Roberts-Jones, Philippe, and Françoise Roberts-Jones. *Pieter Bruegel*. New York: Harry N. Abrams, 2002.

Rocquet, Claude Henri. *Bruegel or the Workshop of Dreams*. Translated by Nora Scott. Chicago: University of Chicago Press, 1991.

Rolin, Dominique. *Divine Madman*. Translated by Elaine L. Corts. New York: Peter Lang, 2006.

Roosen-Runge, Heinz. *Die Rolin-Madonna des Jan van Eyck: Form und Inhalt*. Wiesbaden, Germany: L. Reichert, 1972.

Rooth, Anna Birgitta. *Exploring the Garden of Delights: Essays in Bosch's Paintings and the Medieval Mental Culture*. Helsinki, Finland: Suomalainen Tiedeakatemia, 1992.

Rosenthal, Lisa. *Gender, Politics, and Allegory in the Art of Rubens*. Cambridge: Cambridge University Press, 2005.

Sander, Jochen. *Hugo van der Goes: Stilentwicklung und Chronologie*. Mainz, Germany: P. von Zabern, 1992.

Scallen, Catherine B. *Rembrandt, Reputation, and the Practice of Connoisseurship*. Amsterdam: Amsterdam University Press, 2004.

Schatborn, Peter. *Rembrandt*. Milan: 5 Continents, 2006.

Schwartz, Gary. *The Rembrandt Book*. New York: Abrams, 2006.

Seidel, Linda. *Jan Van Eyck's Arnolfini Wedding Portrait: Stories of an Icon*. Cambridge: Cambridge University Press, 1993.

Silver, Larry. *Hieronymus Bosch*. New York: Abbeville, 2006.

———. *The Paintings of Quentin Massys with Catalogue Raisonné*. Oxford: Phaidon, 1984.

Slive, Seymour. *Frans Hals*. Munich: Prestel-Verlag, 1989.

Smith, Elise Lawton. *The Paintings of Lucas van Leyden: A New Appraisal, with Catalogue Raisonné*. Columbia: University of Missouri Press, 1992.

Snow, Edward A. *Inside Bruegel: The Play of Images in Children's Games*. New York: North Point Press, 1997.

Stechow, Wolfgang. *Pieter Bruegel the Elder*. New York: H. N. Abrams, 1990.

Straten, Roelof van. *Young Rembrandt: The Leyden Years, 1606–1632*. Leiden, Netherlands: Foleor, 2005.

Strong, Roy. *Van Dyck: Charles I on Horseback*. New York: Viking Press, 1972.

Sullivan, Margaret A. *Bruegel's Peasants: Art and Audience in the Northern Renaissance*. Cambridge: Cambridge University Press, 1994.

Thürlemann, Felix. *Robert Campin: A Monographic Study with Critical Catalogue*. Munich: Prestel, 2002.

Tümpel, Astrid. *Rembrandt: Images and Metaphors*. London: Haus, 2006.

Upton, Joel M. *Petrus Christus: His Place in Fifteenth-Century Flemish Painting.* University Park: Pennsylvania State University Press, 1990.

Veldman, Ilja M. *Maarten van Heemskerck and Dutch Humanism in the Sixteenth Century.* Translated by Michael Hole. Maarsen, Netherlands: G. Schwartz, 1977.

Vergara, Alejandro. *Rubens: The Adoration of the Magi.* Madrid: Museo Nacional del Prado & Paul Holberton, 2004.

———. *Rubens and His Spanish Patrons.* Cambridge: Cambridge University Press, 1999.

Vlieghe, Hans, ed. *Van Dyck, 1599–1999: Conjectures and Refutations.* Turnhout, Belgium: Brepols, 2001.

Vos, Dirk de. *Rogier van der Weyden: The Complete Works.* New York: Harry N. Abrams, 1999.

Wallen, Burr. *Jan van Hemessen: An Antwerp Painter between Reform and Counter-Reform.* Ann Arbor, Mich.: UMI Research Press, 1983.

Wallert, Arie, Gwen Tauber, and Lisa Murphy. *The Holy Kinship: A Medieval Masterpiece.* Zwolle, Netherlands: Waanders & Rijksmuseum, 2001.

Westermann, Mariët. *Rembrandt.* London: Phaidon, 2000.

Wetering, Ernst van de, and Bernhard Schnackenburg. *The Mystery of the Young Rembrandt.* Wolfratshausen, Germany: Edition Minerva, 2001.

Winkel, Marieke de. *Fashion and Fancy: Dress and Meaning in Rembrandt's Paintings.* Amsterdam, Netherlands: Amsterdam University Press, 2006.

Winkler, Friedrich. *Das Werk des Hugo van der Goes.* Berlin: De Gruyter, 1964.

Woollett, Anne T., and Ariane van Suchtelen. *Rubens and Brueghel: A Working Friendship.* Los Angeles: J. Paul Getty Museum, The Hague Royal Picture Gallery, & Waanders Publishers, 2006.

Yiu, Ivonne. *Jan van Eyck: das Arnolfini-Doppelbildnis: Reflexionen über die Malerei.* Frankfurt, Germany: Stroemfeld, 2001.

Zell, Michael. *Reframing Rembrandt: Jews and the Christian Image in Seventeenth-Century Amsterdam.* Berkeley: University of California Press, 2002.

Zenker, Nina. *Jan van Eyck: die Madonna in der Kirche; Gemäldegalerie, Staatliche Museen zu Berlin Preussischer Kulturbesitz, Berlin-Tiergarten, Kulturforum, Matthäikirchplatz.* Berlin: Gebr. Mann & Heenemann, 2001.

VIII. GERMANY AND AUSTRIA

Bartrum, Giulia. *Albrecht Dürer and His Legacy: The Graphic Work of a Renaissance Artist.* Princeton, N.J.: Princeton University Press, 2002.

Bätschmann, Oskar, and Pascal Griener. *Hans Holbein.* Translated by Cecilia Hurley and Pascal Griener. Princeton, N.J.: Princeton University Press, 1997.

Bax, Dirk. *Hieronymus Bosch and Lucas Cranach, Two Last Judgement Triptychs: Description and Exposition.* Translated by M. A. Bax-Botha. Amsterdam: North-Holland, 1983.

Bianconi, Piero. *Konrad Witz.* Milan: Fratelli Fabbri, 1965.

Buck, Stephanie. *Hans Holbein the Younger, 1497/98–1543: Portraitist of the Renaissance.* The Hague: Royal Cabinet of Paintings Mauritshuis and Waanders, 2003.

Buck, Stephanie, and Jochen Sander. *Hans Holbein the Younger: Painter at the Court of Henry VIII.* New York: Thames & Hudson, 2004.

Burkhard, Arthur. *Matthias Grünewald: Personality and Accomplishment.* New York: Hacker Art Books, 1976.

———. *The St. Florian Altar of Albrecht Altdorfer.* Munich: F. Bruckmann KG, 1970.

———. *The St. Wolfgang Altar of Michael Pacher.* Munich: F. Bruckmann KG, 1971.

Bussmann, Georg. *Manierismus im Spätwerk Hans Baldung Griens: die Gemälde der zweiten Strassburger Zeit.* Heidelberg, Germany: C. Winter, 1966.

Chapuis, Julien. *Stefan Lochner: Image Making in Fifteenth-Century Cologne.* Turnhout, Belgium: Brepols, 2004.

Compte, Hubert. *Grünewald: Le retable d'Isenheim.* Sarreguemines, France: Pierron, 1999.

Eichberger, Dagmar, and Charles Zika, eds. *Dürer and His Culture.* Cambridge: Cambridge University Press, 1998.

Foister, Susan. *Holbein and England.* New Haven, Conn.: Yale University Press, 2004.

Foister, Susan, Ashok Roy, and Martin Wyld. *Holbein's Ambassadors.* London: National Gallery & Yale University Press, 1997.

Friedländer, Max J., and Jakob Rosenberg, eds. *The Paintings of Lucas Cranach.* Translated by Heinz Norden and Ronald Taylor. Ithaca, N.Y.: Cornell University Press, 1978.

Grimm, Claus, Johannes Erichsen, and Evamaria Brockhoff, eds. *Lucas Cranach: ein Maler-Unternehmer aus Franken.* Augsburg, Germany: Haus der Bayerischen Geschichte and F. Pustet, 1994.

Guillaud, Jacqueline, and Maurice Guillaud. *Altdorfer and Fantastic Realism in German Art.* Paris: Guillaud Editions, 1985.

Hayum, Andrée. *The Isenheim Altarpiece: God's Medicine and the Painter's Vision.* Princeton, N.J.: Princeton University Press, 1989.

Heck, Christian. *Grünewald and the Isenheim Altar.* Translated by Sudeshna André and Valérie Katzaros. Colmar, France: A. S. E. P., 1987.

Holm, Bevers, and Ger Luijten, eds. *Albrecht and Erhard Altdorfer.* Rotterdam, Netherlands: Sound and Vision Interactive, 1997.

Hutchinson, Jane Campbell. *Albrecht Dürer: A Biography*. Princeton, N.J.: Princeton University Press, 1990.

Jansen, Reinhild. *Albrecht Altdorfer: Four Centuries of Criticism*. Ann Arbor, Mich.: UMI Research Press, 1980.

Kantor, Jordan. *Dürer's Passions*. Cambridge, Mass.: Harvard University Press, 2000.

Koepplin, Dieter, and Tilman Falk. *Lukas Cranach: Gemälde, Zeichnungen, Druckgraphik: Ausstellung im Kunstmuseum Basel, 15. Juni–8. September 1974*. Basel, Switzerland: Birkhäuser, 1974.

Koerner, Joseph Leo. *The Moment of Self-Portraiture in German Renaissance Art*. Chicago: University of Chicago Press, 1993.

Luber, Katherine Crawford. *Albrecht Dürer and the Venetian Renaissance*. Cambridge: Cambridge University Press, 2005.

Marx, Harald, and Ingrid Mössinger. *Cranach*. Cologne, Germany: Wienand, 2005.

Mellinkoff, Ruth. *The Devil at Isenheim: Reflections of Popular Belief in Grünewald's Altarpiece*. Berkeley: University of California Press, 1988.

Mende, Matthias. *Albrecht Dürer: ein Künstler in seiner Stadt*. Nuremberg, Germany: W. Tümmels, 2000.

Minott, Charles Ilsley. *Martin Schongauer*. New York: Collectors Editions, 1971.

Müller, Christian. *Hans Holbein the Younger: The Basel Years*. Munich: Prestel, 2006.

Nochlin, Linda. *Mathis at Colmar: A Visual Confrontation*. New York: Red Dust, 1963.

North, John David. *The Ambassadors Secret: Holbein and the World of the Renaissance*. London: Hambledon & London, 2002.

Osten, Gert von der. *Hans Baldung Grien: Gemälde und Dokumente*. Berlin: Deutscher Verlag für Kunstwissenschaft, 1983.

Panofsky, Erwin. *The Life and Art of Albrecht Dürer*. Princeton, N.J.: Princeton University Press, 2005.

Price, David. *Albrecht Dürer's Renaissance: Humanism, Reformation, and the Art of Faith*. Ann Arbor: University of Michigan Press, 2003.

Reichenauer, Berta. *Der Altar zu St. Wolfgang von Michael Pacher*. Thaur, Austria: Druck & Verlagshaus Thaur, 1998.

Roberts, Jane. *Holbein*. London: Chaucer, 2005.

Roskill, Mark, and John Oliver Hand, eds. *Hans Holbein: Paintings, Prints, and Reception*. Washington, D.C.: Washington National Gallery & Yale University Press, 2001.

Saran, Bernhard. *Matthias Grünewald, Mensch und Weltbild; das Nachlass-Inventar, der Kemenaten-Prozess, der Heller-Altar*. Munich: W. Goldmann, 1972.

Schade, Werner. *Cranach: A Family of Master Painters.* Translated by Helen Sebba. New York: Putnam, 1980.

Schoch, Rainer, Matthias Mende, and Anna Scherbaum. *Albrecht Dürer: das druckgraphische Werk.* Munich: Prestel, 2001.

Schröder, Klaus Albrecht, and Maria Luise Sternath, eds. *Albrecht Dürer.* Ostfildern-Ruit, Germany: Hatje Cantz, 2003.

Smith, David. *Realism and Invention in the Prints of Albrecht Dürer.* Durham: University of New Hampshire, 1995.

Stepanov, Alexander. *Lucas Cranach the Elder, 1472–1553.* Edited by Tatyana Mordkova and Valery Fateyev. Translated by Paul Williams. Bournemouth, U.K.: Parkstone, 1997.

Winzinger, Frans. *Die Zeichnungen Martin Schongauers.* Berlin: Deutscher Verein für Kunstwissenschaft, 1962.

Wood, Christopher S. *Albrecht Altdorfer and the Origins of Landscape.* Chicago: University of Chicago Press, 1993.

Zehnder, Frank Günter, ed. *Stefan Lochner, Meister zu Köln: Herkunft, Werke, Wirkung, eine Ausstellung des Wallraf-Richartz-Museums Köln.* Cologne, Germany: Das Museum & Verlag Locher, 1993.

Zwingenberger, Jeanette. *The Shadow of Death in the Work of Hans Holbein the Younger.* London: Parkstone Press, 1999.

IX. FRANCE

Averill, Esther Holden. *Eyes on the World; The Story & Work of Jacques Callot: His Gypsies, Beggars, Festivals, "Miseries of War," and Other Famous Etchings and Engravings, Together with an Account of His Days.* New York: Funk & Wagnalls, 1969.

Avril, François, ed. *Jean Fouquet: Peintre et enlumineur du XVe siècle.* Paris: Bibliothèque nationale de France and Hazan, 2003.

Babelon, Jean-Pierre, and Claude Mignot, eds. *François Mansart: le génie de l'architecture.* Paris: Gallimard, 1998.

Beresford, Richard. *A Dance to the Music of Time by Nicolas Poussin.* London: Trustees of the Wallace Collection, 1995.

Bernstock, Judith E. *Poussin and the French Dynastic Ideology.* New York: Peter Lang, 2000.

Blunt, Anthony. *Philibert de l'Orme.* London: A. Zwemmer, 1958.

Brejon de Lavergnée, Barbara, Geneviève Bresc-Bautier, and Françoise de La Moureyre, eds. *Jacques Sarazin, sculpteur du roi, 1592–1660: Musée du Noyonnais, 5 juin 1992–14 août 1992.* Paris: Réunion des musées nationaux and Musée du Noyonnais, 1992.

Cazelles, Raymond. *Illuminations of Heaven and Earth: The Glories of the Très Riches Heures du duc de Berry*. Translated by Theodore Swift Faunce and I. Mark Paris. New York: H. N. Abrams, 1988.

Chauleur, Andrée, and Pierre-Yves Louis. *François Mansart, les bâtiments: marchés de travaux (1623–1665)*. Paris: C.H.A.N. & Champion, 1998.

Conisbee, Philip. *Georges de La Tour and His World*. Washington, D.C.: National Gallery & Yale University Press, 1996.

Coope, Rosalys. *Salomon de Brosse and the Development of the Classical Style in French Architecture from 1565 to 1630*. University Park: Pennsylvania State University Press, 1972.

Cropper, Elizabeth. *Nicolas Poussin: Friendship and the Love of Painting*. Princeton, N.J.: Princeton University Press, 1996.

Daniel, Howard, ed. *Callot's Etchings*. New York: Dover, 1974.

Dückers, Rob, and Pieter Roelofs. *The Limbourg Brothers: Nijmegen Masters at the French Court, 1400–1416*. Nijmegen, Holland: Ludion, 2005.

Gady, Alexandre. *Jacques Lemercier: architecte et ingénieur du Roi*. Paris: Maisons des sciences de l'homme, 2005.

Green, Tony. *Nicolas Poussin Paints the Seven Sacraments Twice*. Somerset, U.K.: Paravail, 2000.

Ivanoff, Nicola. *Valentin de Boulogne*. Milan: Fratelli Fabbri, 1966.

Kahan, Gerald. *Jacques Callot: Artist of the Theater*. Athens: University of Georgia Press, 1976.

Kren, Thomas, and Mark Evans, eds. *A Masterpiece Reconstructed: The Hours of Louis XII*. Los Angeles: J. Paul Getty Museum, British Library, & Victoria and Albert Museum, 2005.

Lieure, Jules. *Jacques Callot*. 8 vols. New York: Collectors Editions, 1969.

Mahon, Denis. *Nicolas Poussin: Works from His First Years in Rome*. Jerusalem: Israel Museum and Quadri e Sculture, 1999.

Marin, Louis. *Sublime Poussin*. Stanford, Calif.: Stanford University Press, 1999.

McTighe, Sheila. *Nicolas Poussin's Landscape Allegories*. Cambridge: Cambridge University Press, 1996.

Meiss, Millard. *French Painting in the Time of Jean de Berry; The Boucicaut Master*. London: Phaidon, 1968.

———. *French Painting in the Time of Jean de Berry: The Limbourgs and Their Contemporaries*. London: Thames & Hudson, 1974.

Mellen, Peter. *Jean Clouet: Complete Edition of the Drawings, Miniatures, and Paintings*. London: Phaidon, 1971.

Mérot, Alain. *Eustache Le Sueur (1616–1655)*. Paris: Arthena, 1987.

Mojana, Marina. *Valentin de Boulogne*. Milan: Eikonos, 1989.

Morand, Kathleen. *Jean Pucelle*. Oxford: Clarendon Press, 1962.

Musée du Louvre. *Primatice: maître de Fontainebleau, Paris, Musée du Louvre, 22 septembre 2004–3 janvier 2005*. Paris: Réunion des Musées Nationaux, 2004.

Musée Historique Lorrain. *Jacques Callot, 1592–1635: Musée historique Lorrain, Nancy, 13 juin–14 septembre 1992*. Paris: Editions de la Réunion des Musées Nationaux, 1992.

Nicolson, Benedict, and Christopher Wright. *Georges de La Tour*. London: Phaidon Press, 1974.

Olson, Todd. *Poussin and France: Painting, Humanism, and the Politics of Style*. New Haven, Conn.: Yale University Press, 2002.

Pellegrini, Franca, ed. *Capricci gobbi amore guerra e bellezza: incisioni di Jacques Callot dalle raccolte del Museo d'arte di Padova*. Padua: Il poligrafo, 2002.

Pérouse de Montclos, Jean-Marie. *Philibert de l'Orme: architecte du roi, 1514–1570*. Paris: Mengès, 2000.

Reynaud, Nicole. *Jean Fouquet: Catalogue*. Paris: Éditions de la Réunion des Musées Nationaux, 1981.

Rosenberg, Pierre. *Tout l'œuvre peint des Le Nain*. Paris: Flammarion, 1993.

Rosenberg, Pierre, and Jacques Thuillier. *Laurent de la Hyre, 1606–1656*. Paris: Galerie de Bayser and Ars Libri, 1985.

Svereva, Alexandra. *Les Clouet de Catherine de Médicis: chefs-d'œuvre graphiques du Musée Condé*. Paris: Somogy & Musée Condé, 2002.

Thuillier, Jacques. *Les frères Le Nain: exposition organisée par la Réunion des Musées Nationaux, Grand Palais, 3 octobre 1978–8 janvier 1979*. Paris: Ministère de la culture et de la communication, Éditions de la Réunion des Musées Nationaux, 1978.

———. *Georges de La Tour*. Translated by Fabia Claris. Paris: Flammarion, 1993.

———. *Nicolas Poussin*. Paris: Flammarion, 1994.

Unglaub, Jonathan. *Poussin and the Poetics of Painting: Pictorial Narrative and the Legacy of Tasso*. Cambridge: Cambridge University Press, 2006.

Verdi, Richard. *Nicolas Poussin, 1594–1665*. London: Zwemmer and Royal Academy of Arts, 1995.

Vitzhum, Walter. *Jean Goujon*. Milan: Fratelli Fabbri, 1966.

Wieck, Roger S., William M. Voelkle, K. Michelle Hearne, eds. *The Hours of Henry VIII: A Renaissance Masterpiece by Jean Poyet*. New York: George Braziller, 2000.

X. ENGLAND

Anderson, Christy. *Inigo Jones and the Classical Tradition*. Cambridge: Cambridge University Press, 2007.

Buck, Stephanie, and Jochen Sander. *Hans Holbein the Younger: Painter at the Court of Henry VIII*. New York: Thames & Hudson, 2004.

Donovan, Fiona. *Rubens and England*. New Haven, Conn.: Yale University Press, 2004.

Foister, Susan. *Holbein and England*. New Haven, Conn.: Yale University Press, 2004.

Foister, Susan, Ashok Roy, and Martin Wyld. *Holbein's Ambassadors*. London: National Gallery & Yale University Press, 1997.

Leapman, Michael. *Inigo: The Troubled Life of Inigo Jones, Architect of the English Renaissance*. London: Review, 2003.

Martin, Gregory. *The Ceiling Decoration of the Banqueting Hall*. Edited by Arnout Balis. 2 vols. London: Harvey Miller, 2005.

Millar, Oliver. *Van Dyck in England*. London: National Portrait Gallery, 1982.

North, John David. *The Ambassadors Secret: Holbein and the World of the Renaissance*. London: Hambledon & London, 2002.

Piper, David. *Catalogue of Seventeenth-Century Portraits in the National Portrait Gallery, 1625–1714*. Cambridge: Cambridge University Press & National Portrait Gallery, 1963.

Rogers, Malcolm. *William Dobson, 1611–1646*. London: National Portrait Gallery, 1983.

Strong, Roy. *Van Dyck: Charles I on Horseback*. New York: Viking Press, 1972.

Summerson, John. *Inigo Jones*. New Haven, Conn.: Yale University Press, 2000.

White, Christopher. *Anthony van Dyck: Thomas Howard, the Earl of Arundel*. Malibu, Calif.: J. Paul Getty Museum, 1995.

XI. SPAIN AND PORTUGAL

Baticle, Jeannine. *Zurbarán*. New York: Metropolitan Museum of Art, 1987.

Bermejo Martínez, Elisa. *Juan de Flandes*. Madrid: Consejo Superior de Investigaciones Científicas, Instituto Diego Velázquez, 1962.

———. *La pintura de los primitivos flamencos en España*. Madrid: Consejo Superior de Investigaciones Científicas, Instituto Diego Velázquez, 1980.

Boyd, Jane, and Philip F. Esler. *Visuality and Biblical Text: Interpreting Velázquez' Christ with Martha and Mary as a Test Case*. Florence: L. S. Olschki, 2004.

Brown, Jonathan. *Francisco de Zurbarán*. New York: H. N. Abrams, 1974.

———. *Velázquez: The Technique of Genius*. New Haven, Conn.: Yale University Press, 1998.

Calvo Serraller, F. *The Burial of the Count of Orgaz*. New York: Thames & Hudson, 1995.

Carr, Dawson W. *Velázquez*. London: National Gallery, 2006.

Dal Poggetto, Paolo. *Urbino 1470–1480 circa: "Omaggio a Pedro Berruguete" e altro*. Urbino: Quattro venti, 2003.

Davies, David, and Enriqueta Harris. *Velázquez in Seville*. Edinburgh: National Galleries of Scotland & Yale University Press, 1996.

Domenech, Fernando Benito. *The Paintings of Ribalta, 1565–1628*. Translated by Suzanne L. Stratton. New York: Spanish Institute, 1988.

———. *Los Ribalta y la pintura valenciana de su tiempo, Lonja de Valencia, octubre-noviembre 1987: Museo del Prado, Palacio de Villahermosa, diciembre 1987–enero 1988*. Madrid: El Museo, 1987.

Domínguez Ortíz, Antonio, Alfonso E. Pérez Sánchez, and Julían Gállego. *Velázquez*. New York: Metropolitan Museum of Art, 1989.

Felton, Craig, and William B. Jordan, eds. *Jusepe de Ribera, lo Spagnoletto, 1591–1652*. Fort Worth, Tex.: Kimbell Art Museum, 1982.

Justi, Carl. *Diego Velázquez and His Times*. London: Parkstone, 2006.

Kowal, David M. *Francisco Ribalta and His Followers: A Catalogue Raisonné*. New York: Garland, 1985.

Kubler, George. *Building the Escorial*. Princeton, N.J.: Princeton University Press, 1982.

López-Rey, José. *Velázquez*. Cologne, Germany: Taschen & Wildenstein Institute, 1996.

Markl, Dagoberto L. *O essencial sobre Nuno Gonçalves*. Lisbon: Imprensa Nacional-Casa da Moeda, 1987.

Molina Figueras, Joan. *Bernat Martorell i la tardor del gòtic català: el context artístic del retaule de Púbol*. Girona, Spain: Museu d'Art de Girona, 2003.

Moreno Mendoza, Arsenio. *Zurbarán*. Madrid: Electa, 1998.

Mulcahy, Rosemarie. *The Decoration of the Royal Basilica of El Escorial*. Cambridge: Cambridge University Press, 1994.

Museo del Prado. *Alonso Sánchez Coello y el retrato en la corte de Felipe II: Junio/Julio 1990*. Madrid: Museo del Prado, 1990.

Museo e Instituto Camón Aznar. *Navarrete "el Mudo": pintor de Felipe II: 14 junio–16 julio 1995, Centro de Exposiciones y Congresos y Museo "Camón Aznar," Zaragoza*. Logroño, Spain: Cultural Rioja, Gobierno de La Rioja, Ayuntamiento de Logroño and Patrimonio Nacional, 1995.

Museu Nacional d'Art de Catalunya. *La pintura gótica hispanoflamenca: Bartolomé Bermejo y su época, Museu Nacional d'Arte de Catalunya, Barcelona, 26 de febrero-11 de mayo de 2003, Museo de Bellas Artes de Bilbao, 9 de junio–31 de agosto de 2003*. Barcelona: Museu Nacional d'Art de Catalunya and Museo de Bellas Artes de Bilbao, 2003.

Orso, Steven N. *Velázquez, Los Borrachos, and Painting at the Court of Philip IV*. Cambridge: Cambridge University Press, 1993.

Pérez Sánchez, Alfonso E., and Benito Navarrete Prieto, eds. *De Herrera a Velázquez: el primer naturalismo en Sevilla*. Seville: Focus Abengoa & Museo de Bellas Artes de Bilboa, 2005.

Prater, Andreas. *Venus at Her Mirror: Velázquez and the Art of Nude Painting.* Munich: Prestel, 2002.

Quinn, Robert M. *Fernando Gallego and the Retablo of Ciudad Rodrigo. Version española de Renato Rosaldo.* Tucson: University of Arizona Press, 1961.

Salort Pons, Salvador. *Velázquez en Italia.* Madrid: Fundación de Apoyo a la Historia del Arte Hispánico, 2002.

Silva Maroto, María Pilar. *Pedro Berruguete.* Valladolid, Spain: Junta de Castilla y León, Consejería de Educación y Cultura, 2001.

Spinosa, Nicola. *Ribera.* Naples: Electa Napoli, 2003.

Stratton-Pruitt, Suzanne L., ed. *Velázquez's Las Meninas.* Cambridge: Cambridge University Press, 2003.

Vergara, Alejandro. *Rubens and His Spanish Patrons.* Cambridge: Cambridge University Press, 1999.

Volk, Mary Crawford. *Vicencio Carducho and Seventeenth-Century Castillian Painting.* New York: Garland, 1977.

Wind, Barry. *Velázquez's Bodegones: A Study in Seventeenth-Century Spanish Genre Painting.* Fairfax, Va.: George Mason University Press, 1987.

About the Author

Lilian H. Zirpolo received her PhD in art history from Rutgers University, New Jersey, in 1994. She specializes in the art of early modern Italy and Spain, with particular emphasis on Rome and patronage and gender issues. She has published extensively on these subjects at venues such as *Architectura: Zeitschrift fur Geschichte der Baukunst, Agustinian Studies, The Seventeenth Century Journal, Gazette des Beaux-Arts*, and the *Woman's Art Journal*. She is a frequent book reviewer for the *Woman's Art Journal, Renaissance Quarterly, Art History*, and *Sixteenth Century Studies Journal*. Her book, *Ave Papa/Ave Papabile: The Sacchetti Family, Their Art Patronage, and Political Aspirations*, for which she received a Samuel H. Kress Publication grant, was published in 2005. She is working on two new books, one on the art collecting activities of Queen Christina of Sweden and the other on Renaissance and Baroque ceiling paintings in Rome. She is also cofounder and president of the WAPACC Organization and cofounder, coeditor, and copublisher of *Aurora, the Journal of the History of Art*.